501 GREAT ARTISTS

GENERAL EDITOR STEPHEN FARTHING

BARRON'S

First edition for the United States and Canada
published in 2008 by Barron's Educational Series, Inc.

A Quint**essence** Book

ISBN-13: 978-0-7641-6133-9
ISBN-10: 0-7641-6133-4
QSS.FAR

Library of Congress Control Number: 2007906895

All inquiries should be addressed to:
Barron's Educational Series, Inc.
250 Wireless Boulevard
Hauppauge, NY 11788
www.barronseduc.com

This book was designed and produced by
Quint**essence**
226 City Road
London EC1V 2TT

Project Editors	Victoria Wiggins, Chrissy Williams
Editors	Rebecca Gee, Lucinda Hawksley
Picture Researcher	Jo Walton
Designer	Rod Teasdale
Editorial Director	Jane Laing
Publisher	Tristan de Lancey

Color reproduction in Singapore by Pica Digital Pte Ltd.
Printed in China by SNP Leefung Printers Ltd.
9 8 7 6 5 4 3 2 1

CONTENTS

CONTENTS

FOREWORD

By Geoff Dyer

No van Gogh? No Leonardo? No Poussin? It's just unbelievable.

Only joking. They're all here, prominently, along with 498 of their colleagues and rivals.

The question you are bound to ask at the beginning of this book—and possibly at the end as well—is whether 501 is a lot, or not very many at all. It sounds a lot. There are quite a few artists in these pages I'd not even heard of—and still more whose names I recognized but whose works I'd never seen. This combination of familiarity and surprise will, I suspect, be shared by many readers and is undoubtedly one of the pleasures of the experience of reading the book.

The reach is chronologically and geographically vast. We begin in China over a thousand years ago and end, in Iran, with an artist born in 1974—a welcome reminder that the word "artists" is not invisibly or tacitly preceded, either in the book's title or its conception, by the word "western."

It's a commonplace that art does not get better over time (strangely, it is sometimes hard to keep faith with the corollary of this, namely that art does not get worse over time either). In their way, some of the earliest art works ever made have a primal power that is unsurpassable. What changes is the way in which that high quality or standard manifests itself.

Subject to historical fluctuation, we find at various times that the art of a particular period—or a particular artist—seems more in synch with the present moment than that of others. Nevertheless, there would be broad agreement about Stephen Farthing's choice of artists from the past: in a sense this is tautologous. With the passage of time, artists who have not secured a place in the canon simply drop from view. Inevitably, things get more uncertain as we move toward the closing pages, and start thinking about how the art world at present might look to someone compiling a similar book in two hundred years. Even as we speak, artists are duking it out, hoping to get the last few places on this lifeboat to posterity. At which point the question—is 501 a little or a lot?—is rephrased: are these 501 not only great, but the greatest?

Geoff Dyer
London, England, June 2008
ICP Infinity Award for Writing on Photography

INTRODUCTION

By Stephen Farthing, General Editor

When Paul Cezanne said, "The man must remain obscure, the pleasure must be found in the work," he was probably imagining a time when the audience became so interested in the lives of artists, that their art became nothing more than a slide show. I suspect, however, that the weighing of the worth of the object against its maker has always been an important part of the game, and that the personalities and lifestyles of some artists have excited their patrons just as much as, if not more than, the art they purchased.

This said, it is clearly possible to live with, love and enjoy art in the absence of art history—that is, without knowing the when, where, how, why, or even who. Relatively few people will immediately know which Spanish artist painted *The Metamorphosis of Narcissus*, but many will know his name—Salvador Dalí. In the end, art history boils down to people: writers, patrons, collectors, artists, and then finally the audience— without the people there is no art.

Although it started life that way, *501 Great Artists* is more than a list of names; it is a narrative that describes the changing face of art by simply setting out in chronological order the stories of some of the people who have made it.

Whether in Vasari's renaissance bestseller, *The Lives of The Most Excellent Painters, Sculptors & Architects*, or the *London Evening Standard*, the more we are exposed to an artist's name, the more we accept it as a part of the story. Artists' lives are often intriguing, but other than to a loved one or family, the life will be less important than the work that is left behind.

It is however important that critics, historians, patrons, and collectors maintain an interest in owning and writing about what's left, because that's how artists make it into and sustain their position in the lists that are the start of every exhibition and story of art; what art critic Irving Sandler referred to as "sweeping up after artists."

The final word on the matter, I think, should go to an artist who has secured his name on most people's list for all time: "If people knew how hard I worked to get my mastery, it wouldn't seem so wonderful at all."—Michelangelo.

Stephen Farthing
Amagansett, New York, U.S., January 2008
Rootstein Hopkins Professor of Drawing

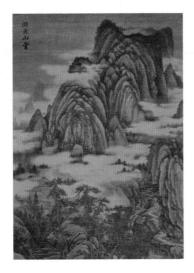

DONG YUAN

Born: Dong Yuan, *c.*900 (Zhongling, Jiangxi, China); died *c.*962 (Zhongling, Jiangxi, China).

Artistic style: Founder of Southern School of Chinese landscape painting; *shan shui* genre; monochrome color; hemp fiber and dot-shading techniques.

Masterworks

The Xiao and Xiang Rivers c.950
 (Palace Museum, Beijing, China)

Summer Mountains c.950
 (Shanghai Museum, Shanghai, China)

Wintry Groves and Layered Banks c.950
 (Kurokawa Institute of Ancient Cultures, Hyogo, Japan)

Dong Yuan was the leading exponent of what became known as the Southern School of landscape painting. Very little is known about his life, but his art has survived and Dong Yuan remains an influential and legendary artist.

In China, traditional painting developed as an offshoot of calligraphy: ink brushwork applied to walls, paper, or silk scrolls. From the earliest surviving examples on tomb walls through to the seventh century, painting content had been primarily figural and representative. This began to change during the Tang Dynasty (618–907), when a more meditative art focusing on the natural world began to emerge.

The landscape genre came to be held as the paradigm of Chinese painting and reached its maturity during the turbulence of the Five Dynasties era (907–960), when Dong Yuan was active. Although he also worked in the "blue and green" style characteristic of the Tang era, Yuan is most famous for his monochrome *shan shui* (mountain-water) images. With long, damp brushstrokes and wet ink washes, he created tranquil, dreamlike panoramas inspired by the topography of the lush Yangtze River basin. He was also renowned for his figure paintings and for his teaching. He went into partnership with his most famous pupil, Ju Ran, founding together the Southern School of landscape painting. This name is not the one they gave their school; it seems to have been applied by a later art historian, who saw their style as markedly different from that of artists he dubbed the "Northern School." Dong Yuan's elegant brushwork, innovative shading techniques, and sophisticated use of deep perspective revealed new possibilities and set an aesthetic ideal that was to be much admired and imitated in centuries to come. **RB**

"Dong Yuan exudes artless tranquility and natural perfection . . ."—Mi Fu

ABOVE: Clouds lay heavy throughout *Mansions in the Mountains of Paradise.*

RIGHT: *Along The Riverbank at Dusk* shows a well-developed use of perspective.

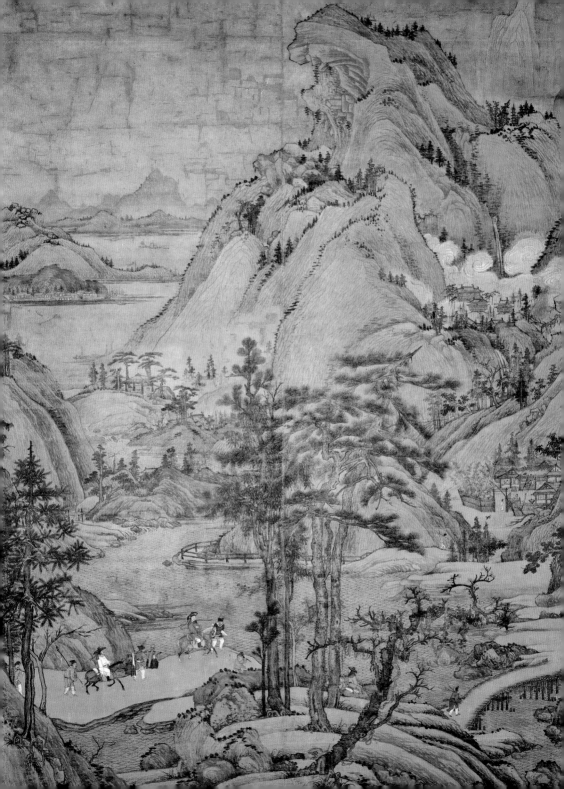

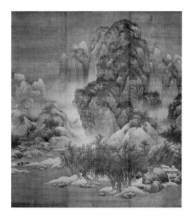

Masterworks

Winter Landscape with Temples and Travelers c.1000 (Museum of Fine Arts, Boston, U.S.)

Temple Among Snowy Hills c.1000 (Museum of Fine Arts, Boston, U.S.)

Travelers Among Mountains and Streams c.1010 (National Palace Museum, Taipei, Taiwan)

"... better than [learning from nature or man] is the way of learning from my own heart."

ABOVE: *Snowy Landscape* draws the viewer's gaze to the wonders of nature.

FAN KUAN

Born: Fan Kuan, c.990 (Hua Xian, China); died c.1030 (China).

Artistic style: Landscape painter of monumental Northern School; monochrome brushwork on silk; raindrop stippling technique; snowscapes; deep, shifting perspectives.

Fan Kuan was a leading artist of what is known as the Northern School of Chinese landscape painting. Many details of his life have been lost in history as, sadly, have most of his works, and several paintings attributed to him cannot be proven, but his fame as one of the greats of the Northern School remains undiminished. Around the time of his birth, the chaotic upheavals of the Five Dynasties era (907–960) ended. Emperor Taizu of Song reunified China and, although the ensuing Song Dynasty (960–1279) could not match the golden age of the Tang Dynasty (618–907), it was, nevertheless, a period of tremendous progress, invention, and cultural richness.

One of the chief glories of the Song Dynasty, the Northern School worked principally in the Chinese heartlands north of the Yellow River. Most artists were influenced by native Taoism, but the reclusive Kuan spent much of his life wandering the mountains and river valleys of Shanxi province. Kuan's most famous painting (definitely attributed to him) is *Travelers Among Mountains and Streams* (c.1010). At nearly 7 feet (2 m) high it fully justifies its central place in the "master mountain" genre of the monumental landscape tradition. From the tiny figures and exquisitely rendered trees of the foreground, Kuan's composition engulfs the viewer and takes the eye through shifting perspectives, past rocky escarpments, and cascades toward the towering bulk of the central peak. An ethereal misty chasm at the mountain's base contributes to the illusion of immense scale and extreme depth, a powerful statement of the Taoist concept of *qi*—the spirit energy infusing and connecting all things. Kuan anticipated ideas that would only begin to be openly explored in Western art many centuries later. **RB**

MA YUAN

Born: Ma Yuan, c.1155 (Hangzhou, China); died 1235 (Hunan, China).

Artistic style: Synthesizer of Northern and Southern Schools of Chinese landscape painting; one-corner compositions; angular axe-cut brushstrokes; bold use of space.

The Ma family of court painters, of whom Ma Yuan is now the best known, were originally from the Shanxi province. They learned their craft from the monumental Northern School landscape tradition. The family's life and artistic style changed when the leaders of the Southern Song Dynasty (1127–1279) were challenged by the Jurchen tribes of Manchuria and forced to flee south of the Yangtze River. The whole Imperial Court, including the Ma family, followed their rulers to the south. The new region, of low-lying hills, pretty lakes, and lush greenery surrounding Hangzhou, demanded a different approach from the style of painting they had employed until now, and in Ma Yuan's mature work there is a synthesis of traditional styles that represents, with his contemporary Xia Gui, the apex of the golden age of Chinese landscape painting.

Yuan was nicknamed "One-Corner Ma" for his distinctive compositions, which organized their content around an axis from one corner and left large areas of empty space in the rest of the frame. Working in strong angular brushstrokes, soft color washes, and with a sure economy of detail, he created images of great subtlety and intimacy, all traits typical of the Southern School, bold evocations of limitless space, which retain the sense of Taoist mystery found in the works of the Northern School painters. Yuan was not a member of the intellectual literati class, and his work later drew criticism for being overly romantic and pandering to courtly decadence, but his example, and that of his son Ma Lin, was to prove enduringly popular. The Ma-Xia School was revived during the Ming Dynasty (1368–1644), and was emulated by the Kanō school of Japanese painters; in the West, Yuan is among the most famous of traditional Chinese painters. **RB**

Masterworks

*On a Mountain Path in Spring c.*1200 (National Palace Museum, Taipei, Taiwan)

*Scholar by a Waterfall c.*1200 (Metropolitan Museum of Art, New York, U.S.)

*Viewing Plum Blossoms by Moonlight c.*1200 (Metropolitan Museum of Art, New York, U.S.)

*Scholars Conversing Beneath a Plum Tree c.*1200 (Museum of Fine Arts, Boston, U.S.)

"[He] envelops his subject in an aura of feeling with an extreme economy of means."—James Cahill

ABOVE: Yuan's *Bare Willows and Distant Mountains* has a characteristic hazy tone.

CIMABUE

Born: Benciviene di Pepo, "Cimabue" (nickname), *c.*1240 (Florence, Italy); died *c.*1302 (Pisa, Italy).

Artistic style: Painter and mosaicist; worked in egg tempera on panel, fresco, and mosaics; Byzantine master who anticipated naturalism; possible teacher of Giotto.

Masterworks

*Crucifix c.*1268–1271 (Basilica of San Domenico, Arezzo, Italy)

*Madonna Enthroned with the Child, St. Francis and Four Angels c.*1278–1280 (Basilica of San Francesco d'Assisi, Assisi, Italy)

*The Madonna in Majesty c.*1285–1286 (Uffizi, Florence, Italy)

Relatively little is known about Cimabue. The most extensive account of his life was provided by Giorgio Vasari, writing some two hundred years after the artist's death. Cimabue's works are undated, some have been damaged, and their attribution has often been challenged, yet his impact on the development of Italian art cannot be overstated. Cimabue is seen as one of the most important, and most overlooked, of the early masters. He is commonly seen as the artistic driving force behind the shift from the strongly two-dimensional, early Byzantine tradition toward greater naturalism via his interest in perspective and the use of classical elements, drama, and emotion in his work.

The earliest work attributed to Cimabue is a *Crucifix* (*c.*1268-1271) in the Basilica of San Domenico, Arezzo. His approach to anatomy and muscle definition is still in its early stages, but the artist's interest in the Romanesque is evident in his attempt to

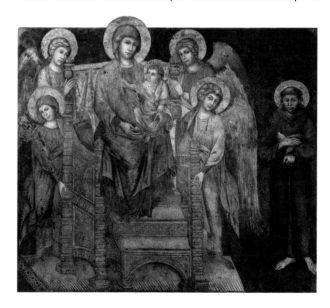

ABOVE: This portrait of Cimabue is one of only a few known images of the painter.

RIGHT: An example of Cimabue's *Maestàs,* marking an early step toward realism.

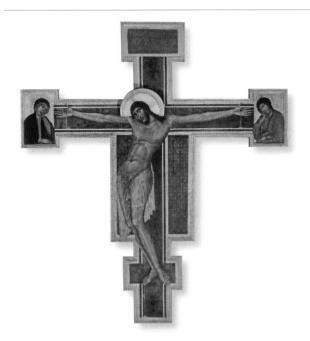

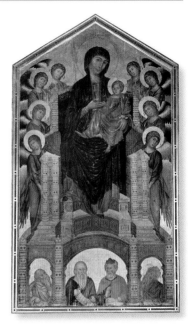

present monumental, smooth forms in a realistic manner. A badly damaged *Crucifix* (1287–1288) in the Basilica di Santa Croce, Florence, reflects a strongly naturalistic approach to figure painting, with subtle depiction of musculature, veins, bones, and sinews. Cimabue also addressed the subject of the crucifixion in a series of frescoes (*c.*1277–1280) in the Basilica of San Francesco d'Assisi. These depict scenes from the *Life of the Virgin* (in the choir), *The Evangelists* (crossing the vault), and the *Lives of the Apostles*; the use of illusionary perspective creates three-dimensional architectural effects, whereas the finely painted, classically conceived drapery evokes ancient Roman precedents. Cimabue invests his scenes of the crowds surrounding Christ on the cross, and the apocalyptic collapse of the city of Babylon, with a sense of high drama.

In 1302 Cimabue began work on a large mosaic of St. John in Pisa Cathedral and was commissioned to complete an altarpiece, but died later that year. His reputation was soon eclipsed by that of Giotto, who may have been his pupil. **TP**

ABOVE LEFT: *Crucifix* demonstrates a deepening understanding of anatomy.

ABOVE: *The Madonna in Majesty* was influenced by Byzantine art.

Cimabue in Purgatory

The Florentine poet Dante Alighieri was a contemporary of Cimabue and referred to him in several of his works, including *Purgatorio* (1308–1321) (*Purgatory*). According to Dante, Cimabue was so arrogant that if one of his works was criticized, he would refuse to continue it. Dante also commented that although Cimabue had led his field, his reputation was overshadowed by that of his alleged pupil, Giotto. An anecdote by Florentine artist Lorenzo Ghiberti recounts how Cimabue saw Giotto draw a single sheep, and, on the strength of that, invited Giotto to be his pupil.

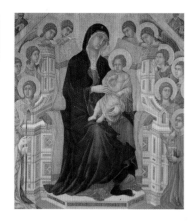

Masterworks

Rucellai Madonna begun 1285 (Uffizi, Florence, Italy)

Maestà 1288–1300 (Kunstmuseum, Bern, Switzerland)

*Madonna and Child c.*1300 (Metropolitan Museum of Art, New York, U.S.)

The Nativity with the Prophets Isaiah and Ezekiel 1308–1311 (National Gallery of Art, Washington, D.C., U.S.)

Maestà with Twenty Angels and Nineteen Saints 1308–1311 (Museo dell'Opera del Duomo, Siena, Italy)

*Triptych: The Virgin and Child, with Saints Dominic and Aurea c.*1315 (National Gallery, London, England)

"The Siena altarpiece . . . is magnificent . . . he was a most noble painter."—Lorenzo Ghiberti

ABOVE: Detail from *Maestà* of the Virgin Mary enthroned with the child and angels.

RIGHT: Eleven scenes from the story of the Passion, part of the monumental *Maestà*.

DUCCIO DI BUONINSEGNA

Born: Duccio di Buoninsegna, *c.*1255 (Siena, Italy); died *c.*1318 (Siena, Italy).

Artistic style: Sienese Gothic painter of religious works and altarpieces; exquisite colorist; innovative design and modeling; human emotion revealed through gesture and expression.

Although only two of Duccio di Buoninsegna's surviving paintings are authoritatively documented, both are testaments to the importance of this innovative artist. His earliest documented work, commissioned by a religious society in Florence for the church of Santa Maria Novella, is a large panel known as the *Rucellai Madonna* (*c.*1285). The central subject of the enthroned Madonna and Child broke with tradition in its convincing modeling of the Virgin's draped robes, naturalistic treatment of the Child, and assured way that Duccio situates the surrounding figures in three-dimensional space.

His most celebrated achievement was a complex double-sided altarpiece for Siena Cathedral, *Maestà with Twenty Angels and Nineteen Saints* (1308–1311). Although some panels are now dispersed across collections worldwide, a visit to what remains in Siena is enough to convince the viewer of the greatness of the artist. The front panels of the enormous altarpiece depict the Virgin and Child enthroned and surrounded by an audience of angels and saints. The main section of the reverse is divided into twenty-six scenes from the life of Christ in addition to the crowning panels and predella panels running along the bottom of the altarpiece. This would have been a test for any artist, but Duccio excelled at dealing with complex challenges. He used color and his innate sense of design to bring harmony to the composition. The result was revolutionary: his imaginative organization of space included creative relationships between figures across different panels. Although elements of Byzantine art remain, Duccio was well ahead of his time. The drama and visual impact of the painting had a lasting effect on contemporary artists and beyond. **KKA**

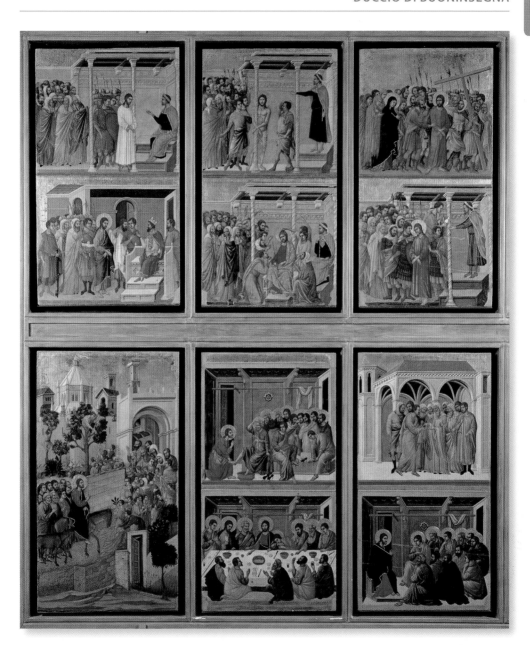

GIOTTO DI BONDONE

Born: Giotto di Bondone, *c.*1266 (Vespignano, Italy); died January 8, 1337 (Florence, Italy).

Artistic style: Sculptural treatment of figures with a psychological depth; lifelike individuals and group scenes; biblical events; palpable sense of pathos.

Masterworks

Scrovegni Chapel 1305 (Padua, Italy)

*Pentecost c.*1306–1312 (National Gallery, London, England)

*Ognissanti Madonna c.*1310 (Uffizi, Florence, Italy)

*Presentation of Christ in the Temple c.*1320 (Isabella Stewart Gardner Museum, Boston, U.S.)

*The Epiphany c.*1320 (Metropolitan Museum of Art, New York, U.S.)

*Church of Santa Croce, Bardi Chapel c.*1320 (Florence, Italy)

*Church of Santa Croce, Peruzzi Chapel c.*1320 (Florence, Italy)

*Madonna and Child c.*1320–1330 (National Gallery of Art, Washington, D.C., U.S.)

Giorgio Vasari relates that Giotto's talent was first discovered by Cimabue, who saw him drawing a sheep on a rock and brought the young apprentice to Florence to train him in the art of painting. Although an apocryphal tale, what is not in doubt is Giotto's prodigious talent. It is no small measure of the magnitude of Giotto's abilities that his talents were celebrated during his own lifetime. Dante Alighieri, for one, noted in a passage in his *Purgatorio* (1308–1321) that the fame of Cimabue had been eclipsed by that of his young apprentice.

Giotto's frescoes in the Capella Scrovegni (Arena Chapel) at Padua, which narrate the life of the Virgin, the life of Christ, and the Passion, comprise his earliest attributed work. They were painted between *circa* 1305 and 1313. Instead of simply relying on a standardized repertoire of religious iconographic types,

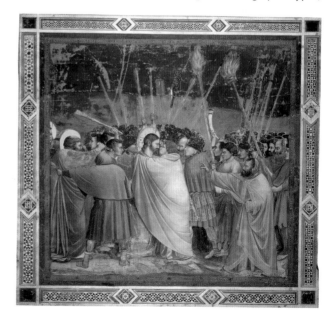

ABOVE: Giotto from *Five Masters of the Florentine Renaissance* (c.1500–1550).

RIGHT: *The Betrayal of Christ* is from the "Arena Chapel" series of frescoes.

Giotto assimilated elements from established styles of painting, notably Byzantine, into a more heightened naturalistic style to compelling effect. This is most readily identifiable with the artist's treatment of the figures that populate the various religious episodes depicted within the chapel. They are imbued with a psychology and an interior life; Giotto enabled their motivations and vulnerability to be palpably felt by the viewer.

Attribution of Giotto's work after this has been subject to much debate, compounded by the fact that much of his work, including everything he produced as court painter to King Robert of Anjou in Naples, has been lost. However, the large *Madonna* (*c.*1310), made for the church of Ognissanti, and the frescoes of the adjacent Bardi (*c.*1320) and Peruzzi (*c.*1320) chapels are known to be his. It is testimony to the lasting significance of Giotto's ability to create figures that appear convincingly lifelike and three-dimensional that British sculptor Sir Henry Moore, after returning from his first trip to Italy in 1925, considered the paintings of Giotto to have been the best sculptures he had seen. **CS**

What Others Have Said

The vast scope of Giotto's talents were recognized by many:

- Giovanni Boccaccio claimed that with his paintbrush, Giotto created not likenesses but actual products of nature that were taken for reality itself.

- Leonardo da Vinci claimed that Giotto surpassed not only his contemporary artists but those from past centuries.

- For Sir John Ruskin, Giotto achieved greatness because he was willing to substitute for the stylized circumstances of artistic convention the events of everyday life.

ANDREA PISANO

Born: Andrea Pisano, *c.*1270 (Pontedera, Italy); died *c.*1348 (Orvieto, Italy).

Artistic style: Goldsmith, architect, and sculptor; Gothic craftsmanship; highly detailed modeling of figures; cogent depiction of biblical scenes; naturalistic treatment of form.

Masterworks

Florence Baptistery Doors 1330–1336 (Florence, Italy)

*Campanile c.*1337–1347 (Florence, Italy)

Andrea Pisano's first major work—one of only two documented as his—was the doors made for the south portal of the baptistery in Florence's Piazza San Giovanni. Commissioned in 1322 by the city's wool merchants, the Calimala Guild, after a decision to replace the old wooden doors with bronze ones, each door comprises fourteen panels set in a frame. Ten of the panels, each set in a quatrefoil mount, depict the life of the city's patron saint John the Baptist, and the lower eight consist of female personifications of the Virtues. Art historian Charles Avery has commented on the exceptionally subtle and highly detailed modeling of the figures that, he notes, "have a dignity and grandeur . . . reminiscent of Roman funerary art and have the same sense of monumentality." Andrea brings an unprecedented degree of verisimilitude and emotional gravitas to the scenes, carved in gilded high relief. For example, the emotional pitch in *The Execution of the Baptist* (1330–1336) is reached partly through the tension in the pose of the young executioner as he wields his sword over the kneeling St. John.

Compositionally, the shallow, stagelike settings the figures inhabit are closely related to Giotto's own naturalistic treatment of form, and the connection was strengthened in Andrea's next commission. In 1337 he succeeded Giotto as *capomaestro* (master of works) for the Campanile of Florence Cathedral and carved many of its reliefs. Although the extent to which Andrea modified Giotto's own notable achievements in the cathedral design remains a point of debate, he is known to have created a number of the hexagonal and lozenge-shaped carvings. In 1347 Andrea was appointed master of works of Orvieto Cathedral. By the following year, however, he had fallen victim to the bubonic plague. **CS**

"The greatest man the Tuscans had . . . in this field, above all in casting bronze."—Giorgio Vasari

ABOVE: Portrait of Pisano from Vasari's *Lives of the Artists*, first published in 1550.

PIETRO LORENZETTI

Born: Pietro Lorenzetti, c.1280 (Siena, Italy); died 1348 (Siena, Italy).

Artistic style: Sienese painter of religious frescoes; dramatic depictions of various emotional biblical scenes; realistic settings; harmonious color; solid-looking figures with engaging expressions.

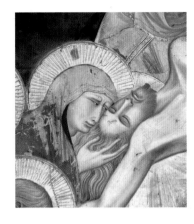

Little is known about the life of the fourteenth-century Italian painter Pietro Lorenzetti, believed to be active between 1306 and 1345; even the chronology of his surviving works is not certain. It is known that he lived in Siena, the chief cultural center of Tuscany in the late Middle Ages. He is now hailed as one of the best-known proponents of naturalism during the transition from medieval to Renaissance modes of art.

It is believed he was a student of the father of Sienese painting, Duccio di Buoninsegna. Along with his equally famous brother Ambrogio, he experimented with fusing Duccio's style with that of the great Florentine painter Giotto and the dynamic sculptures of Giovanni Pisano.

By producing works of harmonious color, Lorenzetti specialized in capturing the dramatic emotions of biblical scenes and placing them in realistic settings. With his works at Arezzo in the Pieve di Santa Maria and Assisi in the Basilica of San Francesco, he experimented with convincing three-dimensional perspectives for buildings and backdrops and painted solid-looking figures with engaging expressions. His move away from Byzantine art and the triumph of his perspective and naturalistic style are why he has been recognized as one of the forerunners of the Renaissance. His paintings are all the more impressive for their lifelike depictions of objects and clothing with intricate patterns. Lorenzetti created rich narratives that include humorous unessential details such as a dog licking a plate in *The Last Supper* (c.1320–1330) while a servant washes up, though some historians read deeper religious meanings into these seemingly innocent additions. Lorenzetti died in the great plague of 1348, which wiped out half the population of Siena. **JM**

Masterworks

Madonna and Child 1320 (Pieve di Santa Maria, Arezzo, Italy)

Madonna with St. Francis and St. John the Evangelist 1320–1325 (Basilica of San Francesco d'Assisi, Assisi, Italy)

The Last Supper c.1320–1330 (Basilica of San Francesco d'Assisi, Assisi, Italy)

Deposition c.1325 (Basilica of San Francesco d'Assisi, Assisi, Italy)

Madonna with Angels Between St. Nicholas and Prophet Elisha 1328–1329 (Pinacoteca Nazionale, Siena, Italy)

Elisha's Well 1329 (Pinacoteca Nazionale, Siena, Italy)

Adoration of the Magi c.1340 (Musée du Louvre, Paris, France)

"The period of great splendor in Sienese painting is climaxed in Pietro Lorenzetti."—Enzo Carli

ABOVE: Detail from *Deposition* of Mary lamenting over the dead Christ.

Masterworks

Madonna and Child c.1326 (Robert Lehman Collection, Metropolitan Museum of Art, New York, U.S.)

The Annunciation with Two Saints 1333 (Uffizi, Florence, Italy)

The Angel of the Annunciation c.1339 (Musée Royal des Beaux-Arts, Antwerp, Belgium)

Christ Discovered in the Temple (The Holy Family) 1342 (Walker Art Gallery, Liverpool, England)

"Where shall we see color more symphonic than … among his Assisi frescoes?"—Bernard Berenson

ABOVE: Portrait of Martini from Vasari's *Lives of the Artists,* first published in 1550.

SIMONE MARTINI

Born: Simone Martini, *c.*1284 (Siena, Italy); died 1344 (Avignon, France).

Artistic style: Painter of the Sienese school; religious subjects such as altarpieces and devotional works; portraits; elegant and innovative, three-dimensional figurative paintings.

Simone Martini was born in Siena in Italy during a period when the city was a leading cultural center, rivaled only by Florence. Nothing is known about his early life. It is thought, though, he studied under Duccio di Buoninsegna, the leader of the Sienese school. It was a time when the Florentine painter Giotto overturned the rules of Gothic and Byzantine painting, and developed a set of conventions that would lay the foundations of Renaissance art.

The first authenticated painting by Martini is the *Maestà* (*c.*1316) in the Palazzo Pubblico in Siena. The graceful painting's three-dimensional forms and space are convincing, and rather radical for the time. Martini was highly valued and respected as a painter and was paid a handsome salary from 1317 by the Angevin court. This helped fund the huge task of painting the fresco cycle in the Chapel of St. Martin in the Basilica of San Francesco d'Assisi in Assisi.

By the 1320s, Martini was a wealthy man. In 1324 he married Giovanna, the sister of the painter Lippo Memmi. He and his brother-in-law collaborated on many works, notably *The Annunciation with Two Saints* (1333). In the late 1330s he moved to Avignon, the new seat of the Holy See and a thriving cultural center. The meeting of northern European and Italian art laid the foundations for the International Gothic style, and Martini was a leading proponent. He was also an innovator in both his choice of subject matter and its treatment. His depiction of the Holy Family in *Christ Discovered in the Temple* (1342) focuses on a moment from the Gospel narrative that had never been portrayed before by any artist and shows the Virgin's attempt to comprehend the divine nature of her son. **MC**

AMBROGIO LORENZETTI

Born: Ambrogio Lorenzetti c.1285 (Siena, Italy); died 1348 (Siena, Italy).

Artistic style: Painter of religious works of the Sienese school; naturalistic approach; depictions of three-dimensional space; smooth, flowing lines; expressive figures.

Siena was a jewel of a city in the early fourteenth century—its wealth built on wool and money lending. Its artistic achievements reached a pinnacle with the work of Duccio di Buoninsegna, who introduced a new way of painting and founded the influential Sienese school. Ambrogio Lorenzetti was born into this rich cultural milieu, and his older brother Pietro was also a painter. In 1327 Ambrogio went to Florence to study art at the Arte dei Medici e Speziali, where he soon absorbed the ideas of Giotto.

In 1336 he established a workshop back in Siena. One of his favorite subjects was the Madonna, possibly because the city was dedicated to the Virgin Mary. Charming depictions, such as *Madonna del Latte* (*c.*1330), are expressive and full of emotion. Ambrogio was surely painting from personal experience, although little is known about his life. He is known best for his fresco cycle *The Effects of Good Government in the City and the Country* (*c.*1338–1340). It is the work of a mature artist giving full rein to his imagination to represent virtue and vice in the political and social spheres. It was very unusual at the time to discuss philosophical ideas without reference to religion.

Ambrogio's capacity for naturalistic expression, his ability to depict three-dimensional space, and his powers of narrative exposition are clear in *Scenes from the Life of St. Nicholas of Bari* (1332) and even better realized some ten years later in *The Presentation in the Temple* (1342). He was the first artist in Europe to use single-point perspective, giving his work unique spatial complexity. Ambrogio died from the Black Death in 1348, along with half the population of Siena. This tragedy ended Siena's cultural flowering, and the city never recovered its former glory. **MC**

Masterworks

Madonna of Vico l'Abate 1319 (Museo di Arte Sacra, San Casciano Val di Pesa, Italy)

*Madonna and Child with Mary Magdalene and St. Dorothea c.*1325 (Pinacoteca Nazionale, Siena, Italy)

*Madonna del Latte c.*1330 (Palazzo Arcivescovile, Siena, Italy)

Scenes from the Life of St. Nicholas of Bari 1332 (Uffizi, Florence, Italy)

*The Effects of Good Government in the City and the Country c.*1338–1340 (Palazzo Pubblico, Siena, Italy)

*Madonna and Child Clutching a Goldfinch c.*1340 (Pinacoteca Nazionale, Siena, Italy)

The Presentation in the Temple 1342 (Uffizi, Florence, Italy)

"Ambrogio combines the weighty and the perceptive in his painting."—Sister Wendy Beckett

ABOVE: Portrait of Lorenzetti from Vasari's *Lives of the Artists,* first published in 1550.

Masterworks

The Book of Hours of Queen Maria of Navarre
*c.*1340 (Biblioteca Marciana of Venice,
Venice, Italy)

Fresco cycle 1345–1346 (Chapel of San Miguel,
Monastery of Pedralbes, Barcelona, Spain)

FERRER BASSA

Born: Jaume Ferrer Bassa, *c.*1285 (unknown); died 1348 (Barcelona, Spain).

Artistic style: International Gothic painter of miniatures and frescoes;
illuminator of manuscripts; smooth flowing lines; subtle use of color;
expressive figures.

Ferrer Bassa's only surviving paintings are a series of frescoes
executed from 1345 to 1346 in the chapel of San Miguel in the
Monastery of Pedralbes in Barcelona. The fresco comprises
nearly thirty scenes, all of which are remarkable examples of
the early International Gothic style: *Christ Seated in Judgment*
and *Three Women at the Tomb* are two of the most notable.

Nothing is known about Bassa's early life, but he is likely to
have studied painting either in one of the Italian states or,
more probably, in Avignon. Both were the artistic centers in
which the Italian Gothic style of painting adopted by
contemporary Florentine and Sienese painters flourished.
Bassa absorbed these radical ideas. He was the first artist to
incorporate them into Catalan painting, thus contributing to
the development of the International Gothic style.

From 1333 Bassa was living at the court of King Alfonso IV,
illuminating manuscripts and traveling in Catalonia to paint
various commissions in churches, royal chapels, and palaces. In
April 1342 Alfonso IV's successor, Peter the Ceremonious, wrote
to his wife Queen Maria of Navarre, asking her to send him "the
extremely beautiful book of hours painted by Ferrer Bassa." He
went on to write that the book was admired far and wide. The
illuminations in *The Book of Hours of Queen
Maria of Navarre* (*c.*1340) are replete with
Italian Gothic influences, such as
expressive figures, three-dimensional
space, use of vivid color, and a sense of
dramatic narrative that Bassa interpreted
in an original way. He also portrayed new
genres of subject matter such as the Madonna dell'Umiltá, in
which the Madonna suckles the baby Jesus.

Bassa died of the Black Death in 1348, but his new style was
continued and developed by his son Arnau. **MC**

"The style of Ferrer Bassa
reflected the pictorial language
of Giotto."—Nadeije Laneyrie-Dagen

ABOVE: The influence of fourteenth-century
Italian art is clear in *Adoration of the Kings*.

ANDREI RUBLEV

Born: Andrei Rublev, *c.*1360 (unknown); died *c.*1427 (Moscow, Russia).

Artistic style: Medieval iconographer whose original combination of formal asceticism with rich emotional expression articulated a quintessential, highly imitated Russian Orthodox style.

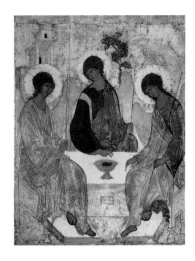

Widely seen as the most influential Russian icon painter, Andrei Rublev's merging of a formally rigorous style with soothing, pictorial balance and psychological depth became the template for meditative religious painting of its time (he was canonized by the Russian Orthodox Church in 1988) and has fascinated artists through the ages. In Andrei Tarkovsky's epic, eponymous film loosely based around Rublev's life, the medieval artist is portrayed as a deeply conscientious figure. Aware of the monumental vastness of existence surrounding his own, straddling the widely different perspectives of pagan and religious cultures in shifting regimes of cruelty and peace, his experience enriches his art with a questioning humanism that would hitherto have been thought inconceivable.

Tarkovsky's politicized, heroic version of Rublev's life is compelling but rather conjectural because little is known about the artist's life. Scholarly work suggests he was respected within his own lifetime and was most likely prolific. The first mention of his name appears in a 1405 record of the artists involved in the decoration of the Cathedral of the Annunciation of the Moscow Kremlin, alongside lauded masters such as Theophanes the Greek and Prokhor of Gorodets. There is also a record of Rublev painting the Assumption Cathedral in Vladimir in 1408 and the frescoes of the Savior Cathedral in Moscow's Andronikov Monastery after 1430, where he remained until his death. Some researchers point to him as one of the artists who illuminated the Khitrovo Gospels between the fourteenth and fifteenth centuries. However, ascertaining the extent of Rublev's entire oeuvre has been difficult, and attributions will continue to be made and refuted because of the wide influence of his style. **LNF**

Masterworks

Nativity 1405 (Cathedral of the Annunciation of the Moscow Kremlin, Moscow, Russia)

*The Old Testament Trinity c.*1410 (Tretyakov Gallery, Moscow, Russia)

"A great artist He incarnates the ethical ideal of his time."—Andrei Tarkovsky

ABOVE: The gentle spirit of *The Old Testament Trinity* was widely copied.

LORENZO GHIBERTI

Born: Lorenzo di Bartolo, c.1378 (Florence, Italy); died December 1, 1455 (Florence, Italy).

Artistic style: Early Renaissance Italian metalworker, sculptor, and fresco painter; use of perspective; dynamic sculptural figures.

Masterworks

Sacrifice of Isaac 1401 (Museo Nazionale del Bargello, Florence, Italy)

St. John the Baptist 1412–1416 (Orsanmichele, Florence, Italy)

The Gates of Paradise 1425–1452 (Duomo, Florence, Italy)

Madonna and Child c.1435 (Detroit Institute of Art, U.S.)

In 1392 Lorenzo Ghiberti was admitted into the Florentine Silk and Gold Guild and started his apprenticeship as a goldsmith with both his father and stepfather. Six years later, he became a guild master goldsmith. At that time, goldsmiths had to be skilled in three-dimensional art, and Ghiberti became proficient in drawing and making small sculptures in bronze. Early in his career he was known as a fresco painter, and during a period of plague in Florence he worked in Rimini, producing a fresco in the local ruler's palace.

In 1401 his stepfather recalled him to Florence to enter a competition opened by the Calimala Guild to make the north door for the octagonal-shaped baptistery in Piazza San Giovanni, replacing the old wooden doors with bronze. The young Ghiberti won, beating Filippo Brunelleschi. The idea was to depict scenes from the Old Testament, but this plan was altered and the door shows scenes from the New Testament.

ABOVE: Portrait of Ghiberti from Vasari's *Lives of the Artists*, first published in 1550.

RIGHT: Detail of the killing of Abel by his brother Cain, from the Florence Baptistery.

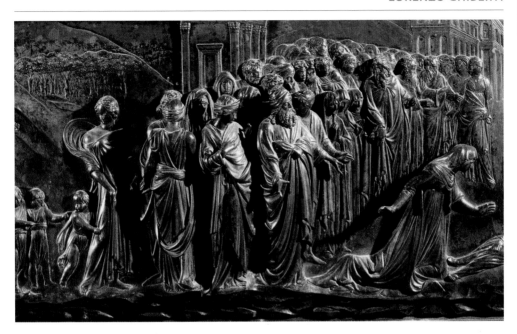

ABOVE: Bas relief of the life of Saint Zenobius, Bishop of Florence.

Ghiberti worked on the doors from 1403 to 1424, running a workshop where many of the future masters of the Florentine school received training, including Paolo Uccello. The scenes on the doors are dramatic: gilt figures set in high relief against neutral backgrounds, surrounded by Gothic-style frames.

When the set of twenty-eight panels was complete, Ghiberti was commissioned to produce a second doorway, the east door, this time with scenes from the Old Testament. He used more initiative for these, spending almost the rest of his life completing the designs. The ten rectangular scenes in a freer, more natural style are very different from the panels in the earlier door. By using daring compositions, Ghiberti created a great sense of depth, picking up on research by Brunelleschi and Donatello. Michelangelo Buonarroti admiringly called them the "Gates of Paradise." The transition toward Renaissance style is also evident in Ghiberti's next commissions, for the Orsanmichele in Florence, as well as bronzes of St. John the Baptist, St. Matthew, and St. Stephen. **SH**

Meaningful Memoirs

More is known about Ghiberti's theories of art than those of his contemporaries because he left behind a written work, *I Commentari* (c.1447) (*The Commentaries*), explaining his methods and thoughts on art. It is a valuable source of information about Renaissance art and is the first known autobiography of an artist. Every page confirms the religious spirit in which the artist lived and worked, and he appears to have cared little for money. He also regards ancient Greek statues with empathy, because for him they demonstrated the highest intellectual and moral attributes of human nature.

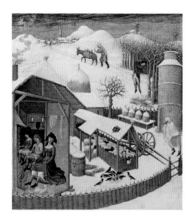

Masterworks

Valerius Maximus, De Dictis Factisque Mirabilibus c.1400 text and c.1410 miniature (Biblioteca Apostolica Vaticana, Vatican City, Rome, Italy)

Bible Moralisée 1402–1406 (Bibliothèque Nationale de France, Paris, France)

The Book of Hours of the Duke of Berry 1404–1409 (Metropolitan Museum of Art, New York, U.S.)

The Very Rich Hours of the Duke of Berry 1412–1416 (Musée Condé, Chantilly, France)

> "The Limbourg brothers are about graphic, atmospheric detail."—Pieter Roelofs, *Time*

ABOVE: February from the notorious *The Very Rich Hours of the Duke of Berry*.

THE LIMBOURG BROTHERS

Born: Herman, Paul, and Jan van Limburg, c.1385 (Nijmegen, the Netherlands); Jan died 1415, Herman and Paul died 1416 (Bourges, France).

Artistic style: International Gothic book illuminators and goldsmiths; elegant, graceful works in miniature; landscapes, religious tableaux, and night scenes.

Herman, Paul, and Jan Limbourg created groundbreaking illuminated manuscripts that became highly influential and continued to inspire artists for centuries after.

The brothers were born into a family of Dutch craftsmen, who painted heraldic emblems on shields, banners, and ensigns. Their uncle, Jan Maelwael, worked for the Duke of Burgundy, Philip the Bold, in Dijon and was one of the highest paid artists in France at the time. The brothers, who had trained in Paris, were commissioned by Philip the Bold to create the *Bible Moralisée* (1402–1406), an illustrated manuscript of the Bible. When Philip the Bold died in 1404, the brothers had completed just the first three books, consisting of approximately 384 miniatures.

After Philip the Bold's death, his brother, Jean de France, the Duke of Berry, became the Limbourg brothers' patron. The work they produced for him brought them fame, and they became part of the duke's esteemed inner circle of courtiers. One of their most praised works was *The Book of Hours of the Duke of Berry* (1404–1409), which comprised 172 miniatures, many along unconventional themes. The brothers' pièce de résistance, *The Very Rich Hours of the Duke of Berry* (1412–1416), is the most famous and richly illuminated medieval manuscript in existence. The brothers worked on it until their deaths, which were possibly caused by the plague or were perhaps lost in a war fought to defend the city of Bourges, where they worked. Although incomplete, the manuscript contains one hundred miniatures. It is particularly notable for the twelve illustrations of the months of the year, depicting the lives of farmers, shepherds, peasants, and nobles, as well as landscapes and biblical stories. **CK**

DONATELLO

Born: Donato di Niccolò di Betto Bardi, c.1386 (Florence, Italy); died December 13, 1466 (Florence, Italy).

Artistic style: Artist and sculptor; inventive works in marble and bronze; creation of the shallow-relief style of sculpting that made the sculpture seem deeper.

Often considered the most original and comprehensive artist of his time, Donatello shaped the artistic revolution in fifteenth-century Italy. The son of a Florentine wool comber, he received his earliest training in a goldsmith's workshop and went on to develop a more detailed and wide-ranging knowledge of ancient sculpture than any other artist of his day.

From 1404 to 1407, he worked with architect and sculptor Filippo Brunelleschi in Rome, excavating ancient artifacts, to learn from artists of the past. This gained them the reputation of treasure hunters. Through their investigations, the two men altered the development of fifteenth-century Italian art, and Donatello influenced practically every sculptor after him, including Michelangelo Buonarroti. It was also around this time that Donatello worked in sculptor Lorenzo Ghiberti's studio, helping create the Florentine Baptistery doors. Another

Masterworks

*St. George c.*1415–1417 (Museo Nazionale de Bargello, Florence, Italy)

St. George Killing the Dragon 1416–1417 (Museo Nazionale de Bargello, Florence, Italy)

*Feast of Herod c.*1435 (Palais des Beaux Arts, Lille, France)

*David c.*1440 (Bargello, Florence, Italy)

*The Borromeo Madonna c.*1450 (Kimbell Art Museum, Fort Worth, U.S.)

*Gattamelatta c.*1453 (Piazza del Santo, Padua, Italy)

*Madonna and Child c.*1455 (Victoria & Albert Museum, London, England)

The Madonna and Child With Four Angels before 1456 (Victoria & Albert Museum, London, England)

*Judith and Holofernes c.*1460 (Palazzo Vecchio, Florence, Italy)

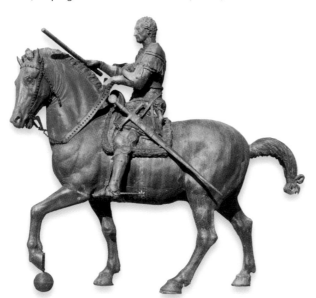

ABOVE: Detail from *Five Masters of the Florentine Renaissance* (c.1500–1550).

LEFT: *Gattamelata*, an iconic statue of a hero, echoes classical sculpture.

A Man on a Horse

From 1443 to 1453, Donatello worked in the northern Italian city of Padua. There he created the High Altar of St. Anthony and executed an equestrian statue that was set up in front of the church in a space then used as a cemetery. Inspired by the statue of Marcus Aurelius in Rome, it was a great bronze equestrian statue of a famous Venetian *condottiere*, or mercenary, Erasmo da Narni, popularly called "Gattamelata," meaning "the honeyed cat," who had died shortly before. The project was unprecedented and shocking because since the days of the Roman Empire, bronze equestrian monuments had been the sole privilege of rulers. The construction of the monument was plagued by delays. Donatello did most of the work between 1447 and 1450, yet the statue was not placed on its pedestal until 1453.

It shows Gattamelata astride his mount, the baton of command in his raised right hand and the horse's hoof on an orb, the ancient symbol for control over the Earth. It idealizes the general at the height of his powers and is the forerunner of all the equestrian monuments erected since. Its fame, enhanced by the controversy, spread far and wide. Even before it was on public view, the king of Naples wanted Donatello to do the same kind of equestrian statue for him.

early work by Donatello is a wooden crucifix in the church of Santa Croce; according to Giorgio Vasari, it was made in friendly competition with Brunelleschi.

In *c.*1408–1409 Donatello produced a marble statue of *David*, which was notable for being the first free-standing nude statue since classical times. The statue shows an artistic debt to Ghiberti, who was then the leading Florentine exponent of International Gothic, a style of graceful, softly curved lines strongly influenced by northern European art.

By 1412, Donatello's revolutionary artistic ideals had become evident, most notably in a series of standing figures made for the Orsanmichele Church in Florence and Florence Cathedral. The series began with two, slightly larger-than-life figures, *St. Mark* (1411–1413) and *St. George* (1417). For the first time since classical antiquity, and in striking contrast to medieval art, the human body was recreated realistically and naturally, expressing personality and emotion.

Ghiberti's relief panels for the San Giovanni Baptistery doors had emphasized perspective with boldly rounded foreground figures against more delicately modeled settings of landscape and architecture. Donatello invented his own new form of relief in his marble panel *St. George Killing the Dragon* (1416–1417). Known as *relievo schiacciato*, meaning "flattened out or low relief," it involved extremely shallow carving and created a striking effect of atmospheric space that had never been seen before.

For a time from 1425, Donatello went into partnership with sculptor and architect Michelozzo di Bartolomeo Michelozzi, yet also worked on his independent

RIGHT: *David* was the first nude bronze to be created for several centuries.

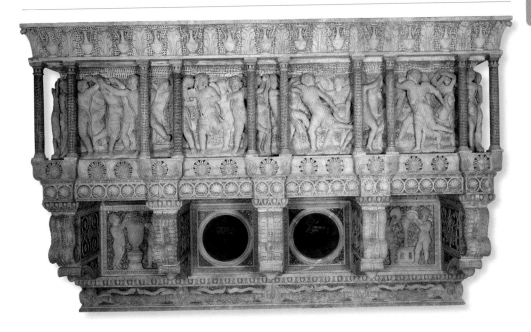

commissions. One of these was the *Feast of Herod* (1435), an intensely dramatic relief with an architectural background that displayed his command of linear perspective, something Brunelleschi had invented only a few years earlier. John the Baptist's severed head presented on a tray to the horrified Herod is surrounded by animated and expressive figures, especially that of Salomé, who continues to dance and to swirl her skirt.

ABOVE: The marble and mosaic singers' gallery from Florence Cathedral.

Donatello died in Florence in 1466 and was buried in the Basilica of San Lorenzo. The powerful fluency of his art made him the greatest sculptor of the early Renaissance, equally at home with low relief as figures in the round, in wood as well as marble and bronze. His figures express emotions by use of a scowl, a stare, or the merest gesture. As a forerunner of humanistic expression, with an advanced technique of creating spatial depth, he was one of the most admired and respected artists of his day. **SH**

"One of the greatest artists who ever lived."

—John Pope-Hennessy

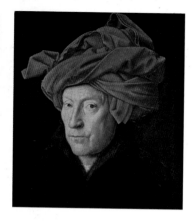

JAN VAN EYCK

Born: Jan van Eyck, c.1390 (Maaseik, Belgium); died 1441 (Bruges, Belgium).

Artistic style: Founding father of the Netherlandish school of painting; dedicated observation of nature; meticulous detail; subjects depicting the splendor of the late medieval Burgundian court.

Masterworks

Madonna in the Church 1430s (Staatliche Museen, Berlin, Germany)

Crucifixion: The Last Judgement c.1430 (Metropolitan Museum of Art, New York, U.S.)

Dedication of the Adoration of the Lamb (The Ghent Altarpiece) 1432 (Cathedral of Saint Bavo, Ghent, Belgium)

The Arnolfini Portrait 1434 (National Gallery, London, England)

The Virgin of Chancellor Rolin c.1435 (Musée du Louvre, Paris, France)

Madonna with Canon van der Paele 1436 (Groeninge Museum, Bruges, Belgium)

One of the first Flemish artists to sign a number of his works, the presence of Jan van Eyck is felt strongly in his paintings, whether through his signature, the powerful realism of his work, or his own image reflected in a mirror. It is possible that his *Portrait of a Man* (1433) in the National Gallery in London is a self-portrait. Van Eyck's work reflects the wealth and display of cities such as Ghent, Bruges, and Ypres as they emerged from the late Middle Ages. He faithfully rendered the surfaces of clothing and interiors, creating a lasting record of a lost world in meticulous detail, and was one of the first artists to use oil paint.

In 1425 van Eyck entered the service of Philip III the Good, Duke of Burgundy, acquiring a court title that would give him the welcome opportunity to travel extensively. His most famous work, *Dedication of the Adoration of the Lamb (The Ghent Altarpiece)* (1432), for the Cathedral of Saint Bavo, was to secure him a place in the history of painting, not least for the controversy surrounding the work. The debate centers around the role and identity of Jan's brother, the painter Hubert van Eyck, who, according to the inscription on the frame, appears to have contributed to the altarpiece and may have in fact done the lion's share of the work. Perhaps the best-loved piece by van Eyck, though, is his iconic image of a couple holding hands in a lavish bedroom, *The Arnolfini Portrait* (1434). As a painting about the art of illusion and the act of looking, the portrait became a touchstone for subsequent generations: the motif of the convex mirror continues to be quoted today. We see the backs of the couple reflected in the mirror and an enigmatic third figure, who may be the artist himself at work at his easel. **KKA**

" … the quintessence of all the poetry of the conversation piece."—Mario Praz on *Arnolfini Portrait*

ABOVE: It is widely believed that *Portrait of a Man* (1433) may be a self-portrait.

RIGHT: The solitary candle in *The Arnolfini Portrait* symbolizes Christ in their marriage.

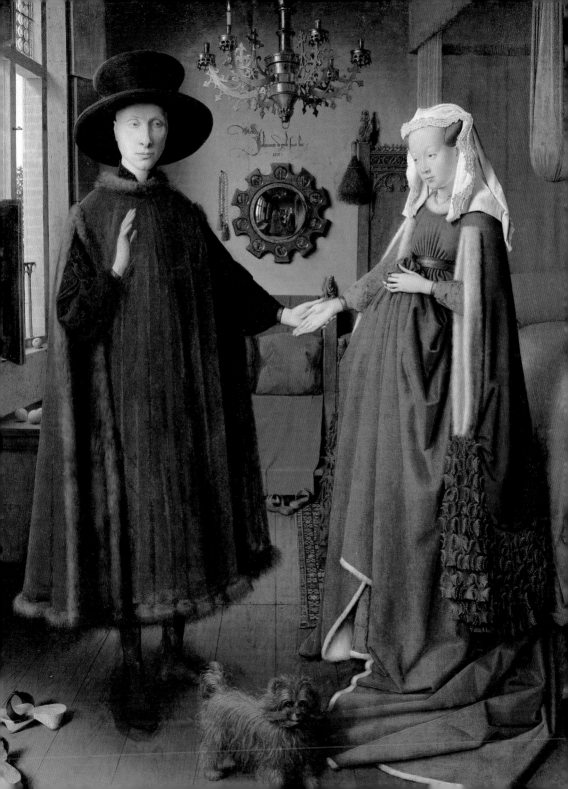

FRA ANGELICO

Born: Guido di Pietro, *c.*1387 (Vicchio di Mugello, Italy); died February 18, 1455 (Rome, Italy).

Artistic style: Early Renaissance painter of miniatures, illuminated manuscripts, frescoes, and altarpieces; realistic fine detail; sense of dramatic narrative.

Masterworks

*Coronation of the Virgin c.*1430–1432 (Musée du Louvre, Paris, France)

*The Annunciation c.*1426 (Museo del Prado, Madrid, Spain)

*The Cortona Altarpiece c.*1432–1434 (Museo Diocesano, Cortona, Italy)

Noli Me Tangere 1440–1441 (Museo di San Marco, Florence, Italy)

*Healing of Palladia by Saints Cosmas and Damian c.*1440–1442 (National Gallery of Art, Washington, D.C., U.S.)

Fra Angelico painted as an act of devotion and is reputed to have said, "To paint the things of Christ, one must live with Christ." He wept when he painted the Crucifixion, and he often knelt while painting. His piety and religiosity is evident in all his work, which records a life spent in the throes of a deepening Christian vocation. As a member of the Dominican friars, also known as the Order of Preachers, Fra Angelico followed St. Dominic's injunction to teach Christ's message using whatever talents he possessed.

He was born Guido di Pietro in Tuscany at the turn of the fifteenth century. As a young man, he trained as a book illustrator, and by 1417 he had acquired a reputation as a skillful artist. He entered the friary of San Domenico in Fiesole in *circa* 1420 and took the name Fra Giovanni. His early work consisted mainly of book illuminations executed in the prevailing International Gothic style. Several surviving manuscripts also demonstrate his artistry as a miniaturist.

As his reputation grew, Fra Angelico was commissioned to paint altarpieces and other large works. In a chapel at Fiesole, he painted one of many versions of *The Annunciation* (*c.*1426), with lifelike, expressive figures set confidently under receding arches. The influence of Masaccio is evident in his use of architectural settings and perspective that were radical developments at the time. Another Annunciation, painted as part of *The Cortona Altarpiece* (1432–1434), enhances and refines the architectural perspective. It is set above six small predella pictures of the life of the Virgin that make full use of Fra Angelico's miniaturist skills and include an innovative use of landscape and composition that influenced later Renaissance painters such as Leonardo da Vinci.

"[It is said] he never handled a brush without fervent prayer"—William Michael Rossetti

ABOVE: The face in *Saint Dominic Adoring the Crucifixion* is said to be a self-portrait.

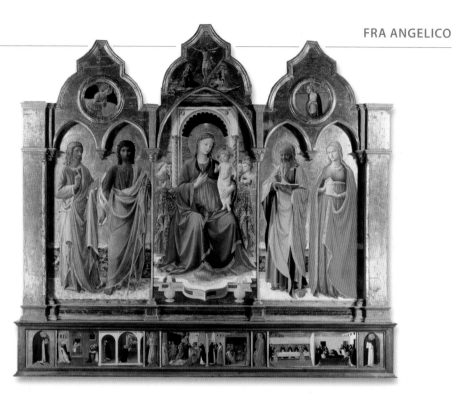

ABOVE: *Virgin and Child Enthroned with Four Saints* has a flawless narrative flow of images.

In 1436 the Dominicans took over the church and friary of San Marco in Florence; Cosimo de Medici funded the renovations. Fra Angelico painted his most famous works here—a series of frescoes that were intended as contemplative aids for the friars. The scale and large number of works necessitated the artist taking on pupils, who may have included his protégé Benozzo Gozzoli.

In 1443 the pope summoned Fra Angelico to Rome to paint for the Vatican. He later returned to Fiesole and became prior of the friary in 1450. However, he continued to paint, completing one of his most stunning frescoes, *Madonna delle Ombre* (1450), at that time.

Fra Angelico was a prolific and talented artist who created devotional objects in pursuit of the Dominican mission to preach the gospel. Little wonder that the Victorian writer and art critic John Ruskin called him "not an artist properly so-called but an inspired saint." **MC**

All in the Name of Art

Writing a century after his death, Giorgio Vasari in his *The Lives of the Most Excellent Painters, Sculptors and Architects* (1550) popularized the use of the name "Angelico" by writing that Fra Giovanni (Brother John) was dubbed "Pictor Angelicus," meaning "angelic painter," shortly after his death in 1455. This was later translated into English as "Fra Angelico." Down the centuries, Fra Giovanni was also known as "Il Beato Angelico" (the blessed angelic one). In 1982 this became official when he was beatified by the Vatican. His full, official appellation is now Blessed Fra Angelico Giovanni da Fiesole.

PAULO UCCELLO

Born: Paolo di Dono, *c.*1397 (Florence, Italy); died December 10, 1475 (Florence, Italy).

Artistic style: Encapsulates fifteenth-century Florentine art; bridges late Gothic and early Renaissance approaches; experiments in pictorial linear perspective.

Masterworks

Creation frescoes 1430s/1440s (Chiostro Verde, S. Maria Novella, Florence, Italy)

Battle of San Romano 1430s–1450s (National Gallery, London, England; Uffizi, Florence, Italy; Musée du Louvre, Paris, France)

The Flood and the Recession of the Flood *c.*1447 (S. Maria Novella, Florence, Italy)

*Hunt in the Forest c.*1465 (Ashmolean, Oxford, England)

ABOVE: Uccello from *Five Masters of the Florentine Renaissance* (*c.*1500–1550).

BELOW: *The Hunt in the Forest*, in the dark of night, is one of Uccello's late treasures.

In the past, some critics derided Uccello, accusing him of sacrificing art in the name of dry illustrations of the perspective theories of his day. More recently, he has been recognized as a major designer-artist (he also worked in mosaic and stained glass) whose work cleverly blends decorative and artistic values. He has even been credited with re-examining the way people view the world, in an approach anticipating that of the cubists. Certainly his oeuvre epitomizes a major artistic conflict of his day: contrived Gothic-style design versus Renaissance ways of representing reality.

The young Uccello was the son of a barber-surgeon. He was artistic from childhood and began his career in the Florentine workshop of sculptor Lorenzo Ghiberti, designer of the beautiful bronze doors for the baptistery of Florence Cathedral. Uccello spent most of his life in Florence, establishing himself there professionally by around 1415.

Details of his early career are sketchy, but from 1425 he was in Venice for a few years, working as a mosaicist. In the 1430s he was back in Florence, where he produced the *Creation* frescoes for the church of Santa Maria Novella, which retain a

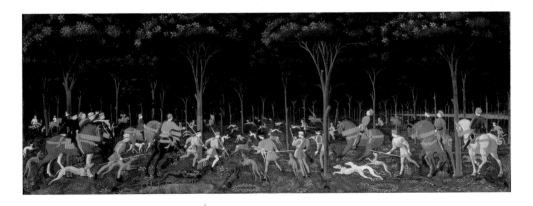

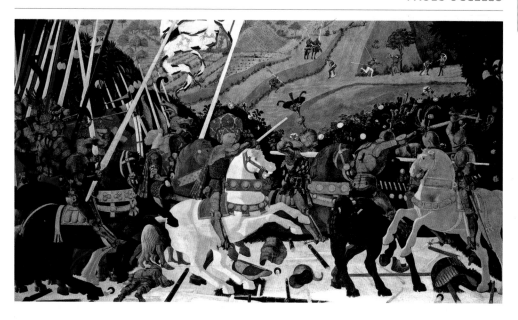

strongly decorative element. By this time he had turned increasingly to the pioneering ideas of his contemporaries Filippo Brunelleschi and Leon Battista Alberti—artists who had devised a precise, mathematical way of representing a three-dimensional world on a two-dimensional painted surface. Uccello's portrait of *Sir John Hawkwood* (1436) shows a strong interest in perspective.

Better was to come. In a fresco depicting the biblical flood and its recession, Uccello used perspective to show two scenes in one. His three famous *Battle of San Romano* paintings (late 1430s–1450s) involve an intensely planned perspectival scheme in which each element was carefully set. The pictures, which apparently hung side by side in the Medicis' Florentine palace, combine bright patterning and careful design in a medieval style with the sculptural and spatial ideas of Renaissance art.

Uccello seems to have worked into old age and to have died from general infirmity. Tradition has it that he spent his latter years as an impoverished recluse, obsessed with perspectival experiments that kept him awake all night. **AK**

Pure Propaganda

Uccello's *Battle of San Romano* scenes were not just essays in precise perspectival theory but impressive pieces of Renaissance propaganda, depicting a minor squabble in 1432 between the city-states of Florence and Siena. The Florentines were led by mercenary Niccolò da Tolentino on a white charger and wearing a flamboyant red headdress. He is depicted as the hero of a chivalrous romance—a popular theme at the time. In fact, contemporary reports suggest that he lost control and was rescued only when his troops came to his aid, later interpreted as a cunning plan devised by Niccolò.

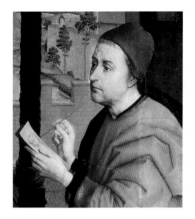

ROGIER VAN DER WEYDEN

Born: Rogier de la Pâture, *c.*1399 (Tournai, Belgium); died June 18, 1464 (Brussels, Belgium).

Artistic style: Restraint and calculated order; frozen moments of pious grief and anguish; acute observation; angular draperies; expressive, manipulated bodies.

Masterworks

*The Annunciation c.*1435–1470 (Musée du Louvre, Paris, France)

*St. Luke Drawing a Portrait of the Madonna c.*1435–1440 (Museum of Fine Arts, Boston, Massachusetts, U.S.)

*Deposition c.*1435–1470 (Museo del Prado, Madrid, Spain)

*Miraflores Altarpiece c.*1440 (Staatliche Museen, Berlin, Germany)

Seven Sacraments Altarpiece 1445–1450 (Koninklijk Museum voor Schone Kunsten, Antwerp, Belgium)

The Last Judgment Polyptych 1446–1452 (Musée de l'Hôtel Dieu, Beaune, France)

*Portrait of a Lady c.*1460 (National Gallery of Art, Washington, D.C., U.S.)

*Christus on the Cross with Mary and St. John c.*1460 (Nuevos Museos, El Escorial, Spain)

"His intensity of expression gives to traditional themes a new reality."—Margaret Whinney

ABOVE: Detail from the fifteenth-century painting *St. Luke Drawing the Virgin*.

Born in Tournai, Rogier van der Weyden was apprenticed to Robert Campin, one of the leading painters in the city. Shortly after his arrival in Brussels in 1435, he was made town painter and entrusted with decorating the new town hall with scenes of justice, which are now lost. Rogier acquired great wealth and international acclaim through civic commissions. He attracted prestigious foreign patrons, including Philip III the Good, Duke of Burgundy, although unlike his contemporary Jan van Eyck, he never held a court position.

Rogier's most remarkable works are his altarpieces of the Passion of Christ, with the greatest example being the *Deposition* (*c.*1435–1470). In this emotionally intense scene of Christ's body being carried down from the cross, the figures of the mourners are contorted with the pain of grief. Bent over and with dipped heads, they are manipulated into a restricted shallow space, adding to the intensity of emotion.

Rogier plays with ideas of space, painting believable surfaces with an immaculate finish, but sets these elements against a solid-gold background, as if they exist in a wooden box of a carved altarpiece. An innovation of Rogier's was to include illusionistic decorative framing at the corners of his paintings, reinforcing the enclosed claustrophobic world that his figures inhabit. His impact on painting in Brussels was great, although few of his followers had the skills in drawing and design to match up to their master. Rogier's work was almost forgotten during the eighteenth century because of a confusion regarding his identity; now his achievements are recognized. He is acknowledged as a supreme master of line, movement, and human emotion. **KKA**

BERNARDO MARTORELL

Born: Bernardo Martorell *c.*1400 (St. Celoni, Catalonia, Spain); died 1452 (Barcelona, Catalonia, Spain).

Artistic style: International Gothic painter and miniaturist; dynamic composition; sense of a dramatic narrative; detailed observation of nature.

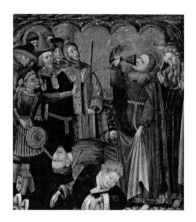

Little is known about the life of painter and miniaturist Bernardo Martorell. He worked in Barcelona and was the leading painter in Catalonia in his day. He is thought to have been a pupil of Gothic painter Luis Borrassá and to have begun his career as an illuminator of manuscripts. Martorell painted in the International Gothic style. His workshop produced highly decorative religious art such as stained-glass windows, as well as flags and coats of arms.

Only one surviving work is definitely attributed to Martorell, *The Altarpiece of St. Peter of Pubol* (1437), although *The Annunciation* (15th century), commissioned by the Franciscan monastery of Santa Maria de Jesus in Barcelona, is also thought to be his work.

The work for which Martorell is best known has still not been definitively attributed to him, but he is credited with painting five panels that once belonged to a larger work, *The Altarpiece of St. George* (1430–1435). This is partly because he is said to have claimed St. George as his patron and partly because the work is in Martorell's distinctive style, with a flair for depicting light, detailed observation, and a dramatic narrative. The story of St. George was taken from *The Golden Legend* (1275), a collection of stories about the lives of the saints. The influence of Byzantine iconography is apparent in the panels that are liberally decorated with gold leaf and gold paint. Martorell adds expressive faces, movement, and a sense of drama, using bright contrasting colors, dynamic composition, and realistic detail. He also uses stucco to emphasize St. George's halo and armor. Such works reveal Martorell's influence in helping to advance the prevailing style toward realistic figures and a compelling narrative. **MC**

Masterworks

The Altarpiece of St. George 1430–1435 (Art Institute of Chicago, Chicago, Illinois, U.S.; Musée du Louvre, Paris, France)

The Altarpiece of St. Peter of Pubol 1437 (Museo Diocesano di Girona, Girona, Spain)

The Nativity 1440s (Collection Lippmann, Berlin, Germany)

The Annunciation 15th century (Montreal Museum of Fine Arts, Montreal, Canada)

" . . . a vigorous sense of drama and delicate handling of light."
—Ian Chilvers

ABOVE: *St. John the Evangelist Drinking from the Poisoned Chalice* **is attributed to Martorell.**

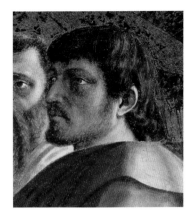

MASACCIO

Born: Tommaso Cassai or Tommaso di Ser Giovanni di Mone, 1401 (San Giovanni Valdarno, Arezzo, Italy); died December 21, 1428 (Rome, Italy).

Artistic style: Florentine painter who ushered in the Italian Renaissance; solid modeling of naturalistic figures; innovative use of linear and aerial perspective.

Masaccio was one of the most important painters of the fifteenth century and a founder of Renaissance painting. His nickname "Masaccio" means "clumsy Tom" and was given to him when he joined one of the craft guilds in Florence as a child. Little is known about his early training, but he was the first painter to use the effects of light and tone in his work to make them appear more solid. He moved away from the Gothic style and elaborate adornment to a more naturalistic approach. His use of expressive faces and positions was groundbreaking. After seeing works by the great Florentine sculptors Donatello and Nanni di Banco, the paintings of Giotto, and the early works of Filippo Brunelleschi, he developed new techniques to depict the illusion of perspective.

In 1422 he enrolled in the painters' guild, the Arte dei Medici e Speziali, in Florence. From 1424 he worked with his older colleague Masolino on the decoration of the Brancacci Chapel in the church of Santa Maria del Carmine in Florence and the following year on an altarpiece in Santa Maria Maggiore in Rome. In these works he applied his innovative methods to show linear perspective. This was achieved to startling effect in 1428 when he unveiled his *The Holy Trinity with the Virgin, St. John, and Two Donors* (1426–1428) in Santa Maria Novella. The fresco marks the first use of systematic linear perspective. Onlookers thought he had knocked a hole in the wall of the church as the painting appeared so three-dimensional.

Despite his brief career, he had a profound influence on other artists, particularly Leonardo da Vinci and Michelangelo Buonarroti. Masaccio died in the autumn of 1428; according to legend, he was fatally poisoned by a jealous rival painter. **SH**

Masterworks

*The Tribute Money c.*1425 (Brancacci Chapel, Santa Maria del Carmine, Florence, Italy)

Madonna Enthroned (Panel from the Pisa Altar) 1426–1427 (National Gallery, London, England)

St. Julian Slaying His Parents (Panel from the Pisa Altar) 1426 (Staatliche Museen, Berlin, Germany)

The Holy Trinity with the Virgin, St. John, and Two Donors 1426–1428 (Santa Maria Novella, Florence, Italy)

"I painted, and my picture was like life; I gave my figures movement, passion, soul . . ."

ABOVE: Detail from *The Tribute Money* painted by Masaccio in *circa* 1425.

FRA'FILIPPO LIPPI

Born: Fra'Filippo Lippi, c.1406 (Florence, Italy); died October 1469 (Spoleto, Italy).

Artistic style: Master of the early Renaissance; pure, exquisite color palette; influence of Netherlandish art; elegant figural forms; fresco and tempera on panel; highly realistic landscape detail.

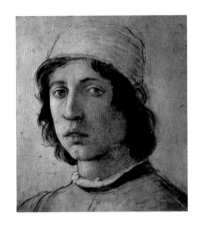

Accounts by art historian Giorgio Vasari indicate that the artist Fra'Filippo Lippi led one of the more colorful lives among his contemporaries, although many of the stories about him have since been discounted. It is known, however, that the artist (who was also a Carmelite monk) abducted a young novice, Lucrezia Buti, in 1456 from the Augustinian convent in Prato. The two lived together, joined by her sister and several other nuns, and had two known children: a son, Filippino Lippi, who became a famous artist and a daughter, Alessandra.

Lippi was one of the leading artists of the early Renaissance. His training is unknown, but he worked under the influence of Masaccio, Donatello, and later in his career Fra Angelico. In turn his work influenced his own pupil, Sandro Botticelli. Filippo Lippi was one of the first Italian artists to incorporate Netherlandish details in his work, and he was highly inventive and original in his paintings. This can be seen in his beautiful *Virgin and Child with SS Frediano and Augustine* (1437), which exhibits his complex but convincing spatial organization and elegant figural style. He was also one of the first Italian masters to paint portraits. He did so with great subtlety, as may be seen in *Portrait of a Man and a Woman at a Casement* (c.1440).

Lippi moved from Florence to Prato in around 1452 and began work on a large fresco cycle in the cathedral. The cycle was not completed until 1466 and represents his mature style with its strongly linear approach and rich palette. During this period he also worked on numerous other commissions. One of his last produced a masterpiece: the *Coronation of the Virgin* (1466–1469), part of a series of frescoes for Spoleto Cathedral that remained unfinished at his death and were later completed by his son, Filippino Lippi. **TP**

Masterworks

Virgin and Child with SS Frediano and Augustine (Barbardori Altarpiece) 1437 (Musée du Louvre, Paris, France)

Portrait of a Man and a Woman at a Casement c.1440 (Metropolitan Museum of Art, New York, U.S.)

Coronation of the Virgin c.1466–1469 (Spoleto Cathedral, Spoleto, Italy)

"No one surpassed him in his day, and but few in our own."
—Giorgio Vasari

ABOVE: Painted in 1485, this self-portrait is held in a collection at the Uffizi, Florence.

PIERO DELLA FRANCESCA

Born: Piero di Benedetto dei Franceschi c.1415–1420 (Sansepolcro, Italy); died October 12, 1492 (Sansepolcro, Italy).

Artistic style: Painter of religious works; innovative use of linear perspective, and light and shadow to create three-dimensional space; subtle color palette.

Piero della Francesca was apprenticed as a painter at the age of fifteen but was also a gifted mathematician. He is likely to have studied art in Florence, and he was certainly there in 1439 working with Domenico Veneziano. The influences of Florentine painters Masaccio and Paolo Uccello are evident in his works.

Piero led a peripatetic life, working in Rome, Ferrara, Rimini, and Arezzo. Much of his work has been lost, but fortunately some of his mature work survives. His portrait of *Sigismondo Pandolfo Malatesta* (1451) echoes the Netherlandish style with its fine, naturalistic detail. The artist did not follow any particular school or influence. The large frescoes depicting the *Legend of the True Cross* (c.1452–1465) that adorn the walls of the Church of San Francesco in Arezzo demonstrate his originality. Large pale spaces, accurate use of perspective, and a subtle color palette are typical of his work. One of the frescoes, *The Dream of Constantine*, uses chiaroscuro to create one of the first night scenes in western art.

Masterworks

Polyptych of the Misericordia 1445–1462 (Pinacoteca Comunale, Sansepolcro, Italy)

The Penance of St. Jerome 1450 (Gemäldegalerie Dahlem, Berlin, Germany)

Sigismondo Pandolfo Malatesta 1451 (Musée du Louvre, Paris, France)

The Flagellation of Christ c.1460 (Galleria Nazionale delle Marche, Urbino, Italy)

The Resurrection of Christ c.1463 (Pinacoteca Civica, Sansepolcro, Italy)

Portraits of Federico da Montefeltro and Battista Sforza c.1465–1470 (Uffizi, Florence, Italy)

Madonna and Child with Saints (Montefeltro Altarpiece) 1472–1474 (Pinacoteca di Brera, Milan, Italy)

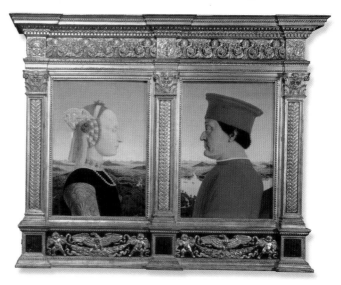

ABOVE: Portrait of the artist from Vasari's *Lives of the Artists*, first published in 1550.

RIGHT: This double portrait of the Duke and Duchess of Urbino is held in the Uffizi.

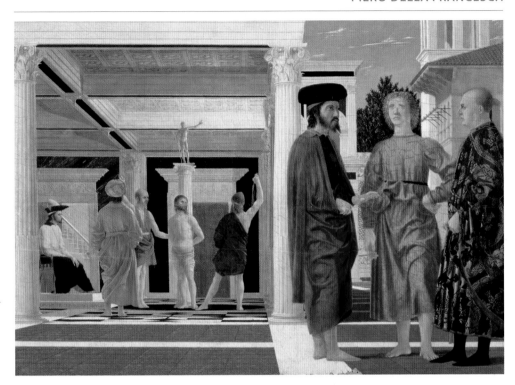

ABOVE: *The Flagellation of Christ* has
aroused speculation since it was created.

Piero was a Renaissance humanist who painted religious scenes for a living. His work is infused with the rediscovery of classical antiquity that revolutionized the thinking of the intelligentsia of the day. Whether these ideas changed his religious beliefs cannot be determined, but they certainly influenced his painting. In his mysterious work *The Flagellation of Christ* (c.1460), the prominent figures are three men who seem to be unaware of Christ's flagellation taking place in a classical setting behind them. Academics continue to speculate about their connection to the subject of the painting.

Piero often returned to his hometown, and painted *The Resurrection of Christ* (c.1463), his most celebrated work, for the Palazzo Communale. He died in Sansepolcro, and his reputation faded and languished in obscurity until the nineteenth century. **MC**

The Geometric Genius

Piero wrote three mathematical treatises and his achievements were considerable —in his study of polyhedrons, he rediscovered Archimedean solids. In his manuscript *Book on the Five Regular Bodies* (c.1480–1489) there is an illustration of an icosahedron—a twenty-faced polyhedron—inscribed in a cube. This was a completely new discovery in polyhedral mathematics. Piero's *On Perspective for Painting* (1474), described the new science of perspective and had a huge influence on Renaissance art and architecture.

JAUME HUGUET

Born: Jaume Huguet, 1415 (Valls, Tarragona, Spain); died c.1492 (Barcelona, Spain).

Artistic style: Catalan Gothic painter of altarpieces; naturalistic figures; expressive and individualistic characterization of figurative works; vivid use of color; fluid line.

Jaume Huguet worked in Barcelona in the fifteenth century when the Catalan Gothic style reached its pinnacle. The leading artist in the region at the time, he is famed for producing ornate altarpieces notable for their fine use of gold leaf and stucco, vivid use of color, complex composition, and fluidity of line.

Perhaps Huguet is most notable for the expressive characterization he brought to the figures he portrayed, which made them sympathetic to the onlooker and promoted compassion. For example, his depiction of the *Last Supper* (c.1470) shows Christ staring out at the viewer, giving the sign of blessing with his right hand to the onlooker. Jesus is present at the table but apart in his divinity, and surrounded by the disciples, whose faces each appear to have been based on individual, observed portraits.

Born in Valls, after the death of his father Huguet moved to the provincial capital, Tarragona, to live with his uncle, painter Pere Huguet. Later, in Barcelona, he encountered the work of Bernat Martorell before moving again to work in Zaragoza and Tarragona, where he absorbed the Flemish style of Luis Dalmáu and its attention to detail. When he returned to Barcelona in 1454, Huguet began to produce his greatest works, such as the panels for the *Altarpiece of Saint Michael and Saint Stephen or of the Retailers* (c.1455–1460), *Saint George and the Princess* (c.1459–1475), and *The Consecration of Saint Augustine. Altarpiece of Saint Augustine or of the Tanners* (c.1466–1475). The elegant and refined altarpieces he produced in his workshop proved influential for ecclesiastical art in Catalonia and Aragon, drawing on contemporary Flemish and Italian styles to produce a distinct Catalan Gothic style. **CK**

Masterworks

Head of a Prophet 1435 (Museo del Prado, Madrid, Spain)

The Flagellation of Christ c.1450–1459 (Musée du Louvre, Paris, France)

Altarpiece of Saint Michael and Saint Stephen or of the Retailers c.1455–1460 (Museu Nacional d'Art de Catalunya, Barcelona, Spain)

Saint George and the Princess c.1459–1475 (Museu Nacional d'Art de Catalunya, Barcelona, Spain)

The Consecration of Saint Augustine. Altarpiece of Saint Augustine or of the Tanners c.1466–1475 (Museu Nacional d'Art de Catalunya, Barcelona, Spain)

Last Supper c.1470 (Museu Nacional d'Art de Catalunya, Barcelona, Spain)

"[He] mixed Flemish and Italian influences with Romanesque conventions."—*New York Times*

ABOVE: *The Virgin and Child with St. Ines and St. Barbara* **shows a quite personal style.**

KANG HUI-AN

Born: Kang Hui-an, 1419 (South Korea); died 1464 (South Korea).

Artistic style: Painter, calligrapher, garden designer, and poet; rough, thick strokes of ink on paper or silk; landscapes influenced by Chinese painting of the Northern and Southern School.

In fifteenth-century Korean society, the gentry loved to paint and were known as "literati." Kang Hui-an was one such artist. Free from the restraints imposed on professional artists employed by the government, he was able to create his own style that was influenced by Chinese landscape painting of the Northern and Southern School of the Song Dynasty (960–1279). Painting and calligraphy were undifferentiated at that time, and known as *sohwa*. Works such as his *Sage Contemplating the Water* (*c.*1420–1464) had an impact on mainstream Korean art for many years to come, with its human figure stark in contrast to its background landscape painted in rough, thick strokes of ink. Little is known of Hui-an's personal life. **CK**

Masterworks

*Sage Contemplating the Water c.*1420–1464
(National Museum of Korea, Seoul, South Korea)

*A Gentleman Crossing the Bridge c.*1420–1464
(National Museum of Korea, Seoul, South Korea)

Hunmin Chongum 1446 (Kansong Art Museum, Seoul, South Korea)

SESSHU

Born: Sesshu Toyo, 1420 (Akahama, Okayama, Japan); died 1506 (Masuda, Iwami, Japan).

Artistic style: Innovative painter of landscapes and decorated screens; free, rapidly executed ink paintings; figures dwarfed by the scale of their environment.

A Zen Buddhist priest and master of the art of *sumi-e* monochrome ink painting, Sesshu studied in Kyoto under the landscape painter Shubun. He then came under the patronage of the ruling Ouichi family and accompanied them to China, where he was influenced by contemporary Ming landscape paintings. On his return he set up the Unkokuan Studio and incorporated the influences of Chinese painting in his work. Sesshu filled his landscapes with the massive forms of mountains, trees, distant buildings, and figures dwarfed by the scale of their environment. By the end of his life, he was regarded as the greatest painter of his time and was much in demand when he traveled on pilgrimages to Japan's shrines. **RS**

Masterworks

*Winter Landscape c.*1470s (Tokyo National Museum, Tokyo, Japan)

Landscape in the Haboku Technique 1495 (Tokyo National Museum, Tokyo, Japan)

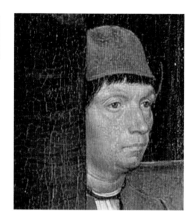

HANS MEMLING

Born: Hans Memling, c.1430 (Seligenstadt, Germany); died August 11, 1494 (Bruges, Belgium).

Artistic style: Master of fifteenth-century Flemish painting; exquisite altarpieces; rational spatial relationships; bold color; supreme powers of compositional design.

Masterworks

Triptych of Jan Crabbe 1467–1470 (Museo Civico, Vicenza, Italy; Pierpont Morgan Library, New York, U.S.)

The Last Judgement Triptych 1467–1471 (Muzeum Narodowe, Gdansk, Poland)

Scenes from the Passion of Christ 1470–1471 (Galleria Sabauda, Turin, Italy)

St. John Altarpiece 1474–1479 (Memlingmuseum, Sint-Janshospitaal, Bruges, Belgium)

The Man of Sorrows in the Arms of the Virgin 1475 (National Gallery of Victoria, Melbourne, Australia)

The Donne Triptych c.1478 (National Gallery, London, England)

Diptych of Maarten Nieuwenhove 1487 (Memlingmuseum, Sint-Janshospitaal, Bruges, Belgium)

One of a generation of southern Netherlandish artists to respond to the innovations of Jan van Eyck, Memling produced religious paintings and portraits of exquisite optic realism for the wealthy citizens of Bruges. Much of his work comprises luxurious, relatively small-scale panels made for easy transport to a private chapel or domestic setting and was readily snapped up by visiting dignitaries from courts across Europe.

Memling's work is set apart from that of his predecessors by the grace of his figures and his bold use of color, moving away from a reliance on gold backgrounds. His paintings achieve a sense of unity through his trademark continuous landscapes, running uninterrupted across panels. He is the first known South Netherlandish artist to have included a landscape view in a portrait, an innovation imitated by later artists.

His pictures radiate a sense of ordered perfection. Silent gatherings of saints and donors exist in a static, untouchable world of contemplation. They avoid the viewer's gaze, eyes downcast, emotionless. This quality, along with a heightened

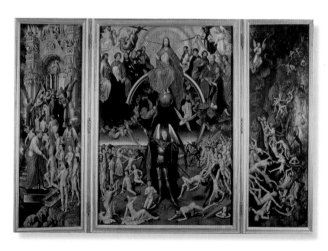

ABOVE: From *The Virgin and Child with Saints and Donors* (*The Donne Triptych*).

RIGHT: *The Last Judgement* shows a strong and well-balanced approach to composition.

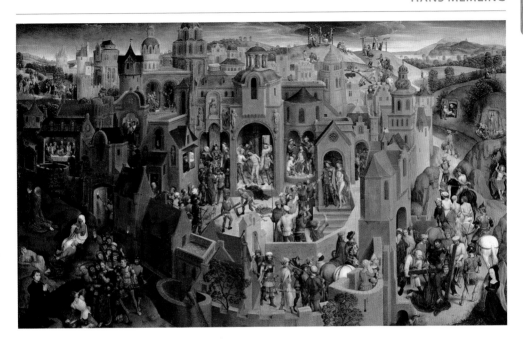

ABOVE: *The Passion* combines all twenty-three scenes into one painting.

awareness of surface, invites the viewer to meditate on the beauty of the scene as an aid to religious reflection.

Although little is known of Memling's early life, it is possible to say he came from Germany, settling in the Netherlands, perhaps to finish his training in the studio of Rogier van der Weyden in Brussels. Arriving in Bruges by the mid-1460s, his earliest recorded painting is the large triptych of *The Last Judgement* (1467–1471), now in Gdansk, Poland. During his time in Bruges, Memling enjoyed long-lasting relationships with patrons, including the Hospital of Saint John and the Confraternity of Our Lady in the Snow at Bruges Cathedral, who invited him to become a member in around 1473.

Memling had a lasting effect on contemporaries in Bruges. He brought the strength of design of van der Weyden and made it into a very specific vision of the material and heavenly world that appealed to his pious, cultured patrons. Through his eyes, the world is a place of perfection, crisply clear surfaces, golden braided hair, and delicate, extended fingers. **KKA**

Spatial Games in Art

Memling's vision is unerringly rational; the viewer believes in the spaces he creates through linear perspective and the play of light. In his portrait of Bruges nobleman Maarten Nieuwenhove, half of a diptych with the Virgin and Child, he consciously plays with illusionistic depth and spatial relationships. The perspective of the windows behind Nieuwenhove, and the direction he faces, takes into account the angle of the diptych when open. Under the paint lies a complex, carefully worked-out linear construction, the first of its kind known in southern Netherlandish painting.

GIOVANNI BELLINI

Born: Giovanni Bellini, *c.*1430 (Venice, Italy); died 1516 (Venice, Italy).

Artistic style: Renowned Venetian colorist; half-length representations of the Virgin and Child; soft, rosy light of dawn and sunset; idyllic pastoral landscapes; spiritual calm; teacher of Titian and Giorgione.

Masterworks

*The Agony in the Garden c.*1465 (National Gallery, London, England)

*Presentation at the Temple c.*1469 (Fondazione Querini Stampalia, Venice, Italy)

*Dead Christ Supported by Angels (Pietà) c.*1470s (Pinacoteca, Museo della Citta, Rimini, Italy)

St. Francis in Ecstasy 1480–1485 (Frick Collection, New York, U.S.)

*Transfiguration of Christ c.*1487 (Museo Nazionale di Capodimonte, Naples, Italy)

Madonna degli Alberetti 1487 (Gallerie dell'Accademia, Venice, Italy)

Portrait of Doge Leonardo Loredan 1501–1507 (National Gallery, London, England)

The Feast of the Gods 1514 (National Gallery of Art, Washington, D.C., U.S.)

> "Bellini may be called the 'Spring of all the World' in the art of painting."—Marco Boschini

ABOVE: *Portrait of Giovanni Bellini* (1505) was painted by Vittore Belliniano.

Marking the beginning of the Venetian school of painting, Giovanni Bellini made an important contribution to the history of painting in subject matter and technique. His long career saw the move away from traditional egg tempera painting to the medium of oil paint, developed in the Netherlands. His atmospheric light, rich colors, and gentle embraces of mother and child were all made possible by Bellini's understanding of the possibilities of oil paint. His innovations paved the way for the subsequent achievements of artists such as Titian, Paolo Veronese, and Tintoretto.

Bellini came from a distinguished family of painters. His father Jacopo ran the Bellini workshop until his death in *circa* 1470. His brother Gentile received great acclaim for his large canvases for public spaces and attended the court of the Turkish sultan at what was then Constantinople (now Istanbul) from 1478 to 1481. By the 1470s Giovanni was a leading painter of small devotional works and portraits, including several commissions for the ducal palace. He produced some of the greatest altarpieces of all time, painted in soft gradations of tone and resonating with spiritual and geometric harmony. Bellini was experimental and groundbreaking with his choice of subject matter. He incorporated poetic landscapes and allegories into his repertoire of religious narratives. In *The Agony in the Garden* (*c.*1465) and *St. Francis in Ecstasy* (1480–1485) a rosy morning glow pervades the scene. *The Agony in the Garden* is the first known painting of dawn light in Italian art. The artist's use of soft pink even inspired the name for the "Bellini" prosecco cocktail. It is an appropriate image by which to remember an artist who represents the first flourishing of the Venetian colorists. **KKA**

ANDREA MANTEGNA

Born: Andrea Mantegna, *c.*1431 (Isola di Carturo, near Padua, Italy); died September 13, 1506 (Mantua, Italy).

Artistic style: Renaissance master; sculptural quality to his figures and landscapes; experimented with perspective and illusion; religious subjects and portraits.

Andrea Mantegna was one of the most important artists of fifteenth-century Italy, a man whose profound influence affected both his contemporaries and generations of artists thereafter. Giovanni Bellini, Albrecht Dürer, Leonardo da Vinci, and Antonio da Correggio all reflected elements of Mantegna's style and technique, while his innovative fresco schemes paved the way forward for several centuries. He worked within the Italian Renaissance tradition. He is especially known for his adherence to classical Roman precedents and virtuoso use of illusionary perspective—notably in his frescoes and in his *sacra conversazione* paintings of the Madonna with Jesus among the saints. Apart from his painted works, he was an expert draftsman and produced many prints now considered to be the best examples of copperplate engraving from his time. He broke new ground with his etchings, developing the technique of combining dry point and burin to give greater tonal range and working on a far larger scale than was usual.

Masterworks

St. Luke Altarpiece 1453 (Pinacoteca di Brera, Milan, Italy)

*Agony in the Garden c.*1460 (National Gallery, London, England)

*Ceiling Oculus c.*1460s–1474 (Palazzo Ducale, Camera degli Sposi, Mantua, Italy)

The Court of Mantua 1471–1474 (Palazzo Ducale, Camera degli Sposi, Mantua, Italy)

*Triumphs of Caesar c.*1486–1505 (Hampton Court Palace, London, England)

*Lamentation over the Dead Christ c.*1490 (Pinacoteca di Brera, Milan, Italy)

Pallas Expelling the Vices from the Garden of Virtue 1499–1502 (Musée du Louvre, Paris, France)

The Introduction of the Cult of Cybele at Rome 1505–1506 (National Gallery, London, England)

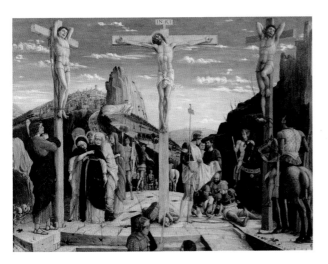

ABOVE: Mantegna was an expert draftsman and etcher, as well as a master painter.

LEFT: *Calvary*, the central predella panel from the *St. Zeno of Verona* altarpiece.

PRE-1500

Mantegna at Work

Mantegna worked in a precise and exacting manner and very slowly—allegedly to the frustration of his patrons. He was a superb draftsman and made careful underdrawings for his paintings, which he followed closely, deviating little once he had planned his design.

- Drawing was an important part of his oeuvre, not just in relation to his paintings and his prints but as a medium in its own right. Late in life, he produced several highly finished drawings, including *Judith with the Head of Holofernes* (*c.*1495–1500), which are now thought to represent some of the earliest instances of drawings being used as finished presentation pieces.

- Another unusual aspect of his work was his frequent use of the medium distemper: pigment mixed with an animal extract known as "size," on canvas. This painting technique produces a similar opaque quality of tone and color seen in the fresco work that Mantegna excelled at and might account for the artist's predilection for it. A good example of this is *The Introduction of the Cult of Cybele at Rome* (*c.*1505) —it has the dry appearance of stone and is similar to a fresco finish.

- The distemper works were probably not meant to be varnished, although later most of them were, resulting in the loss of Mantegna's original aesthetic effect.

Mantegna's talent was precocious. At eleven years old he was apprenticed to Paduan painter Francesco Squarcione and aged seventeen he left Squarcione to establish himself as an independent painter. The extent of Squarcione's influence on the young artist seems negligible, although he adored Roman antiquities—also one of Mantegna's lifelong passions. The work of Donatello was to have a more profound effect on Mantegna's developing visual language, as well as that of Paolo Uccello and Jacopo Bellini. One of Mantegna's earliest identified works is *St. Mark* (*c.*1440s); it displays the foundations of his mature style in its use of perspective and exacting realism.

The first large-scale scheme that Mantegna undertook was the decoration of the Ovetari Chapel in Padua. In 1448 he and fellow artist Nicolò Pizzolo were commissioned to decorate half of the chapel with scenes from the life of St. James, while the artists Antonio Vivarini and Giovanni d'Alemagna were to undertake the other half. Eventually Mantegna completed most of the decorative scheme himself. His sculptural approach to his figurative work is apparent in his muscular and smooth forms and is evident too in his sumptuous portrayal of Roman-style draped material.

RIGHT: *Marchese Ludovico Gonzaga III of Mantua* exhibits Mantegna's eye for detail.

In 1453—the year he married Nicolosia Bellini, daughter of Jacopo—Mantegna was commissioned to paint the St. Luke altarpiece for the Benedictines of San Giustina, Padua. Here again, his characteristic manipulation and use of perspective is at the fore, creating a unified, balanced scheme across the complicated figural composition. In 1460, after having established a glowing reputation in Padua, Mantegna became court painter to the Marquis of Mantua, Ludovico II Gonzaga. He was the first preeminent painter to live in Mantua and remained there from 1466 to 1488, receiving a high salary and working exclusively for the Gonzaga family, with whom he became friendly. He created some of his most famous works at this time, including the decorative scheme in the Camera degli Sposi (Wedding Chamber) at the Palazzo Ducale. His portraits of the Gonzagas were some of the finest of the period.

When in Rome

In 1448 Mantegna traveled to Rome at the request of Pope Innocent VIII to paint the Belvedere Chapel in the Vatican. The building was destroyed in 1780, but descriptions of Mantegna's work lived on in the writings of historian Giorgio Vasari. On his return to Mantua, he began work on a series of nine canvases depicting the *Triumphs of Caesar* (c.1486-1505). They illustrate the artist at perhaps his most Roman, drawing on classical forms, and precedents that re-create the world of antiquity.

Late in life Mantegna produced two notable paintings for Isabella d'Este, consort to Francesco Gonzaga. The two allegorical scenes— *Parnassus (Mars and Venus)* (1497) and *Pallas Expelling the Vices from the Garden of Virtue* (1499–1502)—show the artist's cerebral approach to the subjects and would have been very much appreciated by the intellectual audiences for which they were intended.

Following Mantegna's death in 1506, an impressive monument was built for him in the church of Sant'Andrea, Mantua, by his sons. **TP**

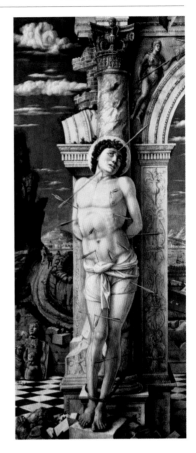

"The *Triumphs of Caesar* . . . are the best thing that he ever did."—Giorgio Vasari

ABOVE: In *St. Sebastian,* the raw fear on the saint's face elicits emotion from the viewer.

ANDREA DEL VERROCCHIO

Born: Andrea di Michele di Francesco de'Cioni, 1435 (Florence, Italy); died 1488 (Venice, Italy).

Artistic style: Leading fifteenth-century Florentine sculptor, painter, and architect; technical wizardry in bronze; conceptual inventiveness; marble tombs and statuary.

Masterworks

Tomb of Piero and Giovanni de'Medici 1469–1472 (Church of San Lorenzo, Florence, Italy)

Tobias and the Angel 1470s (National Gallery, London, England)

The Baptism of Christ 1472–1475 (Uffizi, Florence, Italy)

The Young David c.1475 (Museo Nazionale di Bargello, Florence, Italy)

Christ and Doubting Thomas 1476–1483 (Orsanmichele, Florence, Italy)

Lorenzo de'Medici 1480 (National Gallery of Art, Washington, D.C., U.S.)

Equestrian Statue of Colleoni 1480s (Campo di Santi Giovanni e Paolo, Venice, Italy)

Andrea del Verrocchio's varied career has received mixed criticism from art historians, largely due to his eclectic output and talents. He turned his hand to almost any project, whether sculptural, decorative, or functional. Most significantly, Verrocchio has been overshadowed by the glowing career of Leonardo da Vinci, who shot to fame from Verrocchio's studio. Thanks to the success of his pupil, Verrocchio laid down his paintbrush to concentrate on sculpture. He is best remembered for his technical ability, particularly in bronze, and for the efficient organization of a large and busy workshop. Verrocchio started his artistic life as a goldsmith and then expanded his repertoire to include painting and sculpture.

On the death of Donatello in 1466, Verrocchio stepped into his shoes as the Medicis' favorite artist. This position led to important commissions in later life: providing marble tombs enlivened with animals and plant forms, painted altarpieces, and designs for state receptions. By 1466, he was receiving other prestigious commissions, including a group of *Christ and Doubting Thomas* (1476–1483) in bronze for the church of Orsanmichele. A year later, he provided the marble tomb for Cosimo di Giovanni de'Medici at the church of San Lorenzo in Florence. Verrocchio's crowning moment was to supply a giant gilded copper ball for the top of Florence Cathedral. Completed in 1471, it secured his fame as an artist of exceptional technical and creative powers. His bronze sculpture *The Young David* (c.1475) was a direct response and challenge to Donatello's sculpture of the same subject. Inspired by antique sources and devoted to the study of nature, Verrocchio approached his diverse projects with intelligence and original thought, thus challenging conventions. **KKA**

"Next to ... Leonardo his is the greatest artistic character that has ever existed."—Adolf Bayersdorfer

ABOVE: Portrait of Verrocchio from Vasari's *Lives of the Artists*, first published in 1550.

LUCA SIGNORELLI

Born: Luca d'Egidio di Ventura, *c.*1440–1450 (Cortona, Italy); died October 1523 (Cortona, Italy).

Artistic style: Precise anatomical detail and representation of the human figure; dramatic action; muscular, monumental nudes; frescoes; use of foreshortening.

Luca Signorelli is regarded as one of the great Renaissance draftsmen, best known for his nudes and innovative use of foreshortening. The two major influences on his creative development preached contrasting styles. As a student of Piero della Francesca, he inherited his master's strict sense of composition and majestic style. He then worked with Antonio and Piero del Pollaiolo, whose impact can be most keenly felt on his decorative and wiry athleticism of the human form. One of his earliest pieces of work is the processional banner in *The Scourging of Christ* (*c.*1480). Its sensitive treatment of light and shade and its scientific naturalism showcase how he had consumed a mixture of styles from his masters.

Signorelli journeyed to Rome in 1482 to work on the fresco cycle along the lower walls of the Sistine Chapel, contributing *The Death and Testament of Moses* (1481–1482). The commissions gathered apace. They took him to the monastery at Monte Oliveto Maggiore in the Siena hills to work on a fresco cycle of scenes from the life of St. Benedict and then to Orvieto, where he was to unleash his masterpiece.

Inside the chapel of San Brizio in the Orvieto Cathedral, Signorelli painted *The End of the World* (1504) frescoes, including his magnificent painting of *The Last Judgment* (1499–1502), for which he is largely remembered today. The dramatic scene conveys a chaotic mélange of muscular nudes, highlighting the artist's immense skill at portraying anatomical detail. Michelangelo Buonarroti was greatly influenced by the piece, and Raphael was a keen admirer when visiting the city. It was to such artists that Signorelli cleared a path for the major artistic developments that were to unfold in sixteenth-century Italy. **SG**

Masterworks

*The Scourging of Christ c.*1480 (Pinacoteca di Brera, Milan, Italy)

The Death and Testament of Moses 1481–1482, (Sistine Chapel, Vatican City, Italy)

*Madonna and Child c.*1490 (Uffizi, Florence, Italy)

The Adoration of the Shepherds 1496 (National Gallery, London, England)

The Last Judgment 1499–1502 (Duomo, Orvieto, Italy)

Mary Magdalene 1504 (Museo dell'Opera del Duomo, Orvieto, Italy)

The Trinity, the Virgin and Two Saints 1510 (Uffizi, Florence, Italy)

The Virgin and Child with Saints 1515 (National Gallery, London, England)

"Luca opened to the majority of craftsmen the way to the final perfection of art."—Giorgio Vasari

ABOVE: This self-portrait is a detail from the fresco cycle *The Deeds of the Antichrist*.

SANDRO BOTTICELLI

Born: Alessandro di Mariano di Vanni Filipepi, *c.*1444 (Florence, Italy); died May 17, 1510 (Florence, Italy).

Artistic style: Classical and mythological themes; allegorical figures; strong linear perspective; depictions of divine beauty and love.

Botticelli's paintings are timeless: their heavy use of allegory renders them as much an enigma as their creator. Yet had the young Alessandro not persuaded his father to end his training as a goldsmith, the world would have been robbed of one of the greatest painters of the Florentine Renaissance. Thankfully, the boy known as Botticelli, meaning "little barrel," was apprenticed to the Early Renaissance master Fra'Filippo Lippi, who set his protégé on the way to greatness.

Lippi's own style is evident in much of his pupil's early work, as Botticelli absorbed his master's taste for extravagant decoration and a strong linear sense of form. When Fra Lippi left for Spoleto, Botticelli went to work with the painters and sculptors Antonio Pollaiolo and Andrea del Verrocchio. Both artists favored naturalistically portrayed, muscular figures; Botticelli admired and copied their sculptural approach.

By 1470 he was an independent painter in Florence with his own workshop and had his first commission: *Allegory of Fortitude* (1470). His talents soon attracted the mighty Medici family who—enamored with his secular historical works,

Masterworks

*La Primavera c.*1482 (Uffizi, Florence, Italy)

The Virgin and Child Enthroned (Bardi Altarpiece) 1484 (Staatliche Museen, Berlin, Germany)

*The Birth of Venus c.*1485 (Uffizi, Florence, Italy)

*Venus and Mars c.*1485 (National Gallery, London, England)

St. Augustine in His Cell 1490–1494 (Uffizi, Florence, Italy)

Calumny of Apelles 1494–1495 (Uffizi, Florence, Italy)

*The Descent of the Holy Ghost c.*1495–1505 (Birmingham Museum & Art Gallery, Birmingham, England)

Mystic Nativity 1500 (National Gallery, London, England)

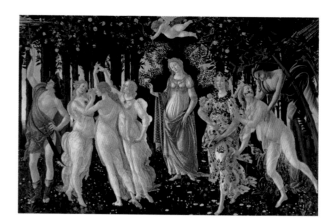

ABOVE: Portrait of Botticelli from Vasari's *Lives of the Artists*, first published in 1550.

RIGHT: *La Primavera* was painted before Botticelli's involvement with Savonarola.

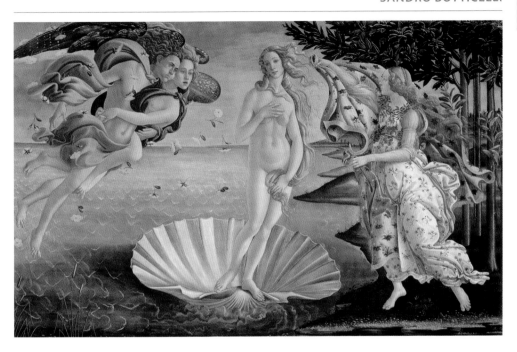

ABOVE: *The Birth of Venus* is one of the world's most recognizable paintings.

treatment of mythical and religious themes, and portraiture skills—showered him with commissions. They were not alone. In 1481 Pope Sixtus IV summoned him to Rome to fresco the Sistine Chapel walls. He studied Florentine art forms, painting altarpieces, frescoes, and tondi of all sizes, creating harmonious compositions of fantastic landscapes and emotive, vital figures. Many of the Medici commissions mirrored the family's taste for classical antiquity represented by mythological figures. This unique style of secular painting peaked with *La Primavera* (c.1482) and *The Birth of Venus* (c.1485), in which the artist employs typically ambiguous allegorical forms.

Botticelli's style and attitude radically altered in his later years under the influence of the Dominican priest Savonarola. His paintings became smaller, the themes apocalyptic and anguished. Toward the end of his life, he dedicated himself to a lifelong ambition of illustrating Dante's *The Divine Comedy* (1308–1321), but ill health curtailed his dream. **SG**

Bonfire of the Vanities

The relationship between Botticelli and the fanatic Dominican monk Girolamo Savonarola has provoked much debate throughout history. According to the chronicler Giorgio Vasari, Botticelli became a devotee of the priest and abandoned pagan themes in his art. A new school of thought now suggests that Botticelli's subordination to the will of Savonarola was so complete it led him to throw some of his own paintings on to the notorious Bonfire of the Vanities, on February 7, 1497. Such a notion defies belief. Like a raging fire, though, the theories continue to gather speed.

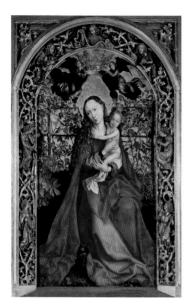

MARTIN SCHONGAUER

Born: Martin Schongauer, c.1448 (Colmar, France); died February 2, 1491 (Breisach am Rhein, Germany).

Artistic style: Painter and engraver of exquisite prints of religious subjects; tender and graceful images; clear and florid line; volume and depth to his figures.

A specialist engraver and painter, Martin Schongauer came from the city of Colmar in the Alsace region of France. It is presumed that he trained as an engraver with his father, a goldsmith. His work was also influenced by the art of an engraver known as "Master E. S." and by early Netherlandish art—especially the work of Rogier van der Weyden. With the hope of meeting Schongauer, the young Albrecht Dürer traveled across Germany in 1492—though sadly, he arrived shortly after the older artist's death.

Mainly working within a Gothic tradition, Schongauer's work is characterized by his use of clear and florid lines. Mostly he depicted religious subjects and produced a number of enchanting images of the Virgin Mary and holy family.

Masterworks

*The Holy Family c.*1470 (Alte Pinakothek, Munich, Germany)

*Madonna and Child in the Courtyard c.*1470s (Hermitage Museum, St. Petersburg, Russia)

Madonna in the Rose Garden 1473 (Church of Saint-Martin, Colmar, France)

Perhaps Schongauer's most exemplary work is the *Madonna in the Rose Garden* (1473). His only dated piece, it represents a distinctive landmark in his career. The deceptively simple and balanced composition is filled by a monumental yet elegant Virgin dressed in a red cloak, a figure that would recur in his paintings. With the use of careful foreshortening, Schongauer is able to represent her form convincingly as a volume in space. Although the Virgin sits in a shallow space, before a flat gold background, the artist was also able to convey a sense of depth by means of the skillful application of perspective. The overwhelming feeling in his art is one of quiet intimacy, and the gracefulness of his work soon became legendary. Although immensely skilled as a painter, it was as a printmaker that Schongauer's fame spread beyond the Alps. Easily reproduced in large numbers and widely distributed, his engravings were appreciated for their wide range of depicted tones and textures. **AB**

"His art earned him the epithet 'Martin Hübsch' (Martin the Beautiful)."—Fritz Koreny

ABOVE: *Madonna in the Rose Garden* remains Schongauer's most famous work.

DOMENICO GHIRLANDAIO

Born: Domenico di Tommaso Curradi di Doffo Bigordi, 1449 (Florence, Italy); died January 11, 1494 (Florence, Italy).

Artistic style: Fresco painter with a flourishing Florentine workshop; careful craftsmanship, accurate perspective, naturalistic details, and skillful compositions.

In comparison with his contemporary Sandro Botticelli, Domenico Ghirlandaio was an old-fashioned painter. The nickname "Il Ghirlandaio," meaning garland maker, came from his father, a goldsmith known for creating necklaces worn by Florentine women. In his father's shop, Ghirlandaio is said to have made portraits of passersby, and he was soon apprenticed to painter Alessio Baldovinetti to study painting and mosaic. By the age of twenty he ran a large, well-organized workshop with his two brothers.

He was excellent at fresco and never used oils, although he painted several portraits in tempera. One of his most significant skills was the inclusion of lifelike contemporary portraits in his paintings. He used simple colors, and it is said that he was the first painter to stop using gilding in his pictures. Summoned by Pope Sixtus IV, he painted a fresco in the Sistine Chapel in Rome. The work, *Calling of the First Apostles* (1481), contains several realistic portraits of prominent contemporary Florentines living in Rome.

Most of Ghirlandaio's frescoes are in Florence. His largest commission is the cycle in the choir of Santa Maria Novella, illustrating scenes from the lives of the Virgin and St. John the Baptist. The work was commissioned by Giovanni Tornabuoni, a partner in the famous and then-powerful Medici bank. Ghirlandaio depicted the story in intricate compositions, arranging characters as if events had taken place in the home of a wealthy Florentine burgher. In an acknowledgment of his benefactor, he included twenty-one portraits of various members of the Tornabuoni family, showing clearly the lifestyles and manners of the time that appealed to middle-class tastes. **SH**

Masterworks

Saint Jerome in His Study 1480
(Ognissanti, Florence, Italy)

Old Man and his Grandson c.1480–1490
(Musée du Louvre, Paris, France)

Calling of the First Apostles 1481
(Sistine Chapel, Rome)

Virgin and Child with Saints Dominic, Michael, John the Baptist and John the Evangelist c.1494 (Alte Pinakothek, Munich, Germany)

"[He] was regarded throughout all Italy . . . as one of the finest living masters." —Giorgio Vasari

ABOVE: This self-portrait of the artist is a detail from one of his altarpieces.

PIETRO PERUGINO

Born: Pietro Vannucci, *c.*1450 (Città della Pieve, Italy); died 1523 (Fontignano, near Perugia, Italy).

Artistic style: Leading painter of the Umbrian school; one of the first Italian artists to use oils; religious works notable for serene atmosphere; ordered composition.

Pietro Perugino was one of the leading early masters of the Renaissance. He enjoyed considerable commercial success. He ran two studios, one in Florence and another in Perugia. His work was in demand for a short period until his reputation dimmed under that of Raphael. His detractors criticized him for a lack of originality. This was directly caused by the popularity and high output of his paintings, which led him to repeat figures and other elements in his work.

Perugino was born in Umbria and is thought to have trained under Andrea Verrocchio and possibly Piero della Francesca in Florence. His style exhibits the influence of both masters in his spatial organization, use of perspective, and clear, pure palette. His work is notable for its consistently harmonious atmosphere. He combines often symmetrical and always balanced compositions with elegant Florentine figures and Umbrian landscape elements. Few of his earliest works have survived.

Masterworks

*Christ Delivering the Keys to St Peter c.*1480–1482 (Sistine Chapel, Rome, Italy)

Madonna and Child 1490 (Pushkin Museum of Fine Art, Moscow, Russia)

The Crucifixion 1493–1496 (Convent of Santa Maria Maddalena dei Pazzi, Florence, Italy)

*The Lamentation Over the Dead Christ c.*1495 (Palazzo Pitti, Florence, Rome)

Combat of Love and Chastity 1503–1505 (Musée du Louvre, Paris, France)

*The Virgin and Child with Saints Jerome and Francis c.*1507–1515 (National Gallery, London, England)

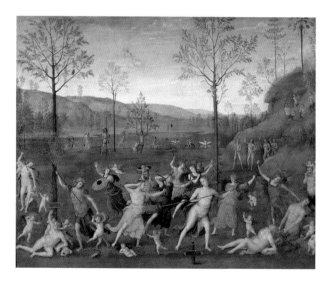

ABOVE: *Portrait of Perugino* was painted *circa* 1504 by Raphael.

RIGHT: The content of *Combat of Love and Chastity* was suggested by its patron.

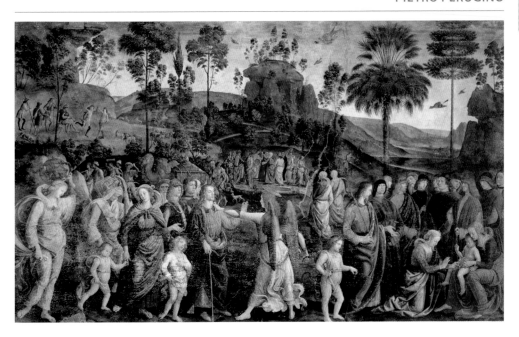

He is recorded as moving to Rome in 1479 when he was commissioned to undertake decorative schemes for the Sistine Chapel, including *The Virgin and Child with Angels* (*c.*1480), now destroyed. Several of his paintings on the altar wall were painted over by Michelangelo Buonarotti for his *The Last Judgment* (1535–1541). One of Perugino's most important works is the fresco *Christ Delivering the Keys to St. Peter* (*c.*1480–1482), which exhibits a maturing style and presents his composed and balanced composition. He returned to Florence and undertook a number of commissions for religious works, including the *Vision of St. Bernard* (1491–1494) for the church of Santa Maria Maddalena dei Pazzi in Florence. Its architectural setting, Umbrian landscape, and soft palette typify Perugino's style of this time. He primarily worked from Florence, where he executed his altarpiece *The Lamentation Over the Dead Christ* (*c.*1495). Expressive of his somber, restrained, and harmonious approach to his subject, it is also believed to have had a direct influence on Raphael's *Entombment* (1507). **TP**

Judgment on Perugino

Perugino achieved great success during his long working life and was widely regarded. Yet he was not immune from criticism. One of the most famous and harshest commentaries came from Michelangelo who, according to Giorgio Vasari, publicly described Perugino as "goffo nell'arte," meaning "awkward in art." Perugino's outrage was such that he tried to bring about legal proceedings against the artist for defamation, but the case was eventually dropped. It is no small irony that several of Perugino's decorative schemes on the altar wall of the Sistine Chapel were later removed to make room for Michelangelo's *The Last Judgment*.

LEONARDO DA VINCI

Born: Leonardo di ser Piero da Vinci, April 15, 1452 (Vinci, Italy); died May 2, 1519 (Amboise, Indre-et-Loire, France).

Artistic style: The ultimate Renaissance man; tightly organized composition; naturalistic light effects; modeling of painted figures with blending technique.

Leonardo da Vinci was the linchpin of the High Renaissance, with a dizzying array of talents embracing art and science. His name comes from Vinci, a town in Tuscany close to the place where he was born. He was the illegitimate son of a well-respected local notary and a peasant girl. His mother married someone else when Leonardo was still very young, but the boy's father raised the child on the family estate. Recognizing his son's artistic talent, he apprenticed him to the Florentine sculptor Andrea del Verrocchio. This was the perfect start for someone with such a multifaceted creativity because del Verrocchio's workshop trained apprentices in a wide range of artistic and technical skills.

The late 1470s saw Leonardo working as an independent artist in Florence and receiving promising commissions. He also showed signs of the innovations that would come to define much of High Renaissance art and influence so many painters and sculptors. This was especially true of his unique ability to organize space creatively and to plan totally harmonious, deceptively simple compositions, as seen in his unfinished *Adoration of the Magi* (started *c.*1481). The artist headed next for Milan, living and working there between 1482 and 1499.

Masterworks

*Portrait of a Lady with an Ermine (Cecilia Gallerani) c.*1482–1490 (Czartoryskich Museum, Kraków, Poland)

Virgin of the Rocks 1483–1486 (Musée du Louvre, Paris, France)

*Virgin of the Rocks c.*1491–1508 (National Gallery, London, England)

*The Vitruvian Man c.*1492 (Gallerie dell'Accademia, Venice, Italy)

*The Last Supper c.*1495–1498 (Convent of Santa Maria delle Grazie, Milan, Italy)

*Mona Lisa c.*1503–1506 (Musée du Louvre, Paris, France)

*Virgin and Child with St. Anne c.*1510 (Musée du Louvre, Paris, France)

ABOVE: *Leonardo Da Vinci* (probably a self-portrait) dates from *circa* 1510s.

RIGHT: *The Annunciation* demonstrates Leonardo's striking use of perspective.

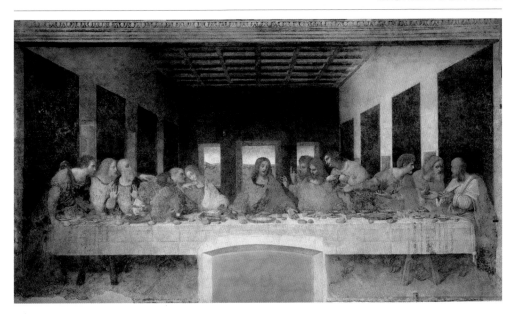

ABOVE: *The Last Supper* has inspired
countless theories, books, and parodies.

Why Leonardo left Florence remains a mystery. He may have felt Duke Ludovico Sforza's Milanese court offered better opportunities to flex his increasing range of artistic muscles. Prestigious work consistently came his way, including the commission that produced his two *Virgin of the Rocks* (1483–1486 and *c.*1491–1508) altarpieces.

Elegant and well mannered, Leonardo became well liked and carved himself out a varied career, producing paintings and sculptures, designing fortifications, and advising on architectural and engineering projects. Leonardo also produced numerous fascinating drawings. Much has been made of his sketched ideas that seem to be well ahead of their time, such as his famous sketch of what appears to be a helicopter. Although research suggests that his designs are actually more rooted in their era than had been previously imagined, they still show a remarkably inventive mind. This period also produced one of the world's best-loved and most

"Knowing is not enough; we must apply. Being willing is not enough; we must do."

Taking to the Stage

As an artist in the pay of royal and noble patrons, Leonardo was often called upon to devise and design a variety of pageants and entertainments at court.

- His copiously illustrated notebooks contain sketches and notes for all kinds of ideas, from fountains to a fake mountain that opened up to reveal a group of musicians.

- The artist was especially talented at theatrical effects, not least because he was able to bring his full range of artistic and technical skills into play. Not only was he able to deploy a rich vocabulary of visual symbolism of the kind that courtiers and kings loved to unscramble, he also employed machinery to create the spectacular effects that lavish occasions often demanded.

- Leonardo possessed considerable musical talent and played a type of fiddle, so he knew how to incorporate musical elements into his mise-en-scène.

- Leonardo was asked to design a suitable stage set for a performance of court poet Bernardo Bellincioni's *La Festa del Paradiso* (1490) (*Feast of Paradise*) to mark the marriage of Gian Galeazzo to Isabella of Aragon in 1490 in Milan. The centerpiece was a huge, spectacular hemisphere covered with planets and glowing stars—the perfect piece for a man whose scientific studies included astronomy.

RIGHT: The enigmatic smile of the *Mona Lisa* has captivated art lovers for centuries.

admired works: *The Last Supper* (*c.*1495–1498). He painted this fresco for the refectory of Milan's Santa Maria delle Grazie convent. Here Leonardo showed the traits that would influence so many other artists, including Raphael and Sir Peter Paul Rubens. These included the human psychology he was able to inject into paintings, his talent for portraiture and gesture (seen in each individual disciple), his mastery of clear compositional organization and arrangement of groups, and his understanding of perspective—the painting is conceived to appear like a three-dimensional upper gallery off the refectory wall. Leonardo also indulged his love of technical innovation and experimentation. He used a fresco method of his own devising that unfortunately meant that the painting deteriorated prematurely.

An incredible range of talents

At the start of the 1500s, Leonardo was based in Florence, where he garnered great acclaim, although he seemed more absorbed by mathematical studies than by painting. He began the *Mona Lisa* (*c.*1503–1506), with her serene, famously enigmatic smile, conjuring her form out of his expert *sfumato* blending technique. The pyramidal composition of the *Virgin and Child with St. Anne* (*c.*1510) shows him developing a mastery of tight but expressive, dynamic figure grouping. In other fields, he was also unstoppable. His many roles included chief surveyor, engineer, and mapmaker to the Borgia family; studying birds' flight patterns; devising hydraulic schemes; analyzing the science of painting; and dissecting human bodies to glean in-depth knowledge of human anatomy.

In 1508 the artist began a happy period in Milan. He acted as architectural consultant for the city's French governor and for King Louis XII. In 1513 political developments forced Leonardo to move to Rome at a time of exciting artistic change. However, he found little challenging work and left Italy for France in 1516. Still working on his scientific studies and writings until the end, he died in Clos Lucé manor house and was buried in French soil in Amboise. **AK**

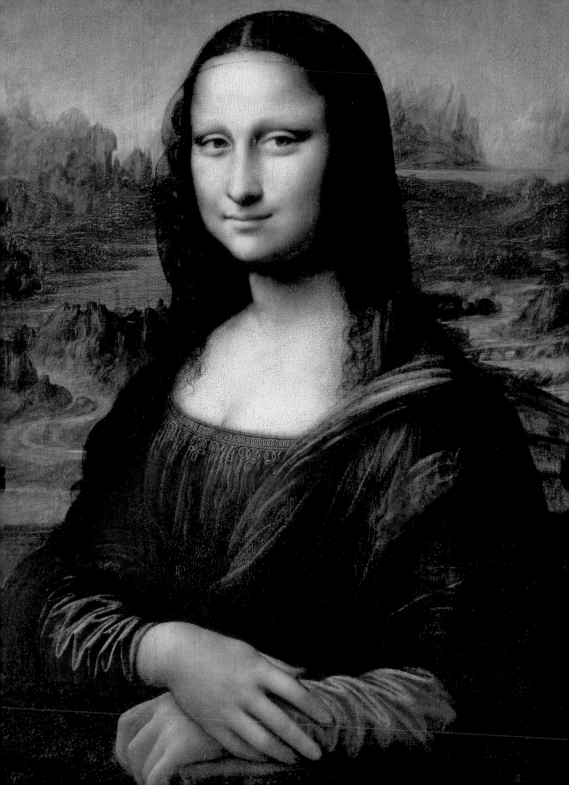

HIERONYMUS BOSCH

Born: Jeroen van Aken, *c.*1450 ('s-Hertogenbosch, the Netherlands); died August 9, 1516 ('s-Hertogenbosch, the Netherlands).

Artistic style: Master of the grotesque and the bizarre; fantastical visions of hell; medieval prophecy depicted in a Renaissance manner; precursor of surrealism.

Masterworks

The Haywain 1485–1490 (Museo del Prado, Madrid, Spain)

The Ship of Fools 1490–1500 (Musée du Louvre, Paris, France)

*The Garden of Earthly Delights c.*1500–1510 (Museo del Prado, Madrid, Spain)

*The Last Judgment c.*1505 (Akademie der Bildenden Künste, Vienna, Austria)

*Adoration of the Magi c.*1510 (Museo del Prado, Madrid, Spain)

Born Jeroen van Aken, Bosch adopted his name from 's-Hertogenbosch, a town of the southern Netherlands in which he lived, worked, and died. He was born to a family of German artists, and a number of original documents confirm his high social status and prominence. Bosch did not have to earn a living as a painter; his tax records show that he was one of the town's wealthiest men. Perhaps his financial freedom is in part the reason for his unusual and bizarre subject matter.

Although Bosch did produce some traditional religious altarpieces, he is best remembered for creating large, open landscapes filled with depictions of fantastic, part-human, part-machine beasts. These large panel paintings portray nightmarish visions with the aim of symbolizing the sins and immorality of mankind. Such visions had been more common in late medieval times, and Bosch was surely influenced by earlier manuscript illustrations. His surreal and symbolic images are depictions of human failings and temptations but aim to teach and redeem their viewers. Such a masterpiece as *The Garden of Earthly Delights* (*c.*1500–1510) depicts the history of the creation of the world and includes visions of Earth, heaven, and hell; yet the work continues to baffle scholars who argue over its complex iconography. Although the meanings of his works remain mysterious, Bosch's use of translucent oil paints and his technical virtuosity allow for vast amounts of painstaking detail. Despite his fame, only twenty-five works can definitely be attributed to him. He rarely signed his work, and because of his persistent popularity many contemporary copies of his works exist. He proved a major source of inspiration to the works of Salvador Dalí and the surrealists. **AB**

"The master of the monstrous ... the discoverer of the unconscious."—Carl Gustav Jung

ABOVE: *Portrait of Hieronymus Bosch* from the collection of portrait copies *Recueil d'Arras.*

PIERO DI COSIMO

Born: Piero di Lorenzo *c.*1462 (Florence, Italy); died *c.*1521 (Florence, Italy).

Artistic style: Renaissance painter of imaginative, idiosyncratic, lyrical, and poetic Christian and pagan subjects, and portraits; masterful painting of animals and landscape; subtle, evocative depiction of light and atmospheric conditions.

Florentine painter Piero di Cosimo had a lasting influence on the development of the arts in Florence, and in particular on the work of Fra Bartolomeo, Mariotto Albertinelli, Jacopo Pontormo, and Andrea del Sarto. His treatment of landscape was virtually unequaled and was of importance for successive artists, as was his quirky, poetic, and inspired treatment of both Christian and mythological subjects. He is also depicted as one of the most interesting and eccentric characters of his period by the eminent biographer Giorgio Vasari.

Di Cosimo trained under Cosimo Rosselli, from whom he eventually took his name, and traveled with the older artist to Rome in 1481. There he worked on the landscape background of Rosselli's fresco *Sermon on the Mount* (1481) in the Sistine Chapel. By the late 1480s di Cosimo was working independently and forging his own style, defined by his subtle and moving treatment of light and atmosphere, his extraordinary rendering of landscape, and his frequent inclusion of animals that he painted with great understanding and realism. He worked most often in tempera on panel, although he also used oils; he used primarily pen and ink for his drawings and sketches. According to Vasari, di Cosimo was highly temperamental, irritated by flies and screaming children, averse to cleaning, and lived on a diet of hard-boiled eggs, which he cooked while boiling his glue. Primary influences through his career were those of Leonardo da Vinci, Filippino Lippi, and Luca Signorelli, although he retained the significantly imaginative and characteristic approach that makes his paintings so recognizable. The *Death of Procris* (*c.*1500–1510), with its soulful dog and lyrical landscape, is among his most famous works. **TP**

Masterworks

*Portrait of Simonetta Vespucci c.*1480 (Musée Condé, Chantilly, France)

*The Visitation with Saint Nicholas and Saint Anthony c.*1490 (National Gallery of Art, Washington, D.C., U.S.)

*A Satyr Mourning over a Nymph c.*1495 (National Gallery, London, England)

*Death of Procris c.*1500–1510 (National Gallery, London, England)

Immaculate Conception with Saints 1505 (Uffizi, Florence, Italy)

*The Forest Fire c.*1505 (Ashmolean Museum, Oxford, England)

The Myth of Prometheus 1515 (Alte Pinakothek, Munich, Germany)

"Piero's art reflects his bizarre, misanthropic personality."

—*Encyclopædia Britannica*

ABOVE: Portrait of Piero di Cosimo from Vasari's *Lives of the Artists* (1550).

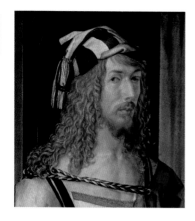

ALBRECHT DÜRER

Born: Albrecht Dürer, May 21, 1471 (Nuremberg, Germany); died April 6, 1528 (Nuremberg, Germany).

Artistic style: The Renaissance man of northern Europe; printmaker, draftsman, painter, and writer; self-consciously an artist, not just a brilliant craftsman.

Considered the most important German artist of all time, Albrecht Dürer was not only an immensely talented painter but also an accomplished draftsman, printmaker, and author. He earned the label of "Renaissance man" as he was one of the first artists to self-consciously market himself more as an intellectual than as a craftsman, an attitude visible in the many self-portraits he painted during his lifetime.

Dürer was born and died in Nuremberg, a center of northern European printmaking, book trade, and humanism. His father, of Hungarian origin, was a goldsmith, but Dürer abandoned the family trade to become a painter. He became an apprentice to

Masterworks

Self-Portrait at Age 13 1484 (Albertina, Vienna, Austria)

The Revelation of St. John (Apocalypse) 1497–1498 (Staatliche Kunsthalle, Karlsruhe, Germany)

Self-Portrait with Gloves 1498 (Museo del Prado, Madrid, Spain)

Self-Portrait with Fur-Trimmed Robe 1500 (Alte Pinakothek, Munich, Germany)

The Hare 1502 (Albertina, Vienna, Austria)

Great Piece of Turf 1503 (Albertina, Vienna, Austria)

Adam and Eve 1504 (Metropolitan Museum of Art, New York, U.S.)

Knight, Death, and the Devil 1513–1514 (Metropolitan Museum of Art, New York, U.S.)

St. Jerome in his Study 1514 (Clark Art Institute, Williamstown, U.S.)

Melancholia 1514 (Metropolitan Museum of Art, New York, U.S.)

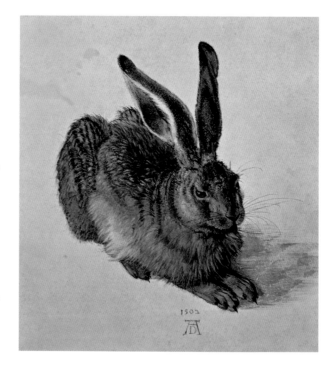

ABOVE: Detail from *Self-Portrait with Gloves*, an oil painting executed in 1498.

RIGHT: Dürer's watercolor of a young hare is one of his best-loved works.

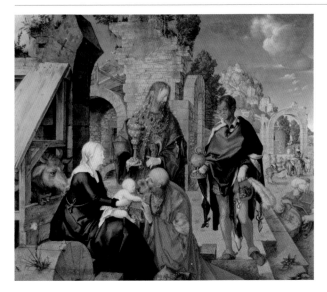

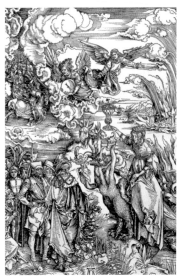

the painter and book illustrator Michael Wolgemut. Subsequently, as was customary at the time, he worked as a journeyman, or itinerant artist, between 1490 and 1494. Traveling across Germany, the Netherlands, northern France, and Switzerland, Dürer hoped to work in Colmar with Martin Schongauer—who died before Dürer's arrival in the city in 1492. Having returned home to marry, Dürer set up a successful studio using his wife's dowry. Soon his yearning for knowledge and new influences led him to travel again, to Italy.

Dürer was one of the earliest northern European artists to experience the art of Renaissance Italy. He visited Italy in 1494 and in 1505. By this time he had completed some of his most important paintings and had established an international reputation. His status was helped by his vast output of exquisite engravings. These easily distributed and reproducible images show Dürer's exemplary talent for delicate hatching and cross-hatchings, and textural representation of forms. In images such as *Melancholia* (1514), he also demonstrated his theoretical approach to art and his ambition to find the governing rules of ideal beauty, harmony, and optics. **AB**

ABOVE LEFT: In Dürer's *Adoration of the Magi*, he sets the Holy Family amid evocative ruins.

ABOVE: This woodcut demonstrates Dürer's prolific talent—and his rich imagination.

Dürer's Sense of Self

A keen sense of self-awareness is already visible in one of Dürer's earliest surviving drawings: *Self-Portrait at Age 13* (1484), meticulously drawn in silverpoint. Perhaps, however, the most revealing image the artist created is his painting *Self-Portrait with Fur-Trimmed Robe* (1500). Painted mid-career, the painting shows its creator in the guise of Christ, and bears the following inscription: "Thus I, Albrecht Dürer from Nuremburg, painted myself with indelible colors at the age of twenty-eight years." The date of its creation would not only prove an epochal year in the western calendar but also in the life of Dürer. Aged twenty-eight in 1500, he would die twenty-eight years later in 1528.

LUCAS CRANACH THE ELDER

Born: Lucas Sunder, 1472 (Kronach, Germany); died Ocober 16, 1553 (Weimar, Germany).

Artistic style: Painter and printmaker of portraits; religious and mythological scenes; coquettish, seductive temptresses; luscious landscapes; precise outlines.

Masterworks

*Cupid Complaining to Venus c.*1525 (National Gallery, London, England)

*The Virgin and Child Under an Apple Tree c.*1525 (The Hermitage, St. Petersburg, Russia)

*The Judgment of Paris c.*1528 (Metropolitan Museum of Art, New York, U.S.)

*Apollo and Diana c.*1530 (Royal Collection, Windsor, England)

*Judith with the Head of Holofernes c.*1530 (Kunsthistorisches Museum, Vienna, Austria)

Eve 1531 (Gemäldegalerie, Dresden, Germany)

The Fountain of Youth 1546 (Staatliche Museen, Berlin, Germany)

"His well-known paintings … invariably elicited a fleeting, superior smile."—Max J. Friedlander

ABOVE: *Portrait of Lucas Cranach the Elder* (1550) by Lucas Cranach the Younger.

RIGHT: *The Judgment of Paris* demonstrates Cranach's skill with figures and landscape.

For most of his career, Lucas Cranach the Elder ran a busy workshop in Wittenberg, north Germany, as court painter to the electors of Saxony. In time, he became a wealthy and valued member of Wittenberg society, respected as a scholar, artist, and politician. More than 1,000 paintings connected to Cranach's workshop have survived, but the overall output must have been several times greater. Many themes and compositions were repeated and have become hallmarks of his work. His images of Venus and Cupid and of Adam and Eve were extremely popular. He excelled at luscious landscape painting. Behind these foreground figures lie rolling hills, glass-smooth lakes, and rocky outcrops. The elector of Saxony was an enthusiastic hunter and is likely to have enjoyed the animals and topographic detail of Cranach's paintings.

Little is known about Cranach's early life or training. He was clearly influenced by the work of Albrecht Dürer, whom he met in later life. Like Dürer, Cranach was a prolific printmaker; he produced several series of woodcuts, and pioneered a three-color tonal technique. As his career progressed, he developed a clearer, more polished painting style. His mature works have little spatial depth and portray an eerily unreal world, populated by skinny naked figures set against minutely detailed dark foliage. Cranach's subject matter and use of symbolism were strongly influenced by the Protestant reformist views of his close friend Martin Luther, who was active in Wittenberg. In 1508 the Elector Frederick the Wise awarded Cranach the right to use a coat of arms, from which he adapted his famous signature of a dragon bearing a ring. The motif can be found lurking in rocky hiding places in his paintings as a mark of provenance. **KKA**

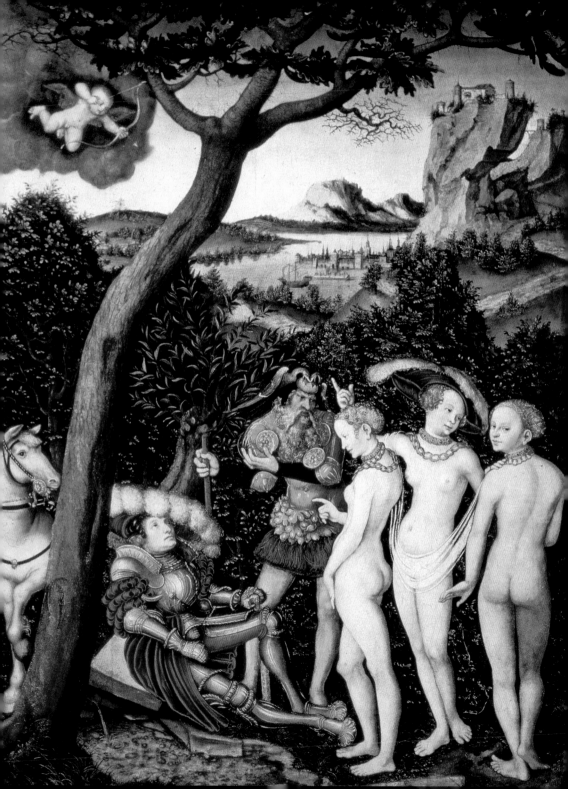

MICHELANGELO BUONARROTI

Born: Michelangelo di Lodovico Buonarroti Simoni, March 6, 1475 (Caprese, Italy); died February 18, 1564 (Rome, Italy).

Artistic style: Genius sculptor, painter, architect, and poet of High Renaissance; powerful, physical, and beautiful male figures; close anatomical observation.

Masterworks

Bacchus c.1497 (Bargello, Florence, Italy)

Pietà c.1498–1499 (St. Peter's, Rome, Italy)

David 1501–1504 (Galleria dell'Accademia, Florence, Italy)

Holy Family/Doni Tondo c.1503–1506 (Uffizi, Florence, Italy)

Sistine Chapel frescoes 1508–1512 (Vatican Museum, Rome, Italy)

Moses, from the Tomb of Pope Julius II c.1513–1515 (S. Pietro in Vincoli, Rome, Italy)

Medici Tombs 1519–1534 (San Lorenzo Church, Florence, Italy)

Last Judgment 1535–1541 (Sistine Chapel, Vatican Museum, Rome, Italy)

Despite his father's opposition, Michelangelo Buonarroti's interest in art started early, and he ultimately rose to achieve almost godlike artistic status. He began an apprenticeship in 1488 in the flourishing Florence workshop of painter Domenico Ghirlandaio but soon became restless and moved on to the academy of sculptor Bertoldo di Giovanni in the gardens of the Medici family. The tale goes that Lorenzo the Magnificent spied the youth carving a marble faun and took him under his wing.

After Lorenzo's death in 1492, Michelangelo went first to Venice and then to Bologna, finally arriving in Rome in 1496. He rapidly secured an impressive reputation with his beautiful and expressive sculptural group *Pietà* (c.1498–1499), which shows Jesus lying dead across his mother's lap. The young artist was then asked to complete an unfinished sculpture in

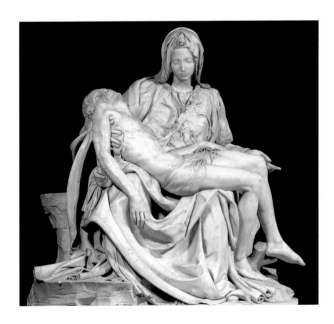

ABOVE: Giuliano Bugiardini's *Portrait of Michelangelo Buonarroti with Turban* (1522).

RIGHT: The highly expressive *Pietà* was an early indication of Michelangelo's talents.

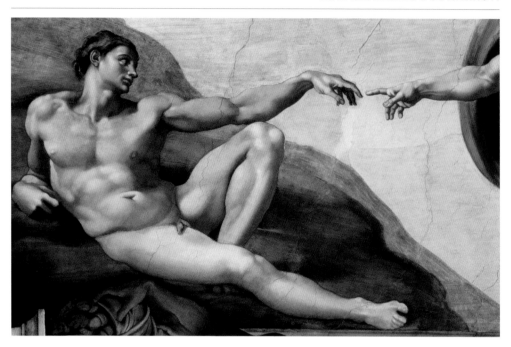

Florence. This commission resulted in the historic masterwork *David* (1501–1504), a massive, potently physical marble sculpture of a young naked man that showed a new level of anatomical understanding fused with artistic passion.

The early 1500s were highly productive for Michelangelo, by then an artistic rival to contemporary giants such as Leonardo da Vinci and Raphael. In 1508 he started work on his masterpiece: the nine paintings that make up *God's Creation of the World*, *God's Relationship with Mankind*, and *Mankind's Fall from God's Grace* (1508–1512) across the barrel-vaulted ceiling of the Cappella Sistina (Sistine Chapel) in Rome. They feature various biblical stories, and the tour de force concentrates on the act of creation. The electrifying moment depicted in *The Creation of Adam* when God's outstretched finger gives life to Adam is one of art's most iconic images. The frescoes were an undertaking of

> "The marble not yet carved can hold the form of every thought the greatest artist has."

David's Story

Michelangelo's statue of David on the point of doing battle with Goliath had an interesting history and found its resting place in dramatic circumstances. The artist's brief was to take a clumsy statue that had been started and then abandoned by another artist and turn it into something memorable.

- He was given a monthly salary and a two-year deadline and was told that if his Florentine patrons were impressed, he would be paid extra. True to his fast work rate, Michelangelo finished ahead of schedule.

- A distinguished panel of leading Florentine artists decided the sculpture should be placed in front of the seat of civic government, the Palazzo Vecchio on Piazza della Signoria. Under cover of darkness, the massive statue was brought out of his workshop near the cathedral.

- The sculpture was so large that a section of wall had to be demolished to let it pass. It took forty men four days to trundle the statue to its destination, supported by scaffolding and ropes, and placed on rollers.

- The night the sculpture emerged, someone threw stones at it—possibly an act of politically motivated solidarity for the artist Donatello, whose statue *Judith and Holofernes* (1460) was being replaced by Michelangelo's *David*.

unimaginable ambition and reveal much about their creator's dedication, focus, and stamina. Michelangelo's stubborn temperament led him to refuse most of the help offered and forge on alone in search of a perfect realization of his vision.

The painted ceiling measures 10,000 square feet (800 sq m) and took approximately six years to complete. It was such an intense undertaking and such a difficult period in Michelangelo's life that after he finished it he renounced painting for twenty-three years. A tower of scaffolding soared up to the vault, where he spent long periods painting in an agonizingly uncomfortable position on his back, sleeping little and eating basic rations. He had to work quickly in case the plaster onto which he was painting dried. He used a *buon fresco* technique, where each area was overlaid with plaster and then paint was applied to fuse with the plaster.

A star is born

When the incredible ceiling was unveiled, its bold coloration and creative use of perspective devices pushed Michelangelo's star even higher. This short-tempered man became a living legend. His reputation was helped by the writings of Giorgio Vasari, who saw Michelangelo's work as the ultimate perfection in art. The following decades saw the artist work on energetically into old age and continue to achieve success in many fields, including poetry. His religiosity intensified with age, and his work darkened in mood, chiming with the Counter-Reformation zeal dominating Europe. Appointed architect to St. Peter's in Rome, Michelangelo began a major program of works there in the mid-1540s, including the cathedral's great dome, which remained unfinished when he died in 1564. **AK**

GIORGIONE

Born: Giorgio Barbarelli da Castelfranco, c.1477 (Castelfranco Veneto, Italy); died 1510 (Venice, Italy).

Artistic style: Brought the High Renaissance to northern Italy; painter of altarpieces and religious works; created a new vision of landscape; use of *sfumato*.

Little is known about this artist, yet his much-loved and admired works were renowned and influential throughout the sixteenth and seventeenth centuries. Although Giorgione's career lasted no more than fifteen years due to his premature death from the plague in 1510, he can be named as the founding father of Venetian painting, having influenced Sebastiano del Piombo and Titian. According to the sixteenth-century biographer Giorgio Vasari, Giorgione was a handsome man who had a genial personality and wore his hair fashionably long.

Giorgione left his birthplace of Castelfranco Veneto at an early age to travel to Venice, where he trained in the workshop of Giovanni Bellini. From the start of his career, his artwork was innovative and he placed an unprecedented importance on the backgrounds of his paintings. Giorgione introduced landscape views into these backgrounds, a technique that was soon imitated by other Venetian artists. He frequently used the landscapes of the mainland around Venice as the pastoral setting for his religious or classical works. Although its subject matter is still unclear, his most renowned work, *The Tempest* (1505–1510), best demonstrates his innovative approach to landscape painting. Here a sense of depth is seamlessly achieved by using cool blue hues at the back and warmer colors toward the front. The whole image is bathed in a warm, golden light, unifying and integrating the different elements of the picture and creating a poetic mood that is today known as "Giorgionesque." His use of *sfumato* (the ability to soften or blur the edges of forms in order to avoid a sharp outline) is something that had previously been used by Leonardo da Vinci; however, how much Giorgione was aware of the master's work remains uncertain. **AB**

Masterworks

The Test of Fire of Moses 1500–1501 (Uffizi, Florence, Italy)

Judith c.1504 (The Hermitage, St. Petersburg, Russia)

The Tempest c.1505–1510 (Gallerie dell'Accademia, Venice, Italy)

Adoration of the Shepherds c.1505–1510 (National Gallery of Art, Washington, D.C., U.S.)

Laura 1506 (Kunsthistorisches Museum, Vienna, Austria)

Sleeping Venus c.1508–1510 (Gemäldegalerie, Dresden, Germany)

"He was careful to . . . avoid copying what any other painter had done."—Giorgio Vasari

ABOVE: The artist demonstrates his skill at portraiture in *Giorgione da Castelfranco*.

MATHIS GRÜNEWALD

Born: Mathis Gothart (also known as Mathis Neithart), c.1470–1480 (Würzburg, Germany); died August 1528 (Halle, Germany).

Artistic style: Once forgotten master of the German Renaissance; expressive vision of pain and horror; use of bold color and dramatic gesture.

Masterworks

Mocking of Christ 1503 (Alte Pinakothek, Munich, Germany)

Isenheim Altarpiece c.1512–1515 (Musée d'Unterlinden, Colmar, France)

After his death in 1528, Mathis Grünewald was largely forgotten by history. Rediscovered in the late 1800s, his importance and fame is based in large part on the phenomenal masterpiece *Isenheim Altarpiece* (c.1512–1515).

Grünewald was undoubtedly one of the greatest painters of the German Renaissance, yet for centuries even his name has remained uncertain. He is today still known by the nickname, Grünewald, given to him by his seventeenth-century biographer Joachim von Sandrart. Very little is known of his training and his early career. It is clear, though, that by 1511 he was working for the Archbishop of Mainz, Uriel von Gemmingen. Skilled not only as a painter but also working as a draftsman, hydraulic engineer, and architect, his artistic aim seemed to unite the Italian trend of idealization with the northern European skill of meticulous realism. This endeavor is clearly visible in the *Isenheim Altarpiece*. Painted for the Monastery of St. Anthony Hospital at Isenheim, it is a vast work made up of nine painted panels. The work and its subject matter are directly relevant to its original audience that would have been sufferers of ergotism, a disease known at the time as St. Anthony's Fire. The horrific illness, caused by eating bread infected with ergot fungus, would ravage muscle and cause acute pain, gangrene of the skin, and hallucinations. Sufferers would best have been able to relate to the dramatic crucifixion depicted in the central panel of the altarpiece: Christ is shown frozen in the agony of death, his body covered in cuts, and he is distorted by pain. It was hoped that this vision of eternal suffering would provide comfort for the dying. Grünewald's expressive style would later influence the German expressionists of the early twentieth century. **AB**

"Grünewald's *Isenheim Altarpiece* was painted for the dying."

—Dr. Jeffrey Chipps Smith, art historian

ABOVE: This pen-and-ink self-portrait was made as a copy of an earlier work.

ALBRECHT ALTDORFER

Born: Albrecht Altdorfer, c.1480 (unknown, but possibly near Regensburg, Germany); died February 12, 1538 (Regensburg, Germany).

Artistic style: Member of the Danube school of painting; innovative use of landscape as atmospheric setting; earliest draftsman of specific natural locations.

Albrecht Altdorfer was a German painter, draftsman, architect, and printmaker who spent most of his life in Regensburg, where he achieved considerable success and influence. He belonged to a group of artists, now known as the Danube school, who lived in Bavaria and Austria and were among the first artists to paint pure landscape. Altdorfer's work is most notable for his use of landscape as an expressive element in his paintings, helping set the tone and mood of the narratives they contain. In the early sixteenth century, landscape was not deemed a worthy subject in its own right. Altdorfer's seemingly pure landscape paintings, which contain little other subject matter, were unusual for the period. In a work such as the oil on parchment *St. George and the Dragon* (1510), small figures and creatures are submerged within the thick, surrounding foliage.

His innovations in the art of landscape also extend to his drawings, some of which are the earliest known depictions of actual identifiable sites. Altdorfer used elements of his pen and ink drawings in his paintings. He produced etchings of these landscapes, thus demonstrating that a significant market for images of the countryside existed at the time. He was also commissioned to make historical and religious works, the largest being *The Battle of Issus* (1529). Commissioned for the ducal residence in Munich in 1529, it depicts a vast worldview landscape seen from above in a vertical format in which a myriad of figures move. The subject is a battle fought in 333 B.C.E. between Alexander the Great and the Persian King Darius III, although once again the protagonists are lost in the swaths of other soldiers and dwarfed by an enormous, expressive sky. **AB**

Masterworks

Landscape with Satyr Family 1507
(Staatliche Museen, Berlin, Germany)

St. George and the Dragon 1510
(Alte Pinakothek, Munich, Germany)

Christ Taking Leave of his Mother c.1520
(National Gallery, London, England)

Susanna in the Bath and the Stoning of the Elders 1526 (Alte Pinakothek, Munich, Germany)

The Battle of Issus 1529 (Alte Pinakothek, Munich, Germany)

"Altdorfer stands with Bach in music and Goethe in literature as a German immortal."—*Time*

ABOVE: This etching of the artist was made posthumously, in 1770 by Rudolf Füssli.

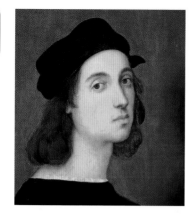

RAPHAEL

Born: Raffaello Sanzio, April 6, 1483 (Urbino, Italy); died April 6, 1520 (Rome, Italy).

Artistic style: Serene harmony; balanced coloration and composition; beautiful facial expressions; images of the Madonna and Holy Family; softly modeled monumental figures.

Masterworks

The Mond Crucifixion c.1502–1503
(National Gallery, London, England)

Sposalizio 1504 (Pinacoteca di Brera,
Milan, Italy)

The Procession to Calvary c.1504–1505
(National Gallery, London, England)

Madonna del Granduca c.1504–1505
(Palazzo Pitti, Florence, Italy)

Madonna of the Meadow 1505
(Kunsthistorisches Museum,
Vienna, Austria)

The Madonna of the Pinks c.1506–1507
(National Gallery, London, England)

Deposition 1507 (Galleria Borghese,
Rome, Italy)

*Madonna and Child ("The Mackintosh
Madonna")* c.1510–1512 (National Gallery,
London, England)

School of Athens c.1510–1512 (Apostolic
Palace, Vatican, Rome, Italy)

Triumph of Galatea c.1512 (Villa Farnesina,
Rome, Italy)

Count Tommasso Inghirami c.1513 (Isabella
Stewart Gardner Museum, Boston, U.S.)

ABOVE: This *Self-Portrait* **of a young
Raphael was painted in 1506.**

RIGHT: *The School of Athens*; **Plato (center,
in red) is based on Leonardo da Vinci himself.**

One of the most significant figures of the Italian High Renaissance was born the son of a painter, Giovanni Santi, court painter to the duke of Urbino. Urbino was an important cultural center, and Raphael's childhood must have given him the refinement that, along with his reputedly sweet nature, helped ease his path to success in high places. Santi died when Raphael was a boy, but it seems inevitable that he would have trained his prodigy son. By around 1500, the young artist was receiving further apprenticeship at nearby Perugia in the studio of Pietro Vannucci (Perugino). The latter had, by this time, completed his frescoes in the Sistine Chapel. Perugino's fluid, graceful style can be glimpsed in early works by Raphael, including the *Mond Crucifixion* (c.1502–1503) altarpiece.

Having already shown greater liveliness and subtlety than Perugino, and having made a name for himself in Perugia, Raphael moved to Florence, a city where Leonardo da Vinci and Michelangelo Buonarroti were pushing artistic boundaries. He stayed for four years, producing some of his best-known Madonna pictures. As well as borrowing something of

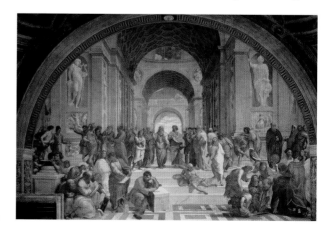

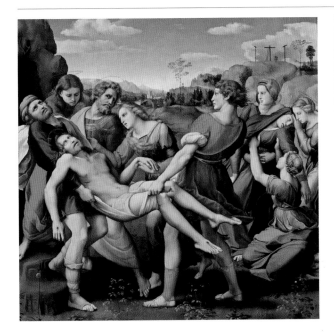

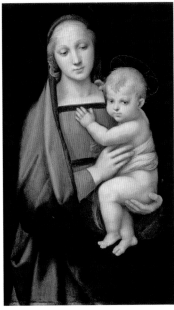

ABOVE: *Madonna del Granduca* displays Raphael's excellence at portraiture.

ABOVE LEFT: *Deposition* was painted for a grieving mother whose son died in battle.

Michelangelo's understanding of human anatomy, he acquired Leonardo's simple, pyramidal formations, clever lighting, and emotional intimacy, as well as his *sfumato* technique of modeling forms with soft blending. From this he created a quietly serene art with enormous general appeal.

In 1508 Raphael began his glittering career as a papal artist, after being summoned to Rome by Pope Julius II. Soon he had earned a formidable reputation and remained in Rome for the rest of his life. He quickly earned an enviable reputation—as both an artist and a handsome man with a charming personality—and produced work at a prodigious rate. Among his greatest successes are frescoes painted for the Vatican apartments, including the *School of Athens* (c.1510–1512), which shows his supreme command of narrative and composition. Other Roman projects include portraits that show a new psychological depth and a series of stunning Vatican tapestries. By the time of his premature death, at just thirty-seven, he was such a revered figure that he was buried with full pomp in the Pantheon. **AK**

A Most Amorous Painter

Raphael was frequently described in the most glowing terms. Sixteenth-century Italian writer Lodovico Domenichi describes him as a "remarkable and most excellent painter." Giorgio Vasari, the contemporary chronicler of artists' lives, claimed that he was "as talented as he was gracious . . . enhanced by an affable and pleasing manner." Raphael certainly seems to have attracted no enemies. He also reputedly loved the company of women and, according to Vasari, pursued love affairs with "no sense of moderation," to the point of bringing on the fever that caused his death.

HANS MALER

Masterworks

Portrait of Sebastian Andorfer 1517
(Metropolitan Museum of Art,
New York, U.S.)

*Portrait of Queen Anne of Hungary and
Bohemia* 1519 (Museo-Thyssen-Bornemisza,
Madrid, Spain)

Portrait of Anton Fugger 1525 (Allentown Art
Museum, Allentown, Pennsylvania, U.S.)

Born: Hans Maler, *c.*1485 (Ulm, Germany); died *c.*1529 (Schwaz, Austria).

Artistic style: Portraitist who worked in the late Gothic style; Habsburg and wealthy mercantile patrons; three-quarter profiles; bust-sized compositions against light blue backgrounds.

Hans Maler trained under Bartholomäus Zeitblom before moving to Schwaz in the Austrian Tyrol, where nearby Innsbruck was one of the main seats of the pan-European Habsburg royals and home to some of Maler's wealthiest patrons.

Maler's mature portraits are skillfully naturalistic and typical of the late Gothic style. He invariably seated his subjects in three-quarter profile, and painted them bust-size against a light blue background. Conveying little personality, and none of the penetrating curiosity of such Renaissance-influenced contemporaries as Albrecht Dürer and Hans Holbein, Maler coolly and formulaically recorded the features of some of the richest and most powerful people who have ever lived. **RB**

SEBASTIANO DEL PIOMBO

Masterworks

*The Holy Family with St. Catherine, St. Sebastian
and a Donor c.*1507 (Musée du Louvre,
Paris, France)

Portrait of Ferry Carondelet with his Secretary
1510–1512 (Museo Thyssen-Bornemisza,
Madrid, Spain)

The Death of Adonis 1511–1512
(Uffizi, Florence, Italy)

Deposition 1516 (The Hermitage,
St. Petersburg, Russia)

*The Raising of Lazarus c.*1517–1519
(National Gallery, London,England)

The Visitation 1519–21 (Musée du Louvre,
Paris, France)

*Portrait of Andrea Doria c.*1526 (Palazzo
Doria Pamphilj, Rome, Italy)

RIGHT: Del Piombo's typically moody
Portrait of Ferry Carondelet with his Secretary.

Born: Sebastiano Luciani *c.*1485 (Venice, Italy); died June 21, 1547 (Rome, Italy).

Artistic style: Venetian artist in Rome; elongated, muscular bodies; motifs borrowed from Michelangelo Buonarroti; solemn, grief-stricken expressions; strong draftsmanship; haunting shadows; restrained drama.

Sebastiano was trained in Venice in the studios of Giovanni Bellini and Giorgione but is best known for his long career in Rome. There he received his most important commissions and patronage. On arriving in Rome, Sebastiano was befriended by Michelangelo Buonarroti, who supplied the younger artist with drawn designs. Sebastiano brought the atmospheric landscapes and warm, rich colors of Venetian painting to Rome, fusing these elements with the sculptural figures of the High Renaissance. His compositions are daringly complex, often held together by a strong diagonal arrangement and deep shadows. Noted for his sophisticated portraits, Sebastiano became the leading painter in Rome at the death of Raphael. **KKA**

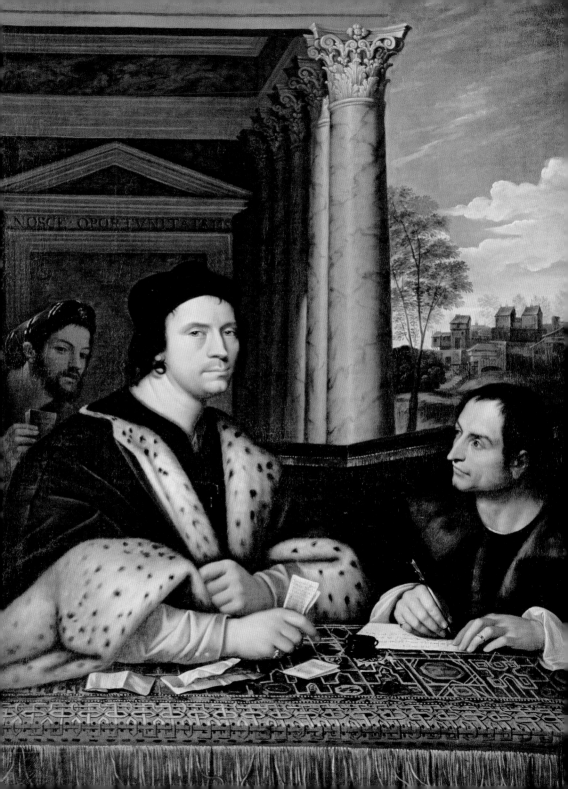

ANDREA DEL SARTO

Born: Andrea d'Agnolo di Francesco di Luca di Paolo del Migliore, July 16, 1486 (in or around Florence, Italy); died c.1530 (Florence, Italy).

Artistic style: Major religious artist of Florentine High Renaissance; consummate draftsman; striking coloration; restrained naturalism and expressiveness.

Masterworks

Life of Filippo Benizzi 1509–1514 (Church of SS. Annunziata, Florence, Italy)

Birth of the Virgin 1513–1514 (Atrium of SS. Annunziata, Florence, Italy)

Madonna and Child with St. Elizabeth and St. John the Baptist (Medici Holy Family) c.1513 (National Gallery, London, England)

Madonna of the Harpies 1517 (Uffizi, Florence, Italy)

Disputation on the Trinity c.1517 (Pitti Palace, Florence, Italy)

Life of St. John the Baptist c.1520–1526 (Cloister of the Scalzo Order, Florence, Italy)

Pietà 1523–1524 (Pitti Palace, Florence, Italy)

Last Supper 1526–1527 (S. Salvi, Florence, Italy)

Girl with the "Petrarchino" c.1528 (Uffizi, Florence, Italy)

Andrea del Sarto was born the son of a tailor (*sarto* means "tailor" in Italian) and rose steadily to become the leading painter in Florence. Probably a pupil of Piero di Cosimo, he began work as an independent artist around 1508. By 1509 he had embarked on the impressive *Life of Filippo Benizzi* (1509–1514) fresco series for the church and convent of the Basilica della Santissima Annunziata. Early influences include the glowing Tuscan colors of Fra Bartolomeo, whose preeminence in Florence del Sarto soon eclipsed.

By 1515, Andrea was enjoying a stellar reputation for paintings that combine Leonardo da Vinci's subtle *sfumato* technique and Michelangelo Buonarroti's classicism with a new, more delicate emotion. At the height of his powers, he produced works such as *Madonna of the Harpies* (1517) that demonstrate the strong, balanced compositions that echo Raphael and came to typify del Sarto's work in the 1520s. Early in the decade he married Lucrezia del Fede, a widow of means, who is said to be the model for many of his female figures and whom he reputedly idolized. Seemingly well off, del Sarto would pick and choose jobs and undertake some for little or no money, although he was always a highly professional craftsman. Equally happy to paint for humble or elevated patrons, the latter included King Francis I of France, Pope Leo X, and the all-powerful Medici family, for whom he painted the Pitti Palace's *Madonna and Child with St. Elizabeth and St. John the Baptist (Medici Holy Family)* (c.1513). Plague was a constant threat in del Sarto's day. After having escaped one bout by fleeing Florence, he fell prey to another and died in 1530. His works left a major mark on a range of mannerist Florentine artists who came after him. **AK**

"A man's reach must exceed his grasp/Or what's a heaven for?"

—Robert Browning, *Andrea Del Sarto*

ABOVE: Del Sarto painted his *Self-Portrait* using a spectrum of warm, rich colors.

TITIAN

Born: Tiziano Vecellio, c.1485–1490 (Pieve di Cadore, Belluno, Italy); died August 27, 1576 (Venice, Italy).

Artistic style: Free and expressive brushwork exploring the potential of oil; portraits, landscapes, altarpieces, and mythological subjects; subtle use of color.

Tiziano Vecellio was born in Pieve di Cadore in around 1488. At the tender age of nine, he left his childhood home with his brother Francesco to embark on a journey to Venice. From this humble beginning, young Tiziano (or Titian, as he would come to be known) would grow to become the greatest Italian Renaissance painter of the Venetian school.

Initially, Titian entered the workshop of the mosaicist Sebastiano. He then passed into the studios of Gentile and Giovanni Bellini, the leading artists in the city at that time, where he was introduced to Giorgione of Castelfranco. The two students embraced the emerging experimentation with oil paint to develop a technique of free, expressive brushwork and a depiction of form through color that amazed contemporaries. The works of the young masters were so similar that even today argument rages over which pieces from this period can be rightly attributed to Titian and which to Giorgione.

Masterworks

St. Mark Enthroned with Four Saints c.1510–1511 (Santa Maria della Salute, Venice, Italy)

Assumption of the Virgin 1516–1518 (Santa Maria Gloriosa dei Frari, Venice, Italy)

Worship of Venus c.1518–1520 (Museo del Prado, Madrid, Spain)

Bacchus and Ariadne 1520–1523 (National Gallery, London, England)

Bacchanals of Andrians 1523–1525 (Museo del Prado, Madrid, Spain)

Portrait of a Young Woman c.1530s (The Hermitage, St. Petersburg, Russia)

Venus of Urbino 1538 (Uffizi, Florence, Italy)

Portrait of Pope Paul III with Unhooded Cape, 1543 (Galleria Nazionale di Capodimonte, Naples, Italy)

Emperor Charles V at Muhlberg 1548 (Museo del Prado, Madrid, Spain)

Portrait of Philip II in Armour 1550–1551 (Museo del Prado, Madrid, Spain)

Diana and Actaeon 1556–1559 (National Gallery of Scotland, Edinburgh, Scotland)

Annunciation c.1559–1564 (San Salvador, Venice, Italy)

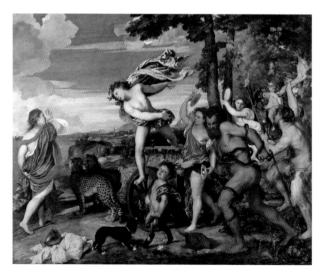

ABOVE: *Self-Portrait (c.1560)* is held at the Museo del Prado, Madrid, Spain.

LEFT: *Bacchus and Ariadne* was originally commissioned from Raphael.

Titian Meets His Match

Unfortunately, due to a lack of journalism at the time, what was said at Rome in 1545 when Titian met Michelangelo is largely left to conjecture or to the accounts of biographer, Giorgio Vasari.

- Having recently completed the ceiling of the Sistine Chapel, Michelangelo was the undisputed leader of the city's art scene, in much the same way that Titian led the Venetian scene.

- Michelangelo was initially reluctant to meet his fellow master before making a surprise visit to see Titian at his Belvedere residence, accompanied by Vasari.

- The meeting of the two great heavyweights of the sixteenth-century art world was recorded by Vasari in *Lives of the Most Excellent Painters, Sculptors, and Architects* (1550). In it he comments that they were witness to one of several variants of Titian's painting, *Danae and the Shower of Gold* (1554).

- Michelangelo outwardly commended Titian for his "lively manner" of painting and was particularly impressed with the application of color. Privately, Michelangelo was less impressed with the quality of drawing, purportedly remarking, "It is a shame that good design was not taught in Venice from the beginning."

- Unsurprisingly, the paths of two of the most important Renaissance artists were never to cross again.

Shortly after the death of Giorgione in 1510, Titian received his first important commission: to produce a series of frescoes in the Scuola del Santo at Padua. His reputation then burgeoned with a series of independent commissions, culminating in the immense success of his first public commission in Venice, the *Assumption of the Virgin* (1516–1518), which was the high altarpiece of the church of Santa Maria Gloriosa dei Frari. With Giovanni Bellini's death in 1516, Titian now stood unchallenged as the master of Venetian art.

The ensuing years saw Titian reveal his versatility as an artist by undertaking more complex subjects. Equally inventive in portraiture, allegories, devotional, and mythological painting, he was able to pick and choose his patrons, becoming the first artist to boast a truly international clientele.

As Titian's working life bordered on the frantic, his private life was struck by tragedy with the death of his wife in 1530. Beset

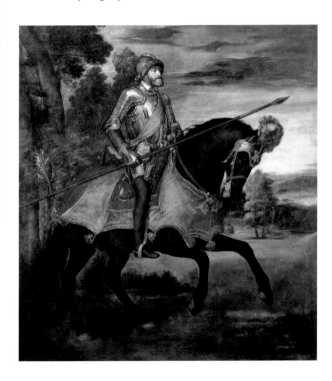

RIGHT: *Emperor Charles V at Muhlberg* was intentionally reminiscent of chivalric times.

by grief, Titian's work after this date would reflect a more tranquil and reflective mood. In the same year, Titian met Holy Roman Emperor Charles V at his coronation. He was to portray Charles V a number of times in the following years. Such was the emperor's delight with Titian's work that he elevated Titian to the rank of Count Palatine and Knight of the Golden Spur in 1533—a remarkable honor for a painter. Further calls for his services came from the Italian princes and inevitably from the papacy. In 1543 Titian visited Bologna to complete the official portrait of Pope Paul III. Two years later he embarked upon his one and only journey to Rome—where he met Michelangelo Buonarroti. In Rome, he produced a number of portraits of the pope and his nephews. The travels continued in 1548 with the arduous journey across the Alps to reach the emperor's court at Augsburg. It was here that Titian carried out one of his great masterpieces, *Emperor Charles V at Muhlberg* (1548). Depicting the emperor riding a horse in emulation of a Christian knight, it remains a quintessential state portrait.

The return to Venice

The latter part of Titian's life was spent back in Venice, working almost exclusively for King Philip II of Spain. The relationship with the Hapsburgs, although not financially rewarding, gave Titian the freedom to experiment with the use of color and subtleties of the human form. He remained productive up until his death in 1576. Titian was laid to rest in the church of Santa Maria dei Frari, where two of his most famous works remain. For sixty years Titian dominated Venetian painting, influencing younger artists, such as Tintoretto and Paolo Veronese, and the great masters of another generation, such as Diego Velázquez. His versatility and long life led to a breathtaking output of work. He was highly successful in whatever art form he chose to depict. His style continued to develop throughout his career, continually stretching the limits of what could be achieved with oil painting. **SG**

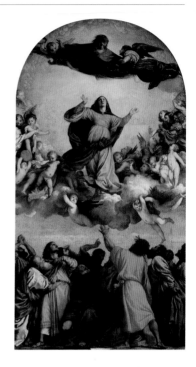

ABOVE: *Assumption of the Virgin* is a superb example of Titian's mastery of color.

"A good painter needs only three colors, black, white, and red."

LUCAS VAN LEYDEN

Born: Lucas Hugensz or Jacobsz, *c.*1489 (Leiden, the Netherlands); died 1533 (Leiden, the Netherlands).

Artistic style: Engraver who experimented with etching; woodcuts, illustrations, and paintings; unusual religious subjects; early exponent of genre painting.

Masterworks

Lot's Daughters Make Their Father Drink Wine
1508–1515 (National Gallery,
London, England)

*The Card Players c.*1520 (National Gallery
of Art, Washington, D.C., U.S.)

The Poet Virgil in a Basket 1525 (Metropolitan
Museum of Art, New York, U.S.)

Lucas van Leyden was one of the leading engravers of the time. His draftsmanship was unequaled and his influence on the development of engraving profound. His work was significant to artists such as Hendrick Goltzius, Jacob de Gheyn II, and Rembrandt van Rijn in the Netherlands and to Andrea del Sarto and Jacopo Pontormo in Italy. He was successful throughout the Netherlands and Germany during his lifetime and posthumously through the repeated reprinting of his work. As well as producing at least 168 engravings, he also made a number of woodcuts, drawings, paintings, book illustrations, and etchings that all exhibit his prodigious talent.

Little is known of his early training. The best source of information is the biographical account by Flemish painter Karel van Mander. He is thought to have received instruction from his father, a painter, and Dutch painter Cornelis Engelbrechtsz, whose influence in his early paintings can be seen. Van Leyden was a child prodigy. At fourteen years old he produced a famous engraving of *Mehmed and the Monk Sergius* (*c.*1508) that reveals the young artist's tendency to choose unusual and rarely depicted myths and stories. This unorthodox approach to subject matter mirrored his imaginative interpretation of scenes. He typically invested his images with a psychological depth that reflected his understanding of human nature. One of the greatest influences on van Leyden's style was that of Albrecht Dürer, although van Leyden's work remained strikingly original and inventive. In the mid-1520s van Leyden met the artist Jan Mabuse, whose work also influenced him and was manifested through a greater dynamism and energy, and a more classical interpretation of his figures. **TP**

"The most notable quality in his paintings is their daylight luminosity."—*Time*

ABOVE: *Self-Portrait* (1509) can be seen at Herzog Anton Ulrich-Museum, Germany.

RIGHT: In *Lot's Daughters Make Their Father Drink Wine,* Sodom burns in the background.

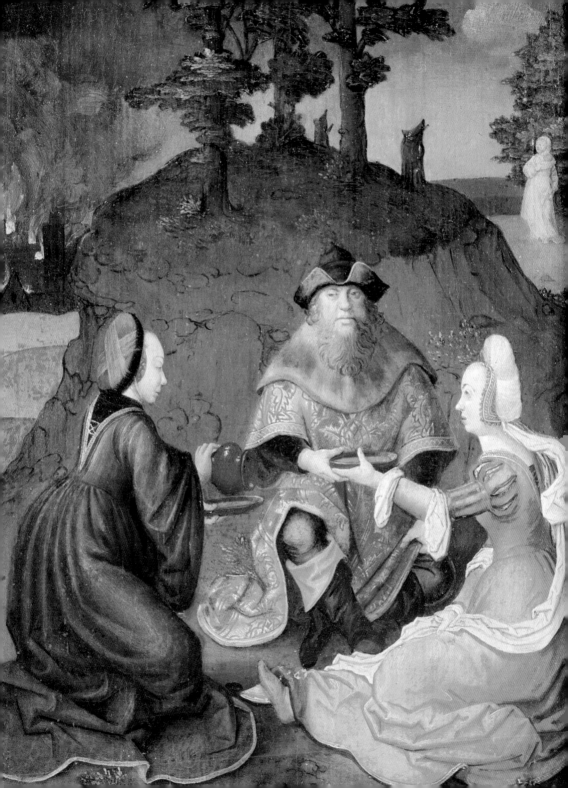

ANTONIO DA CORREGGIO

Born: Antonio Allegri da Correggio, c.1489 (Correggio, Reggio Emilia, Emilia-Romagna, Italy); died March 5, 1534 (Correggio, Reggio Emilia, Emilia-Romagna, Italy).

Artistic style: Northern Italian painter of sweetness and pleasure; peach-colored, soft nudes; refined sensuality and eroticism; intimate scenes of maternal love.

Masterworks

*The School of Love c.*1525 (National Gallery, London, England)

*Noli me Tangere c.*1525 (Museo del Prado, Madrid, Spain)

Assumption of the Virgin 1526–1530 (Duomo, Parma, Italy)

*Venus and Cupid with a Satyr c.*1528 (Musée du Louvre, Paris, France)

*Adoration of the Shepherds c.*1530 (Gemäldegalerie Alte Meister, Dresden, Germany)

*Jupiter and Io c.*1530 (Kunsthistorisches Museum, Vienna, Austria)

Leda with the Swan 1531–1532 (Staatliche Museen, Berlin, Germany)

Although Antonio da Correggio spent most of his career painting religious subjects, he is best known today for his erotically charged mythologies. These are sadly few in number due to the lack of court patronage at Parma, where Correggio was living at the height of his success in the 1520s. After his return to his native town of Correggio in the 1530s, he worked on his last series of mythological paintings for Frederick II, Duke of Mantua, including the wonderfully sensuous *Jupiter and Io* (c.1530). As images of abandoned sexual pleasure, these pictures are almost unsurpassed.

In his use of smoky, softened edges, he was influenced by the *sfumato* blending technique of Leonardo da Vinci, who was working in northern Italy during Correggio's formative years. However, his paintings feel timeless, as if they could comfortably belong to the eighteenth century, a period in which he was greatly admired by rococo artists.

The best place to see Correggio's work on a grand scale is in the city of Parma, where he was engaged in two major religious commissions to paint the ceilings of San Giovanni Evangelista and Parma Cathedral with large illusionistic frescoes. His religious paintings almost anticipate the baroque style in their energy and ecstatic quality. In smaller scale devotional paintings, Correggio depicts tender scenes of a young and timid Virgin Mary sharing intimate moments with her baby son. Throughout the seventeenth and eighteenth centuries, Correggio's name was held in high regard, along with Raphael and Titian. An evidently intelligent and highly educated painter, the sweetness of his work can, for some people, be a barrier to the poetry and beauty of his painted images. **KKA**

> "That's a very pleasant life, to renounce everything but Correggio!"—Henry James

ABOVE: This portrait is thought to be a self-portrait painted by Correggio.

JACOPO DA PONTORMO

Born: Jacopo Carucci, May 26, 1494 (Pontormo, Italy); c.1556 (Florence, Italy).

Artistic style: Leading mannerist painter and draftsman of the Florentine school; distorted figures; unsettling perspective; bold color; religious subjects and portraits; facial expressions imbued with emotions.

Jacopo da Pontormo was one of the most inventive Italian artists of the sixteenth century. He worked slowly and methodically, primarily on religious subjects and portraits, and was a superb draftsman, producing a large body of drawings that are among the best examples of the mannerist style.

According to biographer Giorgio Vasari, Pontormo was orphaned young and then moved between the studios of Leonardo da Vinci, Piero di Cosimo, and Mariotto Albertinelli before training with Andrea del Sarto in *circa* 1512. His early works reflect the influence of del Sarto and show Pontormo working in a classical Renaissance style. It was not until around 1517 that the artist began to develop his radically experimental style—partially as a result of studying the work of Michelangelo Buonarotti. He began to elongate his figures, distort perspective, and create complex compositions with great emotional content. One of the first works to exhibit this was the *Virgin and Child with Saints* (1518).

By the 1520s he had established his mature style and his works became characteristically imbued with complex, and often agitated, emotion and slightly unsettling spatial organization. At this time he began to look toward the work of Albrecht Dürer for inspiration. Between 1525 and 1528 he worked on the decorative scheme at the church of Santa Felicita's Capponi Chapel in Florence that included his *Lamentation* (1525–1528) now recognized as one of his best pieces, and particularly noted for its use of brilliant, pure color. Pontormo's last major commission, the decoration of the Basilica of San Lorenzo in Florence, includes scenes from the Old Testament but was finished, after Pontormo's death, by his former pupil Agnolo Bronzino. **TP**

Masterworks

Virgin and Child with Saints 1518 (S. Michele Visdomini, Florence, Italy)

Study for Lunette with Vertumnus and Pomona 1519 (Uffizi, Florence, Italy)

Lamentation (also known as *Entombment*) 1525–1528 (Santa Felicità Capponi Chapel, Florence, Italy)

"The artist was much esteemed by the people for his numerous beautiful works."—Giorgio Vasari

ABOVE: *Portrait of Pontormo* was painted *circa* 1532–1535 by Agnolo Bronzino.

HANS HOLBEIN THE YOUNGER

Born: Hans Holbein, *c.*1497 (Augsburg, Germany); died 1543 (London, England).

Artistic style: German Renaissance portraitist; championed by humanist thinkers; the enduring image of King Henry VIII; precise observational drawings transferred to painted portraits on wood.

Masterworks

Portrait of Erasmus of Rotterdam 1523 (National Gallery, London, England)

Noli me Tangere 1524 (Royal Collection, Hampton Court, London)

Portrait of Lady Mary Guildford 1527 (Saint Louis Art Museum, Saint Louis, Missouri, U.S.)

Sir Thomas More 1527 (Frick Collection, New York, U.S.)

Portrait of Nikolaus Kratzer 1528 (Musée du Louvre, Paris, France)

*An Allegory of the Old and New Testaments c.*1530s (National Gallery of Scotland, Edinburgh, Scotland)

Jean de Dinteville and Georges de Selve (The Ambassadors) 1533 (National Gallery, London, England)

Portrait of Henry VIII 1536 (Museo Thyssen-Bornemisza, Madrid, Spain)

Hans Holbein the Younger trained in his father's painting workshop in the cosmopolitan Renaissance city of Augsburg. Strongly influenced by Netherlandish art, the family was also aware of trends arriving over the Alps from Italy. From an early age, therefore, Holbein played with motifs from classical art while painting in the northern manner. Like many artists of his generation, he had a desire to travel, and in 1515 he found work in Basel, Switzerland. Basel was a center of humanist thought, which was greatly influential on the artist's career. Through the contacts he made in Basel, Holbein met and painted the Dutch humanist scholar Erasmus, and was introduced to the great minds of the Tudor court in England.

Holbein arrived in London in 1526 with a letter of recommendation from Erasmus to paint the family of Sir

ABOVE: Holbein painted this contemplative *Self-Portrait* shortly before he died.

RIGHT: The skull in *The Ambassadors* is best viewed from the edge of the canvas.

86 · HANS HOLBEIN THE YOUNGER

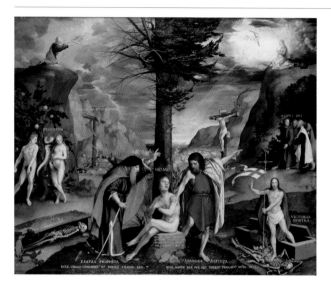

Thomas More. This first period in London was spent at the More family home, where he produced the striking portrait *Sir Thomas More* (1527). His painting of the More family, since destroyed, is the earliest example of a nondevotional group portrait in northern Europe and set the standard for subsequent generations. Aside from his portraits and religious paintings, Holbein produced printed illustrations and graphic work, his most famous series being the *Dance of Death* (1538) collection of woodcuts. He also provided designs for jewelry and silverware, work that made good use of his draftsmanship.

During his second stay in London, from 1532, Holbein developed his distinctive formula for portraits. Set against a plain-colored background, often a jewellike blue, his subjects sit politely upright, their features recorded with almost photographic accuracy, Holbein's brushes delineating their eyebrows, nostrils, and fingernails in fine, dark outlines.

By 1535 Holbein had achieved his ambition to become court painter to King Henry VIII, having already supplied designs for the coronation of Queen Anne Boleyn. His portraits of Henry VIII have become the lasting image of the charismatic ruler and are how Holbein's achievement is best remembered. **KKA**

ABOVE: *Portrait of Erasmus of Rotterdam* was, arguably, Holbein's breakthrough work.

ABOVE LEFT: *An Allegory of the Old and New Testaments* boasts a strong narrative.

Hidden Messages

Not all of Holbein's painted objects are immediately recognizable. In *The Ambassadors* (1533), a human skull stretches across the picture, depicted in anamorphic perspective. Why did Jean de Dinteville want Holbein to include a symbol of death in his portrait? The artist and his patron may have collaborated to include these symbolic objects: a globe, musical instruments, a hymn book, and instruments for the study of astronomy and telling the time. Read in combination, they reveal an interest in the brevity of human life and the foolishness of craving worldly possessions and fame.

BENVENUTO CELLINI

Born: Benvenuto Cellini, November 3, 1500 (Florence, Italy); died February 13, 1571 (Florence, Italy).

Artistic style: Bronze statues, silverware, medallions; mythological themes; classical allusions; intricately wrought surfaces; elegant, graceful, elongated figures.

Masterworks

Medal of Francis I, King of France 1537
(Fitzwilliam Museum, University of Cambridge, Cambridge, England)

La Saliera Salt Cellar 1540–1543
(Kunsthistorisches Museum, Vienna, Austria)

*Satyr c.*1542 (J. Paul Getty Museum, Los Angeles, California, U.S.)

La Nymphe de Fontainebleau 1542–1543
(Musée du Louvre, Paris, France)

Perseus with the Head of Medusa 1545–1554
(Loggia dei Lanzi, Piazza della Signoria, Florence, Italy)

Ganymede and the Eagle 1545–1547 (Museo Nazionale del Bargello, Florence, Italy)

Crucifix 1562 (El Escorial, San Lorenzo de El Escorial, Madrid, Spain)

> "I have done my utmost to prove I am no statue, but a man of flesh and spirit."

ABOVE: This portrait of Cellini is by the writer and art historian Giorgio Vasari.

Musician, murderer, sodomist, thief, womanizer, crack shot, autobiographer, wheeler-dealer, and soldier: Benvenuto Cellini was all these things but is remembered for his spectacular talents as a sculptor and goldsmith. His skill won him the patronage of nobles, kings, and popes and saved him from a four-year prison sentence when the Medici family intervened.

Cellini's father was a musical instrument maker and musician and hoped his son would do likewise; Cellini instead apprenticed himself to goldsmith Antonio "Marcone" di Sandro. Following a brawl, he fled to Siena, where he was apprenticed to goldsmith Francesco Castoro. He moved on to Bologna, Pisa, and eventually to Rome, at the age of nineteen.

In Rome he worked for noble families. A fine flautist, he was appointed court musician and went on to work for Pope Clement VII. He won papal affection, in particular for his courage in the 1527 Sack of Rome when he is said to have shot and killed the invading Duke of Bourbon, Charles III—this meant Cellini was able to return to Florence. His work for the pope allowed him to travel widely. In 1529 he had to flee to Naples after shooting a man in revenge for killing his brother. Once again, he was pardoned and found favor with the new pontiff, Pope Paul III. From 1540 to 1545 he worked in France for King Francis I on the château of Fontainebleau. Returning to Florence, he worked for Duke Cosimo I de'Medici, making the bronze statue *Perseus with the Head of Medusa* (1545–1554). In later life Cellini mellowed, and in 1558 took religious vows. In 1562 he carved a large ivory *Crucifix* based on an earlier vision experienced in prison. He began a racy autobiography (unfinished) and in 1565 started his treatise on sculpture and the art of the goldsmith. **CK**

PARMIGIANINO

Born: Girolamo Francesco Maria Mazzola, January 11, 1503 (Parma, Italy); died August 24, 1540 (Casalmaggiore, Italy).

Artistic style: Mannerist painter and printmaker of portraits and devotional pieces; elegant, fluid figures; elongated, dramatic forms.

Girolamo Francesco Maria Mazzola was better known by his nickname, Parmigianino (the little one from Parma). In his short career he established a reputation as one of the leading mannerist painters of his time. His influence on younger artists was profound, particularly through his prints and drawings.

Parmigianino was born into a family of artists, but his talent far outstripped that of his kin. He was producing significant paintings while still in his teens. The works are characterized by elegant and fluid figures that anticipate the distinctly mannerist elongated and dramatic forms that would become a trademark of his later career.

Antonio Allegri da Correggio, who had moved to Parma *circa* 1519, was an early and important influence on Parmigianino, who spent his first years working on large-scale religious works for various chapels in Parma and undertaking smaller, private commissions for devotional pieces and several portraits. In 1524 Parmigianino moved to Rome and came under the auspices of Pope Clement VII, to whom he had given his remarkable *Self-Portrait in a Convex Mirror* (1523–1524). Rome's artistic climate—in particular the work of Rosso Fiorentino and Polidoro da Caravaggio—had a marked effect on the young artist. His figures now took on greater monumentality and a sharper outline. Parmigianino moved to Bologna in 1527, during the Sack of Rome. He spent a total of three years there, working primarily on small devotional pieces, portraits, and printmaking. He returned to Parma in 1530 and was commissioned for several works to decorate Santa Maria della Steccata. These were never finished, and his broken contract eventually led to his arrest in 1539. He jumped bail and fled to Casalmaggiore, where he died. **TP**

Masterworks

Self-Portrait in a Convex Mirror c.1523–1524 (Kunsthistorisches Museum, Vienna, Austria)

The Mystic Marriage of St. Catherine c.1527–1531 (National Gallery, London, England)

Bow-carving Amor 1533–1534 (Kunsthistorisches Museum, Vienna, Austria)

Madonna with the Long Neck c.1534 (Uffizi, Florence, Italy)

"People said … the spirit of Raffaello had passed into the body of Francesco."—Giorgio Vasari

ABOVE: Detail from *Self-Portrait in a Convex Mirror,* a present to Pope Clement VII.

AGNOLO BRONZINO

Masterworks

Portrait of a Lady in Green 1528–1532
(Royal Collection, Windsor, England)

An Allegory with Venus and Cupid 1540–1550
(National Gallery, London, England)

*Bia, the Illegitimate Daughter of Cosimo
I de' Medici c.*1542 (Uffizi, Florence, Italy)

*Eleonora of Toledo with her son Giovanni
de' Medici* 1544–1545 (Uffizi, Florence, Italy)

Portrait of Andrea Doria as Neptune 1550–1555
(Pinacoteca di Brera, Milan, Italy)

*Portrait of Lodovico Capponi c.*1550–1555
(Frick Collection, New York, U.S.)

Born: Agnolo di Cosimo, November 17, 1503 (Monticelli, Italy); died November 23, 1572 (Florence, Italy).

Artistic style: Emotionally detached portraits of the intellectual elite; immaculate surfaces; smooth-skinned bodies; contorted poses; sophisticated moral allegories.

Hugely influenced by his master Jacopo Pontormo, Bronzino was famed for his portraits of Florentine nobility and for the way he imbued his sitters with an air of assured confidence. He worked mainly in Florence as court painter to Cosimo I de' Medici, Grand Duke of Tuscany, who appreciated the theatricality of Bronzino's vision and commissioned works that reflected his interest in myth and visual puzzles. Quoting from Michelangelo and Raphael, Bronzino contorts his figures, with their elegant necks and long fingers, into impossible poses. His portraits have been criticized for exuding a chilling arrogance, but should also be seen in terms of the type of beauty explored in his mannered allegories and religious works. **KKA**

JUAN DE JUANES

Masterworks

*The Martyrdom of St. Inez c.*1540
(Museo del Prado, Madrid, Spain)

*Annunciation to St. Anne c.*1550–1555
(The Hermitage, St. Petersburg, Russia)

*Christ Carrying the Cross c.*1560 (J. Paul Getty
Museum, Los Angeles, California, U.S.)

*The Last Supper c.*1560 (Museo del Prado,
Madrid, Spain)

Ecce Homo 1565–1575 (Museo de Bellas Artes
de Valencia, Valencia, Spain)

Assumption of Our Lady 1578 (Museo de Bellas
Artes de Valencia, Valencia, Spain)

Born: Juan Maçip Vicente, *c.*1490–1510 (Valencia, Spain); died *c.*1579 (Bocairente, Valencia, Spain).

Artistic style: Painter and draftsman of religious subjects; mythological works; portraits; use of rich color; figures posing in dynamic postures.

Juan de Juanes (also known as Maçip) grew up in Valencia at a time when the region was influenced by the Italian Renaissance and Netherlandish art. It has been suggested, although not verified, that he trained in Italian-born Paolo da San Leocadio's workshop. His first work was with his artist father on a number of Valencia's churches. Around 1560 de Juanes traveled to Italy, where he was deeply influenced by Raphael, which is evident in de Juanes's later works, such as *Christ Carrying the Cross* (*c.*1560). De Juanes's rich use of color and soft, luminous tones, combined with his capacity to create sympathetic tableaux of biblical stories and depictions of saints, has led to him being a highly acclaimed ecclesiastical artist. **CK**

GIORGIO VASARI

Born: Giorgio Vasari, July 30, 1511 (Arezzo, Italy); died June 27, 1574 (Florence, Italy).

Artistic style: "The father of art history"; writer, biographer, painter, and architect; worked primarily in frescoes; painted in the mannerist style; master of overseeing large-scale projects.

One of the first art historians, Giorgio Vasari's fame rests on his biographies of famous artists. The first edition of his two-volume work, *Lives of the Most Excellent Painters, Sculptors, and Architects* (1550), provides a general discussion of architecture, painting, and sculpture with biographies of the major artists. The second, expanded edition was published in 1568 and formed the foundation for subsequent art-historical works.

Vasari was also an accomplished artist and architect, skillfully overseeing projects, providing conclusive and detailed designs, and directing teams of artists to execute them. He traveled widely, ran a busy workshop, and undertook numerous large-scale commissions, many for the powerful Medicis.

Born into a family of artists, Vasari first trained with Luca Signorelli and Guillaume de Marcillat in Arezzo. At sixteen he moved to Florence, where he came into contact with Andrea del Sarto and Baccio Bandinelli. His earliest known painting, the *Entombment* (*c.*1532), was completed for Cardinal Ippolito de' Medici, and was well received. He worked chiefly in fresco, executing large-scale schemes, such as the *Deeds of St. Paul III* (1546), for Alessandro Cardinal Farnese but produced many altarpieces, such as *The Descent from the Cross* (1540), for the high altar at the church in Camaldoli. His work as an architect is perhaps better known. From 1559 he worked on three large projects: the Palazzo degli Uffizi in Florence; a series of buildings for the Order of the Cavalieri di San Stefano (Order of the Knights of St. Stephen) in Pisa; and the highly complex dome of the church of the Madonna dell'Umiltà in Pistoia. From 1555 to 1572 he also worked on the remodeling of the Palazzo Vecchio in Florence as both architect and artist for Cosimo I de' Medici. **TP**

Masterworks

*Entombment c.*1532 (Casa Vasari, Arezzo, Italy)

St. Luke Painting the Virgin after 1565 (SS. Annunziata, Florence, Italy)

*Self-Portrait c.*1567 (Uffizi, Florence, Italy)

Perseus and Andromeda 1570–1572 (Palazzo Vecchio, Florence, Italy)

"Art owes its origin to Nature … this beautiful creation, the world, supplied the first model."

ABOVE: Detail from *Self-Portrait*, which hangs in the Vasari Corridor at the Uffizi.

TINTORETTO

Born: Jacopo Comin, also known as Jacopo Robusti, *c.*1518 (Venice, Italy); died May 31, 1594 (Venice, Italy).

Artistic style: Burlesque distortions; vital sense of energy; dynamic, unstable figure arrangements on sloping checkered floors; dramatic lighting.

Masterworks

*Christ Washing the Feet of His Disciples c.*1547 (Museo del Prado, Madrid, Spain)

The Miracle of St. Mark Freeing the Slave 1548 (Gallerie dell'Accademia, Venice, Italy)

*Creation of the Animals c.*1551–1552 (Gallerie dell'Accademia, Venice, Italy)

Marriage at Cana 1551 (Santa Maria della Salute, Venice, Italy)

*Venus, Mars, and Vulcan c.*1555 (Alte Pinakothek, Munich, Germany)

The Stealing of the Body of St. Mark 1562–1566 (Gallerie dell'Accademia, Venice, Italy)

*The Finding of the Body of Saint Mark c.*1562 (Brera, Milan, Italy)

St. Roch in Prison Visited by an Angel 1567 (Scuola Grande di San Rocco, Venice, Italy)

*The Origin of the Milky Way c.*1575 (National Gallery, London, England)

Born the son of a dyer, Jacopo Comin was known as Tintoretto (little dyer). He is an artist one either loves or loathes, though it is hard not to be awed by his vast inventions. The biographer Giorgio Vasari was unsure how to respond to his bizarre, idiosyncratic style. He criticized Tintoretto's work for being contrary to "the beautiful manners of his predecessors" and despaired at his "extraordinary brain." Tintoretto's works have an internal dynamism and an almost uncontrollable, unsettling energy. Deep shadows add a mystical air to his compositions; figures surge into the light, displaying extremes of emotion.

Tintoretto was a native of Venice and only rarely left the city during his long career. He painted almost entirely for local patrons and the best place to see his finest work is in the public buildings of Venice. He is believed to have studied briefly with Titian, but the careers of the two are distinguished by their

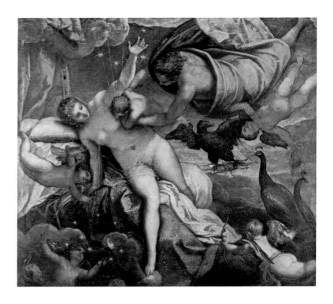

ABOVE: This *Self-Portrait* (1588) was painted in the year the artist turned sixty.

RIGHT: The swirling energy of *The Origin of the Milky Way* is classic Tintoretto.

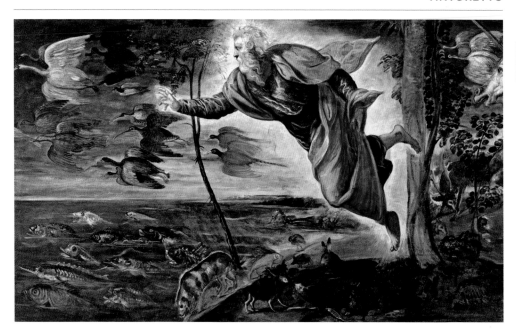

patrons. Titian painted for the courtly aristocracy, Tintoretto more for the middle classes in civic and religious institutions.

In 1562 Tintoretto was commissioned to produce three large paintings for the Scuola Grande di San Marco, two of which can now be seen in public collections: *The Stealing of the Body of St. Mark* (1562–1566) and *The Finding of the Body of St. Mark* (c.1562). In the 1560s he also won the most ambitious commission of his career: painting the walls and ceilings of the Scuola Grande di San Rocco. He worked on them for more than twenty years, until 1588. The series charts the development of his style toward a looser, rougher finish and more summary treatment of landscape.

Tintoretto brought a more violent, mannered aspect to Venetian painting, a contrast to the lighter, decorative schemes of his contemporary Paolo Veronese. He is the painter's painter, admired by many later artists. He continued painting into his seventies. His final contribution to Venetian culture was *Paradise* (1588–1590) on the ceiling of the Palazzo Ducale. **KKA**

ABOVE: In *Creation of the Animals,* God is depicted as a dramatic, almost angry figure.

The Talented Trickster

Vasari records that Tintoretto employed underhand tactics to win the commission to paint the Meeting House of the Scuola Grande di San Rocco. In 1564, several artists were invited to submit designs for the Sala Capitolare. When the brothers of the confraternity gathered under the ceiling to select the winner, however, they saw that Tintoretto had already installed a full-size, painted version of his design, thereby winning the competition. Although most likely elaborated by Vasari, the story attests both to Tintoretto's occasionally unscrupulous behavior and the famed speed at which he painted.

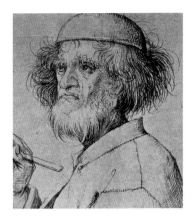

PIETER BRUEGEL THE ELDER

Born: Pieter Brueghel, *c.*1525 (Breda, the Netherlands); died 1569 (Brussels, Belgium).

Artistic style: Painter and printmaker of landscape, moralizing stories, religious subjects, and nightmarish scenes; accurate and detailed scenes of peasant life.

Masterworks

Netherlandish Proverbs 1559 (Staatliches Museum, Berlin, Germany)

The Fight Between Carnival and Lent 1559 (Kunsthistorisches Museum, Vienna, Austria)

*Mad Meg c.*1562 (Museum Mayer van den Bergh, Antwerp, Belgium)

The Hunters in the Snow 1565 (Kunsthistorisches Museum, Vienna, Austria)

Pieter Bruegel the Elder is a key figure in sixteenth-century Dutch art. He was one of the first artists to paint pure landscape, elevating it to the level of traditional history and religious paintings. He broke new ground with his realistic, detailed depictions of peasant life in the Netherlands.

Bruegel trained under Pieter Coecke van Aelst, whose daughter Mayken he married. (Aelst's second wife, Mayken Verhulst Bessemers, was an artist and influenced the artistic training of Bruegel's two sons, Pieter Brueghel [sic] the Younger and Jan Brueghel [sic] the Elder.) After leaving Aelst's studio, Bruegel worked for painter, engraver, printmaker, and publisher Hieronymus Cock. He joined the Antwerp Painter's Guild in 1551 before making a crucial trip to Italy, staying for three or four years. Much of Bruegel's early work reflects the influence of Flemish tradition. He then began to synthesize Italianate elements into his landscapes. His earliest dated work is *Landscape with Christ and the Apostles at the Sea of Tiberias* (1553), although the figures may have been painted by

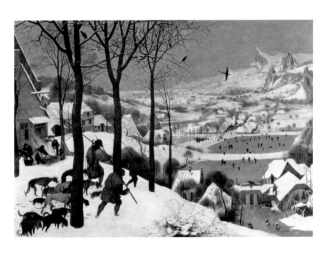

ABOVE: A self-portrait from the pen-and-ink sketch *The Painter and the Buyer* (*c.*1565).

RIGHT: *The Hunters in the Snow* is a characteristic depiction of peasant life.

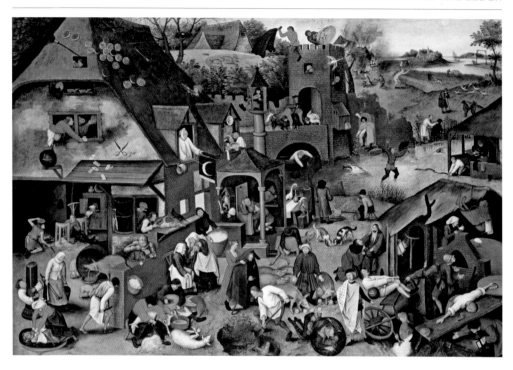

Maarten de Vos. By 1555 he was back in Antwerp. There he produced a series of twelve prints, the *Large Landscapes* (1555), for Cock's publishing house. He was now mixing in intellectual circles and in 1559 dropped the "h" from his name, in line with humanist ideals. He also painted *The Fight Between Carnival and Lent* (1559), a unique depiction of an old theme. The complicated and frenetic scene combines two halves—that of the tavern and the church—in a collision of chaotic energy.

His three next works reflect Hieronymus Bosch's influence: *The Fall of the Rebel Angels* (1562), *The Triumph of Death* (c.1562), and *Mad Meg* (c.1562). They are complicated paintings, massed with a profusion of figures and wrought in rich color, with a fantastic aura of mystery. By contrast, Bruegel's last pieces— the series *The Seasons* (1565)—combine the ideal with the real, the Italianate with the Dutch, and the restful with the energetic, to create works of unparalleled balance. **TP**

ABOVE: *Netherlandish Proverbs* is a witty, chaotic play on words inside a painting.

The Burned Drawings

Shortly before Bruegel's death, he told his wife to burn many of his graphic works as he thought their "inflammatory" nature may cause her problems should they come to the attention of certain people. The content of the works is unclear, but his actions suggest that they were either strongly political or religious in tone. (Bruegel may have been an Anabaptist, a group of Christians who preached radical reform and who were active across Europe, especially in Switzerland, Germany, Austria, and the Netherlands.) The true reason he had the drawings destroyed remains unknown.

GIOVANNI BATTISTA MORONI

Born: Giovanni Battista Moroni, *c.*1525 (Albino, Bergamo, Italy); died February 5, 1578 (Albino, Bergamo, Italy).

Artistic style: Portraits of surly Italian youths; sophisticated men in black; dignified lack of emotion; ruined columns and classical reliefs; masterful blacks and grays.

Masterworks

*A Knight with his Jousting Helmet c.*1554–1558 (National Gallery, London, England)

*A Gentleman in Adoration before the Madonna c.*1560 (National Gallery of Art, Washington, D.C., U.S.)

The Gentleman in Pink 1560 (Palazzo Moroni, Bergamo, Italy)

*The Tailor c.*1565–1570 (National Gallery, London, England)

*The Knight in Black c.*1567 (Museo Poldi Pezzoli, Milan, Italy)

Portrait of Jacopo Foscarini 1575 (Museum of Fine Arts, Budapest, Hungary)

*Portrait of an Elderly Man c.*1575 (Norton Simon Museum, Pasadena, California, U.S.)

"Rarely have painted images before or since been so ripe with latent action."—Timothy Potts

ABOVE: Moroni's *Portrait of a Man* is believed to show poet Clément Marot.

Giovanni Battista Moroni painted the nobility of northern Europe in the sixteenth century. He was born in Albino and chose to make a name for himself in the Bergamo region rather than find his fortune in Venice. A student of Alessandro Bonvicino "Il Moretto" in Brescia in his early teens, Moroni learned much from this leading portrait painter and often quoted from his master's work in his early career. His portraits communicate the chivalry and courtly manners that defined the age. His figures have a studied aloofness, demanding respect and decorum from the viewer.

Moroni is the ultimate painter of men in black. Black cloth was the height of fashion, and Moroni knew how to set these striking silhouettes against a silvery gray background, balanced by the cool tones of a stone column or the white of a folded letter. His pictures are exercises in tonal contrasts, allowing only the flesh color of faces and hands to act as a focal point of warmth. Also active as a religious painter, his altarpieces and frescoed ceilings are relatively conventional in their clarity of narrative and direct emotional impact.

Moroni was working in Trent when the first Council of Trent was held in 1545 and his paintings reflect Counter-Reformation ideals. During this time, he first encountered Titian and began to receive an impressive stream of portrait commissions. Moroni was unparalleled in his ability to capture the inner workings of his sitters' minds: they are real characters, with a look of loss, resilience, or cynicism in their eyes. Most remarkable in this respect is *The Tailor* (*c.*1565–1570), in which the unknown sitter fixes the viewer with his stare as he fingers a sample of the same black cloth that Moroni was to depict so often in his portraits. **KKA**

GIUSEPPE ARCIMBOLDO

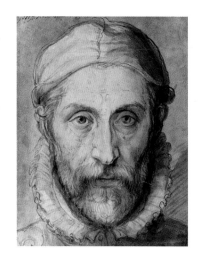

Born: Giuseppe Arcimboldo, c.1527 (Milan, Italy); died July 11, 1593 (Milan, Italy).

Artistic style: Allegorical composite portraits in the form of elaborate still lifes composed of objects such as flowers, built up to create recognizably human features.

The epithet "Renaissance man" suits Giuseppe Arcimboldo as well as it does Leonardo da Vinci, to whom it is usually applied. The sixteenth and seventeenth centuries saw a spirit of change in Europe, opening up new forms of artistic expression. In many ways, Arcimboldo was the visual equivalent of his contemporary, the English poet John Donne, who employed elaborate puns and highly original imagery. Arcimboldo wittily combined conventional subjects with the new genre of still life, producing *teste composte,* or composite heads. Traditional personifications of the seasons or the elements might be embodied as elaborate floral arrangements. Spring flowers convey a young man's healthy complexion, whereas a gnarled tree stump with barren, wintry branches represents an elderly man with thinning hair. Each individual element, whether flora, fauna, or inanimate object, is exquisitely painted yet makes sense to the viewer only as part of a human face. A plucked chicken becomes the haughty nose and beady eye of *The Lawyer* (1566) and, as both satire and caricature, suggests the subject's desiccated nature and ability to fleece his clients.

Arcimboldo was already known as an accomplished designer of stained glass and a fresco painter for the cathedrals in Milan and Monza when he was made court painter to the Holy Roman Emperor Ferdinand I in 1562. Works such as *Rudolph II as Vertumnus* (1590–1591) were prized by successive Holy Roman Emperors, contributing to the artistic flowering of Prague (where they were then housed) in the late sixteenth century. Arcimboldo's unique vision died with him. Four centuries later, his ambiguity found a direct parallel in the works of Salvador Dalí, who similarly hid human faces among random compositions in his paintings. **SC**

Masterworks

The Librarian c.1566 (Skoklosters Slott, Bålsta, Sweden)

The Lawyer 1566 (Statens Konstsamlingar, Gripsholm Slott, Stockholm, Sweden)

Fire 1566 (Kunsthistorisches Museum, Vienna, Austria)

Spring, Summer, Autumn, Winter (Four Seasons) 1573 (Musée du Louvre, Paris, France)

Self-Portrait 1575 (Národni Galerie, Prague, Czech Republic)

Rudolph II as Vertumnus 1590–1591 (Skoklosters Slott, Bålsta, Sweden)

"There's a certain ugliness more beautiful than any beauty."—Gregorio Comanini

ABOVE: Arcimboldo's *Self-Portrait* (c.1575) was executed with pen and blue pencil.

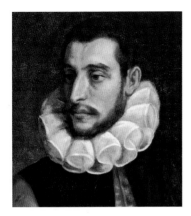

PAOLO VERONESE

Born: Paolo Cagliari, 1528 (Verona, Italy); died April 19, 1588 (Venice, Italy).

Artistic style: Grand Manner decorations for Venetian palaces; foreshortened figures and architectural details; pageantry and splendor; patterned fabrics and silvery, light-filled palette.

Masterworks

Jesus Among the Doctors c.1558 (Museo del Prado, Madrid, Spain)

The Marriage at Cana 1562–1563 (Musée du Louvre, Paris, France)

The Family of Darius Before Alexander 1565–1570 (National Gallery, London, England)

Saints Mark and Marcellinus Being Led to Martyrdom c.1565 (San Sebastiano, Venice, Italy)

The Allegory of Love, I–IV c.1570s (National Gallery, London, England)

The Feast in the House of Levi 1573 (Galleria dell'Accademia, Venice, Italy)

Baptism and Temptation of Christ 1580–1582 (Pinacoteca di Brera, Milan, Italy)

Apotheosis of Venice 1585 (Palazzo Ducale, Venice, Italy)

Paolo Veronese is known as one of the three "greats" of Venetian late Renaissance painting, along with Titian and Tintoretto. He takes his name from Verona, the city in which he was born and trained as a young artist, although he had settled in Venice by around 1553. His name became prominent in Venetian society and he soon became highly sought after as a painter of large-scale decorative frescoes and oil paintings. Some of his largest projects were for the grand villas on the Venetian mainland, owned by the cultured elite who liked the idea of re-creating the splendors of the classical age in their private palaces. For commissions such as the Villa Barbaro at Maser in the late 1550s, he worked with the architect Andrea Palladio, using illusionistic devices to suggest the extension of the architecture into fantastic painted spaces, reminiscent of the grandeur of Roman ruins. For monasteries, Veronese painted a series of large biblical feasts to decorate the refectory walls.

The world Veronese creates is one of refined theatricality. His characters pose and converse on a stagelike setting, draped in rich brocades and velvet costumes against backdrops of

ABOVE: Veronese painted several self-portraits; here he appears contemplative.

RIGHT: *The Marriage at Cana* is a superb profusion of rich colors and textures.

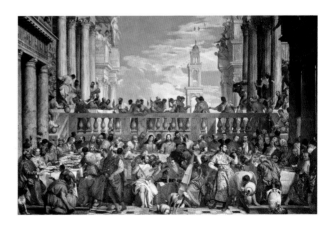

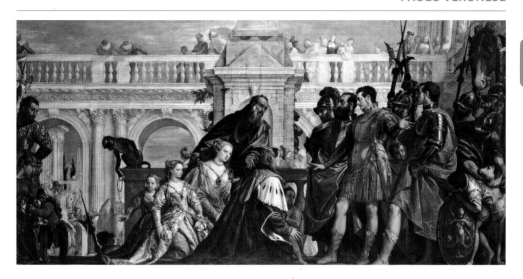

blue skies and classical balustrades. He clearly delighted in the application of paint and is known as one of the greatest colorists, creating a palette of rich paints that he experimented with to great effect, for example often placing cool silver-grays next to warm yellows in a feast of painted pattern and shimmering light. It has been suggested that this color sensibility was fixed in his earliest years in Verona, where he first discovered large fresco cycles.

Veronese was a master of foreshortening. His works can often be recognized by the motif of figures leaning precariously toward the viewer. His ceilings offer wonderful examples of his confident *di sotto in su* technique—employed in compositions specifically designed to be seen from below—creating the illusion of figures floating in space above.

Although dismissed in the eighteenth century by the Royal Academy's Sir Joshua Reynolds as a painter of merely "ornamental" art, Veronese proved influential for the work of Annibale Carracci, Sir Peter Paul Rubens, Sir Anthony van Dyck, and especially Tiepolo, who revived the Veronesian Grand Manner in rococo Venice in the eighteenth century. Veronese's influence continues today. **KKA**

It's All in the Name . . .

Veronese's subjects reflected the lively incidents of court life. His large feast scenes included spectators, jesters, dogs, and monkeys. While this entertained his patrons, such additions were deemed inappropriate for religious scenes.

In 1573 Veronese was called before the Inquisition to defend his inclusion of playful, disrespectful characters in his painting *Christ at the Last Supper*. He escaped the charge of heresy but did not remove the offensive details—instead, he simply changed the title to the less-provocative *The Feast in the House of Levi*.

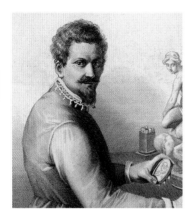

GIAMBOLOGNA

Born: Jean Boulogne, 1529 (Douai, then Flanders; now in France); died 1608 (Florence, Italy).

Artistic style: Mannerist sculptor; primarily marble and bronze; defined by flowing movement and gestures; resolution of complex, multifigural compositions.

Masterworks

*Samson and the Philistine c.*1560–1562 (Victoria & Albert Museum, London, England)

Triton 1560–1570 (Metropolitan Museum of Art, New York, U.S.)

Fountain of Neptune 1563–1566 (Bologna, Italy)

*Venus Urania c.*1573 (Kunsthistoriches Museum, Vienna, Austria)

The Rape of the Sabine Women 1574–1582 (Piazza della Signoria, Florence, Italy)

Flying Mercury 1580 (Bargello Museum, Florence, Italy)

Equestrian Statue of Cosimo I de'Medici 1587–1593 (Piazza della Signoria, Florence, Italy)

" . . . a truly exceptional young man."—Giorgio Vasari, *Lives of the Painters* (1568; second edition)

ABOVE: Giambologna fixes his viewers with an intense stare in this self-portrait.

Jean Boulogne, known as Giambologna, was a highly influential sculptor. He ran a busy workshop in Florence. Via his many pupils, his influence spread across Italy and much of Europe. Many of his large public works were also re-created by the artist as small private pieces for the Medici family, who used them as gifts for traveling heads of state and diplomats. As a result, his work became highly sought after, particularly in Germany and much of northern Europe.

He was born in Flanders and trained there with sculptor Jacques du Broeucq. In 1550 Giambologna traveled to Rome to study classical art, stopping in Florence in 1552 to see Michelangelo Buonarroti's work. There he met the wealthy patron Bernardo Vecchietti, who persuaded him to stay in the city and gave him a number of commissions. Through Vecchietti, Giambologna was introduced to the Medici family, who became his most important patrons. *Samson and the Philistine* (*c.*1560–1562) was his first major commission for them—a complex two-figure composition with great fluidity and energy. During this period he made a number of figural pieces for fountains and was commissioned to produce the dramatic *Fountain of Neptune* (1563–1566) for the city center.

He also spent time in Bologna, where he produced the first of his now-famous flying Mercury figures. His best-known piece is probably his large group *The Rape of the Sabine Women* (1574–1582). The end of his career was largely taken up by two equestrian monuments: one completed in 1593 for Cosimo I de'Medici, Grand Duke of Tuscany, in Florence's Piazza della Signoria and the other completed in 1608 for Ferdinand I de'Medici, Grand Duke of Tuscany, in Florence's Piazza Santissima Annunziata. **TP**

SOFONISBA ANGUISSOLA

Born: Sofonisba Anguissola, c.1532–1535 (Cremona, Lombardy, Italy); died 1625 (Palermo, Sicily, Italy).

Artistic style: Pioneering Renaissance painter of perceptive portraits, self-portraits, and religious works; informal surroundings; mastery of gesture and facial expression.

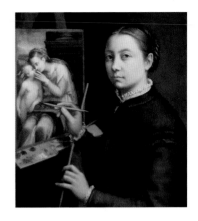

Sofonisba Anguissola was fortunate in having an enlightened father who educated his six daughters as well as he did his son. At fourteen years old she trained with local painters Bernardino Campi and Bernardino Gatti. Unusually for a woman at that time, she went on to establish an international reputation, outshining her sisters. She received praise from writer and artist Leon Battista Alberti, who said that she made "rare and very beautiful paintings," and impressed Michelangelo Buonarotti with her drawing *Asdrubale Bitten by a Crayfish* (1554).

At that time women were not permitted to draw from the nude, so Anguissola could not make grand history or religious paintings. She concentrated instead on portraiture, to which she brought a freshness and informality. *Sisters Playing Chess* (1555), for example, not only makes the point that women were capable of applying logic in what was seen as a man's game but also captures the emotions of the girls as defeat looms for one of them. Even in the formal portraits, Anguissola reveals genuine humanity behind the public persona. She painted many self-portraits, and in her *Self-portrait at the Easel Painting a Devotional Panel* (1556) she shows the accoutrements of her trade, but is careful to present herself as a respectable woman artist painting a religious subject.

In 1559 she became court painter to Elizabeth of Valois, Queen of Spain. So highly was she regarded that King Philip II arranged her first marriage to Fabrizio de Moncada, Viceroy of Sicily, in 1571 and provided her dowry. They lived in Sicily, but de Moncada died in 1579. At the age of forty-seven, Anguissola married the nobleman Orazio Lomellino and moved to Genoa, where she was able to work and teach. Her last years were spent in Sicily, where she continued to paint into old age. **WO**

Masterworks

Asdrubale Bitten by a Crayfish 1554 (Museo Nazionale di Capodimonte, Naples, Italy)

Sisters Playing Chess 1555 (Muzeum Narodowe, Poznan, Poland)

Self-portrait at the Easel Painting a Devotional Panel 1556 (Muzeum-Zamek, Lancut, Poland)

Portrait of the Artist's Family, Minerva Amilcare and Asdrubale 1558 (Nivaagaard Picture Gallery, Nivå, Denmark)

"Life is full of surprises, I try to capture these precious moments with wide eyes."

ABOVE: *Self-portrait at the Easel Painting a Devotional Panel* has a purity of expression.

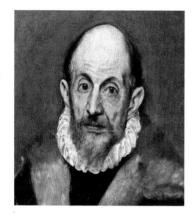

EL GRECO

Born: Doménikos Theotokópoulos, *c.*1541 (Heraklion, Crete); died April 7, 1614 (Toledo, Spain).

Artistic style: Elongated forms; shifting viewpoints; unusual spatial arrangements; dramatic, flickering lighting; acid greens and purple reds; intense spirituality.

Although his astonishing originality was recognized during his own lifetime, El Greco subsequently came to be thought of as either a madman or a victim of serious sight defects. The way in which he formed figures and the nightmarelike colors he brushed together on the palette often proved shocking. In the twentieth and twenty-first centuries, however, he has been reappraised as a rare, pioneering talent.

His nickname of El Greco means "The Greek" and refers to the artist's background in Crete. His Greek Orthodox family worked as traders and officials for the Venetian administration

Masterworks

Annunciation 1560s (Museo del Prado, Madrid, Spain)

Holy Trinity 1577 (Museo del Prado, Madrid, Spain)

Disrobing of Christ 1577–1579 (Toledo Cathedral, Spain)

Burial of the Count of Orgaz 1586–1588, (S. Tomé, Toledo, Spain)

*View of Toledo c.*1597 (Metropolitan Museum of Art, New York, U.S.)

*Portrait of a Cardinal c.*1600 (Metropolitan Museum of Art, New York, U.S.)

*The Opening of the Fifth Seal c.*1608–1614 (Metropolitan Museum of Art, New York, U.S.)

Adoration of the Shepherds 1612–1614 (Museo del Prado, Madrid, Spain)

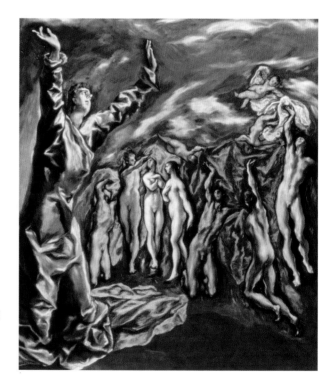

ABOVE: *Portrait of an Old Man* (*c.*1595–1600) is probably a self-portrait.

RIGHT: *The Opening of the Fifth Seal* was a major influence on twentieth-century art.

that governed the island. His family were no strangers to tricky dealings, and legal wrangles remained a feature of El Greco's life. He was a difficult, mercurial, and ambitious man who needed to support his extravagant lifestyle and was determined to get the best price possible for his work.

El Greco seems to have stayed in Crete until the mid-1560s, having become a master painter by 1563. He moved to Venice in around 1567 and stayed until 1570; he may have trained in Titian's workshop there. He had arrived from Crete steeped in the style of the Byzantine icon. The Venetian school must have encouraged his move toward loose brushwork and the use of glowing color to create form, space, and movement—as in his *Annunciation* (1560s). From 1570 until 1577 he was in Rome, adding Roman monumentality to his experimentation with space, color, and vigorous, *impasto* brushwork.

The Toledo years

The height of El Greco's success came with his years in the great Spanish city of Toledo, from 1577 until his death in 1614. In 1578 he had his only son with partner Jerónima de Las Cuevas, to whom he was not married—possibly because he was still bound by an earlier marriage. In Toledo he produced major pieces including *Burial of the Count of Orgaz* (1586–1588).

The move to Spain was probably prompted by hopes of patronage from its ruler, King Philip II. This did happen, although with mixed success. By the 1590s, however, El Greco was receiving plenty of major religious commissions and had become a renowned portraitist. His increasingly free approach to painting at this time, for example in the almost abstract *View of Toledo* (c.1610), which presents different views of the city simultaneously, has influenced many modern artists. Others, such as his *Adoration of the Shepherds* (1612–1614), feature the vivid coloring and elongated figures for which he is often labeled a mannerist. *Adoration of the Shepherds* also exhibits a spiritual ecstasy that chimed with the zeal of the Spanish Counter-Reformation. Whether El Greco personally felt such intensity is open to debate. **AK**

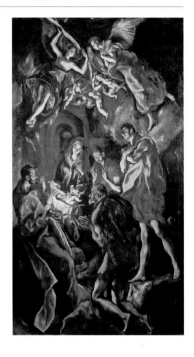

ABOVE: *Adoration of the Shepherds* is often described as a mannerist painting.

The Picasso Connection

El Greco's work influenced many modern artists. Picasso's iconic *Les Demoiselles d'Avignon* (1907), one of the foundations of modernism, is said to have been largely inspired by El Greco's extraordinary *The Opening of the Fifth Seal*, also known as *The Vision of St. John* (c.1608–1614). This painting contains all the features for which El Greco is famed, *in extremis*: the vivid, liverish coloring; apocalyptic sky; extremely distorted forms; and an abstract, unnatural sense of space and perspective. Picasso had seen the work at the Parisian home of its owner—his friend, the artist Ignacio Zuloaga.

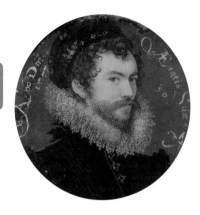

NICHOLAS HILLIARD

Born: Nicholas Hilliard, 1547 (Exeter, England); died January 7, 1619 (London, England).

Artistic style: Founder of Elizabethan British school of miniature painting; linear oval portraits of nobles, courtiers, and royalty; microscopic detail.

Masterworks

Self-Portrait Aged 30 1577 (Victoria & Albert Museum, London, England)

Sir Francis Drake 1581 (National Portrait Gallery, London, England)

*Sir Walter Raleigh c.*1585 (National Portrait Gallery, London, England)

Young Man Among Roses, Possibly Robert Deveraux, Second Earl of Essex 1585–1595 (Victoria & Albert Museum, London, England)

*Portrait of Elizabeth I c.*1600 (Victoria & Albert Museum, London, England)

*Portrait of James I c.*1604 (Victoria & Albert Museum, London, England)

Elizabethan miniaturist and goldsmith Nicholas Hilliard enjoyed considerable success in his lifetime as limner—or miniaturist—to the Crown, working for both Queen Elizabeth I and her successor, King James I. He was held in high esteem by his contemporaries, and poet John Donne wrote a poem, "The Storm" (1597), that included praise for the artist. Hilliard influenced the British school of miniature painting from beyond the grave, having been teacher to notable subsequent miniaturists Isaac Oliver and Rowland Lockey. He even wrote a book explaining the art of painting miniatures, *A Treatise Concerning the Arte of Limning* (c.1600). Yet perhaps his greatest legacy was the use of his work as propaganda to help bolster the image of the monarchy.

Elizabethan miniatures were painted in watercolor on vellum mounted onto card and were made to be kept in small ivory cases in drawers or cabinets, or housed in jeweled lockets. Often they were tokens of amorous affection, but they were also used as signs of support toward the monarchy. Sometimes they were bestowed as a favor to an individual by the monarch. They became increasingly popular during the 1580s, when Protestant England was under threat from Roman Catholic Spain. Elizabeth I's wealthier subjects wore them as a sign of loyalty to the throne. Hilliard was quick to pick up on the potential of his work as a propaganda tool. Toward the end of Elizabeth I's reign, when there was anxiety about who would be her successor, he portrayed her as still youthful, emphasizing her power by depicting her in opulent finery. When James I came to the throne in 1603, he too chose to use miniatures as propaganda, employing Hilliard and Oliver to paint miniatures of himself and his family. **CK**

> "But of all things, the perfection is to imitate the face of mankind."

ABOVE: *Self-Portrait Aged 30* was painted while Hilliard was living in France.

DONG QICHANG

Born: Dong Qichang, 1555 (Huating, Jiangsu, Shanghai, China); died 1636 (China).

Artistic style: Hugely influential calligrapher, painter, art theorist, and historian; defined Southern School Literati style of landscape painting; expressionistic, near-abstract compositions.

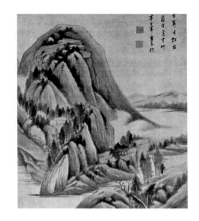

China's conquest by Kublai Khan in 1279 was followed by a century of Mongol domination, and the suppression of the bureaucratic class who had previously played such a dominant cultural role. However, with the restoration of indigenous Chinese rule under the Ming Dynasty, there followed a revival in the scholar-official's fortunes, and a renewed interest in exploring classical art styles and theory.

Dong Qichang was born into a family of minor officials in the latter days of the Ming Dynasty but rose rapidly through the civil service to ultimately tutor the Crown Prince in Beijing. An acknowledged master of calligraphy, Qichang's most profound impact was as an art theorist. It is largely because of his writings that Chinese landscape painting was—and still is—codified into Northern and Southern Schools, and that the concept of the *wenrenhua*, or Literati School, was fully defined.

Qichang identified a Southern School of simple, lyrical subjectivity in contrast to a monumental and laborious naturalism associated with the North—confusingly, this was based more on his interpretations of Chan Buddhism than actual geography. Condemning academicism, he advocated an intuitive and more authentic approach yet, ironically, his own paintings often lacked spontaneity, functioning more as demonstrations of technique. With age he seems to have relaxed, and in his best work the bold, loose brushstrokes expressively model natural forms into near-abstract spatial arrangements, while gentle color washes soften and unify the composition. A controversial figure during his lifetime, in recent years the merits of Qichang's paintings —and the doctrines underpinning them which were to prove so influential—have once again provoked debate. **RB**

Masterworks

Landscape After Wang Meng early seventeenth century (Nelson-Atkins Museum of Art, Kansas City, U.S.)

Stately Trees and Mountain Peaks early seventeenth century (Museum of Fine Arts, Boston, U.S.)

*Reminiscence of Jian River c.*1620 (Yale University Art Gallery, New Haven, Connecticut, U.S.)

"If one considers the wonders of nature, then painting does not equal landscape."

ABOVE: Qichang's loose brushwork and lyrical themes are seen to perfection here.

ANNIBALE CARRACCI

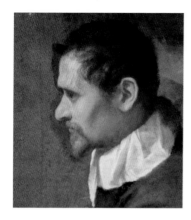

Born: Annibale Carracci, 1560 (Bologna, Italy); died July 15, 1609 (Rome, Italy).

Artistic style: Replaced mannerist artifice with rigorous naturalism; observation of the natural world; commitment to drawing; breathed life into religious painting; helped inspire the Italian baroque.

Masterworks

The Beaneater 1580–1590 (Galleria Colonna, Rome, Italy)

Butcher's Shop 1580–1590 (Christ Church Picture Gallery, Oxford, England)

*Fishing c.*1585–1588 (Musée du Louvre, Paris, France)

*Venus with a Satyr and Cupids c.*1588 (Uffizi, Florence, Italy)

The Galleria Farnese 1597–1601 (Palazzo Farnese, Rome, Italy)

Pietà 1599–1600 (Museo Nazionale di Capodimonte, Naples, Italy)

Christ Appearing to Saint Peter on the Appian Way 1601–1602 (National Gallery, London, England)

Annibale Carracci was the most inventive and talented of a family of artists known as "the Carracci"; the family worked initially in Bologna in the late sixteenth century. Annibale was born into the profession of painter, training from a young age in the studio of his cousin Ludovico, along with his brother Agostino. Together, they aimed to clear away the effect of mannerism and its self-conscious refinement of nature to make way for a return to the rigorous ideals of the earlier Renaissance. The Carracci had a lasting effect on the development of Italian art.

Annibale's first works appear startlingly modern and pioneering, compared with the contrived artifice of mannerism. *Butcher's Shop* (1580–1590) is a good example: loosely applied brushstrokes create a very honest, naturalistic scene of workers hanging animal carcasses. This commitment to truth and reality enabled Annibale to develop a very direct and clear

ABOVE: *Self-Portrait* (c.1590) shows Carracci with a somewhat troubled expression.

RIGHT: *The Beaneater* is a sympathetic, albeit slightly caricaturelike, portrait of the poor.

style of religious painting. He communicated the subject matter with a resounding emotional punch—a quality that would be fundamental to baroque painting in the seventeenth century.

Annibale left for Rome in 1595 to study firsthand the work of Raphael, Michelangelo Buonarotti, and antique sources. Invited by Cardinal Odoardo Farnese, he was commissioned to decorate the Palazzo Farnese with his monumental classical nudes that tumble across the ceiling amid *trompe l'oeil* architecture and frames. He worked on the ceilings for about ten years, and they quickly became the touchstone for artists painting in the Grand Manner. The themes are mythological and make deliberate reference to the other great frescoed ceiling in Rome at the time: Michelangelo's Sistine Chapel. Here, as elsewhere, Annibale worked with his brother Agostino, and their work is often hard to differentiate. At Palazzo Magnani in Bologna, when asked who painted one element of the frieze, they replied, "It is by the Carracci; we have all made it."

It is in his exquisite drawings that Annibale's vision can be best understood. He made hundreds of preparatory drawings, each revealing his assured knowledge of the human form, his expressive power of line, and his strength of design. **KKA**

ABOVE: Carracci spent ten years working on the frescoes for the Palazzo Farnese.

An Influential Academy

In 1582 Annibale and his family opened an academy, originally named the Accademia dei Desiderosi for those "desiring" knowledge and fame. The academy set out its approach to painting, centered upon life drawing and the faithful study of nature, with a motto to reflect its enthusiasm for reform: "The school of those who regret the past, despise the present, and aspire to a better future." Although it had no set program of study, the academy was a forum for new ideas and theoretical discussion. Famous across Italy, it was a prototype for the great European academies to come.

FRANCISCO RIBALTA

Born: Francisco Ribalta, June 2, 1565 (Solsona, Lérida, Spain); died January 13, 1628 (Valencia, Spain).

Artistic style: Painter; use of bold contrasts of light and shade; realistic and highly dramatic ecclesiastical art; early adopter of tenebrist style.

Masterworks

Nailing to the Cross 1582 (The Hermitage, St. Petersburg, Russia)

*Apostles at Christ's Tomb c.*1590–1599 (The Hermitage, St. Petersburg, Russia)

*The Coronation of the Virgin c.*1600–1628 (J. Paul Getty Museum, Los Angeles, California, U.S.)

*Martyrdom of St. Catherine c.*1600–1602 (The Hermitage, St. Petersburg, Russia)

The Vision of Father Simón 1612 (National Gallery, London, England)

*Presentation of the Virgin in the Temple c.*1620 (National Gallery of Art, Washington, D.C., U.S.)

St. Luke the Evangelist 1625–1627 (Museo de Portacoeli, Valencia, Spain)

*Christ Embracing St. Bernard c.*1626 (Museo del Prado, Madrid, Spain)

Francisco Ribalta was born in Catalonia but moved to Madrid in 1581 after his parents died. There he worked as an artist apprentice at the royal place, El Escorial, and was able to study the work of contemporary Spanish and Italian artists. After the death of King Philip II in 1598, Ribalta moved to Valencia. Under the patronage of the influential arts patron and archbishop Saint Juan de Ribera, he became a sought-after artist of religious subjects; commissions were numerous during the climate of the Counter-Reformation.

Valencia was a Mediterranean port, and, as such, a cultural gateway to Europe, and Italy in particular. The beginning of the sixteenth century saw many artists influenced by the work of the Italian artist Michelangelo Merisi da Caravaggio, whose highly dramatic and religiously symbolic use of bold contrasts of light and shade injected a sense of realism into religious art. Ribalta was one of the first Spanish artists to adopt Caravaggio's tenebrist style, which emphasizes darkness rather than light. He may have been influenced by a copy of a Caravaggio altarpiece owned by the archbishop, a work that Ribalta is known to have copied. This led to a string of dark, realistic paintings on religious subjects, such as the *Martyrdom of St. Catherine* (c.1600–1602), which were in keeping with Ribalta's own strong spiritual beliefs. After the death of the archbishop, Ribalta received fewer commissions, and by 1620 his style had changed once more. It now reflected a general artistic shift, to baroque with greater ornament and sometimes dynamic, tumbling figures; this change can be seen in his *Presentation of the Virgin in the Temple* (c.1620).

His work was to prove influential on a subsequent generation of artists, including his son, Juan Ribalta. **CK**

> "[He] was so venerated … he was deeply mourned by the whole city."—Jusepe Martínez

ABOVE: Ribalta painted himself as *St. Luke the Evangelist,* patron saint of artists.

JAN BRUEGHEL THE ELDER

Born: Jan Brueghel, 1568 (Brussels, Belgium); died January 13, 1625
(Antwerp, Belgium).

Artistic style: Lush, velvet landscapes; still lifes; collaborative paintings
with figurative painters; opulent coloring; allegories and religious themes.

The second son of the renowned Flemish painter Pieter Bruegel
[sic] the Elder, Jan Brueghel was also known as "Velvet
Brueghel," and "Flower Brueghel" for his ability to paint rich and
delicate textures of landscapes and still lifes usually depicting
flora. Jan was only a baby when his father died, so he and his
siblings lived with their grandmother, Mayken Verhulst, a
miniature painter (and Jan's first art teacher). He spent several
years in Italy, where he gained the patronage of the influential
Milanese Cardinal Federico Borromeo. After returning to the
Netherlands, he became dean of the Antwerp Guild in 1602.

Brueghel became famous in his lifetime. He gained notable
wealth from his paintings, especially after being appointed
court painter to the Spanish Habsburg governors of the
southern Netherlands, Archduke Albert and Archduchess
Isabella. A master of still lifes, his work with nature involved
traveling far and wide to collect flowers to be painted at home.
He had a particular delight for rare species. His other passion
was for landscapes that incorporated lush woodland scenes
overflowing with exotic animals and flowers.

He often collaborated with other artists, including Joos de
Momper the Younger, Hendrick van Balen, and most
memorably with his friend Sir Peter Paul
Rubens. Brueghel would paint the
landscape, flowers, and animals, and the
collaborating artist supplied the human
figures, as can be seen in *The Battle of the
Amazons* (1598–1600). Brueghel was also
a keen painter of allegorical depictions of
the senses and religious subjects. His distinctive style was
carried on by his sons Jan Brueghel the Younger and Ambrosius.
It also influenced a number of imitators, leading to later
difficulty with the rightful attribution of works. **SG**

Masterworks

Orpheus in the Underworld 1594–1600
(Palazzo Pitti, Galeria Palatina,
Florence, Italy)

The Battle of the Amazons 1598–1600
(Schloss Sanssouci, Potsdam, Germany)

Great Fish Market 1603 (Alte Pinakothek,
Munich, Germany)

Wan-Li Vase with Flowers 1610–1615
(Mauritshuis, The Hague, the Netherlands)

The Entry of the Animals into Noah's Ark 1613
(Getty Center, Los Angeles, California, U.S.)

The Feast of Achelous 1614–1615 (Metropolitan
Museum of Art, New York, U.S.)

Allegory of Hearing 1618 (Museo del Prado,
Madrid, Spain)

Allegory of Sight, with Peter Paul Rubens c.1619
(Museo del Prado, Madrid, Spain)

"Reminiscent of the velvet
lining of an open jewel box."

—Albert Blankert, on *Tableau*

ABOVE: A contemporary portrait of Jan
Brueghel the Elder by an unknown artist.

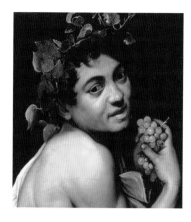

CARAVAGGIO

Born: Michelangelo Merisi da Caravaggio, c.1571 (Caravaggio, Italy); died July 18, 1610 (Porto Ercole, Italy).

Artistic style: Revolutionary painter; highly dramatic and religiously symbolic use of bold contrasts of light and shade; brought an intense realism to religious art.

Masterworks

Sick Bacchus, (or *Self-Portrait as Bacchus*) c.1593–1594 (Galleria Borghese, Rome, Italy)

*Youth with a Basket of Fruit c.*1593–1595 (Galleria Borghese, Rome, Italy)

*Boy Bitten by a Lizard c.*1595–1600 (National Gallery, London, England)

*Rest on the Flight into Egypt c.*1595 (Galleria Doria Pamphili, Rome, Italy)

*Head of Medusa c.*1595–1600 (Uffizi, Florence, Italy)

*Martyrdom of St. Matthew c.*1599–1600 (Contarelli Chapel, Rome, Italy)

Crucifixion of St. Peter 1600–1601 (Cerasi Chapel, S. Maria del Popolo, Rome, Italy)

*Incredulity of St. Thomas c.*1601–1602 (Sanssouci, Potsdam, Germany)

*The Death of the Virgin c.*1601–1606 (Musée du Louvre, Paris, France)

Supper at Emmaus 1601 (National Gallery, London, England)

The Entombment 1602–1603 (Pinacoteca, Vatican City, Italy)

Decapitation of St. John the Baptist 1608 (St. John's Co-Cathedral, La Valletta, Malta)

ABOVE: Caravaggio painted himself as the god of wine in *Sick Bacchus*.

RIGHT: *Supper at Emmaus* demonstrates Caravaggio's superb use of light and shade.

To modern eyes, Michelangelo Merisi da Caravaggio is one of painting's most admired "bad boys," displaying the perfect checklist of artistic genius: a wayward personality and original talent fed by mental instability, heavy drinking and violent brawling in seedy taverns, debt, shady associates, repeated imprisonment, a murder charge, years lived on the run, and a premature death. His painting style was partly clumsy and untutored but filled with a new, powerful, gritty naturalism that made him a major seventeenth-century artist. He attracted many followers across Europe, known as the "Caravaggisti."

Named for his boyhood town, Caravaggio was the son of an architect who died early in his son's life. His mother died when he was a young man, and when Caravaggio headed for Rome via Venice, Cremona, Milan, and Bologna at the start of his career, he was already orphaned and in debt. He had under his belt deft brushwork skills and some uneven training in Venetian-style painting, giving him an appreciation of light and color. Early works were dominated by enigmatic portraits.

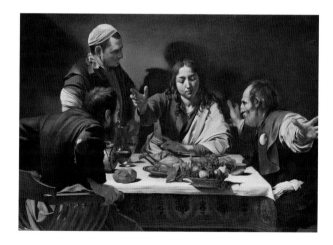

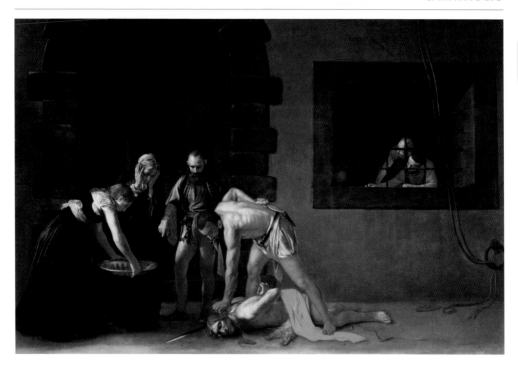

These include his noteworthy self-portrait *Sick Bacchus* (c.1693–1694), which also displays his extraordinary talent for still life.

By 1600 Caravaggio was widely admired. Purists, though, criticized his lack of formal training or preparatory sketches. He simply drew directly on to the canvas, and painted on top. He won prestigious commissions for religious paintings, such as *The Entombment* (1602–1603), though some were rejected as too realistic. His original approach, using striking chiaroscuro and filling his canvases with passion, spoke to ordinary people and chimed with the Roman Catholic Counter-Reformation zeal for spreading the word. In 1606 Caravaggio went on the run after killing a man in a duel. He still received commissions and explored a new, reflective approach—perhaps influenced by guilt. It seems he died from a fever, aged only thirty-nine, while on a desperate return journey to Rome to seek a pardon. Unknown to him, it had already been granted. **AK**

ABOVE: A typically grim biblical scene, *Decapitation of St. John the Baptist*.

Dogged by Scandal

Caravaggio's work has always courted controversy. Some paintings were thought blasphemously "realistic" by their religious patrons. *The Death of the Virgin* (1601–1606) was rejected by the church for which it was painted, not just because Caravaggio's female model was a local prostitute who was also his lover but because he showed the Virgin Mary's death with a mortal naturalism, complete with swollen belly and exposed legs. More recently, much has been made of Caravaggio's possible homosexuality, though many scholars see this as a misleading modern rereading of the past.

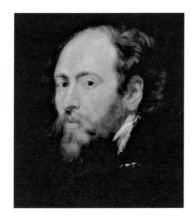

PETER PAUL RUBENS

Born: Peter Paul Rubens, June 28, 1577 (Siegen, Germany); died May 30, 1640 (Antwerp, Belgium).

Artistic style: Voluptuous, fleshy women; plasticity of form; religious passion and drama; opulent, debauched mythological scenes; dynamic compositions.

Masterworks

The Adoration of the Magi 1609
(Museo del Prado, Madrid, Spain)

*Prometheus Bound c.*1611–1618 (Museum of Art, Philadelphia, Pennsylvania, U.S.)

The Descent from the Cross 1611–1614
(Cathedral of Our Lady, Antwerp, Belgium)

Venus Frigida 1614 (Koninklijk Museum voor Schone Kunsten, Antwerp, Belgium)

The Drunken Silenus 1616–1617
(Alte Pinakothek, Munich, Germany)

Allegory of Sight (with Brueghel) *c.*1617–1618 (Museo del Prado, Madrid, Spain)

The Adoration of the Magi 1624
(Koninklijk Museum voor Schone Kunsten, Antwerp, Belgium)

*The Straw Hat c.*1622–1625 (National Gallery, London, England)

Minerva Protects Pax from Mars (or *Peace and War*) 1629–1630 (National Gallery, London, England)

*The Fur c.*1636–1638 (Kunsthistorisches Museum, Vienna, Austria)

Sir Peter Paul Rubens was renowned in his own lifetime as a painter, scholar, and diplomat. During the 1620s and 1630s, he could list some of the most influential personalities of Europe as his patrons, including King Charles I, Philip IV of Spain, and Marie de Medici. In his hometown of Antwerp, he ran a large, bustling workshop filled with assistants and pupils. The studio produced hundreds of compositions packed with figures to Rubens's designs, with the master applying the finishing touches to many paintings that were largely the work of his artistic team. He became very wealthy and could afford to build himself a lavish home and gardens in central Antwerp.

Rubens received a good education as a child and became an independent artist at the age of twenty-two. Two years later, in 1600, he went to Italy—the essential destination for an artist intending to compete on the international stage. In Italy he entered the service of the Duke of Mantua, Vincenzo I of Gonzaga, who sent him on his first diplomatic mission to Spain. Rubens spent eight years in Italy, years that hugely helped

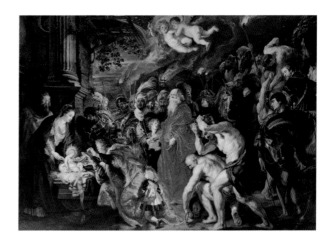

ABOVE: *Self-Portrait Without a Hat* (*c.*1639) shows a mastery of the effects of light.

RIGHT: *The Adoration of the Magi* (1609) was inspired by the art Rubens saw in Italy.

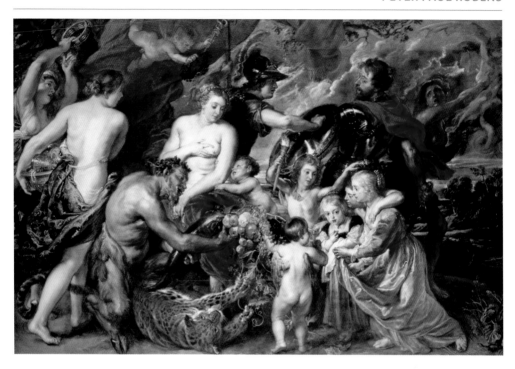

ABOVE: *Minerva Protects Pax from Mars* was a plea for peace between England and Spain.

improve his technique. He returned to Antwerp with a fully fledged individual style and a reputation that preceded him.

The following decade saw Rubens paint an astonishing number of high-profile commissions, including two major altarpieces now in Antwerp Cathedral: *The Raising of the Cross* (1610) and *The Descent from the Cross* (1611–1614). In the 1630s Charles I commissioned him to paint Inigo Jones's Banqueting House in Whitehall, London. Charles I also sent him to Madrid, where he took the opportunity to copy works by Titian—who was to influence him greatly—in the Royal Collection.

In later life, Rubens returned with enthusiasm to landscape painting. The color and movement in these very personal works, typified by loose, thinly applied paint, influenced later generations of painters, including John Constable and the Impressionists. His paintings are alive with the energy of his fluid brushwork and still inspire artists today. **KKA**

The Garden of Love

It is clear from his celebratory female nudes that Rubens loved women. In 1630 he married his second wife, the sixteen-year-old Hélène Fourment. With her very "Rubenesque" full-bodied charm and long, blonde hair, she appears in many of his narrative paintings. In one unforgettably sexy portrait, Hélène wears only a fur coat, as if she has just stepped out of their shared bed. Rubens developed the theme of married bliss in his paintings and drawings of "The Garden of Love"— depicting young lovers giving thanks at the temple of Venus—which was loosely based on his gardens in Antwerp.

FRANS HALS

Born: Frans Hals, c.1581 (Antwerp, Belgium); died 1666 (Haarlem, the Netherlands).

Artistic style: Great portraitist of the Dutch Republic; fleeting, mischievous smiles; superb recreation of facial expression and emotion; swift, flickering brushwork; immediacy and brilliance; festive company scenes.

Masterworks

Banquet of the Officers of the St. George Civic Guard 1616 (Frans Halsmuseum, Haarlem, the Netherlands)

Portrait of Catharina Hooft and her Nurse c.1620 (Gemäldegalerie, Staatliche Museen, Berlin, Germany)

The Laughing Cavalier 1624 (Wallace Collection, London, England)

Young Man Holding a Skull (Vanitas) 1626–1628 (National Gallery, London, England)

*Pieter van den Broecke c.*1633 (Iveagh Bequest, Kenwood House, London, England)

Willem Coenraetsz Coymans 1645 (National Gallery of Art, Washington, D.C., U.S.)

While Sir Peter Paul Rubens provided altarpieces and mythologies for the southern Spanish Netherlands, Frans Hals was painting portraits in the Dutch town of Haarlem to the north. The proud new republic was led by wealthy merchants and burghers, keen to be recorded by one of the most outstanding talents in portraiture. These citizens were eager to commemorate their achievements—both civic and military. Hals's loose, convivial manner of painting perfectly captured this spirit of occasion.

In Hals's portraits, life is good. Young, swashbuckling men are still in their prime, and women glance at the viewer with a knowing smile. His *The Laughing Cavalier* (1624) typifies what has become Hals's trademark: he was one of few artists able to capture a fleeting smile. He is also known for his rather relaxed attitude to managing his finances and was plagued by debts until his death. The artist manages to communicate his carefree existence in his portraits. Nothing in his work looks stiff or contrived, even when tackling large compositions of civic guard companies in uniform.

Hals particularly excelled at group portraiture, matched only by Rembrandt, who was his contemporary in Amsterdam. Hals deftly describes the quality of his sitter's clothes, a reminder of the wealth that pays for their self-assured air. In his portrait *Willem van Heythuysen* (c.1638), the cloth merchant rocks back in his chair, nonchalantly balancing on the back legs as if about to topple over. This immediacy is achieved by swift, visible brushstrokes, applied wet on wet—a technique that was considerably ahead of its time and greatly admired in the nineteenth century by Édouard Manet and the Impressionists. **KKA**

"Whenever I see a Frans Hals, I feel like painting."

—Max Liebermann

ABOVE: This characterful self-portrait was painted in *circa* 1649.

JOSÉ DE RIBERA

Born: José de Ribera, 1591 (San Felipe de Jativa, Spain); died September 1652 (Naples, Italy).

Artistic style: Spanish tenebrist painter; attention to gritty detail in style of Caravaggio; religious themes; inclusion of humble figures.

In 1611 José de Ribera left Spain for Italy, where he produced most of his work. Ribera painted in a direct, naturalistic fashion; he adopted a tenebrist style, whereby sharp contrasts of light and shadow create solid, figurative forms. In 1616 the artist moved to Naples, where he was kept busy by commissions for religious paintings. By the 1630s his style shifted, becoming noteworthy for its luminous light, but the 1640s saw his health deteriorate and his finances become precarious. His later paintings were gentler and less dramatic in subject matter and composition. He began to depict less-fortunate members of society, a concern that was to influence Spanish painters such as Diego Velázquez and Francisco Goya. **CK**

Masterworks

An Apostle c.1615–1619 (National Gallery, London, England)

The Lamentation over the Dead Christ 1620s (National Gallery, London, England)

Drunken Silenus 1626 (Museo di Capodimonte, Naples, Italy)

Jacob with the Flock of Laban c.1638 (National Gallery, London, England)

Martyrdom of St. Philip 1639 (Museo del Prado, Madrid, Spain)

The Clubfoot 1642 (Musée du Louvre, Paris, France)

The Adoration of the Shepherds 1650 (Musée du Louvre, Paris, France)

GUERCINO

Born: Giovanni Francesco Barbieri, February 8, 1591 (Cento, Ferrara, Italy); died December 22, 1666 (Bologna, Italy).

Artistic style: Leading seventeenth-century Bolognese painter and draftsman; shadowy, emotionally intense early work; controlled classicism in a pale palette.

Nicknamed "Il Guercino" ("the squinter"—he was cross-eyed), Guercino was a key artist of the Bolognese school but worked mostly in the nearby town of Cento. He was influenced by the reforms of the Carracci, which took place in Bologna around the time of his birth. Although responding to these classicizing ideals, his earlier work has a brooding intensity. From 1621 he spent two years in Rome working for Pope Gregory XV, painting frescoes at the Villa Ludovisi. Guercino's later work offers a marked contrast to his early period, a lighter palette and more conservative style reflecting the taste in Bologna. In his drawings, Guercino's genius truly shines through—he was one of the century's greatest draftsmen. **KKA**

Masterworks

The Dead Christ Mourned by Two Angels c.1617–1618 (National Gallery, London, England)

Return of the Prodigal Son 1619 (Kunsthistorisches Museum, Vienna, Austria)

Raising of Lazarus c.1619 (Musée du Louvre, Paris, France)

Samson Captured by the Philistines 1619 (Metropolitan Museum of Art, New York, U.S.)

Aurora 1621–1623 (Casino Ludovisi, Rome, Italy)

The Resurrected Christ Appears to the Virgin 1629 (Pinacoteca Civica di Pieve di Cento, Cento, Italy)

The Flagellation of Christ 1644 (Museum of Fine Arts, Budapest, Hungary)

St. Luke Displaying a Painting of the Virgin 1652–1653 (Nelson-Atkins Museum of Art, Kansas City, U.S.)

GEORGES DE LA TOUR

Born: Georges de La Tour, March 1593 (Vic-sur-Seille, France); died January 30, 1652 (Lunéville, France).

Artistic style: Spiritual intensity in apparently ordinary scenes; master of candlelight scenes; simplified forms; closely observed detail; dramatic use of light.

Masterworks

St. Thomas à la Pique c.1628–1632
(Musée du Louvre, Paris, France)

Fortune Teller c.1630s (Metropolitan Museum of Art, New York, U.S.)

The Cheat with the Ace of Diamonds 1635
(Musée du Louvre, Paris, France)

Christ with St. Joseph in the Carpenter's Shop
c.1640 (Musée du Louvre, Paris, France)

Magdalene with a Night Light 1642–1644
(Musée du Louvre, Paris, France)

"Attuned to the presence of
the divine in this world."
—Christopher Allen

ABOVE: *St. Thomas à la Pique* is believed
to be a self-portrait of Georges de La Tour.

Although famous in his own lifetime, thanks to an exhibition entitled "The Painters of Reality in France in the Seventeenth Century" (1934), held in Paris's Musée de l'Orangerie, Georges de La Tour is now considered a key figure in the history of French art. Born into a prosperous family in the duchy of Lorraine in 1593, de La Tour probably traveled to Italy before settling in the city of Lunéville, where he became a wealthy, successful citizen. Indeed, his work was owned, and apparently appreciated, by King Louis XIII.

Unlike the work of his contemporary compatriots Nicholas Poussin, Claude Lorraine, and Simon Vouet, de La Tour's images possess an expressive naturalism, characterized by his use of simplified forms, closely observed detail, and skilled treatment of light. He was a brilliant user of chiaroscuro—the effect of light and shade in a painting balancing or contrasting with each other. It is unclear, though, whether he was responding directly or indirectly to Caravaggio's work. De La Tour used the effects of limited light cast from a single source in a darkened space to imbue his religious narratives with quiet drama.

Only thirty-five paintings are attributed to him. These can be divided into two categories: nocturnal scenes and day scenes. His daytime pictures are usually filled with a greater number of figures dressed in flamboyant costumes, often playing cards or telling fortunes. The nocturnal paintings are typically dramatically lit by the light of a single candle. They poignantly depict biblical narratives set in humble, familiar, and shallow spaces. They are enacted by a limited cast of figures that fill the picture space. Their restrained use of color and their bold, geometric compositions add to a sober and realistic atmosphere. **AB**

ARTEMISIA GENTILESCHI

Born: Artemisia Gentileschi, July 8, 1593 (Rome, Italy); died *c.*1652 (Naples, Italy).

Artistic style: Pioneering female baroque painter of historical and religious subject matter; themes of biblical heroines; dynamic figures; dramatic use of light and shade.

"You will find the spirit of Caesar in this soul of a woman," wrote Artemisia Gentileschi, the greatest female artist of the seventeenth century. At a time when it was hard for a female artist to make a living, she needed such spirit—particularly as she succeeded by painting historical and religious works. Such topics were normally considered unsuitable for women, who were largely confined to painting portraits and floral still lifes.

Raised by her widowed father Orazio—painter and follower of Caravaggio—she became his assistant before eventually taking on her own commissions. She traveled widely and lived in Rome, Florence, Venice, Naples, and even London at the court of King Charles I. The event that set her apart forever was her rape at the age of seventeen by a colleague of her father's and the humiliation and notoriety of the ensuing trial, which saw her undergo a gynecological examination and have her fingers tortured—an experience thought to have influenced her work profoundly.

Much of her subject matter is violent and Gentileschi appears to have channeled her rebellious spirit—and desire for revenge—into her canvases depicting the fortunes of feisty biblical heroines, such as the bloody and graphic *Judith Slaying Holofernes* (1612–1613). This may be true, but she was also a smart woman who was painting for a clientele that was primarily male. Gentileschi may have focused on female subjects just to cater to her market.

This groundbreaking artist's death was as dramatic as her life. Records of her commissions simply appear to have faded away. It is not known exactly when or how she died. She may have perished in the plague in Naples. Whatever her fate, her pioneering spirit and work have inspired artists—and women—ever since. **CK**

Masterworks

Susanna and the Elders 1610 (Collection Graf von Schönborn, Schloss Weissenstein, Pommersfelden, Germany)

*Judith Slaying Holofernes c.*1612–1613 (Museo di Capodimonte, Naples, Italy)

*Judith Slaying Holofernes c.*1620 (Uffizi, Florence, Italy)

*Self-Portrait as a Lute Player c.*1615–1617 (Curtis Galleries, Minneapolis, U.S.)

*Judith and Her Maidservant with the Head of Holofernes c.*1625 (Detroit Institute of Arts, Detroit, U.S.)

Esther before Ahasuerus 1628–1635, (Metropolitan Museum of Art, New York, U.S.)

*Corisca and the Satyr c.*1640s (Private collection)

"She has become so skilled that I can venture to say that she has no peer."—Orazio Gentileschi

ABOVE: Detail from *Self-Portrait as a Lute Player*, painted in her early twenties.

NICOLAS POUSSIN

Born: Nicolas Poussin, June 1594 (Les Andelys, France); died November 19, 1665 (Rome, Italy).

Artistic style: A painter-philosopher with intellectual appeal; vibrant color; rigorously organized compositions; classically inspired subject matter; solemn tone.

Masterworks

The Crossing of the Red Sea c.1634 (National Gallery of Victoria, Melbourne, Australia)

The Triumph of Pan 1636 (National Gallery, London, England)

Arcadian Shepherds, Et in Arcadia Ego c.1637–1640 (Musée du Louvre, Paris, France)

A Dance to the Music of Time c.1634–1636 (Wallace Collection, London, England)

Landscape with the Ashes of Phocion 1648 (Walker Art Gallery, Liverpool, England)

Nicolas Poussin was humbly born in rural Normandy yet became one of the seventeenth century's most celebrated painters. He spent most of his career in Rome and was the period's most significant and serious painter working there.

Poussin's first encounter with painting came through the work of minor painters in northern France. In 1612 he moved to Paris to become an artist, where he struggled to survive for ten years. In 1622 he was commissioned to create six paintings for a Jesuit church. He decided to try his luck in Rome and finally reached the city that would become his home in March 1624. There he studied the prized remains of antiquity and the masterpieces of the Renaissance, falling under the influence of Raphael and Titian. He was patronized by the nephew of the pope, Cardinal Francesco Barberini, and befriended the city's learned intellectuals, poets, and antiquarians.

By 1630, having failed to secure enough commissions for church altarpieces, Poussin had found his own artistic voice in painting smaller canvases for private and erudite collectors.

ABOVE: Detail from *Self-Portrait* (1650) showing Poussin as a self-assured man.

RIGHT: Poussin's *The Crossing of the Red Sea* is historic painting on a grand scale.

His subject matters were historical narratives drawn from antique texts, myths, legends, and biblical stories. His art was not only rooted in classical subjects but also in the classical ideals of reason, balance, harmony, proportion, and order. The canvases depict small-scale, full-length figures acting out their story as actors would on a stage but frozen in time, movement, and expression. The result is rigorously organized images, based on geometrical constructions. Each form is defined by a crisp outline, and modeled with vibrant color. There is evidence that Poussin constructed little stage sets and wax models as the basis for his composition, though none survive.

Poussin's works were hugely popular with the rich and powerful in Rome and beyond. After much urging, he returned to Paris in 1640. King Louis XIII of France made him first painter to the king in 1641. Unhappy there, however, Poussin returned to Rome in 1642, staying there until his death. **AB**

ABOVE: *A Dance to the Music of Time* demonstrates Poussin's love of the classical.

The Critic's Choice

Poussin's clear, geometrically organized paintings, along with his use of crisp outlines and bright colors, saw him heralded as a leading proponent of classicism. His style was radically different from another leading trend of the time, the baroque—exemplified by the swirling movements and loose brushwork of his contemporary Sir Peter Paul Rubens. Throughout the seventeenth century—culminating in debates that took place between 1672 and 1678—artists and connoisseurs argued at length about which style had the greater artistic value: Poussinisme or Rubenisme.

PIETER JANSZ SAENREDAM

Born: Pieter Jansz Saenredam, June 9, 1597 (Assendelft, the Netherlands); died May 31, 1665 (Haarlem, the Netherlands).

Artistic style: Architectural painter of church interiors; meticulous perspective and architectural measurements create accuracy in his works; cool, blond tones.

Masterworks

The Interior of St. Bavo's Church, Haarlem
(the "Grote Kerk") 1628 (National Gallery
of Scotland, Edinburgh, Scotland)

The Interior of the Buurkerk at Utrecht 1644
(National Gallery, London, England)

Interior of the Church of St Anne, Haarlem
1652 (Frans Hals Museum, Haarlem,
the Netherlands)

The extraordinary oeuvre of Pieter Jansz Saenredam is defined by its meticulous architectural style and air of tranquillity—each work is a harmonious marriage of balance and serenity. His father, Jan Pietersz Saenredam, was a respected engraver and mapmaker whose eye for detail greatly influenced his son. At age fifteen the artist joined the workshop of painter Frans Pietersz de Grebber, staying there for eleven years. Little is known of his work during this period, but by the time of his first painting, *The Interior of St. Bavo's Church, Haarlem* (1628), he was clearly a master of perspective and oil painting.

Saenredam worked in a methodical and well-documented manner. He first made on-site sketches that were then followed in the studio by construction drawings. The drawings allowed him to interpret the perspective problems of depicting such wide angles, and he worked out the balance between the mathematical actualities of his drawings and the aesthetic realization of the final painting. (As a result, and as nearly all his sketches and drawings were dated, there is a clear and concise history of Saenredam's working practice, from initial idea to finished work.) The final construction drawings were made on cream paper and traced on to smooth panels that were then painted. By contrast, his contemporaries tended to draw directly on to a panel without making construction drawings first. Saenredam's methods of translating and overcoming perspective problems on to his paintings are comparable to the contemporary Mercator projection mapmaking techniques he would have been familiar with from a young age. Owing to his exacting working process he produced few paintings during his career. Many of these are in churches in Haarlem, Utrecht, Amsterdam, and Rhenen. **TP**

"Perspective is the key to [his] ability to create a focused sense of depth."—J. Paul Getty Trust

ABOVE: *Interior of the Buurkerk at Utrecht*
(1644) is in the National Gallery in London.

FRANCISCO DE ZURBARÁN

Born: Francisco de Zurbarán, November 1598 (Fuente de Cantos, Extremadura, Spain); died August 27, 1664 (Madrid, Spain).

Artistic style: "The painter of monks"; themes of the passion of religious experience in Seville; contemplative still life paintings on black backgrounds.

Francisco de Zurbarán was sent by his family to Seville in 1614 to begin his artistic training with painter Pedro Díaz de Villanueva. From his earliest commissions, he seems to have developed the distinctive style that was to secure him a successful career: solid bodies draped in heavy folds of cloth against a near-black background. His figures are dramatically lit from one side, lending the drapery a haunting and expressive power. Zurbarán's strong sense of design, coupled with his palette of grays against a minimalist plane of black, gives his paintings a startlingly modern appeal.

Behind such formal qualities lies a deep understanding of religious experience in seventeenth-century Spain. He has been labeled "the painter of monks" because a large portion of his work was made for monastic orders: images of monks, often at prayer, and of saints. His female saints stand isolated against dark backgrounds in long, richly embroidered skirts. His depictions of St. Francis in meditation reveal Zurbarán at the height of his power. In several, including the 1635 to 1639 version, the saint's face is almost invisible in the deep shadows cast by a hooded cloak. The viewer is drawn in by his intense concentration. There is little distraction beyond the exquisite play of light on his robes.

Taking individual elements from his religious pictures, Zurbarán created still-life paintings that are masterpieces of daringly spare composition replete with symbolism. Ceramic pots, lemons, flowers, and baskets are placed in neat rows against dark backgrounds. His motif of a bound lamb, a symbol of the sacrifice of Christ, can be seen in *Agnus Dei* (*c.*1635–1640), and is an example of the simplified vision, dramatic lighting, and religious zeal that were Zurbarán's strengths. **KKA**

Masterworks

Christ on the Cross 1627 (Art Institute of Chicago, Chicago, U.S.)

Still-life with Lemons, Oranges and Rose 1633 (Norton Simon Museum of Art, Pasadena, California, U.S.)

Christ and the Virgin in the House at Nazareth *c.*1635–1640 (Museum of Art, Cleveland, Ohio, U.S.)

St. Francis in Meditation 1635–1639 (National Gallery, London, England)

*Agnus Dei c.*1635–1640 (Museo del Prado, Madrid, Spain and San Diego Museum of Art, California, U.S.)

St Casilda of Burgos 1638–1642 (Museo del Prado, Madrid, Spain)

"Zurbarán's work ... offers all that painting can offer of human truth."—Christian Zervos

ABOVE: Many think the saint in *St. Luke as a Painter before Christ on the Cross* is Zurbarán.

GIAN LORENZO BERNINI

Born: Gian Lorenzo Bernini, December 7, 1598 (Naples, Italy); died November 28, 1680 (Rome, Italy).

Artistic style: Leading baroque sculptor, architect, and painter; revolutionized sculptural portraiture; dynamism of sculptural form; architect of St. Peter's, Rome.

Masterworks

The Goat Amalthea with the Infant Jupiter and a Faun c.1609 (Borghese Gallery, Rome, Italy)

Apollo and Daphne 1622–1624 (Borghese Gallery, Rome, Italy)

Cornaro Chapel in S. Maria della Vittoria 1647–1652 (Rome, Italy)

The Ecstasy of St. Theresa 1647–1652 (Santa Maria della Vittoria, Rome, Italy)

Constantine 1654–1670 (Scala Regia, Vatican Palace, Vatican City, Italy)

Elephant and Obelisk 1667 (Piazza S. Maria sopra Minerva, Rome, Italy)

Tomb of Alexander VII 1671–1678 (Basilica di San Pietro, Vatican City, Italy)

Gian Lorenzo Bernini was one of the leading artists of his time and had a profound influence on the development of baroque art and architecture, especially in Rome. He created a new form of expression in marble with a dynamism and energy that saw sculpture transformed into something organic, expressive, and energetic. His work, both sculptural and architectural, dominated Rome during the seventeenth century.

His skill was already apparent in what is taken to be one of his earliest works, *The Goat Amalthea with the Infant Jupiter and a Faun* (*c.*1609). He trained in the studio of his father, mannerist sculptor Pietro Bernini, who introduced him to the Borghese and Barbarini—powerful Roman families and important patrons. In *circa* 1618 he was commissioned by Cardinal Scipione Borghese to create a series of larger-than-life statues, including *Pluto and Proserpina* (1621–1622), *Apollo and Daphne* (1622–1624), and *David* (1623), all highly naturalistic and vital.

In 1623 Maffeo Barbarini was elected Pope Urban VIII and Bernini took over as the chief papal artist, in charge of the

ABOVE: Detail from Bernini's *Self-Portrait as a Young Man* (*c.*1623).

RIGHT: *The Martyrdom of St. Lawrence* (1613) is one of Bernini's earliest known works.

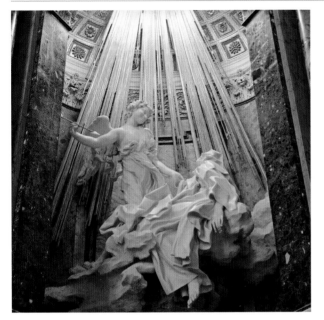

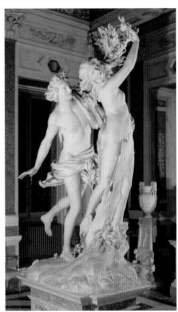

major architectural and artistic projects for the city, including St. Peter's. His association with the basilica lasted almost all his life and resulted in some of his most famous and accomplished works. These include the *Baldacchino* (1623–1634) canopy over the high altar, the *Tomb of Pope Urban VIII* (1627–1647), and the *Cathedra Petri* (*Chair of St. Peter*) (1655).

On Urban VIII's death in 1644, Bernini fell from papal favor but continued to win commissions from individuals, including the Venetian Cardinal Federico Cornaro for the Cornaro Chapel. The latter is regarded as one of his greatest works and houses the sculpture *The Ecstasy of St. Theresa* (1647–1652), a work in marble unparalleled for its expressive emotion and original aesthetic. In 1655, with the accession of Pope Alexander VII, Bernini's favored status with the papacy was restored. He undertook the planning for St. Peter's piazza, colonnades, and the Scala Regia entrance. Bernini continued to work tirelessly throughout his life. In his last years, he created the *Tomb of Pope Alexander VII* (1671–1678), his final large-scale project. **TP**

ABOVE LEFT: *The Ecstasy of St. Theresa* is suffused with Bernini's energy and passion.

ABOVE: *Apollo and Daphne* was made for the powerful Borghese family.

The Ecstasy of St. Theresa

The most remarkable of Bernini's religious sculptures—and one of the most outstanding works of the high baroque period—is *The Ecstasy of St. Theresa*, completed in 1652 for the church of Santa Maria della Vittoria in Rome, for the then-staggering sum of 12,000 scudi. Marble and metal combine in an astonishing vision of the saint visited in her dreams by an angel who pierces her heart with a spear of gold. Some critics have interpreted the saint's semidelirious swoon in terms of erotic rapture, though there is little evidence to suggest that this reading was Bernini's intention.

CLAUDE MELLAN

Born: Claude Mellan, 1598 (Abbeville, Picardie, France); died September 9, 1688 (Paris, France).

Artistic style: Painter and engraver; innovative technique of engraving a whole plate in one continuous line; portraits, technical drawings, and book illustrations.

Masterworks

Moon engravings 1636 (Rice University, Houston, Texas, U.S.)

James Howell 1641 (British Museum, London, England)

Portrait of Louis XIV as a Child 1644–1645 (The Hermitage, St. Petersburg, Russia)

Sudarium of St. Veronica 1649 (Fine Arts Museum of San Francisco, San Francisco, California, U.S.)

Claude Mellan is best known for his engravings, perhaps because many of his paintings are lost. His technique was innovative at the time—refined from that of Italian engravers Francesco Villamena and Agostino Carracci—whereby he varied the thickness of line to create light and shade rather than using the conventional crosshatching technique.

Mellan made engravings of the works of French painters Claude Poussin and Simon Vouet, but he is primarily lauded for his portraits. His most famous work is his striking portrait of Christ, *Sudarium of St. Veronica* (1649). A woman in Jerusalem, later beatified as St. Veronica, is said to have wiped Christ's sweating face with a cloth when he was en route to Calvary; an image of his face was left on the fabric that became known as "St. Veronica's veil." The engraving is a haunting image of Christ crowned with thorns, the folded veil, and lettering saying, "*Formatus unicus una,*" meaning "The one formed in one."

But what is most remarkable about the engraving is that Mellan created it using one continuous spiraling line that starts at the tip of the figure's nose, allowing him to engrave the plate in one go, a technique that came to be known as *gravure á une seule taille.* Thus Mellan's lettering is a pun on the uniqueness of Christ, the miraculous image, and his own use of a single line to create the image. Mellan is also known for engravings of the moon executed in 1636 and intended to illustrate an atlas. The engravings were based on Mellan's observations through a telescope made with lenses provided by revolutionary contemporary scientist Galileo Galilei. Comparisons with twentieth-century photographs of a similar lunar phase show Mellan's work to be strikingly accurate. **CK**

" . . . nothing is more dolorous or touching."—Charles Perrault, on the *Sudarium of St. Veronica*

ABOVE: This self-portrait is one of the artist's earlier engravings, made in 1635.

RIGHT: The *Sudarium of St. Veronica* is recognized as Mellan's masterwork.

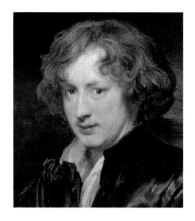

ANTHONY VAN DYCK

Born: Anthony van Dyck, March 22, 1599 (Antwerp, Belgium); died December 9, 1641 (London, England).

Artistic style: Flemish painter; lively, elegant portraits; religious and mythological scenes; luxurious fabrics; breathed life into images of the English aristocracy.

Masterworks

*Self Portrait c.*1622–1623 (The Hermitage, St. Petersburg, Russia)

Marchesa Elena Grimaldi Cattaneo 1623 (National Gallery of Art, Washington, D.C., U.S.)

Rinaldo and Armida 1629 (Baltimore Museum of Art, Baltimore, Maryland, U.S.)

Charles I and Henrietta Maria and their Two Eldest Children 1632 (Royal Collection, London, England)

Three Eldest Children of Charles I and Henrietta Maria 1635 (Royal Collection, Windsor, England)

*Equestrian Portrait of Charles I c.*1637–1638 (National Gallery, London, England)

*Lords John and Bernard Stuart c.*1638 (National Gallery, London, England)

"One of the greatest portraitists in an age of exceptional portrait painters."—Leona Detiège

ABOVE: Van Dyck painted this confident *Self-Portrait* when in his early twenties.

A native of Antwerp, Sir Anthony van Dyck was to work alongside Sir Peter Paul Rubens as a young artist and followed in the footsteps of this great master as painter of portraits, religious scenes, and mythologies. A precocious talent, his earliest independent works were made when he was about seventeen years old. It is not clear in what role van Dyck entered the studio of Rubens. In a letter of 1618, Rubens described van Dyck as his "best pupil," but he may have played a more important role as assistant, entrusted with work on paintings to which Rubens would add the finishing touches.

Word of van Dyck's talents reached beyond Flanders by the 1620s, and he traveled to London, Genoa, Rome, and Palermo to accept commissions. Along with paintings, he produced original engravings and etchings. He supervised the printed reproductions of his paintings, allowing them to be widely circulated and thus contributing to his fame.

His vast mythological composition *Rinaldo and Armida* (1629) reveals van Dyck's love for Paolo Veronese, Titian, and the Grand Manner of Venetian art. The picture was given to King Charles I and instantly had the desired effect. Van Dyck was knighted by the king and appointed his principal painter in 1632. It is the portraits made for Charles I and his English courtiers for which van Dyck is best remembered. He breathed life into royal portraiture, achieving a sense of elegant informality while retaining the gravitas and grandeur of royalty. Van Dyck's sitters, swathed in shimmering fabrics, hold themselves confidently in authoritative and flattering poses. The turned-out wrist and confident stare of so many of van Dyck's sitters have come to typify seventeenth-century Englishness. **KKA**

DIEGO VELÁZQUEZ

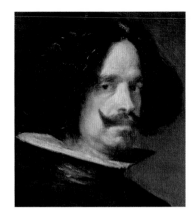

Born: Diego Rodríguez de Silva y Velázquez, June 6, 1599 (Seville, Spain); died August 6, 1660 (Madrid, Spain).

Artistic style: Giant of seventeenth-century painting; realistic and psychologically penetrating portraits; rapid, loose virtuoso brushwork.

Diego Velázquez's talents were honed in his native city of Seville—first in the studio of Francisco de Herrera the Elder and then, at the age of twelve, in the workshop and academy of artist Francisco Pacheco. In 1617 he won a Seville guild license to work as a master painter. Training with Pacheco, a well-connected theorist and humanist, helped Velázquez gain a cultural education and introduced him to the intellectual ideas of the Renaissance. He also came to know his teacher's influential circle of scholarly friends. This vital networking was further enhanced when he married Pacheco's daughter, Juana,

Masterworks

The Water-Seller of Seville c.1620 (Apsley House, London, England)

Prince Baltasar Carlos on Horseback 1635–1636 (Museo del Prado, Madrid, Spain)

The Surrender of Breda (or *The Lances*) 1635 (Museo del Prado, Madrid, Spain)

The Rokeby Venus (or *The Toilet of Venus*) 1647–1651 (National Gallery, London, England)

Juan de Pareja 1650 (Metropolitan Museum of Art, New York, U.S.)

Pope Innocent X 1650–1651 (Galleria Doria Pamphilj, Rome, Italy)

The Family of Philip IV (or *Las Meninas*) c.1656 (Museo del Prado, Madrid, Spain)

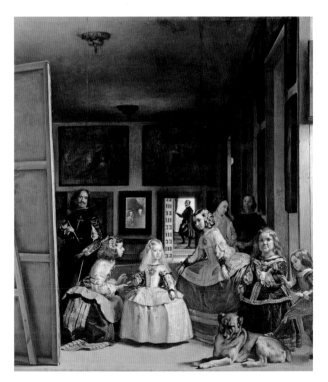

ABOVE: Velázquez painted this *Self-Portrait* in *circa* 1640, in between his trips to Italy.

LEFT: One of Velázquez's most famous paintings, *The Family of Philip IV*.

Velázquez and Venus

Painted between 1647 and 1651, *The Rokeby Venus* (so-called because it was housed at Rokeby Hall in England before being acquired by London's National Gallery) is one of the most celebrated nudes in the history of art. Seen from behind, a naked Venus reclines on her couch, regarding the viewer by means of a mirror, held by Cupid, her son. Curiously, the blurred face of Venus seen in the mirror seems a little older, and perhaps larger, than would be expected.

- Originally, the painting was probably intended for the Marqués del Carpio, who was the son of Spain's first minister, and who was recorded as its owner in June 1651.

- The painting is the only surviving Velázquez female nude (and most likely the earliest nude by a Spanish painter). It was probably displayed only privately as painted nudes were frowned on at the time by the religious authorities in Spain.

- The skin tones for Venus's body are mixed exclusively from the other colors used in the painting.

- Cupid and the dim face of Venus seen in the mirror may have been overpainted in the eighteenth century.

- On March 10, 1914, the painting was attacked by Mary "Slasher" Richardson with a meat cleaver, a day after her fellow suffragette Emmeline Pankhurst was arrested.

in 1618. Velázquez's early pieces include skillfully crafted religious and genre paintings. Spain had little tradition of genre painting, and in works such as *The Water-Seller of Seville* (c.1620) Velázquez pursues a refreshing and honest realism, imbuing ordinary people with humane dignity.

In 1622 the young painter traveled to Madrid, hoping for patronage from the new Spanish king, Philip IV, but returned disappointed. One year later, however, Velázquez painted a portrait of the king that led to his being appointed official court painter. He moved to Madrid, where he remained as a court artist for the rest of his life. Philip IV even decreed that no one else should paint his portrait.

In 1628 the supreme Flemish colorist Sir Peter Paul Rubens visited Madrid and whetted Velázquez's appetite to experience Italian art firsthand. Velázquez visited Italy from 1629 to 1631 and again from 1649 to 1651. The experiences were vital, showing him the coloration of artists such as Titian and the sculptural power of the Italian Renaissance masters. During his second trip he painted two portraits celebrated for their technical brilliance and startling realism. One was of his mulatto assistant, *Juan de Pareja* (1650), the other *Pope Innocent X* (1650–1651). It was said that when de Pareja stood next to his portrait, the viewer could not tell the difference between

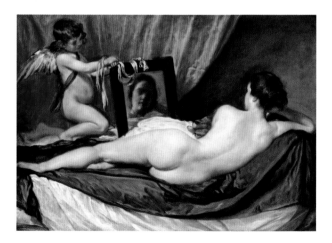

RIGHT: *The Rokeby Venus* has inspired generations of artists and filmmakers.

the man and the painting. The exquisite treatment of the luxurious garb worn by Pope Innocent X in his portrait displays Velázquez's masterful feel for texture, while the pope's sullen expression also demonstrates his gift for conveying character. (Indeed, the pope initially disliked the work, calling it "too real.") It has become one of the most famous painted portraits in history and an inspiration for Francis Bacon's celebrated *Screaming Popes* series in the twentieth century.

Along came his masterpiece

Velázquez proved a devoted, diligent, and competent royal servant who was held in real regard and affection by the king, and lived in a set of apartments in the Alcázar palace. In 1652 he became chamberlain of the palace, which may explain why his output became less prolific. Yet the 1650s saw the artist at the peak of his powers and capable of producing work such as his masterpiece, *The Family of Philip IV (Las Meninas) (c.1656)*. It shows the young Infanta Margarita with her maids-in-waiting in the artist's studio; the images of Philip IV and Queen Mariana are reflected in a mirror. The construction and perspective scheme of the painting reveals the depth of the artist's wide-ranging knowledge of mathematics, geometry, and optical devices. This complex essay in visual illusion also contains a self-portrait of Velázquez at his easel, cutting an impressive, distinguished figure, staring out at the viewer. The issue of who (or what) precisely is the subject of the painting has become one of art history's perennial mysteries and implies a discussion of the role of the artist.

Shortly after returning from ceremonies marking a peace treaty between France and Spain, Velázquez died from a fever. His many and varied royal duties may have weakened him. At the time, his artistic influence was fairly limited because he was confined to court circles. Later artists, from Francisco Goya to Édouard Manet and James Abbott McNeill Whistler to Picasso, found considerable inspiration in his work. **AK**

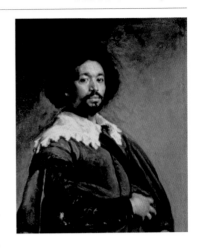

ABOVE: *Juan de Pareja* is one of Velázquez's most remarkable portraits.

> "I would rather be the first painter of common things than second in higher art."

CLAUDE LORRAIN

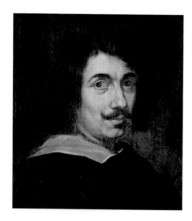

Born: Claude Gellée, c.1600–1604 (Chamagne, France); died November 23, 1682 (Rome, Italy).

Artistic style: Leading idealizing landscape artist; subtle use of light; pastoral, harbor, and coastal scenes; religious and mythological subjects; later classical style.

Masterworks

Landscape with Cattle and Peasants 1629 (Philadelphia Museum of Art, Philadelphia, Pennsylvania, U.S.)

Seaport with the Embarkation of St. Ursula 1641 (National Gallery, London, England)

Landscape with the Rest on the Flight into Egypt 1661 (Gemäldegalerie, Dresden, Germany)

Enchanted Castle (Landscape with Psyche Outside the Palace of Cupid) 1664 (National Gallery, London, England)

ABOVE: The date of Claude Lorrain's appealing self-portrait is unknown.

"A serene, timeless vision of nature."—National Gallery of Art, Washington, D.C.

RIGHT TOP: Diffuse sunlight glows in *Seaport with the Embarkation of St. Ursula.*

RIGHT: A vast expanse of sky is depicted in *Landscape with the Flight to Egypt.*

Claude Lorrain is acknowledged as one of the most important and influential landscape artists in history. He is noted particularly for his striking use of light and the lustrous, luminous quality of his paint, created through his technique of building up the surface of a painting with multiple, thin, semitransparent layers of paint. He brought new form to the landscape genre, combining the real with the ideal to create scenes of unequaled balance and harmony.

Often referred to simply as Claude, Lorrain studied first with Goffredo Wals in Naples and then with Agostino Tassi. Both influenced Lorrain's early style, as did Claude Deruet, whom he assisted for a year, and the work of Paul Bril. One of the earliest surviving paintings by Claude as an independent artist is *Landscape with Cattle and Peasants* (1629), which shows his skill at depicting filtered light and natural detail. He idealizes the composition to create a pervasive tranquillity and harmony, a trait that was to become characteristic of his style.

By the 1630s Claude's works had become highly sought after and he had achieved some level of fame in Rome and beyond. His patrons now included Pope Urban VIII and King Philip IV of Spain. Rome was the center of landscape painting at the time and landscape scenes of the area were popular, both with residents and with foreign visitors as souvenirs of their trip. From the 1640s onward, Lorrain's work began to show the influence of Italianate classicism. His figures, based on classical precedents, showed the influence of Raphael. His paintings also had a grander and more formal structure overall. Claude's use of picturesque detail diminished, and he turned to subjects from the Old Testament and from mythology, such as Virgil's *Aeneid*. **TP**

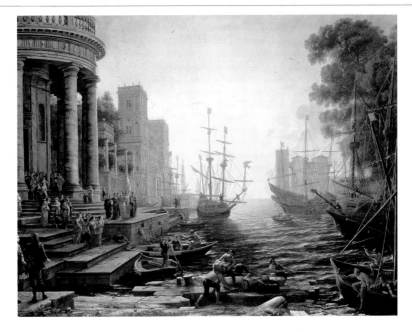

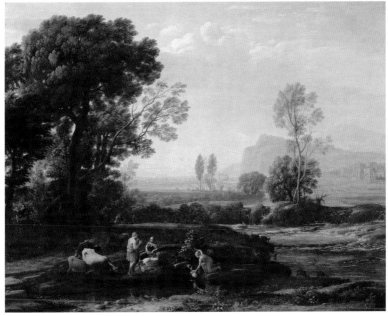

TAWARAYA SŌTATSU

Born: Tawaraya Sōtatsu, birthdate unknown (Kyoto, Japan); active *c.*1600-1640.

Artistic style: Painter of late Momoyama and Edo period; use of blue and gold; bold figural and floral motifs; paintings on fans and illuminated scrolls; collaborative partnership with Hon'ami Kōetsu.

Masterworks

Matsushima screens *c.*1600–1640 (Freer Gallery of Art, Smithsonian Institution, Washington, D.C., U.S.)

*Michinori c.*1600–1640 (New York Public Library, New York, U.S.)

*Covers for the Lotus Sutra c.*1602 (Itsukushima Shrine, Hiroshima Prefecture, Japan)

*Deer Scroll c.*1610s (Seattle Art Museum, Washington, D.C., U.S.)

The work of Japanese artist Tawaraya Sōtatsu grew out of the prosperous artistic milieu of the late Momoyama and early Edo period. The early seventeenth century was a period of renaissance for the arts in Kyoto, led not by painters of the Kano and Tosa lineages but by specialist craftsmen, such as Sōtatsu. The artist began his career at the Tawaraya fan shop and, because of his skill and subtle designs, the business became synonymous with high-quality fans of the Edo period.

Grounded in classical traditions, Sōtatsu initially drew on models from thirteenth-century hand scrolls, reproducing versions of them in fan designs. He displayed considerable creativity and innovation in adapting compositions of these hand scrolls to the curved shape of folding fans. The quality of the fans bearing themes from Japanese classical literature raised the profile of Sōtatsu's fan shop, which is referred to in the novel *Chikusai Monogatari* (1622).

Sōtatsu's renown led to his participation in the repair of the thirty-four scrolls of the *Lotus Sutra* (1164) and his being commissioned to work for the shogun. In undertaking these prestigious works, Sōtatsu continued taking a fresh approach to traditional genres. The *Matsushima* screens (*c.*1600–1640) produced for the shogun exemplify Sōtatsu's skill and his experimental approach to a classical subject. Here he leaves figures out of the picture, instead creating ambiguity between shore, cloud, and rock to suggest metaphors for emotions—a major innovation in the *yamato-e* tradition of Japanese painting. Sōtatsu maintained a creative partnership with Hon'ami Kōetsu, the calligrapher and hereditary sword expert, and their collaborations led to the emergence of the rinpa school. **RS**

" ... Kōetsu's writing chimes wonderfully with the loops and eddies of Sōtatsu's water."—*Time*

ABOVE: Detail of *Raijin, the God of Thunder*, from the *Matsushima* screens.

REMBRANDT VAN RIJN

Born: Rembrandt Harmenszoon van Rijn, July 15, 1606 (Leiden, the Netherlands); died October 4, 1669 (Amsterdam, the Netherlands).

Artistic style: Leading painter, draftsman, and printmaker of the Dutch golden age; innovative use of light and shade; portraits, self-portraits, biblical, and historical works.

Rembrandt van Rijn is one of the greatest storytellers in the history of art. As a child, he was taken out of education prematurely to start an apprenticeship as a painter. He studied under the history painter Jacob Isaacsz van Swanenburgh for three years before moving to Amsterdam to serve a brief apprenticeship with the Netherlands' leading history painter, Pieter Lastman. Armed with new skills, he returned to his hometown to open a studio producing many of his numerous self-portraits. To capture his own image, he would use two mirrors, contorting his face into various expressions, and communicate these emotions in his self-portraits as well as a variety of his dramatic scenes. Early critics admonished this method as pure vanity, but later commentators insisted this was as much an exploration of his art as of the self.

Rembrandt experimented with the consistency of paint and the role of light by using chiaroscuro—the dramatic effect of light and shadow, which was first made famous in the works of Michelangelo Merisi da Caravaggio. The lit areas of his paintings

Masterworks

The Anatomy Lesson of Dr. Nicolaes Tulp c.1632 (Mauritshuis, The Hague, the Netherlands)

The Good Samaritan 1633 (Metropolitan Museum of Art, New York, U.S.)

Portrait of Johannes Wtenbogaert 1633 (Rijksmuseum, Amsterdam, the Netherlands)

Saskia as Flora 1634 (The Hermitage, St. Petersburg, Russia)

Ecce Homo 1634 (National Gallery, London, England)

Self Portrait at the Age of 34 1640 (National Gallery, London, England)

The Night Watch 1642 (Rijksmuseum, Amsterdam, the Netherlands)

The Woman Taken in Adultery 1644 (National Gallery, London, England)

Susanna and the Elders 1647 (Gemäldegalerie, Berlin, Germany)

Woman Bathing in a Stream 1654 (National Gallery, London, England)

Self-Portrait at the Age of 63 1669 (National Gallery, London, England)

ABOVE: Rembrandt painted *Self-Portrait at the Age of 34* in 1640.

LEFT: *The Anatomy Lesson of Dr. Nicolaes Tulp* helped establish the artist in Amsterdam.

Preserving a Masterpiece

Few paintings can boast as many adventures as *The Militia Company of Captain Frans Banning Cocq and Willem van Ruytenburch* (1642)—better known as *The Night Watch*. The painting one sees today is not the original, which was cut down to size to fit within the Amsterdam town hall at the turn of the eighteenth century. By 1939 it was hanging in Amsterdam's Rijksmuseum. With the threat of a Nazi invasion, the painting was driven into the Dutch countryside and kept under lock and key in a fortified castle. With the enemy in their midst, it was moved once again, spending time on a boat and in a blacksmith's shed before being wound around a metal cylinder to rest in a deep vault under the sand dunes along the North Sea. When the dunes became unstable, it was packed off once again to a bomb-proof safe in a catacomb of caves in a hill near Maastricht.

With war a distant memory and *The Night Watch* hanging once again in the Rijksmuseum, the painting fell victim to two random attacks. The first, in 1975, was carried out by a man wielding a carving knife, who believed the captain figure in the work was the devil. Fifteen years later, a man sprayed acid across the iconic image. Remarkably, *The Night Watch* has survived all these adventures and may still be seen today in all its glorious splendor in the Rijksmuseum.

occupy a small space, with large swathes of shadow lurking around the edges and background to create an intensity of light, as though created by a spotlight in the darkness. He personalized this method by rejecting the rigid formality of the subject matter that many of his contemporaries displayed, instilling a great sense of humanity to his compositions. Rembrandt had a keen eye for the ordinary amid the extraordinary, bringing everyday life to his paintings, even in his many religious works. He also produced a prodigious number of etchings that it is believed he printed himself; he gained fame in his lifetime as much from print as from painting.

For richer, for poorer

Rembrandt's work caught the eye of Constantijn Huygens, secretary to the prince of Orange, resulting in a number of lucrative commissions from the court of The Hague. In 1631 he returned to Amsterdam, living at the home of the art dealer Hendrick van Uylenburgh and working on a commission to paint Dr. Nicholas Tulp, the famous Amsterdam surgeon. *The Anatomy Lesson of Dr. Nicolaes Tulp* (*c.*1632) is a startling group portrait detailing the activities within a seventeenth-century operating room. It provided an impressive calling card for Rembrandt's arrival in the city. He soon began to corner the market in portraits for wealthy patricians.

Wishing to train his own apprentices, Rembrandt became a member of the Guild of St. Luke in 1634. He proved to be a popular master, and his workshop prospered. In the same year he married Hendrick's cousin, Saskia van Uylenburgh. After living in rented dwellings, they bought an imposing house in the Jewish quarter—a purchase that would have dire financial implications in later years. Rembrandt's fame increased with a series of biblical and historical masterpieces. The last of these, *The Night Watch* (1642), was his most celebrated piece of work and signaled a turning point in his stylistic development.

Although Rembrandt's output dwindled toward the end of his career, his work continued to evolve as he searched for new modes of expression. His brushwork became broader, less

ABOVE: Rembrandt's largest work *The Night Watch* has survived war and vandalism.

restrained, and generally livelier, while his figures became less gestural and took on a greater stillness. Many critics consider this period to be the summit of his art. With the commissions having dried up and Rembrandt continuing to buy several artworks for his own collection, he was officially declared bankrupt in 1656. His house and possessions were auctioned off.

By the time of his death in 1669, Rembrandt had left behind a canon of work that could stand comparison with that of any of the great artists. His supreme talent with the brush, chalk, or etching needle was superseded only by his genius for accurately portraying the human figure and emotions. Rembrandt observed the world around him in a way never seen previously and rarely matched since. **SG**

"Everything art and the brush can achieve was possible for him."—Gerard de Lairesse

JUDITH LEYSTER

Masterworks

The Jolly Toper 1629 (Rijksmuseum, Amsterdam, the Netherlands)

Serenade 1629 (Rijksmuseum, Amsterdam, the Netherlands)

Carousing Couple 1630 (Musée du Louvre, Paris, France)

*Self-Portrait c.*1630 (National Gallery of Art, Washington, D.C., U.S.)

Man Offering Money to a Young Woman 1631 (Mauritshuis, The Hague, the Netherlands)

*A Boy and a Girl with a Cat and an Eel c.*1635 (National Gallery, London, England)

*The Last Drop (The Gay Cavalier) c.*1639 (Philadelphia Museum of Art, Philadelphia, Pennsylvania, U.S.)

Born: Judith Leyster, July 28, 1609 (Haarlem, the Netherlands); died February 10, 1660 (Heemstede, the Netherlands).

Artistic style: The first professional female painter in Haarlem; close in style to Frans Hals; lively tavern scenes, children at play; spirited brushwork.

Judith Leyster was well known in her own time but largely disappeared from art history until the nineteenth century. As a successful woman artist running her own studio with male assistants, she was unique in her hometown of Haarlem. She may have spent time in the studio of the leading local painter, Frans Hals. Their work is stylistically so similar that in the past Leyster's pictures have been misidentified as Hals's. Her most productive period was in the 1630s, before she married the painter Jans Miense Molenaer and moved to Amsterdam. Her paintings show children and young adults enjoying themselves. These scenes often contain moralizing messages about the brevity of life or the foolish behavior of adults. **KKA**

GIOVANNI CASTIGLIONE

Masterworks

Youth Playing a Pipe for a Satyr 1609–1664 (Metropolitan Museum of Art, New York, U.S.)

*Alexander at the Tomb of Cyrus c.*1645–1650 (National Gallery of Art, Washington D.C., U.S.)

Theseus Finding the Arms of his Father 1648 (Minneapolis Institute of Art, Minneapolis, Minnesota, U.S.)

*The Adoration of the Shepherds c.*1648–1655 (Royal Collection, London, England)

*Pastoral Journey c.*1650 (J. Paul Getty Museum, Los Angeles, California, U.S.)

*Circe c.*1650–1655, (Royal Collection, London, England)

*The Nativity with God the Father c.*1650–1660 (Royal Collection, London, England)

*Arcadian Shepherds c.*1655 (J. Paul Getty Museum, Los Angeles, California, U.S.)

*Noah Leading the Animals into the Ark c.*1655 (National Gallery of Art, Washington, D.C., U.S.)

Born: Giovanni Benedetto Castiglione, *c.*1609 (Genoa, Italy); died May 5, 1664 (Mantua, Italy).

Artistic style: Innovative baroque painter, printmaker, and draftsman of historical and religious subjects, landscapes, and portraits; often depicted pastoral scenes.

Giovanni Benedetto Castiglione is most famous for inventing the monotype printmaking technique in around 1648. It has been suggested he was a pupil of Paggi and Andrea de'Ferrari. He was also an admirer of the works of Raphael and Sir Anthony van Dyck and the etchings of Rembrandt van Rijn.

Born in Genoa, Castiglione settled in Italy *circa*1654 when he was employed as court artist by Carlo Gonzaga II, Duke of Mantua. He is most well known for his depictions of pastoral scenes, markets, fairs, and, most of all, the animals that he frequently incorporated into his work when tackling biblical subjects such as *Noah Leading the Animals into the Ark* (*c.*1655). These influenced many other Italian painters of animals. **CK**

SALVATOR ROSA

Born: Salvator Rosa, 1615 (Arenella, Italy); died March 15, 1673 (Rome, Italy).

Artistic style: Painter and printmaker of romantic and picturesque scenes; landscapes emphasizing the isolation of the individual against an unforgiving and threatening universe.

Masterworks

Self-Portrait c.1645 (National Gallery, London, England)

Witches at their Incantations c.1646 (National Gallery, London, England)

Bandits on a Rocky Coast c.1650s–1660s (Metropolitan Museum of Art, New York, U.S.)

Human Frailty c.1656 (Fitzwilliam Museum, Cambridge, England)

Saul and the Witch of Endor c.1668 (Musée du Louvre, Paris, France)

To look at Salvator Rosa's work is to know the man. His wild, lonely landscapes of trees with broken branches looming over jagged rocks reflect a prickly personality with a genius for stirring up controversy. The savagery of his landscapes cuts humanity down to size: strife between man and the gods, lost travelers. Rosa's brooding expression under a stormy sky in his self-portrait is similarly one of the earliest, and best, portrayals of the artist as misunderstood genius. His forbidding paintings, increasingly peopled with bandits and witches, came into their own in the eighteenth century. They influenced the romantic depiction both of rugged landscapes and of nightmarish creatures crawling out of the human imagination. **SC**

GERARD TERBORCH

Born: Gerard Terborch, December, 1617 (Zwolle, the Netherlands); died December 8, 1681 (Deventer, Salland, the Netherlands).

Artistic style: Extraordinary ability to render silks and satins; elegant mood; deft brushwork; harmonious palette; bare interiors; middle-class genre scenes; portraits.

Masterworks

The Swearing of the Oath of Ratification of the Treaty of Münster, May 15, 1648 1648 (National Gallery, London, England)

Gallant Conversation c.1654 (Rijksmuseum, Amsterdam, the Netherlands)

A Boy Caring For His Dog c.1655 (Alte Pinakothek, Munich, Germany)

Woman Reading a Letter 1660–1662 (Royal Collection, London, England)

Self-portrait c.1668 (Mauritshuis, The Hague, the Netherlands)

The Music Party c.1668–1670 (Cincinnati Art Museum, Cincinnati, Ohio, U.S.)

Gerard Terborch's family background was one of solid, cultured prosperity. A well-traveled, successful artist and city counselor, he appears to have had a restrained pride in his place within the burgher class. He excelled at depicting the world with an unusually delicate grace, especially musicians, people reading letters, and small groups engaged in tantalizingly mysterious activities. He is perhaps best known for his fine depiction of satin, achieved by working layers of thin paint wet-in-wet. He showed an equal talent for humble genre scenes and for portraits, notably a full-length, small-scale format, as well as producing his famous re-creation of the Münster treaty between Spain and Holland, featuring a self-portrait. **AK**

PETER LELY

Masterworks

*Trial by Fire c.*1640s–1650s (The Hermitage, St. Petersburg, Russia)

*Edward Montagu, 1st Earl of Sandwich c.*1655–1659 (National Portrait Gallery, London, England)

Portrait of Lady Penelope Spencer late 1660s (Minneapolis Institute of Arts, Minnesota, U.S.)

*Elizabeth, Countess of Kildare c.*1679 (Tate Collection, London, England)

Born: Pieter van der Faes, September 14, 1618 (Soest, Westphalia, Germany); died November 30, 1680 (London, England).

Artistic style: Painter of society portraits, landscapes, mythological, and history paintings; lively colorist; balanced composition; use of mezzotint; luxurious drapes.

The leading artist of the restoration period, Sir Peter Lely studied painting in Haarlem and became a fluent and lively colorist, known for balanced compositions. He moved to London *circa* 1641, and concentrated on landscapes, figures, and history subjects before turning to a more profitable career as a portrait painter and art dealer. His early English works show influences from Sir Anthony van Dyck and the Dutch baroque. As portraitist to King Charles I, his reputation grew steadily. After the king's execution, he served under Oliver Cromwell, then under King Charles II. Lely redefined society portraiture and introduced the mezzotint to Britain, a technique that continued until the eighteenth century. **SH**

HISHIKAWA MORONOBU

Masterworks

*Red Light District and Theater Scenes c.*1670s (Tokyo National Museum, Tokyo, Japan)

*Genre Scenes of Daily Life in Edo c.*1690s (Idemitsu Museum Of Arts, Tokyo, Japan)

*Beauty Looking Back c.*1690 (Tokyo National Museum, Tokyo, Japan)

Born: Hishikawa Moronobu, 1618 (Hodamura, Japan); died July 25, 1694 (Tokyo, Japan).

Artistic style: Printmaker; father of the Japanese *ukiyo-e* genre; linear clarity; woodblock prints depicting scenes of daily urban life and erotica.

Printmaker Hishikawa Moronobu's career began in textile design. He then moved to Tokyo and studied kanō and tosa styles of painting. There he pioneered woodblock prints without accompanying text and became regarded as the father of the *ukiyo-e* (floating world) genre. In its quality, variety, and subject matter, Moronobu's work reflects the prosperous vibrancy of Tokyo as it re-emerged from the ashes of the great fire of 1657. The artist set new standards of excellence within his medium. Moreover, he brought woodblock printing to public acclaim with his prints depicting erotica and urban daily life, such as the Yoshiwara entertainment district and Kabuki theater. Thus his works were enjoyed as independent pieces of art. **RS**

RIGHT: *Beauty Looking Back* is one of Moronobu's best-known paintings.

房陽菱川友竹筆

SAMUEL VAN HOOGSTRATEN

Born: Samuel Dirksz van Hoogstraten, August 2, 1627 (Dordrecht, the Netherlands); died October 19, 1678 (Dordrecht, the Netherlands).

Artistic style: Dutch painter of portraits, trompe l'oeil, still life, perspective interiors, and perspective peepshow boxes; writer; pupil of Rembrandt.

Masterworks

*View of an Interior c.*1654–1662
(Musée du Louvre, Paris, France)

Perspective Box of a Dutch Interior 1663
(Detroit Institute of Arts, Detroit, U.S.)

A Trompe L'Oeil of Objects Attached to a Letter Rack 1664 (Dordrechts Museum, Dordrecht, the Netherlands)

Self-Portrait late 1670s (The Hermitage, St. Petersburg, Russia)

Samuel Dirksz van Hoogstraten is perhaps most famous today for his *trompe l'oeil* paintings—virtuoso displays of illusionary effects that reached a height late in the artist's career. However, van Hoogstraten enjoyed a long and illustrious creative life during which he produced many genre scenes, religious works, and numerous portraits.

Van Hoogstraten was first taught by his father, Dirk, but after his death he entered Rembrandt's studio in 1642, where he remained for several years. The influence of the older artist was profound, and is evident in many of van Hoogstraten's works, particularly in his rich, evocative palette and interest in the self-portrait. Van Hoogstraten was also a keen author. In the last months before his death, he published the *Inleyding tot de Hooge Schoole der Schilderkonst* (*Introduction to the High School of the Art of Painting*) (1678). This lengthy treatise on painting includes a first-hand account of Rembrandt and his studio, working practice, and artwork. It is one of the few surviving works to offer such an account of the great master.

In 1651 van Hoogstraten left Dordrecht and traveled through Europe, visiting Germany, Italy, and Vienna, where he worked at the court of Holy Roman Emperor Ferdinand III. During this trip, his style matured, and he turned toward the illusionary paintings for which he became so famous. He returned to Dordrecht and in 1656 was created Master of the Mint of Holland, marrying into a prestigious local family soon after. He continued to undertake portrait commissions as well as painting genre scenes and trompe l'oeil pictures before traveling to London in 1662, where his portraiture was in demand. His artistic output declined during his final years, which he spent in Dordrecht. **TP**

"He could not endure anyone passing him in the contest for artistic laurels."—Arnold Houbraken

ABOVE: *A Boy Looking through a Casement Window* shows the artist's portraiture skills.

JACOB VAN RUISDAEL

Born: Jacob Isaackszon van Ruisdael, c.1628 (Haarlem, the Netherlands); died March 14, 1682 (Haarlem, the Netherlands).

Artistic style: Master of the golden age of Dutch landscapes; versatile painter of panoramas; extensive landscapes and seascapes; mountain and forest views.

Landscape painting came of age in the Dutch Republic of the seventeenth century and found its most sophisticated voice in the work of Jacob van Ruisdael. Although images of the outdoors had long existed, they had remained principally the stage sets in which to place narrative action. However, encouraged by the more secular market present in the new Protestant Dutch Republic, landscape images were finally drawn, etched, and painted for the worth of their own subject.

Regarded as the most talented of the many landscape painters to emerge from the second half of the seventeenth century in the Netherlands, van Ruisdael was born into a family of landscape painters. Having at first trained with his father and his uncle, he later traveled to Germany and settled in Amsterdam in 1657. Van Ruisdael was a versatile image maker and produced a number of distinct natural views, including mountains, woodlands, river settings, winter scenes, and seascapes. Particularly noted for his depictions of trees and the rendering of foliage, skilled at observing and describing the effects of light reflected on dunes and the sea, he also became a master of painting vaultlike skies filled with billowing clouds. His use of a low horizon line and the way his compositions are structured to leave two-thirds of the works to be filled by sky create an inviting panoramic effect. Preferring to work on wooden panels rather than canvas, van Ruisdael used grainy paint and left the marks of his bristly brush to remain visible.

As much loved today as he was during his own lifetime, and enthusiastically bought by English collectors, van Ruisdael's vision of the natural world greatly influenced the landscapes of English romantic painters John Constable and Joseph Mallord William Turner. **AB**

Masterworks

The Castle at Bentheim 1653
(National Gallery of Ireland, Dublin, Ireland)

*A Winter Landscape with a Peasant Gathering Firewood c.*1660s (Private collection)

A Landscape with a Ruined Castle and a Church 1665–1670 (National Gallery, London, England)

*View of Haarlem with Bleaching Grounds c.*1670 (Kunsthaus, Zurich, Switzerland)

"A painter should only represent what he has seen with his own eyes."—John Calvin

ABOVE: *A Winter Landscape with a Peasant Gathering Firewood* is classic Ruisdael.

PIETER DE HOOCH

Born: Pieter de Hooch, December 20, 1629 (Rotterdam, the Netherlands); died March 24, 1684 (Amsterdam, the Netherlands).

Artistic style: Painter of the Delft school; domestic genre scenes; use of radiant light and linked spatial areas to extend the narrative psychologically and physically.

Masterworks

The Courtyard of a House in Delft 1658
(National Gallery, London, England)

*The Bedroom c.*1658–1660 (Staatliche
Kunsthalle, Karlsruhe, Germany)

*Suckling Mother and Maid c.*1670–1675
(Kunsthistorisches Museum,
Vienna, Austria)

Pieter de Hooch was one of the leading painters of the Delft school, a group of artists based in that city during the second half of the seventeenth century who specialized in genre scenes and architectural painting. Another leading artist of the time was Jan Vermeer. Together, he and de Hooch redefined the domestic Dutch genre. The two were familiar with each other's work and influenced each another. De Hooch, the older by three years, paved the way with his spatial organization and narrative. Vermeer brought greater clarity of vision and distilled the genre scenes down to one or two figures.

Relatively little is known about de Hooch's training. He is believed to have been taught in Haarlem by landscape painter Nicolaes Pieterszoon Berchem and portrait and domestic interiors painter Jacob Ochtervelt. De Hooch is first documented as being in Delft in 1652. The period he spent there until 1661, when he moved to Amsterdam, is considered to have yielded his finest work, such as *The Courtyard of a House in Delft* (1658). He concentrated on scenes of quiet domestic life in either interior or courtyard settings, frequently depicting women involved in their daily chores. His paintings have particularly subtle and translucent light. They provide an organized, spatial composition that leads from one room or area to another. His move to Amsterdam may have been prompted by the desire to reach the larger and wealthier art market, and his style changed. His interiors, reflective of Amsterdam, became more refined and elegant, and his figures more ostentatious. He also began working on larger canvases, but this development marked a decline in the quality of his brushwork that was increasingly noticeable by the end of the 1670s. **TP**

"He idealized domesticity and nurture . . . bathed in subtle transitions of light."—*Time*

ABOVE: This self-portrait was painted in 1649, when the artist was nineteen.

JAN VERMEER

Born: Johannes Vermeer, 1632 (Delft, the Netherlands); died December 1675 (Delft, the Netherlands).

Artistic style: Introspective; domestic genre scenes; air of controlled detachment; expert brushwork; pearly, closely observed light effects using points of paint.

Jan Vermeer's life is shrouded in almost as much mystery as his enigmatic paintings. He produced few works, of which only a small number can be definitely dated; the authenticity of many of these is disputed. It may be this intriguing uncertainty that has made him so popular in recent times, despite a career of relatively modest success and long years of neglect afterward.

Vermeer was born in Delft into a Protestant family. His father, Reynier Jansz Vermeer, was an expert weaver and art dealer (and also an inn keeper). His son's early training is much debated. For many years he was assumed to have been apprenticed to Carel Fabritius, but this is now disputed. Many

Masterworks

Officer and Laughing Girl c.1655–1660 (Frick Collection, New York, U.S.)

The Procuress 1656 (Staatliche Kunstsammlungen Dresden, Dresden, Germany)

Street in Delft c.1658 (Rijksmuseum, Amsterdam, the Netherlands)

The Milkmaid c.1658 (Rijksmuseum, Amsterdam, the Netherlands)

The Music Lesson c.1662–1665 (St. James' Palace, London, England)

Woman Holding a Balance c.1664 (National Gallery of Art, Washington, D.C., U.S.)

Girl with a Pearl Earring c.1665 (Mauritshuis, The Hague, the Netherlands)

Mistress and Maid 1665–1670 (Frick Collection, New York, U.S.)

The Art of Painting (or *The Artist's Studio*) c.1665–1666 (Kunsthistorisches Museum, Vienna, Austria)

The Lacemaker c.1669–1670 (Musée du Louvre, Paris, France)

ABOVE: A detail from *The Procuress*, believed to be the only extant portrait of Vermeer.

LEFT: One of Vermeer's most popular works, *The Milkmaid* has a simple domestic setting.

Points of Light

Vermeer is known for his extraordinary ability to represent very realistic natural light effects, which he uses to shape his spaces, objects, and people. Many of his best-loved works seem to shimmer with highlights—tiny points of pale paint often referred to as *pointillés*. These are used extensively to tie a painting together into a harmonious whole and often seem to dissolve objects in light. When viewed from a distance, Vermeer's *pointillés* create a highly convincing illusion of light, shade, and form. When seen close-up, it is clear that they are separate dots. In *Girl with a Pearl Earring*, just two strokes create the earring. Its simple highlight both reflects her collar and echoes highlights across her face and head. Vermeer's treatment of light and color later became a great influence on the impressionists.

Reflections and perspective constructions are other important motifs of Vermeer's work, as are his often odd distortions of scale and spatial arrangement. The way in which Vermeer approaches these shows an interest, shared with many artists of his day, in optical effects and devices. He is known to have used a camera obscura to aid his work. Antonie van Leeuwenhoek, an early pioneer of the microscope and fellow Delft citizen, may have been his friend and the executor of his estate.

historians now consider that Leonaert Bramer may have been a mentor. Vermeer's apprentice years very possibly also took him to the important artistic centers of Utrecht and Amsterdam. He may have gained his obvious and considerable knowledge of Italian art in the latter.

We do know that Vermeer married Catharina Bolnes in 1653, overcoming her family's initial resistance. He converted to Roman Catholicism—Catharina's faith—for the marriage. That year he also joined Delft's Guild of St. Luke as a master painter.

Vermeer started out with history painting, tackling the historical, biblical, and mythological subjects that gained the most respect as artistic topics in those days. By the late 1650s, however, he had settled on the more everyday genre scenes for which he is now famed, using impasto brushwork to bring

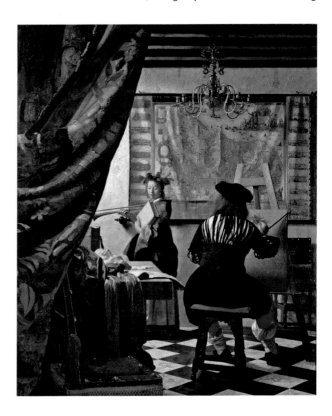

RIGHT: *The Art of Painting* is the largest and most complex of Vermeer's works.

the surface detail alive. Vermeer conveyed extraordinarily naturalistic lighting in his well-organized compositions, for example in works such as *Street in Delft* (c.1658) and *The Milkmaid* (c.1658), and was obviously influenced by fellow artist Pieter de Hooch, who was living in Delft in the 1650s.

Slowly but surely

During the 1660s he was highly successful locally and was elected the leading master of his guild in 1662 and 1663 and again in 1670 and 1671. His style also matured, becoming smoother and subtler. Works such as the famous *Girl with a Pearl Earring* (c.1665) and the puzzling *The Art of Painting* (or *The Artist's Studio*) (c.1665–1666) show the development of the still detachment for which he is known. They also reveal his astonishing skill at suggesting forms and textures by layering and blending paint, using his famed dotted highlights, and suggesting a great deal with a minimum of brushstrokes.

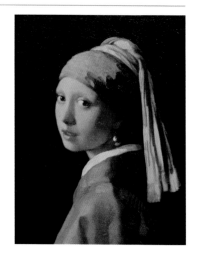

ABOVE: *Girl with a Pearl Earring* (c.1665) is one of Vermeer's greatest works.

In his later years, Vermeer's love of light effects and color seemed to transform his images into much more abstract, harder edged creations. This period was filled with great financial problems. He and his wife had eleven children. With a lifetime's total output currently estimated at only thirty-five paintings, money must have been tight. Vermeer also worked as a picture dealer and inn keeper. On his death in 1675, his widow was left with huge debts and was declared bankrupt.

Perhaps because Vermeer remained rooted in his native Delft, or perhaps because his style was so intensely personal, his influence does not seem to have spread. Not until the nineteenth century did the artist's star began to rise once again. His reputation was boosted in particular by pioneering French realist painters such as Gustave Courbet. In their quest to show the world around them with a convincing naturalism, these artists found great inspiration in the work of seventeenth-century Dutch genre painters such as Vermeer. **AK**

"Vermeer's most remarkable quality . . . is the quality of his light."—Théophile Thoré

JEAN-ANTOINE WATTEAU

Born: Jean-Antoine Watteau, 1684 (Valenciennes, France); died July 18, 1721 (Nogent-sur-Marne, near Paris, France).

Artistic style: Helped shape the French rococo style; romantic idylls with costumed figures; superb coloring; inventor of the *fête galante* genre.

Masterworks

A Lady at her Toilette c.1716–1717
 (Wallace Collection, London, England)

The Music Lesson c.1716–1717
 (Wallace Collection, London, England)

Harlequin and Columbine c.1716–1718
 (Wallace Collection, London, England)

The Pilgrimage to the Island of Cythera 1717
 (Musée du Louvre, Paris, France)

Pierrot (also known as *Gilles*) c.1718–1719
 (Musée du Louvre, Paris, France)

Mezzetin c.1718–1720 (Metropolitan Museum
 of Art, New York, U.S.)

The Fountain c.1720 (Wallace Collection,
 London, England)

Jean-Antoine Watteau was the greatest French painter of his age and one of the leading lights of the rococo genre—a decorative, ornamental style in the arts that emerged in France under King Louis XV. Born in the border town of Valenciennes, Watteau moved to Paris in 1702, receiving his artistic education from 1705 to 1708 in the workshop of Claude Gillot, a painter of theater scenes. Gillot's influence proved particularly crucial, as he took his young charge to see the theatrical antics of the *commedia dell'arte*. These improvised shows were a major inspiration for Watteau's most important creation: the *fête galante*, or courtship party. This was a picture of an outdoor idyll in which elegant, costumed figures idled away the time by talking, flirting, and serenading each other. Inspired by the example of Sir Peter Paul Rubens, their coloring is exquisite. The term *fête galante* was invented by the French Academy when it was looking for a term to categorize Watteau's work after granting him membership in their organization in 1717.

Watteau's pictures often exude an air of melancholy, as if the actors in his scenes are aware that their pleasures are fleeting and will soon be gone. This wistful mood is usually attributed to the artist's poor health. Watteau suffered from tuberculosis, and his illness made him impatient and bad tempered, and may account for the slapdash techniques that he sometimes employed. In 1719, he traveled to England seeking a cure, but the cold weather only made matters worse, and he died prematurely, at age thirty-seven. After his death, the artificiality of Watteau's themes rapidly fell out of favor and, during the revolutionary years, art students used to amuse themselves by throwing chunks of bread at his masterpieces. **IZ**

"One of the greatest and best draftsmen that France has ever produced."—Edmé-François Gersaint

ABOVE: A portrait of Watteau (*c.*1721) by his friend, the Venetian artist Rosalba Carriera.

GIOVANNI BATTISTA TIEPOLO

Born: Giovanni Battista Tiepolo, March 5, 1696 (Venice, Italy); died March 27, 1770 (Madrid, Spain).

Artistic style: Italian rococo painter; light, whitened palette; illusionistic ceiling frescoes; theatrical composition and design; invention and humor.

Giovanni Battista Tiepolo's work has come to typify Venetian rococo painting. His paintings are light and airy. They are filled with fantastic details, from small *putti* dangling their feet over a cornice to Old Father Time sitting weightless on a cloud. The viewer is metaphorically invited to join the cast of angels and goddesses in the dizzy heights of the heavens. These are not merely flights of whimsy—his strength of design and sophisticated understanding of light and shadow give Tiepolo's paintings enduring appeal.

Continuing in the tradition of the great Venetian painters of the sixteenth century, Tiepolo provided large-scale frescoes and altarpieces for the churches and palaces of his home city. He admired the masters of the Venetian High Renaissance, particularly Paolo Veronese, whose work inspired his decorative patterning and playfulness. Tiepolo trained in the Venice studio of Gregorio Lazzarini, a painter of religious subjects. From 1750 to 1753, at the peak of his career, he spent three years with his artist sons at Würzburg in Germany, frescoing the walls and ceilings of Prince Bishop Karl Philipp von Greiffenklau's residence. Shortly after his return to Venice, he was elected president of the Academy of Padua. From 1761 he worked at the court of Charles III in Madrid, painting a large ceiling fresco in the royal palace throne room. He died in the city in 1770.

Tiepolo is remembered as the last shining star of Venetian Grand Manner painting. By the nineteenth century, his works were being dismissed as too saccharine for contemporary taste. French historian and critic Hippolyte Taine derided them as merely expensive "window dressing." In recent years, however, his powers of theatrical invention have found a more appreciative audience. **KKA**

Masterworks

Pope St. Clement Adoring the Trinity 1737–1738 (Alte Pinakothek, Munich, Germany)

The Institution of the Rosary 1737–1739 (Santa Maria del Rosario, Venice, Italy)

The Banquet of Cleopatra 1743–1744 (National Gallery of Victoria, Melbourne, Australia)

Allegory of the Planets and Continents 1752 (Metropolitan Museum of Art, New York, U.S.)

Wedding of Frederick Barbarossa and Beatrice of Burgundy 1752–1753 (Kaisersaal, Residenz, Würzburg, Germany)

Adoration of the Magi 1753 (Alte Pinakothek, Munich, Germany)

An Allegory with Venus and Time c.1754–1758 (National Gallery, London, England)

"[He] put into frescoes an effect of sun and delight perhaps without parallel."—Luigi Lanzi

ABOVE: Rosalba Carriera (1675-1757) painted this portrait of Tiepolo (c.1726).

WILLIAM HOGARTH

Born: William Hogarth, November 10, 1697 (London, England); died October 1764 (London, England).

Artistic style: Pioneering English social and political satirist; painter, cartoonist, and engraver of moral subjects; portrait painter, championed copyright legislation.

William Hogarth was one of the most original British artists, excelling both as a painter and an engraver. Above all, he was an acute observer of human nature, satirizing the fashions and foibles of his times. His early ambitions were fired by a deprived childhood. His father went bankrupt after a failed venture with a coffeehouse, and the family ended up in debtors' prison.

Hogarth trained as an engraver, working for a time as a book illustrator, but he had higher ambitions. His ultimate aim was to establish himself as a history painter, which was the most lucrative and prestigious area of the profession. To that end, he attended a painting academy. He never achieved his goal, but he did succeed in finding a new outlet for his talents: his morality cycles, a series of pictures through which Hogarth traced the decline and fall of a hopeless vagrant. *A Harlot's Progress* (1731–1732) and *A Rake's Progress* (1734) were especially popular and sold extremely well as prints. The former was heavily pirated, however, and Hogarth campaigned vigorously for new copyright legislation to protect such work. This resulted in The Engravers Act (1735)—nicknamed "Hogarth's Act"—which proved to be a boon for artists working in the field. Of all his prints, the best known is *Gin Lane*, a morality picture exposing the evils caused by drinking gin, usually imported from France (as opposed to safe English beer). Although he became best known for his prints, Hogarth continued to paint. In this medium, he produced some of his finest paintings, including the portrait *Captain Coram* (1740) and *The Shrimp Girl* (c.1740–1745). Both display a freedom of handling and an instinctive ability to capture a sitter's personality that are unequaled in the work of any other British artist of the period. **IZ**

Masterworks

A Harlot's Progress 1731–1732 (destroyed in a fire in 1755)

A Rake's Progress 1734 (Sir John Soane's Museum, London, England)

Captain Coram 1740 (The Foundling Museum, London, England)

The Shrimp Girl c.1740–1745 (National Gallery, London, England)

The Graham Children 1742 (National Gallery, London, England)

Marriage á la Mode c.1743 (National Gallery, London, England)

The Painter and His Pug 1745 (Tate Collection, London, England)

Gin Lane 1751 (British Museum, London, England)

"I . . . treat my subjects as a dramatic writer: my picture is my stage."

ABOVE: A respectable, fashionable Hogarth from *Self-Portrait with Palette* (1745).

RIGHT: *Gin Lane*, one of Hogarth's best-known works of political commentary.

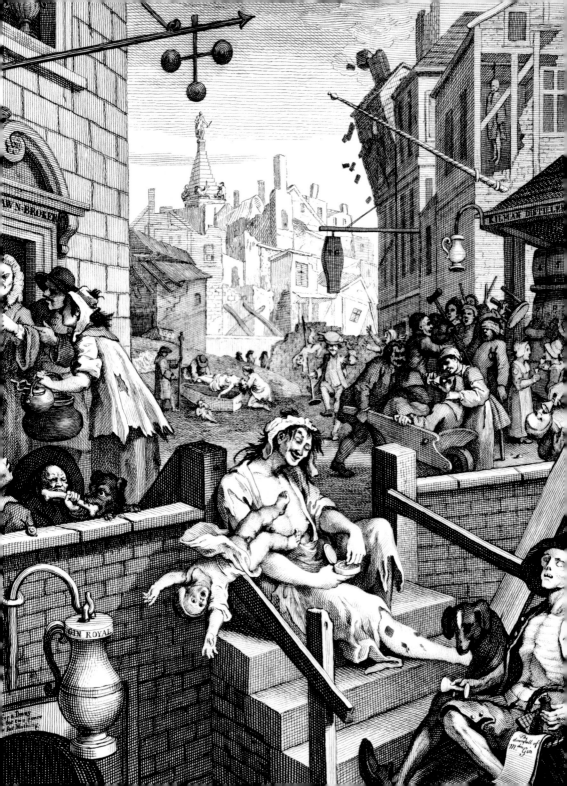

CANALETTO

Born: Giovanni Antonio Canal, October 28, 1697 (Venice, Italy); died April 19, 1768 (Venice, Italy).

Artistic style: The painter of Venice; cityscapes filled with the city's memorable sites; trademark details of canals and gondolas; strong highlights and shadows.

The work of Canaletto will always be associated with the delights of his native city, Venice. Born Giovanni Antonio Canal and known as Canaletto, meaning "little canal," he trained with his father Bernardo Canal, a successful painter of theatrical scenery. Working as his father's assistant, Canaletto learned the perfect mastery of linear perspective, spatial clarity, balanced composition, and the theatrical effect of creating convincing and realistic views that appeared to fall back into the distance.

Canaletto completed his artistic education with a trip to Rome in 1719 to 1720. On his return home, he devoted himself almost exclusively to painting realistic and topographical views of Venice. His dramatic and picturesque cityscapes depicted famous sites, buildings, and canals, including civic pageantry, festivals, and ceremonies. His work is characterized by fluid, and seemingly effortless, brushstrokes and by his use of strong highlights and shadows. His images are filled with the motifs and details most associated with the city: the sunlight reflected

Masterworks

Rome: A Caprice View with Ruins Based on the Forum c.1726 (Royal Collection, Windsor, England)

The Stonemason's Yard 1727–1728 (National Gallery, London, England)

Reception of the French Ambassador in Venice, c.1726–1727 (The Hermitage, St. Petersburg, Russia)

The Piazzetta, Venice, Looking North c.1730s (Norton Simon Museum, Pasadena, California, U.S.)

The Grand Canal with S. Maria della Salute Towards the Riva degli Schiavoni 1744 (Royal Collection, Windsor, England)

The Thames from Richmond House 1747 (Goodwood House, West Sussex, England)

A View of Greenwich from the River c.1750–1752 (Tate Collection, London, England)

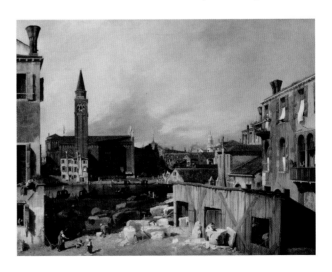

ABOVE: This engraving of Canaletto as a young man was made before 1735.

RIGHT: *The Stonemason's Yard* **is considered one of Canaletto's finest works.**

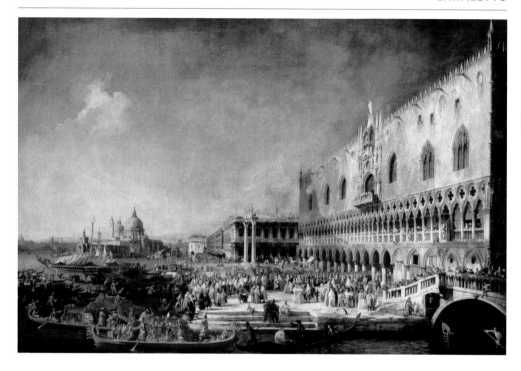

on the waters of the canals, the chimney pots against the skyline, the peeling inscriptions and posters on the city walls, the gondolas carrying visitors, and the city's churches and bell towers.

Such typically Venetian views found keen buyers in the foreign tourists visiting the city. By the eighteenth century Venice was a favored destination for wealthy, aristocratic young men. Finishing their education with a European tour, they flocked to the city that was well known for its carefree living. Painted views of Venice were bought and sent home as records of the things they had seen and experienced. Canaletto's extreme popularity with English gentlemen results in more of his paintings today being in England than in Italy. In 1746 Canaletto came to England, where he painted many views of London and of country houses. By 1755, however, he was back in Venice, where he died in 1768. **AB**

ABOVE: *Reception of the French Ambassador in Venice* **is a typical Canaletto cityscape.**

A Private View

Although Canaletto is most renowned for painting the famous sites of Venice, his earliest acclaimed masterpiece shows a more private view of his city. *The Stonemason's Yard* (1727–1728), today in the National Gallery, London, does not represent a famous landmark but, instead, the intimate view of a Venetian square in the morning. Filled with familiar details of everyday life, one is able to spot laundry being hung out to dry, gondolas crossing the canal, bells ringing in a tower, a lady spinning thread at her window, a cockerel welcoming the day, and a child wetting himself as he falls over.

LOUIS-FRANÇOIS ROUBILIAC

Masterworks

George Frederic Handel, As Apollo 1737 (Victoria & Albert Museum, London, England)

*Alexander Pope c.*1738 (Victoria & Albert Museum, London, England)

*William Hogarth c.*1741 (National Portrait Gallery, London, England)

Sir Isaac Newton 1755 (Wren Library, Trinity College, Cambridge, England)

William Shakespeare 1758 (British Museum, London, England)

Lady Elizabeth Nightingale 1761 (Chapel of St. Nicholas, Westminster Abbey, London, England)

George Frederic Handel 1762 (Westminster Abbey, London, England)

Born: Louis-François Roubiliac, 1702 (Lyons, France); died January 11, 1762 (London, England).

Artistic style: Sculptor of marble busts, statues, and sepulchral monuments; energetic, flowing lines; asymmetrical compositions; informal sculptural portraits.

Louis-François Roubiliac found fame with a full-length sculpture of musician *George Frederic Handel, As Apollo* (1737). The work was much admired for its informality, rococo sense of playfulness, and likeness to the composer. Commissions for busts and statues of various contemporary noteworthies followed, such as poet *Alexander Pope* (*c.*1738) and painter and satirist *William Hogarth* (*c.*1741). The artist was established as a successful sculptor by the 1740s and celebrated for his curvaceous lines and lively facial likenesses. Roubiliac's crowning glories are his works in Westminster Abbey, including *Lady Elizabeth Nightingale* (1761) and *George Frederic Handel* (1762), whose face was modeled on his death mask. **CK**

ALLAN RAMSAY

Masterworks

*Self-Portrait c.*1737–1739 (National Portrait Gallery, London, England)

Hew Dalrymple, Lord Drummore 1754 (Scottish National Portrait Gallery, Edinburgh, Scotland)

*The Artist's Wife: Margaret Lindsay of Evelick c.*1758–1760 (National Gallery of Scotland, Edinburgh, Scotland)

George III 1761–1762 (Royal Collection, London, England)

Portrait of David Hume 1766 (Scottish National Portrait Gallery, Edinburgh, Scotland)

Born: Allan Ramsay, October 2, 1713 (Edinburgh, Scotland); died August 10, 1784 (Dover, Kent, England).

Artistic style: Refined, harmonious portraits; subtle character insights; intimate, natural quality; lightness of touch; expert handling of fabric textures.

No less a figure than Dr. Samuel Johnson praised Allan Ramsay for the grace and learning of his conversation. Trained in Italy, London, and Edinburgh, the dandyish artist was one of London society's most sought after portrait painters by the mid-1700s. He was a major influence on—and later healthy competitor with—Sir Joshua Reynolds as well as on Scottish artists Henry Raeburn and David Wilkie. In 1761, Ramsay became King George III's portraitist. His work combined an elegance and subtle psychological insight increasingly tempered by naturalism and a light, French-style touch. Every bit a creature of the Enlightenment, the son of a poet, and friend to leading thinkers, Ramsay was also an important writer. **AK**

GIOVANNI BATTISTA PIRANESI

Born: Giovanni Battista Piranesi, October 4, 1720 (Mogliano, Veneto, Italy); died November 9, 1778 (Rome, Italy).

Artistic style: Italian engraver, architect, antiquarian, and designer of interiors and furnishings; romanticized representations of ancient architecture and ruins.

Giovanni Battista Piranesi's passion for both classical and fantastic architecture was undeniably influenced by his family environment. His father was a stonemason and a master builder; his uncle, who taught him drawing and engineering, was an engineer. Piranesi's brother, a Carthusian monk, is credited with introducing the young artist to the history and architectural achievements of the ancient Romans.

At twenty years old, Piranesi began an apprenticeship with Giuseppe Vasi, a famous architect and engraver who specialized in tourist views of Rome. Piranesi quickly excelled in etching and printmaking, producing plates for *Prima Parte di Architettura e Prospettive* (1743). He then began working on his most famous etchings, the *Varie Vedute di Roma Antica e Moderna* (1745). Characterized by majestic viewpoints, careful attention to detail, and striking plays between light and shadow, these prints of ancient ruins and modern buildings were immensely popular and provided the artist with a stable income.

Piranesi then worked on the *Imaginary Prisons* (1749–1750) etchings, creating complex visions of crowded, labyrinthine spaces, mysterious machinery, and dark subterranean jails. These haunting images followed in the Venetian tradition of *capricci*, meaning "capricious inventions." They allowed Piranesi to experiment with unusual perspectives and unlikely spatial relationships. The sixteen etchings had a significant influence on the work of surrealists such as Maurits Cornelis Escher.

During the reign of Pope Clement XIII, Piranesi was commissioned to do two architectural projects. The renovation of the choir of San Giovanni was never begun; but Piranesi did restore the church of Santa Maria del Priorato in Rome, where he was buried after a long illness. **NSF**

Masterworks

*Part of a Spacious Magnificent Harbor in the Manner of the Ancient Romans c.*1749–1750 (Metropolitan Museum of Art, New York, U.S.)

An Ancient Port 1749–1750 (J. Paul Getty Museum, Los Angeles, California, U.S.)

*A Magnificent Palatial Interior c.*1750 (National Gallery of Art, Washington, D.C., U.S.)

The Portico of Octavia from *Varie Vedute di Roma (Views of Rome)* 1760 (Metropolitan Museum of Art, New York, U.S.)

Carceri, Plate XI 1761 (British Museum, London, England)

"... if I were commissioned to design a new universe, I would be mad enough to undertake it."

ABOVE: Pietro Labruzzi painted *Portrait of Giovanni Battista Piranesi* in 1779.

JOSHUA REYNOLDS

Born: Joshua Reynolds, July 16, 1723 (Plympton, Devon, England); died February 23, 1792 (London, England).

Artistic style: Eighteenth-century portrait painter of the aristocracy; master of the "grand style"; founding president of the Royal Academy; allegorical references.

Masterworks

Commodore the Honourable Augustus Keppel 1749 (National Maritime Museum, London, England)

Self-Portrait when Young 1753–1758 (Tate Collection, London, England)

Miss Elizabeth Ingram 1757 (Walker Art Gallery, Liverpool, England)

Mrs Susannah Hoare and Child 1763–1764 (Wallace Collection, London, England)

Colonel Acland and Lord Sydney: The Archers 1769 (Tate Collection, London, England)

Mrs Abington as Miss Prue in William Congreve's "Love for Love" 1771 (Yale Center for British Art, London, England)

*Self-Portrait as a Deaf Man c.*1775 (Tate Collection, London, England)

*Lady Worsley c.*1776 (Harewood House, Yorkshire, England)

Admiral Viscount Keppel 1780 (Tate Collection, London, England)

Georgiana, Duchess of Devonshire, and Her Daughter 1784 (Chatsworth House, Derbyshire, England)

Sir Joshua Reynolds was undoubtedly Britain's most influential portrait painter of the eighteenth century. Joshua was one of eleven children. His father was a village schoolmaster, but luckily for his son he had several friends in high places. In 1740, the young Reynolds had the good fortune to be apprenticed to the fashionable and very successful portrait painter Thomas Hudson. Nine years later he was introduced to the aristocratic naval officer Commodore Augustus Keppel, and wisely

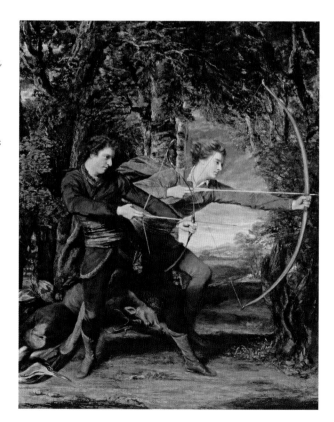

ABOVE: *Sir Joshua Reynolds* was painted by James Northcote (*c.*1773–1774).

RIGHT: *Colonel Acland and Lord Sydney: The Archers* focus on their prey out of the frame.

accepted Keppel's invitation to journey with him to Rome; Reynolds remained in Rome for two years painting portraits and studying works of the Old Masters. While sketching in the Vatican Reynolds caught the chill that is said to have contributed to him being hard of hearing. He lacked a more formal artistic education however. Consequently, some of his paintings have since been criticized for their ignorance of anatomy and linear perspective.

Reynolds settled in London in 1753, where his sister Frances, known as Fanny, generously kept house for him. He entertained the stream of fashionable visitors to his studio with recent paintings in the "grand style," such as the bold and dramatic full-length portrait of Commodore Keppell. Reynold's gregarious nature and aristocratic support resulted in a prolific body of work.

Royal recognition

The foundation of the Royal Academy of Arts in 1768 provided its forty members with the benefits of a recognized social and professional status, a royal patronage, and an appropriate venue for their annual exhibition. There was also the important establishment of the Academy School, with its cast collection, life-drawing classes, prizes, and lectures. Reynolds was elected as president of the Royal Academy unanimously and was later knighted by King George III. His *Seven Discourses on Art* (1769– 1790) to the students were intended to raise the status of the profession by allying painting with scholarship and were among the most important art criticism of the time. They promoted the idea of grandeur in art and rigorous academic training to achieve that end.

Reynolds suffered a stroke in 1782. Initially he appeared to have recovered fully, but by 1789 he was forced to stop painting altogether when one eye, and then the other, clouded. He continued to write though, and delivered his final discourse in December 1790. Although not a religious man, Reynolds was honored with a grand funeral in St. Paul's Cathedral, London, on his death in 1792. **RM**

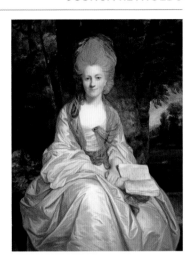

ABOVE: Reynolds's *A Portrait of Dorothy Vaughan* raised the status of portraiture.

Old Masters by Magic

The submission of *The Conjuror* (1774) to the Royal Academy caused one of the greatest art scandals of the eighteenth century. Apparently prompted by Reynolds's discourse on the subject of imitation, Nathaniel Hone's painting depicts him as the conjuror, magically producing a flutter of Old Master prints with a wave of his wand. When painter Angelica Kauffmann objected that Hone had depicted her dancing naked in the painting, it was withdrawn from the show. Hone's real offense, however, was to suggest that Reynolds was stealing ideas and poses from Old Master paintings.

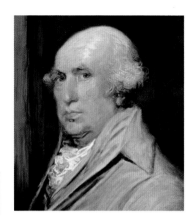

GEORGE STUBBS

Born: George Stubbs, August 25, 1724 (Liverpool, England); died July 10, 1806 (London, England).

Artistic style: Equine sporting subjects; horses, dogs, and exotic animals with psychological depth; exacting anatomical studies; lyrical naturalism.

Masterworks

Anatomy of the Horse 1756–1758 (Royal Academy, London, England)

Duchess of Richmond and Lady Louisa Lennox Watching the Duke's Racehorses at Exercise c.1759–1760 (Goodwood House, Sussex, England)

Whistlejacket c.1762 (National Gallery, London, England)

A Lion Attacking a Horse c.1765 (National Gallery of Victoria, Melbourne, Australia)

The Milbanke and Melbourne Families c.1769 (National Gallery, London, England)

A Horse Frightened by a Lion 1770 (Walker Art Gallery, Liverpool, England)

Haymakers 1785 (Tate Collection, London, England)

Hambletonian, Rubbing Down 1800 (National Trust, Mount Stewart House, Northern Ireland)

George Stubbs's name is synonymous with horses. The artist's fame rests on this subject matter, and he is regarded as one of the foremost animal painters of all time. However, Stubbs's encompassing association with painting horses and dogs, as well as exotic animals, is one that caused problems for the artist and continues to overshadow a wider appreciation of his work. Although his work was popular during his life and he had a number of influential patrons, he never received the critical acclaim within the art world for which he strove.

Stubbs was born in Liverpool and was largely self-taught as an artist. He moved to York in 1745, where he studied anatomy at York County Hospital. There he attended dissections and produced a number of highly accurate drawings that were published in Dr. John Burton's *Essay Towards a Complete New System of Midwifery* (1751). He worked as a portraitist and, in 1755, traveled to Italy. Unmoved by the classical, he remained an adherent to naturalism. Nevertheless, there is a unilateral sense of classical balance and harmony in his work.

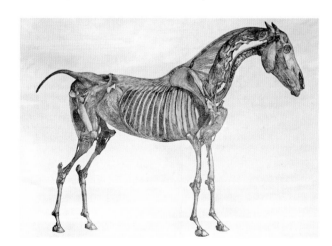

ABOVE: One of several self-portraits by Stubbs; he often depicted himself hatless.

RIGHT: An unsettling and precise engraving from the *Anatomy of the Horse* series.

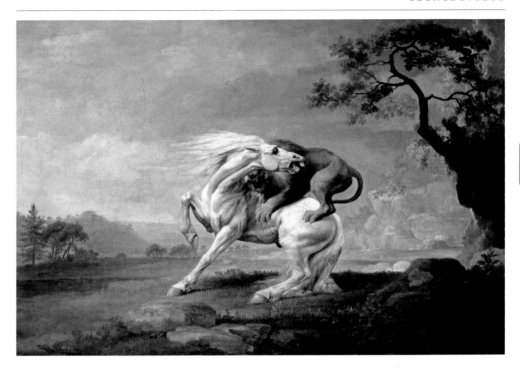

In 1756, Stubbs began work on his *Anatomy of the Horse* (1766) series of precise and eerily beautiful drawings taken from his systematic dissection of horses in a lonely farmhouse in Lincolnshire. He procured carcasses from a local tannery, drained the blood, and filled the veins with wax. He then rigged the horses into natural positions and made detailed drawings of each stage of dissection. He hoped to establish a London clientele because horses were extremely popular among the nobility. Stubbs targeted this market with *Duchess of Richmond and Lady Louisa Lennox Watching the Duke's Racehorses at Exercise* (c.1759–1760) and *Whistlejacket* (1762).

As well as painting numerous portraits of famous horses, Stubbs painted many versions of a horse being attacked by a lion. He also produced a great number of genre scenes, which are particularly notable for their subtle and sympathetic depiction of the rural working classes. **TP**

ABOVE: Stubbs painted this dramatic version of a lion attacking a horse in 1765.

A Sweaty Problem

One of Stubbs's most famous paintings is *Hambletonian, Rubbing Down* (1800) painted for Sir Harry Vane-Tempest. The picture was to be one of two to celebrate the race between Hambletonian and Diamond at Newmarket. However, Stubbs and Vane-Tempest argued over the bill for the picture, and a bitter court case ensued. Vane-Tempest objected to the nature of the picture because—with characteristic honesty—Stubbs depicted a horse gasping for breath and clearly distressed by its heroic efforts, while the trainer and groom look levelly from the canvas with a weighty and impenetrable stare.

THOMAS GAINSBOROUGH

Born: Thomas Gainsborough, 1727 (Sudbury, Suffolk, England); died August 2, 1788 (London, England).

Artistic style: Leading portraitist and landscape painter of the eighteenth century; themes of peasant and rural life; naturalistic detail; lyrical, poetic quality.

Masterworks

Mr. and Mrs. Andrews c.1750
(National Gallery, London, England)

The Painter's Daughters Chasing a Butterfly,
c.1756 (National Gallery, London, England)

Portrait of Ann Ford, later Mrs. Philip Thicknesse
1760 (Cincinnati Art Museum, Cincinnati,
Ohio, U.S.)

Jonathan Buttall: The Blue Boy c.1770
(Huntington Art Collections,
San Marino, California, U.S.)

An Officer of the 4th Regiment of Foot
1776–1780 (National Gallery of Victoria,
Melbourne, Australia)

*Mr. and Mrs. William Hallett (The Morning
Walk)* 1785 (National Gallery,
London, England)

Thomas Gainsborough was one of the leading portrait and landscape painters of the eighteenth century whose technical ability was matched by his innovation. His portraits draw on rococo aesthetics combined with exquisite naturalism. His landscape paintings, although less popular commercially during his lifetime, had a profound influence on the development of landscape painting in England.

Gainsborough trained under engraver Hubert Gravelot and painter and illustrator Francis Hayman in London. There he came into contact with William Hogarth, who was running the St. Martin's Lane Academy. His landscape paintings reflect the influence of northern European art, particularly Jacob van Ruisdael. The works were admired by his contemporaries but failed to attract many buyers.

In 1748, he returned to Sudbury to address the market for portraiture and painted *Mr. and Mrs. Andrews* (*c.*1750). The Gainsboroughs moved to thriving Ipswich in 1752 in search of potential clients and then, in 1759, to the fashionable town of Bath, where the artist was able to charge more for his work. He began to study, and was influenced by Sir Anthony van Dyck's portraits, elements of which can be seen in *Ann Ford* (1760), which also reveals a debt to Hogarth. He continued to paint lyrical landscapes, increasingly reflecting the influence of Sir Peter Paul Rubens, and sent them and his portraits to London to be exhibited at the Society of Artists. He became one of the founding members of the Royal Academy of Arts in 1768. By 1774, Gainsborough was once more on the move in search of clients and returned to London. Toward the end of his career, he began to paint scenes of rural life that subtly reflected the inherent hardships of the people. **TP**

"We find tears in our eyes and know not what brings them."—
John Constable, on Gainsborough's art

ABOVE: *Self-Portrait* (*c.*1787) was painted shortly before Gainsborough died.

JEAN-HONORÉ FRAGONARD

Born: Jean-Honoré Fragonard, April 5, 1732 (Grasse, France); died August 22, 1806 (Paris, France).

Artistic style: Leading rococo painter; rich colors; atmospheric backgrounds; careful use of light and shade, particularly in skin tones; erotic content.

A French painter whose work was forgotten for decades, Jean-Honoré Fragonard is now acknowledged as one of the most important painters of his time. After moving from the south of France to Paris at eighteen years old, he was taught by painters François Boucher, Jean-Baptiste-Siméon Chardin, and Charles André van Loo. In 1752, he won the Prix de Rome, giving him the chance to go to Italy and study the great Italian masters. The landscape of Italy had a huge impact on his work, often serving as scenery for his genre paintings. In later years he traveled through the Netherlands and was greatly influenced by Flemish and Dutch art; he used similarly somber color palettes to create moody backgrounds to his central images.

In Rome, he became a member of the prestigious Académie de France, although he found their rules far too restrictive. Back in France, he attracted important and wealthy patrons, including Madame de Pompadour and Madame du Barry, and became heralded as a key figure of the rococo movement.

Fragonard's most famous work is *The Swing* (1767). At first glance, it appears to be a simple image of an innocent young woman playing, but it is actually an erotic painting: lying lazily down in the left-hand corner of the painting is a young man, her lover, staring directly up her skirt as she kicks her legs apart for his benefit.

Unfortunately, this style of art was only fleetingly popular. When neoclassicism became fashionable, rococo was swiftly seen as passé. In addition, Fragonard's once-lucrative income dried up as his patrons fell foul of the French Revolution's guillotine, leaving him to die impoverished. His artistic inheritance continued into the late nineteenth century and the impressionist era: his granddaughter was the celebrated artist Berthe Morisot. **LH**

Masterworks

Happy Lovers c.1760–1765 (Norton Simon Museum, Pasadena, U.S.)

The Swing 1767 (Wallace Collection, London, England)

Young Girl with a Marmot c.1770–1790 (Portland Art Museum, Oregon, U.S.)

The Progress of Love series c.1771–1773 (four paintings; Frick Collection, New York, U.S.)

A Fisherman Pulling a Net 1774 (Metropolitan Musem of Art, New York, U.S.)

A Boy as Pierrot c.1780 (Wallace Collection, London, England)

The Visit to the Nursery pre-1784 (National Gallery of Art, Washington, D.C., U.S.)

The Fountain of Love c.1785 (Wallace Collection, London, England)

The Stolen Kiss late 1780s (The Hermitage, St. Petersburg, Russia)

"If necessary, I would even paint with my bottom."

ABOVE: This self-portrait in Renaissance clothing is typical of Fragonard's style.

JOHN SINGLETON COPLEY

Born: John Singleton Copley, July 3, 1738 (Boston, Massachusetts, U.S.); died September 9, 1815 (London, England).

Artistic style: Realistic portraits and historical subjects; depictions of contemporary events; vibrant color; facial expressions full of emotion; bold brushstrokes.

John Singleton Copley's works are a chronicle of colonial North America. After his father died, his mother married an English painter and engraver, who had an early influence on the young Copley's art. He then became the pupil of another Englishman, portrait painter Joseph Blackburn. Learning from Blackburn's exciting techniques and use of color he created his own trademark style, as seen in the portrait *Mary and Elizabeth Royall* (c.1758). Copley's use of light and shade to give texture and luminosity can be seen perfectly in the fabrics of the Royall sisters' dresses and the sheen of the younger girl's hair. It was painted soon after meeting Blackburn and is a sharp contrast to the fascinating, but flattering, less-contoured companion portraits of *Joseph Mann* (1754) and *Mrs. Joseph Mann* (1753).

Although associated firmly with Boston, whose museums house a large number of his works, Copley left the United States in 1774. In 1766, he had sent the portrait of his half-brother *Henry Pelham* (1765) to the Royal Academy of Arts in London. It was seen by Sir Joshua Reynolds, who recommended Copley move to Europe to develop a less "hard" style. He studied in Italy and then England and was made a full member of the Royal Academy of Arts. His portrait of his family, completed in 1777, shows his face looking out whimsically and a content, prosperous group amid an artistic landscape. The success of the unusual *Watson and the Shark* (1778) encouraged Copley to turn to historic paintings. They were big crowd-pleasers, often re-creating recent events and commemorating British heroes. Although larger and more dramatic, they never attained the wit or perfection of many of his earlier Boston paintings. Once highly lauded, his art became unfashionable, and Copley died in debt. **LH**

Masterworks

Mrs. Joseph Mann 1753 (Museum of Fine Arts, Boston, Massachusetts, U.S.)

Joseph Mann 1754 (Museum of Fine Arts, Boston, Massachusetts, U.S.)

Mary and Elizabeth Royall c.1758 (Museum of Fine Arts, Boston, Massachusetts, U.S.)

John Hancock 1765 (Museum of Fine Arts, Boston, Massachusetts, U.S.)

The Copley Family 1776–1777 (National Gallery of Art, Washington, D.C., U.S.)

Watson and the Shark 1778 (National Gallery of Art, Washington, D.C., U.S.)

The Death of the Earl of Chatham c.1779–1781 (National Portrait Gallery, London, England)

The Siege and Relief of Gibraltar c.1783 (Tate Collection, London, England)

"In the best of Copley's American paintings, he makes virtues out of vices."—Pepe Karmel

ABOVE: This self-portrait (1780–1784) was painted while Copley was living in London.

BENJAMIN WEST

Born: Benjamin West, October 10, 1738 (Springfield, Pennsylvania, U.S.); died March 11, 1820 (London, England).

Artistic style: Neo-classical, epic-scale historical and religious subjects; portraits; radical innovator who painted historical figures in contemporary dress.

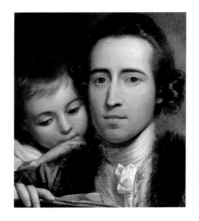

Benjamin West was one of the most influential artists of his time, and having moved to England became one of the foremost history painters in Europe. He was a pioneer in many respects, working at the forefront of the emergent neo-classical style and anticipating the development of romanticism. West was one of the first artists of the time to paint figures in contemporary rather than classical dress, most famously in *The Death of General Wolfe* (1770), going against the advice of King George III and Sir Joshua Reynolds. However, the work was a resounding success and several copies were made of it. West was commercially motivated, making copies and prints of many of his works that were then sold in thousands across Europe and the United States.

West trained in Philadelphia and spent his early career painting portraits. In 1760 he visited Italy, where he spent two years studying in Rome with early neo-classicist Anton Raphael Mengs. In 1763, West traveled to England and exhibited two neo-classical works done in Italy, which were received enthusiastically. He settled in England and earned the favor of George III, who saw his painting *Agrippina Landing at Brundisium with the Ashes of Germanicus* (1768). The king commissioned *The Departure of Regulus from Rome* (1769) and employed West as the royal history painter. West was one of the founders of the Royal Academy of Arts in London, with Reynolds, and became the society's second president in 1792. He fell from royal favor during the war with France because of his sympathy for the French. His career suffered, but in 1805 the wealthy English politician and writer William Thomas Beckford commissioned work from him, and thereafter West's career took a meteoric turn once more. **TP**

Masterworks

Pylades and Orestes Brought as Victims Before Iphigenia 1766 (Tate Collection, London, England)

Agrippina Landing at Brundisium with the Ashes of Germanicus 1768 (Yale University Art Gallery, New Haven, Connecticut, U.S.)

The Death of General Wolfe 1770 (National Gallery of Canada, Ottawa, Canada)

The Immortality of Nelson date unknown (National Maritime Museum, London, England)

Death on a Pale Horse 1817 (Pennsylvania Museum of Fine Arts, Philadelphia, U.S.)

"He is a wonder of a man and has so far outstripped all the painters of his time."—William Allen

ABOVE: *The Artist and his son Raphael* (c.1773) is from the Paul Mellon Collection.

1700-99

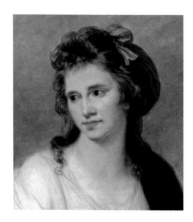

ANGELICA KAUFFMANN

Born: Maria Anna Angelica Katharina Kauffmann, October 30, 1741 (Chur, Switzerland); died November 5, 1807 (Rome, Italy).

Artistic style: Neo-classical painter; history painting; portraits of the aristocracy; allegorical references; founder member of the British Royal Academy of Arts.

Angelica Kauffmann was one of the most successful female artists of the eighteenth century. Born in Switzerland and raised in Austria, she was trained in the basics of painting and drawing by her father. Together they traveled through Italy, and in 1762 she was accepted as a member of Florence's prestigious Accademia dell'Arte del Disegno. Able to speak several languages and possessing a prodigious musical talent, Kauffmann was a sociable and popular figure, and soon became acquainted with a number of well-known artists.

Kauffmann already had a number of British clients by the time she accepted an invitation from Lady Wentworth, wife of the British ambassador, to accompany her to England in 1766. She set up her studio in London and was introduced to Sir Joshua Reynolds, the artist who later became president of the Royal Academy of Arts, founded in 1768. Kauffmann was one of only two women included among the founding members.

Kauffmann is distinguished by her history painting, but it was portraiture that interested the British, who feature in approximately half of her 400 documented single and group portraits. Tremendously successful, she had earned £14,000 ($29,000) on leaving London, a considerable amount at that time, particularly for a female artist. An attractive and educated young woman, Kauffmann was apparently comfortable in male company. Possible attachments to Reynolds, Sir Nathaniel Dance-Holland, Henry Fuseli, and the engraver William Wynne Ryland have been suggested, and she married twice. Her second husband was the Venetian decorative painter Antonio Zucchi, with whom she retired to Italy. When she died in 1807, her funeral procession in Rome was one of the longest the city had ever seen. **RM**

Masterworks

David Garrick 1764 (Burghley House, Stamford, England)

Angelica Kauffmann c.1770–1775 (National Portrait Gallery, London, England)

Rinaldo and Armida c.1772 (Kenwood House, The Iveagh Bequest, London, England)

Portrait of a Lady c.1775 (Tate Britain, London, England)

John Simpson c.1777 (National Portrait Gallery, London, England)

Lady Elizabeth Foster 1784 (Ickworth House, Bury St. Edmunds, England)

Self-Portrait 1787 (Galleria degli Uffizi, Florence, Italy)

Anna Maria Jenkins; Thomas Jenkins 1790 (National Portrait Gallery, London, England)

"This artist, considering her sex, is certainly possessed of very great merit."—*The London Chronicle*

ABOVE: Detail from *Self-Portrait* (1787) painted after her second marriage.

1700-99

HENRY FUSELI

Born: Johann Heinrich Fuseli, February 6 or 7, 1741 (Zurich, Switzerland); died April 16, 1825 (London, England).

Artistic style: Member of the romantic movement; taste for horror and the macabre; paintings explore the dark side of sexual behavior.

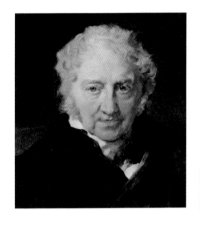

Although Swiss by birth, Henry Fuseli spent most of his career in England, where he became a key figure in the romantic movement. His father, who was also an artist, wanted a career in the church for his son. Accordingly, Fuseli was ordained as a minister in 1761. The young man proved too outspoken for this calling, however, and was obliged to leave his homeland, moving to London in 1765. There he met Sir Joshua Reynolds, who encouraged him to become a painter. Fuseli had learned the basics from his father, but his main artistic training took place in Italy from 1770 to 1778, where he was inspired by the work of Michelangelo Buonarroti.

After returning to England in 1779, Fuseli began to pursue his career as an artist in earnest, concentrating on grandiose themes from literature and history. He rapidly made his name in spectacular fashion when his masterwork *The Nightmare* (1781) caused a sensation at the Royal Academy of Arts. It is Fuseli's most famous and most controversial painting, and art historians have produced acres of print trying to analyze its precise meaning. Yet the real reason for its impact was quite simple: it combined sex and horror in a devastating image.

Fuseli echoed this approach in many of his other paintings. Whether tackling themes from William Shakespeare, John Milton, or Dante Alighieri, his pictures were invariably flavored with a hint of sexual perversity or suppressed violence—a feature that later endeared him to the surrealists. Despite this, Fuseli was a popular and respected figure. In 1799, he was appointed professor of painting at the Royal Academy, also becoming its keeper in 1804. After his death in 1825, he was buried in St. Paul's Cathedral, an honor usually reserved for presidents of the Royal Academy. **IZ**

Masterworks

The Nightmare 1781 (Detroit Institute of Arts, Michigan, U.S.)

Titania and Bottom c.1790 (Tate Collection, London, England)

Mad Kate c.1806–1807 (Frankfurter Goethe-Museum, Frankfurt am Main, Germany)

"The engines in Fuseli's mind are blasphemy, lechery, and blood."—Benjamin Haydon, artist

ABOVE: *Portrait of Henry Fuseli* by his friend Sir Thomas Lawrence.

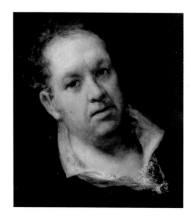

FRANCISCO GOYA

Born: Francisco José de Goya y Lucientes, March 30, 1746 (Fuendetodos, Spain); died April 16, 1828 (Bordeaux, France).

Artistic style: Dramatic, figurative painting; bold free-flowing technique; drawings and etchings depict dark, satirical, and macabre visions of human suffering.

Masterworks

The Parasol 1777 (Museo del Prado, Madrid, Spain)

Condesa de Altamira and Her Daughter, Maria Agustina 1787–1788 (Metropolitan Museum of Art, New York, U.S.)

The Puppet 1791–1792 (Museo del Prado, Madrid, Spain)

Game of the Little Giants c.1791–1792 (Museo del Prado, Madrid, Spain)

The Naked Maja 1797–1800 (Museo del Prado, Madrid, Spain)

The Clothed Maja 1800–1808 (Museo del Prado, Madrid, Spain)

The Family of Charles IV 1800 (Museo del Prado, Madrid, Spain)

José Costa y Bonells date unknown (Metropolitan Museum of Art, New York, U.S.)

The Second of May 1808 1814 (Museo del Prado, Madrid, Spain)

The Third of May 1808 1814 (Museo del Prado, Madrid, Spain)

The Disasters of War c.1810–1820

Saturn Devouring His Son c.1819–1823 (Museo del Prado, Madrid, Spain)

ABOVE: This detail from *Self-Portrait* (c.1800) shows Goya in middle age.

RIGHT: *The Family of Charles IV* affords each sitter a certain element of individuality.

Francisco Goya is the most important Spanish artist of the late eighteenth and early nineteenth centuries. Unusually, he achieved success in his lifetime, acquiring and retaining noble patronage. In 1774, he was introduced to the royal workshops, thus beginning a lifelong relationship with royalty that would span four ruling monarchies. In contrast to the dark visions that dominated his later career, Goya's early work was fresh and lighthearted. His vivacious celebrations of Spanish people at leisure reflect the hopefulness of the age in which he was living, and recall the playful rococo style of artists such as Giambattista Tiepolo.

At the start of his career, Goya joined the Madrid studio of the painter brothers Francisco and Ramón Bayeu y Subías soon after they established themselves in the city in 1763. Goya formed a close bond with the artists (eventually marrying their sister, Josefa, in 1774). Two failed attempts to submit entries to the Real Academia des Bellas Artes, San Fernando, however, prompted Goya to leave Madrid for Rome in 1770. He probably met the German artist Anton Raphael Mengs in Rome. It was

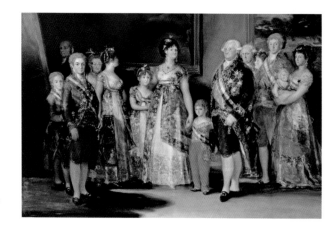

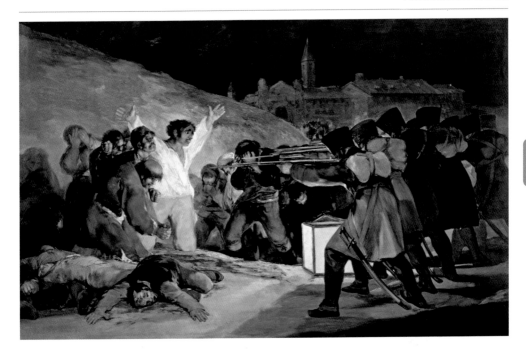

ABOVE: Goya's patriotic *The Third of May 1808* is dominated by the Christlike figure.

Mengs who started Goya on his career at court, summoning him to Madrid in 1774 to paint cartoons for the tapestries of the Royal Factory of Santa Barbara. Goya went on to receive a stream of commissions from the aristocracy, creating sensitive and flamboyant portraits that, with their broad and quick brushstrokes, testify to the wealth and power of the sitters as well as to their emotional states of mind.

By the age of forty, Goya was appointed painter to King Charles III, and in 1789 he became court painter to the newly crowned King Charles IV. The year 1789 marked the start of a period of great turbulence, beginning with the overthrow

"I have had three masters: Nature, Velázquez, and Rembrandt."

of the French monarchy and continuing to 1793 with France declaring war on Spain. During this period, Goya traveled to Cadiz, Andalusia, with his friend, the wealthy businessman and art collector Sebastián Martínez y Pérez. While in Cadiz, Goya

The Black Paintings

Embittered both by his deafness and the turbulent events of his time, Goya created numerous dark, disturbing works in later life. Some of the most memorable featured in his "Black Paintings" (so called because of their generally dark palette and somber air), which he created in La Quinta del Sordo, his house just outside Madrid, starting in 1820.

- Using oils, Goya painted straight on to the plaster of the walls, never intending the works to be seen by the public.

- One recurring theme appears to be civil strife—witness the grotesque *Saturn Devouring His Son*. The two protagonists in *Fight with Cudgels* have been taken as a premonition of the civil war that was to engulf Spain.

- Goya did not give any of the works a title—the names by which they are known today have been applied, in retrospect, by art critics.

- The meaning of these works, if any were intended, has never been fully explained.

- In the early 1870s, the then owner of the house—Baron d'Erlanger—arranged for the fourteen frescoes to be transferred to canvas and they were exhibited at the Exposition Universelle in 1878. Today, they hang in Madrid's Prado museum.

- The house's nickname did not originate with Goya—its previous owner had also been deaf.

RIGHT: Goya's disturbing depiction of *Saturn Devouring His Son* is very, very dark.

suffered a severe illness that was to leave him deaf. He returned to Madrid in 1793, but from this time on his work became much darker. In 1799, he completed and published his famous allegorical etchings *The Caprichos*. These and the later series *The Disasters of War* (*c*.1810–1820), not published until 1863, testify to the brutalities and terror of the time. Although Goya's etchings are grounded in the baroque tradition of dramatically contrasting light and dark, they have a newfound modernity thanks to his unique treatment of the compositions.

For king and country

Goya's later paintings became increasingly naturalistic, even grotesque. His portrait *The Family of Charles IV* (1800) is both a depiction of a strong and united monarchy and a lifelike, unidealized group portrait. The enlightened monarchy of Charles IV was ended by Napoleon Bonaparte's invasion of Spain in 1808 and the ensuing Peninsular War (1808–1814). Although repulsed by French atrocities, Goya pledged his allegiance to Napoleon. The Bourbon monarchy was restored with Napoleon's fall in 1814 but the new king, Ferdinand VII, rejected the enlightened views of his predecessors, reinstated the Spanish Inquisition, and declared himself "absolute monarch" before unleashing a reign of terror. Questioned about his loyalty to the occupiers, Goya responded by commemorating Spain's uprising against the French in two paintings: *The Second of May 1808* (1814) and *The Third of May 1808* (1814). The second of these depicts the merciless execution of Spaniards on a hill just outside Madrid. Both paintings exemplify the brooding atmosphere and loose, fluid brushstrokes of Goya's late work and his stylistic debt to Sir Peter Paul Rubens and Diego Velázquez.

Between 1820 and 1823, in his small country retreat nicknamed La Quinta del Sordo (the deaf man's house), Goya completed a series of sinister, terrifying wall paintings and canvases known as the Black Paintings. Aggrieved by the political situation in Spain, Goya retired to Paris and Bordeaux. He remained there until his death, aged eighty-two. **JN**

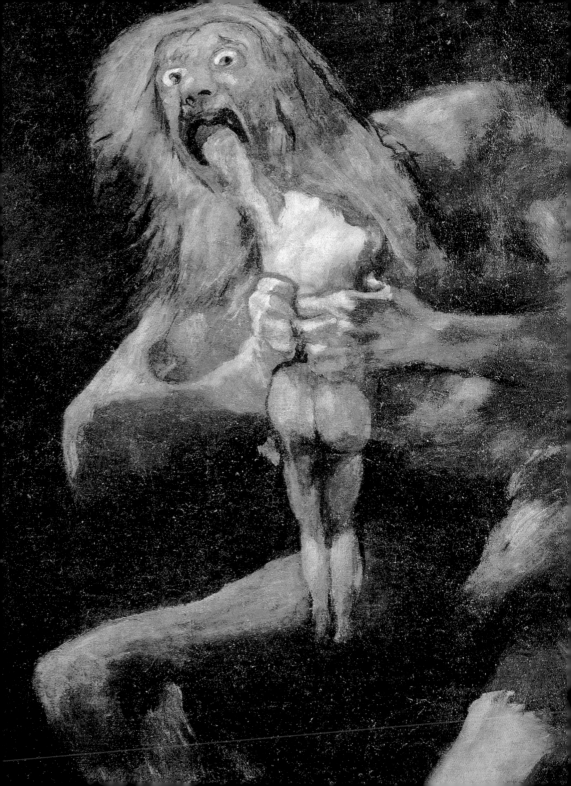

JACQUES-LOUIS DAVID

Born: Jacques-Louis David, August 30, 1748 (Paris, France); died December 29, 1825 (Brussels, Belgium).

Artistic style: Neo-classical painter of portraits and historical subjects; somber and moralizing tone; political propaganda; radical political views.

The influence of Jacques-Louis David's work was profound and widespread on the development of French art in the early nineteenth century; he was one of the country's leading artists. His work began under the influence of painters François Boucher and Jean-Honoré Fragonard and it came to represent a definitive change in direction of the arts, culminating in the progression of a form of neo-classicism that became the antithesis of the French rococo tradition. However, David's work fell from favor after his death and did not come to public attention again until after World War II.

Masterworks

Belisarius Receiving Alms 1781 (Palais des Beaux Arts, Lille, France)

Oath of the Horatii 1784 (Musée du Louvre, Paris, France)

The Death of Marat 1793 (Musée d'Art Ancient, Musées Royaux des Beaux-Arts, Brussels, Belgium)

The Sabine Women 1799 (Musée du Louvre, Paris, France)

Napoleon Crossing the Alps 1801 (Château National de Malmaison, Malmaison, France)

Mars Disarmed by Venus and the Three Graces 1824 (Musée d'Art Ancient, Musées Royaux des Beaux-Arts, Brussels, Belgium)

ABOVE: In *Self-Portrait* (1794) David was in his forties, but he appears much younger.

RIGHT: *Napoleon Crossing the Alps* was closely dictated by the emperor himself.

1700-99

David trained in the studio of painter Joseph-Marie Vien from 1766. He also attended lessons at the Académie Royale, an institution that he later rejected. In 1775, he traveled to Rome with Vien and stayed for five years, during which time he made studies of classical works as well as studying the paintings of Michelangelo Merisi da Caravaggio, Guido Reni, Annibale Carracci, and Nicolas Poussin. This was an important period for David's development because he fully began to compound the classical with the precedent of the Old Masters, creating a simple, somber, and elegant synthesis of the real and ideal. He returned to Paris in 1780 and produced what is his first clearly mature work, *Belisarius Receiving Alms* (1781). He then produced the austere *Oath of the Horatii* (1784); balanced and cerebral, it epitomized the rationale of the neo-classical. Less celebrated, although of equal importance, are his portraits and mythological subjects made during the 1780s. These works represent a change in approach, reflecting a lighter touch and palette, and more discernible emotion, while retaining purity of line and form.

David became increasingly politicized in the 1790s and went into self-imposed exile, fleeing to Brussels after Napoleon's defeat at Waterloo in 1815. His final years saw his style develop with an increasing use of brilliant, jewel-like color and a return to mythological subjects and portraiture. **TP**

ABOVE LEFT: The theme of *The Sabine Women* is love over conflict.

ABOVE: *Death of Marat* is a glorified account of the murder of the revolutionary leader.

A Political Painter

Strongly revolutionary and a stout republican, Jacques-Louis David aligned himself with one of the leaders of the French Revolution, Maximilien Robespierre. After Robespierre was executed in 1794, David himself was imprisoned briefly. Despite this, he continued to paint and produced *The Sabine Women* (1799), with its complicated figural composition. David then rallied to Napoleon Bonaparte and painted the strident *Napoleon Crossing the Alps* (1801)—a suitably heroic and impassioned portrait conveyed within linear classical precision.

UTAMARO

Born: Kitagawa Ichitaro, *c.*1753 (possibly Tokyo, Japan); died 1806 (Tokyo, Japan).

Artistic style: Painter and woodblock printmaker; master of *bijin-ga* form of *ukiyo-e*; stylized female figures; subtle, natural colors on mica-dust background; cropped compositions.

Woodblock printing, although originating in China, attained a uniquely high degree of technical skill and artistic achievement in Japan during the Edo Period (1600–1868). At this time the most popular prints were the *ukiyo-e* (pictures of the floating world) genre that celebrated the leisure activities of an emerging urban bourgeoisie. Like modern *manga*, *ukiyo-e* were cheap, mass-produced, and readily available; in a feudal and duty-bound society they provided a window on a world of idle and sometimes disreputable pleasure.

Kitagawa Ichitaro, who would adopt the *gō*, or art name, pseudonym "Utamaro," was born at an interesting time when printing was in transition away from monochrome (or two-color) processes, and he would become recognized as a master of the new polychrome methods. After studying painting under Toriyama Sekien, Utamaro worked for the famous publisher Tsutaya Jūzaburō before, in the 1790s, he began to produce a series of magnificent *bijinga*, or courtesan, pictures that cemented his reputation.

Utamaro's slender, elongated female figures were idealized portraits that demonstrated an unrivaled adeptness with natural color. His innovative half-length and *okubi-e*, or close-up of a head, compositions, frequently of women engaged in everyday matters, emphasized the suggestion of great intimacy with his models, many of whom were from the streets of the Yoshiwara brothel district in Edo. Utamaro also produced distinguished nature studies, and vigorous contributions to the *shun-ga* genre of erotica. When Japanese prints began to reach the West in large numbers, the work of Utamaro, Katsushika Hokusai, and others was to have a profound impact on the development of European modernism. **RB**

Masterworks

Lovers in an Upstairs Room of a Teahouse from "Poem of the Pillow" 1788 (Victoria & Albert Museum, London, England)

The Waitress Okita of the Naniwaya Teahouse c.1792–1793 (Minneapolis Institute of Arts, Minneapolis, Minnesota, U.S.)

The Courtesan Konosumi c.1793–1794 (Minneapolis Institute of Arts, Minneapolis, Minnesota, U.S.)

The Coquettish Type from "Ten Physiognomic Types of Women" c.1795 (Tokyo National Museum, Tokyo, Japan)

"The nature of life is embedded in true paintings of the heart."

—Toriyama Sekien, on Utamaro

ABOVE: *Courtesan Applying Lip Rouge* (date unknown) is at the British Library in London.

THOMAS BEWICK

Born: Thomas Bewick, August 1753 (Mickley, England); died November 8, 1828 (Gateshead, England).

Artistic style: Naturalist and illustrator who revived and refined the art of woodcut engraving; master of vividly detailed vignettes of mammals, birds, and fish.

Bewick started out as a printer's apprentice. Woodcut prints were considered fit only for apprentice pieces, but in Bewick's skilled hands they became miniature works of art. His detailed wood engravings enabled him to combine two trends in eighteenth-century publishing: natural history and the use of miniature illustrations, or "vignettes." He published his own volumes of natural history, enlivening each chapter with vignette tailpieces depicting anecdotal scenes of rural life. Contemporary readers were enthralled by his illustrations, as was the heroine of *Jane Eyre* (1847) by his *History of British Birds* (1797–1804). His original volumes may now be difficult to find, but his legacy lives on in the work of Beatrix Potter. **SC**

Masterworks

The Chillingham Bull 1789 (Victoria & Albert Museum, London, England)

Waiting for Death 1828 (Newcastle Library, Newcastle-upon-Tyne, England)

Books of Engravings

A General History of Quadrupeds 1790

History of British Birds, Vol. 1, Land Birds 1797

History of British Birds, Vol. 2, Water Birds 1804

1700-99

JOHN FLAXMAN

Born: John Flaxman, July 6, 1755 (York, England); died December 9, 1826 (London, England).

Artistic style: Sculptor, pottery designer, illustrator, and draftsman; simple, strong outlines; classical references; sharply molded graphical forms; mythical themes.

John Flaxman studied sculpture at the Royal Academy and then joined the workshop of Josiah Wedgwood. A fascination with Grecian design and austere classical form informed his work throughout his career. After leaving Wedgwood, Flaxman traveled to Italy, absorbing a variety of classical and Renaissance influences. In the 1790s, he published a series of striking and stylized line illustrations for *The Odyssey* (*c.*800/600 B.C.E.) and *The Iliad* (*c.*800/700 B.C.E.). Flaxman later earned a number of important commissions, including the *Statue of Nelson* in St. Paul's Cathedral and the *Lord Mansfield Monument* in Westminster Abbey. His unique outline drawings of classical works were especially popular with British patrons in Rome. **PS**

Masterworks

Apollo and Marpessa 1790–1794 (Royal Academy, London, England)

Jupiter sending the Evil Dream to Agamemnon 1792–1793 (Royal Academy, London, England)

Lord Mansfield Monument 1801 (Westminster Abbey, London, England)

Mercury Descending with Pandora 1804–1805 (Ny Carlsberg Glypthotek, Copenhagen, Denmark)

Statue of Nelson 1808 (St. Paul's Cathedral, London, England)

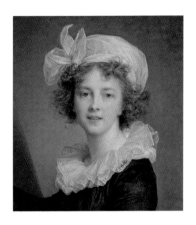

ÉLISABETH VIGÉE-LE BRUN

Born: Marie Élisabeth-Louise Vigée, April 16, 1755 (Paris, France); died March 30, 1842 (Paris, France).

Artistic style: Neo-classical portraitist of nobility; charming portrayals of children; depiction of contemporary fashion; lively, elegant poses; coquettish femininity.

Masterworks

Peace Restoring Abundance 1780
(Musée du Louvre, Paris, France)

Self-Portrait in a Straw Hat 1782
(National Gallery, London, England)

Madame Molé-Reymond 1786
(Musée du Louvre, Paris, France)

The Marquise de Pezay and the Marquise de Rougé with Her Two Sons 1787 (National Gallery of Art, Washington, D.C., U.S.)

Queen Marie-Antoinette and Her Children 1787 (Chateau de Versailles, Versailles, France)

Madame Perregaux 1789 (Wallace Collection, London, England)

Madame Vigée-Le Brun with Her Daughter, Jeanne-Lucie-Louise 1789 (Musée du Louvre, Paris, France)

"I continued to paint furiously, sometimes taking three sittings in a single day."

ABOVE: *Self-Portrait* (1790), painted before Vigée-Le Brun was forced to flee Paris.

Much is known regarding the life of Élisabeth Vigée-Le Brun thanks to her memoirs published in 1835, which give an intimate account of her experiences as portraitist to the French court. Her portraits were in demand from the 1770s, and she received regular royal commissions from 1788. She painted Queen Marie-Antoinette at least thirty times, including the portrait at the Palace of Versailles, *Queen Marie-Antoinette and Her Children* (1787).

In 1781, Vigée-Le Brun had the opportunity to study the paintings of Sir Peter Paul Rubens in Flanders, which had a profound effect on her technique and palette. Her *Self-Portrait in a Straw Hat* (1782) is an homage to the seventeenth-century master, making reference to Rubens's painting *Le Chapeau de Paille* (1622–1625) (*The Straw Hat*). This self-image exemplifies her style: in an understated but elegant pose, she paints herself in a flattering light, with her perfectly glossy lips parted as if about to utter a witty remark. The artist is known for her animated poses, particularly in portraits of women who appear to breeze into the picture, and for charming portrayals of children. Her keen interest in the most up-to-date fashions led her to design exotic costumes and headdresses to be worn by her sitters. In 1799, Vigée-Le Brun was forced to flee Paris to escape the violence of the French Revolution. She offered her services as portraitist to the courtly circles of Rome, Naples, Berlin, and St. Petersburg. Eventually returning to France in 1805, she continued to paint portraits, including on a trip to England that saw her receive commissions from various members of the nobility. She also wrote her memoirs, which, combined with her elegant portraits, are a fascinating record of a turbulent period in French history. **KKA**

GILBERT STUART

Born: Gilbert Charles Stewart, December 3, 1755 (Saunderstown, Rhode Island, U.S.); died July 9, 1828 (Boston, Massachusetts, U.S.).

Artistic style: Distinctly U.S. portraiture style; uncanny facial likenesses; captured the truth of sitters' personalities; masterful, fluid brushwork; glowing colors.

The "father figure" of U.S. portraiture was born the son of a Scottish snuff-mill worker. Early apprenticeships included a stint at the London studio of artist Benjamin West. By the 1780s Stuart had his own London studio and a waiting list of well-to-do sitters who admired his fluid reinterpretation of Thomas Gainsborough and Sir Joshua Reynolds. The first half of Stuart's life brought moves across the Atlantic, sometimes fleeing debts born of great extravagance. He finally settled in Boston in 1805, to become the major chronicler of the eminent men and women of a newly independent United States. These included six presidents, most famously the iconic image of George Washington later immortalized on the dollar bill. **AK**

Masterworks

The Skater (Portrait of William Grant) 1782 (National Gallery of Art, Washington, D.C., U.S.)

Mrs. Richard Yate 1793–1794 (National Gallery of Art, Washington, D.C., U.S.)

George Washington (the famous unfinished portrait) 1796 (jointly National Portrait Gallery, Smithsonian Institution, Washington, D.C., U.S., and Museum of Fine Arts, Boston, Massachusetts, U.S.)

Sarah Wentworth Apthorp Morton c.1800–1802 (National Portrait Gallery, Smithsonian Institution, Washington, D.C., U.S.)

Major-General Henry Dearborn 1812 (Art Institute of Chicago, Chicago, Illinois, U.S.)

JAMES GILLRAY

Born: James Gillray, August 13, 1756 (London, England); died June 1, 1815 (London, England).

Artistic style: Grotesque caricatures of King George III and Napoleon Bonaparte; political and social satire; first professional English cartoonist; expressive distortions.

James Gillray was the greatest, and most savage, of all the English caricaturists. His taste for this type of work may have stemmed from his strict, religious upbringing. In his youth, London print sellers were impressed with his humorous drawings of political figures. Satire was fashionable and Gillray's name soon became well known. For much of his career, Gillray wittily pilloried the celebrities of the day. King George III was portrayed as a bloated nincompoop; his wife, Queen Charlotte, became a toothy old hag; but Gillray's greatest venom was reserved for Napoleon Bonaparte. The artist transformed the great military leader into "Boney," a bug-eyed, manic dwarf, enveloped in a giant hat and boots. **IZ**

Masterworks

John Bull's Progress 1793 (National Portrait Gallery, London, England)

The Plum Pudding in Danger 1805 (Musée Carnavalet, Paris, France)

Tiddy-Doll, The Great French Gingerbread Maker, Drawing Out a New Batch of Kings 1806 (Leeds Museums and Galleries, Leeds, England)

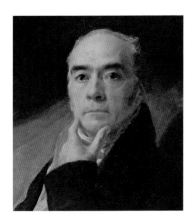

HENRY RAEBURN

Born: Henry Raeburn, March 4, 1756 (Stockbridge, Edinburgh, Scotland); died July 8, 1823 (Edinburgh, Scotland).

Artistic style: Leading Scottish artist of his age; founder of the Scottish School of Painting; sympathetic, original portraits; dramatic use of light.

Masterworks

Sir John Sinclair of Ulbster 1794
 (Location unknown)

The Reverend Robert Walker Skating on Duddingston Loch ("The Skating Minister") c.1796 (National Galleries of Scotland, Edinburgh, Scotland)

William Forbes of Callendar 1798
 (Scottish National Portrait Gallery, Edinburgh, Scotland)

Sir Henry Raeburn was one of the finest portrait painters of his age, working mainly in his native Scotland. His father was a mill owner in a village near Edinburgh, but the artist was orphaned at an early age and raised by his elder brother. In 1772, he was apprenticed to a goldsmith, although he also began painting miniatures at the same time. He seems to have had little formal training as an artist, but his ambitions were clear by 1784, when he traveled to Italy to further his career. By the time of his return in 1787, his style was fully developed.

Using Edinburgh as his base, Raeburn drew his clientele from two main sources: the soberly dressed Lowlanders, who formed the backbone of the Scottish Enlightenment, and a number of Highland chiefs, who were keen to be portrayed in their traditional garb. The wearing of tartan and other Highland regalia had been banned in the wake of Bonnie Prince Charlie's uprising in the 1740s. These measures were eventually repealed in 1782, producing an immediate demand for portraits in this costume. Raeburn frequently adopted a low viewpoint for such pictures, to lend them an added air of drama. Raeburn's technique was highly original. He painted directly onto the canvas without the preliminary drawings that most artists employed. He also strove for ambitious light effects, often placing his figures in front of the main light source so that their features were partly in shadow. His studio was fitted with a complex system of shutters, which enabled him to control the lighting. Raeburn's methods proved immensely successful, bringing him so many clients that, unlike most Scottish artists, he never felt the need to move to England. He was knighted in 1822, and appointed His Majesty's limner for Scotland in 1823. **IZ**

> "By a few skillfully managed touches, he produced striking light effects."—Cumberland Hill

ABOVE: This *Self-Portrait* from *circa* 1815 shows the artist in middle age.

THOMAS ROWLANDSON

Born: Thomas Rowlandson, July 14, 1756 (London, England); died April 21, 1827 (London, England).

Artistic style: Social caricatures of contemporary urban and rustic life; lively pen and watercolor drawings; curving, rococo lines; exaggerated physical types.

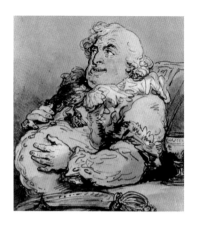

Rowlandson was a brilliant draftsman and watercolorist, yet his greatest assets were a keen observational eye and well-developed sense of humor. As a young man he underwent the classical training of the Royal Academy schools, where he was nearly expelled for firing a peashooter at a female model during a life class. This instinct for comic incident found a natural outlet in a prolific career mocking the foibles and vulgarities of human nature. In common with many cartoonists of the day, his early work focused on anti-Napoleonic themes, but his forte lay with social rather than political satire. He had a talent for conjuring gesture and expression in lively pen and watercolor drawings that are sometimes coarse and ribald, sometimes macabre and melodramatic, and at other times gently humorous and affectionate. They capture the spirit and character of the late Georgian era.

Some of Rowlandson's most famous series, such as the misadventures of the hapless cleric Doctor Syntax, were produced with publisher and printmaker, Rudolph Ackermann. Rowlandson also provided roguish illustrations to books by Henry Fielding, Oliver Goldsmith, and Laurence Sterne. Rowlandson's caricatures tend to differ from the moralizing flavor of William Hogarth's or the caustic bite of James Gillray, and are based on a subtle mockery and celebration of the ridiculous. The most distinctive feature of his style is the presentation of rustic or urban types rather than individuals, and the deliberate placement of physical contrasts within his pictures. Much of his humor is derived from the juxtaposition of character extremes such as young and old, grotesque and beautiful, and rich and poor, all entertainingly portrayed through the drawn line. **NM**

Masterworks

Vauxhall Gardens 1784 (Victoria & Albert Museum, London, England)

Skating on the Serpentine 1784 (National Museum of Wales, Cardiff, Wales)

The English Review, exh. 1786 (Royal Collection, Windsor Castle, England)

The Hunt Supper c. 1790 (Victoria & Albert Museum, London, England)

A Gaming Table at Devonshire House 1791 (Metropolitan Museum of Art, New York, U.S.)

The Exhibition "Stare-case," Somerset House c. 1811 (British Museum, London, England, and other collections)

"His invention, his humor, his oddity is exhaustless."

—W. H. Pyne, author, 1822

ABOVE: A Thomas Rowlandson caricature poking fun at himself.

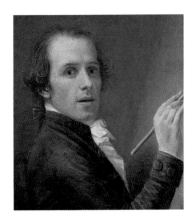

ANTONIO CANOVA

Born: Antonio Canova, November 1, 1757 (Possagno, Treviso, Italy); died October 13, 1822 (Venice, Italy).

Artistic style: Neo-classical sculptor; graceful sculptures with rich curves and delicate features; sepulchral monuments, busts, and nudes; mythological themes.

Masterworks

Orpheus 1770s (The Hermitage, St. Petersburg, Russia)

Psyche Revived by the Kiss of Love 1787 (Musée du Louvre, Paris, France)

The Graces and Venus Dance Before Mars c.1798 (Canova Museum, Possagno, Italy)

The Boxer Kreugas 1800 (Vatican Museum, Rome, Italy)

Napoleon 1806 (Apsley House, London, England)

Bust of Paris 1809 (Art Institute of Chicago, Chicago, Illinois, U.S.)

Dancer 1812 (The Hermitage, St. Petersburg, Russia)

Sleeping Nymph 1820–1824 (Victoria & Albert Museum, London, England)

A troubled child, whose father died when he was four years old and whose mother left him when she married a new husband and moved away, Antonio Canova grew up in his grandfather's house near Treviso in Italy. He never got over the sadness of these early years, and this sentiment and sensitivity was gracefully expressed in his sculpture. His grandfather, Pasino Canova, was a sculptor and a stonemason, and the young Antonio Canova grew up surrounded by a variety of tools and materials ideal for his own early work.

A popular story in circulation at the time was that the young Canova was reputed to have carved a superb figure of a lion from a pat of butter during a dinner party hosted by a senator, who subsequently became Canova's patron. Why, however, such a humble boy as Canova was at a senator's dinner party has been lost in the retelling.

In adulthood Canova became the principal sculptor of the neo-classical movement, having trained in Venice in sculpture and life drawing. He then traveled to Rome, where his reputation led to a number of important commissions, including two papal monuments. His work was soon in high demand, bought by patrons from across Europe, and Canova became the owner of a thriving studio and a sympathetic tutor to young artists. When Napoleon I came to power, Canova became his reluctant court sculptor. The result was some of Canova's most brilliant work, such as the superb naked statue *Napoleon* (1806) that was later given to the first Duke of Wellington and taken to his home at Apsley House in London. Canova resisted Napoleon's efforts to make him move to Paris. He died in Venice, that rarest of species: an artist recognized and applauded in his own time. **LH**

> "Italy … the country and native soil of the arts. I cannot leave; my infancy was nurtured here."

ABOVE: This light-hearted self-portrait was painted in 1792.

WILLIAM BLAKE

Born: William Blake, November 28, 1757 (London, England); died August 12, 1827 (London, England).

Artistic style: Painter, printmaker, engraver, and illustrator; biblical, mystical, and literary subject matter; themes of prophecy and imagination; personal mythology.

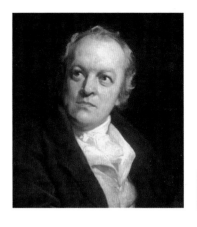

Mystic, visionary, saint, poet, prophet, painter, illustrator, and even mad: William Blake has been called all these things. Few artists could have created works such as *The Ghost of a Flea* (*c.*1819–1820) depicting a monstrous almost demonic figure—based on a vision he had had—and not be considered mentally unsound. Blake's elegant use of line, vivid color, fantastical figures, and wild imagination make his work fascinating, and the mythical universe he created compelling viewing.

As famous as a writer as an artist, his two professions were symbiotic. Although he illustrated works such as John Milton's *Paradise Lost* (1667) in 1808, he also illustrated his own poems such as *Songs of Innocence* (1790), integrating text into his illustrations that enhances, and sometimes alters, the meaning.

Blake spurned the contemporary vogue for academic art. He preferred to look back to the works of fifteenth-century artists such as Albrecht Dürer, Michelangelo Buonarotti, and Raphael, which supported his idea of art as a craft, together with a preference for a gothic use of line. Blake's work was also influenced by the revolutionary sensibility generated by the U.S. War of Independence and French Revolution, with their concepts of liberty and protest, as evident in works such as *Visions of the Daughters of Albion* (1793).

Above all, Blake was a devoutly religious man and claimed to see visions of angels, biblical prophets, and spirits. His spiritual devotion saw him illustrate *The Book of Job* (1823–1826), but his spiritual outlook was highly personal and stood apart from ecclesiastical convention; he invented his own mythology as seen in works such as *The First Book of Urizen* (1794). Puzzling though his oeuvre may be, whether it is the work of a madman or a genius, it is as mesmerizing as ever. **CK**

Masterworks

*The House of Death c.*1794–1805 (Tate Collection, London, England)

*Newton c.*1795–1805 (Tate Collection, London, England)

*Nebuchadnezzar c.*1795–1805 (Tate Collection, London, England)

*The Body of Christ Borne to the Tomb c.*1799–1800 (Tate Collection, London, England)

*Satan in his Original Glory c.*1805 (Tate Collection, London, England)

*The Ghost of a Flea c.*1819–1820 (Tate Collection, London, England)

Illustrated Books

Songs of Innocence and of Experience 1790

The Marriage of Heaven and Hell 1790–1793

Visions of the Daughters of Albion 1793

The First Book of Urizen 1794

"Art is the tree of life. Science is the tree of death. Art is the tree of life. God is Jesus."

ABOVE: *Portrait of William Blake* painted by Thomas Philips in 1807.

KATSUSHIKA HOKUSAI

Born: Tokitarō, September 23, 1760 (Tokyo, Japan); died April 18, 1849 (Tokyo, Japan).

Artistic style: Japanese painter, draftsman, and printmaker of eclectic moral tales, erotica, *ukiyo-e*, book illustrations, and landscapes; enormous production.

Masterworks

Fifty-Three Stations of the Tokaido Highway after 1803 (UCL Art Collection, University College London, London, England

*Woman Looking at Herself in the Mirror c.*1805 (Museum of Fine Art, Boston, Massachusetts, U.S.)

*The Great Wave of Kanagawa c.*1830–1832, (Metropolitan Museum of Art, New York, U.S.)

Thirty-Six Views of Mount Fuji 1831 (British Museum, London, England and elsewhere)

*Chinese Warrior on Horseback c.*1830–1840 (Fine Arts Museum of San Francisco, San Francisco, California, U.S.)

Katsushika Hokusai was perhaps one of the greatest Japanese artistic forces in the nineteenth century, and his influence was particularly profound on the work of the French Impressionists. He began his artistic training when he was fourteen years old, and apprenticed as a woodblock carver before entering the studio of Katsukawa Shunshō, a master of the *ukiyo-e* (pictures of the floating world) woodblock print that became the most popular Japanese genre of the time. The genre was noted for its bright color and decorativeness, often depicting a narrative and including animals, birds, and landscapes as well as people of the lower social classes, such as actors, courtesans, and wrestlers. Hokusai spent nineteen years under Shunshō, and referred to this period as a time that was truly inspirational in the development of his own visual language.

In 1795 he left Shunshō and affiliated himself with the Tawaraya school. He worked on illustrations and calendars as well as a series of *bijinga*, which were pictures of elegant, beautiful women. He set up independently in 1798, and during

ABOVE: This self-portrait, *The Old Man Mad About Drawing*, dates from *c.*1830.

RIGHT: This woodblock is from the *Fifty-Three Stations of the Tokaido Highway* series.

1700-99

this time he developed his *ukiyo-e* pictures, bringing together eclectic influences from the West, China, and Japan. He also illustrated books, often in black and white, and invariably produced images with a moral tone or highly dramatic scenes. In *circa* 1811, the artist embarked on one of his most famous series, the fifteen-volume *Hokusai Manga*. It comprised drawings and paintings wrought with fine, energetic strokes, depicting fantastic scenes as well as scenes from everyday life.

By 1820 Hokusai had gained a considerable level of success in Japan. Toward the end of his career, he produced some of his most widely acclaimed works, including the much-reproduced *Thirty-Six Views of Mount Fuji* (1831). There are actually forty-six images, and they represent some of the finest of his career, being the culmination of his mature style that combined realistic detail with imaginary views. Hokusai continued to work almost until the day he died. **TP**

ABOVE: The waves of *The Great Wave of Kanagawa* frame Mount Fuji in the distance.

Improving with Age

Katsushika Hokusai was a truly eccentric artist. He believed that nothing he did before the age of seventy was worthy of artistic merit and that from this age on his work improved. It was his great regret that he died at eighty-nine years old and he famously announced on his deathbed that with another five years, he could have really made it as an artist. It was his wish to live to 130 years or more. He believed that by this age everything he painted would come alive under his brush. As it was, Hokusai enjoyed critical acclaim during his lifetime but seems not to have accrued much financially.

JOHANN GOTTFRIED SCHADOW

Masterworks

Graf Alexander von der Mark (tomb) 1790
(Dorotheenstädtische Kirche,
Berlin, Germany)

*Quadriga (four-horse chariot) of Victory,
Brandenburg Gate* 1793 (Unter den Linden,
Berlin, Germany) (Copy in place now after
serious WWII damage)

General von Zieten 1794 (Bodemuseum,
Berlin, Germany)

The Princesses Luise and Friederike 1797
(Alte Nationalgalerie, Berlin, Germany)

Friedrich Gilly 1801 (Akademie der Künste,
Berlin, Germany)

Goethe 1823 (Alte Nationalgalerie,
Berlin, Germany)

Born: Johann Gottfried Schadow, May 20, 1764 (Berlin, Germany); died January 27, 1850 (Berlin, Germany).

Artistic style: Sculptor of monuments and portraits; typically worked in marble; combined classical refinement with a Baroque liveliness.

The Berlin of Johann Gottfried Schadow's day was the glittering capital of the powerful Prussian Empire. In 1788 he became its principal court sculptor, and in 1816 director of the Berlin Academy. Schadow's work was broadly neo-classical, but he added a livelier, more modern feel to antique traditions—seen clearly in his touching, naturalistic piece *The Princesses Luise and Friederike* (1797)—and founded a distinctive school of nineteenth-century Berlin sculpture in the process. One early influence was the Baroque work of Jean-Pierre-Antoine Tassaert, to whom he was apprenticed when young. When his eyesight began to deteriorate, Schadow's later career saw a greater focus on teaching and writing about art theory. **AK**

CONSTANCE MARIE CHARPENTIER

Masterworks

Scene of Family Life 1796 (Private collection)

Melancholy 1801 (Musée de Picardie,
Amiens, France)

Born: Constance Marie Blondelu, 1767 (Paris, France); died 1849 (Paris, France).

Artistic style: Highly regarded by her contemporaries as a painter of portraits and genre subject matter; empathetic interpretation of her sitters; simplicity; high finish.

Few of Constance Marie Charpentier's works have survived and little is known about her life, except that she studied with François Gérard and Jacques-Louis David. Her most famous work, *Melancholy* (1801), is neo-classical in style and has a romantic and charming lack of certainty. She exhibited at the Paris Salon from 1795 to 1819, during which time she received recognition in the form of a Prix d'Encouragement and a gold medal. Since then, her reputation has suffered through misattribution and neglect. *Portrait of Mademoiselle Charlotte du Val d'Ognes* (1801), once thought to be by David, was attributed to Charpentier in 1951, resulting in immediate devaluation. After a fierce debate, the work has since been attributed to Marie-Denise Villers. **WO**

BERTEL THORVALDSEN

Born: Albert Bertel Thorvaldsen, *c.*1768 (Copenhagen, Denmark); died March 24, 1844 (Copenhagen, Denmark).

Artistic style: Neo-classical sculptor; reliefs, monuments, and portrait busts in marble and bronze; mythological and religious themes; rhythmic sense of line.

Neo-classical sculptor Bertel Thorvaldsen loved the classical, so much so that he was an avid collector of antique artifacts. His love affair with the ancient was developed during his forty-year sojourn away from his native Denmark, spent in Rome. He created reliefs, monuments, and portrait busts in marble and bronze, and his work was highly sought after in Europe. Such was his reputation as a giant in his field that sculpture in Denmark fell into the doldrums after his death in 1844, and almost everything produced by his countrymen was a reaction to his oeuvre, both negatively and positively for some time.

Born the son of an Icelandic woodcarver, Thorvaldsen's talent was evident at a young age, and he was admitted to the Royal Danish Academy of Fine Arts in Copenhagen at eleven years old. In 1793 he was awarded the Major Gold Medal and a bursary that allowed him to travel and complete his studies: he left Denmark in 1797 and settled in Rome. There he was influenced not only by his surroundings, but by archeologists and fellow artists caught up in the craze for the classical that saw the arrival of neo-classicism in contemporary European art. Thorvaldsen began to produce works on mythological themes indebted to the sculptures of the ancient Greeks, such as *Jason and the Golden Fleece* (1803). The artist was soon in demand across Europe, and in later life received many commissions for monuments of national figures, which he frequently portrayed in classical poses.

When Thorvaldsen returned to live in Denmark in 1838, he organized for his collection of classical antiquities, various works, and his original plaster models to be left to the nation. The Thorvaldsen Museum was built in Copenhagen to house these gifts, but sadly the artist died a week before it opened. **CK**

Masterworks

Jason and the Golden Fleece 1803 (Thorvaldsen Museum, Copenhagen, Denmark)

Alexander the Great's Triumphal Entry into Babylon 1812 (Palazzo del Quirinale, Rome, Italy)

Lion of Lucerne 1819 (Lucerne, Switzerland)

Nicolaus Copernicus 1822 (Polish Academy of Sciences, Staszic Palace, Warsaw, Poland)

Monument to Pope Pius VII 1823–1831 (St. Peter's, Vatican City, Rome, Italy)

Prince Józef Poniatowski 1826–1827 (Presidential Palace, Warsaw, Poland)

Johann Gutenberg 1833–1834 (Mainz, Germany)

Christ 1839 (Cathedral Church of Our Lady, Copenhagen, Denmark)

"Thorvaldsen's life represented the romanticism of the 18th and 19th centuries."—*Frommer's*

ABOVE: This portrait of Thorvaldsen was painted by Christoffer-Wilhelm Eckersberg.

CASPAR DAVID FRIEDRICH

Born: Caspar David Friedrich, 1774 (Greifswald, Germany); died 1840 (Dresden, Germany).

Artistic style: Best-loved member of the German romantic movement; symbolic and atmospheric treatment of landscape; concern for man's place within the world.

Masterworks

Cross in the Mountains, The Teschen Altar 1808 (Gemäldegalerie Neue Meister, Dresden, Germany)

*Wanderer above the Sea of Fog c.*1818 (Hamburger Kunsthalle, Hamburg, Germany)

The Polar Sea 1824 (Hamburger Kunsthalle, Hamburg, Germany)

*Stages of Life c.*1835 (Museum der Bildenden Künste, Leipzig, Germany)

Caspar David Friedrich was the most important landscape painter of the romantic movement. Born the son of a soap and candle maker of strict Lutheran faith in Greifswald, a small harbor town on the Baltic Sea, his youth was filled with personal tragedy. His mother died of smallpox when he was seven years old, his sister succumbed to typhus, and in 1787 his brother drowned while trying to rescue him when he fell through ice. These sad events are still seen by many as the reason for his melancholic disposition and the spiritual appeal of his landscapes.

At the age of twenty, Friedrich began his artistic training at the Academy of Copenhagen, and by 1798 he had settled in Dresden, where he would spend the rest of his life. At the time famous for its art collections, Dresden was also the center of the romantic movement in Germany, whose poets and thinkers, along with the artist Philipp Otto Runge, would greatly influence Friedrich.

Coming to the realization that landscape could be a vehicle for spiritual revelation, Friedrich's first great work was *Cross in the Mountains, The Teschen Altar* (1808); its subject was one that he would return to time and again. This work, in common with his other landscapes, is filled with the intense and poetic depictions of northern European scenery, and painted in a meticulous and deliberately formal style. Although based on direct observation, his landscapes do not aim to reproduce nature faithfully, but to produce a dramatic and memorable effect. Although his images have become a byword for a melancholic contemplation of the world, his attitude to landscape was, at the time, not just a personal outlook but a fashion of the period. **AB**

> "Close your bodily eye, that you may see your picture first with the eye of the spirit."

ABOVE: *Self-Portrait with Cap and Eye Patch* was sketched on May 8, 1802.

J. M. W. TURNER

Born: Joseph Mallord William Turner, April 23, 1775 (London, England); died December 19, 1851 (London, England).

Artistic style: Landscapes exploring the effects of light, sunsets, or sunrises; indistinct, hazy forms; virtuoso watercolors; emotional and intense use of color.

Joseph Mallord William Turner rose from humble beginnings to become one of the most successful artists of the nineteenth century and, arguably, the greatest landscape painter of all time. Overcoming such social disadvantages as his cockney roots and a mentally unstable mother, the young Turner joined the prestigious ranks of the Royal Academy of Art Schools. By the age of just fifteen, he had progressed from displaying his drawings in the window of his father's Covent Garden barber shop to exhibiting professionally at the Royal Academy, where he quickly established a reputation for himself as an accomplished painter of topographic views in watercolor.

His prodigious talent was matched by huge ambition and, as Turner matured, his work increasingly demonstrated a desire to break new ground and to challenge the accepted hierarchies of art. In particular, he was concerned with raising the profile of landscape and demonstrating to the world its versatility and expressive power. The originality of his approach lay in his translation of a view. Turner was not merely concerned with depicting the local details of a place but, instead, described

Masterworks

Tintern Abbey c.1795 (British Museum, London, England)

Sun Rising Through Vapour: Fishermen Cleaning and Selling Fish pre-1807 (National Gallery, London, England)

Snow Storm: Hannibal and his Army Crossing the Alps c.1812 (Tate Collection, London, England)

Frosty Morning c.1813 (Tate Collection, London, England)

Dido Building Carthage, or The Rise of the Carthaginian Empire 1815 (National Gallery, London, England)

Sketch for a "Rivers of England" series, drawing of Durham Cathedral c.1824 (Tate Collection, London, England)

The Fighting Temeraire Tugged to her Last Berth to Be Broken Up 1839 (National Gallery, London, England)

Slave Ship: Slavers Throwing Overboard the Dead and Dying—Typhoon Coming 1840 (Museum of Fine Arts, Boston, Massachusetts, U.S.)

The Blue Rigi, Sunrise 1842 (Tate Collection, London, England)

ABOVE: This portrait of Turner is by Cornelius Varley (1781–1873).

LEFT: *Dido Building Carthage* shows greater attention to detail than much of Turner's art.

Storm in a Teacup

Although he is now recognized as a modern master, Turner's late oil paintings were not always held in high regard. One of his most controversial paintings was *Snow Storm—Steam-Boat Off a Harbour's Mouth* (1842), a dramatic evocation of a steamboat caught in the vortex of a storm. According to popular anecdote, it is almost certainly apocryphal.

- The scene is said to record Turner's own experience of being tied to a ship's mast during a storm.
- Contemporary viewers were unprepared for the painting's indistinct appearance, derisively labeling it "Soapsuds and whitewash!" and advising Turner to wait next time until the storm had cleared off.
- The critic of *The Athenaeum* denounced the artist who chose "to paint with cream or chocolate, yolk of egg or currant jelly" and here "uses his whole array of kitchen stuff. Where the steam-boat is, where the harbour begins, or where it ends . . . are matters past our finding out."
- Such negative publicity inspired the writer and art critic John Ruskin to champion the artist in his controversial publication *Modern Painters* (1843), a famous and intellectual vindication of Turner's art. Ruskin described *Snow Storm* as "one of the very grandest statements of sea-motion, mist, and light that has ever been put on canvas."

how atmospheric effects transformed the scene and the emotional impact aroused within the viewer. Drawing upon his own observations of the world, he conjured authentic naturalistic effects of weather, water, and, above all, the spectacle of light in all its infinite variety.

Broadening his horizons

As his contemporary John Constable noted, Turner had "a wonderful range of mind" and the scope of his professional activity was extraordinary. Blending intellect and learning with his passion for landscape, he explored themes from history and classical mythology, politics, literature, and art. He was also intensely interested in the world in which he lived, confronting contemporary events such as the Battle of Waterloo and the arrival of steam power. Unusually for an artist of his stature, he devoted his energies equally between oil and watercolor, and the practice of one often helped the other. The result was an unfettered and unorthodox approach to painting that saw him push the boundaries of both media to startling effect and to develop ways of working that reflected his obsession with light. In particular, he perfected the use of limpid wet washes of pure color that produced nebulous visual effects. Consequently, his most bewitching paintings are those where the haziness and intangibility of his technique provides a perfect vehicle for the insubstantiality of a subject, for example *Rain, Steam, and Speed—The Great Western Railway* (*c.*1844) and the ravishingly vaporous late paintings of Venice.

In an age that saw the birth of tourism and modern forms of transport, he was possibly one of the most well-traveled artists of his day. His hunger for stimulating subject matter was insatiable, and every year he embarked on a summer sketching tour for fresh visual material. The Napoleonic Wars restricted his early travels to native shores, but in later years he journeyed ever farther: to France, the Netherlands, Germany, and the golden country of every artist's dreams, Italy. His most beloved destination was Switzerland, a landscape that offered a perfect "Turnerian" combination of mountains, lakes,

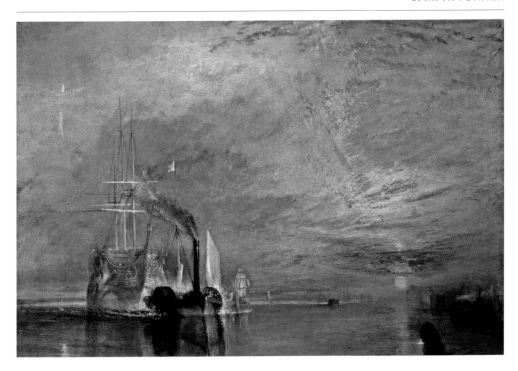

architecture, and soft, clear light. The luminous beauty of the late Swiss watercolors, such as *The Blue Rigi, Sunrise* (1842), represents the pinnacle of artistic expression in that medium, transforming landscape from the particular to the universal and from the earthly to the metaphysical.

ABOVE: Painted in his sixties, *The Fighting Temeraire* was one of Turner's favorite works.

For a man who achieved such fame and fortune, Turner left frustratingly few written records. The greatest sources of information, therefore, are his works. Complications with his will led to the transfer to the nation of the entire contents of his studio: around 280 oil paintings; thousands of watercolors, drawings, and preparatory studies; and almost 300 sketchbooks. Housed at Tate Britain's Clore Gallery, London, the Turner Bequest represents a unique insight into his life and working practices. **NM**

"He seems to paint with tinted steam, so evanescent and so airy."—John Constable

JOHN CONSTABLE

Born: John Constable, 1776 (East Bergholt, England); died 1837 (London, England).

Artistic style: Landscape painter; direct observations of nature; atmospheric effects of changing light and weather using rapid brushstrokes; large scale; application of pure pigment.

Masterworks

The Bridges Family 1804 (Tate Collection, London, England)

The Hay Wain 1821 (National Gallery, London, England)

The Leaping Horse 1824 (Royal Academy, London, England)

Salisbury Cathedral from the Bishop's Grounds c.1825 (Metropolitan Museum of Art, New York, U.S.)

The Vale of Dedham 1828 (National Gallery of Scotland, Edinburgh, Scotland)

Hadleigh Castle 1829 (Yale Center for British Art, New Haven, U.S.)

Cenotaph to the Memory of Sir Joshua Reynolds 1833–1836 (National Gallery, London, England)

ABOVE: *Portrait of John Constable aged 20* **(1796) by Daniel Gardner.**

> "When I sit down to sketch from nature . . . I try to forget I have ever seen a picture."

ABOVE RIGHT: Love it or hate it, *The Hay Wain* is renowned worldwide.

RIGHT: Constable's best works were often of places he loved, such as *Salisbury Cathedral*.

An admirer of Claude Lorrain, Thomas Gainsborough, and Dutch landscapists, John Constable is ranked with Joseph Mallord William Turner as one of the greatest British landscape artists. Unlike Turner, he was not financially successful, and sold only twenty paintings in England in his lifetime, although he had greater success in France.

The son of a successful merchant and farmer, Constable began working in the family business in 1792, but in 1799 he entered the Royal Academy schools. He first exhibited at the Royal Academy in 1802, but his paintings of the landscapes of his childhood were ordinary in comparison with the Grand Manner idyllic landscapes of biblical and mythological scenes that were fashionable, and he was not awarded full membership of the Royal Academy until 1829.

He based his paintings on sketches made directly from nature: clouds, trees, and the effects of changing light. He never went abroad, usually working close to home in the open air, sketching full size in oil, and using the sketch as a model for the painting in his studio. He called his larger scenes "six-footers." Landscapes had never before taken on such proportions for their own sake. In 1816 Constable's father died, leaving him an inheritance. His wife had poor health so, from 1819, they began renting a house in the popular area of Hampstead, London. There he made studies of cloud formations, numerous oil sketches, and finished paintings. In 1824, three of his works were exhibited at the Paris Salon. One of them, *The Hay Wain* (1821), won a gold medal—attaining the success in France that eluded him at home. His works greatly influenced French artists, including Eugène Delacroix and painters of the Barbizon school. **SH**

JEAN-AUGUSTE DOMINIQUE INGRES

Born: Jean-Auguste Dominique Ingres, August 29, 1780 (Montauban, France); died January 14, 1867 (Paris, France).

Artistic style: Neo-classical portrait and narrative painter; serpentine lines; idiosyncratic style; smooth-skinned women; disregard for underlying anatomy.

Masterworks

Mademoiselle Caroline Rivière 1806
(Musée du Louvre, Paris, France)

Napoleon I on His Imperial Throne 1806
(Musée de l'Armée, Paris, France)

The Bather, known as *The Valpinçon Bather*
1808 (Musée du Louvre, Paris, France)

Jupiter and Thetis 811 (Musée Granet,
Aix-en-Provence, France)

The Grand Odalisque 1814 (Musée du Louvre,
Paris, France

Madame Moitessier 1856 (National Gallery,
London, England)

The Turkish Bath 1862 (Musée du Louvre,
Paris, France)

Originally from the south of France, Jean-Auguste Dominique Ingres arrived in Paris *circa* 1796 to study under the great neo-classical painter Jacques-Louis David. By 1801 he had won the coveted Prix de Rome and was soon receiving portrait commissions from Napoleon Bonaparte. Although working in a conventional portrait manner in this early period, Ingres's work already showed signs of his oddly idiosyncratic style. The large *Napoleon I on His Imperial Throne* (1806) is unashamedly hieratic and awkward in its reference to antique sources.

Ingres lived in Rome for fourteen years from 1806, drawing from ancient sculpture and ruins, and selling portraits to members of the French colony there. In Rome, he produced his

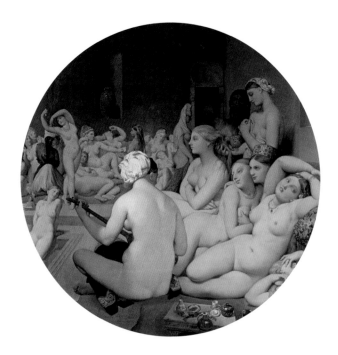

ABOVE: This self-portrait was painted in 1865, just a couple of years before he died.

RIGHT: The round canvas echoes the curves of the female bodies in *The Turkish Bath*.

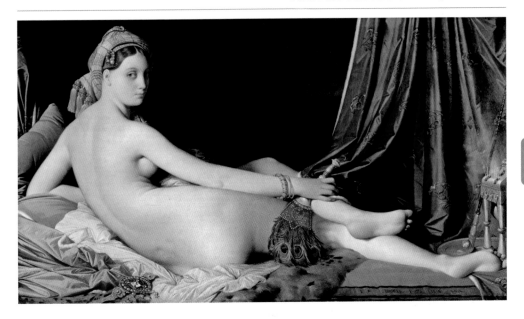

first female nude, *The Bather,* known as *The Valpinçon Bather* (1808), followed by *The Grand Odalisque* (1814). There is no escaping the elongations and distortions that Ingres knowingly applied to these idealized nudes in order to achieve the sensual flowing contours he sought. Ingres delighted in the outline of forms: fixing a profile, the nape of the neck, or the turn of a foot in one perfectly judged pencil line. A great admirer of High Renaissance painting, the work of Agnolo Bronzino and the influence of mannerism is clear in his nudes.

Success in France finally came in 1824. *Vow of Louis XIII* (1824), the showstopper of the Paris Salon that year, established Ingres as official painter to the newly restored monarchy. In a triumphant return to Paris, he received the cross of the Légion d'Honneur in 1825 and became a professor at the Paris École des Beaux-Arts in 1826. Although Ingres's ceiling cycle of *The Apotheosis of Homer* (1827) in the Louvre confirms the heights of his success, he is best known for his smaller portraits and nudes in oriental settings. They are some of the most curiously sensuous images of the female body of all time. **KKA**

ABOVE: The subject twists her torso away from the viewer in *The Grand Odalisque*.

The Turkish Bath (1862)

One painting has been seen by many as the epitome of Ingres's work. The aging artist seems to have worked on this composition for approximately ten years. Crowded with idealized female nudes, the women typify what the name Ingres has come to stand for: the female body treated as a somewhat passive, boneless entity, with a focus on flawless surface and distorted anatomy. Much has been written about the voyeuristic, peephole quality of this painting, which can disturb with its oriental air as much as it can delight with its sumptuousness and near surrealism.

JOHN SELL COTMAN

Born: John Sell Cotman, May 16, 1782 (Norwich, England); died July 24, 1842 (London, England).

Artistic style: Expressive landscape watercolors particularly of Wales, Norfolk, and Yorkshire; semi-abstract transcription of natural form; flat, clearly defined planes.

Masterworks

On the Greta c.1805–1806 (Tate Collection, London, England)

The Drop Gate, Duncombe Park c.1806 (British Museum, London, England)

Greta Bridge c.1807 (British Museum, London, England)

Norwich Market Place c.1809 (Tate Collection, London, England)

Palais de Justice and the Rue St. Lo c.1817–1818 (Victoria & Albert Museum, London, England)

Mont St. Michel 1828 (Manchester City Art Galleries, Manchester, England)

Cader Idris c.1835 (Norwich Castle Museum, Norwich, England)

A contemporary of James Mallord William Turner and a leading exponent of the golden age of British watercolor, John Sell Cotman was born in Norwich and moved to London in 1798 at age sixteen. Despite little apparent training before this time, by 1800 he was awarded the prestigious Greater Silver Palette of the Society of Arts and was exhibiting landscapes at the Royal Academy.

Material for his paintings was gathered on regular sketching tours, the most famous and productive of which was a trip to Yorkshire in 1805. Here he explored the wooded beauties of Rokeby Park near the River Greta, and the resulting watercolors represent some of the finest and most original achievements in the medium. Cotman also painted in oil and forged a reputation as an etcher of architectural subjects, with print series such as the *Architectural Antiquities of Normandy* (1822), earning him the title of "The English Piranesi."

In 1823, he returned to his birthplace and became a leading member of the Norwich school, an important group of landscape painters working and exhibiting in the city. Cotman's sons, Miles Edmund and John Joseph, were also associated with the school and their work is often similar in appearance and style to their father's. Cotman's originality lay with both his talent for pictorial composition and his developments in technique. He was one of the first artists to apply pure clear washes without any underpainting, and his distinctive works are characterized by flattened, simplified forms and a sense of pattern that, at times, appears almost abstract. In later life, he moved away from the cool tonality of his earlier palette and experimented with richer colors and textural watercolor thickened with flour paste. **NM**

> " . . . the most perfect examples of pure watercolor ever made in Europe."—Laurence Binyon

ABOVE: *Self-Portrait Holding the Book Normandie* is a pencil and watercolor work.

DAVID WILKIE

Born: David Wilkie, November 18, 1785 (Fife, Scotland); died June 1, 1841 (Bay of Gibraltar).

Artistic style: Genre painter; early work is small scale with subtle color and elegant, unpretentious brushwork; later work larger, with broad brushwork and rich color.

Sir David Wilkie studied in Edinburgh and at the Royal Academy in London. By 1806, he was established as a hugely popular genre painter and was made a Royal Academician in 1811. In 1822, the academy needed to erect barriers around one of his works to protect it from the admiring public. Suffering from ill health, Wilkie spent three years abroad. On his return in 1828, his style showed the influence of Spanish and Italian painting. Delicate brushstrokes, subdued colors, and clear tones were replaced with broad brushwork and deep colors. His new style attracted criticism, but in 1830 he became Painter-in-Ordinary to King George IV and was knighted in 1836. In 1840, he traveled to the Middle East, dying on the return voyage. **SH**

Masterworks

The Blind Fiddler 1806 (Tate Britain, London, England)

Chelsea Pensioners Reading the Gazette of the Battle of Waterloo 1816 (Apsley House, Wellington Museum, London, England)

Reading of the Will 1820 (Neue Pinakothek, Munich, Germany)

LOUIS DAGUERRE

Born: Louis-Jacques-Mandé Daguerre, November 18, 1787 (Cormeilles-en-Parisis, France); died July 10, 1851 (Bry-sur-Marne, France).

Artistic style: French inventor of the daguerreotype, an image-capturing process acknowledged as the most direct precursor to the modern photographic method.

When Louis Daguerre explained the silver-based chemical process behind the daguerreotype, the French government bought its copyright in exchange for a life pension, offering its use "to the world," and revolutionizing the way it would picture itself forever. An artist, chemist, and inventor of the Diorama device, featuring lighting effects and theatrical painting, Daguerre had spent a decade perfecting the process invented by Nicéphore Niépce (c.1826). Niépce's heliograph photographs needed long exposure times, making them unable to capture human subjects. With a much faster exposure and relative affordability, the daguerreotype catalyzed the popularity of portrait photography in the late nineteenth century. **LNF**

Masterworks

*Ruins of Holyrood Chapel c.*1824 (Liverpool Museums, Liverpool, England)

Interior of Rosslyn Chapel 1824 (Musées Haute Normandie, Normandy, France)

*Boulevard du Temple c.*1838 (Location unknown)

DAVID D'ANGERS

Born: Pierre-Jean David, March 12, 1788 (Angers, France); died January 6, 1856 (Paris, France).

Artistic style: Romantic sculptor; fused classicism and realism; important national figures in statues, sometimes nude; busts, reliefs, and medallions cast in bronze.

Masterworks

Pierre-François, Comte de Réal c.1820s (Private collection)

Bust of Rossini 1831 (Cleveland Museum of Art, Cleveland, Ohio, U.S.)

Portrait Medallion of Pigault Lebrun 1831 (Cleveland Museum of Art, Cleveland, Ohio, U.S.)

Thomas Jefferson 1832 (National Gallery of Art, Washington, D.C., U.S.)

Philopoemen 1837 (Musée du Louvre, Paris, France)

Panthéon Distributing Crowns to Genius 1837 (Paris, France)

Monument to General Jacques Gobert Date unknown (Père Lachaise Cemetery, Paris, France)

Despite being born into poverty, David D'Angers reinvigorated the renaissance tradition of the cast metal sculpture in nineteenth-century France. Using the physiological features of the face, his work reflected his subjects' life experiences and their psychological characteristics.

Although discouraged by his father, as a young man D'Angers was determined to study as a sculptor in Paris. He arrived in the city at the age of twenty, and went to study at the École des Beaux-Arts, under the teaching of Philippe-Laurent Rolands. Here he developed his style of neo-classicism, a preview to the Romantic style seen later in his career.

In 1815, D'Angers modeled his first portrait medallion, depicting French operatic composer Ferdinand Hérold. He later studied the antiquities in Rome, where he became acquainted with the work of Italian neo-classical sculptor Antonio Canova. After five years D'Angers returned to Paris at the time of the restoration of the Bourbons. This led to another departure; this time to London. His republican beliefs meant he was unable to stomach the royalist sentiment in France.

D'Angers did later return to Paris and, over the years, created many realistic medallions and busts, including representations of Victor Hugo, Thomas Jefferson, and Lord George Byron. His most famous works are his pediment of the *Panthéon Distributing Crowns to Genius* (1837), his monument to General Jacques Gobert in Paris's Père Lachaise Cemetery, and his marble *Philopoemen* (1837) in the Musée

"I have always been profoundly stirred by profile The profile is in relation to other beings."

ABOVE: D'Angers is depicted as having risen well above his impoverished background.

RIGHT: The bronze statue *Gutenberg* stands proud in a public square in Strasbourg.

du Louvre. D'Angers's legacy provides an impressive body of work, including more than 50 full-size statues, 150 busts, and some 500 or so portrait medallions of the era's major literary, political, and artistic figures. **KO**

THÉODORE GÉRICAULT

Born: Jean-Louis-André-Théodore Géricault, September 26, 1791 (Rouen, France); died January 26, 1824 (Paris, France).

Artistic style: Energetic brushwork, stirring passion and drama; bold mix of classical and baroque styles; macabre realism; use of contemporary subject matter.

Masterworks

*Charging Chasseur c.*1812 (Musée du Louvre, Paris, France)

Wounded Cuirassier Leaving the Field of Battle 1814 (Musée du Louvre, Paris, France)

*Raft of the Medusa c.*1819 (Musée du Louvre, Paris, France)

*Portrait of a Kleptomaniac c.*1820–1824 (Museum of Fine Arts, Ghent, Belgium)

The 1821 Derby at Epsom 1821 (Musée du Louvre, Paris, France)

This passionate, unconventional man, with a taste for dandyish dressing and horse riding, amply fills out his reputation as a pioneer of French romanticism. Théodore Géricault's middle-class family, who had no artistic background, moved to Paris during his boyhood. Finding a natural aptitude for art, he ignored initial parental objection and forged a career in which he achieved remarkable things within a tragically short time.

Early mentors of this restless student were Carle Vernet, who fed his talent for sporting art, and the classicist Pierre-Narcisse Guérin. Much of Géricault's early training was self-propelled, however, consisting of years spent copying the Louvre's Old Masters. He developed a particular passion for the baroque vigor of Sir Peter Paul Rubens. The classical thread was furthered by studying Michelangelo Buonarroti's work during a two-year stay in Italy from 1816.

Géricault was young and inexperienced when the *Charging Chasseur* (*c.*1812) won both a Paris Salon gold medal and the admiration of forward-thinking artists, who favored realism over rigid neo-classicism. He then won another medal with his masterpiece *Raft of the Medusa* (*c.*1819). This has been called

ABOVE: This self-portrait is in the Musée des Beaux Arts in Rouen.

RIGHT: Géricault depicted *The 1821 Derby at Epsom* with a very real sense of speed.

1700-99

the "manifesto" of Géricault's then-pioneering preoccupation with creating epic paintings from actual contemporary events. Controversially, he chose a recent shipwreck that was shrouded in possible governmental ineptitude and depicted it with a brutal realism blended with classical-style grandeur. The heroism comes from the human suffering, not the event itself.

Between 1820 and 1822 Géricault was in England, where showing his *Raft of the Medusa* to massive crowds assuaged some of the disappointment he felt at French criticism of the work. Back in France, he produced a set of remarkable late portraits depicting mental patients with a new humanity. This was yet another aspect of an incredibly varied career that embraced lithography as well as painting, and was impressive because it lasted for only twelve or so years. He died in his early thirties from waning health brought on by a series of riding accidents and a reckless, self-destructive bent. **AK**

In the Saddle

Géricault's death was hastened by severe spinal injuries caused by yet another bad fall from a horse. This ending seems fitting for an adventure seeker with a real passion for horses and riding. His work includes a high proportion of extremely accomplished pictures of horses, and the subject seems to bring out the essence of who he was. Just a glance at his *The 1821 Derby at Epsom* (1821) of sweat-shiny horses straining at ferocious speed over bare ground and under stormy skies shows the romantic at work, filling this not-so-remarkable event with energy, drama, movement, and potential danger.

GEORGE CRUIKSHANK

Born: George Cruikshank, September 27, 1792 (London, England); died February 1, 1878 (London, England).

Artistic style: Satirical political caricatures; comic prints chronicling social eccentricities and injustices; illustrations to works by Charles Dickens.

In a career that spanned more than seventy years George Cruikshank's incisive illustrations chronicled London society in all its colorful, grotesque variety. Following in the footsteps of his father, Isaac, he began producing political caricatures of Napoleon Bonaparte, the British government, and the royal family. He later turned his attention to social satire, coupling irreverent humor with a strong sense of morality and a desire for reform. In 1820, he collaborated with his brother Robert on *Life in London* (1821), a comic survey of low-life highjinks featuring the Regency characters Tom and Jerry. Meanwhile, his annual *Comic Almanac* (1835–1853) was a regular favorite with the public.

The bulk of Cruikshank's achievements lay in book illustration, and his plates enlivened the works of many popular authors including Sir Walter Scott and William Harrison Ainsworth. His pictures for *Grimm's Fairy Tales* (1812) were described by John Ruskin as the finest images in etching after Rembrandt van Rijn, but his most famous creative partnership was with the young Charles Dickens, at a time when the author was being described as "the Cruikshank of writers." The whimsical vignettes produced for *Sketches by Boz* (1836) and *Oliver Twist* (1838–1841) teem with detail and character, both mirroring and embellishing the accompanying text. In 1871, the artist controversially claimed the credit for the original idea behind *Oliver Twist*. During his fifties, Cruikshank become a teetotaler and a zealous campaigner for temperance reform. His artwork became a platform for his views, expounding the evils of drink in a print series called *The Bottle* (1847) and a vast visionary oil painting entitled *The Worship of Bacchus* (1860–1862). **NM**

Masterworks

Snuffing out Boney! 1814 (British Museum, London, England)

Inconveniences of a Crowded Dressing Room 1818 (British Museum, London, England)

Illustrations to Charles Dickens's Sketches by Boz 1836 (British Library, Charles Dickens Museum, Princeton University Library, and other collections)

Illustrations to the Works of Charles Dickens, Oliver Twist 1838–1841 (British Library, Charles Dickens Museum, Princeton University Library, and other collections)

The Worship of Bacchus 1860–1862 (Tate Collection, London, England)

The British Beehive 1867 (Victoria & Albert Museum, London, England)

"I have long believed Cruikshank to be quite mad."
—Charles Dickens

ABOVE: Cruikshank photographed at the age of sixty, in 1852.

JEAN-BAPTISTE-CAMILLE COROT

Born: Jean-Baptiste-Camille Corot, July 16, 1796 (Paris, France); died February 22, 1875 (Paris, France).

Artistic style: Landscapes, portraits, and figural, allegorical, and religious works; naturalistic details within idealized settings; aesthetic harmony; lyrical and poetic.

The landscape painting of Jean-Baptiste-Camille Corot bridged the gap between the work of earlier decades and that of the movement that manifested itself first in the paintings of the Barbizon school and led on to impressionism. His influence on younger landscape artists was profound, as seen in the work of Gustave Courbet, Claude Monet, and Berthe Morisot. Significantly, and characteristic of the artist who was coined "Père Corot" on account of his affability, he allowed artists to make direct copies of his work, even occasionally signing paintings by them to increase their sale value, and this has led to confusion over the attribution of works.

He trained with Achille Etna Michallon and then Jean-Victor Bertin, both of whose work reflected their master, Pierre-Henri de Valenciennes, a leading historical landscape painter. Elements of this academic approach and classical tradition can be seen in Corot's work, although he later denied that his teachers had had any influence on him. Corot traveled widely, including extended trips to Italy and France, and while traveling he drew and painted directly from the motif. He would then reference his small studies and sketches to produce fully worked-up oil paintings in the studio. His poetic landscapes, with their naturalism, subtle idealism, and luminous quality, became popular through the 1840s, and by the 1850s his reputation as a leading landscape artist had been established. From about this time, his style changed. He began to use a softer, more diffuse light and adopted a limited palette, concentrating on tonal qualities rather than color. This technique lent his paintings the atmospheric and serene ambience for which he is now famous, with the *Souvenir de Mortefontaine* (1864) being one of his most lyrical. **TP**

Masterworks

Diana and Actaeon 1836 (Metropolitan Museum of Art, New York, U.S.)

Cows in a Marshy Landscape c.1860–1870 (National Gallery, London, England)

Souvenir de Mortefontaine 1864 (Musée du Louvre, Paris, France)

"Beauty in art is truth bathed in an impression received from nature."

ABOVE: *Self-Portrait, Sitting Next to an Easel* was painted in 1825.

ANDO TOKITARO HIROSHIGE

Born: Ando Tokitaro, 1797 (Tokyo, Japan); died October 12, 1858 (Tokyo, Japan).

Artistic style: Woodblock print artist; *ukiyo-e* style prints; views from unusual angles; depictions of the seasons; vibrant color; use of strong perspective; poetic landscapes.

Masterworks

The Fifty-Three Stations of the Tokaido
 c.1832–1834 (Tokyo National Museum,
 Tokyo, Japan)

Annaka, No. 16 from the series *Sixty-Nine
Stations of the Kisokaidō* c.1835–1840
(Fine Arts Museum, San Francisco,
California, U.S.)

One Hundred Famous Views of Edo
 1856–1858 (Brooklyn Museum,
 New York, U.S.)

Ando Tokitaro Hiroshige was one of the most influential Japanese artists and printmakers of the nineteenth century. His brilliantly colored and dynamic work had a profound effect on many of the impressionist and post-impressionist artists as well as on James McNeill Whistler. Through much of his career, his main competition was from the widely respected Katsushika Hokusai, whose work was reputed to have inspired Hiroshige's decision to become an artist.

As a child, Hiroshige received drawing lessons in the manner of the Kano school before studying under Ōoka Unpō, who worked in the Chinese style. As a teenager, Hiroshige applied to enter the studio of Utagawa Toyokuni, who specialized in *ukiyo-e* woodblock prints primarily of landscapes. He was unsuccessful, and so joined the workshop of Utagawa Toyohiro where he trained for a year and took his master's name.

As an independent artist, Hiroshige first concentrated on *bijinga* prints of beautiful women and actors, both popular at the time, and then began to produce the landscape scenes that assured his fame. In 1832, he was invited to join a delegation of Shogun officials traveling from Tokyo to Kyoto. Afterwards he produced his series of prints, *The Fifty-Three Stations of the Tokaido* (1832–1834; a subject also used by Hokusai), which was an instant success. He followed with various series of landscapes including *Sixty-Nine Stations of the Kisokaidō* (1834–1842) and *One Hundred Famous Views of Edo* (1856–1858), notable for their bold coloring, exquisite lyricism, and sweeping use of perspective creating great and realistic spatial recession. Toward the end of his career, Hiroshige worked increasingly with *nishiki-e* polychrome prints, producing atmospheric landscapes. **TP**

> "I leave my brush in the East and set forth on my journey. I shall see the famous places . . ."

ABOVE: *Memorial Portrait of Ando Hiroshige* is a woodblock by Utagawa Kunisada.

EUGÈNE DELACROIX

Born: Ferdinand Victor Eugène Delacroix, April 26, 1798 (Charenton-Saint-Maurice, France); died August 13, 1863 (Paris, France).

Artistic style: Supreme colorist; leading romantic; powerful works of grandeur and verve; fresh approach to violent subjects; in tune with the artistic spirit of the age.

Eugène Delacroix entered the Paris studio of leading neo-classical painter Pierre-Narcisse Guérin in 1815. Later hailed as France's greatest romantic painter, Delacroix was unhappy with the label. His work came to embrace much more, weaving early classicism with baroque and romantic threads, among others. Delacroix's Paris Salon debut *The Barque of Dante* (1822), for example, blends romantic expressiveness and the coloration of an Old Master he much admired, Sir Peter Paul Rubens, with classically sculptural figures. This landmark romantic work was criticized by some for straying from classical ideals. Literary subjects such as this, along with past or recent history, became Delacroix's favorite topics.

Artist friends such as the unconventional French romantic Théodore Géricault and English watercolorist Richard Parkes Bonington were already influencing Delacroix's painting. In 1825, working extensively in England and meeting J. M. W. Turner and John Constable helped Delacroix loosen his approach. Ensuing masterpieces included *Liberty Guiding the People* (1831), which marks the Paris Revolt of July 1830. Here classical compositional and figurative elements collide with a gritty modern realism and typically exuberant romanticism.

Light effects and colors seen by Delacroix on his travels to North Africa and Spain brought new directions: impasto handling and color experiments that later influenced impressionists and post-impressionists Pierre-Auguste Renoir and Georges-Pierre Seurat. Delacroix's later career was notable for historical paintings and masterful mural commissions for government buildings. By 1857, finally elected to the Institut de France, he sat firmly at the top of the tree of French art. **AK**

Masterworks

The Barque of Dante 1822 (Musée du Louvre, Paris, France)

The Massacre at Chios 1824 (Musée du Louvre, Paris, France)

The Death of Sardanapalus 1827 (Musée du Louvre, Paris, France)

Liberty Guiding the People 1831 (Musée du Louvre, Paris, France)

Women of Algiers in Their Apartment 1834 (Musée du Louvre, Paris, France)

Jewish Wedding in Morocco c.1839 (Musée du Louvre, Paris, France)

> "They have let the wolf into the sheepfold!"
> —Jean-Auguste Dominique Ingres

ABOVE: This rather debonair self-portrait was painted in 1837.

THOMAS COLE

Born: Thomas Cole, February 1, 1801 (Bolton-le-Moor, England); died February 8, 1848 (Catskill, New York, U.S.).

Artistic style: British father of U.S. landscape painting; founder of the Hudson River school; romantic, moralizing, and allegorical visions of the natural world.

Masterworks

Subsiding of the Waters after the Deluge 1829
(Smithsonian American Art Museum, Washington, D.C., U.S.)

View from Mount Holyoke, Northampton, Massachusetts, after a Thunderstorm; The Oxbow 1836 (Metropolitan Museum of Art, New York, U.S.)

The Course of Empire; Desolation 1836
(New York Historical Society, New York, U.S.)

American Lake Scene 1844 (Detroit Institute of Art, Detroit, Michigan, U.S.)

The history of U.S. landscape painting begins with Thomas Cole. Although born in England in 1801, he and his family emigrated to the United States when he was seventeen years old. All the more overwhelmed than his U.S. contemporaries by the grandeur and sublime nature of the landscape, his work helped to establish the first national school of U.S. art.

Having settled in Ohio, Cole learned the skill of woodblock engraving in his father's business. Being precocious and naturally gifted, he began his training largely by teaching himself, followed by time spent as an itinerant artist earning a living painting portraits. He finished his artistic education at the Pennsylvania Academy of the Fine Arts in Philadelphia in 1824, then moved to New York. Throughout this time Cole painted landscapes in a romantic manner, aspiring to the subjects and the manner of Claude Lorrain and Joseph Mallord William Turner, the two artists who most influenced him.

By 1825, he was building a solid reputation for himself and gaining patronage. Only a year later he became a founding member of the new National Academy. Having made regular sketching trips along the Hudson River and Catskill Mountains in the summer time, Cole then spent his winters in the studio producing landscapes charged with the drama of nature and the weather, and demonstrating the vulnerability of the landscape due to settlement and industry. He returned to Europe in 1829 and 1834, spending time in England and in Rome. By the time he returned home, his work had gained religious overtones within which nature came to symbolize spiritual values. Cole's influence and importance was, until his untimely death in 1848, central to what became known as the Hudson River school of painting. **AB**

"None know how often the hand of God is seen in a wilderness . . ."

ABOVE: This self-portrait, *Thomas Cole*, was painted in oils in *circa* 1836.

EDWIN LANDSEER

Born: Edwin Henry Landseer, March 7, 1802 (London, England); died October 1, 1873 (London, England).

Artistic style: Painter and sculptor; anthropomorphic animal paintings; Scottish Highlands, family groups, and genre scenes; high drama and sweeping emotion.

Sir Edwin Henry Landseer was very successful in his lifetime but suffered from mental health problems in his old age. He was honored with a knighthood in 1850, having turned one down eight years earlier. Although not in the best of health, he sculpted one of his most powerful works in later life: the bronze lions surrounding Nelson's Column in London's Trafalgar Square, which were installed in 1867. Landseer was one of the foremost animal painters of Victorian Britain, combining a tremendous realism with emotional content.

Landseer came from an artistic family and trained under the history painter Benjamin Robert Haydon, from whom he learned the importance of studying anatomy. This early lesson set Landseer's career on its path. His animal paintings are startlingly realistic and reflect his understanding of anatomy and physiology. At fourteen years old, he was regularly exhibiting at the Royal Academy of Arts, and entered the Royal Academy School at this age, too; at twenty-four years old he was elected an associate of the academy.

A defining feature of Landseer's work is the anthropomorphic quality he brought to his animal paintings, often referencing a dramatically emotional narrative, such as the disturbing *Cat's Paw* (1824), *Attachment* (1829), and *The Old Shepherd's Chief Mourner* (*c.*1837). In 1824 Landseer traveled to Scotland and was immediately drawn to the picturesque and rugged landscape and the people. He made many trips to the Scottish Highlands and painted numerous pictures of the area, such as *Monarch of the Glen* (*c.*1851). Landseer's greatest patron was Queen Victoria. His first painting for the queen was of her beloved King Charles spaniel, Dash; it marked the beginning of a long and supportive patronage from the royal family. **TP**

Masterworks

Dash 1836 (Royal Collection, London, England)

The Old Shepherd's Chief Mourner *c.*1837 (Victoria & Albert Museum, London, England)

Victoria, Princess Royal, with Eos 1841 (Royal Collection, London, England)

Eos 1841 (Royal Collection, London, England)

Windsor Castle in Modern Times 1841–1845 (Royal Collection, London, England)

Monarch of the Glen *c.*1851 (Private collection)

Four bronze lions around Nelson's Column, Trafalgar Square, London, England *c.*1867

"If people only knew as much about painting as I do, they would never buy my pictures."

ABOVE: *Portrait of Sir Edwin Landseer* was painted by J. C. Watkins.

FRIEDRICH VON AMERLING

Masterworks

The Painter Robert Theer 1831 (Belvedere, Vienna, Austria)

Kaiser Franz II 1832 (Kunsthistorisches Museum, Vienna, Austria)

Graf Breunner and his Family 1834 (Private collection)

The Widow 1836 (Historisches Museum, Vienna, Austria)

Rudolf von Arthaber and his Children 1837 (Belvedere, Vienna, Austria)

Born: Friedrich Amerling, April 14, 1803 (Vienna, Austria); died January 14, 1887 (Vienna, Austria).

Artistic style: Painter of single, family groups, and genre portraits in the Viennese academic style; works combine subtle realism and sumptuous detail.

In the 1830s an ambitious Friedrich von Amerling was riding high as Vienna's foremost portraitist. The picture that had put him there was a spectacular life-size portrait of Holy Roman Emperor Franz II of Austria resplendent in imperial robes, and Von Amerling went on to become court painter. This work deftly balanced sumptuous detail with a naturalistic sense of a real man, and it was this mix that appealed to the Vienna bourgeoisie who provided many of the painter's clients.

Von Amerling is often identified as a leading Biedermeier artist. His sophisticated English style was fed by spells in London during the 1820s, where he met the great English society portraitist Sir Thomas Lawrence. **AK**

THE GREENOUGH BROTHERS

Masterworks

Horatio:

Samuel F. B. Morse 1831 (Smithsonian American Art Museum, Washington, D.C., U.S.)

Venus Vitrix 1839 (Boston Athenaeum, Boston, Massachusetts, U.S.)

George Washington 1840 (Smithsonian American Art Museum, Washington, D.C., U.S.)

Richard:

Cornelia Van Rensselaer 1849 (New York Historical Society, New York, U.S.)

Benjamin Franklin 1855 (City Hall, Boston, Massachusetts, U.S.)

Horatio: Born 1805 (Massachusetts, U.S.); died 1852 (Massachusetts, U.S.).

Richard: Born 1819 (Massachusetts, U.S.); died 1904 (Rome, Italy).

Artistic style: Neo-classical-style sculptors; famous statues of U.S. presidents; Richard infused his classicism with livelier, more naturalistic elements than Horatio.

Horatio Greenough spent most of his adult life in Italy, and became an influential art theorist, who espoused marrying form to function, as well as a sculptor. He is the first known American to make sculpture his sole profession and attract international acclaim. His trademark piece is a massive marble statue of *George Washington* (1840) as the mythic Greek god Zeus. It was the first major sculpture commission given by the government to a native. While Horatio fueled interest among U.S. sculptors for living in Italy, his brother Richard did the same for Paris. Richard developed a decorative naturalism and triggered a U.S. love of bronze statuary. His best-known work is his bronze monument of *Benjamin Franklin* (1855). **AK**

HONORÉ DAUMIER

Born: Honoré Victorin Daumier, February 26, 1808 (Marseille, France); died February 10, 1879 (Valmondois, France).

Artistic style: Caricaturist; acerbic satire of nineteenth-century bourgeois France; themes of political oppression, power, greed, social injustice, and hypocrisy.

Dubbed "Molière with a crayon," Honoré Daumier brilliantly chronicled his times producing more than 4,000 lithographs satirizing the hypocrisies of nineteenth-century France.

Born in 1808, Daumier first gained notoriety at age twenty-three with his censored *Gargantua* (1831), a grotesque rendering of King Louis-Phillipe I drawn in protest to an outrageous tax increase. Inspired by the giant Gargantua of François Rabelais's novels, Daumier daringly depicted the king as a massive, bloated glutton seated on a commode, greedily devouring baskets of gold being filled by the nation's poor, while politicians fought over the royally excreted spoils. The blistering attack landed Daumier a six-month prison sentence in the notorious Sainte-Pélagie prison in Paris, which he called "a charming resort where I enjoy myself, if only to be contrary."

After all freedom of political expression was banned in France, Daumier directed his sardonic crayon toward society in its entirety, attacking its greed, corruption, and foibles with his caricature of the fictitious archetypal villain Robert Macaire. Daumier's ferocious satires so profoundly captured the human condition—from political oppression and social injustice to war—that they stand as contemporary narratives. In his censored *Council of War* (1872), an army of skeletons marches in protest to the office of the Council of War. His powerful masterwork, *The Third-Class Carriage* (*c.*1862–1864), depicts a stoic, gnarled old woman and poignantly personifies the loneliness of modern life. Not only was Daumier an astute critic of the cruelties and follies of mankind, he was also a master draftsman. Celebrated to the very end, his epitaph reads: "People, Here Lies Daumier, A Good Man, Great Artist, Great Citizen." **SA**

Masterworks

Gargantua 1831 (Bibliothèque Nationale de France, Paris, France)

Lower The Curtain, The Farce Is Over 1834 (Museum of Fine Arts, Boston, Massachusetts, U.S.)

*The Third-Class Carriage c.*1862–1864 (Metropolitan Museum of Art, New York, U.S.)

Council of War 1872 (Metropolitan Museum of Art, New York, U.S.)

"As an artist, what distinguishes Daumier is his sureness of touch."—Charles Baudelaire

ABOVE: This photograph of Honoré Daumier was taken *circa* 1874–1878.

1800-99

EUGENE VON GUERARD

Masterworks

Warrenheip Hills Near Ballarat 1854 (National Gallery of Victoria, Melbourne, Australia)

Bush Fire Between Mount Elephant and Timboon 1857 1859 (Ballarat Fine Art Gallery, Ballarat, Australia)

North-east View from the Northern Top of Mount Kosciusko 1863 (National Gallery of Australia, Canberra, Australia)

Mr. Clarke's Station, Deep Creek, near Keilor 1867 (National Gallery of Victoria, Melbourne, Australia)

Ballarat in the early times; as it appeared in the summer of 1853–54 1884 (Ballarat Fine Art Gallery, Ballarat, Australia)

Eugene von Guérard's Australian Landscapes (A series of 24 original lithographs) Published 1866–1868 and 1975

Born: Johann Joseph Eugen von Guerard, November 1811 (Vienna, Austria); died April 17, 1901 (London, England).

Artistic style: A Viennese painter in the German Romantic mold, known for his paintings and lithographs of Australian landscapes, especially of homesteads.

The son of a painter at the Viennese court, Eugene von Guerard spent the 1820s to 1840s traveling in Europe, and studying art. In 1852, he settled in Melbourne, Australia, working as an artist.

An interest in exploration took him around Australia, from the outback to the country's Alps. Accompanying pioneering explorers, he made sketches as he went, often working these up into paintings later. He created an impressive topographical record, and found clients in wealthy landowners. His work portrayed the land as a romanticized, European-style arcadia— tiny settlements in a vast, idealized landscape suggestive of God's great power. In 1870 he became curator of Melbourne's National Gallery of Victoria and director of its School of Art. **AK**

CURRIER AND IVES

Masterworks

Tight Fix: Bear Hunting in Early Winter (Artist: Arthur Fitzwilliam Tait) 1861

New England Winter Scene (Artist: G. H. Durrie) 1861

Life of a Fireman series (Artist: Louis Maurer)

The largest collection of Currier & Ives prints is in the Museum of the City of New York.

Nathaniel Currier: Born 1813 (Massachusetts, U.S.); died 1888 (Massachusetts, U.S.).

James Merritt Ives: Born 1824 (New York, U.S.); died 1895 (Rye, New York, U.S.).

Artistic style: Hugely successful printing partnership selling inexpensive, hand-colored lithographic prints covering U.S. life in an upbeat, homey way.

During the late 1800s, the highly drilled Currier & Ives assembly line—in-house artists, expert lithographers, and an army of female hand-colorers—churned out millions of prints from a catalog of more than 7,000 titles. Lithographer Nathaniel Currier founded the company in 1834, and from 1857 he operated in partnership with James Ives. Subjects ranged from picturesque New England scenes to animals, celebrities, and news events. The style appears simplistically all-American now, but in their day the prints caught the popular mood, as well as the tide of increased mechanization, and led the field. Today they are valued collectors' items. By the 1890s, the rise of photography and a shift in values had lessened the prints' appeal. **AK**

JEAN-FRANÇOIS MILLET

Born: Jean-François Millet, October 4, 1814 (Gruchy, France); died January 20, 1875 (Barbizon, France).

Artistic style: Painter of peasant subjects conceived in a heroic vein; landscapes combine classical Italianate style with realism; founder of the Barbizon school.

Jean-François Millet's paintings represent the shift from traditionalism to modernism that occurred during the late nineteenth century. They combine a strongly classical and academic premise with striking realist details. His paintings of peasants and other depictions of rural life were controversial subjects at the time, because France was still struggling to heal itself in the aftermath of the French Revolution. Millet's work was lauded by the socialists but heavily criticized by the more conservative elements in French society.

He first trained with a portrait painter, Bon Dumouchel, before moving to Cherbourg and the studio of Théophile Langlois de Chèvreville, a pupil of Antoine-Jean Gros. Initially, Millet was mainly a portraitist, working in oils, crayon, and pastel, though he also produced pastoral scenes and nudes.

In 1849, he moved to Barbizon, the area with which he is most associated, and his mature style evolved. He turned to peasant scenes, and later landscapes, combining classical Italianate elements within a strongly realist framework. His peasant paintings are imbued with a sense of timelessness and compassion, and highlight the plight of the working classes. Millet exhibited his paintings at the Paris Salon regularly, though works such as *The Gleaners* (1857) received a mixed critical reception. However, he achieved some success and recognition during his life, aided by a fêted retrospective of his work in 1867 at the Exposition Universelle in Paris, and the following year he was awarded the Légion d'Honneur (Legion of Honor). His work was of enormous importance to the development of realism and later to impressionist and post-impressionist artists, in particular Camille Pissarro and Vincent van Gogh. **TP**

Masterworks

The Sower 1850 (Museum of Fine Art, Boston, Massachusetts, U.S.)

The Gleaners 1857 (Musée d'Orsay, Paris, France)

The Angelus 1857 (Musée d'Orsay, Paris, France)

Bird's-Nesters 1874 (Philadelphia Museum of Art, Philadelphia, Pennsylvania, U.S.)

" . . . even if you think me a socialist, the human side of art is what touches me most."

ABOVE: *Self-Portrait* (1847) is a charcoal sketch that can be seen in the Louvre, Paris.

ADOLPH MENZEL

Born: Adolph Friedrich Erdmann Menzel, December 8, 1815 (Breslau, Poland); died February 9, 1905 (Berlin, Germany).

Artistic style: Versatile realist painter of history paintings, landscapes, and interior scenes; informal treatment of interior spaces and figures; pronounced use of detail.

Masterworks

The French Window 1845 (Alte Nationalgalerie, Berlin, Germany)

Sitting Room with Menzel's Sister 1847 (Neue Pinakothek, Munich, Germany)

Afternoon in the Tuileries Gardens 1867 (National Gallery, London, England)

The Interior of the Jacobskirche at Innsbruck 1872 (National Gallery of Art, Washington, D.C., U.S)

Although the development of the realist movement in nineteenth-century Europe is usually discussed in terms of it being a distinctive phase of French art and represented by the figures of Jean-Francois Millet and Gustave Courbet, a number of other artists made their own contribution toward the rejection of romanticism, including Adolph Menzel.

He first gained popular acclaim with his wood engravings that served as illustrations for Franz Kugler's *History of Frederick the Great* (1840). Certainly he helped to contribute toward the public image of the founder of the Prussian state. Menzel's reputation today rests upon a series of relatively small-scale studies of informal interiors and landscapes he made during the 1840s. During his own lifetime, his reputation was more readily based on a number of historical paintings, several of which related to significant events in the life of King Frederick II the Great of Prussia. The informal treatment of the subject, together with a fascination with the effects of light, has meant that Menzel's paintings have come to be seen, both formally and thematically, as anticipating impressionism.

Toward the latter half of the 1860s, Menzel became increasingly drawn toward the depiction of what were called "modern subjects." *Afternoon in the Tuileries Gardens* (1867), for example, is based on a series of sketches the artist had made during a visit to Paris that year to see the Universal Exposition. Probably inspired by Édouard Manet's own somewhat looser treatment of the Tuileries Gardens, Menzel's depiction of this bustling scene, replete with incidental details, remains wholly legible. After his death at the age of ninety, Menzel was given a state funeral in recognition of his artistic achievements. **CS**

"It's a cursive mode of painting, almost disdainful in its certitude . . ."—Edmond Duranty

ABOVE: *Portrait of Adolf von Menzel* by Sir William Rothenstein (1872–1945).

RIGHT: Perhaps Menzel's finest informal interior—*Sitting Room with Menzel's Sister.*

1800-99

GUSTAVE COURBET

Born: Jean Désiré Gustave Courbet, June 10, 1819 (Ornans, France); died December 31, 1877 (La Tour-de-Peilz, Switzerland).

Artistic style: Anti-establishment in art and life; committed socialist; leader of realism in art; explores the dignity of ordinary life in an unidealized fashion.

Masterworks

Self-Portrait (The Desperate Man) c.1843 (Private collection)

The Stone Breakers 1849 (Registered missing by Galerie Neue Meister, Dresden, Germany, destroyed during World War II)

A Burial at Ornans 1849 (Musée d'Orsay, Paris, France)

The Bathers 1853 (Musée Fabre, Montpellier, France)

Bonjour Monsieur Courbet 1854 (Musée Fabre, Montpellier, France)

Painter's Studio 1854 (Musée d'Orsay, Paris, France)

Origin of the World 1866 (Musée d'Orsay, Paris, France)

The Sleepers 1866 (Petit Palais, Paris, France)

Cliff at Étretat after the Storm 1870 (Musée d'Orsay, Paris, France)

Although eager to portray himself as an uncouth rebel, Gustave Courbet actually came from a fairly wealthy farming family based near the Swiss border. They supported his decision to pursue art and gave him a financially secure start.

Courbet studied first at Besançon and moved to Paris in 1839. He never settled in the capital, however; his more down-to-earth rural background pulled him back again and again. He rejected the elevated academic training at the Parisian École des Beaux-Arts in favor of classes at the city's independent schools. Soon he had evolved a bold, original style that squarely addressed the realities of everyday country life. This did not always endear him to an art establishment still enthralled with idealized art, although his *Self-Portrait (Courbet with a Black Dog)* (1842) was accepted by the conservative Paris Salon exhibition when he was just twenty-five years old.

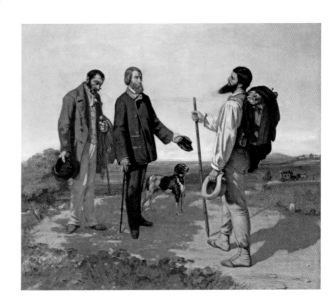

ABOVE: Courbet's *Self-Portrait (Man with a Pipe)* was painted in 1848–1849.

RIGHT: Bruyas and his servant stand in awe of the artist in *Bonjour Monsieur Courbet.*

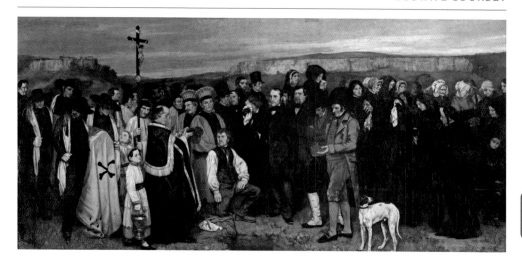

1800-99

Courbet achieved a major milestone at the 1851 Salon with *The Stone Breakers* (1849) and *A Burial at Ornans* (1849). These two works reflected the unidealized misery of peasant life, the first depicting dirt-poor agricultural laborers busy at grindingly hard work, and the second a country funeral. These were large paintings that invested everyday life with the monumentality that was the traditional preserve of grand "history" painting. Some critics were shocked; others, such as influential French writer and critic Jules-François-Félix Husson Champfleury, saw in them a beacon of realism.

Courbet's work was often uneven but embraced honestly sensuous nudes, interesting allegories, and landscapes that recalled his boyhood. They also prefigured Impressionism in their true-to-nature approach—witness his late Étretat works.

By the early 1870s, Courbet had been appointed president of the Fédération des Artistes (Federation of Artists) dedicated to expanding art and freedom from censorship. He was politically active, too, but his involvement with the republican Paris Commune saw him first imprisoned and then bankrupted. After escaping to Switzerland to avoid massive fines, he ended his days a somewhat broken man in an old inn he had bought in La Tour-de-Peilz. **AK**

ABOVE: *A Burial at Ornans* was exhibited to great critical and public acclaim.

A Messiah Complex?

Courbet's *Bonjour Monsieur Courbet* (1854) seems to show the ordinary man—in this case, represented by a self-portrait—as a kind of messiah condescending to those he meets (in the painting, Courbet's real-life patron and his manservant) on the allegorical road to righteousness. Courbet enjoyed presenting himself as a vagabond thorn in the side of every form of establishment, from the church to the government. His self-portrait in the *Painter's Studio* (1854) turns his back on the art establishment, represented by the posing nude, and places himself as the king of all he surveys.

FORD MADOX BROWN

Born: Ford Madox Brown, April 16, 1821 (Calais, France); died October 6, 1893 (London, England).

Artistic style: Moral and historical subjects; naturalistic details; dark and dramatic early works; later works of brilliant color painted on bright white grounds.

Masterworks

Lear and Cordelia 1849–1852 (Tate Collection, London, England)

Pretty Baa-Lambs 1851–1859 (Birmingham Museums and Art Gallery, Birmingham, England)

Work 1852–1865 (Manchester City Art Galleries, Manchester, England)

The Last of England 1855 (Birmingham Museums and Art Gallery, Birmingham, England)

Chaucer at the Court of Edward III 1856–1868 (Tate Collection, London, England)

Mauvais Sujet 1863 (Tate Collection, London, England)

Elijah and the Widow's Son 1864 (Birmingham Museums and Art Gallery, Birmingham, England)

" . . . I had an attraction towards Holbein, after being once chiefly swayed by Rembrandt."

ABOVE: Painted in 1877, *Self-Portrait* is typical of Brown's intense, realistic style.

Born to English parents, Ford Madox Brown studied art in Belgium, Italy, and France before moving to England in 1845. In Rome, he met several German artists of the Nazarene school, which fostered his interest in clear color and medievalism.

In 1848, Dante Gabriel Rossetti became Brown's student for a short time, and the two became friends. Brown might have become a key member of the Pre-Raphaelite Brotherhood, established in London that year, but he remained on the fringe of the group. Despite this, he was an important figure and esteemed by the main members: Rossetti, William Holman Hunt, and John Everett Millais. Years later, he was regarded as the definitive Pre-Raphaelite because of his style and subjects.

All his European influences amalgamate in his work, which was original at a time when British art was becoming predictable. Brown was, however, largely ignored by his contemporaries. He painted in a realistic and intense style, and his works dealt with modern life and contemporary social issues. His earlier style changed in favor of a more realistic representation of figures and landscape, with clear, strong colors, all bathed in sunlight, and an inclination to be meticulous. From 1853, after receiving little attention for his painting, he stopped exhibiting at the Royal Academy and became a pioneer of the solo show. By 1856, he had started to collaborate with William Morris and in 1861 became a founder member of Morris, Marshall, Faulkner & Company; Brown's main contribution was designing furniture and stained glass. In 1878, he was commissioned to paint twelve large murals for Manchester Town Hall, depicting the city's history. The project was his major preoccupation throughout the last years of his life. **SH**

JEAN-LÉON GÉRÔME

Born: Jean-Léon Gérôme, May 11, 1824 (Vésoul, France); died January 10, 1904 (Paris, France).

Artistic style: Neo-classical painter and sculptor; Orientalist, mythological, biblical, and historic themes; portraits; pale color; meticulous finish; smooth brushwork.

Nineteenth-century Orientalist painting looked to what is now Turkey, Greece, the Middle East, and North Africa as a region full of exoticism and sensuality. Jean-Léon Gérôme was one of its leading French proponents, depicting scenes of slave markets, harems, and baths populated by European-looking naked women, all of which were meticulously painted. In 1854 he traveled to Turkey in search of his subjects, and to pursue an authenticity for his painstakingly detailed canvases. It was the first of several such trips that also saw him visit Egypt, Syria, and Palestine, and resulted in works such as his allegorical mural *The Age of Augustus, the Birth of Christ* (1852–1854).

Gérôme was born the son of a goldsmith, who discouraged his son from pursuing his interests, before finally relenting to a trial period of study at the Paris studio of historical painter Paul Delaroche in 1840. When Delaroche closed his studio in 1843, Gérôme traveled with his teacher to Italy, where he began to develop a neoclassical style of sculptural figurative painting known for its veracity and dramatic mood, which he pursued for the rest of his life, whatever the theme.

Gérôme continued his studies with the guidance of Swiss painter Charles Gleyre, and attended the École des Beaux-Arts in Paris. Keen to return to Italy, he entered the 1846 Prix de Rome, but failed to win. Encouraged by Delaroche, he entered his *Young Greeks Attending a Cock Fight* also called *The Cock Fight* (1846–1847) in the 1847 Paris Salon. Its classical narrative and smooth brushwork won him critical acclaim, and set him on the path to a highly successful career.

A sculptor as well as a painter, Gérôme was also commissioned to do bronze portraits such as his statue of the *Duke of Aumale* (1899). **CK**

Masterworks

Young Greeks Attending a Cock Fight (The Cock Fight) 1846–1847 (Musée d'Orsay, Paris, France)

The Age of Augustus, the Birth of Christ 1852–1854 (J. Paul Getty Museum, Los Angeles, California, U.S.)

The Draft Players 1859 (Wallace Collection, London, England)

Napoleon in Egypt 1863 (The Hermitage, St. Petersburg, Russia)

Pool in a Harem 1876 (The Hermitage, St. Petersburg, Russia)

Slave Market in Rome 1884 (The Hermitage Museum, St. Petersburg, Russia)

Duc d'Aumale (Duke of Aumale) 1899 (Château de Chantilly, Chantilly, France)

"[*The Cock Fight* exhibits the] wonders of drawing, action, and color."—Théophile Gautier

ABOVE: A formal studio portrait of Jean-Léon Gérôme with a splendid moustache.

GUSTAVE MOREAU

Born: Gustave Moreau, April 6, 1826 (Paris, France); died April 18, 1898 (Paris, France).

Artistic style: Forefather of symbolism; history, mythical, and religious paintings in a romantic–symbolist frame; paired intellectual ideas with aesthetic paradigms.

Masterworks

*Death of Darius c.*1853 (Museum Moreau, Paris, France)

Oedipus and the Sphinx 1864 (Metropolitan Museum of Art, New York, U.S.)

Jupiter and Semele 1894–1895 (Museum Moreau, Paris, France)

Gustave Moreau was one of the forefathers of the symbolist movement, although toward the end of his life he disassociated himself from the work of the younger symbolist artists. He developed a visual language based on a combination of classical precedents, Romantic coloring, decorative detail, and heavily symbolic elements. Yet it was the intellectual content of his work that was of greatest importance to the artist, who strove to express conceptual ideas and confront the polarities of human life, such as good and evil, and death and rebirth.

Moreau trained with history painter François-Édouard Picot, and from 1846 studied at the École des Beaux-Arts in Paris, returning there in 1891 as a professor. His early work is strongly Romantic and clearly shows the influence of Eugène Delacroix and Théodore Chassériau; throughout his career, he favored the rich and vibrant palette of these artists. Moreau was also drawn to classical art and strove to strike a balance between that genre and romanticism. This interest was compounded by a trip to Italy in 1841, followed by a two-year stay from 1857, during which he studied works by the Old Masters.

Moreau's intellectual and aesthetic ideals are reflected in the painting *Oedipus and the Sphinx* (1864), which won a medal at the Paris Salon the same year. During the late 1860s his style changed—in part as a response to a diminishing public appreciation of his work. He turned toward baroque precedents and the influence of Rembrandt Harmensz van Rijn. He also began to paint the femme fatale subject in various guises—a popular theme at the time. In later life, Moreau painted primarily small works in oils and watercolors and reworked some of his earlier subjects. By this time, he was enjoying great public acclaim. **TP**

"I am dominated by . . . an irresistible . . . attraction towards the abstract."

ABOVE: Gustave Moreau made this oil on canvas *Self-Portrait* in 1850.

FREDERIC EDWIN CHURCH

Born: Frederic Edwin Church, May 4, 1826 (Hartford, Connecticut, U.S.); died April 7, 1900 (New York, U.S.).

Artistic style: Explorer and painter; large canvases of sublime natural sites; painter of icebergs, volcanoes, the Andes, and Niagara Falls; fanatical eye for detail.

Born the son of a wealthy businessman in 1826, Frederic Edwin Church first studied painting and drawing in his hometown of Hartford. In 1844, he went to Catskill, New York, to become the only student accepted by Thomas Cole, the founder of the Hudson River school of landscape painters. Under his tutelage, Church made regular sketching trips and perfected the genre of historical landscape painting favored by his master. Cole's influence and the persistence of a landscape painting tradition in the United States allowed Church to become the leading figure of the second generation of the Hudson River school.

By the time of Cole's death in 1848, Church was established as a successful landscape artist and embarked on larger and larger canvases, composed from the many oil and pencil sketches he made on summer drawing trips. He increasingly sought out dramatic and sublime landscapes.

Inspired by the writings of the German naturalist Alexander von Humboldt—especially by his detailed descriptions of the natural world—Church traveled to South America in 1853 and again in 1857. He continued to work from the wealth and quantity of the studies and sketches made on these journeys all the way into the 1880s. His interest and talent lay in his depiction of atmospheric effects, his use of bright color, his eye for the details of foliage, flora, and rocks, and a minutely descriptive finish. He also painted scenes at Niagara Falls and in Newfoundland; Church's exhibition of *Niagara* (1857) caused a sensation and propelled him to fame. He displayed his large-scale *Heart of the Andes* (1859) in New York and in London, to great public acclaim. It sold for $10,000—the highest price ever paid for a work by a living American artist up to that date. **AB**

Masterworks

A Country Home 1854 (Seattle Art Museum, Seattle, Washington, U.S.)

Niagara 1857 (Corcoran Gallery of Art, Washington, D.C., U.S.)

Heart of the Andes 1859 (Metropolitan Museum of Art, New York, U.S.)

> "Church has the finest eye for drawing in the world."
> —Thomas Cole

ABOVE: Frederic Edwin Church as he looked at the height of his fame.

JEAN-BAPTISTE CARPEAUX

Born: Jean-Baptiste Carpeaux, May 11, 1827 (Valenciennes, France); died October 11, 1875 (Courbevoie, France).

Artistic style: Sculptor and painter; statues and monuments notorious for their Romanticism, vitality, and sensuality; sinuous nudes often based on the everyday.

Masterworks

Neapolitan Fisherboy 1857–1861 (National Gallery of Art, Washington, D.C., U.S.)

Girl with a Shell 1858 (Musée du Louvre, Paris, France)

Ugolino and his Sons 1860 (Metropolitan Museum of Art, New York, U.S.)

The Dance 1866–1869 (Musée d'Orsay, Paris, France)

*Crouching Flora c.*1873 (Musée d'Orsay, Paris, France)

Portrait of Nadine Dumas 1873–1875 (J. Paul Getty Museum, Los Angeles, California, U.S.)

Jean-Baptiste Carpeaux was something of a bad boy of sculpture in his day. Perhaps a strange concept, given that in his career he received commissions for significant public monuments such as the architectural decoration of the Pavillon de Flore of the Palais du Louvre in 1863, and *The Dance* (1866–1869) for the facade of the new Paris Opéra. Yet his work often provoked heated debate because he spurned the classicism of the French Academic style, creating works notorious for their romanticism, vitality, decorativeness, and sensuality. Their sinuous, writhing figures were at odds with the existing artistic norm but did find favor at Emperor Napoléon III's court, and this helped lead to Carpeaux's eventual popularity.

Despite rebelling against the prevailing taste for the classical by adopting a more liberal approach that saw him create works from everyday subjects notable for their spontaneity, he went on to win the Prix de Rome in 1854, and headed for Italy in 1856. There he began work on his energetic *Neapolitan Fisherboy* (1857–61) based on a street urchin, and it was this work that caught the attention of the Empress Eugènie, who bought it. Carpeaux created numerous reproductions and variations of the work, as well as a piece on a similar theme, *Girl with a Shell* (1858). In Italy he also came up with the idea for *Ugolino and his Sons* (1860) based on a story from Dante Alighieri's *The Divine Comedy* (1308–1321). When he showed *Neapolitan Fisherboy* and *Ugolino and his Sons* at the Paris Salon in 1863 his position as a rising star was assured. However, when the Second Empire fell, Carpeaux escaped the Paris Commune in 1871 by fleeing to England. His later life was beset by financial problems and mental and physical illness. **CK**

"La Danse [was] considered so scandalous that attempts were made to deface it."—*The Independent*

ABOVE: *Self-Portrait as Henri IV* was painted using a warm spectrum of color in 1870.

WILLIAM HOLMAN HUNT

Born: William Holman Hunt, April 2, 1827 (London, England); died September 7, 1910 (Sonning-on-Thames, England).

Artistic style: Founder of the Pre-Raphaelite Brotherhood; landscapes and portraits; religious and literary subjects; meticulous attention to detail; vivid color.

William Holman Hunt was a rebel. As one of the founding members of the Pre-Raphaelite Brotherhood with his friends John Everett Millais and Dante Gabriel Rossetti, he sought to regenerate British art. The group looked back to medieval times for their inspiration and favored artists prior to the Renaissance master Raphael. They longed to create art that had a spiritual message and rejected the rational learning by rote that they felt had overwhelmed contemporary art.

Hunt and other members of the group initially found their work scorned by the art establishment and critics. The one exception was Sir John Ruskin, who championed the young men's work and aspirations. Hunt remembered the establishment's hostile treatment even when he had found success—proclaimed by his being awarded the Order of Merit in 1905—and refused to join the Royal Academy of Arts.

Typical of the Pre-Raphaelites' oeuvre, Hunt's work was characterized by its realistic style, vivid color, microscopic attention to detail, allegorical subject matter, and themes of social problems, nature, religion, and literature; but it is his capacity to add emotion to his canvas that is most compelling, particularly in his religious paintings. Hunt traveled to the Holy Land and Egypt in search of biblical settings for his work and to reinforce his own faith. The landscape in *The Scapegoat* (*c.*1854–1856) was painted in situ beside the Dead Sea at Osdoom and shows the distant mountains of Edom. Among the scorched terrain, Hunt skillfully portrays a humble goat—referred to in the Old Testament as a suffering Christlike figure that will atone for the sins of the people. Perhaps this painting best represents his aim to bring together nature and religion in a piece that is spiritually profound. **CK**

Masterworks

Claudio and Isabella 1850 (Tate Britain, London, England)

Our English Coasts, 1852 (Strayed Sheep) 1852 (Tate Britain, London, England)

The Awakening Conscience 1853 (Tate Britain, London, England)

The Light of the World 1845–1853 (Keble College, Oxford, England)

*The Scapegoat c.*1854–1856 (Lady Lever Art Gallery, Port Sunlight, England)

The Finding of the Saviour in the Temple 1854–1860 (Birmingham City Museum and Art Gallery, Birmingham, England)

The Ship 1875 (Tate Collection, London, England)

"I had almost despaired of overcoming the . . . opposition to our style."

ABOVE: A lithograph of a portrait of William Holman Hunt.

DANTE GABRIEL ROSSETTI

Born: Gabriel Charles Dante Rossetti, May 12, 1828 (London, England); died April 9, 1882 (Birchington-on-Sea, England).

Artistic style: Poet and painter; brilliant use of color on wet, white paint; great detail; direct observation of nature; co-founder of the Pre-Raphaelite Brotherhood.

Dante Gabriel Rossetti grew up in a strong artistic and literary environment. His father, an academic, was a political refugee from Italy and his siblings included the poet Christina Rossetti and the writer and critic William Michael Rossetti. Dante Rossetti aspired to be a poet and painter and was fascinated by medieval art and the poetry of Dante Alighieri; his art tutors included John Sell Cotman and Ford Madox Brown. At the Royal Academy schools he met William Holman Hunt and John Everett Millais and together they founded the Pre-Raphaelite

1800–99

Masterworks

The Girlhood of Mary Virgin 1848–1849 (Tate Collection, London, England)

Ecce Ancilla Domini 1849–1850 (Tate Collection, London, England)

Beata Beatrix 1864–1870 (Tate Collection, London, England; another version, painted in 1872, is in the Chicago Art Institute, Chicago, Illinois, U.S.)

Lady Lilith 1867 (Metropolitan Museum of Art, New York, U.S.)

The Blessed Damozel 1871–1878 (Fogg Art Museum, Harvard University, Massachusetts, U.S.)

Proserpine 1874 (Tate Collection, London, England)

Pandora 1878 (Lady Lever Art Gallery, Liverpool, England)

ABOVE: *Portrait of Dante Gabriel Rossetti* (1853) is by William Holman Hunt.

RIGHT: Rossetti's *The Blue Bower* is rich in color and sensuous in mood.

Brotherhood (PRB). They aimed to emulate Italian painters from the time before Raphael, and to produce art that was true to nature and inspired by literature and mythology. They made their own paints, in richly vibrant colors, and developed a way of preparing the canvas to make the colours stand out even more. Rossetti's talents, charisma, energy, and enthusiasm made him the central figure of the group, and of the ensuing Pre-Raphaelite Movement. His first major work, *The Girlhood of Mary Virgin* (1848–1849), was well received. His sister Christina Rossetti was the model and it was exhibited bearing the initials "PRB"—a mystery to the uninitiated.

Developing a unique style

Rossetti's poems and paintings inspired many younger artists, including William Morris and Edward Burne-Jones, with whom Rossetti collaborated in the painting of the Oxford Union. With Morris, Rossetti also designed stained glass, textiles, and wallpaper. For many years his muse was the poet and artist Elizabeth Siddal. They married in 1860 after a tortuous ten-year relationship, but just two years later she died from an drugs overdose. Griefstricken, Rossetti buried most of his unpublished poems with her, although seven years later he had her coffin exhumed so he could publish them.

All the while Rossetti's work was changing and developing a more sensuous—or as one angry critic derided it "fleshly"—style, usually featuring beautiful women. Following Lizzie's death his health began to fail and he was judged insane by several contemporaries. He became addicted to the drug chloral and suffered from delusions. After Lizzie died he became the lover of Janey Morris (wife of William Morris, one of his closest friends); she also became his muse.

Rossetti dabbled with watercolors but soon returned to oils—by now his work commanded extremely high prices. In 1881, he published another volume of poems, but his health was deteriorating and he died at age fifty-three. His work became a major influence on the development of the European symbolist movement. **SH/LH**

ABOVE: Model Janey Morris reflects upon her unfortunate fate in *Proserpine*.

Reading the Frames

Rossetti often annotated his paintings with poems and texts to explain the symbolism within. In *The Girlhood of Mary Virgin*, he wrote sonnets on the frame about the painting's dove, lamp, rose, and vine, as well as the symbolic use of color: gold for charity, blue for faith, green for hope, and white for temperance. *Beata Beatrix* symbolizes his wife Lizzie's death: a red dove, a sundial pointing to her hour of death, and a poppy representing the opiate laudanum that killed her.

JOHN EVERETT MILLAIS

Born: John Everett Millais, June 8, 1829 (Southampton, England); died August 13, 1896 (London, England).

Artistic style: Pre-Raphaelite painter; precise and detailed; jewel-bright colors on wet white ground; brilliant handling of paint on creamy, textured surfaces.

Masterworks

Isabella 1848–1849 (Walker Art Gallery, Liverpool, England)

Christ in the House of His Parents 1850 (Tate Britain, London, England)

Mariana 1851 (Tate Britain, London, England)

Ophelia 1852 (Tate Britain, London, England)

The Proscribed Royalist 1853 (Private collection)

Autumn Leaves 1855–1856 (Manchester City Art Gallery, Manchester, England)

The Black Brunswicker 1860 (Lady Lever Art Gallery, Liverpool, England)

Portrait of Mrs Perugini 1874–1880 (Private collection)

Bubbles 1886 (Lady Lever Art Gallery, Liverpool, England)

Born into a prosperous family, Sir John Everett Millais became the youngest pupil ever at the Royal Academy schools at the age of eleven; he had already won a silver medal at the age of nine. While there, he forged friendships with Dante Gabriel Rossetti and William Holman Hunt, and in 1848, the three men established the Pre-Raphaelite Brotherhood.

Millais's early paintings were scrupulously planned and observed. He often painted landscape backgrounds in the summer and added foreground figures in his studio during the winter. Yet the first Pre-Raphaelite paintings were ridiculed, with Millais's own painting *Christ in the House of His Parents* being harshly singled out by Charles Dickens. Pre-Raphaelitism could have foundered had it not been for the support of John Ruskin, the foremost art critic of the day. What began as a close friendship ended when Millais fell in love with Ruskin's wife, whom he married in 1855 (after a scandalous annulment).

Tiring of his early style, Millais moved away from Pre-Raphaelitism; he began working in book illustration and in 1869 was recruited as an artist for the weekly newspaper *The Graphic*. His paintings became highly commercial and, after moving into the lucrative world of portrait painting in the 1870s, he became the highest paid artist in Victorian Britain. He also achieved popularity with his paintings of children, notably *Bubbles* (1886), famous for being used in the advertising of Pears soap (to which Millais violently objected). In 1853, he had become an associate member of the Royal Academy of Arts and a full member in 1863. Millais was granted a baronetcy in 1885, the first artist to be honored with a hereditary title. In 1896, he was elected president of the Royal Academy, but he died later the same year. **SH/LH**

"I may honestly say that I have never consciously placed an idle touch upon canvas . . ."

ABOVE: Millais painted this *Self-Portrait* while still a teenager, in 1847.

CAMILLE PISSARRO

Born: Jacob-Abraham-Camille Pissarro, July 10, 1830 (Charlotte Amalie, St. Thomas, U.S. Virgin Islands); died November 13, 1903 (Paris, France).

Artistic style: Impressionist painter; use of pastels, oil paints, and gouache; small, multidirectional brushstrokes; rich color; high horizons and figures in landscapes.

Often considered the founder of impressionism because he advised so many younger artists, Camille Pissarro studied at the École des Beaux-Arts and the Académie Suisse under several masters, including Camille Corot, Gustave Courbet, and Charles-François Daubigny. Corot encouraged him to paint from nature and was a great influence. At the Académie Suisse, he met Édouard Monet, Armand Guillaumin, and Paul Cézanne.

His early landscapes were highly praised by writer Émile Zola and other critics but received little public recognition. Nevertheless, his work was exhibited at the Paris Salon during the 1860s, and in 1863 he participated with Manet, James McNeill Whistler, and others in the "Salon des Refusés." From the late 1860s, he was a major figure among the impressionists, largely organizing all their shows and exhibiting at each. He was influential as a teacher to Cézanne and Paul Gauguin, who both referred to him toward the end of their careers as their "master." In turn, Pissarro was inspired by other artists' ideas, including Georges Seurat and Paul Signac's pointillism, and Claude Monet's series of paintings under changing light. He also greatly admired Jean-François Millet and Honoré Daumier, sharing their respect for the plight of the ordinary working man.

During the Franco-Prussian War of 1870 to 1871, he fled to London where he met Paul Durand-Ruel, the Parisian dealer who became an ardent supporter of the impressionists. In later life, Pissarro witnessed the impressionists' fame and was revered by the post-impressionists. In the 1870s, Pissarro worked closely with Monet, Pierre-Auguste Renoir, and Alfred Sisley, brightening his palette and reducing his brushmarks. Eye trouble forced him to abandon outdoor painting, so he painted views from windows in Paris. **SH**

Masterworks

The Hermitage at Pontoise c.1867 (Guggenheim Museum, New York, U.S.)

Route to Versailles, Louveciennes 1869 (Walters Art Gallery, Baltimore, Maryland, U.S.)

White Frost c.1873 (Musée d'Orsay, Paris, France)

Portrait of Cézanne 1874 (National Gallery, London, England)

Rabbit Warren at Pontoise, Snow 1879 (Art Institute of Chicago, Chicago, Illinois, U.S.)

The Little Country Maid 1882 (National Gallery, London, England)

Quays at Rouen 1883 (Courtauld Gallery, London, England)

"Don't be afraid in nature: one must be bold, at the risk of having been deceived . . ."

ABOVE: Set against a pastel background, Pissarro painted his *Self-Portrait* in 1873.

GUSTAVE DORÉ

Born: Paul Gustave Doré, January 6, 1832 (Strasbourg, France); died January 23, 1883 (Paris, France).

Artistic style: Engraver, illustrator, painter, and sculptor; dynamic and dramatic compositions; often dreamlike or grotesque illustrations; detailed, lively caricatures.

Masterworks

Jacob Wrestling with the Angel 1855
(Granger Collection, New York, U.S.)

The Punishment of Evil Counselors 1864
(Metropolitan Museum, New York, U.S.)

The Neophyte (First Experience of the Monastery) c.1866–1868 (Chrysler Museum of Art, Norfolk, Virginia, U.S.)

Naked Wood Nymph 1868–1874
(Royal Collection, London, England)

La Nuit de Noel undated (Musée d'Orsay, Paris, France)

Memorial to Alexandre Dumas 1883
(Place Malesherbes, Paris, France)

During Gustave Doré's fifty-one years, the most celebrated French book illustrator of the mid-nineteenth century produced more than 10,000 engravings and illustrated more than 200 books, some with more than 400 plates.

With no art training, Doré astounded a Parisian publisher with his drawings when he was just fifteen years old; his first illustrated book was published that same year. He began supplying lithographs for a weekly paper and at sixteen years old, he was the highest paid illustrator in France. Soon he was making drawings that could be engraved on wood by teams of skilled craftsmen; he was so prolific that at one time he employed more than forty block cutters. Between 1860 and 1900, one of his illustrated books was published every eight days. The poet and literary critic Théophile Gautier dubbed him the "Boy Genius." His book illustrations include those for works by François Rabelais, Honoré de Balzac, John Milton, Dante Alighieri, Lord George Byron, and Edgar Allan Poe.

In 1867, Doré had a major exhibition in London, which led to the foundation of the Doré Gallery in New Bond Street. In 1869, he collaborated with Blanchard Jerrold on a comprehensive portrait of London, *London: A Pilgrimage* (1872). It contained somber studies of poverty-stricken quarters of the city, and captured the attention of Vincent van Gogh. Nearly thirty years later, van Gogh painted a prison courtyard from a Doré print of London's Newgate Prison. Doré's success also attracted further commissions, including works by Samuel Coleridge, Milton, and Lord Alfred Tennyson. In the 1870s, he took up painting and sculpture but was not well received in France, so he moved to London, where he found the respect he sought. **SH**

"I have tried to copy the . . . *Convict Prison* by Doré; it is very difficult."—Vincent van Gogh

ABOVE: This studio photograph of Gustave Doré was taken in Paris *circa* 1865.

RIGHT: The enchanting *La Nuit de Noel* depicts the childlike magic of Christmas.

ÉDOUARD MANET

Born: Édouard Manet, January 23, 1832 (Paris, France); died April 30, 1883 (Paris, France).

Artistic style: Pivotal painter of contemporary urban life; bold contrasts of light; solid color; flat composition; avant-garde innovator; forefather of modernism.

Masterworks

The Spanish Singer 1860 (Metropolitan Museum of Art, New York, U.S.)

Music in the Tuileries Gardens 1862 (National Gallery, London, England)

Olympia 1863 (Musée d'Orsay, Paris, France)

Le Déjeuner sur l'Herbe 1863 (Musée d'Orsay, Paris, France)

Le Balcon 1868 (Musée d'Orsay, Paris, France)

Bar at the Folies-Bergère 1882 (Courtauld Institute of Art, London, England)

Édouard Manet has long been regarded as one of the founding fathers of modernism. Although he was for a time regarded as one of the impressionists and was a great influence on them, he never showed his work in their independent exhibitions, preferring to make his radical mark within the establishment and seek recognition within the context of Salon exhibitions.

Manet was born into a wealthy Parisian family. Although destined to study law, the young Manet showed an early interest in drawing and a love of art. Encouraged by his uncle, Charles Fournier, and his childhood friend, Antonin Proust, he enrolled in the atelier of the innovative and influential teacher Thomas Couture. Manet supplemented his education with visits to the Louvre, where he copied Old Master paintings. He also traveled to Belgium, Holland, Germany, and Italy; he learned a great deal by studying the paintings of Frans Hals, Titian, Giorgione, and particularly Diego Velázquez.

By February 1856 he had set up his own studio, and gained some early success: two of his works were accepted in the

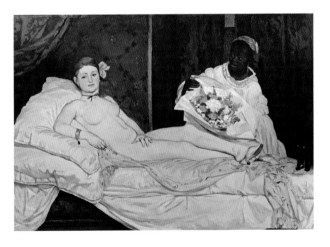

ABOVE: The oil painting *Self-Portrait with a Palette* (1879) is in a private collection.

RIGHT: The stark contrast of light and shade in *Olympia* is as bold as the nude herself.

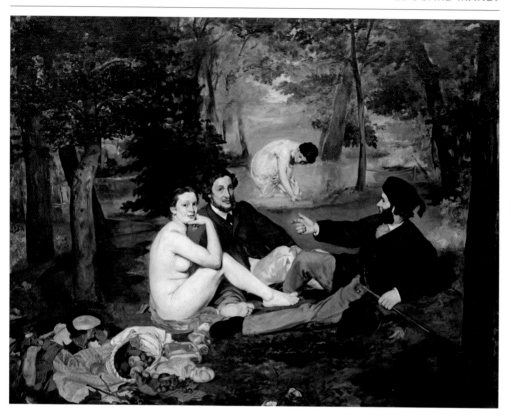

Salon of 1861 and he won an honorable mention for *The Spanish Singer* (1860). This early praise was not to last, however. As his style matured, Manet became increasingly concerned with contemporary urban life. He set up home with his family's piano teacher, Suzanne Leenhoff, who later became his wife, and moved within a circle of intellectuals that included poet Charles Baudelaire and novelist Émile Zola. In keeping with this lifestyle, Manet's first major work depicting city life was *Music in the Tuileries Gardens* (1862). It depicts a fashionable crowd gathered at an outdoor concert and includes portraits of Baudelaire, painter Henri Fantin-Latour, composer

ABOVE: Manet deliberately flouted artistic conventions in *Le Déjeuner sur l'Herbe.*

"No one can be a painter unless he cares for painting above all else."

Corpse or Beauty?

When first shown at the Paris Salon of 1865, Manet's *Olympia*—a painting of a reclining female nude—caused outrage. The subject had been common in Western art for centuries, but viewers were horrified by Manet's twist on it.

This was no naked goddess of ancient Greece, as found in the work of Titian; nor was she an exotic Turkish bather by Jean-Auguste-Dominique Ingres. The public's ire was aroused by the fact that this was clearly a contemporary Parisian courtesan, depicted as such, and self-confidently returning their stares. In their eagerness to savage both artist and subject, the critics repeatedly compared Manet's *Olympia* to a dead body:

- "The expression of [her] face is that of being prematurely aged and vicious; the body's putrefying color recalls the horror of the morgue."—Victor de Jankovitz
- "That Hottentot Venus with a black cat, exposed and completely naked on a bed like a corpse."—Geronte
- "The crowd throngs around Monsieur Manet's gamy *Olympia* like onlookers at a morgue."—Paul de Saint-Victor
- "Her face is stupid, her skin cadaverous . . . she does not have a human form." —Félix Deriège
- "A courtesan with dirty hands and wrinkled feet . . . has the livid tint of a cadaver displayed at the morgue."—Ego

Jacques Offenbach, and Manet himself. The work exemplifies Manet's mature technique: a flat and graphic composition painted in thick strokes of color, freely handled paint, bright light set against shadow, a limited palette, and the application of a significant amount of black.

A controversial figure

Manet and his oeuvre were much appreciated by a new and radical generation of artists, including Claude Monet, Pierre-Auguste Renoir, Edgar Degas, and Berthe Morisot. The establishment frowned upon it, however, and Manet caused scandal and public outrage with the display of two of his works in particular: *Le Déjeuner sur l'Herbe* (1863) and *Olympia* (1863). Shown at the infamous 1863 "Salon des Refusés" exhibition of works rejected by the official Salon, *Le Déjeuner sur l'Herbe* became the center of a critical storm—less because of its baffling subject than its style. The contemporary nature of the depicted figures—a naked woman sat with men dressed in modern clothes—and the way the scene mimicked poses from historical artworks shocked and confused many viewers. This reaction upset Manet, yet he persisted with images celebrating Parisian leisure. In later works, he used sketchier brushstrokes and a lighter palette to depict contemporary life. **AB**

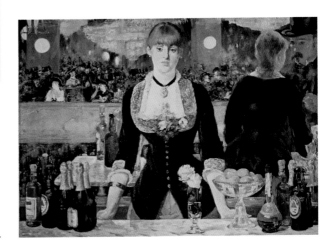

RIGHT: Much of *Folies-Bergère* was painted from memory when Manet was terminally ill.

HENRI-MICHEL-ANTOINE CHAPU

Born: Henri-Michel-Antoine Chapu, September 29, 1833 (Le Mée-sur-Seine, Seine-et-Marne, France); died April 21, 1891 (Paris, France).

Artistic style: Neo-classical sculptor and painter; allegorical and classical themes; statues, portraiture, reliefs, and public monuments; notable for funerary sculpture.

Henri-Michel-Antoine Chapu moved with his family to Paris from his native Le Mée-sur-Seine in 1847. He attended the Petit École to study drawing and become an interior decorator. However, his evident talent saw him admitted to the École des Beaux-Arts in 1849 where he studied sculpture with Jean-Jacques Pradier and Francisque Duret, and painting with Léon Cogniet. He won the Prix de Rome for sculpture in 1855, and continued his studies in Italy until 1860. On his return to Paris he received commissions; many were for public monuments such as railway stations, universities, and department stores, and his relief work was admired as far away as the United States by contemporary sculptors such as Augustus Saint-Gaudens.

The piece that shot him to fame was *Joan of Arc at Domremy, Listening to the Heavenly Voices* (1870–1872), which was remarkable for its affecting and innovative portrayal of the French heroine as a peasant girl praying rather than as a warrior, and it has become one of the most famous images in France. Chapu received numerous commissions as a result, and helped revive the trend for portrait medals. He was also sought after for his funerary sculpture, such as the *Tomb of the Comtesse Marie d'Agoult* (1877) . But his pièce de resistance was yet to come in the form of *Effigy of Victoire Auguste Antoinette of Saxe-Coburg-Gotha, Duchesse de Nemours* (1881–1883), created for a deceased member of the French royal family. The graceful reclining figure was admired for its poignant elegance, naturalism, and truthfulness to his subject, and was the crowning glory of Chapu's career. It was even admired by the Duchess of Nemours's cousin, Queen Victoria, when it first appeared *in situ* at the English church of St. Charles Borromeo in Weybridge, Surrey. **CK**

Masterworks

*La Cantate c.*1860–1869 (Opéra de Paris, Paris, France)

Léon Bonnat 1864 (Musée d'Orsay, Paris, France)

*Music c.*1869 (Metropolitan Museum of Art, New York, U.S.)

Joan of Arc at Domremy 1870–1872 (Musée d'Orsay, Paris, France)

La Jeunesse 1875 (Musée d'Orsay, Paris, France)

Tomb of the Comtesse Marie d'Agoult 1877 (Père-Lachaise Cemetery, Paris, France)

La Pensée 1877–1891 (National Gallery of Art, Washington, D. C., U.S.)

Effigy of Victoire Auguste Antoinette of Saxe-Coburg-Gotha, Duchesse de Nemours 1881–1883 (Walker Art Gallery, Liverpool, England)

"Ideally if one wants to leave an immortal trace one should be entombed by Mr. Chapu."—*Fidière*

ABOVE: *Joan of Arc at Domremy* is at the Musée Conde, Chantilly, France.

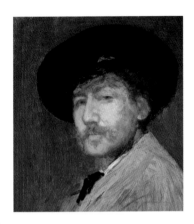

JAMES MCNEILL WHISTLER

Born: James Abbott McNeill Whistler, July 11, 1834 (Lowell, Massachusetts, U.S.); died July 17, 1903 (London, England).

Artistic style: Misty, low-toned landscapes known as "nocturnes;" smooth, liquid application of paint; stylish, full-length, and profile portraits; atmospheric etchings.

1800-99

Masterworks

Symphony in White, No.1: The White Girl 1862 (National Gallery of Art, Washington, D.C., U.S.)

Symphony in White, No. 2: The Little White Girl 1864 (Tate Collection, London, England)

*Portrait of the Artist's Mother (*later called *Arrangement in Grey and Black No.1)* 1871 (Musée d'Orsay, Paris, France)

Nocturne: Blue and Gold—Old Battersea Bridge c.1872–1875 (Tate Collection, London, England)

Harmony in Grey and Green: Miss Cicely Alexander 1872–1874 (Tate Collection, London, England)

Nocturne in Black and Gold: The Falling Rocket c.1875 (Detroit Institute of Arts, Detroit, Michigan, U.S.)

Harmony in Blue and Gold: The Peacock Room 1876–1877 (Freer Gallery of Art, Washington, D.C., U.S.)

First and Second Venetian Set 1880 and 1886 (University of Glasgow, Glasgow, Scotland, and other collections)

Harmony in Pink and Grey: Portrait of Lady Meux 1881–1882 (Frick Collection, New York, U.S.)

ABOVE: *Arrangement in Gray, Portrait of the Artist (Self-Portrait)* was made in 1872.

RIGHT: The angular *Arrangement in Grey and Black No.1* is the artist's most famous work.

Born in Massachusetts, James McNeill Whistler sailed for Europe in 1855, never to return. The rest of his life was spent in Paris and London, where he became known as much for his cutting wit, affected mannerisms, and dandified mode of dress as for his art. He deliberately styled himself as a fragile, elegant butterfly, a motif that he used in lieu of a signature on all his works after the 1860s. This particular butterfly, however, had an aggressive sting, as many of his patrons found out to their cost. In later life, he published his extensive public writings in *The Gentle Art of Making Enemies* (1890)—an art at which he excelled.

Whistler's combative nature was ironically at odds with the enchanting harmony of his paintings. The creed for which he is best remembered was the idea that art should exist for its own sake, a belief that he outlined in his *Ten O'Clock Lecture* (1885).

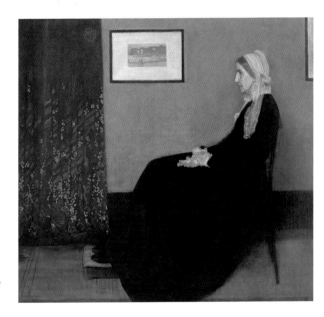

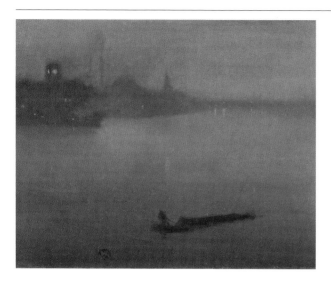

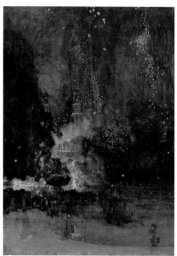

Whether painting landscapes or fashionable portraits, his work prioritized aesthetics over narrative and concentrated upon the perfect arrangement of color and form. The most celebrated example of this approach, *Portrait of the Artist's Mother* (later called *Arrangement in Grey and Black No.1*) (1871), became an icon of modern painting. A stunningly tender and perceptive portrait, the striking composition and chromatic harmonies conformed to Whistler's strictly held aesthetic principles. He further developed these theories in his fashionable society portraits, and the *Nocturnes*, a series of shadowy, twilight views of the River Thames influenced by the simplicity of Japanese woodcuts.

Technique was crucial to achieving the desired fluidity of Whistler's works. Multiple layers of paint thinned with oil and turpentine were applied in one "wet," to achieve the correct liquidity and a rare and beautiful unity. Such patience and skillful dexterity also made him a superb printmaker and he produced more than 460 etchings. Through such subtle masterpieces as the prints for the first and second Venetian sets created in 1880 and 1886, Whistler established himself as a leading figure of the British etching revival. **NM**

ABOVE LEFT: *Thames: Nocturne in Blue and Silver* (c.1872–1878) is classic Whistler.

ABOVE: *Nocturne in Black and Gold* is a key work in the history of abstract painting.

Whistler Versus Ruskin

In 1877, Whistler's *Nocturne in Black and Gold: The Falling Rocket* (c.1875) became the centerpiece of an acrimonious lawsuit after the critic John Ruskin accused the artist of exhibiting an unfinished work— or "flinging a pot of paint in the public's face," in his colorful phrase. Never one to shrink from a fight, Whistler sued Ruskin for libel in 1878, and the case became a public debate about an artist's right to decide what constituted a finished work. The court settled in Whistler's favor—but the victory was a hollow one. Awarded just one farthing in damages, he spent the rest of his life crippled by legal costs.

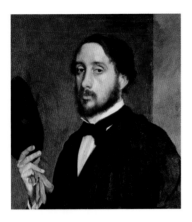

Masterworks

*Young Spartans Exercising c.*1860
(National Gallery, London, England)

Race Horses 1866 (Musée d'Orsay,
Paris, France)

The Star 1871 (Musée d'Orsay,
Paris, France)

The Rehearsal 1873–1878 (Fogg Art Museum,
Harvard University, Massachusetts, U.S.)

The Absinthe Drinker 1875 (Musée d'Orsay,
Paris, France)

*Little Dancer Aged Fourteen c.*1880–1881
(Tate Collection, London, England)

The Bathtub 1886 (Musée d'Orsay,
Paris, France)

*Woman Ironing c.*1890 (Walker Art Gallery,
Liverpool, England)

*Dancers on a Bench c.*1898 (Kelvingrove Art
Gallery and Museum, Glasgow, Scotland)

ABOVE: Degas's self-portrait was painted
early on in his career, in 1862.

RIGHT: *Dancers on a Bench* shows Degas's
mastery in depicting movement.

EDGAR DEGAS

Born: Hilaire-Germain-Edgar de Gas, July 19, 1834 (Paris, France); died
September 27, 1917 (Paris, France).

Artistic style: Impressionist painter and sculptor; expressive use of line; vivid-
colored pastels; depictions of horse racing, dancers, and women bathing.

One of the world's greatest draftsmen, Edgar Degas has been
credited as the link between classical and modernist art. He
mastered painting, drawing, sculpture, and photography—
taking up the latter in earnest from 1895 onward.

Noting his talent, Degas's wealthy parents allowed him to
have a studio at home, and by the age of twenty he was
determined to become an artist. His early pieces were
influenced by the work of Jean-Auguste-Dominique Ingres
and Eugène Delacroix; in 1855 he met Ingres who gave him his
famous advice to "follow the lines." Degas enrolled in the École
des Beaux-Arts in Paris and spent three years studying in Italy.
He first exhibited at the Paris Salon in 1865, and was one of the
Société Anonyme des Artistes who exhibited together from
1874 onward. The first show included work by Degas, Claude
Monet, Berthe Morisot, and Pierre-Auguste Renoir, and was
later labeled pejoratively the "Exhibition of the Impressionists"
by critic Louis Leroy because the artists' style of insufficient
detail, obvious brushstrokes, and use of unblended colors.

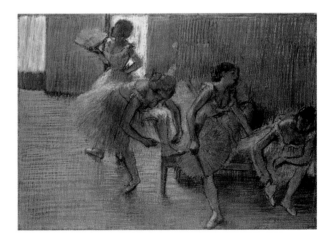

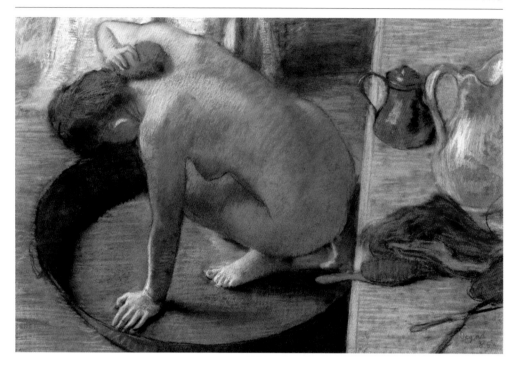

Throughout his career, Degas was supported by his greatest patron, gallery owner Paul Durand-Ruel. Not everyone understood or liked Degas's work at first, but by 1880 his paintings, with their compositions of unusual angles and loose, rapid brushstrokes, were being warmly received. Yet his masterpiece sculpture, a wax and fabric model (later cast in bronze) *Little Dancer Aged Fourteen* (*c.*1880–1881), still divided opinion, provoking adoration, outrage, and disgust. In 1886 Degas's works were shown in New York, and in 1905 Degas and many of the impressionists exhibited paintings in London.

Somewhat misogynous, Degas never married, considering women a poor second to his art. Yet many of his most famous works depict dancers and working women, such as laundresses and seamstresses. Toward the end of his life he was plagued by failing eyesight, but somehow retained an ability to sketch, paint, and sculpt. **LH**

ABOVE: Some found the woman's vulnerability in *The Bathtub* vulgar.

The Impressionists

Degas exhibited in seven of the eight impressionist exhibitions, but was keen to distance his style from impressionism. He openly criticized the *plein air* technique declaring: "If I were the government I would have a special brigade of gendarmerie to keep an eye on artists who paint landscapes from nature …." He also became embroiled in "The Dreyfus Affair," a debate that divided France in which a Jewish soldier, Alfred Dreyfus, was falsely accused of treason. Degas's insistence that Dreyfus was guilty revealed his anti-Semitism, and he lost many of his impressionist friends as a result.

HENRI FANTIN-LATOUR

Born: Ignace Henri Jean Théodore Fantin-Latour, January 14, 1836 (Grenoble, France); died August 25, 1904 (Buré, Orne, France).

Artistic style: Painter and lithographer; harmonious, floral still lifes; individual and group portraits; use of neutral backgrounds; understated composition.

1800-99

Masterworks

Flowers 1860 (The Hermitage, St. Petersburg, Russia)

Homage to Delacroix 1864 (Musée D'Orsay, Paris, France)

Portrait of Édouard Manet 1867–1880 (Art Institute of Chicago, Chicago, Illinois, U.S.)

A Studio at Les Batignolles 1870 (Musée D'Orsay, Paris, France)

Charlotte Dubourg 1882 (Musée D'Orsay, Paris, France)

Flowers in an Earthenware Vase 1883 (The Hermitage, St. Petersburg, Russia)

Das Rheingold 1888 (Kunsthalle, Hamburg, Germany)

Naiad (also called *Undine*) *c.*1896 (The Hermitage, St. Petersburg, Russia)

"First I copied the masters, then life. For a few years I have been painting my dreams."

ABOVE: *Self-Portrait* (1859) can be seen at the Galleria degli Uffizi, Florence, Italy.

Henri Fantin-Latour produced work that bridged the gap between the realists and the impressionists, although he could identify himself as neither.

Fantin-Latour was born into an artistic home—his father was a painter and art teacher. The young Henri was a pupil of the great realist painter Gustave Courbet and he later became an integral part of the group of artists who lived and worked alongside the impressionist master Édouard Manet. He was also hugely influenced by the works and imagination of romantic painter Eugène Delacroix.

Fantin-Latour's work veered between the crisp brilliance of such early works as his *Homage to Delacroix* (1864) and *Portrait of Édouard Manet* (1867–1880), and the dreamy impressionistic style of *Das Rheingold* (1888) and *Naiad* (*c.*1896). Although his earlier works are realist, and many of his later works are more impressionist and treat light in terms of tone rather than color, the distinction cannot be said to be caused by the passage of time; instead he switched easily between the two painting styles and fused the techniques to suit his own style.

Fantin-Latour's portraits of the Duborg family and of Charlotte Duborg show an intensity of emotion and link superbly the two artistic movements. Both his portraiture and his still lifes tend to have neutral backgrounds. Although he is best known for his still lifes, in particular those of flowers, his group portraits are perhaps more interesting, such as *A Studio at Les Batignolles* (1870). The work is an evocation of the Parisian art world just before the Franco–Prussian War, and is most poignant for its inclusion of the young Frédéric Bazille, who was killed in battle only months after Fantin-Latour painted the group. **LH**

WINSLOW HOMER

Born: Winslow Homer, February 24, 1836 (Boston, Massachusetts, U.S.); died September 29, 1910 (Prout's Neck, Maine, U.S.).

Artistic style: Depictions of the bloodshed of the U.S. Civil War; pictorial poet of U.S. landscapes; explorations of the relationship between man and nature.

Although Winslow Homer is best characterized as a painter of landscapes following on the U.S. tradition of the Hudson River School, he began his professional career as an illustrator. Born and educated in Boston, Massachusetts, he began working for a firm of lithographers, and by 1859 had moved to New York where he produced illustrations for *Harper's Weekly*. During the U.S. Civil War he followed the Union armies south as the artist correspondent for *Harper's Weekly*. This early training provided Homer with his skill of careful observation, and encouraged his clear sense of line and form, and rigorous composition.

Homer's first acclaimed masterpiece, *Prisoners from the Front* (1866), was painted in oils but carries the same direct frankness and bold composition as his illustrations. The work caused a sensation when it was first displayed in the United States and later in Paris. After his election at the age of twenty-nine to the National Academy of Design, Homer went on his first trip to Europe, and discovered firsthand the works of Jean-François Millet, Eugène Boudin, and Gustave Courbet.

Throughout the 1870s he painted in watercolor, exploring the luminous and translucent effects of the medium. Favoring outdoor subjects, he concentrated on outdoor scenes, and increasingly painted outside and in front of his subject. After a stay of nearly two years in the North Sea fishing village of Cullercoats in England, Homer returned to the United States in 1882, and permanently settled in Prout's Neck on the coast of Maine. Living and working in isolation on this rocky Atlantic coast, his style and subject matter shifted from an idyllic world of leisure to a concern for the relationship between man and nature, producing thickly painted images of man's struggle against the perils and grandeur of the sea. **AB**

Masterworks

Prisoners from the Front 1866 (Metropolitan Museum, New York, U.S.)

Snap the Whip 1872 (Butler Institute of American Art, Youngstown, Ohio, U.S.)

Breezing Up; A Fair Wind, 1873–1876 (National Gallery of Art, Washington, D.C., U.S.)

Northeaster 1895 (Metropolitan Museum, New York, U.S.)

"The sun will not rise or set without my notice, and thanks."

ABOVE: This undated drawing was made from a photograph of the artist.

LAWRENCE ALMA-TADEMA

Born: Laurens Tadema, January 8, 1836 (Dronrijp, the Netherlands); died June 25, 1912 (Wiesbaden, Germany).

Artistic style: Painter of portraits, landscapes, and watercolors but most famed for oils of classical subjects; attention to architectural detail and depiction of textures.

Masterworks

The Education of the Children of Clovis 1861
 (Private collection)

Egyptian Chess Players 1865
 (Private collection)

A Foregone Conclusion 1885 (Tate Collection, London, England)

The Rose of Heliogabalus 1888
 (Private collection)

*Unconscious Rivals c.*1893 (Bristol City Museum and Art Gallery, Bristol, England)

Spring 1894 (J. Paul Getty Museum, Los Angeles, California, U.S.)

*Silver Favourites c.*1903 (Manchester City Art Galleries, Manchester, England)

The Finding of Moses 1904 (Private collection)

A Favourite Custom 1909 (Tate Collection, London, England)

"I have always been possessed of the beauty of antiquity."

ABOVE: Alma-Tadema's *Self-Portrait*
(1896) is painted using a warm palette.

With the advent of modernism, Sir Lawrence Alma-Tadema's paintings of classical and antique subjects—with their azure skies and seas, female beauties clad in togas, and nostalgia for the grandeur and decadence of the ancient world—fell from favor. However, by the late 1960s, he was once again being celebrated for his obsessive attention to architectural detail and the virtuosity of his rendering of textures—notably marble, a skill that saw him labeled "the marbelous painter."

He studied at the Royal Academy of Antwerp in Belgium in 1852 and went on to make a living as a painter of classical subjects, but it was only after he moved to London in 1870 to escape the outbreak of the Franco–Prussian War that his fortunes rose. He befriended the Pre-Raphaelites and was influenced by their meticulous eye for detail and bright palette. He became a naturalized British subject in 1873, and—being a shrewd man—changed his first name from "Laurens" to the more English-sounding "Lawrence," and his surname from "Tadema" to "Alma-Tadema," to ensure his name appeared near the top of the list in exhibition catalogs. England was the ideal market for his brand of classical landscapes and the works made him one of the most famous and highly paid artists of the day. In 1873 and 1883 he traveled to Italy, using his visits to ancient ruins in Rome and Pompeii to gather photographs and details on ancient Roman life that would enhance the authenticity of his work. By the early 1900s, he was in demand as a theatrical set and costume designer, and even moved into furniture and textile design. His latter years were dogged by a decline in popularity and ill health, and it was while on a trip to Wiesbaden's Kaiserhof Spa to undertake treatment for a stomach ulcer that he died. **CK**

MARIANO FORTUNY Y CARBÓ

Born: Mariano José María Bernardo Fortuny y Carbó, June 11, 1838 (Reus, Spain); died November 21, 1874 (Rome, Italy).

Artistic style: Catalan painter; Moroccan, oriental and Spanish themes; loose brushstrokes; flair for bold use of color; realistic depictions.

1800-99

After four years' studying at the Academy of Barcelona, Mariano Fortuny y Carbó won the Prix de Rome in 1857 and made Italy his home. When Spain declared war on Morocco, he was sent by the Spanish authorities to document the war in paintings. Although he made a large number of studies, he never finished the work, but the light and colors of Morocco made a significant impact on his later works. One of his masterpieces, *La Vicaria* (1870), was particularly well regarded for its luxurious color and detailed composition, and contributed to his considerable commercial success. *Nude on the Beach at Portici* (1874) is an outstanding example of the painter's talent for realistic drawing. Sadly, he died shortly after its completion. **SH**

Masterworks

*The Bull-Fighter's Salute c.*1869
(National Gallery, London, England)

The Spanish Wedding (La Vicaria) 1870
(Museum of Modern Art, Barcelona, Spain)

Nude on the Beach at Portici 1874
(Museo del Prado, Madrid, Spain)

JAN MATEJKO

Born: Jan Matejko, June 24, 1838 (Kraków, Poland); died November 1, 1893 (Kraków, Poland).

Artistic style: Romance; theatricality; moody lighting; fine detail; rich colors; epic scenes from Polish history; much-copied image of Stańczyk—from Polish lore.

The grand sweep of his country's history, its struggles against oppression, and his brother's death during a major uprising fed the fertile imagination of this leading Polish painter. Trained in Kraków, Munich, and Vienna, Jan Matejko's specialty was monumental historical set pieces through which he commented on Poland's current affairs. He also created his own take on the traditional jester figure, Stańczyk, using him as a commentator that still resonates with Poles today. Matejko's nationalistic zeal found great popularity at home and farther afield, but open criticism of certain Polish statesmen made him unpopular. Though his later work became tamer, he remained a national icon and an inspiration to aspiring Polish artists. **AK**

Masterworks

Stańczyk 1862 (Muzeum Narodowe, Warsaw, Poland)

The Sermon of Skarga 1864 (Royal Castle, Warsaw, Poland)

Princess Marcelina Czartoryska z Radziwitt 1874 (National Museum of Kraków, Kraków, Poland)

Battle of Grunwald 1875–1878 (Muzeum Narodowe, Warsaw, Poland)

*Jan Sobieski Vanquisher of the Turks at the Gates of Vienna c.*1883 (Sobieski Room, Vatican Museums, Vatican City, Italy)

AIMÉ-JULES DALOU

Masterworks

Retour des bois Date unknown (Musée d'Orsay, Paris, France)

*Maternity c.*1873 (Royal Exchange, London, England)

Triumph of the Republic 1889 (Place de la Nation, Paris, France)

Monument on the Grave of Victor Noi 1889 (Père Lachaise Cemetery, Paris, France)

*Paysan revelant sa manche c.*1899 (Musée d'Orsay, Paris, France)

Born: Aimé-Jules Dalou, December 31,1838 (Paris, France); died April 15, 1902 (Paris, France).

Artistic style: simple, weighty sculptures; realist figures; natural shapes and rough surfaces; everyday subject matters; often unrefined handling of material.

Jules Dalou was born into a working-class family, and his sculptural work reflects his early experiences. He combines an astounding technical ability and understanding of academic practice with an unapologetic insistence on realism in both his subjects and style. He became involved in the Paris Commune of 1871 and had to leave for England, where he taught at what is now the Royal College of Art. He continued to produce images of the French peasantry, one of the best known being *Maternity* (*c.*1873). Returning to France in 1878, Dalou produced a number of public monuments. His *Triumph of the Republic* (1889) symbolizes the eventual concordance between Dalou's political leanings and his public work. **PS**

ALFRED SISLEY

Masterworks

The Bridge at Argenteuil 1872 (Memphis Brooks Museum of Art, Memphis, Tennessee, U.S.)

Snow at Louveciennes 1875 (Musée d'Orsay, Paris, France)

Floods at Port-Marly 1876 (Musée des Beaux-Arts, Rouen, France)

Snow at Véneux 1880 (Musée d'Orsay, Paris, France)

RIGHT: Sisley's *Snow at Louveciennes* has a beautiful and lyrical tonal quality.

Born: Alfred Sisley, October 30, 1839 (Paris, France); died January 29, 1899 (Moret-sur-Loing, France).

Artistic style: Lyrical impressionist painter; lightness of touch; subtle tones, quivering reflections; harmonious palette; explorations of sky and weather effects.

Alfred Sisley studied painting with Claude Monet, Pierre-Auguste Renoir, and Frédéric Bazille. The companions painted together in the open air, trying to capture the effects of light and in a more colorful and sketchy style than was acceptable at the time. Influenced by the work of John Constable, Joseph Mallord William Turner, and Gustave Courbet, Sisley lightened his palette as Monet and Renoir had. He took lessons with Camille Corot in 1867 and exhibited at the Paris Salon and the "Salon des Refusés." Although he spent most of his life in France, he spent time in Britain, too, and painted landscapes of both countries. Yet it was only at the age of fifty-nine, when he was dying of cancer, that he received some recognition. **SH**

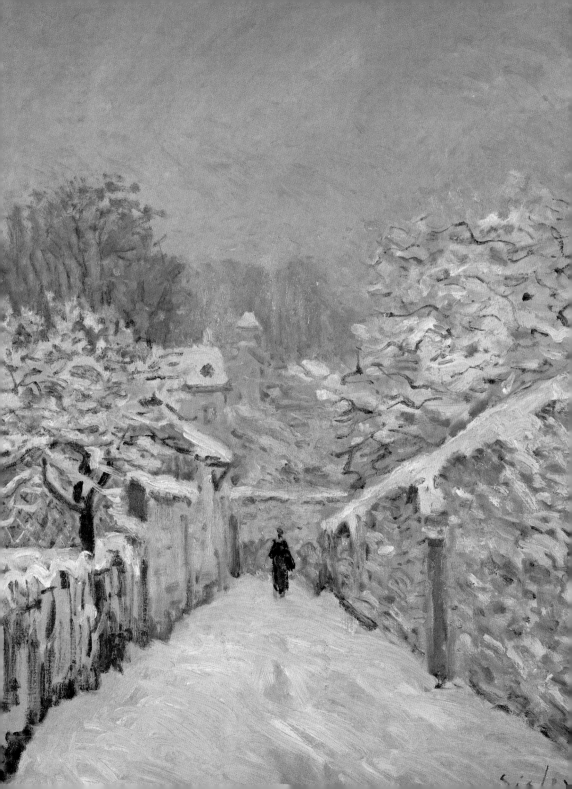

PAUL CÉZANNE

Born: Paul Cézanne, January 19, 1839 (Aix-en-Provence, France); died October 22, 1906 (Aix-en-Provence, France).

Artistic style: Bold use of color; innovative use of perspective; preoccupation with geometric shapes and interchange between light and shade; unusual composition.

Born the illegitimate child of a wealthy banker, Paul Cézanne desired to become an artist from childhood, an ambition of which his overbearing father sternly disapproved. Fear of his father and the insecurity associated with his own illegitimacy seem to have plagued Cézanne throughout his life.

At the age of twenty-two, Cézanne spent six months in Paris studying art and mixing with other artists; the period led to one of his great depressions, and his feelings of low self-worth led him to destroy many of his paintings. He returned to Aix-en-Provence but by 1862 he was back in Paris, determined to make it as an artist. Together with his great friend, the writer Émile Zola, he became politically active, declaring himself a revolutionary. Despite this stance, Cézanne was desperate to be accepted by the elite world of Parisian artistic society. When his works were rejected by the Salon, he was eaten up with depression again, yet this time he persevered. In 1863, an

Masterworks

Portrait of Louis-Auguste Cézanne, the Artist's Father 1866 (National Gallery of Art, Washington, D.C., U.S.)

Paul Alexis Reading to Émile Zola 1869–1870 (Sao Paolo Museum of Art, Brazil)

*The Avenue at the Jas de Bouffan c.*1871 (National Gallery, London, England)

Self-Portrait in a Straw Hat 1875–1876 (Museum of Modern Art, New York, U.S.)

Melting Snow, Fontainebleau 1879–1880 (Museum of Modern Art, New York, U.S.)

*The Bather c.*1885 (Museum of Modern Art, New York, U.S.)

*Banks of the Marne c.*1888 (The Hermitage, St. Petersburg, Russia)

*Bathers c.*1890–1892 (Musée d'Orsay, Paris, France)

*Les Grandes Baigneuses c.*1894–1905 (National Gallery, London, England)

*Apples and Oranges c.*1895–1900 (Musée d'Orsay, Paris, France)

*An Old Woman with a Rosary c.*1895–1896 (National Gallery, London, England)

*Mont Sainte-Victoire c.*1897–1898 (The Hermitage, St. Petersburg, Russia)

ABOVE: One of several well-known self-portraits, this work was painted in 1875.

RIGHT: *Paul Alexis Reading to Émile Zola* evokes a typically somber mood.

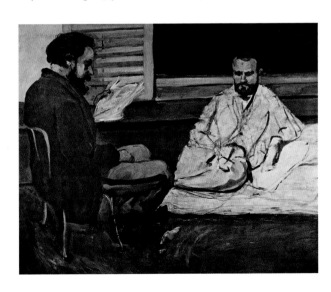

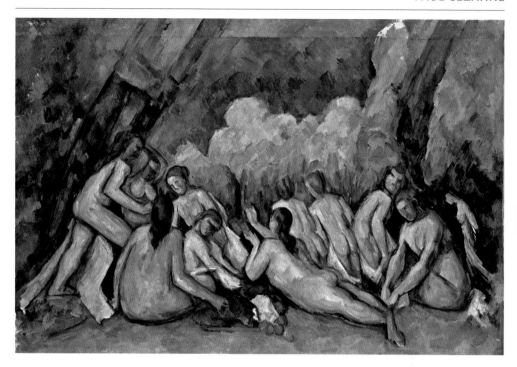

alternative exhibition, the "Salon des Refusés," was created. Cézanne exhibited alongside other "rejects," including Édouard Manet, Camille Pissarro, and Henri Fantin-Latour. Two decades later, the first of his works was accepted by the Salon in 1882.

ABOVE: *Les Grandes Baigneuses* brings an element of modernism to the human form.

Cézanne's early works evoke a moody atmosphere with a somewhat claustrophobic feel and are painted with a dark and gloomy palette. In the 1870s, his style changed. At around this time, he fell in love with Emilie-Hortense Fiquet and also came to be associated with the impressionists, working particularly closely with Pissarro. In 1874, Cézanne exhibited with the group, although he did not consider himself a true impressionist. He wanted his art to be more "solid and durable." Long impressed by Flemish art, Cézanne painted a number of still lifes in color palettes similar to those used by the

"My one and only master … Cézanne was like the father of us all."—Pablo Picasso

A Beautiful Friendship?

Cézanne first met Émile Zola in 1852 when they were pupils attending the same school. Their friendship remained close, with each appearing to hero-worship the other, Zola seemingly in awe of Cézanne's art, and Cézanne of Zola's writing. Zola was also an amateur artist, and the two boys spent most of their free time together, walking and sketching in the countryside of Aix-en-Provence. Cézanne always kept in his possession a screen that the two friends had painted together, an object that appears in many of his paintings; Zola also modeled for Cézanne.

It was thanks to Zola that the artist left Aix-en-Provence and moved to Paris. After Zola's father died, the writer and his mother moved to the city. Zola persuaded his friend to follow them, and concentrate on his art, despite Cézanne's father's clear disapproval.

The two men had been friends for more than thirty years when Zola, who was by then a successful novelist, published his book *L'Oeuvre* (*The Masterpiece*) in 1886. Its main character, Claude Lantier, is a failing, anxious, sexually insecure artist who commits suicide. Although believed to have been an amalgam of many of the artists Zola knew, Cézanne saw it as a direct satire of himself, ridiculing many of the secrets he had revealed to Zola over the years. It caused the end of their once-beautiful friendship.

Flemish masters. His best known is *Apples and Oranges* (*c.*1895–1900), a painting that manages to elevate a prosaic subject to the realm of great art.

Back to his roots

In 1886, Cezanne's father died and the artist inherited his wealth. By this time, his work was being sought by serious art collectors; yet despite this success, Cézanne could never rid himself of the feeling that he was a failure. An artist who felt empathy with the scenes he created, Cézanne's artistic style evolved with the changes that took place in his life. In the latter half of the 1860s, he was using an almost clumsy, perhaps angry, style of layering paint on canvas, such as in the 1866 portrait of his father, yet soon he was producing such sensual scenes as *The Avenue at the Jas de Bouffan* (*c.*1871), a rich, unusual interpretation of the parkland on his father's estate. He returned repeatedly to landscapes and themes that intrigued him, attempting numerous re-creations according to the varied emotions they provoked in him at different stages of his career. Toward the end, his work was characterized by the harmonious, dreamily colored studies he produced of nudes, most famously in *Les Grandes Baigneuses* (*c.*1894–1905). **LH**

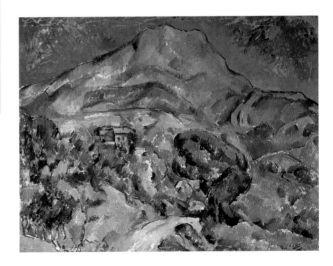

RIGHT: The *Mont Sainte-Victoire* landscape is a recurring theme in Cézanne's oeuvre.

ODILON REDON

Born: Odilon Redon, April 20, 1840 (Bordeaux, France); died July 6, 1916 (Paris, France).

Artistic style: Symbolist painter and graphic artist; early work in black and white; later use of pastels and oils in glowing colors; mysterious, dreamlike images.

A contemporary of impressionism, Odilon Redon developed in an independent direction with an intensely personal style. At fifteen years old, he began studying drawing. He then changed to architecture on his father's insistence but soon abandoned thoughts of an architectural career. Back in his native Bordeaux, he became proficient in sculpture, etching, and lithography. After serving in the Franco–Prussian War in 1870 to 1871, he moved to Paris and worked almost exclusively in charcoal and lithography, producing images of bizarre creatures and plants, influenced by the writings of Edgar Allan Poe. Nevertheless, he remained relatively unknown until the publication of a novel by Joris-Karl Huysmans, *À Rebours* (*Against Nature*) (1884); the story featured an aristocrat who collected Redon's drawings.

In the early 1890s, Redon experienced a religious crisis, and he developed a serious illness in 1894, after which his personality became more buoyant. He began working with pastels and oils in glowingly colored mythological scenes and flower paintings. These conform to the ideals of symbolism in that they are mysterious, unexpected, and dreamlike.

The thematic content of his work over his last twenty years became more optimistic, overflowing with hope and light. In 1899, he exhibited with the Nabis, and he was awarded the Légion d'Honneur in 1903. An isolated figure in his time, Redon was a fruitful influence on later generations of artists. Henri Matisse admired his flower paintings in particular, and the surrealists regarded him as one of their precursors because his art was dominated by his dreams. His popularity increased when a catalog of etchings and lithographs was published in 1913. In the same year, he was given the largest single representation at the New York Armory Show. **SH**

Masterworks

*Flower Clouds c.*1903 (Art Institute of Chicago, Chicago, Illinois, U.S.)

*Flowers c.*1903 (Künstmuseum St. Gallen, Switzerland)

*The Buddha c.*1905 (Musée d'Orsay, Paris, France)

Portrait of Violette Heymann 1910 (Cleveland Museum of Art, Cleveland, Ohio, U.S.)

*The Cyclops c.*1914 (Museum Kroller-Mueller, Otterlo, the Netherlands)

"Like music, my drawings transport us to the ambiguous world of the indeterminate."

ABOVE: Redon has his arms crossed in a firm pose for this photograph by Guy & Mockel.

AUGUSTE RODIN

Born: François-Auguste-René Rodin, November 12, 1840 (Paris, France); died November 17, 1917 (Meudon, France).

Artistic style: Realistic re-creations of the human figure; religious subjects; modernized public sculpture; expressive facial modeling to render emotions.

Auguste Rodin is one of the greatest sculptors the world has ever seen. The figures he created are imbued with life and are enticingly tactile; his media, whether clay, plaster, marble, or bronze, were animated by the superb way in which he re-created skin, muscle, unique physical characteristics, and facial expressions.

As a short-sighted child of a poor family, Rodin was teased for his lack of academic ability and retreated into shyness. He

Masterworks

*The Man with the Broken Nose c.*1865 (Musée Rodin, Paris, France)

The Age of Bronze 1877 (Musée D'Orsay, Paris, France)

The Thinker 1880 (Musée Rodin, Philadelphia, Pennsylvania, U.S.)

Camille Claudel 1882–1899 (Victoria & Albert Museum, London, England)

The Burghers of Calais 1884–1886 (Musée Rodin, Paris, France)

*Danaid c.*1889 (Musée Rodin, Paris, France)

The Eternal Idol 1889 (Musée Rodin, Paris, France)

Thought 1890 (Musée D'Orsay, Paris, France)

*Crouching Woman c.*1891 (Victoria & Albert Museum, London, England)

The Fallen Angel 1895 (Victoria & Albert Museum, London, England)

Balzac 1899 (Musée D'Orsay, Paris, France)

The Kiss 1901–1904 (Tate Britain, London, England)

*La France c.*1904 (Victoria & Albert Museum, London, England)

*Torso of a Woman c.*1914 (Victoria & Albert Museum, London, England)

ABOVE: Auguste Rodin's face has become as famous as his works.

RIGHT: Rodin's *The Kiss* is one of the most recognized sculptures in the world.

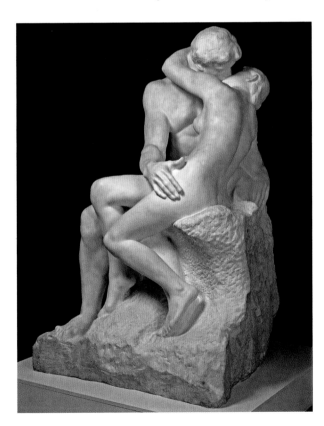

began drawing in earnest at ten years old and soon began sculpting in clay. Yet his talent was not recognized for many years, and he was rejected by the École des Beaux-Arts in Paris three times. His first public artworks were created in labor-intensive workshops, working on decorative street sculpture from other people's designs.

During the 1860s, Rodin became increasingly frustrated with his artistic output, and as a result suffered an emotional breakdown. He spent time in a monastery to recuperate, and when he was well again he rented a studio and began hiring models. Despite being ignored by the Paris Salon, he continued undaunted until his work was receiving the recognition he knew it deserved.

Back on track

In 1875 he visited Italy, where he was inspired by classical art—especially the works of Michelangelo Buonarotti—and determined to update it in his own work. His depiction of the human body became so exact that, when his work began to be exhibited, he was accused of cheating by making a cast of a real person rather than sculpting a model.

His first major public work was *The Gates of Hell* (1880), intended as the entrance doors into a museum; however the museum was never completed, and Rodin did not finish the commission. His fame and position were now assured and over the ensuing couple of decades, he produced some of his most famous works, including *The Thinker* (1880), *The Burghers of Calais* (1884–1886), and *The Kiss* (1901–1904).

Rodin was a man whose romantic life was as passionate and expressive as his art. His love of women can be seen in the tender portraits he created, such as the bust of his lover and model *Camille Claudel* (1882–1899), and exquisite sculptures such as *The Eternal Idol* (1889). Rodin remains globally famous, his works housed in art galleries throughout the world. His former home in Paris is now the Musée Rodin, which exhibits examples of almost all of his oeuvre, and there is another Rodin Museum in Philadelphia, Pennsylvania. **LH**

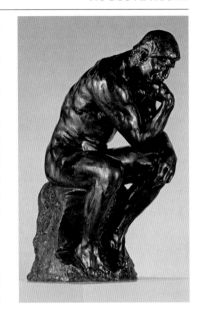

ABOVE: Bronze cast of *The Thinker* (1880–81) from the Burrell Collection, Glasgow, Scotland.

1800–99

A Retreat From Art

In the late 1850s, Rodin's health began to deteriorate, because of depression caused by his lack of artistic recognition. His health worsened sharply after the premature death of his sister in 1862. Overwhelmed with grief, he sought solace in religion and joined a monastery. The head of the order, Father Peter Julian Eymard, recognized that Rodin did not have a religious vocation but was a man who needed time to grieve. It was he who suggested Rodin start sculpting again to ease his mind. It was thanks to Father Eymard—whom Rodin also sculpted—that the world has the art of Rodin.

CLAUDE MONET

Born: Claude Oscar Monet, November 14, 1840 (Paris, France); died December 5, 1926 (Giverny, France).

Artistic style: Colorful landscape and figurative paintings observed from nature; compositions inspired by Japanese woodcuts; broken brushwork.

Masterworks

Impression, Sunrise c.1873 (Musée Marmottan, Paris, France)

Poppies 1873 (Musée d'Orsay, Paris, France)

The Walk (Argenteuil) 1875 (Private collection)

Woman with a Parasol Mme. Monet and her Son 1875 (National Gallery of Art, Washington, D.C., U.S.)

Haystacks, White-Frost Effect 1888–1889 (Hill-Stead Museum, Farmington, Connecticut, U.S.)

Poppy Field (Giverny) 1890 (Art Institute of Chicago, Chicago, Illinois, U.S.)

Rouen Cathedral: The Portal (Sunlight) 1892 (Metropolitan Museum of Art, New York, U.S.)

Water-Lilies and Japanese Bridge 1899 (Art Museum, Princeton University, New Jersey, U.S.)

Houses of Parliament, Effect of Sunlight in the Fog 1900–1901 (Musée d'Orsay, Paris, France)

Claude Monet was born in Paris, although his family moved to Le Havre when he was five years old. It was a move that was to have a great impact on his future work, for Monet's childhood was spent exploring the Normandy coastline and countryside and watching the effects of the rapidly changing weather on the sea and the land. Furthermore, the technique of local artist Eugène Boudin was to influence Monet's approach to painting for life. Boudin introduced him to the concept of *plein-air* painting, done outdoors directly from observation.

At the age of twenty-two, Monet joined the Paris studio of academic painter Charles Gleyre, where he met fellow future impressionists Pierre-Auguste Renoir and Frédéric Bazille. Monet enjoyed limited success with a number of landscapes, seascapes, and portraits that were accepted for exhibition at the annual Salons, but his large-scale, more challenging works were refused. The bitter disappointment of the rejection of works such as *Woman in the Garden* (1866) prompted Monet to

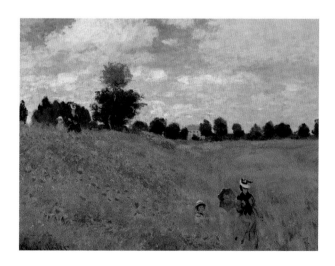

ABOVE: Monet focuses sharply on the viewer in *Self-Portrait with a Beret* (1886).

RIGHT: In Argenteuil, Monet painted some of his most uplifting works, such as *Poppies*.

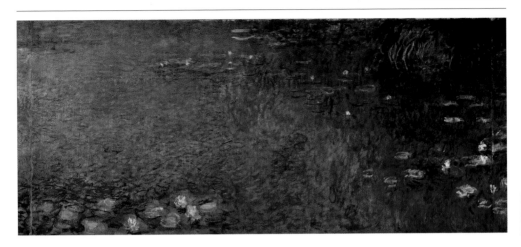

join with Édouard Manet, Edgar Degas, Camille Pissarro, Renoir, and others in establishing the Société Anonyme des Artistes. The group held its first independent exhibition in 1874.

ABOVE: *Waterlilies: Morning* captures the tranquillity of the "enchanted pond."

One of Monet's submissions to the exhibition was *Impression, Sunrise* (c.1873). The work drew scorn from the critics for its apparently unfinished appearance. Critic Louis Leroy borrowed the painting's title for his damning review of the show, mockingly describing it as "The Exhibition of the Impressionists." Yet far from being disheartened, the artists embraced the derisory term "impressionist"; they determined to take their lead from the accusation and forged a new, highly successful way of working.

Monet was never at a loss for subject matter, usually seeking to capture the people and places he knew best. Both his wives served as models, and he drew inspiration from the gardens and buildings of Paris, the Normandy coastline and countryside, and his beloved garden in Giverny. This idyllic setting became a magnet for Monet's friends, such as Manet and Renoir, providing them with a tranquil break from the hustle and bustle of Paris. Monet continued the practice of the Barbizon school of painters from the early nineteenth century, observing his subject matter directly from life. Yet unlike the Barbizon

"No one is an artist unless he carries his picture in his head before painting it . . ."

Birth of Impressionism

Monet's *Impression, Sunrise* (1873) gave the impressionist artistic movement its name. The work's subject is the harbor of Le Havre in France. The painting is evocative and atmospheric, with Monet employing loose, gestural brushwork to convey how the bright orange sun emerges through the wispy sea mist, and reflects its light off the surface of the water below.

When Parisian newspaper *Le Charivari*'s art critic, Louis Leroy, saw the painting in the independent impressionist exhibition of 1874, he exclaimed, "Impression—I was certain of it. I was just telling myself that, since I was impressed, there had to be some impression in it . . . and what freedom, what ease of workmanship! Wallpaper in its embryonic state is more finished than that seascape."

The impressionists remained undaunted by such a reception. Later in life, Monet explained how he came to title his now famous sunrise painting: "Landscape is nothing but an impression, and an instantaneous one, hence this label that was given us, by the way because of me. I had sent a thing done in Le Havre, from my window, sun in the mist and a few masts of boats sticking up in the foreground They asked me for a title for the catalogue, it couldn't really be taken for a view of Le Havre, and I said, 'Put *Impression*.'"

artists who painted only their preliminary sketches outdoors, Monet worked more extensively out of doors, even on his large-scale canvases.

In a natural light

Monet's desire to capture nature as freshly as possible turned him away from the traditions of western landscape painting toward oriental art, most notably Japanese woodcuts. His fascination with the perceptual process and how it changed according to the time of day or season reached new heights in his series paintings: *Haystacks* (1888–1889), *Poplars* (1892), and *Rouen Cathedral* (1892–1894), which depict versions of a given scene at various different times of day. The works are a landmark in the history of painting because light and shadow appear as tangible as solid matter. The latter period of Monet's career was focused on the waterlily ponds at Giverny. The works take the form of outsize, mural-like canvases. Plants and water merge into abstract visions of color, and differentiated texture is created using crisscross strokes of impastoed paint. Shortly after Monet's death, the French government installed his last waterlily series in a specially commissioned gallery, the Musée de l'Orangeries des Tuileries. **JN**

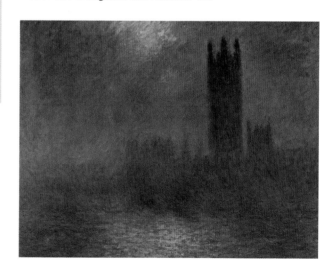

RIGHT: *Houses of Parliament* is one of many Monet works exploring natural light.

BERTHE MORISOT

Born: Berthe Pauline Morisot, January 14, 1841 (Bourges, France); died March 2, 1895 (Paris, France).

Artistic style: Impressionist painter; domestic scenes; feathery touches of paint; subtle nuances of light; oils, watercolors, pastels, dry point, and lithographs.

The granddaughter of rococo artist Jean-Honoré Fragonard, Berthe Morisot was brought up in highly cultured surroundings. She met Henri Fantin-Latour in 1859 and Camille Corot in 1860, both of whom influenced her; in 1860 she received favorable reviews at the Paris Salon for two landscapes. After meeting Édouard Manet in 1864 and being inspired by his work, her painting style became more spontaneous. She also modeled for Manet and is said to have persuaded him to experiment with the multihued palette of the impressionists and *plein-air* painting. Her themes reflect the nineteenth-century cultural restrictions of her class and gender: no urban scenes and nudes, but landscapes, portraits, and images of domestic life. **SH**

Masterworks

La lecture (Reading: The Mother and Sister Edma of the Artist) 1869–1870 (National Gallery of Art, Washington, D.C., U.S.)

The Cradle 1872 (Musée d'Orsay, Paris, France)

Catching Butterflies 1873 (Musée d'Orsay, Paris, France)

Woman at her Toilette 1875 (Art Institute of Chicago, Chicago, Illinois, U.S.)

LOUIS-ERNEST BARRIAS

Born: Louis-Ernest Barrias, April 13, 1841 (Paris, France); died February 4, 1905 (Paris, France).

Artistic style: Neoclassical romanticized sculpture; gave weighty subjects a more informal and human aspect; amply proportioned female figures in allegorical works.

Louis-Ernest Barrias's successfully produced sculpture that was uplifting and momentous while also having an accessible, romanticized naturalism with popular appeal. For this reason he was an excellent choice to execute war memorials, such as *Defence of Paris in 1870* (1881), and other public pieces marking great deeds and heroic people.

From an artistic family, Barrias's rather academic training included study under the successful French sculptor François Jouffroy at the École des Beaux-Arts. In 1865 he won the Prix de Rome, entailing a spell at the French Academy's school in the Italian capital. Favorite subjects included historical, biblical, and allegorical themes, often featuring female figures. **AK**

Masterworks

Spinner of Megara 1870 (Musée d'Orsay, Paris, France)

Oath of Spartacus 1872 (Tuileries Gardens, Paris, France)

Defence of Paris in 1870 1881 (Rond Point de la Défense, Courbevoie, France)

Young Mozart 1887 (Copy in Ny Carlsberg Glyptotek, Copenhagen, Denmark)

Joan of Arc Taken Prisoner 1892 (Plâteau des Aigles, France)

Nature Unveiling Herself Before Science 1899 (Musée d'Orsay, Paris, France)

PIERRE-AUGUSTE RENOIR

Born: Pierre-Auguste Renoir, February 25, 1841 (Limoges, France); died December 3, 1919 (Cagnes-sur-Mer, France).

Artistic style: Impressionist painter and sculptor; muted colors merging into each other; bold color; interplay of light and shadow; voluptuous female nudes.

Pierre-Auguste Renoir's first job was painting patterns onto ceramics. With his wages he paid for art lessons, and it was at these classes that he met the men who would help him found impressionism: Claude Monet, Alfred Sisley, and Frédéric Bazille.

In 1862, he was accepted into the École des Beaux-Arts and soon began exhibiting at the Paris Salon—this early work no longer exists because Renoir destroyed it. In 1867, a portrait of his then mistress, *Lise with a Parasol* (1867), was accepted by the Salon. It was remarkable for being a portrait executed outdoors instead of in a studio. Renoir and the impressionists became famous for their *plein-air* paintings, and *Lise with a Parasol* paved the way. The artists worked as a group, using each other as models. Renoir and Monet were particularly close friends and often painted together, producing unique versions of the same subject. Their most famous joint series are those painted at *La Grenouillère* (1869).

Renoir fought in the Franco–Prussian War of 1870 to 1871, in which he lost his friend Bazille. After the war ended, as

Masterworks

Lise with a Parasol 1867 (Folkwang Museum, Essen, Germany)

Portrait of Frédéric Bazille 1867 (Musée D'Orsay, Paris, France)

La Grenouillère 1869 (National Museum, Stockholm, Sweden)

The Promenade 1870 (J. Paul Getty Museum, Los Angeles, California, U.S.)

The Dancer 1874 (National Gallery of Art, Washington, D.C., U.S.)

At the Theatre (La Première Sortie) 1876–1877 (National Gallery, London, England)

Portrait of Actress Jeanne Samary 1878 (The Hermitage, St. Petersburg, Russia)

Luncheon of the Boating Party 1880-1881 (The Phillips Collection, Washington, D.C., U.S.)

The Umbrellas 1881–1886 (National Gallery, London, England)

Aline and Pierre 1887 (Cleveland Museum of Art, Cleveland, Ohio, U.S.)

Girls at the Piano 1892 (Musée D'Orsay, Paris, France)

Dancing Girl with Castanets 1909 (National Gallery, London, England)

The Great Bathers (The Nymphs) 1918–1919 (Musée D'Orsay, Paris, France)

ABOVE: *Self-Portrait at Age 35* (1876) can be seen at Fogg Art Museum, Massachusetts.

RIGHT: Renoir's palette reflects the season and weather in *La Grenouillère* (1869).

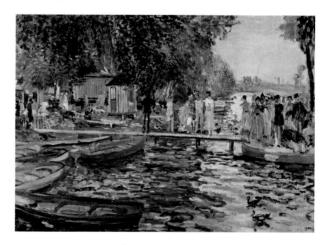

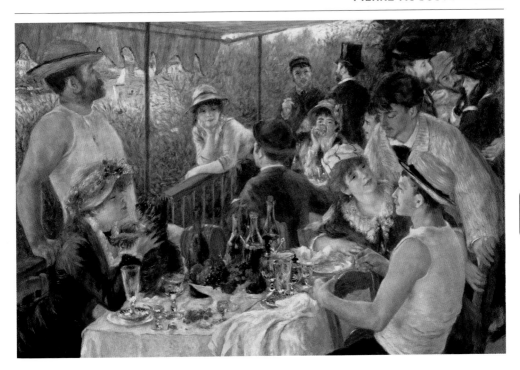

Renoir tried to paint away the horrors, art dealer Paul Durant-Ruel asked to meet him and bought what would be the first of many Renoirs for his gallery; commissions soon followed.

Despite being such an integral part of the group, Renoir exhibited in just four of the eight impressionist exhibitions. In later life, he turned away from the movement he had helped to found, becoming more interested in his earlier passion: classical art of the eighteenth century. His style became less impressionistic, although he never emulated the classical masters directly; he took the lessons he had learned from their works and mixed them with impressionist techniques to give his work more direction and solidity.

Renoir was blighted by poor health. He moved to the south of France, hoping that a warm climate would ease his arthritic pain. When it paralyzed his finger joints, he strapped a brush to his arm and painted with wide, sweeping strokes. **LH**

ABOVE: Renoir's *Luncheon of the Boating Party* is a typical impressionist scene.

A Talented Family

Pierre-Auguste and Aline Renoir had three sons: Pierre, Jean, and Claude. Renoir painted them on several occasions, often with their mother or their beautiful nanny, Aline's cousin Gabrielle Renard. Both Pierre and Jean were old enough to fight in World War I, and both were wounded. After the war, Pierre became a respected actor, initially in the theater but later in films. Jean became one of the most important film directors in early French cinema, winning an Academy Award for *L'Homme du Sud* (*The Southerner*) (1945). His films exhibit a great artistic understanding inherited from his father.

HENRI ROUSSEAU

Born: Henri Julien Félix Rousseau, May 21, 1844 (Laval, Mayenne, France); died September 2, 1910 (Paris, France).

Artistic style: Naïve painter; jungle subjects populated by exotic plants, birds, and animals; innovative portraiture; still life; vibrant color and multiple shades of green.

Masterworks

Surprised! 1891 (National Gallery, London, England)

The Hungry Lion Throws itself on the Antelope 1905 (Fondation Beyeler, Basel, Switzerland)

The Snake Charmer 1907 (Musée d'Orsay, Paris, France)

Fight Between a Tiger and a Buffalo 1908 (Cleveland Museum of Art, Cleveland, Ohio, U.S.)

Exotic Landscape with Monkeys and a Parrot 1908 (Private collection)

The Dream 1910 (Museum of Modern Art, New York, U.S.)

Tropical Forest with Monkeys 1910 (National Gallery of Art, Washington, D.C., U.S.)

Henri Rousseau once described himself as one of France's best realist painters. Most critics of his time did not share his enthusiasm: Rousseau was often mocked, and people referred to him by his occupation as *le douanier*, the customs officer. In the last few years of his life, however, public opinion began to change, and since his death his popularity has continued to grow. In 2005 and 2006, a retrospective show featuring forty-nine of his paintings toured Paris, London, and Washington.

Rousseau left school in 1860, and by 1868 he was living in Paris, working as a civil servant. He did not begin to paint seriously until he was in his early forties, claiming to have had no training and no teacher "other than nature."

Some of Rousseau's best works portray the exotic nature of wild animals and foliage in the jungle. However, the artist was not painting from personal experience because he never actually left France. Instead, his subject matter was researched during trips to the Natural History Museum in Paris, botanical gardens, and zoos and also from carefully selected printed materials. By 1895, he had exhibited at least one painting every year for a decade at the Salon des Indépendants and had attracted some attention for his work but few sales. In 1907, Rousseau met the art dealer Wilhelm Uhde and the painter Robert Delaunay, whose mother commissioned Rousseau to paint *The Snake Charmer* (1907). From this point on, many other artists began to make friends with Rousseau and acknowledge his influence. His young admirers included Pablo Picasso, Georges Braque, and Constantin Brancusi. Three years later, Rousseau exhibited *The Dream* (1910) at the Salon des Indépendants to critical acclaim, thus enjoying long-awaited success during his lifetime. **HP**

> "When . . . I see the strange plants of exotic lands, it seems to me that I enter into a dream."

ABOVE: *Henri (Le Douanier) Rousseau in His Studio at Rue Perrel, Paris, 1907* is by Dornac.

RIGHT: *Exotic Landscape with Monkeys and a Parrot* is typical of Rousseau's jungle scenes.

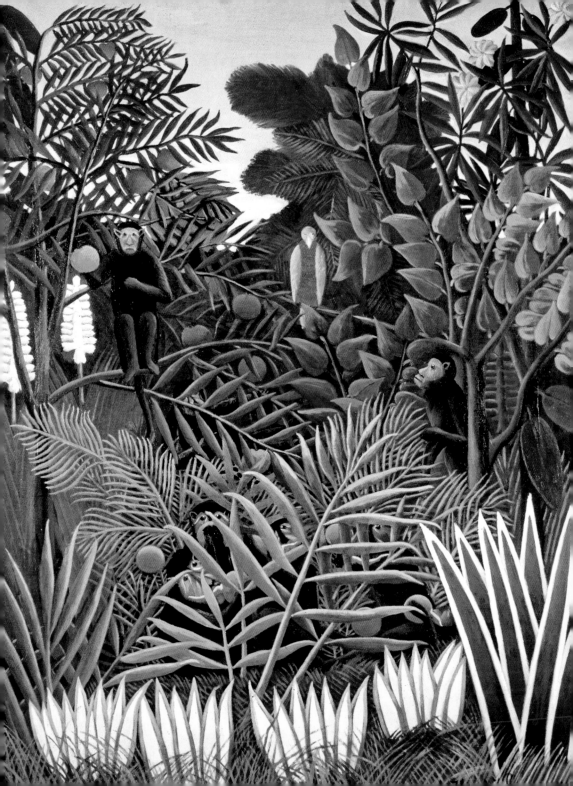

MARY STEVENSON CASSATT

Born: Mary Stevenson Cassatt, May 22, 1844 (Allegheny City (now Pittsburgh), Pennsylvania, U.S.); died June 14, 1926 (Château de Beaufresne, France).

Artistic style: Painter and printmaker; themes of mothers and children; exhibited with the French Impressionists; pastel drawings; *Japonisme* prints.

Masterworks

Little Girl in a Blue Armchair 1878 (National Gallery of Art, Washington, D.C., U.S.)

In the Loge 1878 (Museum of Fine Arts, Boston, Massachusetts, U.S.)

*The Tea c.*1880 (Museum of Fine Arts, Boston, Massachusetts, U.S.)

*Mrs. Robert S. Cassatt, the Artist's Mother (Katherine Kelso Johnston Cassatt) c.*1889 (Fine Arts Museums of San Francisco, San Francisco, California, U.S.)

*Woman Seated with a Child in her Arms c.*1890 (Museo de Bellas Artes de Bilbao, Bilbao, Spain)

Woman Bathing 1890–1891 (National Gallery of Canada, Ottawa, Canada)

The Child's Bath 1893 (Art Institute of Chicago, Chicago, Illinois, U.S.)

Born into a wealthy bourgeois family, Cassatt traveled widely in Europe in her youth. Having studied at the Pennsylvania Academy of Fine Arts, she continued her education in Paris from 1866 under Jean-Léon Gérôme, sending paintings in the academic style to the annual Paris Salon exhibition.

Making Paris her permanent home in 1874, the year of the first impressionist exhibition, she soon aligned herself with this group of emerging artists, adopting their loose brushwork and light color palette. Edgar Degas became a close friend and mentor and invited Cassatt to exhibit at the fourth impressionist exhibition in 1879; the two worked closely on experimental printmaking projects, using Degas's own printing press. They shared a love of the Japanese prints in vogue at the time, and both became enthusiastic collectors. Following her visit to an exhibition of Japanese art in 1890, Cassatt created a series of color prints inspired by the domestic subject matter and clarity of design of the Japanese sources—they count among the most beautiful prints produced in nineteenth-century Paris.

Cassatt drew inspiration for her paintings from the comfortable, female-dominated world around her, and her work depicts the daily routines that occupied women in her social circle—tending to children, dressing for dinner, and taking tea in upholstered interiors. Whereas such images share a leisured informality, works such as *The Tea* (*c.*1880) communicate the uncomfortable realities of social ritual and the world of polite society that Cassatt inhabited. Now remembered principally as a painter of intimate and touching scenes of motherhood, Cassatt is less well known for her constant promotion of fellow artists. Yet she was instrumental in promoting impressionism in the United States. **KKA**

> "There is a woman who feels things like me."
>
> —Edgar Degas

ABOVE: This watercolor-on-paper *Self-Portrait* was painted by Cassatt in 1880.

THOMAS EAKINS

Born: Thomas Cowperthwait Eakins, July 25, 1844 (Philadelphia, Pennsylvania, U.S.); died June 25, 1916 (Philadelphia, Pennsylvania, U.S.).

Artistic style: Realist painter, sculptor, and photographer; an unflattering portrait painter; scientific approach; genre scenes of U.S. outdoor life, often featuring nudes.

Thomas Eakins was born in Philadelphia in 1844, the son of a Scottish immigrant weaver who was also an amateur artist. Having begun his training at the Pennsylvania Academy of the Fine Arts, he traveled to Paris, where he joined the École des Beaux-Arts in 1866 and trained in the studio of Jean-Léon Gérôme. He completed his education with a tour of Europe and spent six months in Spain, where he was particularly influenced by the work of Diego Velázquez, which he saw at the Museo del Prado. Although Eakins remained unsuccessful throughout his career, he has since come to be regarded as the greatest American painter of his era.

Determined to earn a living as an artist, he began taking commissions as a portrait painter on his return to the United States in 1870. Eakins worked exactingly from life, creating portraits that were rarely flattering to the sitters, preferring instead to offer incisive depictions based on direct and frank observations. His uncompromising approach meant that by the end of his life many of these were still in his studio, having been rejected by their subject. Dedicated and highly disciplined, he had a near-scientific approach to his art and attended anatomical dissections in order to understand further the workings of the human body. Indeed, a number of his larger group portraits depict surgeons at work, as is the case with his *The Gross Clinic* (1875) and *The Agnew Clinic* (1889). Dramatically lit and painted in layered brushstrokes built up from dark to light, they broke new ground; as paintings of operations in progress, though, they caused some outrage and disgust. Although many of his subjects were not always becoming, Eakins is also remembered for his images of leisurely outdoor pursuits. **AB**

Masterworks

The Champion Single Sculls (Max Schmitt in a Single Scull) 1871 (Metropolitan Museum of Art, New York, U.S.)

Portrait of Dr. Samuel Gross (The Gross Clinic) 1875 (Pennsylvania Academy of the Fine Arts and the Philadelphia Museum of Art, Philadelphia, Pennsylvania, U.S.)

The Agnew Clinic 1889 (University of Pennsylvania, Philadelphia, Pennsylvania, U.S.)

Concert Singer 1890–1892 (Philadelphia Museum of Art, Philadelphia, Pennsylvania, U.S.)

"The big artist ... keeps an eye on nature and steals her tools."

ABOVE: The detail in Eakins's self-portrait showcases his discipline as a portrait painter.

MAX LIEBERMANN

Masterworks

An Old Woman with Cat 1878 (J. Paul Getty Museum, Los Angeles, California, U.S.)

The Twelve-Year-Old Jesus in the Temple 1879 (Hamburger Kunsthalle, Hamburg, Germany)

Ropewalk in Edam 1904 (Metropolitan Museum of Art, New York, U.S.)

The Flower Terrace in the Wannsee Garden, facing Northwest 1921 (Städtisches Museum Gelsenkirchen, North Rhine-Westphalia, Germany)

Cabbage Field 1923 (Leo Baeck Institute, New York, U.S.)

Born: Max Liebermann, July 20, 1847 (Berlin, Germany); died February 8, 1935 (Berlin, Germany).

Artistic style: Impressionist painter, draftsman, and printmaker; idyllic landscapes, portraits, and depictions of rural laborers; lively, spontaneous brushwork; rich color.

Born into a family of Berlin Jews, Max Liebermann's art was influenced by the works of the Dutch Old Masters, French impressionists, and Barbizon school painters Gustave Courbet and Jean-François Millet. He often painted scenes of everyday life and is credited with introducing impressionism to Germany. Later works reflect the impressionist trend for bourgeois leisure scenes, and he often painted near his home at Lake Wannsee. However, Liebermann avoided Jewish subject matter. Indeed, he caused a stir with *The Twelve-Year-Old Jesus in the Temple* (1879) because his Jesus was "too Jewish-looking." The work was deemed blasphemous and Liebermann later transformed the Jesus into a blond figure. **CK**

AUGUSTUS SAINT-GAUDENS

Masterworks

Admiral David Farragut monument 1881 (Madison Square Park, New York, U.S.)

Abraham Lincoln monument 1887 (Lincoln Park, Chicago, Illinois, U.S.)

The Adams Memorial 1891 (Rock Creek Cemetery, Washington, D.C., U.S.)

Robert G. Shaw monument 1897 (Beacon Street, Boston, Massachusetts, U.S.)

Amor Caritas 1899 (Art Institute of Chicago, Chicago, Illinois, U.S.)

Robert Louis Stevenson 1904 (St. Giles Cathedral, Edinburgh, Scotland)

Born: Augustus Saint-Gaudens, March 1, 1848 (Dublin, Ireland); died August 3, 1907 (Cornish, New Hampshire, U.S.).

Artistic style: Sculptor famed for moving U.S. sculpture away from neo-classicism; favored bronze; stirring monuments to military heroes; sculptural reliefs and coins.

A man of drive, perfectionism, and industry, Augustus Saint-Gaudens was the United States's preeminent sculptor by his early thirties. He made his name with his monument to a hero of the U.S. Civil War (1861–1865), Admiral David Farragut.

Saint-Gaudens attended the École des Beaux-Arts in Paris, as well as studying in Rome. He favored French influences, and brought an energetic but refined naturalism and expressiveness to much of his work, as opposed to the idealistic classicism of his predecessors. Many believe that Saint-Gaudens's best sculpture is his powerfully moving allegorical memorial to socialite Marian Hooper Adams, *The Adams Memorial* (1891). Some of his designs featured on U.S. coinage in the early 1900s. **AK**

ALBERT PINKHAM RYDER

Born: Albert Pinkham Ryder, March 19, 1847 (New Bedford, Massachusetts, U.S.); died March 28, 1917 (Elmhurst, New York, U.S.).

Artistic style: Dreamlike, gothic landscapes; literary, operatic, mythic, and biblical subjects; themes of redemption; dark-colored palette; thickly layered paint.

Often described as a visionary hermit, Albert Pinkham Ryder's diminutive canvases are meticulously painted, and the artist often spent years reworking layer upon layer until he arrived at a painting that evoked a dreamlike poetic mood of loneliness. Frequently drawn to themes taken from opera, literature, poetry, legend, and the Bible, his paintings are, however, more than illustrative narratives: his somber palette, sense of simple composition, and solitary, twisted figures and forms create a moody Gothic world of landscapes and moonlit seascapes that was uniquely his.

Ryder suffered from a problem with his eyes that made looking at bright light painful. It is perhaps this condition that accounted for his escape into an imaginative, almost mystical, world, because he was unable to work in the strong light required to depict the natural world around him.

He first trained with portrait painter and engraver William Marshall, and then from 1871 to 1875 he studied at New York's National Academy of Design. In 1878 Ryder joined the Society of American Artists, which sought to avoid the prevailing Academic style. His early work was of pastoral landscapes, but by the 1880s his mature style of moody landscapes and seascapes developed, and the rest of the century proved to be his most creative period, producing signature works such as *Toilers of the Sea* (1880–1885) and *Siegfried and the Rhine Maidens* (1888–1891). After his father's death in 1900, Ryder's output waned and, always a shy loner, he became ever more reclusive. Yet, conversely, his reputation grew, and he was invited to exhibit in New York's influential *Armory Show* (1913) where his work was hailed as a precursor to modernism in its tendency toward abstraction. **CK**

Masterworks

Moonlight Marine 1870–1890 (Metropolitan Museum of Art, New York, U.S.)

Toilers of the Sea 1880–1885 (Metropolitan Museum of Art, New York, U.S.)

Siegfried and the Rhine Maidens 1888–1891 (National Gallery of Art, Washington, D.C., U.S.)

The Forest of Arden 1888–1897 (Metropolitan Museum of Art, New York, U.S.)

The Race Track (Death on a Pale Horse) 1895–1910 (Cleveland Museum of Art, Cleveland, Ohio, U.S.)

The Flying Dutchman c.1896 (National Gallery of Art, Washington, D.C., U.S.)

"Ryder was considered one of the ablest and strongest of modern U.S. painters."—*ARTnews*

ABOVE: An undated photograph of the artist, taken in the late nineteenth century.

PAUL GAUGUIN

Born: Eugène Henri Paul Gauguin, June 7, 1848 (Paris, France); died May 8, 1903 (Atuona, Hiva Oa, French Polynesia).

Artistic style: Post-impressionist painter and engraver with a love of the exotic; idealized visions of Polynesian culture; use of bright color and bold outlines.

Masterworks

Vision of the Sermon (Jacob Wrestling with the Angel) 1888 (National Gallery of Scotland, Edinburgh, Scotland)

Agony in the Garden 1889 (Norton Museum of Art, Florida, U.S.)

Te aa no areois (The Seed of the Areoi) 1892 (Metropolitan Museum of Art, New York, U.S.)

Manao Tupapau (Spirit of the Dead Watching) 1892 (Metropolitan Museum, New York, U.S.)

Nevermore 1897 (Courtauld Institute of Art, London, England)

Where Do We Come From? What Are We? Where Are We Going? 1897–1898 (Boston Museum of Fine Art, Boston, Massachusetts, U.S.)

The Guitar Player c.1900 (National Gallery, London, England)

Paul Gauguin was born in Paris, but after the death of his journalist father, he spent his childhood years with his half-Peruvian mother in Lima living in his uncle's house. The family later returned to France to live in Orléans, but the memory of warmer climes and of South America had a profound influence on the artist's work.

By 1872, after having spent five years in the merchant navy, Gauguin was a successful stockbroker in Paris. A year later he married Mette Sophie Gad from Denmark, with whom he had five children. Gauguin later abandoned his young family in Copenhagen in order to pursue his artistic goals. His guardian Gustave Arosa had introduced him to art, nurtured his knowledge and enthusiasm, and consistently encouraged his practice of painting as an amateur in his spare time.

In June 1874, Gauguin visited the first Impressionist Exhibition and met the artist Camille Pissarro, who also encouraged his artistic pursuits. By 1885, Gauguin had lost his

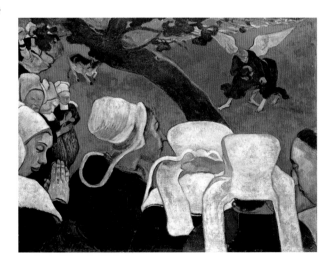

ABOVE: Gaugin's addition of bright colors lifts the tone of his self-portrait of 1893.

RIGHT: *The Vision After the Sermon* uses a vivid palette and bold outlines.

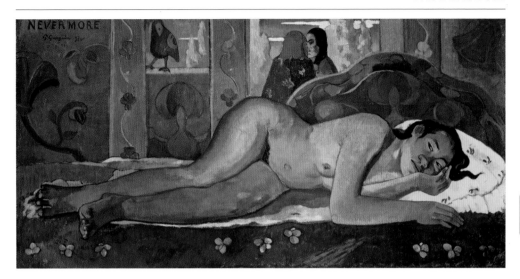

job as a banker but had become a dominant figure in the artistic and intellectual circles in Paris. He had shown a landscape painting at the official Paris Salon and some works with the impressionists and thus became a full-time painter.

Before long, penniless and disillusioned by his lack of popular success, Gauguin looked for a more carefree life in the village of Pont-Aven in rural Brittany. By 1888, working alongside like-minded artists such as Emile Bernard, his work departed from its impressionistic style and became more expressive. Experimenting with bolder outlines, expressive shapes, and unnatural, bright colors, Gauguin produced images of mystical and idealized visions of rural people in local costumes, including his *The Vision of the Sermon* (1888). The painting also demonstrates the increasing influence of Japanese prints and rustic pottery decoration in his work.

Soon Gauguin was looking for more exotic and primitive sources for his painting. Disillusioned by his western European lifestyle, he traveled to Tahiti in search of ancient and indigenous inspiration. Gauguin spent the last years of his life in Oceania, where suffering from depression, he created idealized visions of Polynesian culture. **AB**

ABOVE: The uneasy mood of *Nevermore* perhaps reflected Gaugin's fragile state.

Sunflowers for Gauguin

In 1888, van Gogh invited Gauguin to come and live with him in his Yellow House. Having long cherished the idea of an artists' colony, in anticipation of the visit, van Gogh decorated Gauguin's room with four now-famous paintings of sunflowers. The stay only lasted nine weeks—the two artists did not get along and the tension mounted. It culminated in the dramatic events of December 24 when van Gogh cut off a piece of his ear in a state of mental turmoil.

DANIEL CHESTER FRENCH

Born: Daniel Chester French, April 20, 1850 (Exeter, New Hampshire, U.S.); died October 7, 1931 (Stockbridge, Massachusetts, U.S.).

Artistic style: Monumental sculptor of bronze and marble; neo-classical style; monuments for parks, cemeteries, and buildings; lively, realistic, animated forms.

Masterworks

The Minute Man 1875 (Old North Bridge, Concord, Massachusetts, U.S.)

*Bust of Ralph Waldo Emerson c.*1879–1884 (Art Gallery of the University of Rochester, New York, U.S.)

The Angel of Death Staying the Hand of the Sculptor 1889–1893 (Forest Hills Cemetery, Boston, Massachusetts, U.S.)

Seated Abraham Lincoln 1922 (Lincoln Memorial, Washington, D.C., U.S.)

And the Sons of God saw the Daughters of Men That They Were Fair 1923 (Corcoran Gallery of Art, Washington, D.C., U.S.)

U.S. sculptor Daniel Chester French's lively mix of a neo-classical style with an animated realism shot him to fame and saw him complete major monumental works for parks, cemeteries, and buildings throughout the United States.

Born in New Hampshire, French was a neighbor of essayist and poet Ralph Waldo Emerson and author Louisa May Alcott. Encouraged by Emerson, Alcott, and her sister May, French moved to Boston, Massachusetts, to study sculpture with William Hunt. He later went to New York to study in the studio of John Quincy Adams Ward.

Emerson commissioned the sculpture that would bring French wide public recognition, *The Minute Man* (1875). The work commemorates the reserve soldiers from the Revolutionary War who were ready to fight at a minute's notice, and it was unveiled on the centenary of the Battle of Lexington and Concord. The statue was well received and has become an iconic image in the United States, appearing on defense bonds, stamps, and posters during World War II.

French's success brought with it the opportunity to study abroad, and he traveled to Italy. On his return he opened a studio in Washington, D.C. The location proved ideal, and French was soon in demand to sculpt public monuments for the city. By the turn of the century, French was the United States's most renowned and respected sculptor, and he created statues of former U.S. presidents, including that of George Washington presented to France, and most famously his *Seated Abraham Lincoln* (1922) for the Lincoln Memorial. He cofounded the nation's National Sculpture Society in 1893, and in 1917 he designed the gold medal given to recipients of the Pulitzer Prize. **CK**

"Very few people do [know what they like in art] They have to be educated up to it."

ABOVE: *Daniel Chester French (c.*1920s) photographed by Zaida Ben-Yusef.

VINCENT VAN GOGH

Born: Vincent Willem van Gogh, March 30, 1853 (Zundert, the Netherlands); died July 29, 1890 (Auvers-sur-Oise, France).

Artistic style: Post-impressionist painter of landscapes and portraits; early intense, somber peasant themes; later expressionistic use of bold color and thick impasto.

Despite his tragically short career, Vincent van Gogh is one of the world's best-known artists. His work paved the way for the development of twentieth-century art movements, particularly fauvism and German expressionism.

He was born into a religious family and was preoccupied with religion and spiritualism throughout much of his life. In 1869, he joined French art dealership Goupil & Cie as a junior clerk in The Hague. These early years saw van Gogh exposed to a wide spectrum of painting, including Old Masters and contemporary works, and he began collecting prints.

After teaching in England for a short time, he returned to the Netherlands, having decided to become a minister. In 1878 he enrolled for theological studies in Brussels, and worked as a preacher for two years. By 1880 van Gogh had changed direction again, this time resolving to become a painter of the working classes in the manner of Jules Breton and Jean-François Millet. On the advice of his art dealer brother, Theo, he enrolled at the Royal Academy of Art in Brussels. He was,

Masterworks

The Potato Eaters 1885 (Van Gogh Museum, Amsterdam, the Netherlands)

Le Père Tanguy 1887–1888 (Musée Rodin, Paris, France)

Sunflowers 1888 (National Gallery, London, England)

Terrace of a Café at Night (Place du Forum) 1888 (Kröller-Müller Museum, Otterlo, the Netherlands)

Memory of the Garden at Etten (Ladies of Arles) 1888 (The Hermitage, St. Petersburg, Russia)

The Sower 1888 (Van Gogh Museum, Amsterdam, the Netherlands)

The Yellow House 1888 (Van Gogh Museum, Amsterdam, the Netherlands)

The Bedroom 1888 (Van Gogh Museum, Amsterdam, the Netherlands)

The Night Café 1888 (Yale University Art Gallery, New Haven, Connecticut, U.S.)

Starry Night 1889 (Museum of Modern Art, New York, U.S.)

Wheatfield with Crows 1890 (Van Gogh Museum, Amsterdam, the Netherlands)

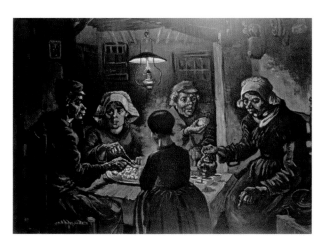

ABOVE: Detail from *Self-Portrait as an Artist*—one of many works painted in 1888.

LEFT: *The Potato Eaters* conveys the honesty with which the workers toil to earn a meal.

Dear Theo . . .

Apart from the huge body of paintings and drawings that van Gogh produced, his legacy is also manifested in the large volume of correspondence that he wrote. The majority of the letters are written by Vincent to his younger brother Theo, an art dealer who tirelessly promoted the work of the impressionists and post-impressionists. They provide valuable information regarding van Gogh's works and his perception of his painting but also shed light on the details of the artist's life, his depression, failed love affairs, daily routine, and the nature of his relationship with Theo.

The sibling bond between the brothers was close, bordering on symbiotic. Theo supported Vincent financially and emotionally throughout his adulthood, while Vincent, although undoubtedly a burden, was a central figure in Theo's emotional life. As the letters make plain, the two quarreled fiercely, but they also lived together prior to Theo's marriage.

Having acted as a stalwart pillar of strength and having supported his older brother for so many years, Theo's life crumbled after Vincent's death. He quickly succumbed to depression and three months later was admitted to the mental asylum at Auteuil in Utrecht, where he died in January 1891; he was later buried there. In 1914, Theo's body was exhumed and reburied alongside that of Vincent in the cemetery at Auvers-sur-Oise.

1800-99

however, largely self-taught and produced copious naturalistic drawings of the countryside around Etten and in The Hague.

By 1885 van Gogh had moved to Nuenen, North Brabant, and there he painted his first major work, *The Potato Eaters* (1885). Its dark and somber tones are characteristic of his early works, which reflect the stark realities of peasant life. The work was poorly received. Shortly after van Gogh left for Antwerp, where he studied the work of Sir Peter Paul Rubens and moved toward a greater assimilation of color.

The Parisian factor

Moving to Paris in 1886, van Gogh was immediately influenced by the avant-garde art climate in the city, in particular by the works of the impressionists and neo-impressionists. He studied at history painter Fernand Corman's studio and befriended Emile Bernard, Henri de Toulouse-Lautrec, Camille Pissarro, and others. The work of Adolphe Monticelli, Paul Cézanne, Paul Gauguin, Paul Signac, and Georges Seurat proved a strong influence on his own art. Van Gogh studied color theory, exploring the luminous effects created by the juxtaposition of complementary colors, and briefly worked in a more scientific manner. He also developed an interest in Japanese woodblock prints, often referencing them in his own works, such as *Le Père Tanguy* (1887–1888).

Exhausted by the pace of Parisian life and having quarreled with Theo, van Gogh moved to the south of France in 1888, with plans to create an artists' colony. There he produced more than 200 paintings in fifteen months, including *Still Life: Vase with Twelve Sunflowers* (1888) and *Terrace of a Café at Night (Place du Forum)* (1888). In October Gauguin joined van Gogh at his Yellow House. The two painted together for some weeks before the relationship disintegrated and van Gogh went to the dramatic lengths of severing his earlobe. Gauguin departed, and van Gogh was hospitalized. In May 1889 he entered the asylum at Saint-Rémy as a voluntary patient, remaining there for a year. He continued to work and painted *Starry Night* (1889), an expressionistic work of deep spiritual significance.

ABOVE: Van Gogh's swirling brushstrokes churn up the dramatic sky in *Starry Night*.

He also painted the dark cypress trees and olive groves surrounding the hospital and copied favorite works by Millet, Honoré Daumier, and Eugène Delacroix.

In 1890, van Gogh moved to Auvers-sur-Oise, near Paris. He continued to paint with frenetic energy, his last works defined by rapid, strident brushstrokes and inspired use of color. One of his paintings, *Wheatfield with Crows* (1890), is especially intense and is an example of the unusual double-square canvas size that he used for some of his late works. On July 27, 1890, he walked to a nearby field and shot himself in the chest. He died in bed two days later, with his brother Theo by his side. **TP**

"This man will either go mad or he will outpace us all."
—Camille Pissarro

FERDINAND HODLER

Born: Ferdinand Hodler, March 14, 1853 (Berne, Switzerland); died May 19, 1918 (Geneva, Switzerland).

Artistic style: Landscapes and portraits; figurative works; themes of death; mountainous landscapes; rhythmic bands of parallel colors; mystical attitude.

Masterworks

The Night 1889–1890 (Kunstmuseum, Bern, Switzerland)

The Day, Second Edition 1904–1906 (Kunsthaus Zurich, Switzerland)

Lake Thun and the Stockhorn Mountains 1910 (Scottish National Gallery of Modern Art, Edinburgh, Scotland)

Song in the Distance 1914 (Hamburger Kunsthalle, Hamburg, Germany)

After being orphaned at fifteen years of age, Ferdinand Hodler trained with the artist Ferdinand Sommer, copying pictures of the Berner Oberland and villages, which were to be sold to tourists. This apprenticeship influenced his later attitude toward a faithful representation of nature in his panoramic landscapes of his native Switzerland at a time when fellow symbolists were given to using motifs.

Hodler's figurative painting developed through the teaching of Barthélemy Menn in Geneva, and his studies of Albrecht Dürer's writing on proportion. His first realist landscapes and genre paintings were influenced by his study of European masters at the Museo del Prado on a trip to Madrid from 1878 to 1879, and he began to paint *plein air*. By 1885, he had developed his style of "parallelism," which is characterized by groups of figures symmetrically arranged in ritualistic poses. For example, in *The Night* (1889–1890), the figures are rhythmically placed to convey the terror of death, a subject close to Hodler, who had lost his entire family by his thirties.

Hodler exhibited with the symbolists and, in keeping with his mystical attitude toward the spirituality of art, joined the Rosicrucians in 1892. He then joined in the Vienna and Berlin Secessions in 1900, and on a visit to Vienna in 1903 he met and then established a friendship with Gustav Klimt. Hodler had become firmly established on the European art scene by 1904, in which year he was invited to participate in the Vienna Secession as a guest of honor. He increasingly depicted natural forms, such as cloud formations and rolling mists, as planes of color, so that works such as *Lake Thun and the Stockhorn Mountains* (1910) are almost abstract in conception. **WO**

> "The work of art will bring to light a new order inherent in things … the idea of unity."

ABOVE: Ferdinand Hodler, Swiss painter of panoramic landscapes of his native country.

CARL LARSSON

Born: Carl Larsson, May 28, 1853 (Stockholm, Sweden); died January 22, 1919 (Falun, Sweden).

Artistic style: Swedish realist painter of oils, watercolors, and historically themed murals; book illustrations of pastoral and domestic scenes of idealized family life.

After training at the Royal Swedish Academy of Arts, Carl Larsson joined a Swedish artists' colony in Paris in 1882, where he met his wife, artist Karin Bergöö. The couple had eight children, and in 1888 the family moved to a house donated by Larsson's father-in-law, Little Hyttnäs, in Sundborn. Larsson became famous for his paintings of idyllic domestic life, often depicting his own family. His book illustrations took the publishing world by storm, notably those for *Das Haus in der Sonne* (*The House in the Sun*) (1895), though Larsson saw his large-scale murals for public buildings as his most important work. These depict major events and figures from Swedish history. Some still adorn Stockholm's National Museum. **CK**

Masterworks

Angel on a Bed with Sleeping Child Date unknown (Mary and Leigh Block Museum of Art, Northwestern University, Chicago, Illinois, U.S.)

Self-examination 1906 (Uffizi, Florence, Italy)

Midwinter Sacrifice 1914–1915 (Nationalmuseum, Stockholm, Sweden)

WALTER WITHERS

Born: Walter Herbert Withers, October 22, 1854 (Birmingham, England); died October 13, 1914 (Eltham, Victoria, Australia).

Artistic style: Impressionist-inspired painter; sought to depict the specificity of the Australian landscape rather than a generalized effect.

Sent from England to Australia in 1882 by his father, who was intent upon dispelling his son's fantasies of an artistic career, Walter Withers was enrolled, by 1884, in night classes at the Melbourne-based National Gallery School of Art. Withers left Australia in 1887 for Europe and returned a year later with a wife and a new enthusiasm for painting *en plein air* just in time to participate in the controversial *9 by 5* Impressionist Exhibition (1889). Soon Withers was established as a significant figure in the Heidelberg school. It is possible to discern in his vigorous, impressionistic works a desire to represent place as much as effect, suggesting that John Constable and Thomas Hardy were stronger influences than Claude Monet. **JR**

Masterworks

The Fossickers 1893 (National Gallery of Australia, Canberra, Australia)

Tranquil Winter 1895 (National Gallery of Victoria, Melbourne, Australia)

The Storm 1896 (Art Gallery of New South Wales, Sydney, Australia)

FREDERICK MCCUBBIN

Masterworks

Lost 1886 (National Gallery of Victoria, Melbourne, Australia)

A Bush Burial 1890 (Geelong Art Gallery, Geelong, Australia)

On the Wallaby Track 1896 (Art Gallery of New South Wales, Sydney, Australia)

A Winter's Evening 1897 (National Gallery of Victoria, Melbourne, Australia)

The Pioneer 1904 (National Gallery of Victoria, Melbourne, Australia)

Shelling Peas 1912 (National Gallery of Victoria, Melbourne, Australia)

1800-99

RIGHT: *Shelling Peas* depicts Frederick McCubbin's wife in their kitchen.

Born: Frederick McCubbin, February 25, 1855 (Melbourne, Australia); died December 20, 1917 (Melbourne, Australia).

Artistic style: Painter; strong narrative component; tragic, poetic stories rendered in carefully layered, impressionistic mode; lyrical celebration of the Australian bush.

One of Australia's most popular late nineteenth-century painters, Frederick McCubbin struggled initially to make a living from art but went on to become a successful artist and a much-revered teacher. His paintings are melancholic, poetic images of the late pioneering period.

McCubbin and Tom Roberts initiated the artists' camps that led to the development of the Australian Heidelberg school. He was a participant in the much-reviled *9 by 5* Impressionist Exhibition (1889). A strong narrative component characterizes much of his oeuvre. His later works are lyrical celebrations of the Australian bush, with the distinctive Australian light an especially powerful element of his work. **JR**

DOROTHY TENNANT STANLEY

Masterworks

The Death of Love 1888 (Private collection)

London Street Arabs published 1890 (British Library, London, England, and other collections)

His First Offence 1896 (Tate Collection, London, England)

Born: Dorothy Tennant, March 22, 1855 (London, England); died October 5, 1926 (London, England).

Artistic style: Victorian painter of neo-classical nudes in mythological settings; portraits and genre scenes of London street urchins; children's book illustrations.

Like many female artists at the end of the nineteenth century, British painter Dorothy Tennant studied at London's Slade School and completed her art education in Paris. Her portraits and highly worked neo-classical nudes regularly appeared at the Royal Academy and Grosvenor Gallery; she also illustrated children's books, such as *Anyhow Stories* (1882).

Tennant is most famous for a series of sentimental genre scenes featuring vagabond children, published in the volume *London Street Arabs* (1890). Her career was eclipsed by that of her first husband, the eminent explorer Sir Henry Morton Stanley. In 1890 she traveled to Australasia and the United States with her husband and persuaded him to enter politics. **NM**

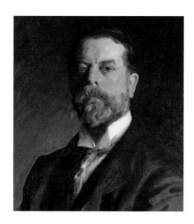

JOHN SINGER SARGENT

Born: John Singer Sargent, January 12, 1856 (Florence, Italy); died April 15, 1925 (London, England).

Artistic style: Landscapes; photorealistic portraits of high society; the rich, famous, and glamorous; sumptuous re-creation of fabrics; exquisitely detailed work.

Masterworks

El Jaleo 1882 (Isabella Stewart Gardner Museum, Boston, U.S.)

The Daughters of Edward Darley Boit 1882 (Museum of Fine Arts, Boston, U.S.)

Madame X (Madame Pierre Gautreau) 1883–1884) (Metropolitan Museum of Art, New York, U.S.)

Carnation Lily, Lily Rose 1885-1886 (Tate Collection, London, England)

Lady Agnew of Lochnaw 1892–1893 (National Gallery of Scotland, Edinburgh, Scotland)

Mr. & Mrs. I. N. Phelps-Stokes 1897 (Metropolitan Museum of Art, New York, U.S.)

President Theodore Roosevelt 1903 (The White House, Washington, DC, U.S.)

The Duke of Marlborough and Family 1905 (Blenheim Palace, England)

Breakfast in the Loggia 1910, (Smithsonian Institute, Washington, DC, U.S.)

A Tent in the Rockies 1916 (Isabella Stewart Gardner Museum, Boston, U.S.)

Gassed 1918–1919 (Imperial War Museum, London, England)

ABOVE: John Sargent is best known for his portraits of wealthy, high-society patrons.

RIGHT: *The Daughters of Edward Darley Boit* are essentially each on their own.

A charming, intelligent man from a prosperous family, John Singer Sargent could not have been less like the stereotype of the tortured, impoverished artist working in a cold attic studio. His life was not one that would make a great novel, filled as it was with artistic success and personal contentment, with few setbacks. Usually described as an American artist, Sargent was actually born in Florence, Italy, to American parents and spent most of his life in Europe. The first time he visited his parents' native country was just before his twenty-first birthday.

Sargent studied in Paris under the eminent portrait painter Emile Auguste Carolus-Duran. Both teacher and student moved comfortably among the elite of the Parisian art world. Sargent knew the impressionists well and, although not all the

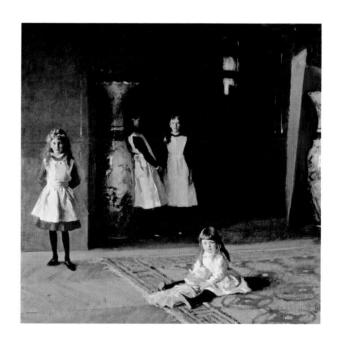

group looked on Sargent and his work favorably, he formed a particularly close and profitable friendship with Claude Monet.

Initially, Sargent's work was fêted by the establishment, but after the scandal caused by his *Madame X (Madame Pierre Gautreau)* (1883–1884), Sargent left Paris. He was twenty-eight years old and from this time onward he lived in London. He seldom spent more than a few months at a time in England, however, because he continued to travel often, and regularly visited the United States to work on commissions.

Portraying the rich and the poor

Sargent's portraiture took him into some of the most exalted homes in the world: British aristocracy, U.S. presidents, and globally renowned millionaires—he earned a large income from painting the rich. Yet he spent time portraying the poor and neglected, too, making the homeless or impoverished workers he painted appear as important as their employers. His portraits of performers exhibit a deep understanding of, and admiration for, their hard work. *El Jaleo* (1882) is a wonderful, huge canvas of a gypsy dancer, who is given more prominence and created with more passion than most of the rich and wealthy subjects who paid him for their portraits.

In later life, Sargent began to paint landscape and genre paintings, and he moved from oils to watercolors. Sometimes he is referred to as an impressionist but, although he and Monet occasionally worked together and Sargent did attempt an impressionistic style in certain paintings, such as *Carnation Lily, Lily Rose* (1885–1886), it was only one technique out of many that inspired him throughout his career.

Sargent never married, nor did he have children. He lived for his painting and, just occasionally, allowed his art to speak politically, most notably in *Gassed* (1918–1919), a poignant tribute to the dead of World War I. An increase in the popularity of his work since the 1960s led to a number of large-scale exhibitions, including a retrospective at the Whitney Museum of American Art in 1986 to 1987. John Sargent bequeathed most of his paintings to the National Gallery in London, England. **LH**

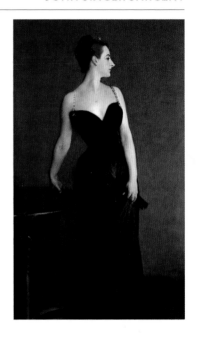

ABOVE: The seductive *Madame X (Madame Pierre Gautreau)* caused outrage in Paris.

1800-99

Madame X

Sargent's *Madame X (Madame Pierre Gautreau)*—rightly seen today as one of his greatest works—was almost his downfall. With the model's seductively revealing gown and porcelain-white skin, the portrait was spoken of as though pornographic. (The figure's right-hand dress strap was originally painted slipped down her shoulder—*quelle horreur!*) The Paris Salon refused to show the work, and Sargent's anger and humiliation at the rejection led him to leave France and move to England. He eventually sold the painting to the Metropolitan Museum of Art in New York.

TOM ROBERTS

Born: Thomas William Roberts, March 9, 1856 (Dorchester, England); died September 14, 1931 (Kallista, Melbourne, Australia).

Artistic style: Prime instigator of Heidelberg school of artists; nationalistic, pioneering themes; themes of masculine labor; energetic urban imagery.

Masterworks

The Artists' Camp 1886 (National Gallery of Victoria, Melbourne, Australia)

Slumbering Sea, Mentone 1887 (National Gallery of Victoria, Melbourne, Australia)

Holiday Sketch at Coogee 1888 (Art Gallery of New South Wales, Sydney, Australia)

Shearing the Rams 1888-1890 (National Gallery of Victoria, Melbourne, Australia)

Aboriginal Head—Charlie Turner 1892 (Art Gallery of New South Wales, Sydney, Australia)

Tom Roberts is renowned for his robust images evoking the nationalistic mythologies of the hardworking, tough, pioneering Australian. English born, Roberts emigrated to Australia with his widowed mother and two siblings when he was thirteen. By the age of eighteen, he was taking night classes at the National Gallery School in Melbourne.

In 1881, Roberts undertook the journey required of any serious Australian artist of the period—he traveled "home" to England. There he encountered the controversial impressionism of James McNeill Whistler. In France he discovered the work of *plein-air* artist Jules Bastien-Lepage. Returning to Australia in 1885 he combined painting *en plein air* with an academic version of the impressionist style and, together with Frederick McCubbin and Louis Abrahams, set up the first of several artists' camps. This desire to confront the new land and to paint what they saw infused the work of Roberts and his peers, and most famously led to the development of the Heidelberg school, a specifically Australian style of impressionism.

Although their *9 by 5* Impressionist Exhibition (1889) was ridiculed and reviled at the time, the Heidelberg artists have become the most revered of all Australian artists. Roberts's masculine scenes have become iconic images of early settlement and are frequently reproduced. His subjects are of a life that was already being eclipsed by modernity and are subtly imbued with nostalgia for an era already on the wane.

> "We went to the bush and . . . tried to get it down as truly as we could."

Less well known are his fine portraits, including some of the best portraits of Aboriginal Australians from the nineteenth century, in which he resists the fashion of depicting Australia's indigenous people as types, but rather presents his subjects as individual characters. **JR**

ABOVE: Tom Roberts, prime instigator of the Heidelberg school of impressionism.

MAX KLINGER

Born: Max Klinger, February 18,1857 (Grossjena, Germany); died July 5, 1920 (Naumburg, Germany).

Artistic style: Haunting, detailed, linear drawings; themes of love, eroticism, fetishism, and death; polychromatic stone sculpture; early link to surrealism.

Educated at the Royal Academy of Art, Berlin, Max Klinger developed a haunting, dreamlike, and sometimes morbid style that is frequently associated with the symbolist movement.

Although Klinger produced paintings and sculpture, he is best known for his work as a graphic artist. *Paraphrases on the Finding of a Glove* (1881) is perhaps his most famous work, created after Klinger found a glove at an ice-skating rink. Composed of ten drawings later engraved in several editions, the series describes the bizarre tale of a young man's obsession with a woman's elbow-length glove. The surrealists, especially Giorgio de Chirico, admired Klinger's controversial interest in sexual fetishism. **NSF**

Masterworks

Paraphrases on the Finding of a Glove 1881 (National Gallery of Scotland, Edinburgh, Scotland)

The Glove: Place 1881 (Fine Arts Museums of San Francisco, San Francisco, California, U.S.)

Kiss (In The Park) from A Love, Opus X:4 1887 (Art Gallery of New South Wales, Sydney, Australia)

Cassandra 1888 (Musée d'Orsay, Paris, France)

Beethoven 1902 (Museum der Bildenden Künste, Leipzig, Germany)

Shame 1903 (Museum of Fine Arts, Houston, Texas, U.S.)

FRANK SHORT

Born: Francis Job Short, June 19, 1857 (Wollaston, Stourbridge, England); died April 22, 1945 (Ditchling, England).

Artistic style: Influential teacher; mezzotints with dramatic light effects; delicate etchings of low-lying English land-, sea-, and shorescapes.

Sir Frank Short was one of the most influential figures of the British etching revival. As professor of engraving at the Royal College of Art, he invested a generation of artists with his own high standards and his talent was such that even the notoriously self-assured James McNeill Whistler consulted him. One of his greatest feats was to single-handedly revive the forgotten art of mezzotint. Much of his career was devoted to making reproductive prints after notable artists, but Short's own compositions are masterpieces of modern printmaking. His mezzotints are unparalleled studies in the tonal effects of light, and his landscape etchings are lyrical impressions sketched directly from nature with an economy of line. **NM**

Masterworks

Mezzotints after J. M. W. Turner's Liber Studiorum 1885 (Tate Collection, London, England)

Low Tide and the Evening Star and Rye's Long Pier Deserted 1888 (Tate Collection, London, England)

LOVIS CORINTH

Born: Franz Heinrich Louis Corinth, July21, 1858 (Gvardeysk, Russia); died July 17, 1925 (Zandvoort, the Netherlands).

Artistic style: Academic naturalist; Impressionist nudes, portraits, and self-portraits; late Expressionistic landscapes utilizing violent brushstrokes and unusual colors.

Masterworks

Self-Portrait with Skeleton 1896 (Städtische Galerie im Lenbachhaus, Munich, Germany)

Bacchanal 1899 (Städtisches Museum, Gelsenkirchen, Germany)

The Temptation of St. Anthony after Gustave Flaubert 1908 (Tate Collection, London, England)

Walchensee, Silverway 1923 (St. Louis Art Museum, St. Louis, Missouri, U.S.)

Self-Portrait 1924 (Museum of Modern Art, New York, U.S.)

"[The artwork] is an end in itself. It is egotistic like a god . . . and allows itself to be worshipped."

ABOVE: Corinth's intense *Self-Portrait in Armour* was painted in 1914.

A restlessly prolific painter and printmaker, Lovis Corinth was born at the dawn of the modernist era, and his career, although always stubbornly individualistic, connected several of the movements that progressively reshaped European art over the next few decades.

After attending the Königsberg and Munich Academies, Corinth enrolled at the Académie Julian in Paris where he practiced a naturalistic style much influenced by Gustave Courbet and the *plein-air* painters of the Barbizon School. Adopting the pseudonym "Lovis," he returned to Germany in 1891 where he was associated with the Munich Secession group. Here he developed a looser technique, frequently with symbolist elements, which helped pioneer a German response to Impressionism. In 1900, Corinth settled in Berlin where he opened a school for women painters (marrying one of its pupils), and finally began to attract serious critical attention.

Behind his success and outward bluster, Corinth had been battling alcoholism and manic depression for years, and in 1911 he suffered a stroke that left him partially paralyzed. With his wife's support he recovered and began to paint again, but his work underwent a profound transition. Famous for his nudes and classical allegories, Corinth now began to concentrate on landscapes and self-portraits with an increasingly searching, expressionistic intensity. Working at a furious pace, the paintings he executed in the last few years of his life at his house in the Walchensee region of Bavaria are among the most famous of his varied career. Despite difficulties in fixing him within a wider modernist narrative, the forceful, probing qualities of Corinth's late work have helped sustain critical interest in him. **RB**

MEDARDO ROSSO

Born: Medardo Rosso, June 21, 1858 (Turin, Italy); died March 31, 1928 (Milan, Italy).

Artistic style: Sculptor; innovator of impressionist sculpture; ordinary subjects drawn from contemporary urban life; delicate, realistic modeling; figurative works, especially of faces.

Such was the talent of innovative Italian sculptor Medardo Rosso that even Auguste Rodin followed in his footsteps: Rodin was inspired by Rosso's *The Bookmaker* (1894) when he cast *Balzac* (1893–1897).

Rosso's delicately modeled works rendered his subjects' emotional frailty in a fashion that was groundbreaking for the time. Their faces almost melt with the fluidity of his line in what was a form of impressionist sculpture Rosso created prior to his contact with the French Impressionists and their work. In the early 1880s he was already sculpting works such as *The Kiss under the Lamplight* (1881), which portrayed ordinary subjects drawn from contemporary urban life. He had an ability to capture the fleeting moment in diminutive, fragile-looking, realistic pieces often made of wax over plaster. Such works went against the prevailing Academic style and the taste for monumental sculpture that depicted historical, allegorical, and mythical scenes.

Rosso moved from Turin to Milan in 1870, and there he came into contact with the avant-garde Scapigliati group that fostered his desire to portray the ordinary in a naturalistic fashion. Having been expelled from art school for protesting against the traditional teaching methods, he left for Rome, there enduring great poverty that saw him sleeping rough. In 1884 he went to Paris, where his work was well received and admired by painter and sculptor Edgar Degas, and writer Émile Zola. The Italian futurists Carlo Carrà and Umberto Boccioni went on to acknowledge Rosso's influence, although he was always more popular in his lifetime in France than in Italy. However, his style revivified sculpture in his native Italy and beyond. **CK**

Masterworks

The Kiss under the Lamplight 1881 (Galleria Nazionale d'Arte Moderna, Rome, Italy)

The Concierge 1883 (Museum of Modern Art, New York, U.S.)

Sick Boy 1889 (Hirshhorn Museum and Sculpture Garden, Washington, D.C., U.S.)

Sick Man in the Hospital 1889 (Hirshhorn Museum and Sculpture Garden, Washington, D.C., U.S.)

Laughing Woman (Large Version) c.1891 (Tate Collection, London, England)

The Bookmaker 1894 (Museum of Modern Art, New York, U.S.)

Behold the Boy 1906 (Hirshhorn Museum and Sculpture Garden, Washington, D.C., U.S.)

"… a work of art that is not concerned with light has no right to exist."

ABOVE: A somber-looking Medardo Rosso, one of Italy's most influential sculptors.

GEORGES-PIERRE SEURAT

Born: Georges-Pierre Seurat, December 2, 1859 (Paris, France), died March 29, 1891 (Paris, France).

Artistic style: Scientific approach to color application; worked in a method called pointillism; associated with the symbolists; painted mostly landscapes.

Masterworks

Peasant with Hoe 1882 (Solomon R. Guggenheim Museum, Las Vegas, Nevada, U.S.)

Sunday Afternoon on the Island of La Grande Jatte 1884–86 (Art Institute of Chicago, Chicago, Illinois, U.S.)

Bathers at Asnières 1884 (National Gallery, London, England)

Circus Sideshow 1887–88 (Metropolitan Museum, New York, U.S.)

The Circus 1890–91 (Musee d'Orsay, Paris, France)

ABOVE: Leading neo-impressionist Seurat adopted a scientific approach to color.

"Art is Harmony. Harmony is the analogy of the contrary and of [the] similar."

ABOVE RIGHT: Seurat's renowned *Sunday Afternoon on the Island of La Grande Jatte.*

RIGHT: *Bathers at Asnières* illustrates the artist's pointillist technique.

During Seurat's short career he established himself as a leader of the avant-garde in Paris, developing neo-impressionism and a scientific approach to color application that was influential on a host of artists, including Vincent van Gogh, Pablo Picasso, and others.

Early in his career, Seurat began to study the color theories of scientists Michel Chevreul and Charles Blanc. These theories explored the understanding of optical effects and perception and the emotional significance of color on the viewer. Seurat was also influenced by the work of Eugène Delacroix and Peter Paul Rubens, and studied their paintings at the Louvre in Paris.

In 1879, Seurat spent a year in the military, during which time he executed a large number of drawings in pencil and crayon. He was a superb draftsman, with drawing an important part of his working practice, both as preliminary sketches and as finished works that were exhibited.

Seurat's first large-scale painting, *Bathers at Asnières* (1884), was begun in 1883 and reflects his application of color theories and painstaking pointillist technique. The piece was rejected by the Paris Salon in 1884 but was hung at the Salon des Indépendants and admired by Paul Signac. The companion piece to this, *Sunday Afternoon on the Island of La Grande Jatte* (1884–1886), perhaps his most famous work, was exhibited at the Eighth Impressionist Exhibition in 1886. Around this time, he became associated with the symbolists, although they later rejected him. Toward the end of his life, Seurat continued to paint and concentrated on coastal scenes and scenes of entertainment such as *The Circus* (1890–1891), which remained unfinished at his death and received little enthusiasm. **TP**

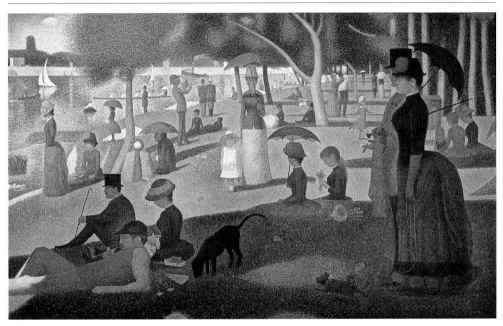

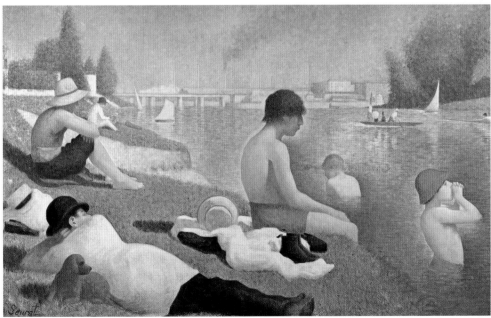

ANDERS ZORN

Born: Anders Leonard Zorn, February 18, 1860 (Mora, Dalarna, Sweden); died August 22, 1920 (Mora, Dalarna, Sweden).

Artistic style: Realist painter, sculptor, and etcher; portraits and nudes; painted in the open air; interest in traditional Swedish arts and crafts.

Anders Zorn is known for his evocative and lyrical paintings of water—especially the effects of light on water—and for his nudes and portraits. His style combines elements of impressionism with naturalism and a richly, vibrant palette evolved into a visual language that came to represent the most significant statement of Swedish national romanticism.

Zorn began his training aged fifteen in Stockholm as a wood carver before entering the Royal Academy of Art. His early works were in watercolor, and later, when he worked in oils, he retained much of his watercolor style in the fluidity of his brushstrokes and subtle nuance of color. In 1881 he began to travel, visiting England, France, Spain, Italy, and the Balkans, before settling in Paris. He was influenced by Édouard Manet, Auguste Renoir, and the impressionists in France, and also studied the work of Diego Velázquez and Sir Peter Paul Rubens. While in England, Zorn worked alongside James McNeill Whistler and started to paint in oils; *The Fishermen, St. Ives, Cornwall* (1891) is one of his earliest works in this medium.

Anders Zorn became sought after as a portrait painter, and in 1893 he made his first of many trips to the United States, becoming popular enough to be commissioned to paint two U.S. presidents. These included *Grover Cleveland* (1899). In 1896 Zorn returned to live in his hometown of Mora, on the northern shore of Lake Siljan. He became interested in traditional Swedish folk arts and crafts, an interest that was reflected in his later paintings, such as *Midsummer Dance* (1897). Toward the end of his career, returning to his early training as a wood carver, Zorn produced several sculptural works. The house in Mora, in which Zorn was born, has now become a museum bearing his name. **TP**

Masterworks

Our Daily Bread 1886 (National Museum, Stockholm, Sweden)

Mother c.1890 (Zornsamlingarna, Mora, Sweden)

The Fishermen, St. Ives, Cornwall 1891 (Art Gallery of New South Wales, Sydney, Australia)

Isabella Stewart Gardner 1894 (National Portrait Gallery, Washington, D.C., U.S.)

Midsummer Dance 1897 (National Museum, Stockholm, Sweden)

Mrs. Frances Cleveland 1899 (National Portrait Gallery, Washington, D.C., U.S.)

Grover Cleveland 1899 (National Portrait Gallery, Washington, D.C., U.S.)

> "In London, you can paint like a God, but still be starving."

ABOVE: Anders Zorn, acclaimed painter of portraits and nudes, etcher, and sculptor.

WALTER SICKERT

Born: Walter Richard Sickert, May 31, 1860 (Munich, Germany); died January 22, 1942 (Bath, England).

Artistic style: Dark, painterly surfaces; London music hall scenes; landscapes of Dieppe and Venice; nudes; portraits; photograph-based compositions.

Walter Sickert was a cosmopolitan figure: born in Germany to an Anglo-Irish mother and a Danish-German father, he spent most of his life in England but also lived for periods in Dieppe and Venice. After a short-lived career in the theater, Sickert studied art under James McNeill Whistler but also formed a close relationship with Edgar Degas. At the turn of the nineteenth century, he provided an important link between the London and Parisian art worlds. His early paintings of London's music halls reflect a distinctly impressionistic interest in popular entertainment.

In the years before World War I Sickert immortalized a particular type of urban experience, via the lives of London's working classes in the Camden Town district where he lived. His paintings of shabby interiors and their equally shabby inhabitants illustrated his belief that art should confront the gritty facts of ordinary life. In 1911, his ideas led to the creation of an independent artistic society called the Camden Town Group that predominantly painted realistic scenes of city life. His contribution to the group's 1911 exhibition was the *Camden Town Murder* series (1908 onward)—the title is a reference to the murder of a local prostitute in 1907. The paintings paired an unclothed female with a fully dressed male to ambiguous and disturbing effect.

In later life, Sickert courted a level of celebrity, reported in the papers for changing his appearance, or name, or for his latest controversial painting stunt. He caused a sensation by openly basing some of his compositions on press photographs. *Miss Earhart's Arrival* (1932), for example, was derived from newspaper reportage of Amelia Earhart's solo Atlantic flight and appeared in an exhibition only five days after the event itself. **NM**

Masterworks

Little Dot Hetherington at the Bedford Music Hall 1888–1889 (Private collection)

*La Hollandaise c.*1906 (Tate Collection, London, England)

Noctes Ambrosianae 1906 (Castle Museum and City Art Gallery, Nottingham, England)

*The Camden Town Murder or What Shall We Do for the Rent? c.*1908 (Yale Center for British Art, New Haven, Connecticut, U.S.)

*Ennui c.*1914 (Tate Collection, London, England)

Brighton Pierrots 1915 (Ashmolean Museum, Oxford, England, and Tate Collection, London, England)

Miss Earhart's Arrival 1932 (Tate Gallery, London, England)

"The plastic arts are gross arts, dealing joyously with gross material facts."

ABOVE: German-born Walter Sickert was the instigator of the Camden Town Group.

ANTOINE BOURDELLE

Born: Émile-Antoine Bourdelle, October 30, 1861 (Montauban, France); died October 1, 1929 (Paris, France).

Artistic style: Sculptor; use of flat, simplified forms; rough, rippling surfaces; portraiture and mythological subjects; architectural and monumental sculpture.

(side tab) 1800–99

Masterworks

Ludwig van Beethoven 1903 (Musée d'Orsay, Paris, France)

Hercules Killing the Birds of Lake Stymphalis 1909 (Musée d'Orsay, Paris, France)

Eloquence 1917 (The Hermitage, St. Petersburg, Russia)

Sculptor Antoine Bourdelle trained in his native Montauban before studying at the École des Beaux-Arts in Toulouse. He then worked as an assistant in Auguste Rodin's studio, and the rough, rippling surfaces of Rodin's sculptures influenced Bourdelle's own style. Rodin's work also overshadowed that of his assistant, and it was only after Rodin's death in 1917 that Bourdelle's work was fully appreciated in its own right. Bourdelle was also a highly influential teacher, and among his pupils was the Swiss sculptor Alberto Giacometti.

Yet Bourdelle did develop his own style of flat, simplified forms that are indebted to Greek and Romanesque art. He produced dynamic, energetic pieces often depicting mythological themes such as his *Hercules Killing the Birds of Lake Stymphalis* (1909).

Bourdelle was also drawn to the integration of architecture and monumental sculpture. He made a series of reliefs for Paris's Théâtre des Champs-Elysées based on the dances of Isadora Duncan, and in 1912 he was commissioned to produce a monument to General Carlos María de Alvear, a hero of the Argentinean War of Independence, which would stand in Buenos Aires. Bourdelle designed the equestrian statue and its pedestal, which had statues on all four corners symbolizing allegorical figures such as *Eloquence* (1917), and which have come to be admired more then the statue of De Alvear itself. The composer Ludwig van Beethoven was one of the subjects that Bourdelle was drawn to frequently. He created more than eighty sculptures of the musician, initially having developed an interest in the musical genius because he identified a strong physical resemblance between himself and Beethoven. **CK**

"Contain, maintain and master are the rules of construction."

—Instruction to his pupils

ABOVE: Bourdelle was considered to be one of France's greatest living sculptors.

ARISTIDE MAILLOL

Born: Aristide Maillol, 1861 (Banyuls-sur-mer, France); died 1944 (Banyuls-sur-mer, France).

Artistic style: Sculptor, painter, printmaker, and tapestry maker; Greco-Roman tradition; large-scale figurative sculptures, and memorials; often female figures.

Aristide Maillol started his career as a painter, moving to Paris in 1881 to study at the École des Beaux-Arts under neo-classical painter and sculptor Jean-Léon Gérôme. There he became part of *Les Nabis* (The Prophets), a group of post-impressionist avant-garde artists that included Pierre Bonnard and Édouard Vuillard. The movement was known for its use of pattern, decoration, flattened perspective, and line. Maillol's work at this time was also influenced by that of Paul Gaugin. Maillol was inspired by medieval tapestry and he returned to Banyuls-sur-mer to set up a studio where he made tapestries in an art nouveau style, revivifying the craft in France.

Although today he is most famed as a sculptor, Maillol only began to sculpt in 1895. At first he made mostly wooden and terra-cotta objects similar in style to his tapestries. In 1900 eyestrain forced him to devote himself to sculpture, and encouraged by his dealer he began to sell cast bronzes. When he showed his large-limbed female nude, *Mediterranean* (1902–1905), at the Paris Salon d'Automne in 1905, he received widespread acclaim. From then on he was in demand to create bronze figurative works and memorials to individuals, such as *Action in Chains: Monument to Louis-Auguste Blanqui* (1905–1906). Maillol bridged the worlds of romanticism and modernism and was notable for his ability to draw on classicism to create works of elegant serenity and grace, at a time when many of his contemporaries were keen to portray the turbulence of urban modern life in an abstract fashion. His figurative works, especially of women, with their sense of clean line, mass, balanced harmony, and poise, influenced the direction of European and U.S. figurative sculpture well into the 1950s. **CK**

Masterworks

Mediterranean 1902–05, cast 1951–53 (Museum of Modern Art, New York, New York, U.S.)

Action in Chains: Monument to Louis-Auguste Blanqui 1905–06, cast 1969 (Hirshhorn Museum and Sculpture Garden, Washington D.C., U.S.)

Flora 1911 (Dallas Museum of Art, Dallas, Texas, U.S.)

The Three Nymphs 1930–38, cast 1937–38 (Tate Collection, London, England)

The River 1943, cast 1948 (Museum of Modern Art, New York, New York, U.S.)

"For my taste, there should be as little movement as possible in sculpture."

ABOVE: Detail from a portrait of Aristide Maillol by József Rippl-Rónai in 1899.

GUSTAV KLIMT

Born: Gustav Klimt, July 17, 1862 (Baumgarten, Penzing, Vienna, Austria); died February 6, 1918 (Vienna, Austria).

Artistic style: Symbolist and art nouveau painter and designer; sensual and erotic depictions of women; highly ornamental with gilding and flowing decorations.

Masterworks

Love 1895 (Museum der Stadt Wien, Vienna, Austria)

Judith I 1901 (Osterreichische Galerie, Belvedere, Vienna, Austria)

The Beethoven Frieze 1902 (Secession Building, Vienna, Austria)

Hope I 1903 (National Gallery of Canada, Ottawa, Canada)

Portrait of Adele Bloch-Bauer I 1907 (Neue Galerie, New York, U.S.)

Hope, II 1907–1908 (Museum of Modern Art, New York, U.S.)

The Kiss 1908 (Osterreichische Galerie Belvedere, Vienna, Austria)

From *circa* 1900 to his death in 1918, Gustav Klimt dominated the art scene in Vienna. He was the founder of the Viennese secession school of painting and the principal member of the Viennese art nouveau movement.

The son of an engraver, Klimt studied at the State School of Applied Arts in Vienna. In 1882, he opened a studio with his brother Ernst and a fellow student, and for the next fifteen years they produced murals for public buildings. In 1890, Klimt painted the auditorium of the Old Burgtheater with almost photographic accuracy and was awarded the Imperial Prize. At this point, he became increasingly experimental.

Klimt continued to experiment with both contemporary art and historical styles that were disregarded at the time, such as Japanese, Chinese, ancient Egyptian, and Mycenaean art. In 1897, he and other notable Viennese artists resigned from the Academy of Arts to found the Union of Austrian Painters, which became known as the secession; he was its first president.

The secession was opposed to what it saw as the oppressive classicist establishment, and became the Viennese version of art nouveau. Their first exhibition was in March 1898, and in 1900 Klimt won the Grand Prize at the World Fair in Paris.

ABOVE: Gustav Klimt painted highly ornamental, erotic portraits of women.

RIGHT: Klimt painted *Watersnakes II* (*The Friends*) between 1904 and 1907.

LEFT: *Portrait of Adele Bloch-Bauer I* was painted during Klimt's Golden Phase.

By 1905, Klimt had become dismayed with the secession as he saw it no longer adhering to its original ideals. This marked the beginning of what became known as his Golden Phase. His influences were European avant-garde movements, British painters such as Edward Burne-Jones and Sir Lawrence Alma-Tadema, Japanese art, Byzantine frescoes, and mosaics that he had seen in churches in Ravenna, Italy. His richly interlaced patterns of gold or silver, kaleidoscopic colors, movement, erotic elements, and heavy symbolism continued to develop. He distanced himself from real life, focusing on the occult and spiritual. He also drew inspiration for many landscapes from summers spent in Salzburg.

In 1909, Klimt traveled to Paris, where he met Henri de Toulouse-Lautrec and the fauves. Over the next two years, he traveled to Venice and Rome, winning first prize at Rome's Universal Exhibition in 1911. After the death of his mother in 1915, he began to paint in more somber tones. He died a few months before the end of World War I. **SH**

Scandalous Status

A controversial artist in his lifetime, Klimt was both loved and hated by the public, the establishment, and critics. He was often the target of violent criticism, and his work was sometimes displayed behind a screen to avoid corrupting the sensibilities of the young. In 1900, he was incriminated for pornography and excessive perversion. Klimt's emphasis on the importance of sexuality as the determining element of life was shocking at the time, but he created the erotic prelude to modern sexuality, of which expressionism and surrealism made constant use.

JOAQUÍN SOROLLA

Masterworks

The Guitarists, Valencian Customs 1889
(Museo Sorolla, Madrid, Spain)

The Bath, Jávea 1905 (Metropolitan Museum
of Art, New York, U.S.)

*Portrait of Mr. Taft, President of the United
States* 1909 (Private collection)

My Wife and Daughters in the Garden 1910
(Private collection)

Oxen on the Beach 1910 (Memorial Art
Gallery of the University of Rochester,
New York, U.S.)

Corner of Garden 1910 (J. Paul Getty Museum,
Los Angeles, California, U.S.)

The Provinces of Spain 1911–1918 (Hispanic
Society of America, New York, U.S.)

Valencian Fisherwomen 1915 (Museo Sorolla,
Madrid, Spain)

The Courtyard of the Sorolla House 1917
(Museo Thyssen-Bornemisza, Madrid, Spain)

Born: Joaquín Sorolla y Bastida, February 27, 1863 (Valencia, Spain); died August 10, 1923 (Madrid, Spain).

Artistic style: Portraits; *plein air* landscapes, townscapes, and seaside scenes; master of the effects of light; figurative works depicting Spanish culture.

Joaquín Sorolla began his artistic studies in 1877 in Valencia and then spent time in Madrid and Rome before returning to Spain. The influence of the French impressionists saw him begin to focus on painting the *plein-air* landscapes, townscapes, and seaside scenes for which he became famous. Sorolla was commissioned by the Hispanic Society of America to paint a series of fourteen panels depicting the people and customs of Spain, *The Provinces of Spain* (1911–1918), to decorate its library. His success also saw him commissioned to paint numerous portraits, including one of the U.S. president, William Howard Taft. He suffered a stroke in 1920 while painting a portrait in his garden and remained paralyzed until his death in 1923. **CK**

FREDERICK MACMONNIES

Masterworks

James S. T. Stranahan 1891 (Prospect Park,
Brooklyn, New York, U.S.)

Nathan Hale 1891 (City Hall Park,
New York, U.S.)

Bacchante and Infant Faun 1893–94
(Metropolitan Museum of Art,
New York, U.S.)

*Work on the Soldiers and Sailors Memorial
Arch* 1898–1901 (Prospect Park, Brooklyn,
New York, U.S.)

Marne Battle Memorial 1920–32
(near Meaux, France)

Born: Frederick William MacMonnies, September 28, 1863 (Brooklyn, New York, U.S.); died March 22, 1937 (New York, U.S.).

Artistic style: Important sculptor of the Beaux-Arts school; animated, decorative, highly dramatic style; famed for his fountain pieces and public monuments.

Frederick MacMonnies was at the hub of the U.S. Renaissance of the late 1800s, and found fame with his massive *Columbian Fountain* (1893) sculpture for a Chicago exposition; sadly it was later destroyed. Technically talented, MacMonnies sparked the fashion for fountain sculpture in the United States's grand gardens. His uplifting public monuments were often nationalistic and sometimes controversial: *Bacchante and Infant Faun* (1893–1894) was removed from Boston Library because of the realism of its nude female. MacMonnies's style embraced art nouveau, baroque (he greatly admired Diego Velázquez), and impressionist surface modeling. He played a major role in training future sculptors, and was also an accomplished painter. **AK**

EDVARD MUNCH

Born: Edvard Munch, December 12, 1863 (Ådalsbruk, Løten, Norway); died January 23, 1944 (Ekely, Skøyen, Oslo, Norway).

Artistic style: Painter and printmaker; intense treatment of psychological and emotional themes; influential forerunner of German expressionism.

Growing up in Oslo, Edvard Munch studied art at the Royal School of Art and Design under the guidance of naturalistic painter Christian Krohg. Through trips to France, Germany, and Italy, he became influenced by impressionism and symbolism and particularly by Vincent van Gogh, Henri de Toulouse-Lautrec, and Paul Gauguin's use of color and simplified forms. He also had a keen interest in psychoanalysis: his parents, a brother, and a sister died while he was young, and mental illness affected both him and another sister. All this helps to explains the atmosphere of hopelessness and a preoccupation with sickness and isolation in Munch's works—such as *The Sick Child* (1907), a portrait of his deceased sister Sophie.

Although his emotional life was troubled, Munch carefully planned his angst-ridden paintings, and *The Scream* (1893) is regarded as an icon of existential anguish. In the 1890s, he began reducing his compositions to broad areas of color with sinuous contours accentuated by heavy brushstrokes and distorted figures. He gained notoriety when he exhibited at the Verein Berliner Künstler (1892) show in Berlin, and his work *Love and Pain* (1893–1894), often known as *Vampire*, provoked such controversy that the exhibition was closed down after a week. The show also saw him portray the first paintings in his series *Frieze of Life: A Poem About Life, Love and Death* (1893–1913) that he would return to throughout his life. Following a nervous breakdown in 1908, Munch's work became more optimistic and he increasingly painted scenes from nature. He also produced a series of murals for Oslo University and a vast quantity of graphic works. In 1916, Munch moved to Ekely, near Oslo, and he lived there until his death, just after his eightieth birthday. **SH**

Masterworks

The Scream 1893 (Nasjonalgalleriet, Oslo, Norway)

Love and Pain (Vampire) 1893–1894 (Munchmuseet, Oslo, Norway)

Ashes 1894 (Nasjonalgalleriet, Oslo, Norway)

Madonna 1895–1902 (Museum of Modern Art, New York, U.S.)

The Dance of Life 1899–1900 (Nasjonalgalleriet, Oslo, Norway)

The Sick Child 1907 (Tate Collection, London, England)

"Illness, madness, and death were the black angels that kept watch over my cradle."

ABOVE: Detail from *Self-Portrait with Cigarette* painted in 1895.

HENRI DE TOULOUSE-LAUTREC

Born: Henri Marie Raymond de Toulouse-Lautrec Monfa, November 24, 1864 (Albi, Tarn, Midi-Pyrénées, France); died September 9, 1901 (Malrome, France).

Artistic style: Scenes of bohemian Paris nightlife and decadence; use of blocks of color; striking graphic designs for posters; stylized portraits.

Henri de Toulouse-Lautrec, painter, draftsman, graphic artist, illustrator, and lithographer, became one of the art world's most recognizable figures—due to a childhood deformity. The son of a French count, he was born in the town of Albi near Toulouse. After breaking both his legs, he was left with two stunted legs while the rest of his body grew normally. His resulting stature made him the subject of countless cartoons.

Toulouse-Lautrec's wealthy, eccentric father paid for his son—a keen artist from a young age—to study in Paris and rented a studio for him. He became well known in Montmartre, spending night after night sketching at the Moulin Rouge and other nightspots. He regularly made advertising posters for his favorite places. He adored women and spent much of his time in brothels. He not only slept with the prostitutes but became friends with them and used them as his models.

His works include characteristic vivacious views of bohemian life, such as *At the Moulin Rouge: the Dance* (1890), lesbian scenes, including *The Kiss* (1892), and tender images, such as *The Two Friends* (1894). He painted many of his works on cardboard and used specially thinned oil paint, or paint mixed with gouache or tempera, to create distinctive lines and colors. Thanks to his work, the names of dancers such as Jane Avril and La Goulue are still known today. He was influenced by Paul Gauguin, Francisco Goya, and Edgar Degas in his use of color, lively style, and choice of subject matter, respectively; in turn, he tutored other artists, including his model and lover Suzanne Valadon. Toulouse-Lautrec was an alcoholic who suffered from syphilis. A combination of the two illnesses led to deep periods of depression, as well as to his death aged just thirty-six. **LH**

Masterworks

At the Moulin Rouge: the Dance 1890 (Philadelphia Museum of Art, Philadelphia, Pennsylvania, U.S.)

Jane Avril 1892 (Courtauld Institute, London, England)

The Kiss 1892 (Collection Mme Porta, Le Vesinet, France)

La Goulue Enters the Moulin Rouge 1892 (Museum of Modern Art, New York, U.S.)

Jane Avril with Gloves 1893 (Courtauld Institute, London, England)

The Two Friends 1894 (Tate Collection, London, England)

The Salon in the Rue des Moulins 1894 (Toulouse-Lautrec Museum, Albi, France)

Side-saddle 1899 (Tate Collection, London, England)

"Only the human figure exists; landscape is, and should be, no more than an accessory."

ABOVE: Toulouse-Lautrec was well known for his posters of Parisian nightlife.

RIGHT: A detail from Toulouse-Lautrec's poster *La Goulue Enters the Moulin Rouge.*

H autrec

VILHELM HAMMERSHØI

Born: Vilhelm Hammershøi, May 15, 1864 (Copenhagen, Denmark); died February 13, 1916 (Copenhagen, Denmark).

Artistic style: Linked with naturalist and symbolist schools; lone figures, architectural studies, and cityscapes devoid of people; muted, desaturated palette.

Masterworks

Portrait of a Young Girl 1885
(Location unknown)

Interior 1899 (Tate Collection, London, England)

Interior of Courtyard, Strandgade 30 1899
Toledo Museum of Art, Ohio, U.S.)

Dust Motes Dancing in the Sunlight, Interior of the Artist's House 1900
(Ordruppgaard, Copenhagen, Denmark)

Montague Street, London 1906 (New Carlsburg Glyptotek, Copenhagen, Denmark)

Like his most obvious antecedent, Johannes Vermeer, the silent, solitary, and enigmatic art of Vilhelm Hammershøi faded almost completely from critical and popular memory after his death. Born into upper-middle-class gentility, Hammershøi began his artistic training in childhood, progressing to the Royal Academy of Fine Arts, and then concurrently studying at the less conservative Free Study Schools. He made his professional debut aged twenty-one at the Charlottenborg Exhibition with *Portrait of a Young Girl* (1885). This picture of his sister Anna, ostensibly in the naturalist tradition, generated much comment for its subdued emotional intensity.

Hammershøi spent the next years painting in and around Copenhagen, but was twice rejected in exhibitions. In the 1890s, his marriage to Ida Ilsted and their move to the city's old quarter provided the two defining elements of his later work.

Using a soft, muted tonal range to capture the gray northern light, Hammershøi repeatedly painted the spartan rooms of his period home; sometimes empty, sometimes containing a lone figure—usually his wife—facing away. Clearly indebted to the seventeenth-century Dutch masters, Hammershøi's mood of quiet alienation is unmistakably modern—if very different from the agitated angst of his contemporary Edvard Munch. Regrettably, his work met with little understanding from the Danish art establishment, while his formal technique was at odds with the escalating abstractions of the avant-garde.

After decades in obscurity, touring exhibitions in the 1980s and 1990s have brought the quiet mystery of Hammershøi's paintings to wider public attention. In the contemporary information-saturated age, this elusive artist is more strangely compelling than ever. **RB**

" . . . a weird but heady fusion of Vermeer and Edward Hopper."
—Michael Palin, actor and writer

ABOVE: Hammershøi painted this typically downcast self-portrait in 1891.

ALEXEJ VON JAWLENSKY

Born: Alexej Georgewitsch von Jawlensky, March 26, 1864 (Torzhok, Russia); died March 15, 1941 (Wiesbaden, Germany).

Artistic style: Expressionist painter; abstract, flat compositions; clashing color combinations; masklike portraits; themes of Russian icons and folk art.

Russian expressionist painter Alexej von Jawlensky studied at the St. Petersburg Academy of Art. In 1896, he moved to Munich to study at Azbé School of Painting, where he met other Russian artists, including Wassily Kandinsky. He helped found the New Munich Association of Artists (NKV) in 1909, from which emerged the German Expressionist group *Der Blaue Rieter* (The Blue Rider). With the outbreak of World War I, he was deported from Germany and went to live in Switzerland, where he became involved with the Zurich Dadaists. In Asconia, Jawlensky began the abstract heads for which he is best known. In 1924, he joined Paul Klee, Lyonel Feininger, and Wassily Kandinsky in The Blue Four group. **WO**

Masterworks

Alexander Sakharoff 1909 (Städtische Galerie, Munich, Germany)

Still Life with a Vase and a Mug 1909 (Museum Ludwig, Cologne, Germany)

Mystical Head (Head of a Girl) 1917 (Merzbacher Collection, Switzerland)

Face of the Redeemer: Floriason 1921 (Kulturhistorisches Museum, Rostock, Germany)

CAMILLE CLAUDEL

Born: Camille Claudel, December 8, 1864 (Fère-en-Tardenois, France); died October 19, 1943 (Montfavet, Avignon, France).

Artistic style: Sculptor; figurative works exploring the human body; scenes of daily life; narrative compositions; influenced by her lover, sculptor Auguste Rodin.

Camille Claudel's family arrived in Paris in 1881 and the talented and beautiful Claudel enrolled at Académie Colarossi. Through sharing studio space with French sculptor, Alfred Boucher, she met sculptor Auguste Rodin in the early 1880s, becoming his pupil, lover, and model: her hands and feet are in Rodin's *The Burghers of Calais* (1888). Claudel had a great interest in groups of figures and the body's sensuality. Her work *Maturity* (1894–1895) shows vigorous, Rodin-like modeling, plus her philosophical and symbolic bent. Rodin's influence proved inspirational at first, but finding her own voice became increasingly difficult. This, and the rejection of some pieces as being too sensual for public display, no doubt fueled her mental instability. **AK**

Masterworks

Woman from Gérardmer 1885 (Musée Boudin, Honfleur, France)

Maturity, plaster version 1894–1895 (Musée Rodin, Paris, France)

Maturity, bronze version 1899 (Musée d'Orsay, Paris, France and Musée Rodin, Paris, France)

Çacountala, bronze version 1905 (Musée Rodin, Paris, France)

WASSILY KANDINSKY

Born: Wassily Kandinsky, December 4, 1866 (Moscow, Russia); died December 13, 1944 (Neuilly-sur-Seine, France).

Artistic style: Father of abstract painting; interest in the relationship between art and music and the spiritual value of art; exploration of color.

Masterworks

Sketch for Composition II 1909–1910 (Guggenheim Museum, New York, U.S.)

Cossacks 1910–1911 (Tate Collection, London, England)

Lyrically 1911 (Museum Boijmans Van Beuningen, Rotterdam, the Netherlands)

Improvisation 31 (Sea Battle) 1913 (National Gallery of Art, Washington, D.C., U.S.)

Composition VI 1913 (The Hermitage, St. Petersburg, Russia)

Composition No. 218 1919 (The Hermitage, St. Petersburg, Russia)

Circles on Black 1921 (Guggenheim Museum, New York, U.S.)

Wassily Kandinsky changed art forever. His focus on creating works of pure color and abstract shapes marked a revolution in art: the birth of abstraction. His energetic melées of circles, zigzags, curves, and diagonal lines revealed that a canvas composed of vivid blocks of color and geometric forms has an aesthetic sense of beauty and can provoke an emotional response akin to listening to classical music.

A writer, theoretician, wood engraver, lithographer, and painter, Kandinsky studied law and economics at the University of Moscow before changing direction to study art. In 1896, he moved to Germany and went on to study under Franz von Stuck at the Munich Academy of Art. Initially, he painted colorful landscapes and themes inspired by Russian folk art, before veering away from the representational to concentrate on creating abstract works.

Kandinsky wrote an influential essay, *Concerning the Spiritual in Art* (1910), outlining his theories on the spiritual value of art and the emotional potential of color. By 1911, he had formed the avant-garde group *Der Blaue Reiter* (The Blue Rider) together with artist Franz Marc. The name of the group comes from a drawing by Kandinsky, and the group came to epitomize German expressionism with a focus on abstraction and the spirituality of nature. In 1922 Kandinsky was appointed a professor at the influential Bauhaus School in Berlin. The school was closed in 1933 because of pressure from the Nazi Party and Kandinsky moved into exile in Paris, where he spent the rest of his life. His ability to distill the emotional and spiritual power of art to its most condensed form, without any apparent representational reference, still resonates among artists and viewers today. **CK**

> "Color is a power which directly influences the soul . . . to cause vibrations in the soul."

ABOVE: Kandinsky, father of abstract painting and founder of *Der Blaue Reiter*.

RIGHT: *Composition No. 218* is one of Kandinsky's works of pure color.

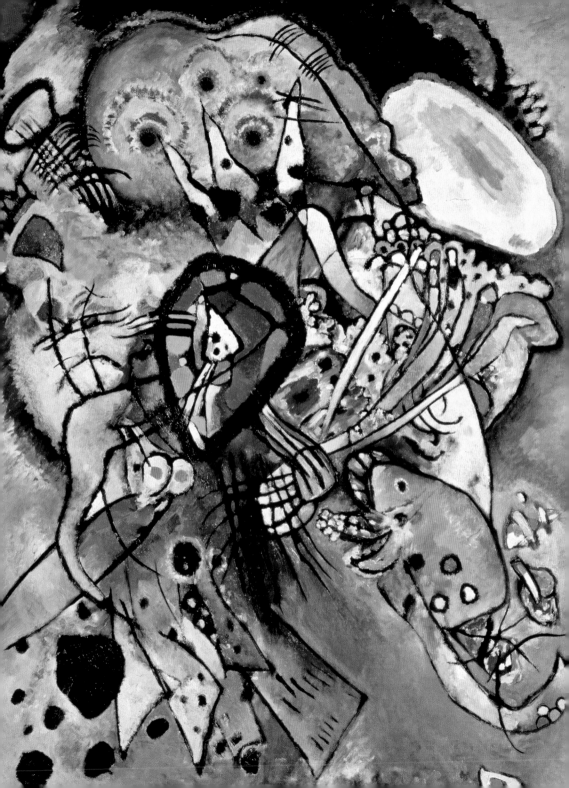

RAMON CASAS

Masterworks

Dance at the Moulin de la Galette c.1890–91 (Museu Cau Ferrat, Consorci del Patrimoni de Sitges, Spain)

The Garroting 1894 (Museo Nacional Centro de Arte Reina Sofía, Madrid, Spain)

Ramon Casas and Pere Romeu on a Tandem 1897 (Museu Nacional d'Art de Catalunya, Barcelona, Spain)

Pel & Ploma 1899 (Museu Nacional d'Art de Catalunya, Barcelona, Spain)

Born: Ramon Casas i Carbó, January 4, 1866 (Barcelona, Spain); died February 29, 1932 (Barcelona, Spain).

Artistic style: Painter and graphic designer; illustrations for posters, postcards, advertising, and magazines; notable for portraits and paintings of crowd scenes.

Ramon Casas was in great demand as a portrait artist in his lifetime. However he is best known for his role at the heart of Barcelona's artistic circle, from which the art nouveau style of Catalan Modernisme emerged in the late nineteenth century. Born the son of a wealthy industrialist, Casas used his wealth to open the *Els Quatre Gats* (The Four Cats) bar in 1897. Modeled on Paris's *Le Chat Noir* (The Black Cat), it became the focal point for artists including the young Pablo Picasso, who held one of his early solo shows there. Casas's posters for the café came to define Catalan Modernisme with their simple but lively lines, while his canvases of crowd scenes such as *The Garroting* (1894) chronicle the turbulent life of the city. **CK**

ARTHUR STREETON

Masterworks

Golden Summer, Eaglemont 1889 (National Gallery of Australia, Canberra, Australia)

Fire's On 1891 (Art Gallery of New South Wales, Sydney, Australia)

The Purple Noon's Transparent Might 1896 (National Gallery of Victoria, Melbourne, Australia)

Australia Felix 1907 (Art Gallery of South Australia, Adelaide, Australia)

Land of the Golden Fleece 1926 (National Gallery of Australia, Canberra, Australia)

Born: Arthur Ernest Streeton, April 8, 1867 (Mount Duneed, Australia); died September 1, 1943 (Olinda, Australia).

Artistic style: Australian landscapes lit by bright coloring; impressionist-influenced *plein air* images; landscapes of the French countryside during World War I.

After studying at the National Gallery School in Melbourne, Sir Arthur Streeton co-founded the first major art movement in Australia, the Heidelberg school. Streeton and his fellow artists shared a simple ethos of painting uniquely Australian subject matter. Influenced by the French impressionists and J. M. W. Turner, Streeton painted several realistic Australian landscapes depicting the golden-yellow color of a sunlit field and blue skies. One of these, *Golden Summer, Eaglemont* (1889), became the first painting by an Australian-born artist to be hung in London's Royal Academy of Arts. In 1918, Streeton became an Australian Official War Artist; the resulting watercolors expertly captured the everyday minutiae of wartime. **SG**

EMIL NOLDE

Born: Emil Hansen, August 7, 1867 (Nolde, Denmark); died April 15, 1956 (Seebüll, Neukirchen, Germany).

Artistic style: Expressive colors to achieve illuminating images; brooding landscapes; violent religious imagery; watercolors, woodcuts, and lithographs.

Emil Hansen was born in the town of Nolde on the Danish–German border, and from 1902 he took the name of the town as his own. He made his living as a wood carver, supplementing his income by selling postcards. Nolde then went on to study art in Munich and Paris. From the outset, his work incorporated a strong feel for nature and a range of brilliant colors that he arrived at by applying thick layers of paint with broad brushstrokes. In 1906, he accepted an invitation to join *Die Brücke* (The Bridge), a group of Dresden-based expressionist artists, but the association lasted barely eighteen months as Nolde returned to his independent methods of painting.

Nolde embraced the use of watercolors. As a deeply devout man, he felt almost obliged to paint religious and spiritual images, such as *Dance Around the Golden Calf* (1910), which displayed frenzied activity, violent colors, and deliberately crude movements. Another change in the artist's style occurred when he traveled to the Far East and became absorbed by the primitive forms of nature and human existence he witnessed. Nolde reverted to familiar themes of light and sea, infusing them with exotic images and exaggerated human features. He later reworked some of these watercolor paintings in woodcut.

By the 1920s, Nolde had retreated to the peaceful surroundings of his home by the Danish border, finding endless sources of inspiration for his paintings in his garden. Although initially a Nazi supporter, he was later prohibited from painting by the Nazis who denigrated his work—yet he secretly created hundreds of watercolors, labeling them the "Unpainted Pictures." Shortly before his death in 1956, Emil Nolde received the German Order of Merit, his country's highest civil decoration. **SG**

Masterworks

Autumn Sea VII 1910 (Nolde-Stiftung, Seebull, Germany)

Dance Around the Golden Calf 1910 (Staatsgalerie Moderner Kunst, Munich, Germany)

Child and Large Bird 1912 (Statens Museum for Kunst, Copenhagen, Denmark)

Crucifixion 1912 (Nolde-Stiftung, Seebull, Germany)

Moonlit Night 1914 (Private collection)

Still Life with Dancers 1914 (Musée National d'Art Moderne, Paris, France)

"Clever people master life; the wise illuminate it and create fresh difficulties."

ABOVE: This portrait of painter and graphic artist Emil Nolde was taken in 1952.

ÉMILE BERNARD

Born: Émile Bernard, April 28, 1868 (Lille, France); died April 16, 1941 (Paris, France).

Artistic style: Seemingly simple images with unnaturalistic forms and spatial arrangements; flat areas of color; strong black outlines; popular subjects included Breton country life and Parisian scenes.

Masterworks

Bathers With a Red Cow 1887 (Musée d'Orsay, Paris, France)

Breton Women in the Meadow 1888 (Private collection)

Madeleine au [or in the] Bois d'Amour 1888 (Musée d'Orsay, Paris, France)

Buckwheat Harvesters at Pont-Aven 1888 (Josefowitz Collection, Switzerland)

The Hashish Smoker 1900 (Musée d'Art et d'Industrie, Roubaix, France)

Negress with a Cloche Hat 1932 (Private collection)

At a young age Émile Bernard found himself at the epicenter of progressive French art. During the 1880s Bernard trained as a painter at the Paris studio of Fernand Cormon; he befriended or met pioneers such as Henri de Toulouse-Lautrec, Paul Gauguin, and Vincent van Gogh; and he encountered the then little-known Paul Cézanne's work.

It was during the late 1880s that, after dabbling with impressionism and pointillism, a precociously talented Bernard developed a style of flat color and thick black outlines that was dubbed "cloisonnism." This took its name from an enameling technique and owed much to Bernard's decorative skills as a craftsman and printmaker with a typically contemporary love of Japanese woodcuts. Bernard's early cloisonnist milestone—*Breton Women in the Meadow* (1888)—seems to have affected Gauguin profoundly, and the two became close colleagues in the symbolist-synthetist movement. By the early 1890s, however, Bernard and Gauguin had fallen out. Never the easiest of men to get along with, Bernard felt that his friend was gaining far too much credit for symbolism's progress.

The 1890s and first decades of the 1900s brought spells in Egypt, where subjects included Cairo street life and brothels, and in Italy, whose Renaissance masters helped fuel a more traditional, naturalistic style with monumental figures. By the 1920s Bernard's work was dominated by rather conventional female portraits. However, these decades also brought varied literary projects, and Bernard became recognized as an accomplished writer. He wrote numerous articles and had work published on artists such as Van Gogh, Odilon Redon, and Cézanne—including his illuminating correspondence with them. **AK**

"You have to simplify the spectacle in order to make some sense of it."

ABOVE: Detail from a self-portrait painted toward the end of the artist's career.

CHARLES CONDER

Born: Charles Edward Conder, October 24, 1868 (London, England); died February 9, 1909 (Virginia Water, Runnymede, England).

Artistic style: Romantic use of impressionist style, married with art nouveau-inspired linear quality; scenes of languid enjoyment of the Australian bush.

The most bohemian and romantic figure of the Australian Heidelberg school of artists, Charles Conder's short life fits all the criteria of the tragic life of an artist. His mother died from tuberculosis when his family was visiting India, and he was sent back to an English boarding school with his brother. When his brother died, his father was anxious to dissuade Conder's artistic ambitions and sent his son to an uncle in Australia.

Arriving in Sydney in June 1884, Conder dutifully commenced work in his uncle's land survey office and undertook extensive travel throughout the countryside of New South Wales. Soon, however, he was studying art in Sydney and winning prizes for his illustrations and paintings from nature. In 1888, he met painter Tom Roberts, founder of the Heidelberg school of impressionistic landscape painters. The two artists formed an enduring friendship, painting together in Sydney and later in Melbourne. Conder also met the Italian painter, Girolamo Nerli, who reinforced the currency of the impressionist method of rendering the landscape.

Conder was charming and poetic in his representations of place. He became an influential member of the emerging nationalistic, landscape-focused artistic milieu. His works married the elegant line of art nouveau with the delicate touch of the impressionist vision. A key instigator of the *9 by 5 Impressionist Exhibition* (1889), Conder and fellow exhibitors were subjected to harsh criticism. Leaving Australia in 1890, he traveled to Europe and studied in Paris, where he mixed in bohemian circles with artists such as Henri de Toulouse-Lautrec. In the late 1890s, he produced work that drew praise from contemporaries such as Edgar Degas and Camille Pissarro. Conder died in February 1909. **JR**

Masterworks

A Holiday at Mentone 1888 (Art Gallery of South Australia, Adelaide, Australia)

Under A Southern Sky 1890 (National Gallery of Australia, Canberra, Australia)

Rickett's Point 1890 (National Gallery of Victoria, Melbourne, Australia)

"I see Conder quoted as a very great Modern Master . . ."
—Fred McCubbin, artist

ABOVE: Detail from *Charles Conder* by Sir William Rothenstein (1872–1945).

ÉDOUARD VUILLARD

Born: Jean-Édouard Vuillard, November 11, 1868 (Cuiseaux, France); died June 21, 1940 (La Baule, France).

Artistic style: Highly patterned, decorative, and aesthetic canvases; domestic interiors, landscapes, portraits, and theatrical scenes; member of the Nabis.

Masterworks

After the Meal 1890 (Musée d'Orsay, Paris, France)

Woman in a Striped Dress 1895 (Washington, National Gallery of Art, Washington, D.C., U.S.)

Théodore Duret 1912 (National Gallery of Art, Washington, D.C., U.S.)

Place Vintimille, Paris 1916 (Metropolitan Museum of Art, New York, U.S.)

Édouard Vuillard is most closely identified with his scenes of domestic interiors, and these paintings represent the essential balance in his art—an innovative and modern interpretation of the realist tradition in seventeenth-century Dutch painting. He worked in the manner of the Nabis and in the synthetist style of Paul Sérusier, bringing together a keen aesthetic sense of pattern, decoration, and line with an adhesion to the actuality of the scene. Many of his works are invested with a mysterious, otherworldly air, whereas his subtle palette and lyrical use of light and atmosphere evoke a profound emotional response.

Vuillard spent some time at the studio of Diogène Maillart in Paris before entering the Académie Julian in 1886. There he trained under Tony Robert-Fleury; he later studied briefly at the École des Beaux Arts under the auspices of Jean-Léon Gérôme.

In 1888, Vuillard joined the Nabis, a group of avant-garde artists who met through the Académie Julian and came under the influence of Sérusier, who had himself been influenced by Paul Gauguin. In common with their impressionist peers, they also looked toward the decorative and patterned art of Japan. During the 1890s, Vuillard began to take on large-scale decorative commissions, and by 1900 he had turned toward portraits and landscapes, both of which became very popular. He moved away from the flattened perspective of his early Nabis style toward scenes of greater realism with more calculated spatial recession while maintaining the poetic quality of his early works. By the time of his death in 1940, Vuillard had achieved considerable acclaim and was widely admired by fellow artists. He lived with his mother until her death. She was a dressmaker, and this may have inspired his interest in textiles and patterns. **TP**

> "I do not belong to any school, I simply want to do something that is personal."

ABOVE: Detail from *Self-Portrait* by Édouard Vuillard, which is held in a private collection.

GUSTAV VIGELAND

Born: Gustav Vigeland, April 11, 1869 (Mandal, Norway); died March 12, 1943 (Oslo, Norway).

Artistic style: Portrait busts and reliefs; naturalistic look conveying emotion; medieval motifs; themes of birth, childhood, maturity, and death.

Gustav Vigeland inherited his father's skills as a carpenter, but it was sculpture that really fascinated the young Vigeland. He studied in both Oslo and Copenhagen before spending several months in Paris, where he became influenced by the work of Auguste Rodin. His sculptures—predominantly of portrait busts and reliefs, with recurring themes of death and the relationship between man and woman—took on a naturalistic feel. Vigeland attached great importance to feeling and expression, portraying skeletal figures in contrasting moods of desolation and ecstasy.

Two exhibitions of his work toward the end of the nineteenth century received favorable responses from art critics; yet he was still unable to make a living working for himself. He found employment on the restoration of Nidaros Cathedral in Trondheim where he absorbed medieval imagery and began using in his work the symbolic motifs of lizards and dragons battling man. His portrait busts of prominent Norwegian figures, such as playwright Henrik Ibsen, allowed him to make a living from sculpture and led him to the vast project that would occupy him for the rest of his life.

Frogner Park, later referred to as Vigeland Park, in Oslo, became Vigeland's open-air exhibition hall because he designed more than 200 individual sculptures to reside in the park. The sculptures depict men, women, and children—running, wrestling, dancing— and center on the theme of man's journey from birth to death. At the heart of the park is the spectacular *The Monolith* (1929–1943), carved from a single column of solid granite 57 feet (17 meters) high and consisting of 121 figures. Vigeland worked on sculptures for the park in his studio until his death in 1943. **SG**

Masterworks

Accursed 1891 (Vigeland Museet og Parken, Oslo, Norway)

Hell 1897 (Vigeland Museet og Parken, Oslo, Norway)

Henrik Ibsen 1903 (Vigeland Museet og Parken, Oslo, Norway)

Young Man and Woman 1906 (Vigeland Museet og Parken, Oslo, Norway)

The Children's Playground c.1925–1940 (Vigeland Museet og Parken, Oslo, Norway)

The Monolith 1929–1943 (Vigeland Museet og Parken, Oslo, Norway)

The Wheel of Life 1933–1934 (Vigeland Museet og Parken, Oslo, Norway)

"I was a sculptor before I was born. I was driven and lashed onward by powerful forces."

ABOVE: This picture of Vigeland was taken in 1891 and is held in the Vigeland Museum.

HENRI MATISSE

Born: Henri-Émile-Benoît Matisse, December 31, 1869 (Le Cateau-Cambrésis, France); died November 3, 1954 (Nice, France).

Artistic style: Briskly drawn lines that suggest rather than define; bold use of color, shapes, and patterns together; fluid movement; distinctive paper cutouts.

Born in the countryside of northern France, Henri Matisse did not discover his passion for art until he was nineteen years old, yet he went on to become one of the most highly regarded and influential painters in Paris. He remains renowned worldwide for his painting, sculpture, and graphic art, including his paper "cutouts."

In his late teens, while working as a legal clerk, Matisse began taking drawing classes. A couple of years later, he began painting in earnest during a long convalescence following an operation for appendicitis. In 1891, he gave up the law and moved to Paris to study painting; he studied under academic painter William-Adolphe Bouguereau before enrolling in the École des Beaux-Arts, where he was taught by symbolist painter Gustave Moreau. His early work was somber, including a large number of still lifes and landscape scenes. After a holiday in Brittany, however, his palette changed. His works began to come to life, infused with the hues of natural sunlight and concentrating more on people swathed in, and surrounded by, vivid fabrics rather than inanimate objects.

Masterworks

Nude Study in Blue c.1899–1900
(Tate Collection, London, England)

Open Window, Collioure 1905 (National Gallery of Art, Washington, D.C., U.S.)

Woman on a Terrace c.1907 (The Hermitage, St. Petersburg, Russia)

Harmony In Red 1908 (The Hermitage, St. Petersburg, Russia)

La Danse 1909 (Museum of Modern Art, New York, U.S.)

The Red Studio 1911 (Museum of Modern Art, New York, U.S.)

The Painter's Family 1911 (The Hermitage, St. Petersburg, Russia)

Portrait of the Artist's Wife 1912–1913 (The Hermitage, St. Petersburg, Russia)

Odalisque in Red Trousers c.1924–1925 (Musée de l'Orangerie, Paris, France)

The Rumanian Blouse 1940 (National Museum for Modern Art, Paris, France)

Blue Nude IV 1952 (Henri Matisse Museum, Nice, France)

The Snail 1953 (Tate Collection, London, England)

ABOVE: Henri Matisse is revered for his brilliant use of color and draftsmanship.

RIGHT: *La Danse* (1909) is widely regarded as marking a turning point in Matisse's career.

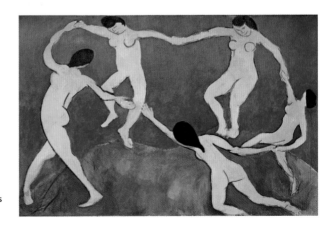

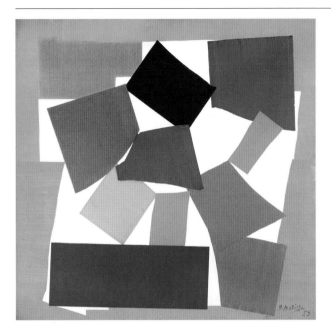

LEFT: *The Snail* is constructed from painted paper cutouts on a white background.

1800-99

Matisse was impressed by the impressionists and began experimenting with different styles of painting and light techniques. He had long been in awe of the work of Édouard Manet, Paul Cézanne, Georges-Pierre Seurat, and Paul Signac, and in 1899 he bought Cézanne's masterpiece, *The Bathers* (*c.*1890–1892). By 1905 he had become associated with André Derain, and they traveled together back to the south of France to study the paint effects of the color and light that Matisse did not believe could be seen anywhere else. When Derain and Matisse exhibited together for the first time, unimpressed critics derisively nicknamed them *Les Fauves*, meaning "The Wild Beasts," accusing them of primitivism. Visitors to the exhibition were shocked by what was considered their "savage" use of color, complaining that the subject matter was "barbaric." The nickname stuck, but as the artists' fame grew and their work became respected and sought after, the

"I don't paint things, I only paint the difference between things."

Drawing With Scissors

In 1943 Matisse began work on a new project—originally a portfolio—of which a limited edition of 250 was published in 1947. Entitled *Jazz*, it is personified by one of the artist's most famous cutouts, the lively figure of *Icarus* (1947). The boy whose dreams of flying were doomed when he flew too close to the sun is depicted plunging through a brilliantly blue, yellow-starred sky; his sun-scorched wings have been lost but although it is only moments before his death, his strong black figure appears to be dancing with joy. Some have speculated that this and many other cutouts in the book were Matisse's veiled criticism of the Nazi occupation of France at the time and that *Icarus* may represent the French Resistance fighters.

Matisse described his paper cutouts, of which twenty appeared in the original portfolio, as "drawing with scissors." When the portfolio was turned into a book in 1947, the twenty illustrations were accompanied by text written by Matisse. He took some time to come up with a title for the book. Many of the cutouts were inspired by circus acts, such as *The Horse, The Rider, and The Clown*; *The Sword Swallower*; and *The Knife-Thrower*, so its original title was *The Circus*. He eventually decided on *Jazz* because the frenetic style of jazz music suggested so many picture ideas to him. Other illustrations in the book, which form a random selection of titles, include *The Heart, The Toboggan, The Funeral of Pierrot*, and *The Swimmer in the Aquarium*.

RIGHT: *Blue Nude IV (Nu Bleu IV)* is probably Henri Matisse's most famous work.

nickname became less pejorative and grew to describe a recognizable artistic movement—fauvism.

By 1907 Henri Matisse and Pablo Picasso had become friends. They often socialized together and exchanged paintings, and their names remain inextricably linked today. Together, Picasso and Matisse changed the face of twentieth-century art. Matisse was never an impressionist, a neo-impressionist, nor a cubist. He admired them, and he often experimented with elements of their work, but he created his own distinct style.

From Paris to the French Riviera, via Moscow

One of Matisse's most important patrons was Sergei Shchukin, who would appear regularly in Paris to buy the entire contents of the artist's studio to be shipped back to Russia. Shchukin was a wealthy industrialist from Moscow, where he owned a grand palace. He commissioned Matisse to paint two murals on the themes of music and dance, so Matisse traveled to Moscow, taking in various European cities on the way.

Except for a brief visit to Morocco in 1916, Matisse remained in Paris during most of World War I. He was forty-five when war broke out, too old to be called up. In 1917, he decided it was time to leave Paris and so moved to Nice, on the French Riviera. His artistic style and use of color grew more intense, most apparent in his wonderful, sensual paintings of odalisques and interiors of rooms with views out to the Riviera through wide-flung windows. In 1925, he was awarded the highest French honor, the Légion d'Honneur, for his services to the art world.

Following surgery for abdominal cancer in 1941, Matisse found himself unable to paint, the simple action of standing in front of an easel proving agonizing. This was the time when he began making his famous paper cutouts that he could do, with assistance, from a bed or armchair. Studio assistants would paint vividly colored gouache on to sheets of paper. Matisse then cut out shapes and arranged them on to canvas. Necessarily abstract and naive in style, Matisse loved this new form of art, stating that he felt his cutouts achieved "greater completeness" than his painting or sculpture. **LH**

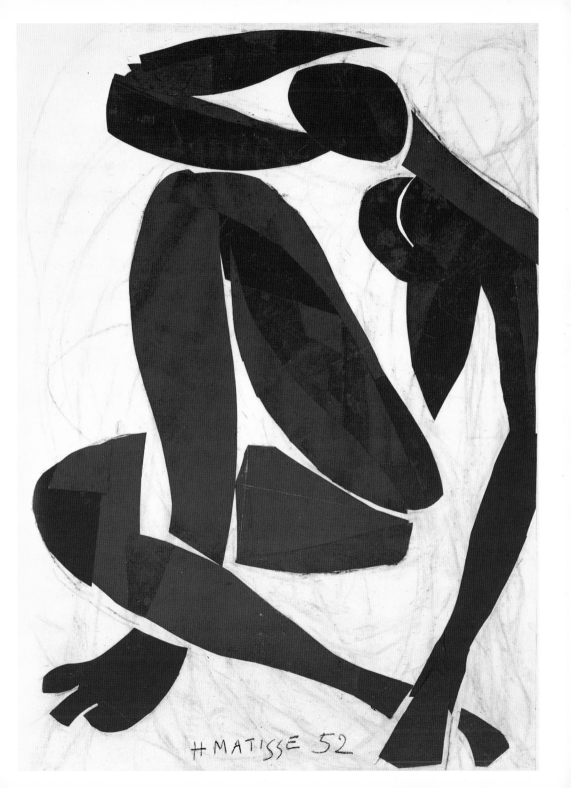

FRANCES HODGKINS

Born: Frances Mary Hodgkins, April 28, 1869 (Dunedin, New Zealand); died May 13, 1947 (Dorchester, England).

Artistic style: Expatriate artist; neo-romanticism; portraits; still lifes; landscapes; fluid calligraphic style; moody, limpid colors; member of Seven and Five Society.

Masterworks

*Berries and Laurel c.*1930 (Auckland Art Gallery Toi O Tamaki, New Zealand)

*Cut Melons c.*1931 (Museum of New Zealand Te Papa Tongarewa, Wellington, New Zealand)

Pumpkins and Pimenti 1935 (Fletcher Trust Collection, New Zealand)

Circular Barn 1939 (Dunedin Public Art Gallery, Dunedin, New Zealand)

Portrait of Kitty West 1939 (Tate Collection, London, England)

Purbeck Farm 1942 (Auckland Art Gallery Toi O Tamaki, New Zealand)

Frances Hodgkins is one of the most accomplished artists to have come out of New Zealand in modern times. Brought up in 1870s provincial Dunedin, she was greatly influenced by her father, an amateur painter. Three years after his death, she sailed for Europe in search of great art and a more adventurous artistic lifestyle. That lifestyle was to leave her almost penniless at times, and for most of her career she struggled to subsist through her paintings and teaching. Many friends helped her, including British painters John Piper and Cedric Morris.

Hodgkins became an itinerant artist, living and working in Spain, Italy, Morocco, and France, always seeking work and inspiration. (Her experiences in Europe are vividly retold in her letters home.) She settled in England in 1914, where she met with success, and in 1929 she was elected to the progressive Seven and Five Society, which was keen to see a return to order in the arts after World War I.

By the end of her career, Hodgkins was enjoying success in Europe. In New Zealand, however, she was seen as a British modernist. Not until 1962 was she formally honored there, when her hometown of Dunedin set up a prestigious fellowship in her name. Hodgkins's painting style was unique. She preferred to paint domestic subjects or rural scenes, often depicting farmyard machinery with a sense of desolation or pathos. But she was best known for her "still life landscapes," a combination of the two genres thought very radical in its day. These flattened, one-planed compositions show the influence of cubism and surrealism. Her brave experimentation with sometimes rich, sometimes subtle color—combined with her calligraphic marks and brushwork—made her stand out among her peers. **NG**

> "Each picture is as indicative of a mood as a blushing and sensitive skin."—Myfanwy Evans

ABOVE: This photograph of Frances Hodgkins was taken in November 1912.

ERNST BARLACH

Born: Ernst Barlach, 1870 (Wedel-an-der-Niederelbe, Germany); died 1938 (Rostock, Germany).

Artistic style: Sculptor, printmaker, and writer; early jugendstil style, later expressionism; large-scale figurative sculptures in drapery; woodcarvings; bronzes.

Ernst Barlach is known primarily for his sculptures that bridged the gap between jugendstil and expressionism in Germany. He is also widely known for his printmaking, creating woodcuts and lithographs for illustrations for poems, and his own plays. A prolific writer, Barlach wrote an autobiography, two novels, and eight expressionist plays that were successfully performed in the Weimar Republic, and are still performed today.

Barlach was an outspoken critic of the Nazi Party. Several of his World War I memorials were removed from churches in 1937 because they caused conflict in the Nazi Party regarding the legacy of World War I; by the summer of that year nearly 400 of his works had also been confiscated from German museums. He had created his woodcarving *Das schlimme Jahr 1937* (*The Terrible Year 1937*) in 1936, but then gave the carving its name in response to the Entartete Kunst (1937) (Degenerate Art) exhibition mounted by the Nazis to denigrate modern art, including some of his work.

Barlach's early bronzes and woodcarvings were decorative in the jugendstil style, but a soul-searching trip to Russia in 1906 caused him to change direction. Influenced by German medieval woodcarving and the sturdy solidity of Russian peasants, he simplified the lines of his work. In addition, the misery he witnessed during World War I saw Barlach strive to convey the emotional suffering he saw in works with allegorical titles, such as *Der Rächer* (*The Avenger*) (1914), that seek to portray the human condition from ecstasy to loneliness, resulting in large-scale figurative sculptures swathed in drapery. His work has drawn some comparisons with the expressionists, but his aim was to attempt to portray man's existential crisis and possible salvation. **CK**

Masterworks

Steppenhirt 1908 (*Steppe Shepherd*) (Ernst Barlach Haus, Ratzeburg, Germany)

Sitzendes Weib 1908 (*Sitting Woman*) (Ernst Barlach Haus, Ratzeburg, Germany)

Der Rächer (*The Avenger*) 1914 (Tate Collection, London, England)

Der singende Mann 1928 (*The Singing Man*) (Germanisches Nationalmuseum, Nuremberg, Germany)

The Dreamer from *The Frieze of Listeners* 1931 (Ernst Barlach Haus, Ratzeburg, Germany

Das schlimme Jahr 1937 (*The Terrible Year 1937*) 1936 (National Galleries of Scotland Collection, Edinburgh, Scotland)

"Barlach early learned to respect the mute suffering of the peasant."—*Time*

ABOVE: Barlach created this *Self-Portrait* (1928) with charcoal.

GIACOMO BALLA

Born: Giacomo Balla, July 18, 1871 (Turin, Italy); died March 1, 1958 (Rome, Italy).

Artistic style: Futurist painter, sculptor, and stage designer; depicted light, movement, energy, and speed on his canvases of landscapes, urban scenes, and portraits.

Giacomo Balla was an artist of extraordinary imagination and vision who made enormous contributions to the development of modern art forms, seen most clearly in his futurist and abstract works. He explored scientific theories concerning the diffusion and refraction of light, and brought this understanding to his highly sophisticated depiction of light, movement, and the intangible forces of speed and energy. He also studied the groundbreaking work of photographers such as Anton Giulio Bragaglia, Eadweard Muybridge, and Étienne-Jules Marey, which gave form and shape to the mechanics of movement.

Largely self-taught, Balla moved from Turin to Rome in 1895 to make his living as a portraitist and illustrator. In 1900 he visited Paris, where he was impressed by the works of the neo-impressionists. On his return to Rome, he adopted a similar pointillist approach to his painting, which suited his continued experimentation with the depiction of light, atmosphere, and movement, as demonstrated in *Street Light* (*c.*1909–1910).

Balla's style became more abstract during this period, and he established himself as a leading figure in the futurist movement, signing the group's two manifestos in 1910. His dynamic canvases of this period, such as *Speeding Automobile* (1912), were full of explosive energy, rhythm, and intensity. From around 1914, he began to experiment with sculpture, his most famous piece being *Boccioni's Fist* (1915). In 1917, he began producing highly inventive stage designs and acted in several plays. He pursued his abstract and scientific take on art, exploring optical illusions and phenomena, and from 1925 began a series of works based on letters and numbers. In later life, his work became more pointillist, turning away from the brilliant abstraction of his earlier career. **TP**

Masterworks

Street Light c.1909–1910 (Museum of Modern Art, New York, U.S.)

Dynamism of a Dog on a Lead 1912 (Albright–Knox Art Gallery, Buffalo, New York, U.S.)

Speeding Automobile 1912 (Museum of Modern Art, New York, U.S.)

Boccioni's Fist 1915 (Hirshhorn Museum, Washington, D.C., U.S.)

Autoballarioso 1946 (Civic Gallery of Modern Art, Turin, Italy)

ABOVE: Italian Giacomo Balla became a leading figure in the futurist movement.

"All things move, all things run, all things are rapidly changing."

—*Technical Manifesto of Futurist Painting*

ABOVE RIGHT: *Dynamism of a Dog on a Lead* marked the artist's new direction.

RIGHT: *Velocity of Cars and Light* illustrates Balla's interest in speed and energy.

LYONEL FEININGER

Born: Leonell Charles Feininger, July 17, 1871 (New York, U.S.); died January 13, 1956 (New York, U.S.).

Artistic style: Painter, illustrator, caricaturist, and cartoonist; landscapes, seascapes, and cityscapes; motifs of churches, skyscrapers, strolling figures, and boats at sea.

Masterworks

Uprising 1910 (Museum of Modern Art, New York, U.S.)

Gelmeroda III 1913 (National Gallery of Scotland, Edinburgh, Scotland)

The Green Bridge II 1916 (North Carolina Museum of Art, Raleigh, North Carolina, U.S.)

The Village Pond of Gelmeroda 1922 (Stadel Museum Frankfurt, Frankfurt, Germany)

Lady in Mauve 1922 (Museo Thyssen-Bornemisza, Madrid, Spain)

Gelmeroda XII 1929 (Museum of Art, Rhode Island School of Design, Rhode Island, U.S.)

Regler Church, Erfur 1930 (Museum of Fine Arts, Boston, Massachusetts, U.S.)

Manhattan II 1940 (Modern Art Museum of Fort Worth, Texas, U.S.)

Lyonel Feininger combined many of the great art movements of the first half of the twentieth century in his own idiosyncratic work. Claimed as a modernist, he was born in the United States of German parents and traveled widely, living in Chicago, Paris, Berlin, and New York. He started as an illustrator and successful cartoonist, producing the iconic comic strips *The Kin-der-Kids* and *Wee Willie Winkie's World*.

Feininger found inspiration in villages such as Gelmeroda in the countryside near Weimar. The churches, houses, and landscape of the area became the subject matter for his lyrical paintings. A major influence came when he lived in Paris from 1906 to 1908 and studied the work of Henri de Toulouse-Lautrec and Paul Cézanne. Next he went to Berlin where he became an exhibiting member of the secession and was admired by the *Der Blaue Reiter* (The Blue Rider) artists. Walter Gropius invited Feininger to join the Bauhaus as head of the graphics workshop, where he taught until it closed in 1932. In 1924, he founded *Der Blaue Vier* (The Blue Four) with Alexej von Jawlensky, Wassily Kandinsky, and Paul Klee.

The final part of Feininger's development came with his return to the United States in 1937 after the Nazis denounced his art as "degenerate." His teaching, writing, and late watercolors paved the way for abstract expressionism in the United States. He named his style prismaismus; others called it crystalline cubism. With its intersecting rays of light and figures influenced by his graphic work, he fused expressionist and cubist influences to create atmospheric and enigmatic paintings. In 1944, Feininger had a large retrospective exhibition at the Museum of Modern Art in New York. Since the 1990s, there has been a surge of interest in his work. **JJ**

> "[Paintings] . . . must enrapture, and must not stop portraying an episode."

ABOVE: Lyonel Feininger began his career as an illustrator and cartoonist.

PIET MONDRIAN

Born: Pieter Cornelis Mondriaan, March 7, 1872 (Amersfoort, the Netherlands); died February 1, 1944 (New York, U.S.).

Artistic style: Gridlike paintings; primary-colored squares and rectangles; paintings organized around a series of overlapping horizontal and vertical lines.

The development of Piet Mondrian's oeuvre echoes the course that painting itself took during the first two decades of the twentieth century, shifting away from the desire to render forms legible in favor of either an impressionist treatment of the nature and its variant forms, or schematic treatment. Mondrian's early work also owes a debt to symbolism, especially in its bold use of color. However, such a close affinity should not detract from the significance of the paintings Mondrian made after this period. In many respects, he radically altered the possibilities of what paintings could be and how they might communicate subject matter.

The only discernable connection between the various paintings Mondrian made during the 1910s is their preoccupation with the underlying structure of the sensible world and how this might be used to identify and structure an image. This desire to seek and uncover a hidden, underlying reality and its universal patterns became a theme that clearly preoccupied the artist repeatedly throughout his career. In the early 1920s, Mondrian apparently took from cubism, particularly from its analytical phase, the possibility that form might be liberated. Implicit within this act of emancipation was that a certain truth might then be revealed, a truth pertaining to how the sensible world is organized.

By 1920, Mondrian was creating a series of gridlike paintings that juxtaposed discrete squares and rectangles of either primary colors or of white and black. They would be divided by a pronounced black line that is read as part of the overarching composition. Mondrian continued to develop this strategy for the next twenty years, his paintings gradually becoming more refined and subtle. **CS**

Masterworks

Mill by the Water c. 1905 (Museum of Modern Art, New York, U.S.)

Mill in Sunlight: the Winkel Mill 1908 (Gemeentemuseum, The Hague, the Netherlands)

Avond (Evening): the Red Tree 1908-1910 (Gemeentemuseum, The Hague, the Netherlands)

Composition 10 in Black and White 1915 (Kröller-Müller Museum, Otterlo, the Netherlands)

Composition C (No. 111) with Red, Yellow, and Blue 1935 (Tate Collection, London, England)

Composition with Yellow, Blue and Red 1937–42 (Tate Collection, London, England)

Broadway Boogie Woogie 1942–1943 (Museum of Modern Art, New York, U.S.)

"The position of the artist is humble. He is essentially a channel."

ABOVE: Dutch artist Piet Mondrian is best known for his series of gridlike paintings.

JOAQUÍN TORRES-GARCÍA

Born: Joaquín Torres-García, July 28, 1874 (Montevideo, Uruguay); died August 8, 1949 (Montevideo, Uruguay).

Artistic style: Painter, draftsman, muralist, and sculptor; founder of universal constructivism; abstracts, cityscapes, and portraits; use of symbols.

Masterworks

New York 1921 (Museo Nacional Centro de Arte Reina Sofia, Madrid, Spain)

Primitive Face 1928 (Museo Patio Herreriano de Valladolid, Valladolid, Spain)

Universal Constructivism 1930 (Museo Nacional Centro de Arte Reina Sofia, Madrid, Spain)

Composition 1932 (Museum of Modern Art, New York, U.S.)

Urban Landscape 1940 (Museo Thyssen-Bornemisza, Madrid, Spain)

Portrait of Wagner 1940 (Museum of Modern Art, New York, U.S.)

The Port 1942 (Museum of Modern Art, New York, U.S.)

Universal Art 1943 (Museo Nacional de Artes Visuales, Montevideo, Uruguay)

"[The artist must] remain conscious of the world without forgetting what is close at hand."

ABOVE: This was taken after García's 1909 marriage to Manolita Piña de Rubiés.

Joaquín Torres-García was highly influential in introducing modernism to Latin America. He helped develop a distinct Latin American cultural identity for the region's twentieth-century art and architecture.

Born in Montevideo, Torres-García studied art in Barcelona, Spain. By the turn of the century, he was mixing in avant-garde circles and meeting artists such as Pablo Picasso. Alongside commissions for murals and illustrations for journals, in 1903 Torres-García helped local architect Antoni Gaudí create stained glass windows for the Cathedral of Palma de Mallorca and later for La Sagrada Família in Barcelona.

Torres-García struggled financially, however, and in 1920 he moved to New York in search of greater wealth. There he produced various paintings of cityscapes, such as *New York* (1921). He then went to Paris and in 1929 founded the Circle and Square group of abstract artists with critic and artist Michel Seuphor. He continued to develop his ideas for an abstract-geometrical style fusing constructivism and cubism, a style that became known as "universal constructivism."

His works used an earthy color palette, and their gridlike structures included a personal set of symbols, often referencing pre-Colombian art. In 1934 Torres-García decided to return to live in his native Uruguay, a move that encouraged his continued interest in pre-Colombian art. He formed the Association of Constructivist Art with thirty-two native artists and outlined his ideas in his manifesto, *School of the South* (1935). In 1943, he established the Torres-García Studio where he taught students of painting, sculpture, ceramics, and architecture, infusing them with modernist ideas. **CK**

PAULA MODERSOHN-BECKER

Born: Paula Becker, February 8, 1876 (Dresden, Germany); died November 20, 1907 (Worpswede, Germany).

Artistic style: Expressionist painter; flat areas of color; strong outlines; portraits of peasants; images of mothers and babies; striking self-portraits.

In her short life, early German expressionist painter Paula Modersohn-Becker showed resilience and determination in following the path that would lead to the discovery of her own form of expression. She trained in Bremen, London, and Berlin. In 1898, infatuated by the landscape and excited by the anti-academic ethos of the artists, she joined an artistic community in the small town of Worpswede, taking lessons from art nouveau painter Fritz Mackensen. She soon became dissatisfied with the naturalistic style to which the community's artists aspired. Her work was already more linear and emphasized physical peculiarity for expressive effect, as in her drawing *Spinning Peasant Woman* (1899). In 1900, she made the first of several trips to Paris, where she studied in the Académie Cola Rossi and was inspired by Paul Cézanne.

Her marriage to painter Otto Modersohn in 1901 resulted in a brief collaboration, but her restless pursuit of a simpler form of expression took her back to Paris in 1903 and 1905, where she saw work by Cézanne, Paul Gauguin, and Vincent van Gogh. She also studied classical, Gothic, and Egyptian art in the Louvre, visited sculptor Auguste Rodin, and studied at the Académie Julian. During her next visit to Paris, Modersohn-Becker produced some of her strongest work, including self-portraits and mother and child paintings. Works such as *Reclining Mother and Child* (1906) depict motherhood without sentimentality and draw on her experience of peasant life. Her self-portraits, notably *Self-Portrait with Amber Necklace* (1906), are important in terms of the history of women's painting and artistic identity. In that year, she was acclaimed for work shown in a group show. She died in 1907, shortly after the birth of her daughter. **WO**

Masterworks

Self-Portrait on Her Sixth Wedding Day 1906 (Paula Modersohn-Becker Museum, Bremen, Germany)

Self-Portrait with Amber Necklace 1906 (Paula Modersohn-Becker Museum, Bremen, Germany)

Reclining Mother and Child 1906 (Paula Modersohn-Becker Museum, Bremen, Germany)

Nude Girl with Flowers c.1907 (Von der Heydt-Museum, Wuppertal, Germany)

"One needn't think so much about nature . . . my own perception is the main thing."

ABOVE: The artist holds a serene pose for her *Self-Portrait* of 1906–1907.

GWEN JOHN

Born: Gwen John, June 22, 1876 (Haverfordwest, Wales.); died September 18, 1939 (Dieppe, France).

Artistic style: Small-scale paintings with a narrow tonal range and intense emotional quality; three-quarter-length portraits of seated female figures.

Masterworks

Self-Portrait 1902 (Tate Collection, London, England)

A Corner of the Artist's Room in Paris (With Open Window) 1907–1909 (National Museums & Galleries of Wales, Cardiff, Wales)

Nude Girl 1909–1910 (Tate Collection, London, England)

A Young Nun (Portrait of a Nun) c.1915–1920 (Scottish National Gallery of Modern Art, Edinburgh, Scotland)

Young Woman Holding a Black Cat 1910s–1920s (Tate Collection, London, England)

The Convalescent 1923–1924 (Fitzwilliam Museum, Cambridge, England; also several other versions in collections elsewhere)

Like her younger brother, artist Augustus John, Gwen John studied at the Slade School of Fine Art in London during the 1890s, but her career followed a very different path from that of her famous sibling. He courted celebrity with his flamboyant talent and wild bohemian life; she lived and worked in relative isolation and obscurity. Yet in her own way, she too resisted social convention and pursued an independent existence.

Her art education was completed in Paris and in 1904, after traveling to Toulouse with friend and model Dorothy "Dorelia" McNeill, she moved permanently to France, supplementing her meager income by working as an artist's model. She most famously posed for the great modern sculptor Auguste Rodin, with whom she had a passionate and somewhat obsessive relationship. In 1913 she converted to Roman Catholicism, and later moved to the village of Meudon, where she lived quietly and privately for the rest of her life, devoting herself to her art.

The unassuming interiors and portraits that characterize John's work possess a restrained beauty and emotional intensity. Although primarily studies in tone and color, her subjects exhibit an aloof detachment and quiet stillness that is nonetheless powerfully expressive. During the 1910s she developed an approach to painting that involved multiple variations of a chosen theme, usually a solitary female figure seated within an austere interior. These repeated motifs include the convalescent girl and a profoundly meditative series of nuns that evolved from a portrait commission of Mère Poussepin, founder of the local convent. Largely remembered for her oil paintings, some of her most affecting works are spontaneous vivid studies in watercolor and chalk of Breton peasant children and her beloved cat. **NM**

> "I may never have anything to express except this desire for a more interior life."

ABOVE: Detail from the pencil drawing, *Self-Portrait,* held in a private collection.

RIGHT: John's acute awareness of tonality is seen in *The Convalescent* (1923–1924).

JULIO GONZÁLEZ

Born: Julio González, September 21, 1876 (Barcelona, Spain); died March 27, 1942 (Arcueil, France).

Artistic style: Sculptor, metalworker, painter, and draftsman; cubist and abstract works suggestive of the figure; welded-iron sculpture using linear and spatial form.

A pioneer of welded-iron sculpture, Julio González learned at the feet of Pablo Picasso by executing the artist's designs for welded-iron sculptures from 1928 to 1932; the experience inspired him to devote himself to being a sculptor.

González had acquired his metalworking skills in his father's workshop in Barcelona. He also attended evening classes at the Escuela de Bellas Artes, where he studied painting and sculpture. In 1897, he began to frequent Barcelona's center for avant-garde artists, Els Quatre Gats (The Four Cats) café, which was where he met Picasso. In 1900, González moved to Paris, where he mixed with artists Juan Gris, Constantin Brancusi, Manolo Hugué, Max Jacob, and Jaime Sabartés. He made jewelry and metalwork, and continued to paint and sculpt.

In 1918, González worked at the Renault factory at Boulogne-Billancourt; he would later use the welding techniques he learned there in his iron sculptures. By 1920 he had renewed his friendship with Picasso, and in 1922 he had his first solo show at Paris's Galerie Povolovsky. González gave Picasso technical assistance in executing his iron sculptures and was in turn encouraged to work on his own art. His pieces from this period are abstract in style and use an almost bare, linear form to play with space and allude to the figure. In *Maternité* (1934), the graceful, swirling lines are suggestive of a mother figure. During the 1930s he exhibited frequently with surrealist and abstract artists. Sadly, by the end of the decade, he was forced to abandon sculpture, probably because of the shortage of iron and other materials caused by World War II. He returned to painting and drawing, often concentrating on military subjects, working steadily until he died of a heart attack aged sixty-two. **CK**

Masterworks

Los Enamorados II (*The Lovers II*) 1932 (Museo Nacional Centro de Arte Reina Sofía, Madrid, Spain)

Tête dite "Le Tunnel" (*Head Called "The Tunnel"*) 1933–1934 (Tate Liverpool, Liverpool, England)

Maternité (*Maternity*) 1934 (Tate Liverpool, Liverpool, England)

Femme sauvage (*Native Woman*) 1940 (Tate Collection, London, England)

"It is high time [iron] ceases to be a murderer . . . [in] the peaceful hands of artists."

ABOVE: Photograph of Julio González from the Modern Art Institute in Valencia.

CONSTANTIN BRANCUSI

Born: Constantin Brancusi, February 19, 1876 (Hobitza, Romania); died March 16, 1957 (Paris, France).

Artistic style: Sculptor of wood, stone, marble, and bronze; use of direct carving; basic forms; themes of fish and birds in movement.

Constantin Brancusi's sculpture was forever informed by the country of his birth: Romania. It was there that he learned to carve wood and stone; its folk art and folk tales inspired him to create works such as *Maiastra* (*c.*1912) and *Bird in Space* (1923). He studied at the School of Arts and Crafts in Craiova and then at the National School of Fine Art in Bucharest. Throughout his life he would return to his studio in Romania, where he was commissioned to do public works, such as his 96-foot-high (29 m) cast-iron sculpture *The Endless Column* (1938) at Târgu Jiu, a memorial to the country's fallen soldiers in World War I.

Brancusi left Romania for Paris in 1904 to study at the École des Beaux-Arts. He lived in Paris for the rest of his life, and absorbed the influence of artists such as Paul Gauguin, Henri Rousseau, Henri Matisse, and sculptor Auguste Rodin, whom he briefly worked for in 1907, carving his marble sculptures. But Brancusi was keen to carve his own work. At that time, sculptors often made plaster or clay casts, and stonemasons carved their work for them—using a method known as "direct carving." He sought to release a sculpture from his material in a way that was sympathetic to the material itself. This desire, coupled with his interest in folk art, African art, and the shift toward modernism in Paris, led to him creating groundbreaking geometric works such as *The Kiss* (1910), *Torso of Young Man* (1924), and *Fish* (1926), whose basic forms spurned realism and the representational. Some labeled his work abstract art, which Brancusi strongly denied, and some even wondered whether it was sculpture at all. But history has proved the latter wrong: Brancusi's sculptures, methods, and beliefs went on to influence sculptors such as Sir Henry Moore throughout the twentieth century and beyond. **CK**

Masterworks

The Kiss 1910 (Cimetière du Montparnasse, Paris, France)

*Maiastra c.*1912 (Peggy Guggenheim Collection, Venice, Italy)

*Danaïde c.*1918 (Tate Liverpool, Liverpool, England)

Socrates 1922 (Museum of Modern Art, New York, U.S.)

Bird in Space 1923 (Metropolitan Museum of Art, New York, U.S.)

Torso of Young Man 1924 (Hirshhorn Museum and Sculpture Garden, Washington, D.C., U.S.)

Fish 1926 (Tate Collection, London, England)

The Endless Column 1938 (Târgu Jiu, Gorj County, Oltenia, Romania)

"Create like a god, command like a king, work like a slave."

ABOVE: An artistically lit photograph of Constantin Brancusi.

MARSDEN HARTLEY

Born: Edmund Hartley, January 4, 1877 (Lewiston, Maine, U.S.); died September 2, 1943 (Ellsworth, Maine, U.S.).

Artistic style: Explored range of modernist styles; later landscapes and figural studies in a personal expressionistic style; linked with regionalists.

Masterworks

Storm Clouds, Maine 1906–1907 (Walker Art Center, Minneapolis, U.S.)

Autumn Lake and Hills 1908 (Sheldon Memorial Art Gallery, University of Nebraska-Lincoln, Nebraska, U.S.)

Portrait of a German Officer 1914 (Metropolitan Museum of Art, New York, U.S.)

Landscape No. 3, Cash Entry Mines, New Mexico 1920 (The Art Institute of Chicago, Chicago, U.S.)

Mount Katahdin 1939–1940 (Sheldon Memorial Art Gallery, University of Nebraska–Lincoln, U.S.)

Young Worshipper of the Truth 1940 (Sheldon Memorial Art Gallery, University of Nebraska-Lincoln, Nebraska, U.S.)

> "I returned to my tall timbers and my granite cliffs . . . the kind of integrity I believe in."

ABOVE: This photograph was taken toward the beginning of the artist's career.

One of the most important U.S. painters of the early twentieth century, the diversity of Hartley's art reflected his nomadic lifestyle and an incessant search for spiritual meaning.

Born in Maine to English parents, Hartley's childhood was so fractured by his mother's death that, after completing an artistic fellowship in New York, he adopted his stepmother's maiden name in 1906 to try to rebuild family ties. Although his early impressionistic landscapes were much influenced by Albert Pinkham Ryder and Giovanni Segantini, Hartley's primary inspirations were literary: the U.S. transcendentalism of Ralph Waldo Emerson, Walt Whitman, and their followers.

In 1909, Hartley met Alfred Stieglitz, the owner of New York's 291 Gallery, who staged his first major exhibition and introduced him to work by the European post-impressionists and cubists. On his first trip to Europe, Hartley met, and was much impressed by, Wassily Kandinsky and Franz Marc. Berlin's artistic vibrancy, hedonism, and military pageantry proved intoxicating and he responded with a series of cubist abstractions using a bright fauvist palette. *The German Officer* (1914) series was made in part homage to his friend and possible lover, Prussian Lieutenant Karl von Freyburg, who was killed in the early months of World War I. Now the most famous works of his career, they met hostility in the United States and Hartley soon returned to a more objective representational style. For the next twenty years, he traveled restlessly in Europe and the Americas, producing fine landscapes and still lifes but always in search of an authentic voice of sturdy realism. In his final years, he came full circle, devoted to painting the people and places of his rugged home state with a simple expressionistic directness. **RB**

KATHERINE DREIER

Born: Katherine Sophie Dreier, 1877 (Brooklyn, New York, U.S.); died 1952 (Milford, Connecticut, U.S.).

Artistic style: Abstract painter; explorations of color, line, and geometric forms; influential curator, patron, and promoter of modernist art in the United States.

Katherine Dreier is best known as the person who introduced surrealism to the United States, as curator of the International Exhibition of Modern Art (1926). In 1920, she had co-founded the U.S. section of the Société Anonyme with Marcel Duchamp and Man Ray. A supporter, patron, and friend of artists, she was an avid collector of modernist art, forming the basis of the Museum of Modern Art and Guggenheim collections. Yet she was also an artist of colorful abstract paintings influenced by Wassily Kandinsky; two of her paintings appeared in New York's Armory Show (1913). Her supreme achievements as a patron of the arts eclipsed her own talent; as a female artist in a male-dominated world of art, her work was often sidelined. **CK**

Masterworks

Abstract Portrait of Marcel Duchamp 1918 (Museum of Modern Art, New York, U.S.)

Two Worlds (Zwei Welten) 1930 (Yale University Art Gallery, New Haven, Connecticut, U.S.)

Variation 12 1937 (Fairchild Gallery, Georgetown University Library, Georgetown, Washington, D.C., U.S.)

GABRIELE MÜNTER

Born: Gabriele Münter, February 19, 1877 (Berlin, Germany); died May 19, 1962 (Murnau am Staffelsee, Germany).

Artistic style: Expressionist painter of landscapes and still lifes; simplified shapes; dark outlines; angular distortions; explorations of identity and relationships.

A founder member of the avant-garde German expressionist *Der Blaue Reiter* (The Blue Rider), Gabriele Münter introduced the other members of the group to Bavarian glass painting and its use of geometric blocks of bold color. Yet her contribution to the group has been overshadowed by her long relationship with fellow member, Russian painter Wassily Kandinsky. Münter's early paintings are primarily landscapes and still lifes, and feature a constant exploration of her identity and relationships. The outbreak of World War I forced Kandinsky's return to Russia, and the couple never met again. Münter returned to painting in the 1920s and her style moved away from expressionism, becoming more linear, particularly in her portraits. **WO**

Masterworks

Portrait of Marianne Von Werefkin 1909 (Städtische Galerie im Lenbachhaus, Munich, Germany)

Toward Evening 1909 (Galerie Daniel Malingue, Paris, France)

Portrait of Jawlensky 1909 (Städtische Galerie im Lenbachhaus, Munich, Germany)

Still Life in Grey 1911 (Städtische Galerie im Lenbachhaus, Munich, Germany)

*Kandinsky c.*1910 (Private collection)

Boating 1910 (Milwaukee Art Museum, Milwaukee, Wisconsin, U.S.)

1800-99

KASIMIR MALEVICH

Born: Kasimir Severinovich Malevich, February 26, 1878 (Kiev, Russia [now Ukraine]); died May 15, 1935 (Leningrad [now St. Petersburg], Russia).

Artistic style: Suprematist painter; spurned the concept of art as illusion; ultimate denial of representational art using geometric shape and monochromatic color.

Masterworks

Haymaking 1909 (The Tretyakov Gallery, Moscow, Russia)

Black Square 1915 (The Tretyakov Gallery, Moscow, Russia)

*Untitled c.*1916 (Guggenheim Museum, New York, U.S.)

Suprematist Composition: White on White 1918 (Museum of Modern Art, New York, U.S.)

Red Cavalry Riding 1928–1932 (State Russian Museum, St. Petersburg, Russia)

*Black Square c.*1930 (The Hermitage, St. Petersburg, Russia)

Although the work of Russian Kasimir Malevich drew inspiration from a number of movements, notably futurism and cubism, the significance of Malevich's contribution toward the development of European abstraction resides in a movement unique to the Russian avant-garde. In 1915, Malevich abandoned any last-remaining vestiges of recognizable imagery in his paintings in favor of basic geometric shapes, such as a circle, a square, or a cross placed on a stark, monochrome background. His intention was to liberate form from what he saw as the "rubbish-filled pool" of academic art.

Moreover, the suprematism movement, launched in 1915 in Petrograd by Malevich and five other artists, was deemed the "pure art of painting." Malevich pursued a keen interest in iconography. The most significant painting he produced at this

ABOVE: Malevich painted a number of portraits in 1933, including this self-portrait.

RIGHT: *Suprematist Composition: White on White* was a revolutionary piece of art.

time was his *Black Square* (*c*.1930), painted freehand. The work consists of a black square painted on a white background and was first exhibited hung high up across a corner like an iconic religious image in a Russian Orthodox home. Malevich spurned the concept of art as illusion, and this painting was the ultimate denial of representational art, and radical in its use of one geometric shape and only one color.

Malevich fulfilled a series of pedagogical roles, teaching first at the Free Art Studios in Moscow and then at Vitebsk Popular Art School, invited by Marc Chagall. While teaching at the Institute of Artistic Culture in Petrograd, Malevich pursued his interests in *arkhitekton* (rudimentary models of architectural projects), which he hoped would one day be realized. By 1927, he had returned to painting, but the inability of his figurative works to challenge the prescribed imagery of social realism confirmed that his lasting legacy was rooted in the works he produced under the rubric of suprematism. **CS**

ABOVE: The soldiers in *The Red Cavalry Riding* are on their way to defend Soviet borders.

The Malevich Touch

Malevich was a pioneer of geometric abstract art, and his work an important precursor to minimalism. Generations of artists have drawn inspiration from his break with representational art.

- Malevich's influence is clearly seen in the monochrome works of Barnett Newman, Yves Klein, and Ad Reinhardt as well as the abstract paintings of El Lissitzky.

- With *Suprematist Composition: White on White* (1918), Malevich was perhaps the first artist to paint an entirely white painting, yet numerous artists have since adopted the same strategy.

PAUL KLEE

Born: Paul Klee, December 18, 1879 (Münchenbuchsee, Switzerland); died June 29, 1940 (Muralto, Switzerland).

Artistic style: Tessellated graphic patterns; interwoven figural and abstract art forms; pointillism; use of strong and varied colors as a compositional device.

1800-99

Masterworks

Red and White Domes 1914 (Nordrhein-Westfalen, Düsseldorf, Germany)

They're Biting 1920 (Tate Collection, London, England)

Architecture of the Plain 1923 (Staatliche Museum, Berlin, Germany)

Jungwaldtafel 1926 (Staatgalerie, Stuttgart, Germany)

Ad Parnassum 1932 (Kunstmuseum, Berne, Germany)

New Harmony 1936 (Guggenheim Museum, New York, U.S.)

The defining feature of Paul Klee's work is the impossibility of ascribing it to any one movement. Working simultaneously in figural and abstract art traditions and experimenting with rigid cubing of the picture surface, pointillism, and free drawing, Klee exploited the potential of every artistic trend he encountered. Although involved with artistic collectives, including *Der Blaue Reiter* (The Blue Rider), the New Munich Secession, the Blue Four, and the Bauhaus, Klee remained independent, rejecting the surrealists' attempts to claim him as one of their own.

He chose to study art at the Munich Academy of Fine Arts. Not until after a trip to Tunisia with artists Louis Moilliet and August Macke did Klee declare, "Color and I are one: I am a

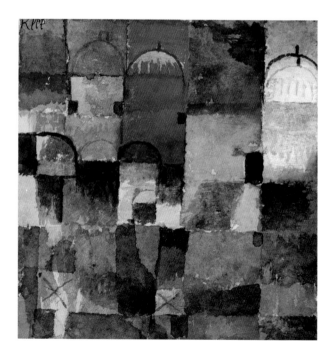

ABOVE: Klee's somber pose belies his colorful paintings.

RIGHT: The colors of *Red and White Domes* were inspired by Klee's visit to Tunisia.

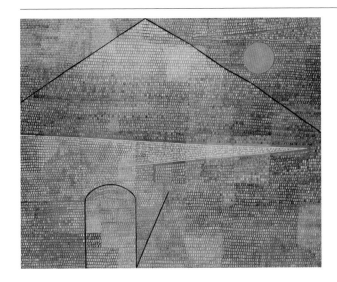

LEFT: *Ad Parnassum* (1932) was the last work in Klee's magic square series.

painter." This statement symbolizes the predominant concern of his practice, in which color is used as both a tool to evoke times of day or elicit emotional responses and as a compositional element, where a mathematical understanding of rhythm and pattern may determine the distribution of different tonalities across the canvas. Klee's early interest in music proved a formative influence on his work. A number of pieces, such as *Fugue in Red* (1921) and *Landscape in A Major* (1930), are ordered around musical structures, using the movements of notes along a stave as a model for the precise arrangement of colors. Rhythm was of fundamental significance for Klee, defined not as repetition but as a balance between the regular and irregular. Canvases are often covered with uniform lines, over which incongruous shapes appear as accents, interrupting the passage of the eye across the surface.

Involved with a number of radical organizations of artists before fleeing Germany, Klee was always politically engaged. He suffered persecution during the rise of the Nazi Party. He was removed from the list of teachers at the Bauhaus for being Jewish (although he was not), and more than one hundred of his works were confiscated from German collections. **PS**

Art?—It's Simple

Paul Klee lectured and published extensively on the ways and means of producing great art. His writings promote an autonomous practice, which would champion the aesthetic of the work over any apparent message or theme. He claimed, "To paint well is simply this: to put the right color in the right place." One of his notebooks records a similar attitude to the art of drawing, "A line comes into being. It goes for a walk, so to speak, aimlessly, for the sake of the walk." Restraint was also key, "Nature is loquacious to the point of confusion; let the artist be silent and orderly."

NORMAN LINDSAY

Masterworks

Satyr Pursuing a Nymph 1913
(Norman Lindsay Gallery & Museum,
Faulconbridge, Australia)

The Sphinx 1922 (Norman Lindsay Gallery
& Museum, Faulconbridge, Australia)

The Black Hat 1924 (Norman Lindsay Gallery
& Museum, Faulconbridge, Australia)

Female Figure Holding Her Breasts 1930s
(Norman Lindsay Gallery & Museum,
Faulconbridge, Australia)

Spring's Innocence 1937 (National Gallery
of Victoria, Melbourne, Australia)

Rita of the Eighties 1940
(Norman Lindsay Gallery & Museum,
Faulconbridge, Australia)

Born: Norman Alfred William Lindsay, February 22, 1879 (Creswick, Australia); died
November 21, 1969 (Springwood, Australia).

Artistic style: Excellent draftsmanship; fantasy, mythology, and eroticism; pastiche
pastoral scenes; sumptuous nudes; exciting experimentation with artistic media.

A hugely controversial artist, Norman Lindsay, the son of a
surgeon, became a brilliant sculptor, illustrator, cartoonist, and
painter as well as an accomplished novelist. A large number of
his works depict sexually aroused women, which led to
accusations of indecency, especially in the United States, where
many of his works were deliberately set on fire.

Except for a couple of years in Europe, Lindsay spent his life
in Australia, moving between the states of Victoria and New
South Wales. His former home in Faulconbridge, New South
Wales, is now an art gallery dedicated to his works. An
embellished story of his life inspired the film *Sirens* (1994), which
in turn inspired a renewed interest in Lindsay and his art. **LH**

EDWARD STEICHEN

Masterworks

Rodin—The Thinker 1902 (Cleveland Museum
of Art, Cleveland, Ohio, U.S.)

The Pond-Moonlight 1904 (Museum
of Modern Art, New York, U.S.)

The Flatiron 1904 (Metropolitan Museum,
New York, U.S.)

The Family of Man series 1955 (Museum
of Modern Art, New York, U.S.)

Born: Edward Steichen, March 27, 1879 (Bivange, Luxembourg); died March 25,
1973 (West Redding, Connecticut, U.S.).

Artistic style: Nuanced sense of the possibilities of photography; early adherence
to pictorialism, portraiture, and documentary approaches.

Edward Steichen was one of the earliest proponents
of photography as an art medium, experimenting with color
photography as early as 1904 and realizing its experimental
and political potential. Steichen quickly established himself as
a master of the pictorialist approach, a style that emulated
painterly techniques and subject matter. In the 1920s, he took
on commercial work for magazines such as *Vanity Fair* and
Vogue. Closing his studio in 1938, he focused on a documentary
style. After the war, he became director of photography of New
York's Museum of Modern Art and curated the *Family of Man*
exhibition (1955), comprising 503 images by 273 photographers
on universal themes such as love, children, and death. **LNF**

FRANCIS PICABIA

Born: Francis-Marie Martinez Picabia, January 22, 1879 (Paris, France); died November 30, 1953 (Paris, France).

Artistic style: Abstract painter and poet who is said to have painted the first Abstract picture in 1908–1909; key figure of both Dadaism and surrealism.

Francis Picabia grew up in Paris and studied at École des Beaux-Arts and École des Arts Decoratifs. Early on, he was influenced by Alfred Sisley's landscapes and produced some successful impressionistic works of his own, but by 1909 he was more interested in cubism.

Picabia was particularly influenced by the work of Marcel Duchamp. Together they formed the Section d'Or Cubists, an offshoot of cubism, in 1912. Picabia used his secure financial position to fund his art and began producing his first purely abstract pieces. His style merged brightly colored fauvism with the more muted tones of cubism, as seen in his most famous work, *I See Again in Memory My Dear Udnie* (1914).

The abstract paintings that Picabia exhibited at the Armory Show in the United States in 1913 were well received. He followed up this success with a visit to New York two years later when he, Duchamp, and Man Ray were instrumental in forming the New York society of Dadaists. Picabia's interest in the movement was relatively short-lived though, and by 1917 he had published his first "mechanical drawings" to great critical acclaim. Soon he began converting colored images of technical drawings into human figures, intending to demonstrate the contradictions of visual perception. In 1921, Picabia dissociated himself from Dadaism, transferring his loyalty to surrealism. He started to construct collages and began working with transparent overlaid images, looking for methods to depict three-dimensional space without employing the traditional rules of perspective.

After World War II, Picabia returned to Paris to live in his childhood home. There he resumed abstract painting and writing poetry until his death at age seventy-four. **SH**

Masterworks

Entrance to New York 1913 (Art Institute of Chicago, Chicago, Illinois, U.S.)

I See Again in Memory My Dear Udnie 1914 (Museum of Modern Art, New York, U.S.)

Machine Turn Quickly 1916–1918 (National Gallery of Art, Washington, D.C., U.S.)

Lucie Desnos 1940–1941 (Metropolitan Museum of Art, New York, U.S.)

> "Between my head and my hand, there is always the face of death."

ABOVE: In this detail from *Self-Portrait* (1940), Picabia has an air of flamboyance.

FRANZ MARC

Born: Franz Marc, February 8, 1880 (Munich, Germany); died March 4, 1916 (Verdun, France).

Artistic style: Painter and founding member of *Der Blaue Reiter*; animal subjects; used color in the manner of the fauves and expressionists.

Masterworks

Siberian Dogs in the Snow 1909–1910 (National Gallery of Art, Washington, D.C., U.S.)

Horse in the Landscape 1910 (Museum Folkwang, Essen, Germany)

The Large Blue Horses 1911 (Walker Art Center, Minneapolis, U.S.)

The Unfortunate Land of Tyrol 1913 (Guggenheim Museum, New York, U.S.)

Franz Marc's artistic career spanned only sixteen years from the start of his training in 1900 to his untimely death in 1916 during World War I. He began his studies in 1900 at the Akademie der Bildenden Künste in Munich, working in a traditional landscape manner. He trained for two years before moving to Upper Bavaria, where he made many studies from nature. His understanding of anatomy and the natural world is apparent in his work, and he continued to draw from life throughout his career.

In 1903 and 1907 he visited Paris and became familiar with the work of Vincent van Gogh and Paul Gauguin. In this period he developed his use of intense color, using it to project emotion and to convey a deep spiritual resonance. He concentrated on animal subjects, using them in a symbolic capacity to reflect his interpretation of spirituality and, through his seamless compositions, to create the balance and harmony of the animal nature to its landscape.

Marc met the artist Auguste Macke in 1910, and the two quickly became close. A year later, Marc forged an important friendship with Wassily Kandinsky through the Munich New Artist's Association group of artists. Marc and Kandinsky shared similar aspirations for their work and perceived their art within a cerebral spiritual framework. They exhibited together in 1911, calling the exhibition *Der Blaue Reiter* (The Blue Rider). They brought together artists whose styles and expressions differed but whose intentions were to convey spiritual truth through their paintings. The following year, they published their manifesto, considered one of the most important collections of essays on modern art of the twentieth century. **TP**

"We are searching for things in nature . . . We look for and paint this inner, spiritual side . . . "

ABOVE: This portrait was taken in 1912, a few years before Marc was killed in action.

ERNST LUDWIG KIRCHNER

Born: Ernst Ludwig Kirchner, May 6, 1880 (Aschaffenburg, Germany); died June 15, 1938 (Frauenkirch, Switzerland).

Artistic style: Expressionist painter and printmaker; expressive color and line that became sharper and aggressive in later works; landscapes, cityscapes, and portraits.

Ernst Ludwig Kirchner's association with the group *Die Brücke* (The Bridge) is important. He was a founding member, and his actions also caused its demise. *Die Brücke* was founded in 1905 in Dresden. Its original five members lived and worked together collaborating on paintings and prints. Their manifesto appealed to young artists in its effort to overthrow the old order of academism, and the founders were soon joined by others.

The group was inspired by several exhibitions held in Dresden featuring avant-garde artists such as Vincent van Gogh, the fauves, Gustav Klimt, and Edvard Munch. These shows influenced the group to create a style of art that was erotic and primitive, whether painted in the studio or *en plein air*, such as Kirchner's *Bathers at Moritzberg* (1909–1926) and *Girl Under a Japanese Umbrella* (1909).

However, this fertile period came to an end when the group moved to Berlin. Kirchner's paintings at this time lose their love of life and become jagged. Colors are muddy, and his subjects depict city angst, loneliness, and despair. In 1913, he positioned himself as leader in a history of *Die Brücke*. This angered his fellow members and precipitated the demise of the group. A few years later, Kirchner fiddled with history again by changing the dates of his works to suggest that he had not been influenced by the fauves.

While serving in World War I, he suffered a breakdown and moved to Frauenkirch, near Davos, in Switzerland, where he spent the rest of his life. Kirchner exhibited widely in the 1930s but again succumbed to depression. His inclusion in the Nazi's Exhibition of Degenerate Art in Munich in 1937 increased his instability, and he committed suicide in 1938. Today his reputation is restored as one of the most important expressionists. **WO**

Masterworks

Girl Under a Japanese Umbrella 1909 (Kunstsammlung Nordrhein-Westfalen, Düsseldorf, Germany)

Bathers at Moritzburg 1909–1926 (Tate Collection, London, England)

Standing Nude with a Hat 1910 (Städtische Galerie, Frankfurt, Germany)

Self-Portrait with Model 1910–1926 (Kunsthalle, Hamburg, Germany)

Berlin Street Scene 1913 (Museum of Modern Art, New York, U.S.)

"The great poet Walt Whitman was responsible for my outlook on life."

ABOVE: Detail from *Self-Portrait with Model* (1905), one of the artist's earliest portraits.

ANDRÉ DERAIN

Born: André Derain, June 1880 (Chatou, France); died September 8, 1954 (Garches, Hauts-de-Seine, France).

Artistic style: Founder of fauvism; painter, illustrator, sculptor, and set designer; landscapes in vivid colors; vigorous brushstrokes; outlined portraits and nudes.

Masterworks

Charing Cross Bridge 1901 (Musée d'Orsay, Paris, France)

Mountains at Collioure 1905 (National Gallery of Art, Washington, D.C., U.S.)

London Bridge 1906 (Museum of Modern Art, New York, U.S.)

Madame Derain in Green 1907 (Museum of Modern Art, New York, U.S.)

The Bagpiper 1910–1911 (Minneapolis Institute of Arts, Minneapolis, Minnesota, U.S.)

Portrait of a Man with a Newspaper 1911–1914 (The Hermitage, St. Petersburg, Russia)

Madame Derain in a White Shawl c.1919–1920 (Tate Collection, London, England)

The Painter and his Family c.1939 (Tate Collection, London, England)

Opinions of André Derain's character have been as divided as those of his art. He was said to have been a man of good will, a marvel of intelligence, and the author of some of the most vivid and amusing of all artists' letters. Yet he was also labeled a Nazi collaborator and, according to art critic Clement Greenberg, was "technically one of the most gifted of all painters, but one who always suffered from a bad character."

Derain was one of the founding fathers of fauvism and one of its wildest practitioners, bringing his fierce vision to maturity with Henri Matisse in 1905. Although best known for his early fauve landscapes, Derain constantly reinvented his art practice. Initially displaying the influence of African art (of which he was a pioneer collector) and of cubism, he later delighted in archeological finds and High Renaissance painting. From 1921, his figurative works, in particular, saw a return to tradition.

When a collection of essays, *Pour et Contre Derain* (*For and Against Derain*) (1931), was published, the title was characteristic of the informed yet divided opinion held of Derain's work and its increasing stylistic conservatism. For his supporters, he became the pretext for a general condemnation of modernism; others regarded his new work as cerebral and mechanical. Nevertheless, he enjoyed a period of continued success, reaching its zenith with a retrospective in Bern in 1935 and his inclusion in the Exposition des Artistes Indépendants (1937) in Paris. But World War II saw the beginning of a string of disastrous events. Reported associations with the Third Reich, the birth of two illegitimate sons, and the breakdown of his marriage contributed to Derain's decline, transforming a self-assured man into a self-doubting recluse. He died in 1954 after being knocked down by a truck. **TC**

"Always a pipe in his mouth, phlegmatic, mocking, cold, an arguer."—Fernande Olivier

ABOVE: Detail from *Self-Portrait* (1913), depicting the artist's more somber mood.

HANS HOFMANN

Born: Hans Hofmann, March 21,1880 (Weissenburg, Germany); died February 17, 1966 (New York, U.S.).

Artistic style: Abstract expressionist painter; use of exuberant color; influential teacher for generations of artists.

When he was six years old, Hans Hofmann's family moved to Munich from Bavaria. The city would later benefit from this when Hofmann established an art school there in 1915. It gained international recognition, and Hofmann personally taught students until he emigrated to the United States in 1932. Hofmann's main contribution to art is seen by some to be his strengths as a teacher rather than as an artist.

Although interested in mathematics, science, and music as well as art, he began studying art formally in 1898. In 1904, he moved to Paris, where he studied for ten years. He befriended many leaders of the modernist movement, including Henri Matisse, Pablo Picasso, and Georges Braque, but his most influential friendship was with Robert Delaunay, whose emphasis on color over form was highly infuential. Hofmann developed and wrote about his own color and composition theories throughout his lifetime, tirelessly exploring pictorial structure, spatial tensions, and color relationships. For some critics, these written works compounded the theory that Hofmann was more of an academic than a creative painter.

After moving to the United States, he continued both teaching and painting. He opened the Hans Hofmann School of Fine Arts in Manhattan and exhibited in San Francisco, New York, and Paris. In spite of his growing recognition as a painter, it was not until he was seventy-eight that he was able to give up teaching and devote himself completely to his art. In 1960, he was one of four artists representing the United States at the Venice Biennale. Three years later, a retrospective exhibition of his work at the Museum of Modern Art traveled throughout the United States and to South America and Europe. **SH**

Masterworks

Landscape 1942 (Detroit Institute of Arts, Detroit, Michigan, U.S.)

Smaragd Red and Permiating Yellow 1959 (Cleveland Museum of Art, Cleveland, Ohio, U.S.)

Pompeii 1959 (Tate Modern, London, England)

Untitled (Renate series) 1965 (Thyssen-Bornemisza Museum, Madrid, Spain)

"When I paint, I improvise . . . In teaching, I must account for every line, shape and color . . ."

ABOVE: This photograph of Hans Hofmann painting in his studio was taken in 1952.

FERNAND LÉGER

Born: Joseph Fernand Henri Léger, February 4, 1881 (Argentan, France); died August 17, 1955 (Gif-sur-Yvette, France).

Artistic style: Cubist painter, sculptor, and filmmaker; cylindrical forms in primary colors and in black and white; figurative paintings; large areas of uniform color.

Masterworks

Nude Model in the Studio 1912–1913 (Guggenheim Museum, New York, U.S.)

Contrast of Forms 1913 (Guggenheim Museum, New York, U.S.)

The Railway Crossing 1919 (Art Institute of Chicago, Chicago, Illinois, U.S.)

Mechanical Elements 1920 (Metropolitan Museum of Art, New York, U.S.)

The Mechanic 1920 (National Gallery of Canada, Ottawa, Ontario, Canada)

Three Women 1921 (Museum of Modern Art, New York, U.S.)

Still Life with a Beer Mug 1921–1922 (Tate Collection, London, England)

Mechanical Elements 1926 (Tate Collection, London, England)

The Acrobat and his Partner 1948 (Tate Collection, London, England)

The Great Parade 1954 (Guggenheim Museum, New York, U.S.)

After being apprenticed to an architect in Caen from 1897 to 1899, Fernand Léger began his career as an architectural draftsman in Paris. His first paintings were impressionist in style. However, in 1907, the young artist was highly impressed by a retrospective of Paul Cézanne's work. After befriending avant-garde artists such as Robert Delaunay and Marc Chagall and coming into contact with the cubist pictures of Pablo Picasso and George Braque, Léger developed an individual approach to cubism. Dubbed "tubism," Léger's style focused on colorful, cylindrical, and abstract forms. He was given his first solo exhibition at the Galerie Kahnweiler in 1912.

World War I interrupted Léger's burgeoning success. He spent two years in the French army, and during this period developed a fascination with the beauty of machinery, producing sketches of cannons, guns, and airplanes. He then returned to painting and embarked on his postwar "mechanical"

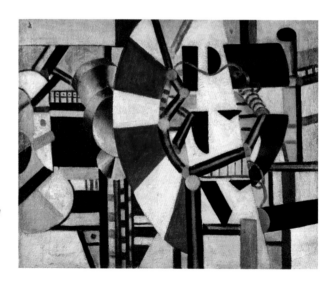

ABOVE: Detail from the photograph *Fernand Leger with One of his Paintings* (1948).

RIGHT: One of his series of paintings *Mechanical Elements* (c.1918).

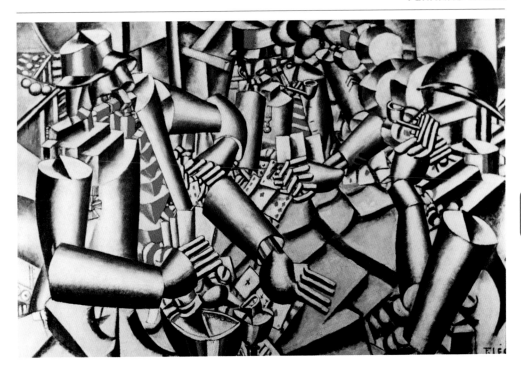

period. His tubular forms became streamlined, and references to enigmatic, elaborate machines occupied his canvases; even his figures adopted a robotic quality.

In the 1920s, Léger became close friends with Le Corbusier and Amédée Ozenfant. He aligned his work with their purist styles, painting large areas of flat, uniform color with bold, black outlines. Léger took refuge in the United States during World War II, teaching at Yale University and working on paintings of acrobats, cyclists, musicians, divers, and builders. He also worked on a series of pictures inspired by agrarian machinery abandoned in fields, the juxtaposition of mechanical elements with organic, natural forms. After returning to France in 1945, Léger continued his studies of the human figure. In the decade before his death, his prolific output included book illustrations, murals, stained glass windows, tapestry, mosaics, sculpture, and set and costume design. **NSF**

ABOVE: *Soldiers Playing at Cards* (1917) is a fine example of Léger's tubular forms.

For the Love of Man

During his service in the French army, Léger both "discovered the French people" and was dazzled by the potential of a new machine aesthetic. He considered his painting *Soldiers Playing at Cards* (1917) "the first picture in which I deliberately took my subject from our own epoch." Tubular human forms in the painting mark the beginning of Léger's mechanical period, whereas the subject matter reflects a newfound interest in figurative painting and the human spirit. In later years, Léger would focus primarily on seeking to depict the beauty of the common man.

PABLO PICASSO

Born: Pablo Picasso, October 25, 1881 (Málaga, Spain); died April 8, 1973 (Mougins, France).

Artistic style: Sculptor, printmaker, ceramist, collagist; inventor of cubism; recurring motifs; still lifes, portraits, genre scenes, landscapes, and homages.

The genius of Pablo Picasso dominated twentieth-century art, and all other artists of the century appear obscured by his shadow in comparison. Talented in the way of predecessors such as Leonardo da Vinci and Michelangelo Buonarotti, his creativity knew no bounds in terms of skill, inventiveness, and playfulness. Shifting like a chameleon from one style to the next and between media, his output was prolific but always original, and often provocative. His influence on contemporaries such as Georges Braque, Henri Matisse, and Fernand Léger was significant. He also influenced successive generations of artists, including Arshile Gorky, Willem de Kooning, and David Hockney, for example.

1800-99

Masterworks

First Communion 1896 (Museu Picasso, Barcelona, Spain)

Woman In Blue 1901 (Museo Nacional Centro de Arte Reina Sofía, Madrid, Spain)

The Tragedy 1903 (National Gallery of Art, Washington, D.C., U.S.)

Family of Saltimbanques 1905 (National Gallery of Art, Washington, D.C., U.S.)

Les Demoiselles d'Avignon 1907 (Museum of Modern Art, New York, U.S.)

Woman with a Guitar 1911 (Museum of Modern Art, New York, U.S.)

Dead Birds 1912 (Museo Nacional Centro de Arte Reina Sofía, Madrid, Spain)

Bottle and Wine Glass on a Table 1912 (Metropolitan Museum, New York, U.S.)

Guitar 1912–1913 (Museum of Modern Art, New York, U.S.)

Minotauromachy 1935 (Museum of Modern Art, New York, U.S.)

Guernica 1937 (Museo Nacional Centro de Arte Reina Sofía, Madrid, Spain)

Weeping Woman 1937 (Tate Collection, London, England)

The Maids of Honor 1957 (Museu Picasso, Barcelona, Spain)

ABOVE: This portrait was taken in Picasso's studio at the turn of the century.

RIGHT: *Les Demoiselles d'Avignon* was a turning point in the history of art.

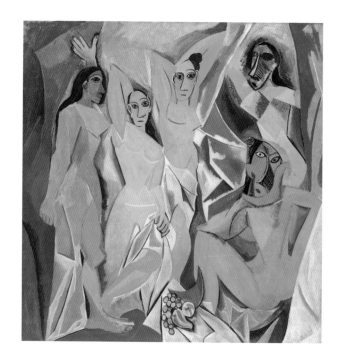

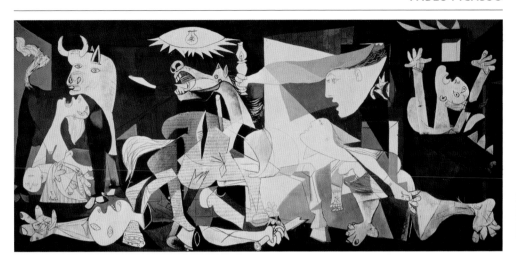

Picasso received his early training from his artist father and studied painting from when he was eleven years old at La Coruña Arts School. By the age of fourteen, Picasso had produced the staggering realist work *First Communion* (1896), which reveals he had the mastery of composition, color, and technique of an Old Master. His work adopted a melee of styles from other artists, resulting in paintings that look like they are by Sir Peter Paul Rubens, such as *Portrait of Aunt Pepa* (1896), or Henri de Toulouse-Lautrec, such as *Woman in Blue* (1901).

In 1904, Picasso settled in Paris, where he became the heart of the city's avant-garde artists and writers circle, and he lived in France for the rest of his life. The artist's early work in painting, printmaking, and sculpture is divided into his Blue Period (1901–1904), his Rose Period (1905–1907), his Primitive Period (1908–1909), analytic cubism (1908–1912), and synthetic cubism (1912–1913).

ABOVE: *Guernica* has become a universal symbol of the pain and anguish of wars.

". . . at fifteen I painted like Velázquez, and it took me eighty years to paint like a child . . ."

The Blue Period consists of melancholy works. Often in tones of blue, they feature El Greco-like elongated, emaciated figures, alcoholics, beggars, whores, tramps, and the poor, such as in *The Tragedy* (1903). His Rose Period is notable for its pink and orange

Guernica (1937)

Hanging behind bulletproof glass at Madrid's Museo Nacional Centro de Arte Reina Sofía lies Picasso's *Guernica*, the painting that is perhaps the best summation of the horror and brutality of war since Francisco Goya's series of etchings *Disasters of War* (c.1810–1820).

Picasso was living in France when the Spanish Civil War broke out in 1936. Loyal to the republic, he was commissioned by the Spanish government to paint the canvas for the 1937 Exposition Universelle in Paris. In April, the Basque town of Guernica was bombed during a Nazi raid, killing up to 1,600 people. Picasso thus had the subject matter that would form his powerful protest against the fascists led by Generalissimo Francisco Franco.

The vast 11-foot (3.5 m) by 23-foot (7.8 m) canvas is painted in gray and white. Its monochromatic tones reflect the sadness of the event and give the painting a reportage feel. It is rich with imagery that has been widely interpreted—a bull, a horse, a lightbulb; individuals running pell-mell with agonized faces of incredulous horror, an arm holding a flower, and a broken sword—yet Picasso refused to be drawn on their possible meaning. However, the significance of the famous image of a weeping woman clutching the body of her dead child is obvious.

After being shown in Paris, the painting went on tour in Europe before it was hung in New York's Museum of Modern Art. It was returned to Spain in 1981, after Franco's death, because Picasso had stipulated that the mural be returned only when Spain was a democracy.

RIGHT: Painted after *Guernica*, *Weeping Woman* is part of a series of mourning.

palette and features harlequins, acrobats, and circus performers, as in *Family of Saltimbanques* (1905). His Primitive Period shows the artist inspired by pre-Roman Iberian sculpture and by African and Oceanic art that led to the groundbreaking *Les Demoiselles d'Avignon* (1907), with angular figures and a shift toward cubism.

With his friend Braque, Picasso formed the techniques and theories of the audacious cubist style, which portrays three-dimensional forms on a two-dimensional plane, producing the figurative work *Woman with a Guitar* (1911) and the still life *Dead Birds* (1912). He also reversed the spatial process to make three-dimensional objects appear almost pictorial with cubist sculptures such as *Guitar* (1912–1913). The two men developed synthetic cubism in tandem, which saw paintings incorporating collages of newspaper, cut paper, and cloth, such as *Bottle and Wine Glass on a Table* (1912).

The master works on

Picasso's later work is less easily categorized, shifting from solid, statuesque neo-classical figurative works during World War I to surrealism in the 1920s, and exploring mythological themes in the 1930s, as in his etching *Minotauromachy* (1935), which shows his excellent draftsmanship. Yet throughout his career he played with composition, space, technique, and color, and adopted recurring motifs, such as the bullfight, guitar, and harlequin. During the Spanish Civil War, his work became antifascist, with the mural *Guernica* (1937). The ensuing series of jagged drawings, etchings, and paintings, such as *Weeping Woman* (1937), typify the pain of the war. He also paid homage to early artists with works such as *The Maids of Honor* (1957), an interpretation of Diego Velázquez's original, whereas the 1960s saw him produce colorist works that some see as a first move toward neo-expressionism.

Picasso's personal life was as fluid as his artistic one: married twice, he had four children by three different women. Ever changing, ever inventive, one can only wonder what works the master would create were he alive today. **CK**

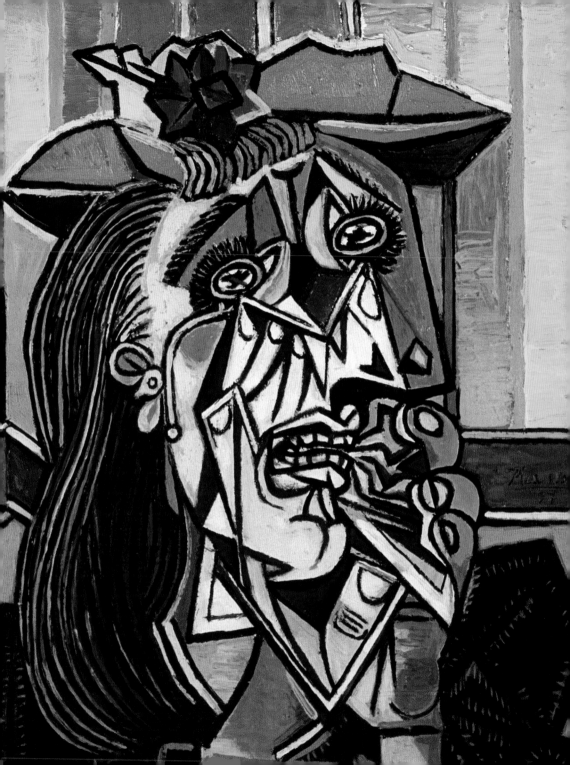

UMBERTO BOCCIONI

Born: Umberto Boccioni, October 19, 1882 (Reggio di Calabria, Italy); died August 17, 1916 (Sorte, Italy).

Artistic style: Futurist theorist, painter, and sculptor; splintered images suggestive of dynamism, technology, and speed; prismatic colors; contemporary subjects.

Umberto Boccioni was the leading theorist of the Italian futurist movement. He studied design in Rome, and in 1901 became a pupil of painter Giacomo Balla, who introduced him to the post-impressionist techniques that inspired him to make a trip to Paris the following year. Other travels followed; then, after the publication of Filippo Marinetti's first futurist manifesto in 1909, he cowrote *The Manifesto of the Futurist Painters* (1910) and *The Technical Manifesto of Futurist Painting* (1910) with other futurists Gino Severini, Carlo Carrà, and Balla. That same year, Boccioni held his first solo show in Venice, and in 1912 he participated in the first futurist exhibition that traveled from Paris to other European cities.

His painting exemplifies futurist beliefs in dynamism, speed, violence, technology, and modern life. In *The Forces Enter the Street* (1911), people, buildings, traffic, and sounds coexist and are experienced in a single moment in time. This is achieved through an interplay of forms derived from cubism but fractured with prismatic light to imply movement.

Boccioni attacked the subjects and materials of traditional sculpture in his *The Technical Manifesto of Futurist Sculpture* (1912), and his sculpture *Unique Forms of Continuity in Space* (1913) represents the ideals of the futurist movement in its attempts to render space, movement and time in a single figure. From 1912 to 1914 he traveled and exhibited widely, also contributing to journals. He wrote *Futurist Painting and Sculpture (Plastic Dynamism)* (1914), which expounds his theory that matter must be activated. He argued that the difference between cubism and futurism is in the use of the fourth dimension to activate matter. In 1915, he enlisted in the army and died after a fall from his horse. **WO**

> "A portrait, to be a work of art, neither must nor may resemble the sitter . . ."

ABOVE: Boccioni's *Self-Portrait* (1908) can be seen in Pinacoteca di Brera, Milan, Italy.

GEORGE WESLEY BELLOWS

Born: George Wesley Bellows, August 12, 1882 (Columbus, Ohio, U.S.); died January 8, 1925 (New York, U.S.).

Artistic style: Painter and lithographer; working-class and sporting subjects; somber palette; strong light; social and political views often conveyed in his work.

George Wesley Bellows is one of the most important U.S. artists of the twentieth century, renowned not only for his paintings of gritty urban reality, but also for his printmaking.

He attended Ohio State University from 1901 to 1904 and was heavily involved in sporting activities. Later he would frequently paint sporting events, especially prizefighting and boxing, creating images of immense power and tangible physical presence. While in college, Bellows worked as an illustrator, and he left before graduating to pursue a career as an artist. He moved to New York and trained under Robert Henri at the New York School of Art. Bellows became associated with the New York Ashcan school, a group of artists who depicted scenes of urban reality and the struggles of the working classes against poverty. His early style is defined by somber tones and white scumbling with broad, textured brushstrokes. There is a sense of profound physicality in Bellows's paintings that lends them an immediacy of the event, bringing his dark, violent scenes of illicit prizefighting to life.

In 1923, fighting was made legal in New York. It was named boxing and fast became fashionable. Bellows's style similarly had evolved away from the freedom and tangibility of his earlier brushstrokes and into a more controlled and linear form. His figures took on a monumental feel with smoother, idealized outlines and much greater concentration on compositional pattern and structure. Toward the end of his career, he moved away from subjects of masculine vitality and social commentary, instead focusing on domestic scenes, often including his wife and children. Bellows's work as a lithographer was also of importance and contributed toward the development of printmaking in the United States. **TP**

Masterworks

Stag at Sharkey's 1909 (Cleveland Museum of Art, Cleveland, Ohio, U.S.)

Both Members of this Club 1909 (National Gallery of Art, Washington, D.C., U.S.)

Anne in Black Velvet 1917 (Amherst College, Mead Art Museum, Massachusetts, U.S.)

Dempsey and Firpo 1924 (Whitney Museum of American Art, New York, U.S.)

"The ideal artist . . . retains his experience in a spirit of wonder and feeds it with creative lust."

ABOVE: Bellows was photographed in casual mode *circa* 1924.

1800-99

GEORGES BRAQUE

Born: Georges Braque, May 13, 1882 (Argenteuil, France); died August 31, 1963 (Paris, France).

Artistic style: Painter and printmaker; coinventor of cubism; originator of *papier collé*; main subject matter of still lifes, interiors, the studio, billiard tables, and birds.

Masterworks

The Viaduct at l'Estaque 1908 (Musée National d'Art Moderne, Paris, France)

Violin and Pitcher 1910 (Kunstmuseum, Basel, Switzerland)

Still Life with Tenora 1913 (Museum of Modern Art, New York, U.S.)

The Billiard Table 1945 (Tate Collection, London, England)

Lauded as the father of modern French painting, Georges Braque is perhaps best known for his role in the revolutionary adventure that produced cubism. He trained as a painter-decorator, learning sign painting and the simulation of wood and marble surfaces. This grounding instilled in Braque a lasting sense of discipline, and he used the practical techniques to exciting effect in the development of the cubist language.

He entered the Parisian avant-garde in 1906 with fauvist landscapes, in which he employed energetic brushwork and unnatural colors. In 1907, Braque left a calling card at Pablo Picasso's Montmartre studio on which he wrote the words "anticipated memories" and thus began one of the most exhilarating collaborations of the century. For six years or so, the two artists lived and worked in close proximity, breaking down compositional conventions to examine three-dimensional objects on the two-dimensional surface.

ABOVE: Braque won first prize for painting at the 34th Venice Festival.

RIGHT: In *Estaque* (1906), Braque uses colors typical of his early fauvist landscapes.

Although Braque was not an adept draftsman, his dexterity with paint was intuitive. Using a monochromatic palette, he deconstructed still lifes into a series of planes and motifs that became increasingly complex and abstract. Using his artisan skills to imitate wood paneling, he reiterated the illusionistic nature of painting. His innovation of *papier collé* (pasted paper) in 1912, in which he introduced cut pieces of paper into the frame, drew attention to the flatness of the picture plane.

From its inception, cubism remained vital to Braque. He was fascinated with the depiction of simple, everyday things in space. His still lifes and interiors of the 1930s and 1940s are animated by a subtle yet highly assured use of color, decoration, and texture. Often working in series, such as the monumental sequence of billiard tables he painted between 1944 and 1952, Braque's focus continued on the material process of painting. **LA**

ABOVE: *Still Life with Tenora* is a fine example of Braque's *papier collé* technique.

A Flair for Music

Braque was, by all accounts, an accomplished singer and is said to have been able to play Beethoven symphonies on the accordion. In a photograph taken *c.*1911, the artist is shown seated playing such an instrument. On the wall behind him, among the accoutrements of his studio, hang a violin and a lute. Musical motifs are often used as prominent subject matter in Braque's pictures, particularly in his cubist works. He later commented that "a musical instrument as an object had the peculiarity that one could animate it by touching it."

EDWARD HOPPER

Born: Edward Hopper, July 22, 1882 (Nyack, New York, U.S.); died May 15, 1967 (New York, U.S.).

Artistic style: Painter and printmaker; images of solitude in urban United States; unusual light and atmosphere; gas stations, motels, offices, and empty streets.

Edward Hopper's paintings evoke the loneliness and sense of hopelessness that characterized U.S. city life between the world wars. His locations appear bleak, with vast empty spaces and contrasts of natural and artificial light. His popularity stems from his ability to create scenes from everyday life that have a timeless quality, becoming profound statements about the human condition. Although best known for his oil paintings, he was equally proficient in watercolor and etching.

While studying commercial art and painting in New York, Hopper was taught by William Merritt Chase, an elegant imitator of John Singer Sargent, and Robert Henri, who encouraged his students to create realistic paintings of urban life. Between 1906 and 1910, Hopper made three trips to Paris, but he was indifferent to the avant-garde movements he saw, such as cubism. He earned his living as a commercial artist but continued painting in his spare time, and sold his first painting at the Armory Show in New York in 1913. He remained unrecognized and did not sell any more work until 1923.

Hopper married Josephine Verstille Nivison, whom he had known when they were fellow art students. Their long and

Masterworks

Apartment Houses 1923 (Pennsylvania Academy of Fine Arts, Philadelphia, U.S.)

The House by the Railroad 1925 (Museum of Modern Art, New York, U.S.)

Lighthouse Hill 1927 (Dallas Museum of Art, Dallas, U.S.)

Automat 1927 (Des Moines Art Centre, Des Moines, Illinois, U.S.)

Chop Suey 1929 (Private collection)

Tables for Ladies 1930 (Metropolitan Museum of Art, New York, U.S.)

Hotel Room 1931 (Fondation Thyssen-Bornemisza, Madrid, Spain)

New York Movie 1939 (Museum of Modern Art, New York, U.S.)

Gas 1940 (Museum of Modern Art, New York, U.S.)

Nighthawks 1942 (Art Institute of Chicago, Chicago, Illinois, U.S.)

Morning in a City 1944 (Williams College Museum of Art, Massachusetts, U.S.)

Rooms for Tourists 1945 (Yale University Art Gallery, Connecticut, U.S.)

ABOVE: This photograph was taken at the artist's studio in New York in February 1950.

RIGHT: *Gas* (1940) reveals the eloquent beauty of the mundane.

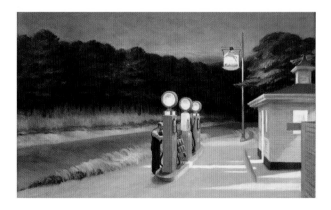

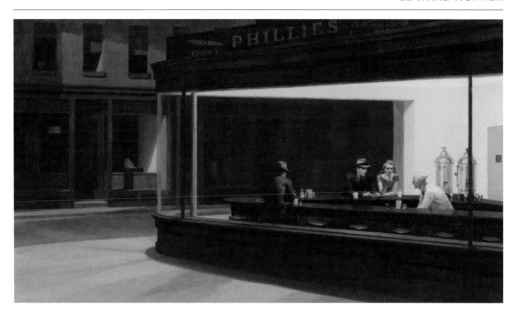

1800-99

complex relationship was the most important of Hopper's life, although the couple often quarreled violently. Conversely, her presence was essential to his work because she modeled for all the female figures in his paintings and was adept at enacting the various roles he required.

From the time of his marriage, Hopper's professional fortunes changed. His second solo show in New York in 1924 was a sellout and he decided to turn to painting full time, rapidly gaining recognition as the main advocate of the new realism: American scene painting. He was the first artist to make U.S. urban and rural scenes the main theme of his work, and by 1933 the Museum of Modern Art in New York had given him a retrospective exhibition that sealed his reputation.

As the years passed, he found suitable subjects increasingly difficult to unearth and the rise of abstract expressionism left him at variance with the world. He died in 1967, remote if not forgotten, but his work has inspired generations of artists, writers, and filmmakers, including Mark Rothko, Norman Mailer, and Sir Alfred Hitchcock. **SH**

ABOVE: *Nighthawks* (1924) became an iconic vision of urban loneliness.

Hopper's Sketchbooks

Hopper kept numerous sketchbooks, showing that he planned and considered various compositions before starting a painting and selected only essential details that would evoke the mood he was aiming for. He also made careful drawings of his finished paintings before each left the studio. His wife then annotated the drawings in the sketchbooks, making note of the title, date of completion, description, sale price, and buyer. She often added her own notes, such as how Hopper had been feeling when he painted a picture or why a painting was not given a title she liked.

WYNDHAM LEWIS

Masterworks

Workshop 1914–1915 (Tate Collection, London, England)

The Crowd c.1915 (Tate Collection, London, England)

A Battery Shelled 1918 (Imperial War Museum, London, England)

A Canadian Gun Pit 1918 (National Gallery of Canada, Ottawa, Canada)

A Reading of Ovid (Tyros) c.1920 (Scottish National Gallery of Modern Art, Edinburgh, Scotland)

Edith Sitwell 1923–1935 (Tate Collection, London, England)

Born: Percy Wyndham Lewis, November 18, 1882 (on his father's yacht off Amherst, Canada); died March 7, 1957 (London, England).

Artistic style: War paintings with dehumanized, stylized figures; semiabstract art; angular, geometric forms; grotesquely grinning satirical characters known as "tyros."

Throughout his life, Wyndham Lewis fulfilled the role of the avant-garde rebel. He was one of the first British artists to develop a personal style based on the lessons of European modernism. In the years before World War I, his ideas led to the creation of vorticism, a movement of writers and artists who celebrated the experience of modernity and published their work in a radical journal called *Blast* (1914–1915). Lewis's use of fractured planes and mechanized forms seemed to encapsulate the spirit of machine-age aggression, and during the war he was employed as an official artist by the British and Canadian governments. His art was later eclipsed by the time he devoted to writing and by his authoritarian political views. **NM**

ELIE NADELMAN

Masterworks

Man in the Open Air 1915 (Museum of Modern Art, New York, U.S.)

Woman's Head (Goddess) c.1916 (Whitney Museum of American Art, New York, U.S.)

Sur la Plage 1916 (Whitney Museum of American Art, New York, U.S.)

Dancing Figure (Artemis) c.1916–1918 (Smithsonian American Art Museum, Washington D.C., U.S.)

Orchestra Conductor 1918–1919 (Hirshhorn Museum and Sculpture Garden, Smithsonian Institution, Washington D.C., U.S.)

Dancer (High Kicker) c.1918–1919 (The Jewish Museum, New York, U.S.)

Born: Elie Nadelman, February 20, 1882 (Warsaw, Poland); died December 28, 1946 (Bronx, New York, U.S.).

Artistic style: Modernist sculptor; references to classical sculpture, folk art, and vaudeville; lean, simple shapes; sense of graceful line; sculptures of performers.

Elie Nadelman, a middle-class Jewish boy, left Poland for Munich and then Paris. At a time when classical art was passé, Nedelman was still drawn to it emulating its aesthetic beauty. When World War I broke out, he immigrated to New York, where he was drawn to the world of vaudeville. A fan of folk art, he amassed a significant collection after he married a wealthy widow in 1919. His oeuvre is an eclectic synthesis that reflects both his high- and low-brow influences. Although distinctly lean and modernist, his playful subjects often depict performers, with references to both folk art and the classical. His ability to draw on both the everyday and academic was innovative and inspirational for successive U.S. artists. **CK**

JOSÉ CLEMENTE OROZCO

Born: José Clemente Orozco, November 23, 1883 (Ciudad Guzmán, Mexico); died September 7, 1949 (Mexico City, Mexico).

Artistic style: Painter and lithographer; murals; themes of suffering of Mexico's Indian population, and life in the metropolis and its dehumanizing effect.

Along with Diego Rivera and David Alfaro Siqueiros, painter and lithographer José Clemente Orozco was one of the trio of men at the vanguard of the Mexican muralist movement. His vast murals, with their dramatic use of perspective and vivid color palette of blood reds, bitter ochers, sky blues, and acid yellows, depict the suffering of Mexico's Indian population through their country's troubled history. Despite Orozco's sometimes quixotic views on politics in later life, which saw him declaring support for Adolf Hitler, his contrariness never extended to his work, in which his capacity to sympathize with the underdog and issues of social justice was unabated.

Like his fellow muralists, Orozco espoused left-wing political views, and his first foray as an artist was as a political cartoonist, where his disdain for the power hungry was evident in his work's biting satire. By 1922, he had moved from painting oils and watercolors to painting frescoes. Unlike Rivera and Siqueiros, he became disillusioned with socialism because of the bloody toll taken by the Mexican Revolution (1910–1921). In 1927, he moved to the United States, where he lived until 1934. Already successful during this period, he was commissioned to do several murals, including *The Epic of American Civilization* (1932–1934), which depicts the history of the Americas from the migration of the Aztecs to Mexico, to contemporary industrialized society. The mural's twenty-four panels cover some 3,200 square feet (297 sq m). They see Orozco once more involve himself in the plight of the man on the street, this time by highlighting the dehumanizing effect of mechanization in urban society. Yet it was after he returned to his homeland that he produced his best works, including what is arguably his masterpiece, *The Man of Fire* (1936–1939). **CK**

Masterworks

Prometheus 1930 (Pomona College, Claremont, California, U.S.)

The Epic of American Civilization 1932–1934, (Baker Library, Dartmouth College, Hanover, New Hampshire, U.S.)

The Man of Fire 1936–1939 (Hospicio Cabañas, Guadalajara, Jalisco, Mexico)

Christ Destroying his Cross 1943 (Museo de Arte Alvar y Carmen T. de Carrillo Gil, Mexico City, Mexico)

"Orozco was the only great artist of the counterrevolution."
—Diego Rivera

ABOVE: This portrait was taken when the artist was in his sixties.

ERICH HECKEL

Born: Erich Heckel, July 31, 1883 (Döbeln, Germany); died January 27, 1970 (Radolfzell, Germany).

Artistic style: Painter and printmaker; founder member of *Die Brücke* group; figures in interiors and landscapes; use of heightened color; thickly smeared paint.

Masterworks

Fränzi Reclining 1910 (Museum of Modern Art, New York, U.S.)

Dancers 1911(Museum of Modern Art, New York, U.S.)

Sitting in Water 1913 (Museumsberg Flensburg, Schleswig Holstein, Germany)

Portrait of a Man 1919 (Museum of Modern Art, New York, U.S.)

Autumn Landscape 1924 (Museumsberg Flensburg, Schleswig Holstein, Germany)

After studying architecture, Erich Heckel switched direction to become a painter and printmaker. He cofounded the influential German expressionist group *Die Brücke* in Dresden in 1905 with three other architecture students: Fritz Bleyl, Karl Schmidt-Rottluff, and Ernst Ludwig Kirchner. The group espoused its members' radical political views and their desire to leap forward from tradition and forge a new style of painting to reflect contemporary modern life in its fast pace, continuing upheaval, and liberal sexuality. The artists were noted for their landscapes; nudes; rapid, gestural brushwork; use of vivid color; and simple forms. In 1911, Heckel moved to Berlin with the rest of *Die Brücke*, but the group was disbanded by 1913.

Heckel's personal style was influenced by Paul Gauguin, Henri Matisse, and Vincent van Gogh. He often painted figures in interiors and landscapes in heightened colors, using thickly smeared paint to create richly textured surfaces. He was also a prolific printmaker, making more than one thousand prints, most of them between 1905 and 1923. Although known for his etchings and lithographs, he is most acclaimed for his woodcuts with their simplified forms and innovative flat style. Following active service in World War I, Heckel's work became increasingly melancholy. His angular self-portrait *Portrait of a Man* (1919) resonates with the sadness of both himself and his country, enhanced by a departure from his normal technique to create a painterly surface using a brush rather than the conventional ink roller. In 1937, Heckel's work was condemned as "degenerate" by the Nazi Party, and many of his works were destroyed and removed from national museums. After World War II, he worked as teacher and continued to paint until his death. **CK**

> "What intrigues me is the secret of color relations. This excitement has never ceased."

ABOVE: Detail from one of several melancholy self-portraits, painted in 1915.

AMEDEO MODIGLIANI

Born: Amedeo Clemente Modigliani, July 12, 1884 (Livorno, Italy); died January 24, 1920 (Paris, France).

Artistic style: Painter; sculptor; primitive-style figures characterized by elongated necks, oval heads, and graceful lines; sparse settings; simplified, broad brushstrokes.

Amedeo Modigliani developed a unique style influenced by his artist friends and associates, by studying in both Italy and Paris, by a range of art movements, and by primitive art. Passionate about painting from a young age, he attended the best art school in Livorno from 1898 to 1900. In 1901, he went to Rome and in 1902 he enrolled in the Accademia di Belle Arti in Florence. He then moved to Venice to study at the Istituto di Belle Arti, but he also began frequenting disreputable parts of the city. At the same time, he developed an interest in radical philosophy, such as that of Friedrich Nietzsche.

He moved to Paris in 1906, where he encountered the works of Henri de Toulouse-Lautrec, Georges Rouault, and Pablo Picasso in his Blue Period, and assimilated their ideas. The strong influence of Paul Cézanne's paintings is also evident, both in Modigliani's deliberate distortion of the figure and free use of large, flat areas of uniform color. A friendship with Constantin Brancusi stimulated his interest in sculpture, in which he continued to create strong, linear rhythms and simple, stretched forms.

After 1915, he devoted himself entirely to painting. His interest in African masks and sculpture is evident, especially in the treatment of the sitters' faces: flat and masklike, with almond-shaped eyes, twisted noses, pursed mouths, and extended necks. Despite their economy of composition and neutral backgrounds, the portraits convey a clear sense of the sitters' personalities. Many of them are elegant, arresting arrangements of curved lines and planes as well as striking idealizations of feminine sexuality. Modigliani died in Paris of tubercular meningitis, his health having suffered because of his excessive use of alcohol and narcotics. **SH**

Masterworks

Head of a Woman 1912 (Philadelphia Museum of Art, Philadelphia, Pennsylvania, U.S.)

Female Nude c.1916 (Courtauld Institute Galleries, London, England)

Woman with Red Hair 1917 (National Gallery of Art, Washington, D.C., U.S.)

Reclining Nude 1917 (Metropolitan Museum, New York, U.S.)

Portrait of the Artist's Wife, Jeanne Hébuterne 1918 (Norton Simon Art Foundation, Pasadena, California, U.S.)

Gypsy Woman with Baby 1919 (National Gallery of Art, Washington, D.C., U.S.)

"What I am seeking is not the real and not the unreal but rather the unconscious . . ."

ABOVE: The artist's self-portrait of 1919 has a characteristic, masklike expression.

MAX BECKMANN

Born: Max Beckmann, February 12, 1884 (Leipzig, Germany); died December 27, 1950 (New York, U.S.).

Artistic style: Self-portraits; large-scale triptychs; intense colors with bold outlines; complex allegorical compositions; mythology, landscapes, and masked figures.

One of Germany's leading artists of the twentieth century, Max Beckmann defied categorization because he flirted with varying styles. After a brief spell in Paris, he moved to Berlin in 1904, and in 1910 he was elected to the board of the prestigious Berlin Secession. The influence of impressionism is prevalent throughout Beckmann's early work, but his style radically changed after serving as a medical volunteer in World War I. Traumatized by the horrors he saw, Beckmann suffered a breakdown and was discharged in 1915.

When he finally took to the brush again, his work held a mirror up to the agonies and traumas of his own personal anxieties. His paintings depicted social, religious, and mythical themes and adopted a distinctly cubist character, with a greater intensity of color and contortions of space and form as well as an increase in the allegorical use of costumed figures.

During the Weimar Republic of the 1920s, Beckmann enjoyed success. He taught at the Städel School in Frankfurt, received the Honorary Empire Prize for German Art, and was

ABOVE: Detail from Beckmann's *Self-Portrait in Florence*, painted in 1907.

RIGHT: With equally compelling imagery, *Death* (1938) is a partner work of *Birth* (1937).

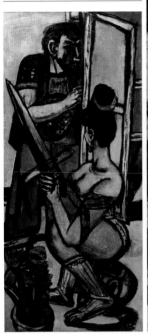
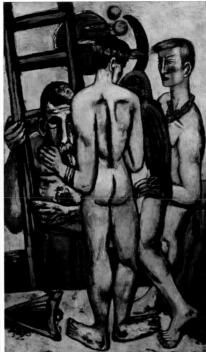
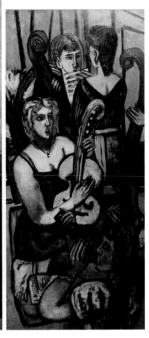

1800-99

hailed as the leader of *Neue Sachlichkeit* (New Objectivity), a movement that rejected expressionism in favor of realism. His fortunes were to alter drastically, however, with the rise to power of Adolf Hitler in 1933. The Nazis viewed modern art as socially and morally corrupt, and confiscated more than 500 of Beckmann's works. The day after the opening of the notorious *Entartete Kunst* (Degenerate Art) (1937) exhibition mounted by the Nazis to denigrate modern art, and containing ten Beckmann paintings, the artist left for Amsterdam.

Through hardship and poverty, Beckmann continued his painting unabated. Remarkably, his powerful series of triptychs, conveying epic and violent images, stand as his most important works. After the war, he moved to the United States, spending the last three years of his life teaching art. He completed further triptychs mirroring the landscapes, skyscrapers, and people of the United States. The last, *The Argonauts* (1949-1950), he finished the day before his death. **SG**

ABOVE: *The Argonauts* is significantly less brutal than Beckmann's earlier works.

Cryptic Triptych

Beckmann was a keen student of German medieval art and the triptych. The ability to represent past, present, and future in one piece held huge appeal for an artist eager to document the changing times. *Departure* (1933) contains dark, oppressive panels symbolizing the cruelty of the Nazi party and a bright, open, central panel offering relief from the torment. The mythological symbolism of the figures was a recurring theme of the subsequent triptychs that Beckmann produced. Fearful of offending the Nazis, he hid the picture in an attic, attaching the cryptic label "Scenes from Shakespeare's Tempest."

WALTER JOSEPH PHILLIPS

Born: Walter Joseph Phillips, October 25, 1884 (Barton-on-Humber, England); died July 5, 1963 (Victoria, Canada)

Artistic style: Painter, printmaker, and draftsman; watercolor; color woodcut prints; still lifes; portraiture; landscapes of the Prairies and Rocky Mountains.

Masterworks

Winter 1917 (National Gallery of Canada, Ottawa, Ontario, Canada)

Water-Baby 1920 (National Gallery of Canada, Ottawa, Ontario, Canada)

Evening 1921 (National Gallery of Canada, Ottawa, Ontario, Canada)

Summer Idyll 1926 (The Winnipeg Art Gallery, Winnipeg, Manitoba, Canada)

Karlukwees, B.C. 1929 (Glenbow Museum, Calgary, Alberta, Canada)

York Boat on Lake Winnipeg 1930 (Glenbow Museum, Calgary, Alberta, Canada)

Johnson's Creek near Banff 1947 (National Gallery of Canada, Ottawa, Ontario, Canada)

British-Canadian artist Walter Joseph Phillips's affinity with nature brought Canada's Prairies and Rocky Mountains to life on paper. His watercolor paintings and highly popular, color woodcuts capture the feel of the outdoors in all its seasons. His portrayals of Canada's snowy mantles changing from blue to green and pink according to the light, tranquil lakes reflecting the moods of the weather, vast open skies, bare rock, grassy hillocks, and luxuriant woods of pine, birch, and poplar have yet to be equaled.

He was also a prolific and influential writer on nature, art, and the woodcut, authoring *The Technique of the Color Wood-Cut* (1926) and *Wet Paint*, a manuscript on watercolor sketching that never found a publisher, although he used parts for his column in *The Winnipeg Tribune* newspaper.

English-born Phillips trained at the Birmingham Municipal School of Art. There he visited the Birmingham Art Gallery and was influenced by its collections of early English watercolors and works by the Pre-Raphaelites and William Morris. In 1901, he went to South Africa, but returned to England in 1907 and worked as a commercial artist, eventually finding success as a watercolorist before he and his wife, Gladys Pitcher, emigrated to Winnipeg, Canada, in 1913, where he made a living teaching and painting. Although watercolor remained his primary medium, Phillips is also widely lauded for his color woodblock prints that were strongly influenced by the simple, graphic lines of Japanese woodcuts and which gave his work a wider audience. In 1940, Phillips was asked to be artist in residence at the Banff School of Fine Arts and in 1941 he moved to Calgary, where he taught at the provincial Institute of Technology and Art. **CK**

"The sketcher is necessarily a lone hunter . . . looking inward as well as out upon nature."

ABOVE: Phillips was well respected as an artist and teacher.

KARL SCHMIDT-ROTTLUFF

Born: Karl Schmidt-Rottluff, December 1, 1884 (Rottluff, Germany); died August 9, 1976 (Berlin, Germany).

Artistic style: Painter, sculptor, and printmaker; founder member of *Die Brücke*; figures, landscapes, and still lifes; distorted figures; exaggerated contrasting colors.

In 1905, the German expressionist group *Die Brücke* (the Bridge) was founded. Schmidt-Rottluff had been friends with one of the cofounders, Erich Heckel, since 1901 and through him met the other founders. Schmidt-Rottluff coined the group's name, a moniker that was symbolic of the young artists' desire to bridge the gap between the prevailing academic style of German neo-romanticism and that of the emerging modernism with a new style of art. The group moved to Berlin in 1911 and was disbanded by 1913, yet its reinvigoration of German painting was to prove highly influential for decades.

Schmidt-Rottluff's landscape paintings, such as *The Bursting Dam* (1910) and *Houses at Night* (1912), are typical of the group's work, featuring blocks of bright, contrasting, acid colors, rapid brushwork, and simplified forms. After the beginning of World War I, Schmidt-Rottluff entered military service and was sent to the Russian front in the fall of 1915. His work took on a darker palette, seen in his painting *Woman with a Bag* (1915), and he began a series of religious woodcuts at this time. The distorted, elongated faces of works including his sculpture *Male Head* (1917) also reflect his passion for untainted primitive art, an interest inspired by the West African masks he observed at Dresden's Ethnographic Museum. In the 1930s, with the rise of the Nazi Party in Germany, Schmidt-Rottluff became one of the artists who was severely persecuted under the new regime. His work was not just destroyed and labeled degenerate. In 1941, he was forbidden to paint and was placed under the supervision of the notorious SS. After the end of World War II, his career was revived and he was appointed professor at the School of Fine Arts in Berlin in 1947. **CK**

Masterworks

The Bursting Dam 1910 (Brücke Museum, Berlin, Germany)

Pharisees 1912 (Museum of Modern Art, New York, U.S.)

Houses at Night 1912 (Museum of Modern Art, New York, U.S.)

Melancholie 1914 (Museum of Fine Arts, Boston, Massachusetts, U.S.)

Woman with a Bag 1915 (Tate Collection, London, England)

Male Head 1917 (Tate Collection, London, England)

Portrait of Emy 1919 (North Carolina Museum of Art, Raleigh, U.S.)

"Art is forever manifesting itself in new forms, since there are forever new personalities."

ABOVE: Detail from *Self-Portrait with Monocle* painted in 1910.

ROBERT DELAUNAY

Born: Robert-Victor-Félix Delaunay, April 12, 1885 (Paris, France); died October 25, 1941 (Montpellier, France).

Artistic style: Painter; use of bold color and tonal contrasts; lively compositions; focus on portraying more than one viewpoint at a time.

Masterworks

Champs de Mars: la tour rouge 1911 (Art Institute of Chicago, Chicago, Illinois, U.S.)

Sun, Tower, Airplane 1913 (Albright-Knox Art Gallery, Buffalo, New York, U.S.)

Simultaneous Contrasts: Sun and Moon 1913 (Museum of Modern Art, New York, U.S.)

Homage to Blériot 1914 (Künstmuseum, Basle, Switzerland)

Robert Delaunay trained in fine arts in Paris. Initially, he worked in set design before beginning his painting career in 1905. His paintings use bold colors and play with depth, tone, and viewpoints. He drew his early influences from impressionism and post-impressionism. He was inspired by Paul Cézanne to examine volume and color through paint. As Delaunay grew older, his style changed and evolved and his later paintings are more reminiscent of the work of Paul Klee. From 1904 until World War I, Delaunay exhibited at the Salon des Indépendants and, in 1906, at the Salon d'Automne.

In 1909, Delaunay began his famous series of studies of Paris and the Eiffel Tower. Experimenting with the emotional effects of color contrasts, they depict the energy of city life and celebrate the modern world. The painter Sonia Terk, whom he married in 1910, collaborated with him on many projects. Having accepted Wassily Kandinsky's invitation to join *Der Blaue Reiter* (The Blue Rider), a Munich-based group of abstract artists, Delaunay became the first French artist to paint completely abstract works. Poet and art critic Guillaume Apollinaire christened Delaunay's style orphism, referring to the similarity of his abstract paintings to music. From 1914 to 1920, the Delaunays designed decor for the Ballets Russes. They returned to Paris, and Robert began his second Eiffel Tower series. In 1925 he created murals for the Exposition Internationale des Arts Décoratifs, and in 1937 he decorated the railway and air travel pavilions at the Paris Exposition Internationale des Arts et Techniques dans la Vie Moderne (International Exposition Dedicated to Art and Technology in Modern Life). His last works were decorations for the sculpture hall of the Salon des Tuileries. **SH**

"Direct observation of the luminous essence of nature is for me indispensable."

ABOVE: Delaunay's *Autoportrait* (1905) shows remnants of a fauvist influence.

RIGHT: The gray cityscape frames the Eiffel Tower in *Champs de Mars: la tour rouge*.

DIEGO RIVERA

Born: Diego Rivera, December 1886 (Guanajuato City, Mexico); died November 24, 1957 (Mexico City, Mexico).

Artistic style: Mexican imagery and symbolism; political and historical themes; bold, sun-filled colors; pre-Colombian rituals and beliefs; large murals and frescoes.

Masterworks

Classical Head 1898 (Museo Casa Diego Rivera, Guanajuato, Mexico)

The Threshing Floor 1904 (Museo Casa Diego Rivera, Guanajuato, Mexico)

Self Portrait 1907 (Museo Dolores Olmedo Patiño, Mexico City, Mexico)

Head of a Breton Woman 1910 (Museo Casa Diego Rivera, Guanajuato, Mexico)

The Mathematician 1918 (Museo Dolores Olmedo Patiño, Mexico City, Mexico)

The Embrace 1923 (Ministry of Education, Mexico City, Mexico)

The Tortilla Maker 1926 (University of California, San Francisco, U.S.)

The History of Mexico—The Ancient Indian World 1929–1935 (National Palace, Mexico City, Mexico)

Man, Controller of the Universe 1934 (Palacio de Bellas Artes, Mexico City, Mexico)

Day of the Dead 1944 (Museo de Arte Moderno, Mexico City, Mexico)

A politically aware, freethinking, and anti-religious man, Diego Rivera was physically enormous with an ebullient, sometimes bullish personality. He is considered one of Mexico's most important artists, together with his wife Frida Kahlo. Rivera famously linked pre-Colombian art with the most modern artistic movements: cubism and social realism.

As a young boy, Rivera went to Mexico City to study art, and early works survive as testament to his ability. His oil painting *Classical Head* (1898) is an accomplished still life of a marble bust that he painted when twelve years old. At twenty years old, he won a scholarship to travel to Europe and continue his studies. He remained in Europe for fifteen years, and it was while in Italy that he began to develop his great love of frescoes and murals. In France, he discovered cubism, seen to superb effect in *La Tour Eiffel* (1914) and *Portrait of Luis Guzmán* (1915).

In the early 1920s, Rivera returned to Mexico and began researching his country's heritage, becoming fascinated by

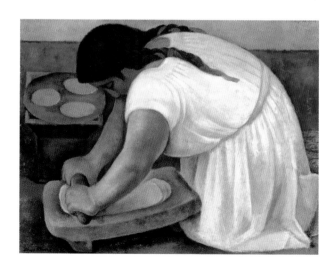

ABOVE: With a large physique and a big personality, Rivera made his presence felt.

RIGHT: *Woman Grinding Maize* (1924) is a documentary painting of life in Mexico.

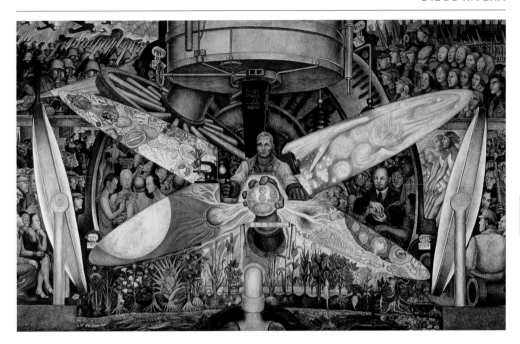

pre-Colombian art and culture. He traveled to the Yucatán Peninsula to visit the ruins at Chichén Iztá and Uxmal. There he was intrigued by the way the indigenous people lived and made a series of sketches. A committed Marxist and member of the Mexican Communist Party—although he often quarreled with them—Rivera painted several portraits of Vladimir Lenin.

From 1923 to 1928, Rivera was employed by Mexico's Ministry of Education. During this time, he painted an incredible number of frescoes, which are among his most impressive works. Together with artists such as José Clemente Orozco and David Alfaro Siqueiros, he was instrumental in forging the Mexican muralist movement. He was commissioned to do murals for several public buildings in the United States in the 1930s—a country where his art was much admired but his political allegiances were not. Rivera remains as feted in Mexico today as he was during his lifetime, both for his work and his desire to forge a new Mexican identity through it. **LH**

ABOVE: *Man, Controller of the Universe* is a painstaking work of social realism.

Forever a Ladies' Man

Rivera was as famous for his turbulent love life as for his art. He loved women, yet often treated them with disdain. In 1911, he claimed to have married a Russian artist, Angeline Beloff. Their relationship lasted for ten years, during which time he was constantly unfaithful. He then married Guadelupe Marín, but their marriage foundered after five years, a victim of his meeting Frida Kahlo. He married Kahlo in 1929, but his infidelities continued and they divorced in 1939. Only a year later, they remarried and they remained together for fourteen years, until her death in 1954.

AUGUST MACKE

Born: August Macke, January 3, 1887 (Meschede, Germany); died September 26, 1914 (Perthes-les-Hurlus, France).

Artistic style: Co-founder of *Der Blaue Reiter*; paved the way toward German expressionism; landscapes, portraits, interiors, and still lifes; expressive use of color.

August Macke worked at a time of extraordinary innovation in German art and was at the forefront of his field despite a short career. At the time of his tragic death in 1914, one month after being called up to fight in World War I, his artistic style was still evolving. The works undertaken only months before his death, after a trip to Tunisia, are considered among his best.

He trained in Düsseldorf at the Kunstakademie and the Kunstgewerbeschule, where he was taught by printmaker Fritz Helmuth Ehmcke, before embarking on a trip to Italy and to the Netherlands, Belgium, and England. However, his encounter with the work of the impressionists in Paris in 1907 proved most significant on his early style. He rapidly absorbed their influence and that of the post-impressionists and fauves. He returned to Paris in 1909, where he met Louis Moilliet and Karl Hofer and began working with simplified compositions, breaking down forms to their most basic state and using bold, vivid colors, as seen in *Tegernsee Landscape* (1910).

Macke met Franz Marc in 1910 in Munich and the two became friends, sharing a similar intensity of vision. Shortly afterward, he met Wassily Kandinsky, and the trio contributed to the first *Der Blaue Reiter* (Blue Rider) exhibition and almanac—one of the most important art manifestos of the twentieth century. In 1912, Macke met Robert Delaunay, whose work was also to have a profound influence on him. He moved toward greater abstraction, exploring the cubist theories of Delaunay, although his work remained grounded in objectivity. Macke traveled to Tunisia in 1914 with Paul Klee and Moilliet and produced a series of breathtaking watercolors and several oils, including *Turkish Café* (1914). **TP**

Masterworks

Tegernsee Landscape 1910 (Lenbachhaus, Munich, Germany)

Lady in a Green Jacket 1913 (Museum Ludwig, Cologne, Germany)

Turkish Café II 1914 (Lenbachhaus, Munich, Germany)

Farewell 1914 (Museum Ludwig, Cologne, Germany)

> "[I have found] a joy in working that I have never known."—
>
> Macke, on the allure of Tunisia

ABOVE: Detail from *Self-Portrait at Home*, made by August Macke in 1912.

JUAN GRIS

Born: José Victoriano Carmelo Carlos González-Pérez, March 23, 1887 (Madrid, Spain); died May 11, 1927 (Boulogne-Billancourt, Paris, France).

Artistic style: Experimental cubist painter of portraits and still life; bright colors and unexpected forms; playful use of space and perspective.

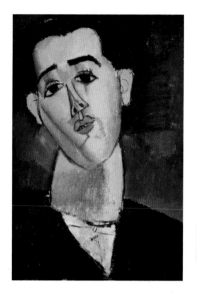

The defining moment of Juan Gris's short life was his move to Paris in 1906, where he began to move in the same circles as Pablo Picasso and Georges Braque. Like them, he began to explore the principles of cubism, subverting the traditional genres of portraiture and still lifes. In this early cubism, the subject of the painting was fractured into its individual elements, lacking traditional perspective, so that the viewer is forced to put them together as if they were pieces of a jigsaw puzzle. By the time Gris became involved, cubism itself was splintering in different directions. Real objects could be integrated into the painting, while shattered forms, with no apparent relationship to a particular thing, could be combined to suggest its shape. Gris attempted to integrate, or synthesize, these elements (synthetic cubism) using other fragments, this time of natural color, shape, or perspective. Shadows embody objects, suggesting space or background, while objects themselves may be distorted out of their natural forms.

His continuous experimentation brought him back to the themes of his earlier compatriot, Diego Velázquez: still lifes beside a window opening out into a world within the painting but leading into a world beyond. A real item, such as a newspaper page, may be inserted at such an angle that it appears artificial yet also builds a bridge in the other direction, reaching out into the viewer's space. An example is his work *The Sunblind* (1914).

Gris's achievement involved treating his subject from all possible angles by playing with space yet using perspective. He combined solid bodies with planes of shadow and layered bone structure, personality, flesh, and clothes, as in *Portrait of Josette* (1916), thus foreshadowing developments later in the century. **SC**

Masterworks

Portrait of Picasso 1912 (Art Institute of Chicago, Chicago, Illinois, U.S.)

The Sunblind 1914 (Tate Collection, London, England)

Le Jounral (The Newspaper) 1916 (Norton Museum of Art, West Palm Beach, Florida, U.S.)

Portrait of Josette 1916 (Museo Nacional Centro de Arte Reina Sofia, Madrid, Spain)

Violin 1916 (Kunstmuseum, Basel, Switzerland)

The View Across the Bay 1921 (Musée Nationale d'Art Moderne, Paris, France)

"You are lost the moment you know what the result will be."

ABOVE: Amedeo Modigliani painted this elongated portrait, *Juan Gris*, in 1915.

ALEXANDER ARCHIPENKO

Born: Alexander Porfiryevich Archipenko, May 30, 1887 (Kiev, Ukraine); died February 25, 1964 (New York, U.S.).

Artistic style: Sculptor, painter, and graphic artist; innovative use of negative space to portray the human figure; depictions of the female form.

1800-99

Masterworks

Walking 1912 (Von der Heydt-Museum, Wuppertal, Germany)

Torso 1914 (Chi-Mei Museum, Taiwan)

Glass on a Table 1920 (Museum of Modern Art, New York, U.S.)

La Boxe 1935 (Peggy Guggenheim Collection, Venice, Italy)

King Solomon 1966 (Smithsonian American Art Museum, Washington, D.C., U.S.)

"The geometric character . . . is due to extreme simplification of form and not cubist dogma."

ABOVE: This portrait was taken *circa* 1930 in the artist's studio.

RIGHT: *Glass on a Table* confirms the artist's competence as a cubist painter.

Ukrainian sculptor, painter, and graphic artist Alexander Archipenko created an innovative way of viewing the human figure using negative space, thus challenging the traditional understanding of sculpture.

He studied painting and sculpture at the Kiev Art School from 1902 to 1905. He moved to Paris in 1908 and attended the École des Beaux-Arts but quickly rejected its academicism. He left after two weeks to study independently at the Louvre, where he was attracted by Egyptian, Assyrian, ancient Greek, and early Gothic sculpture. In 1910, he began showing his work at the Salon des Indépendants, and the following year exhibited as a cubist sculptor alongside Kasimir Malevich, Marcel Duchamp, Pablo Picasso, and Georges Braque. Two years later, Archipenko opened the first of his many art schools. He joined the Section d'Or group that included Braque, Duchamp, and Picasso, and produced his first plaster-carved and painted reliefs, which he called "sculpto-peintures."

By this time, Archipenko was experimenting with using negative space and concave, convex, and geometric forms, which can be seen in his bronze sculpture *Walking Woman* (1912). His work was predominantly of female figures, and its flatness gave it an almost two-dimensional appearance. As well as his bronzes, Archipenko followed the lead of Picasso and began sculpting using everyday materials. His works attracted great acclaim and his reputation swiftly spread throughout Europe. After World War I, Archipenko resumed his career with his first solo show in New York. He emigrated to the United States and continued to produce notable works, although their caliber was not on a par with that of his earlier European pieces. **SH**

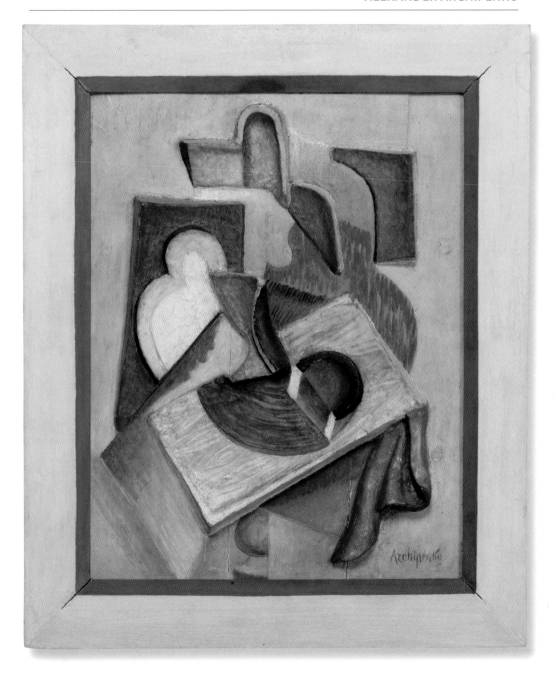

JEAN ARP

Born: Jean Arp, September 16, 1886 (Strasbourg, France); died June 7, 1966 (Basle, Switzerland).

Artistic style: Dadaist sculptor, collagist, engraver, and poet; biomorphic forms; wooden reliefs; repetition of motifs such as mustaches; experiments with chance.

Masterworks

Collage with Squares Arranged According to the Laws of Chance 1916–1917 (Museum of Modern Art, New York, U.S.)

*Mustaches c.*1925 (Tate Collection, London, England)

*Overturned Blue Shoe with Two Heels Under a Black Vault c.*1925 (Peggy Guggenheim Collection, Venice, Italy)

Sculpture to be Lost in the Forest 1932 (Tate Collection, London, England)

*Head and Shell c.*1933 (Peggy Guggenheim Collection, Venice, Italy)

Human Concretion 1935 (Museum of Modern Art, New York, U.S.)

Impish Fruit 1943 (Tate Collection, London, England)

Pistil 1950 (La Fondation Arp, Paris, France)

> "Dada is, like nature, without meaning. Dada is for nature and against art."

ABOVE: The artist was also known as Hans Arp; he is pictured here *circa* 1940.

Jean Arp began making abstract sculptures in 1910, and the outbreak of World War I saw him in Paris mixing with the capital's avant-garde. Rather than return home to face military service, he went to Switzerland and founded the Zurich Dadaists in 1916. The Dadaists sought to use art as a form of subversion against the bourgeois order. Their revolt was not just against an academic aesthetic. They also felt that bourgeois attitudes precipitated the dour war years and its bloodshed, and they advocated a return to the order of nature.

Some artists responded with a brighter palette or humorously playful work, including Arp, who began to produce compositions of string nailed to canvas and shallow wooden reliefs, such as *Mustaches* (*c.*1925), incorporating motifs of mustaches, hats, and ties that wryly mock bourgeois arrogance and hierarchical order. Perhaps because the war and the 1918 flu pandemic made Arp aware life hung by a thread, he also started to experiment with the ideas of spontaneity and automatic composition. This led him to create "chance collages," such as *Collage with Squares Arranged According to the Laws of Chance* (1916–1917), which consisted of scraps of torn paper dropped onto paper and fixed wherever they fell. The 1920s saw him found the Cologne Dadaists with Max Ernst and return to live in Paris. There he flirted with surrealism before establishing the abstraction-création group. Arp continued to develop his art along themes of chance and began to make freestanding sculptures, such as *Sculpture to be Lost in the Forest* (1932), which he left in the woods near his home so people would come across them by accident. In keeping with his desire to emulate nature, his sculptures took on biomorphic forms resembling stones, vegetation, or plants. **CK**

MARCEL DUCHAMP

Born: Henri-Robert-Marcel Duchamp, July 28, 1887 (Blainville-Crevon, France); died October 2, 1968 (Neuilly-sur-Seine, France).

Artistic style: Surrealist and Dadaist sculptor and painter; early cubist paintings; inventor of the readymade; female alter ego; witty explorations of sexuality.

Art would never be the same again after Marcel Duchamp created the concept of the "readymade," using subjects as diverse as a urinal and a bicycle wheel. He opened the doors to art being a can of excrement—Piero Manzoni's *Artist's Shit* (1961), or even a shark—Damien Hirst's *The Physical Impossibility of Death in the Mind of Someone Living* (1991).

In his youth, Duchamp developed a love of symbolist painting and cited the symbolist painter, Odilon Redon, as the greatest influence on his early career. His early works also reveal influences of post-impressionism, cubism, and fauvism. Duchamp attended the Académie Julien, but seemed to prefer drawing caricatures or playing games that tested his mental ability. He loved puns, both visual and verbal, and he often

Masterworks

Nude Descending a Staircase, No.2 1912 (Philadelphia Museum of Art, Philadelphia, Pennsylvania, U.S.)

Bicycle Wheel 1913 (Re-created in 1951) (Museum of Modern Art, New York, U.S.)

The Bride Stripped Bare by Her Bachelors, Even (The Large Glass) 1915–1923 (Philadelphia Museum of Art, Philadelphia, Pennsylvania, U.S.)

Fountain 1917 (Work was lost shortly after first displayed in New York)

Why Not Sneeze Rrose Selavy 1921(Philadelphia Museum of Art, Philadelphia, Pennsylvania, U.S.)

Etant Donnes 1968 (Philadelphia Museum of Art, Philadelphia, Pennsylvania, U.S.)

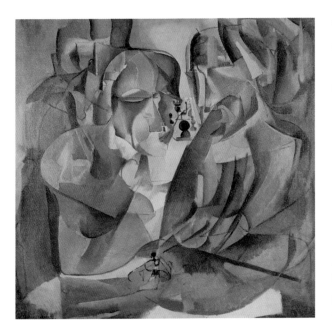

ABOVE: Duchamp holds a dramatic pose for this portrait shot *circa* 1934.

LEFT: The Duchamp brothers contemplate their moves in *Portrait of Chess Player* (1911).

Significant Other

After withdrawing from pre-war cubist circles, Duchamp became increasingly interested in changing his identity. He first thought to take on a Jewish name because he felt it would make a change to go from one religion to another, but he decided it would be more dramatic to "become" a woman. Rose (or Rrose as it later became) Selavy became the artist's most famous pseudonym. She afforded him the opportunity to explore, albeit superficially, what it would be like to live life as a woman and to indulge his lifelong love of puns. Duchamp's alter ego's name sounds like the common French phrase: *Eros, c'est la vie*, which translates as "Love, that's life," although another possible pun has been suggested: *Arroser la vie* (to make a toast to life).

In common with many men who dress enthusiastically in drag, Duchamp as Selavy was a vision of glamor. This is evident from the photographs taken by Man Ray throughout the 1920s. Duchamp's friend, the writer Robert Lebel, suggested that Man Ray's photographs of Duchamp as a woman "might suggest . . . the artist's inherent androgyny in the manner of Leonardo da Vinci to whom Duchamp had paid homage in his own way by providing the Mona Lisa with masculine attributes."

Duchamp signed several works by Selavy and incorporated her into the title of at least one of his sculptures, *Why Not Sneeze Rrose Selavy* (1921).

incorporated witticisms into his caricatures. The work/life pattern Duchamp established at this time—a combination of art making, joke telling, and game playing—became a formula he followed for life. However, 1906 saw Duchamp entering a period of serious commitment to painting. The works from this time lean toward the mystical and the religious, with subject matter akin to that chosen by Munch and Gauguin. Critic Guillame Appollinaire was apparently unconvinced by the young artist's paintings, but Duchamp did not seem to have let this affect him, nor did he seem to have held a grudge against the critic because the two men became good friends.

From 1911, Duchamp was associated with the Puteaux group, which included Francis Picabia, Robert Delaunay, and Juan Gris. The group described their work as orphic cubism. Although Duchamp temporarily adopted a cubist style, he was not committed to the movement nor happy with the group after they voiced objections to his controversial work, a fractured-looking nude entitled *Nude Descending a Staircase*

RIGHT: The artist famously signed his readymade *Fountain*, "R. Mutt."

No. 2 (1912). Duchamp submitted the work to the Cubist Salon des Indépendents but was asked to rename the piece or remove it. He removed the work and determined never to be part of a group again. He submitted the painting to the 1913 Armory Show in New York, where it bemused a U.S. audience more accustomed to realism. Duchamp was bitterly disappointed by the reaction to his work and especially by the lack of open-mindedness on the part of the so-called avant-garde artists of the day.

Out of the frying pan into the fire

Fed up with playing by the rules, Duchamp determined to subvert traditional forms of art making by introducing the readymade. Greatly influenced by a book by Max Stirner called *The Ego and Its Own*, Duchamp figured any banal or mass-produced object could be transformed into art as long as the artist willed it. The first of Duchamp's iconoclastic readymades was *Bicycle Wheel* (1913). The most notorious was *Fountain* (1917), a porcelain urinal that prompted a scandal at its New York unveiling.The extensive number of preparatory drawings, writings, and studies behind Duchamp's *The Bride Stripped Bare by Her Bachelors (The Large Glass)* (1915–1923) reveals just how far Duchamp had moved from realistic representations to a more abstract, mathematical way of signifiying reality and a desire to accommodate the advent of mass production in his work.

ABOVE: Replicas of Duchamp's *Bicycle Wheel* can be seen in museums across the world.

Duchamp's iconoclastic approach to art appealed to the Dada movement. His own experience with the movement occurred in New York through his associations with Picabia and Man Ray. Duchamp abandoned art making in favor of chess playing in the 1920s. Although he became a world-class player, it is his role as the *enfant terrible* of the art world for which he is best remembered. His legacy is vast; associated with the cubist, Dada, and surrealist movements, Duchamp also inspired pop, conceptualism, and minimalism and went on to influence generations of artists. **JN**

"I have forced myself to contradict myself to avoid conforming to my own taste."

1800-99

MARC CHAGALL

Born: Moishe Shagal, July 7, 1887 (Vitebsk, Belarus); died March 28, 1985 (Saint-Paul de Vence, Alpes-Maritimes, France).

Artistic style: Painter, printmaker, and ceramist; Russian themes; dreamlike sequences; love scenes; biblical stories; folk art and cubist influences.

A Russian immigrant who lived most of his adult life in France, Marc Chagall never stopped missing his homeland but found it impossible to live there. In his writing, he famously commented, "Neither Imperial Russia nor Soviet Russia needs me. I am a mystery, a stranger to them. Perhaps Europe will love me, and with her, my Russia." This sense of dual nationality and personality remained with him, and informed his works.

Chagall studied in St. Petersburg, Paris, and Berlin. As well as painting, he produced ceramics and stained glass. He mastered the arts of printmaking, making stage sets, and mural painting. Critics claim Chagall spread himself too thinly. Yet the beauty of his work lies in this diversity: a dichotomy that reflected his personal history and personality.

It was in Paris in 1910 that Chagall first encountered cubism, and many of his works from this time show strong cubist influences, such as *Homage to Apollinaire* (1911–1912) and *Self-*

Masterworks

View From a Window, Vitebsk c.1910
(Tretyakov Gallery, Moscow, Russia)

I and the Village 1911 (Museum of Modern Art, New York, U.S.)

Homage to Apollinaire 1911–1912 (Van Abbemuseum, Eindhoven, the Netherlands)

Calvary 1912 (Museum of Modern Art, New York, U.S.)

Self-Portrait with Seven Fingers 1912 (Stedelijk Museum, Amsterdam, the Netherlands)

Paris Through the Window 1913 (Solomon R. Guggenheim Museum, New York, U.S.)

Birthday 1915 (Museum of Modern Art, New York, U.S.)

Double Portrait with a Glass of Wine 1917 (Musée d'Art Moderne, Paris, France)

Self-Portrait from My Life 1923 (Museum of Modern Art, New York, U.S.)

White Crucifixion 1938 (Art Institute of Chicago, Chicago, U.S.)

Stained Glass Windows at Metz Cathedral, 1958–1960 (Metz, France)

Ceiling of the Palais Garnier 1964 (Paris, France)

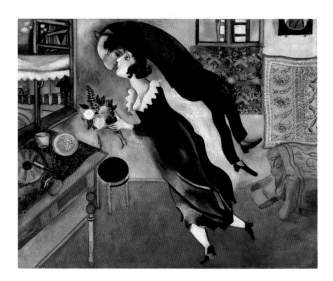

ABOVE: Chagall was in fine form at the age of ninety-seven, when this portrait was taken.

RIGHT: In *Birthday*, the young couple seem to float above the everyday world.

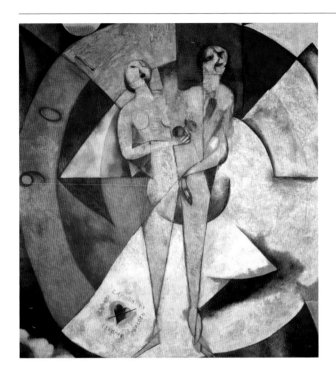

LEFT: Strong cubist influences are evident in Chagall's *Homage to Apollinaire*.

Portrait with Seven Fingers (1912). Just before World War I, Chagall held his first solo exhibition, in Berlin, after which he returned to Vitebsk. The year after the Russian Revolution of 1917, he was made director of the art school in Vitebsk. This honor was short-lived and, disappointed, he left for Moscow.

Chagall was initially a great supporter of the revolution. However, he grew increasingly disillusioned and returned to Paris and Berlin, traveled through the Middle East, and then decided to settle in France. He lived for several years in fear of what was happening to the world, a fear displayed in works such as *White Crucifixion* (1938). In 1941, as Jews living in Nazi-occupied Paris, he and his family were forced to flee to the United States. He returned to France in 1948 and made his home on the French Riviera. He continued to travel the world, often to fulfill commissions for prominent public art. A museum dedicated to Chagall was opened in Nice in 1973. **LH**

Beloved Bella

In 1915, Chagall married his childhood sweetheart Bella Rosenfeld, the daughter of a wealthy merchant. Their happy marriage was the inspiration for many paintings. He met Bella in Vitebsk, and the town is a constant, recurring theme in his works. Bella's portrait can often be discerned in his paintings, such as in *Birthday* (1915) and *Double Portrait with a Glass of Wine* (1917). Bella died in 1944 while they were living in New York, but her memory continued to inspire his works. Several depressed years after her death, Chagall had a son with Virginia Haggard, but they did not marry.

GEORGIA O'KEEFFE

Born: Georgia Totto O'Keeffe, November 15, 1887 (Sun Prairie, Wisconsin, U.S.); died March 6, 1986 (Santa Fe, New Mexico, U.S.).

Artistic style: Melding of Abstraction and representational; energetic oils and watercolors; landscapes, cityscapes, and natural forms; erotic depictions of flowers.

Masterworks

Birch and Pine Tree No. 1 1925 (Philadelphia Museum of Art, Philadelphia, U.S.)

New York with Moon 1925 (Museo Thyssen-Bornemisza, Madrid, Spain)

Oriental Poppies 1927 (Weisman Art Museum at the University of Minnesota, Minneapolis, U.S.)

Red Hills with Flowers 1937 (Art Institute of Chicago, Chicago, U.S.)

Bella Donna 1939 (Georgia O'Keeffe Museum, Santa Fe, New Mexico, U.S.)

Growing up in a large family, Georgia O'Keeffe's creative skills were recognized early on. From 1905 to 1906, she studied at the School of the Art Institute of Chicago, and from 1907 to 1908 at the Art Students' League in New York, where she won the William Merritt Chase still life prize for oil painting.

In a summer art course, O'Keeffe was introduced to the ideas of painter and teacher Arthur Wesley Dow, who believed that art should be the expression of the artist's feelings through harmonious compositions of line, color, and tone. In 1915, she began to experiment with his ideas. She sent some of the resulting abstract charcoal drawings to a friend, who later showed them to photographer Alfred Stieglitz. In 1916, Stieglitz exhibited ten of these drawings at his New York gallery, known as the 291. A year later, he held a solo exhibition of her work, and the following spring he offered her financial support to paint for a year in New York, which she accepted. For the next few years they worked together, and then married in 1924, when she began painting her large-scale canvases of flowers that were well received from their first showing.

The couple moved to an apartment on the thirtieth floor of the Shelton Hotel in New York, and for twelve years, O'Keeffe painted natural forms and cityscapes from there. In 1928, however, she visited New Mexico; the stunning vistas and stark landscapes haunted her, and three years after Stieglitz's death, she decided to move and live there permanently. Until the mid-1970s, O'Keeffe painted atmospheric views and aerial landscapes in New Mexico, but her failing eyesight eventually caused her to abandon oil painting. She continued working in pencil and watercolor, and later in clay. O'Keeffe died in Santa Fe in 1986. **SH**

"Most people in the city rush around so they have no time to look at a flower."

ABOVE: Georgia O'Keeffe photographed at an exhibition of her work in 1931.

JOSEF ALBERS

Born: Josef Albers, March 19, 1888 (Bottrop, Westphalia, Germany); died March 25, 1976 (New Haven, Connecticut, U.S.).

Artistic style: Artist, mathematician, and educator whose work formed the basis of some of the most influential art education programs of the twentieth century.

Accomplished as a designer, photographer, typographer, printmaker, and poet, Josef Albers's early inspiration was taken from cubism and the works of Paul Cézanne and Henri Matisse. Although he studied art in Berlin, Essen, and Munich, his most significant education took place at the Bauhaus in Weimar. By 1923, Albers was teaching furniture design, calligraphy, and drawing there, helping to guide the prestigious school from an expressionist to a constructivist approach, and contributing significantly to developments in industrial design. His teaching methods were both innovative and shocking, because he eliminated copying from nature and from other artists.

When the Bauhaus closed in 1933, Albers emigrated to the United States. He spent the next sixteen years as head of the art department at Black Mountain College in North Carolina, a school based on the principle that fine art integrates all learning. During this period Albers's own reputation as an abstract painter began to develop.

Albers's book *Interaction of Color* (1963) explains some of his progressive theories. He was one of the first modern artists to investigate the psychological effects of color and space, and to question the nature of perception. His masterwork, the series of abstract paintings *Homage to the Square* (1950–1976), shows his disciplined approach to composition. In it he chose subdued colors that create optical illusions and the simple man-made form of the square—far removed from the natural world. Hard-edge abstract painters drew inspiration from his use of patterns and intense colors, whereas conceptual and op artists explored his ideas on perception. Josef Albers was the first living artist to have a solo exhibition at the Metropolitan Museum in New York. **SH**

Masterworks

Impossibles 1931 (Solomon R. Guggenheim Museum, New York, U.S.)

Homage to the Square (733) 1965 (Dallas Museum of Art, Dallas, Texas, U.S.)

Homage to the Square: Stepped Foliage 1963 (National Gallery of Canada, Ottawa, Canada)

Verrant I 1966 (Southern Alleghenies Museum of Art, Loretto, Pennsylvania, U.S.)

"You can go from one master to another and learn other tricks and other secrets."

ABOVE: Josef Albers photographed before he emigrated to the United States.

GIORGIO DE CHIRICO

Born: Giorgio de Chirico, July 10, 1888 (Volos, Greece); died November 20, 1978 (Rome, Italy).

Artistic style: Metaphysical painter; recurring motifs of mannequins, Renaissance architecture, classical statuary, trains, and fruit; themes of time, travel, and nostalgia.

1800-99

Masterworks

The Nostalgia of the Infinite c.1912–1913 (Museum of Modern Art, New York, U.S.)

The Anxious Journey 1913 (Museum of Modern Art, New York, U.S.)

The Uncertainty of the Poet 1913 (Tate Collection, London, England)

The Red Tower 1913 (Peggy Guggenheim Collection, Venice, Italy)

The Song of Love 1914 (Museum of Modern Art, New York, U.S.)

The Melancholy of Departure 1916 (Tate Collection, London, England)

Metaphysical Interior with Large Factory 1916 (Staatsgalerie Stuttgart, Stuttgart, Germany)

Self-Portrait 1953 (Foundation Giorgio De Chirico, Rome, Italy)

Giorgio de Chirico's early paintings seem hauntingly enigmatic. Prefiguring the surrealists, his melancholy canvases feature architectural landscapes, colonnades, arches, and towers; deserted squares; bunches of bananas; truncated classical statuary; and an exaggerated perspective.

De Chirico's dreamlike cityscapes reflect life in an Italian town. The architecture nods to the Italian Renaissance, the desolate town squares to piazzas empty of human life on hot afternoons. The bright blue skies and elongated shadows indicate the intense heat of a Mediterranean summer, and the classical heads and torsos are typical of the weather- and time-worn statuary that populate the country at almost every turn.

De Chirico studied art in Athens, Florence, and finally in Munich, where he was influenced by the writings of philosophers Friedrich Nietzsche and Arthur Schopenhauer. He then moved back and forth between Paris, New York, and Italy before finally settling in Rome in 1944. As such, his life was full of journeys and good-byes. His early works reflect his

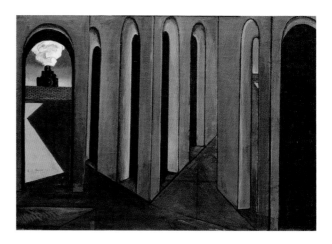

ABOVE: De Chirico pictured in 1946, probably in Italy where he was living at the time.

RIGHT: *The Anxious Journey* was painted during a period of constant travel.

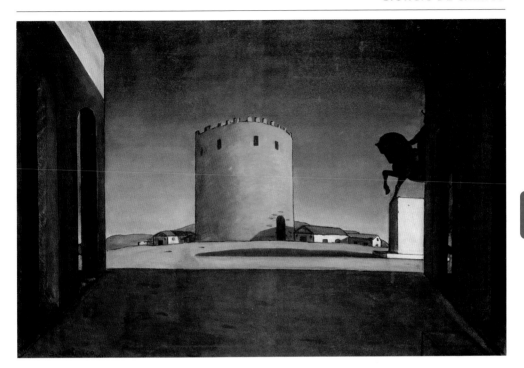

longing and nostalgia for Italy with titles such as *The Nostalgia of the Infinite* (c.1912–1913) and *The Anxious Journey* (1913).

On one such journey he came across work by Nietzsche, an experience that was to have a profound effect on his outlook. World War I saw De Chirico return to Italy. There he met Filippo de Pisis and Carlo Carrà, and they formed the Scuola Metafisica (Metaphysical School). De Chirico's work then became increasingly bizarre: still lifes and interiors crammed with faceless mannequins, easels, and incongruous objects from biscuits to rubber gloves. Yet in among them, he explored themes of travel and longing as seen in *The Melancholy of Departure* (1916).

Although De Chirico had rejected his metaphysical style by the 1930s, he remains most famous for the works produced between 1909 and 1919, works that influenced surrealist artists such as Max Ernst, Salvador Dalí, and René Magritte. **CK**

ABOVE: Works such as *The Red Tower* influenced later surrealist artists.

We Have No Bananas

De Chirico lived in an apartment in Rome that is now open to the public as the Foundation Giorgio De Chirico. Its reproduction Empire furnishings reflect the painter's love for the neo-classical. The museum is also home to a number of the artist's works. Perhaps the most interesting of these is his *Self-Portrait* (1953) that shows an almost patrician De Chirico in a nod to the Old Masters. A red sash is draped across the sitter's black doublet, and a white collar peeps out almost like a ruff, while behind lie swirling clouds and a Giorgione-like landscape— with not a banana in sight.

THOMAS HART BENTON

Masterworks

*Struggle for the Wilderness c.*1924–1926 (Series Title: *American Historical Epic*) (Nelson-Atkins Museum of Art, Kansas City, U.S.)

Indiana Murals 1933 (Indiana University, Bloomington, Indiana, U.S.)

Persephone 1938–1939 (Nelson-Atkins Museum of Art, Kansas City, U.S.)

Buffalo and Sunflower 1944 (Museum of Nebraska Art, Kearney, Nebraska, U.S.)

Bartering with Traders 1944 (Museum of Nebraska Art, Kearney, Nebraska, U.S.)

Independence and the Opening of the West 1960 (Harry S. Truman Library and Museum, Independence, Missouri, U.S.)

Born: Thomas Hart Benton, April 15, 1889 (Neosho, Missouri, U.S.); died January 19, 1975 (Kansas City, Missouri, U.S.).

Artistic style: Painter, sculptor, and writer; murals and canvases of scenes of everyday life in the North-American Midwest, pioneers, and social histories.

Eclipsed by the wild success of his former pupil, Jackson Pollock, American regionalist painter Thomas Hart Benton nevertheless experienced considerable fame in his lifetime. He studied painting at the Chicago Art Institute, and in 1908 went to study at the Académie Julian in Paris.

Benton's early work was modernist, following the trend for abstraction. Later in life, however, he became a member of the American regionalist movement and was vehement in his attacks upon modernism. He began to specialize in folksy murals of everyday rural life in the Midwest and also painted the early pioneers: the traders, hunters, and explorers that he saw as capturing the spirit of what made the nation. **CK**

HANNAH HÖCH

Masterworks

Cut with the Dada Kitchen Knife Through the Last Weimar Beer-Belly Cultural Epoch in Germany 1919–1920 (Staatliche Museum, Berlin, Germany)

Indian Dancer: From an Ethnographic Museum 1930 (Museum of Modern Art, New York, U.S.)

With Seaweed 1950 (Museum of Modern Art, New York, U.S.)

Born: Joanne Höch, 1889 (Gotha, Thuringia, Germany); died 1978 (Berlin, Germany).

Artistic style: Dadaist; inventor of photomontage; use of collage; exploration of gender issues; feminist and racial themes; androgynous figures; references to mannequins.

Hannah Höch is accredited, with Raul Hausmann, with the invention of photomontage. After early works such as *Cut with the Dada Kitchen Knife* (1919–1920), she began dealing with gender issues in a rapidly changing society. Images from magazines were spliced into a critique of stereotyped representations of women, often using references to dolls and mannequins. Her later *Ethnographic Museum* (1920s–1930s) works further challenged Western conventions of beauty by taking on notions of exoticism and primitivism as well as taking a swipe at Nazi aesthetic ideology and its racial discrimination. A bisexual, Höch's sexuality was frequently reflected in her depiction of androgynous figures. **WO**

1800-99

PAUL NASH

Born: Paul Nash, May 11, 1889 (London, England); died July 11, 1946 (Boscombe, Hampshire, England).

Artistic style: Powerful images of battlefields; abstracts of found, natural objects; visionary landscapes of ancient sites; surreal images of aerial battles.

Paul Nash is best known for his work as an official war artist, and his paintings represent some of the most memorable images of both world wars. Although his early watercolors and drawings, such as *The Wanderer* (*c.*1911), had focused on the inherent dreamlike beauty of nature, his experiences on the Western Front as a soldier and official war artist forged a vision that he described as "a bitter truth." The pictorial vocabulary of landscape became that of barbed wire, craters, and blasted stumps of trees. During World War II, Nash focused on the surreal interactions between man and landscape in the "aerial flowers" of *The Battle of Britain* (1941) and in *Totes Meer (Dead Sea)* (1940–1941), a seething sea of airplane wreckage.

Nash's most experimental artistic period occurred during the interwar years when his style was most closely allied to European abstraction and surrealism. In 1933, he was a founder member of Unit One, an influential but short-lived modernist movement that also included Barbara Hepworth and Henry Moore. He always retained a naturalistic element within his work but transformed organic forms such as stones into abstract geometric shapes. His lifelong aim was to attempt to define a national character within contemporary English art, a problem he tackled in his own paintings through landscape. In his late works, he achieved a visionary synthesis of romanticism and surrealism that enabled him to access an inner, metaphysical sense, described as *genius loci*, or "spirit of place." He was repeatedly drawn to certain ancient sites, such as Wittenham Clumps in Oxfordshire and the standing stones at Avebury in Wiltshire, which he explored for their historic and mystical significance and their symbolic representation of the passage of time. **NM**

Masterworks

We Are Making a New World 1918
 (Imperial War Museum, London, England)

The Menin Road 1919 (Imperial War Museum, London, England)

The Shore, Dymchurch, Kent 1922 (Manchester City Art Galleries, Manchester, England)

Landscape at Iden 1929 (Tate Collection, London, England)

Totes Meer (Dead Sea) 1940–1941 (Tate Collection, London, England)

The Battle of Britain 1941 (Imperial War Museum, London, England)

Flight of the Magnolia 1944 (Tate Collection, London, England)

"I am no longer an artist interested and anxious. I am a messenger . . ."

ABOVE: Paul Nash photographed in his studio in 1944.

Masterworks

Pregnant Woman and Death 1910 (Narodni Gallery, Prague, Czech Republic)

Self-Portrait 1910 (Leopold Museum, Vienna, Austria)

Girl with Black Hair 1911 (Museum of Modern Art, New York, U.S.)

Self-Portrait 1911 (Metropolitan Museum of Art, New York, U.S.)

Dead City III 1911 (Leopold Museum, Vienna, Austria)

Portrait of Wally 1912 (Disputed ownership)

Setting Sun 1913 (Leopold Museum, Vienna, Austria)

Death and the Maiden 1915 (Österreichische Galerie, Vienna, Austria)

Portrait of Johann Harms 1916 (Solomon R. Guggenheim Museum, New York, U.S.)

The Embrace 1917 (Österreichische Galerie Belvedere, Vienna, Austria)

The Family 1918 (Österreichische Galerie, Belvedere, Vienna, Austria)

ABOVE: Detail from a portrait photograph of Schiele, taken *circa* 1914.

RIGHT: *Death and the Maiden* is regarded as one of Egon Schiele's masterpieces.

EGON SCHIELE

Born: Egon Schiele, June 12, 1890 (Tulln, Austria); died October 31, 1918 (Vienna, Austria).

Artistic style: Expressionist painter of portraits, self-portraits, and landscapes; angst-ridden figures; explicit drawings of teenage girls; claustrophobic cityscapes.

A friend and protégé of painter Gustav Klimt, Egon Schiele took Klimt's expressive line further to describe angst-ridden bodies, and brought his sexual honesty to subject matter that was shocking in early-twentieth-century Vienna.

Schiele's self-portraits show an angular, anguished figure set against a void, exemplifying the myth of the tortured male artist. This is only one aspect of his work; his townscapes are composed rhythmically, and although there is an underlying tension in their crowded canvases, they have great charm. His tree paintings are animated to the point where they can be seen as emotionally invested portraits of trees. His actual portraits, such as that of his father-in-law, are empathetic and among the most accomplished works in the genre.

Schiele was admitted to the Akademie der Bildenden Künste at sixteen but resisted the stuffy academic teaching

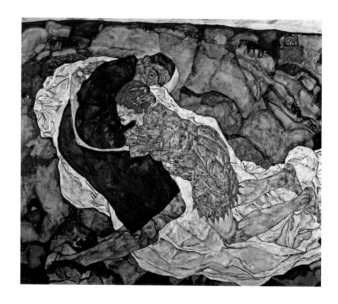

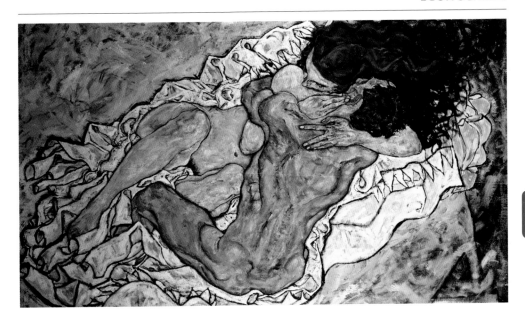

and left to form the New Art Group. He then began drawing nude women and girls with a frankness that caused trouble in 1911 after he moved to Kramau. He was forced to leave the town because he lived with his girlfriend, Valerie "Wally" Neuzil, and used minors as models. He was no better understood in Neulengbach, where he was sentenced to prison in 1912 for making immoral drawings available to children.

In 1915, Schiele left Wally and married Edith Herms. As World War I arrived he joined the army, but by 1917 he was back in Vienna and was able to resume painting. By 1918, Schiele was more stable than he had been for years, Edith was pregnant, and he had huge success at the Vienna Secession; Klimt died in this year, and Schiele was seen as his successor. During this period, and in anticipation of fatherhood, he painted *The Family* (1918), which shows him, his wife, and their child naked and happy, reflecting his newfound optimism. Tragedy struck in October when his wife and their unborn child died in the flu pandemic that ravaged through Europe; Schiele died only three days later. **WO**

ABOVE: *The Embrace*, painted in 1917 after Schiele's return to Vienna after army service.

Schiele Trivia

- The distortion in his figure studies was achieved by working from a stepladder.
- The largest quantity of Schiele's work is in the Leopold Museum in Vienna.
- A diary supposedly written by Schiele in prison was actually written by his friend, the critic Arthur Roessler.
- *Portrait of Wally* (1912) and *Dead City III* (1911) languished in storage for twenty-one months in New York. The paintings had been on loan, but it took a court case to order their return to Austria because it was claimed that the Nazis looted them from the original owners.

1800-99

EL LISSITZKY

Born: Lazar Markovich Lissitzky, November 22, 1890 (Pochinok, Smolensk Oblast, Russia); died December 30, 1941 (Moscow, Russia).

Artistic style: Suprematist designer, photographer, teacher, typographer, and architect.

Masterworks

Proun P23, no. 6 1919 (Van Abbemuseum, Eindhoven, the Netherlands)

Chad Gadya (The Tale of the Goat) 1919 (National Gallery of Art, Washington, D.C., U.S.)

Proun 19D c.1922 (Museum of Modern Art, New York, U.S.)

Globetrotter in Time 1923 (Norton Simon Museum, Pasadena, California, U.S.)

Kurt Schwitters c.1924 (Museum of Modern Art, New York, U.S.)

El Lissitzky's style dominated twentieth-century graphic design, and he was one of the most important figures of the Russian avant-garde. He grew up and studied in Vitebsk until 1909, when he moved to Germany to study architecture and engineering. He also spent time in Paris and Italy, studying art and sketching architecture and landscapes. He was heavily influenced by Vladimir Tatlin and constructivism.

In 1919, Lissitzky became a professor of architecture and graphic art at the art school in Vitebsk, run by Marc Chagall. There Lissitzky also met painter and art theoretician Kasimir Malevich, whose geometric suprematist works were to prove hugely inspirational. Malevich invited Lissitzky to join the Unovis (The Champions of the New) Suprematist association. Although Unovis disbanded in 1922, it played a key role in spreading suprematist ideology in Russia and abroad as well as establishing the artist's reputation.

At this time, Lissitzky developed an alternative suprematist style: a series of abstract, geometric works he called *Proun*. The series included lithographs, installations, and paintings. One of the best known pieces is the oil painting *Proun 19D* (c.1922), which Lissitzky alluded to as "the interchange station between painting and architecture." During this prolific period, he became the Russian cultural ambassador in Weimar, Germany, soon influencing important figures of the Bauhaus and De Stijl movements. Yet by 1930, he had abandoned painting and devoted himself mainly to typography and industrial design. Achieving a unique fusion between suprematism, constructivism, and neo-plasticism, his dynamic techniques of photomontage, printing, and lighting were outstandingly influential. **LH**

"The artist constructs a new symbol with his brush . . . it is a symbol of a new world . . ."

ABOVE: El Lissitzky in a detail from his self-portrait created in 1924.

GIORGIO MORANDI

Born: Giorgio Morandi, July 20, 1890 (Bologna, Italy); died June 18, 1964 (Bologna, Italy).

Artistic style: Still life paintings consisting of jugs, bottles, and other vessels; quiet, contemplative paintings imbued with psychological and poetic resonance.

Although Giorgio Morandi never considered himself to be an ascetic, one could readily imagine that the singular nature of his contribution toward twentieth-century painting was the result of self-imposed exile. Despite the clamor of the various movements that were vying for position during the course of modernism, Morandi's art, with its stillness and sense of outward repose, is distinct from the outside world. Maybe this is because he worked all of his life in a small atelier in his hometown, bar one trip outside Italy.

Initially, Morandi was associated with the Italian metaphysical painting movement. His contribution in the shape of a number of early still lifes appears to have been informed by a reluctance to eschew the world of concrete, observable fact. Toward the end of the 1920s, Morandi's tenuous allegiances to the movement dissolved. From then on he pursued his enquiry into the nature of painting free from making any concessions to stylistic advances.

Morandi received critical acclaim during his lifetime, and was awarded second place for painting at the 1939 Quadriennale in Rome and first prize for painting at the Venice Biennale in 1948, yet he was somewhat uncomfortable with the attention his work elicited. The paintings themselves are subtle still life arrangements of bottles, jugs, kitchen utensils, and bowls that are devoid of any extraneous detail. The artist would peel off labels to be able to concentrate on the form of the subject matter itself. The intense, quiet nature of a painting such as *Still Life* (1958) is a meditation on the nature of the objects themselves. It is the unique nature of Morandi's enquiry that ensures his continuing relevance. **CS**

Masterworks

Still Life 1946 (Tate Collection, London, England)

Still Life 1949 (Museum of Modern Art, New York, U.S.)

Still Life 1962 (National Gallery of Art, Washington, D.C., U.S.)

Still Life 1962 (National Gallery of Scotland, Edinburgh, Scotland)

"There is nothing more surreal, nothing more abstract than reality."

ABOVE: Giorgio Morani as the artist saw himself, an undated self-portrait (detail).

MAN RAY

Born: Emanuel Rudnitsky, August 27, 1890 (Philadelphia, Pennsylvania, U.S.); died November 18, 1976 (Paris, France).

Artistic style: Surrealist and Dadaist photographer, sculptor, and painter; avant-garde photographic portraits; pioneering fashion stills; innovative collages.

Man Ray was an artist with a diverse range of talents who gained fame not so much for his conventional paintings as for his avant-garde fashion and portrait photography, "readymades", and expressive assemblages he constructed using found materials. Born Emanuel Rudnitsky, he changed his name in an attempt to disguise his Jewish heritage. Combining his childhood nickname, "Manny," and a surname constructed by his family, Man Ray would never again refer to his past, instead favoring his new identity.

Masterworks

Marcel Duchamp as Rrose Sélavy c.1920–1921 (Philadelphia Museum of Art, Philadelphia, U.S.)

Gift 1921 (Private collection)

Untitled Rayograph 1922 (George Eastman House, New York, U.S.)

Le Violon d'Ingres 1924 (J. Paul Getty Museum, Los Angeles, California, U.S.)

Tears 1930–1932 (J. Paul Getty Museum, Los Angeles, California, U.S.)

ABOVE: A portrait of Man Ray, one of the most inventive photographers of his time.

RIGHT: *Gift*—an iron with a row of nails—is one of Man Ray's best-known sculptures.

Man Ray spent the first part of his career in New York, where he trained as a painter. His early works are cubist, consisting of three-dimensional subjects flattened and broken into strongly delineated blocks of color, in a similar style to works of Pablo Picasso. He had his first solo exhibition in 1915 when he exhibited cubist landscapes and a small number of abstract works. The exhibition was notable in his career because it was the first time he had photographed his works. He began to explore creatively the possibilities offered by the camera.

Man Ray moved to Paris in 1921, where he became one of the most inventive photographers of his time. He became involved with surrealism and diversified as an artist, producing works in a range of media including photographs, paintings, and sculptures. Yet it was his commercial portraits and fashion photography that earned Man Ray his reputation. He produced cropped images of female models at unusual angles and photographed famous people, including Georges Braque, Pablo Picasso, Henri Matisse, Gertrude Stein, and Ernest Hemingway. During World War II, he returned to the United States, where he continued his work in fashion photography. The artist returned to Paris in 1951 and continued to enjoy a successful career until his death at age eighty-six. **WD**

ABOVE LEFT: Although the face in *Tears* is real, the tears are glass beads.

ABOVE: In *Le Violon d'Ingres*, Man Ray painted two f-holes on a classical nude shot.

The Rayograph

Man Ray enjoyed experimenting in his dark room, leading to a technique he named the "Rayograph." The artist would place a random selection of objects on to a sheet of white sensitized paper and expose it to light, causing the uncovered areas to turn black. Man Ray was not the first to produce a cameraless photograph, known as a "photogram," yet his technique was unique. He would move objects and light sources or even refract the light through glass objects to create a more dynamic image made up of many hues of gray rather than just black and white.

NAUM GABO

Born: Naum Neemia Pevsner, August 5, 1890 (Bryansk, Russia); died August 23, 1977 (Waterbury, Connecticut, U.S.).

Artistic style: Constructivist sculptor; use of plastic, celluloid, perspex, sheet metal, glass, and found stones; explorations of volume, space, time, and movement.

Masterworks

Head No. 2 1916 (Tate Collection, London, England)

Construction in Space: Diagonal 1921–1925 (Tate Collection, London, England)

Two Cubes (*Demonstrating the Stereometric Method*) 1930 (Tate Collection, London, England)

Monument for an Airport c.1932–1948 (Tate Collection, London, England)

Kinetic Stone Carving 1936–1944 (Tate Collection, London, England)

Construction in Space with Crystalline Center 1938–1940 (Tate Collection, London, England)

Constructie 1955–1957 (De Bijenkorf, Rotterdam, the Netherlands)

Constructivist sculptor Sir Naum Gabo is best known for his use of transparent materials such as plastic, which allowed him to create shiny, colored sculptures in the 1920s that make use of light as much as of space. Yet the artist is also notable for his pioneering kinetic sculptures and his later work with carved stone, found stones, and wood engravings.

Gabo had a peripatetic existence that saw him move to Norway at the outbreak of World War I and return to Russia in 1917. He stayed in Russia during the 1920s. There he was one of a group of artists, including Alexander Rodchenko and Vladimir Tatlin, who spearheaded the constructivist movement and aimed to create abstract art with an emphasis on the form and texture of the materials used. Gabo chose to construct rather than carve or cast his geometric-shaped sculptures, opting for man-made materials that would emphasize their modernity. Influenced by cubism, he sought to explore volume and mass in a novel way using his "stereometric system" whereby space, depth, and volume are suggested through multiple viewpoints, flat and curved planes, and transparency.

In 1922, after the Soviet Union's nascent regime condemned constructivism, Gabo left for Berlin. His principles were influential on European artists in the De Stijl movement in the Netherlands, the Bauhaus in Germany, and the Abstraction-Création group in France; but his move to England in 1936 was to prove most influential. From 1939 to 1946, he lived in Cornwall, where his ideas influenced British artists, such as painter Ben Nicholson and sculptor Barbara Hepworth, and younger architects, designers, and artists, such as painter Peter Lanyon. He moved to the United States in 1947, where he spent the rest of his life. **CK**

> "[I am] making images to communicate my feelings of the world."

ABOVE: Naum Gabo photographed in 1970 at the Tate Gallery in London.

ALEXANDER RODCHENKO

Born: Aleksander Mikhailovich Rodchenko, December 5, 1891 (St. Petersburg, Russia); December 3, died 1956 (Moscow, Russia).

Artistic style: Painter, sculptor, and graphic designer; founder of constructivism; dynamic diagonal composition; experimental close-up photography; circus themes.

Alexander Rodchenko was one of the most versatile artists to emerge after the Russian Revolution in 1917. A leading photographer, painter, collagist, and poster artist, he produced posters for movie theaters and designed front covers for books, and was noted for his avant-garde typography and design sense. A master of photography, he successfully experimented with close-up photography of objects removed from their usual surroundings, eliminating unnecessary detail, and emphasizing dynamic diagonal composition. His favorite themes were sport, the circus, festive processions, and Soviet life.

Rodchenko attended the Kazan School of Art, and went on to study graphic art at college. Influenced by the futurists, cubism, and art nouveau, he produced his first abstract drawings in 1915 inspired by suprematist and fellow Russian Kasimir Malevich. He soon produced his famous geometric works, *Black on Black* (1918), clearly influenced by Malevich's series of *White on White* paintings. Rodchenko also came to know Constructivist Vladimir Tatlin, and from 1922 onward began to concentrate on photography, the medium in which, he, arguably, made his greatest contribution to the art world.

Impressed by the photomontage of the German Dadaists, he began his own experiments in the medium. First he used found images, and from 1924 he started shooting his own photographs. He joined the October circle of artists in 1928, an important organization for photographic and cinematographic art at the time, but was expelled three years later, charged with "formalism." In the 1940s, he returned to painting and produced abstract expressionist works, some of which are remarkably similar in style to Jackson Pollock's "drip" paintings. **SH**

Masterworks

Non-Objective Painting no. 80 (*Black on Black*) 1918 (Museum of Modern Art, New York, U.S.)

Abstract Composition 1919 (State Russian Museum, St. Petersburg, Russia)

Spatial Construction Number 12 c.1920 (Museum of Modern Art, New York, U.S.)

Balconies 1925 (Museum of Modern Art, New York, U.S.)

"One has to take several shots of a subject . . . as if one examined it in the round . . ."

ABOVE: Detail from Alexander Rodchenko portrait by Nikolai Russokov (1915).

STANLEY SPENCER

Born: Stanley Spencer, June 30, 1891 (Cookham, Berkshire, England); died December 14, 1959 (Cliveden, Buckinghamshire, England).

Artistic style: Painter of religious themes in earthly context, especially Cookham; exaggerated and naive stylization of figures; intimate self- and family portraits.

Masterworks

Travoys Arriving with Wounded Soldiers at a Dressing Station at Smol, Macedonia 1919 (Imperial War Museum, London, England)

The Resurrection, Cookham 1924–1927 (Tate Collection, London, England)

Murals 1927–1932 (Sandham Memorial Chapel, Burghclere, England)

Double Nude Portrait: The Artist and His Second Wife 1937 (Tate Collection, London, England)

The Beatitudes of Love c.1937–1938 (Various collections, including Stanley Spencer Gallery, Cookham)

A Village in Heaven 1937 (Manchester City Art Gallery, Manchester, England)

Shipbuilding on the Clyde 1940–1946 (Imperial War Museum, London, England)

During his years at the Slade School of Fine Art, Sir Stanley Spencer's devotion to his Berkshire birthplace earned him the eponymous nickname "Cookham," and throughout his life he was a familiar local figure in the village. The quaint Thames-side location provided the inspiration and setting for his highly personal artistic approach, and his idiosyncratic pictures depict the village as an "earthly paradise," combining spiritual conviction with secular homeliness. The most famous of these works is *The Resurrection, Cookham* (1924–1927), a joyful, poignant vision of Judgment Day set in the local churchyard.

A strong autobiographical element exists in Spencer's work, and he usually selected subjects according to their personal significance. His preoccupation with love—both religious and sexual—culminated in an ambitious (though unfinished) scheme known as the "Church-House," or "Chapel of Me." Among the many works related to this lifelong project is the *Beatitudes of Love* (*c.*1937–1938) a sexually charged series of images depicting physically eccentric, mismatched couples.

Although the characters in most of his paintings are naively rounded and stylized, Spencer also painted intimate naturalistic portraits of himself and his family, such as *Double Nude Portrait: The Artist and His Second Wife* (1937). Spencer's Cookham-centric focus was interrupted twice by war. During World War I, he was conscripted and served first as a hospital orderly and then as a soldier in Macedonia—experiences that formed the basis for a cycle of murals that he completed for the Sandham Memorial Chapel in Burghclere, Hampshire. During World War II, he was commissioned to paint shipbuilding yards at Port Glasgow, Scotland, after which he once again revisited the theme of the Resurrection. **NM**

"Everything has a sort of double meaning for me . . . the ordinary . . . and the imaginary."

ABOVE: Stanley Spencer photographed a few years before he died.

RIGHT: Spencer painted *Shipbuilding on the Clyde: Furnaces* during World War II.

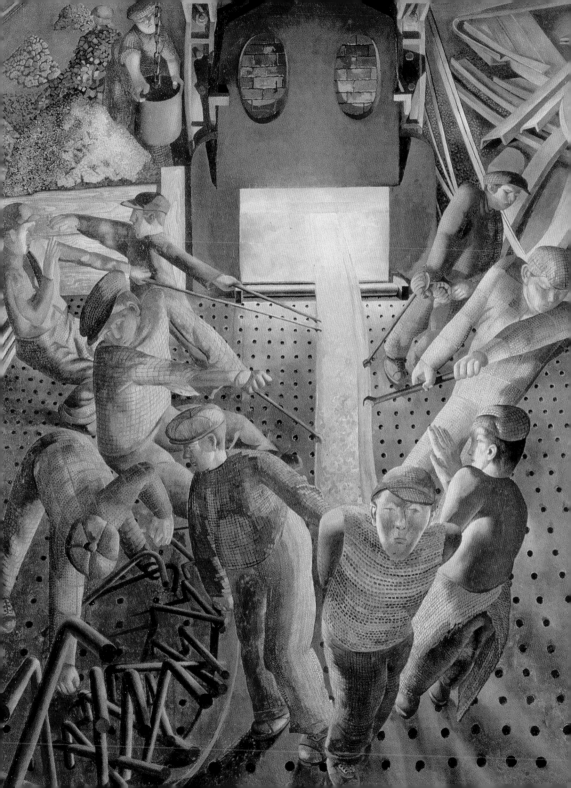

OTTO DIX

Born: Otto Dix, December 2, 1891 (Gera, Germany); died July 25, 1969 (Singen, Germany).

Artistic style: German expressionist; visions of war expressed with brutal realism; social and political commentary; portraits; violent, sexual, and coarse images.

Masterworks

Match Seller 1920 (Staatsgalerie, Stuttgart, Germany)

Prague Street 1920 (Galerie der Stadt, Stuttgart, Germany)

Pimp with Prostitutes 1922 (Private collection)

Homage to Beauty 1922 (Von der Heydt Museum, Wuppertal, Germany)

Metropolis 1928 (Kunstmuseum, Stuttgart, Germany)

Triptych of the War 1929–1932 (Gemäldegalerie Neue Meister, Dresden, Germany)

The Seven Deadly Sins 1933 (Staatliche Kunsthalle, Karlsruhe, Germany)

Otto Dix lived through cataclysmic times in Germany during the first part of the twentieth century and was the creator of socially critical works that reflected this turbulent period. He entered the Hochschule für Bildende Künste Dresden art school in 1910, exerting an impressionist style in his early work as a portrait painter. Both his style and life were to alter drastically with the outbreak of World War I, in which he served as a volunteer soldier, winning the Iron Cross.

The traumatic effects of the war on Dix were played out in expressionist form as he produced a series of works that took the biting reality of contemporary society to absurd extremes. Alongside his friend George Grosz, he was a founding member of the Neue Sachlichkeit (New Objectivity) movement.

Dix was particularly embittered by the treatment of crippled war veterans, as reflected in work such as *Match Seller* (1920), *Prague Street* (1920), and the triptych *Metropolis* (1928), which depict graphic scenes of soldiers with stumps for legs ignored by a decadent Berlin public. He was relentless in the exploration of the darker sides of life through images of violence, death, and prostitution juxtaposed against the constant pleasure seeking of what he saw as a morally redundant Germany. In 1927, he was appointed a professor at the Dresden Academy and elected to the Prussian Academy in 1931. The advent of Nazism led to his removal from these institutions. His works were forbidden from being exhibited; though many were shown at the Degenerate Art Exhibition in 1937. Convicted as part of a plot to kill the Führer, only to be released and later captured by the French, Dix continued his painting after the war, adopting themes of a religious nature in a less frenetic style than that of his Berlin period. **SG**

"Artists should not reform and convert. They are much too low. They should only testify."

ABOVE: Dix painted this self-portrait in 1912, while a student in Dresden.

JACQUES LIPCHITZ

Born: Chaim Jacob Lipchitz, August 22, 1891 (Druskininkai, Lithuania); died May 26, 1973 (Capri, Italy).

Artistic style: Cubist sculptor; biblical and mythological subject matter; bronzes; naturalistic anatomy.

Lithuanian artist Jacques Lipchitz embraced the ideologies of cubism and successfully translated it into sculpture. He is recognized worldwide as the most significant cubist sculptor.

After studying engineering, Lipchitz moved to Paris in 1909 to attend the École des Beaux-Arts and the Académie Julian. There he encountered a number of high-profile avant-garde artists, including Henri Matisse, Amedeo Modigliani, Juan Gris, and Pablo Picasso. In 1912, he exhibited at the Salon National des Beaux-Arts and the Salon d'Automne. Lipchitz began to apply the principles of cubism to three-dimensional space and held his first solo show in Paris in 1920. He then began experimenting with open forms and relationships between solids and space, using ribbons of metal, which he called "transparent sculptures." These led to dynamic bronzes that showed a tendency toward more naturalistic forms. They are perhaps his most recognizable works, characterized by the contorted, entwined composition of the classical or biblical figures and animals that dominate his subject matter.

With the Nazi occupation of France during World War II and the deportation of fellow Jews to Nazi death camps, Lipchitz escaped to the United States in 1941. With nothing but one or two maquettes, he successfully rebuilt his career and became recognized as a pioneer in a new cross-cultural view of art. He was one of the first artists to show links between large, outdoor sculpture and architecture, and the surrounding environment. In 1949, Lipchitz exhibited in the 3rd Sculpture International held at the Philadelphia Museum of Art, Pennsylvania. A retrospective of his work toured the United States in 1954 and his late works include several monumental sculptures. **SH**

Masterworks

Pregnant Woman 1912 (Tate Collection, London, England)

Man with Guitar 1915 (Museum of Modern Art, New York, U.S.)

Reclining Woman 1921 (Tate Collection, London, England)

Seated Bather 1924 (Currier Museum of Art, New Hampshire, U.S.)

The Snuffer 1930 (Tate Collection, London, England)

Hagar in the Desert III 1957 (Von der Heydt-Museum, Wuppertal, Germany)

"Cubism is like standing at a certain point on a mountain It is a point of view."

ABOVE: Jacques Lipchitz, complete with artist's beret, photographed in 1967.

1800-99

MAX ERNST

Born: Max Ernst, April 2, 1891 (Brühl, Germany); died April 1, 1976 (Paris, France).

Artistic style: Dadaist and surrealist painter; hallucinatory, irrational, and absurd imagery; use of non-traditional techniques and materials; inclusion of birdlike figure alter ego.

Masterworks

Celebes 1921 (Tate Collection, London, England)

Two Children Are Threatened by a Nightingale 1924 (Museum of Modern Art, New York, U.S.)

The Virgin Chastises the Infant Jesus before Three Witnesses: André Breton, Paul Éluard, and the Painter 1926 (Museum Ludwig, Köln, Germany)

Oedipus (from a collage novel *A Week of Kindness*) 1934

Europe After the Rain 1940–1942 (Wadsworth Atheneum, Hartford, U.S.)

Capricorn 1948 (Nationalgalerie, Berlin, Germany)

In 1948, Max Ernst began his autobiography with the words: "Max Ernst died the 1st of August 1914. He returned to life on the 11th of November 1918, a young man who wanted to become a magician, and to find the central myth of his age." Ernst did not die in 1914, but he did find the myth of his time through his reinvention of the techniques of frottage, collage, grattage, and decalcomania.

Ernst's four years serving in the German army in World War I made him see the world as absurd. This perception found its

ABOVE: Ernst in 1946 with his painting *The Temptation of St. Anthony.*

RIGHT: A Sudanese corn-bin is transformed into a sinister elephant in *Celebes.*

way into his art, not least in the representation of his alter ego, the birdman Loplop. Ernst said the figure resulted from his childhood confusion between humans and birds and their association with birth and death for him.

Ernst wrote that artists, revolted by the war, attacked aspects of the system that had brought it about, such as logic, language, and painting. With Jean Arp and Johannes Theodor Baargeld, he held the first Cologne Dadaist exhibition in 1920. Designed to shock, it was closed on grounds of obscenity.

Ernst's dreamlike oil painting *Celebes* (1921) was one of the first surrealist paintings. By the time he moved to Paris in 1922, he had started using collage to create apparently nonsensical juxtapositions of objects, culminating in his dark, surreal collage novel *A Week of Kindness* (1934) featuring images taken from Victorian literature, and first published as a series of pamphlets. Forty-nine of his works were shown in the legendary exhibition *Fantastic Art: Dada Surrealism* (1936) at the Museum of Modern Art in New York.

At the outbreak of World War II, Ernst left Paris for the south of France with his partner, Leonora Carrington, but was taken prisoner by the French as an enemy alien, and then pursued by the Nazis. He escaped to the United States with arts patron Peggy Guggenheim, whom he married in 1942. Within two years, he met British painter Dorothea Tanning; they married in 1946, living first in Arizona and then in France. **WO**

ABOVE: Begun in occupied France, *Europe After the Rain* was completed in New York.

Ernst's Techniques

- Collage: Ernst used fragments from book illustrations, advertisements, and photographs to make unsettling images.
- Frottage: Staring at rubbings from floorboards produced a hallucinatory effect evoking strong associations; Ernst developed frottage along this vein.
- Grattage: He scraped away paint to reveal other layers and added texture by using the surface of objects beneath the canvas.
- Decalcomania: Ernst pressed paper or other material onto paint, thus providing a means to investigate chance.

GRANT WOOD

Born: Grant DeVolson Wood, 1892 (Anamosa, Iowa, U.S.); died 1942 (Iowa, U.S.).

Artistic style: Leading proponent of U.S. Regionalism; simplified, idealized landscapes and historical scenes; portraits and figural studies of exaggerated realism inspired by late Gothic painters.

Masterworks

Woman with Plants 1929 (Cedar Rapids Museum of Art, Cedar Rapids, Iowa, U.S.)

American Gothic 1930 (Art Institute of Chicago, Chicago, U.S.)

Young Corn 1931 (Cedar Rapids Museum of Art, Cedar Rapids, Iowa, U.S.)

The Midnight Ride of Paul Revere 1931 (Metropolitan Museum of Art, New York City, U.S.)

Daughters of Revolution 1932 (Cincinnati Art Museum, Cincinnati, US.)

He once described it simply as "an exercise in verticality," but Grant Wood's *American Gothic* (1930), a painting of a stern rural couple (actually the artist's sister and dentist) standing in front of a Carpenter Gothic farmhouse, has become one of the most iconic and parodied images in U.S. art.

Wood was a native of Iowa and a gifted artist and craftsmen in many media, despite being largely self-taught. During the 1920s he made several trips to Europe, and his painting displayed a strong Impressionist influence until, in Munich, he encountered the work of Jan van Eyck and Hans Memling. The visceral clarity of late medieval Gothic painting was revelatory, and Wood determined to apply similar principles to distinctively U.S. milieus. In the 1930s this made him a leading figure of the U.S. regionalist movement, a domestic reaction against the increasing abstractions of European Modernism. Having built a studio in his home town of Cedar Rapids, Wood went on to found the Midwest's first artists' colony, and from 1934 until his death, teach at the University of Iowa's School of Art.

Wood's characteristic paintings of the 1930s were simplified, sensually rounded landscapes—idealized visions of an agrarian U.S. distant from the hard realities of the machine age, the dustbowl and the Depression. Yet he also created tougher and more problematic images, including *American Gothic*. When first exhibited, the painting was generally assumed to be a sly critique of provincial repression, provoking the amusement of metropolitan art critics, and outrage from his fellow Iowans. Gradually, however, it came to be interpreted more as a valediction of the stoical enduring values of the Midwest. Today the enigmatic image is still controversial and entirely overshadows everything else he achieved. **RB**

"It is the depth and intensity of an artist's experience that are the first importance in art."

ABOVE: This is a detail from the only self-portrait that Wood ever painted.

CHAÏM SOUTINE

Born: Chaïm Soutine, 1893 (Smilovichi, Belarus); died August 9, 1943 (Paris, France).

Artistic style: Expressionistic painter of landscapes, portraits, and still lifes; use of intense bold color; psychologically intense yet tender portraits; wild, rhythmic brushwork.

Chaïm Soutine's parents were unhappy with their son's decision to become a painter. In 1912, the young artist left Lithuania and went to live in southern France before finally settling in Paris. While living in absolute poverty, Soutine made use of the Louvre gallery and visited every day to study paintings by artists such as Titian, Jacopo Tintoretto, Gustave Courbet, Paul Cézanne, and Vincent van Gogh. His expressionist style was undoubtedly inspired by these visits, exemplified later in his distorted scene *Landscape with Red Donkey* (1922–1923) and the contemplative *Woman Seated in an Armchair* (1919).

By 1915 Soutine had made several significant friends and useful contacts, including Italian painter and sculptor Amedeo Modigliani, but it was not until 1923 that patrons such as the wealthy American art collector Albert Barnes and interior decorator Madeline Castaing began to purchase his paintings, offering much-needed financial support.

Now in a position to dine in the fanciest of restaurants, Soutine began to paint portraits of the hard working but badly paid staff who now served him, as seen in *Le Pâtissier de Cagnes* (1922–1923) (sold at auction in London for an astonishing £5 million in 2005), as well as controversially painting still lifes from dead pheasants, turkeys, and rabbits. *Carcass of Beef* (1925) pays homage to Rembrandt's *The Flayed Ox* (1655) and is one of Soutine's more gruesome pieces. He can be described as "an artist's artist," and his work influenced many of them: Willem de Kooning, who described Soutine as his favorite artist; Jackson Pollock, whose painting *Scent* (1955) was an homage to Soutine; and Francis Bacon, who claimed to have been dramatically affected by Soutine's paintings when he first saw them in the 1940s. **HP**

Masterworks

Self-Portrait 1916 (The Hermitage, St. Petersburg, Russia)

Woman Seated in an Armchair 1919 (Barnes Foundation, Merion, Pennysylvania, U.S.)

Landscape with Red Donkey 1922–1923 (Private collection)

Le Pâtissier de Cagnes 1922–1923 (Private collection)

Carcass of Beef 1925 (Minneapolis Institute of Art, Minneapolis, U.S.)

"When . . . Chaïm Soutine painted a portrait . . . his father flogged him."—Paul Johnson

ABOVE: Soutine seems melancholy in this detail from an undated *Self-Portrait*.

1800–99

GEORGE GROSZ

Born: Georg Ehrenfried Grosz, July 26, 1893 (Berlin, Germany); died July 6, 1959 (Berlin, Germany).

Artistic style: Dadaist painter and draftsman; caricatures of German society, greed, and violence; political satire; economy of line; grotesque and perverse themes.

Masterworks

Metropolis 1916–1917 (Museo Thyssen-Bornemisza, Madrid, Spain)

Dedication to Oskar Panizza 1917–1918 (Staatsgalerie, Stuttgart, Germany)

Fit for Active Service 1918 (Museum of Modern Art, New York, U.S.)

Beauty, I Wish to Praise Thee! 1919 (Sammlung Karsch, Nierendorf, Berlin, Germany)

The Pillars of Society 1926 (Nationalgalerie, Berlin, Germany)

Painter and draftsman George Grosz had an early taste for the macabre; he read stories about executions, murders, and suicides. Prior to World War I—studying art in Dresden, Berlin, and Paris—he was apolitical, but his experiences in military service resulted in a mental breakdown and changed him completely. After his discharge, Grosz returned to art with a purpose, creating savagely satirical pen-and-ink drawings.

With artists Wieland Herzfelde and Helmut Herzfelde (also known as John Heartfield), Grosz became active in the Berlin Dada movement. He anglicized his name, changing Georg to George, as a gesture against society and German nationalism, and in 1919 he joined the Communist Party.

In *Metropolis* (1916–1917), Grosz attacked those Germans whose behavior he saw as morally indefensible, believing that they were propelling society toward inevitable destruction. His painting shows the corrupt and the ignorant fleeing a city that appears to be an imploding hell on Earth. Soon he was combining caricature with academic realism to attack those in power, targeting nationalists, the press, the clergy, and the military in works such as *The Pillars of Society* (1926). His drawings of the 1920s contain some of his most barbed attacks, and at one point his representations of Christ with a gas mask led to prosecution for blasphemy. Although his political commitment waned as his fame increased, his position became precarious, as did that of all dissident and avant-garde artists when the Nazi Party gained power. In 1932, Grosz moved to the United States with his family, returning in 1959 to Berlin, where he died soon after. In his later years, he came to believe art changes nothing, and his work lost its acerbic quality as he focused on painting nature. **WO**

"My aim is to be understood by everyone. I reject the depth that people demand . . ."

ABOVE: A detail from Grosz's *Self-Portrait, Admonishing* (undated).

RIGHT: *Suicide* (1916) reflects the moral corruption of Berlin during the war years.

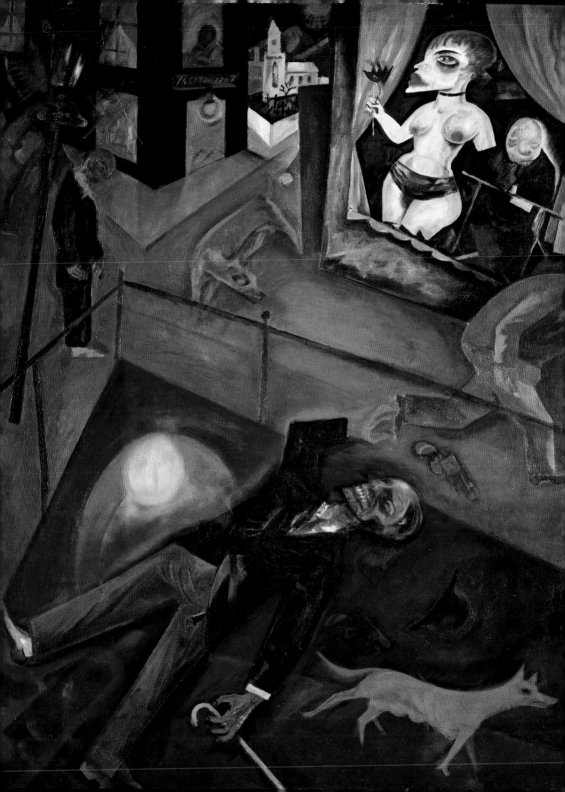

JOAN MIRÓ

Born: Joan Miró i Ferrà, April 20, 1893 (Barcelona, Catalonia, Spain); died December 25, 1983 (Palma de Mallorca, Spain).

Artistic style: Painter, sculptor, and ceramist; bright colors; dreamlike, fluid shapes; floating objects; use of calligraphy; influence of cubism and surrealism.

Masterworks

Vegetable Garden with Donkey 1918 (Moderna Museet, Stockholm, Sweden)

Self-Portrait 1919 (Picasso Museum, Paris, France)

Still Life II (The Carbide Lamp) 1922–1923 (Museum of Modern Art, New York, U.S.)

Person Throwing a Stone at a Bird 1926 (Museum of Modern Art, New York, U.S.)

Rope and People I 1935 (Museum of Modern Art, New York, U.S.)

Blue II 1961 (Musée National d'Art Moderne, Centre Georges Pompidou, Paris, France)

The Gold of the Azure 1967 (Fundació Joan Miró, Barcelona, Spain)

Woman and Bird 1982 (Parc Joan Miró, Barcelona, Spain)

One of the most highly regarded of all Spanish artists, Joan Miró trained at the Francesco Gali Art Academy in his home town of Barcelona. Originally intending to go into business—which he studied alongside art—his life plans changed after he suffered a severe nervous breakdown. His parents, who until this time had been strictly against him becoming an artist, finally gave in and allowed him to pursue the career he had chosen. Influenced by fauvism, cubism, and surrealism, he absorbed various elements of them all and created his own exciting style. His works are characterized by intense bright colors and abstract forms that appear naive but, on closer inspection, are revealed as far more complex and artistic. His body of work includes painting, etching, printing, sculpture, lithography, and calligraphy.

During the 1920s, Miró lived in Paris at the heart of the art world, meeting Pablo Picasso and becoming part of the surrealist movement. He returned to Spain for a few years but left to live in Paris again because of the Spanish Civil War in an attempt to escape fascism. In 1937, his work was exhibited at the Paris World's Fair. After the start of World War II and the Nazi invasion of France, he was forced to flee from fascism once more, and in 1940 returned to Spain. In 1941, an exhibition of his work was held at the Museum of Modern Art in New York, and it enticed him to visit the United States for the first time. In 1956, he moved to Palma in Mallorca, where he had always longed to live. As a young artist in Paris, he was often so poor he could not afford to buy food; being able to buy his dream home on the island affirmed to him how far he had come. There are galleries dedicated to Miró's work in both Barcelona and Mallorca. **LH**

> "Painting or poetry is made as one makes love —a total embrace."

ABOVE: Miró photographed at his studio in Ibiza in 1974.

NORMAN ROCKWELL

Born: Norman Percevel Rockwell, February 3, 1894 (New York, New York, U.S.); died November 8, 1978 (Stockbridge, Massachusetts, U.S.).

Artistic style: Painter and illustrator; detailed Realist style; wholesome, idealistic visions of U.S. life; early works optimistic in tone, and later social commentary.

From the age of fourteen, Norman Rockwell studied at various art colleges in New York. At sixteen, still a student, he painted his first commission of four Christmas cards. By the time he was eighteen, he was a full-time professional illustrator. Four years later, he painted his first cover for the *Saturday Evening Post*, the biggest selling weekly publication in the United States, and during the next forty-seven years he produced 321 covers for the magazine. This gave him a contemporary audience larger than that of any other artist in history.

Rockwell also worked for many other publications, drawing his subjects from everyday American life. His work was extremely popular, anecdotal, and detailed, although critics often dismissed it as sentimental. He was also commissioned to illustrate more than forty books and annual Boy Scouts of America calendars from 1925 to 1976. Among several other great world figures, U.S. Presidents Dwight D. Eisenhower, John F. Kennedy, and Lyndon Johnson sat for him for portraits. Inspired by President Franklin D. Roosevelt's address to Congress, he painted the *Four Freedoms* (1943), which were reproduced in the *Saturday Evening Post*. The works toured the United States in an exhibition sponsored by the *Saturday Evening Post* and the U.S. Treasury Department, raising more than $130 million for the war effort. In 1953, Rockwell moved with his family from Vermont to Massachusetts. From 1963 to 1973, he worked for *Look* magazine, illustrating some of his deepest concerns and interests, including civil rights, the United States' war on poverty, and space exploration. In 1977, Rockwell was awarded the Presidential Medal for Freedom, and in 2001 his work was exhibited at New York's Guggenheim Museum. **SH**

Masterworks

No Swimming 1921 (Norman Rockwell Museum, Stockbridge, Massachusetts, U.S.)

The Four Freedoms 1943 (Norman Rockwell Museum, Stockbridge, Massachusetts, U.S.)

April Fool 1948 (National Museum of American Illustration, Newport, Rhode Island, U.S.)

Triple Self-Portrait 1960 (Norman Rockwell Museum, Stockbridge, Massachusetts, U.S.)

The Golden Rule 1961 (Norman Rockwell Museum, Stockbridge, Massachusetts, U.S.)

"In the city you are constantly confronted by unpleasantness. I find it sordid and unsettling."

ABOVE: Rockwell photographed in 1969 at the Norman Rockwell Museum.

LÁSZLÓ MOHOLY-NAGY

Born: László Weisz, July 20, 1895 (Bácsborsod, Hungary); died November 21, 1946 (Chicago, Illinois, U.S.).

Artistic style: Constructivism; photographic investigations into the effects of light; flat-surfaced paintings; paper collages; wood, metal, and glass sculptures.

Masterworks

Large Railway Painting 1920 (Museo Thyssen-Bornemisza, Madrid, Spain)

All 1924 (Solomon R. Guggenheim Museum, New York, U.S.)

Study with Pins and Ribbons 1937–1938 (Eastman House Museum of Photography & Film, Rochester, New York, U.S.)

Twisted Planes 1946 (Addison Gallery of American Art, Andover, Massachusetts, U.S.)

Born to a family of mixed Jewish and Hungarian heritage, László Weisz changed his German-Jewish surname to that of his uncle, "Nagy," and later added "Moholy" after the town in which he grew up. After serving in World War I, he quit his law studies at Budapest University to study art. He then went to Vienna in 1919, where he first discovered constructivism, and the work of Kasimir Malevich and El Lissitzky.

In 1920, he moved to Berlin, where he met the Dadaists and began to be interested in photography. He started to make collages of juxtaposed colored paper strips and transferred these arrangements into paintings. In 1923, he started work as a teacher at the Bauhaus School of Architecture, Art, and Design, and introduced a constructivist style to the school. He resigned in 1928 and worked in film and stage design for some years in Berlin. Throughout his career, he was innovative in photography, typography, sculpture, painting, and industrial design. He experimented with exposing photosensitive paper with objects overlaid on top of it, inventing the "photogram" that led him to create abstract works.

In 1934, Moholy-Nagy left Germany, fearful of the rise of the Nazi Party. He moved to Amsterdam and then London, where he worked as a photographer and designer. He lived with Bauhaus founder architect Walter Gropius for eight months. They planned to establish a British version of the Bauhaus, but they were unable to secure sufficient backing. In 1937, Moholy-Nagy emigrated to Chicago to become the director of the New Bauhaus. Unfortunately, the school closed after just a year when it lost financial backing. In 1939, he founded his own school of design, which became known as the Institute of Design in 1944. **SH**

"Machines have replaced the transcendental spiritualism of past eras."

ABOVE: Detail from a self-portrait created with watercolor and black chalk.

PAUL OUTERBRIDGE

Born: Paul Outerbridge, Jr., 1896 (New York, U.S.); died 1958 (Laguna Beach, U.S.).

Artistic style: Photographer, illustrator, and graphic designer; innovative use of color photography; erotic, often shocking, female nudes; still-life studies of everyday objects.

Groundbreaking Modernist photographer Paul Outerbridge was a pioneer of color photography. He applied his significant technical skills in the commercial world of advertising and to creating avant-garde works that often featured nude women in what were considered shockingly erotic photographs.

Outerbridge studied at New York's Art Students League from 1915 to 1917 before military service in the British Royal Flying Corps (Canada) and the U.S. Army. In 1921, after working as an illustrator and designer, he enrolled at Clarence H. White's School of Photography. His talents were such that within a year he was having his work published. One of his earliest advertising images, *Ide Collar* (1922), published in *Vanity Fair*, attracted such attention that Marcel Duchamp is said to have torn the black-and-white image of a starched collar out of the magazine and pinned it to the wall in his studio; the photo was also soon on gallery walls, and exhibited in the New York International Salon (1923).

Having gained a reputation as an innovative photographer, in 1925 Outerbridge moved to Paris to work for French *Vogue*; in Paris he met Man Ray and Picasso. Outerbridge returned to New York in 1929, and experimented with color photography, in particular the laborious three-color *carbro* process that allowed him to control hues to create strikingly realistic images. He focused on portraying erotic female nudes such as his fleshy *The Dutch Girl* (1936) as well as alarming surreal images, such as *Woman with Claws* (1937). With his works deemed scandalous, he became disillusioned. In 1943 he moved to Hollywood where he only took photographs on a sporadic basis. Instead, he set up a fashion business, and finally closed his photographic studio in 1945. **CK**

Masterworks

Ide Collar 1922 (Museum of Modern Art, New York, U.S.)

Toy Display (*Circus*) 1924 (Corcoran Gallery of Art, Washington, D.C., U.S.)

The Dutch Girl 1936 (Cleveland Museum of Art, Cleveland, Ohio, U.S.)

Woman with Claws 1937 (Getty Center, Los Angeles, U.S.)

Tools with Blueprint c.1938 (J. Paul Getty Museum Collection, Los Angeles, U.S.)

House Under Construction c.1938 (J. Paul Getty Museum Collection, Los Angeles, U.S.)

1800-99

"The artist is given the privilege of pointing the way and inspiring towards a better life."

ABOVE: Detail from a characteristically unique self-portrait, photographed in 1927.

DAVID ALFARO SIQUEIROS

Born: David Alfaro Siqueiros, December 29, 1896 (Santa Rosalía de Camargo, Chihuahua, Mexico); died January 6, 1974 (Cuernavaca, Morelos, Mexico).

Artistic style: Socialist realist painter, engraver, and lithographer of monumental, heroic, and public art; themes of Mexican identity, oppression, and revolution.

1800-99

Masterworks

Portrait of Mexico Today 1932 (Santa Barbara Museum of Art, Santa Barbara, U.S.)

Collective Suicide 1936 (Museum of Modern Art, New York, U.S.)

Echo of a Scream 1937 (Museum of Modern Art, New York, U.S.)

War 1939 (Philadelphia Museum of Art, Philadelphia, Pennsylvania, U.S.)

For the Complete Safety of All Mexicans at Work 1952–1954 (Hospital de La Raza, Mexico City, Mexico)

The March of Humanity on Earth and Toward the Cosmos 1965–1971 (Polyforum Cultural Siqueiros, Mexico City, Mexico)

Along with Diego Rivera and José Clemente Orozco, David Alfaro Siqueiros spearheaded the Mexican muralist movement. Like them, he was a socialist who sought to depict the troubles and sufferings of his people and establish a national identity for his country after the Mexican Revolution (1910–1921) with his murals for public buildings. Siqueiros was the most radical of the trio. An avowed Marxist all his life, he espoused the idea of "collective art" that would educate the proletariat in his Marxist ideology. He rarely used an easel, deeming it "bourgeois," but preferred commercial and industrial paints and methods, such as enamel paint and a spray gun.

Influenced by indigenous Mexican peoples and travels that saw him exposed to cubism in Paris and Renaissance frescoes in Italy, Siqueiros's work depicts heroic, muscular peasants, and everyday workers struggling against invaders, totalitarian regimes, and capitalist oppressors. His politics led to periods of exile from Mexico in 1932 and 1940, the latter after his part in an assassination attempt on Leon Trotsky. He managed to turn such periods into opportunities by traveling to the United States, where he received commissions for murals for public buildings. Nevertheless his revolutionary spirit was unabated, and from 1960 he spent three years in a U.S. prison for inciting a riot. On his return to Mexico City, he completed his last and largest work, at Polyforum Cultural Siqueiros, the epic *The March of Humanity on Earth and Toward the Cosmos* (1965–1971). The mural fulfills his dream for collective art on a monumental scale—portraying the history of mankind and decorating the building both inside and out. Larger than Michelangelo Buonarotti's Sistine Chapel ceiling, the work was nicknamed the "Capilla Siqueiros." **CK**

"David Alfaro Siqueiros is as peppery as a dish of chili and red as a matador's cape."—*Time*

ABOVE: Siqueiros photographed in Mexico, in front of his work, in 1966.

ANDRÉ MASSON

Born: André-Aimé-René Masson, January 4, 1896 (Balagne-sur-Thérain, Picardy, France); died October 28, 1987 (Paris, France).

Artistic style: Paintings inhabited with semi-legible forms, canvases that have been created using a range of seemingly spontaneous techniques.

While Masson's name is most synonymous with the legacy of surrealism, the artist's oeuvre as a whole encompassed mythological subjects as in *Ariadne's Thread* (1938), quasi-cubist treatments of landscape as in *The Capucin Monastery at Céret* (1919), and lyrical abstraction as in *In the Forest* (1944).

Masson's education began when he was only eleven, when he enrolled at the Royal Academy of Fine Art in Brussels, but his training was profoundly disrupted by World War I. He sustained serious injuries in the Battle of the Somme in 1916 and began to paint again only in 1919. His first significant works of this period entailed forestlike imagery and were notable for their quasi-cubist treatment of space and form.

However, the paintings that Masson produced after this series were perhaps more representative of his contribution to art. Having met André Breton in September 1924, Masson's work was shown in the first exhibition of surrealist painting the following year at the Galerie Pierre in Paris.

With surrealism's desire to make manifest the workings of the unconscious mind, one can see why Masson's paintings were so admired. By adopting a range of automatist techniques, he sought to uncover a more fundamental level of reality. *Battle of Fishes* (1926), for example, is the result of a number of spontaneous techniques, including glue being poured directly onto canvas that is then covered in sand. The fishlike forms that emerge are a direct result of the artist, and, for that matter the viewer, seeing into the painting. Although Masson increasingly sought to differentiate himself from surrealism, what continued to underpin his work was his indomitable belief in the spontaneous gesture and its capacity to reveal certain truths. **CS**

Masterworks

Pedestal Table in the Studio 1924 (Tate Collection, London, England)

Automatic Drawing 1924 (Museum of Modern Art, New York, US.)

Battle of Fishes 1926 (Museum of Modern Art, New York, US.)

Figure 1926–1927 (Museum of Modern Art, New York, U.S.)

Ibdes in Aragon 1935 (Tate Collection, London, England)

In the Forest 1944 (Albright-Knox Art Gallery, Buffalo, New York, U.S.)

Pasiphae 1945 (Museum of Modern Art, New York, US.)

Riez 1953 (Tate Collection, London, England)

Kitchen Maids 1962 (Tate Collection, London, England)

> "No taboo can intervene to drive me to the fixity of one style."

ABOVE: André Masson, photographed in Paris in 1987, shortly before he died.

JOHN BUCKLAND WRIGHT

Born: John Buckland Wright, 1897 (Dunedin, New Zealand); died 1954 (London, England).

Artistic style: Printmaker, engraver, and illustrator; intaglio and etching processes; romantic, lyrical, erotic nudes, nymphs, and classical figures; swirling draperies.

John Buckland Wright played a major role in the revival of the graphic arts that took place in Europe between the two world wars. He came from a middle-class New Zealand background, but from the age of eleven he lived in England, where his family relocated after the death of his father. Said to be quietly courteous, Buckland Wright also proved to be a man of determination and drive. On receiving his inheritance, he abandoned a promising career in architecture and moved to Brussels to teach himself printmaking techniques. This was not the whim of a wealthy dabbler. Buckland Wright went on to attain the status of a master engraver and was instrumental in helping his friend Stanley William Hayter to build the legendary printmaking workshop, Atelier 17, in Paris. The workshop attracted artists such as Pablo Picasso, Henri Matisse, and particularly surrealists, including Max Ernst and Yves Tanguy.

"J. B. W.," as he styled himself, devised a personal aesthetic founded on a plastically expressive line and impeccable composition. He earned acclaim for his book illustrations and especially enjoyed working on the oeuvre of the great poets, such as Homer, Edgar Allan Poe, and John Keats. His prints were strongly romantic, often depicting classical pubescent nudes lounging around in erotically charged natural settings. During World War I, Wright joined the ambulance service and was posted to France, where he was decorated for bravery. But it is said that he was badly affected by his war experiences. His feelings about the ravages of war were expressed in powerful prints such as *London Fire* (1941), depicting the devastation of the London Blitz. From 1948, he taught in London at Camberwell School of Arts and Crafts, and from 1953 at the Slade School of Fine Art. **NG**

Masterworks

Baigneuses Balinaises 1931 (Rare Book Collection, University of Florida, Gainesville, Florida, U.S.)

Metamorphosis No. III 1938 (Auckland Art Gallery Toi O Tāmaki, Auckland, New Zealand)

Forest Pool 1938 (Auckland Art Gallery Toi O Tāmaki, Auckland, New Zealand)

Endymion: A Poetic Romance by John Keats with engravings by John Buckland Wright 1944–1947 (Rijksmuseum, Amsterdam, the Netherlands)

Camber Sands 1953 (Auckland Art Gallery Toi O Tāmaki, Auckland, New Zealand)

"… at his best J. B. W. triumphs with extraordinary lyricism and expressive power."—David Eggleton

ABOVE: This photograph is owned by Wright's son, Chris Buckland-Wright.

RENÉ MAGRITTE

Born: René François Ghislain Magritte, November 21, 1898 (Lessines, Hainaut, Belgium); died August 15, 1967 (Brussels, Belgium).

Artistic style: Surrealist painter; witty and amusing images; bizarre arrangements of often familiar objects set in unfamiliar contexts.

The eldest son of a tailor, Léopold Magritte, and a milliner, Adeline, René Magritte's childhood was shaped by the tragic death of his mother in 1912. Adeline committed suicide by drowning herself in the River Sambre, and Magritte was present during the recovery of her body. The image of his mother floating in the river with her dress obscuring her face may have influenced many of Magritte's paintings, including *The Lovers* (1928), that depict people with cloth obscuring their faces. Magritte rejected this argument.

In 1916, Magritte began his studies at the Académie Royale des Beaux-Arts in Brussels. In 1922, he married Georgette Berger, whom he had first met in 1913. He worked in a variety of jobs, working predominantly as a poster and advertisement designer until, in 1926, he received a contract with Galerie La Centaure in Brussels that enabled him to paint full time.

In the same year, he produced his first surrealist painting, *The Lost Jockey* (1926). This signalled the start of a prolific

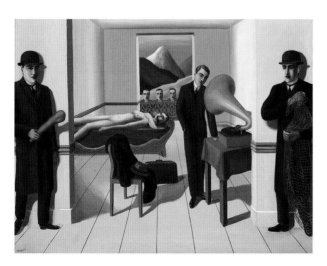

Masterworks

The Menaced Assassin 1927 (Museum of Modern Art, New York, U.S.)

The False Mirror 1928 (Museum of Modern Art, New York, U.S.)

The Lovers 1928 (Museum of Modern Art, New York, U.S.)

The Treachery of Images (*This is Not a Pipe/Ceci n'est pas une Pipe*) 1929 (Los Angeles County Museum of Art, Los Angeles, U.S.)

The Rape (*Le Viol*) 1934 (Menil Collection, Houston, Texas, U.S.)

The Portrait 1935 (Museum of Modern Art, New York, U.S.)

The Listening Room 1952 (Menil Collection, Houston, U.S.)

Golconda 1953 (Menil Collection, Houston, U.S.)

The Empire of Lights 1954 (Museum of Modern Art, Brussels, Belgium)

The Son of Man 1964 (Private collection)

The Carte Blanche (*The Blank Signature*) 1965 (National Gallery of Art, Washington, D.C., U.S.)

ABOVE: Magritte photographed in his trademark bowler hat.

LEFT: *The Menaced Assassin* is a disturbing work, with references to crime fiction.

Influencing Pop Culture

The decade known as the Swinging Sixties is synonymous with the advent and establishment of popular culture. Mass production, technology, and consumerism were new and driving forces for the baby boomer generation. An artist like Magritte, who may previously have been known to only a rarefied section of society, suddenly became accessible to thousands thanks to the mass reproduction of his images on rock album covers.

The Jeff Beck Group was one of the first bands to reproduce Magritte's work, selecting *The Listening Room* (1952) for their 1969 album *Beck-Ola*. Five years later, Jackson Browne's *Late for the Sky* featured artwork that clearly referenced Magritte's *L'Empire des Lumieres*.

Magritte's lasting popularity has not been confined to the music business. The cult American cartoon show *The Simpsons* referred to Magritte's painting *The Son of Man* (1964) in "The Treehouse of Horror IV" episode; and the online video game, "Kingdom of Loathing" features visuals inspired by both *The Son of Man* and *The Treachery of Images* (1929).

Some of the most interesting and memorable spin-offs from Magritte's work can be found in cinema history. The 1992 film *Toys*, *The Thomas Crown Affair*, and *I Heart Huckabees* all contain references to Magritte's *The Son of Man*—the painting that features a man in a bowler hat, his face obscured by an oversized apple.

period for Magritte, and it was not unusual for the artist to produce a painting every day.

He held his first exhibition in Brussels in 1927, but it was panned by the critics. This depressing experience prompted Magritte to leave Brussels for Paris, where he became friends with André Breton and began his involvement with the surrealists. In 1930, Magritte had no choice but to move back to Brussels after his contract with Galerie La Centaure ended and he could not afford to stay in Paris. He remained in Brussels during the Nazi occupation of Belgium in World War II. This led to a break with Breton, who left for the United States in 1941.

Bringing surrealism to the masses

Magritte's work became lighter and more experimental during the mid to late 1940s. He produced comical pastiches of fauvist paintings that were so rough and ready his friends described them as *vache*, meaning "crude" or "cowlike." He was probably reacting to the dark period of the war and actively seeking to throw off the pessimism and violence of his earlier works.

Magritte was also fascinated by posing challenges to the viewer. Although his paintings might contain ordinary, familiar objects, they are frequently displayed in such unexpected contexts they lend new meaning to familiar things. An example of this can be found in *The Treachery of Images* (1929). The work depicts a pipe, yet below the pipe, Magritte wrote the words, "Ceci n'est pas une pipe," meaning "This is not a pipe." Although this may initially seem a contradiction in terms, the words are true. The painting is not a pipe; it is an image of a pipe. Magritte sought to demonstrate that no matter how realistically an artist might portray an item, the resulting work is never the object itself but a representation.

Although Magritte enjoyed success in his lifetime, his fame has been assured by the legacy of his work. Generations of artists and filmmakers have been inspired by his paintings. For example, the two film versions of *The Thomas Crown Affair* (1968 and 1999) refer directly to Magritte's painting *The Son of Man* (1964), which features a man in a bowler hat with his face

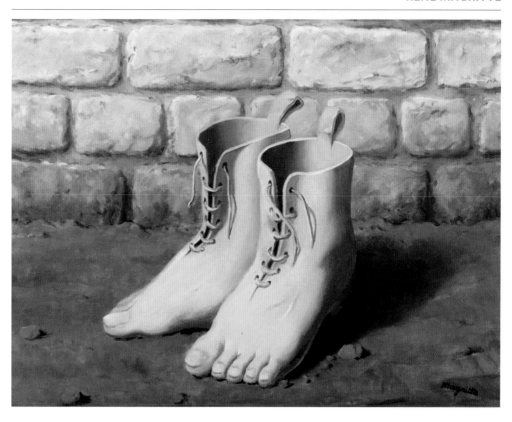

obscured by an oversized apple. Magritte's imagery also became familiar to a wider public thanks to mass production techniques and popular culture. Various music artists have taken images by Magritte for their album covers. For example, the band Styx adopted *The Carte Blanche* (1965) for the cover of the album *The Grand Illusion* (1977). A retrospective of Magritte's work was held at the Museum of Modern Art in New York in 1965, and in 1992, more than twenty years after the artist's death in Brussels in 1967, the Metropolitan Museum of Art also had a posthumous retrospective of the artist's work. **JN**

ABOVE: Another of Magritte's visual riddles, *The Red Model*, painted in 1935.

"I do not literally paint that table, but the emotion it produces upon me."

ALEXANDER CALDER

Born: Alexander Calder, July 22, 1898 (Lawnton, Pennsylvania, U.S.); died November 11, 1976 (New York, U.S.).

Artistic style: Lyrical, suspended mobile sculptures; basic forms and colors; large-scale works of public sculpture that are anthropomorphic in their organic fluidity.

Masterworks

Arc of Petals 1941 (Solomon R. Guggenheim Museum, New York, U.S.)

Glassy Insect 1953 (Museum of Modern Art, New York, U.S.)

Big Crinkly 1969 (San Francisco Museum of Modern Art, San Francisco, U.S.)

Les Flèches 1976 (National Gallery of Art, Washington, D.C., U.S.)

"To most ... a mobile is no more than a series of flat objects that move. To a few, it may be poetry."

ABOVE: A jovial Alexander Calder photographed in 1963.

It is probably not too far fetched to say that Alexander Calder's original training in mechanical engineering enabled him to develop an understanding of form, structure, and balance that informed the making of his sculptures and, in particular, his mobiles. During the early part of his career, Calder remained acutely aware of the artistic currents of the European avant-garde. A number of visits to Paris allowed him to develop his own identity as an artist while exposing him to a number of figures, including the surrealist Joan Miró, who would subsequently influence his own lyrical style of sculpture.

In 1931, Calder joined the group Abstraction-Création, an artists' collective with a number of eminent members, including Piet Mondrian and Wassily Kandinsky. The sculptor's experiments with abstract and kinetic structures in the first few years of the 1930s gradually evolved into a series of "mobiles;" the term was coined by Marcel Duchamp.

Calder's first mobiles could be moved either by hand or by small electric motors. Pieces such as *Untitled* (c.1932) were the development of this discovery to the extent that their movement was generated by air currents. As objects, the mobiles occupied space in a highly distilled, sophisticated manner. They functioned on painterly terms, with a harmonious balance of form, line, and color. Calder's name, though, is not associated with only the mobiles he made: Jean Arp labeled Calder's static sculptural forms "stabiles" because they did not move. However, whatever form Calder's dynamic, responsive sculptures took, the artist brought to the language and tradition of sculpture a new way by which three-dimensional form could be conceived and, more importantly, activated within space. **CS**

TAMARA DE LEMPICKA

Born: Maria Górska, c.1898 (Warsaw, Poland or Moscow, Russia);
died March 18, 1980 (Cuernavaca, Mexico).

Artistic style: Art deco; stylized, precise application of paint; often pure color;
angular lines contrasting against rounded, soft forms; glamorous, elegant subjects.

According to her own account, Tamara de Lempicka (as she later became known) was born in Warsaw in 1898—but she may have been born in Moscow a few years earlier. In 1916 she married Tadeusz Łempicki, a Russian lawyer and socialite, and in 1918, they fled the Russian Revolution for Paris. There she studied art with Maurice Denis and André Lhôte, changed her name, and mixed with the most important and literary figures in Paris at the time. By 1923, she was showing her work at major salons. For her first major show in Milan in 1925, she painted twenty-eight works in six months.

De Lempicka developed a distinctive and bold style, sometimes referred to as soft cubism, that came to embody art deco. Her paintings are carefully composed and her subjects glamorous and elegant. Her occasional nudes in curved, sinuous compositions recall those of Jean-Auguste-Dominique Ingres, and her stylish portraits convey the wealth of her aristocratic sitters. She was soon the most fashionable portrait painter of her generation, painting duchesses, dukes, and socialites in her chic, decadent style. Similar to Fernand Léger's approach, her work is more feminine and it received considerable critical acclaim. She became a social celebrity, famous for her aloof beauty, her parties, and her love affairs with both sexes. In 1939, De Lempicka moved to the United States with her second husband and former patron, Baron Raoul Kuffner, repeating her artistic and social success in Hollywood and New York. However, by the 1950s, her work fell out of fashion. She tried painting in a looser style, but this was coolly received. Interest in her earlier work did not revive until the 1970s, but before she died in 1980, her art was again being greeted with enthusiasm. **SH**

Masterworks

Self-Portrait in Green Bugatti 1925
(Private collection)

Kizette on the Balcony 1927 (Musée National
d'Art Moderne, Paris, France)

Young Girl in Green c.1927 (Musée National
d'Art Moderne, Paris, France)

Spring 1928 (Private collection)

Portrait of Madame M 1930 (Private collection)

Adam and Eve 1932 (Private collection)

Lady in Blue 1939 (Metropolitan Museum
of Art, New York, U.S.)

> "I live life in the margins of society, and the rules of normal society don't apply."

ABOVE: A portrait photograph of Tamara
de Lempicka taken in 1925.

HENRY MOORE

Born: Henry Spencer Moore, July 30, 1898 (Castleford, West Yorkshire, England); died August 31, 1986 (Much Hadham, Hertfordshire, England).

Artistic style: Sculptor, draftsman, and printmaker; exponent of direct carving and abstraction; organic form; monumental public art.

Masterworks

Reclining Figure 1929 (City Art Gallery, Leeds, England)

Recumbent Figure 1938 (Tate Collection, London, England)

Madonna and Child 1943–1944 (Church of St. Matthew, Northampton, England)

Family Group 1948–1949 (Barclay School, Stevenage, England)

Helmet Head I 1950 (Tate Collection, London, England)

Reclining Figure 1957–1958 (UNESCO Headquarters, Paris, France)

Upright Motive No. 9 1979 (Hofstra University Museum, Hempstead, New York, U.S.)

Yorkshire-born Sir Henry Moore was an artist with an affinity for stone. He decided at the age of eleven to become a sculptor. He soon rejected conventional sculptural practice and academic classical principles for direct carving and was influenced by pre-Colombian, Oceanic, and African art. While he excelled in imitating classical models at London's Royal College of Art in the 1920s, he learned at least as much from sketching at the British Museum. In early and non-Western art, he found a sculptural ideal founded on "truth to materials" that explored the artistic possibilities of abstract form and the inherent potential of his materials. He later took inspiration from natural objects such as stones, shells, and bones to make works that resemble landscape forms of hills and caves. Though exhibiting abstract and surreal elements, his work can always be related to the human body, especially to his recurring themes of mothers and children and of reclining figures.

During the 1930s, Henry Moore was an important member of the British avant-garde, joining the Seven and Five Society and Unit One, and taking part in the International Surrealist Exhibition in London in 1936. Moore lived and worked in Hampstead, north London, in close contact with both British and European émigré artists associated with international modernism. While distorting the human figure and introducing radical new forms in sculpture, Moore was always conscious of tradition and concerned for humanity in his works. Both preoccupations are vividly expressed in his drawings of people sheltering in underground tube stations during the Blitz. After World War II, he became internationally recognized for his monumental bronze sculptures that can now be seen in cities across the world. **TA**

"... of equal importance [to abstract design] is the psychological, human element."

ABOVE: Henry Moore photographed near one of his sculptures in 1972.

RIGHT: The commanding and starkly beautiful *The Arch* (1963–1969).

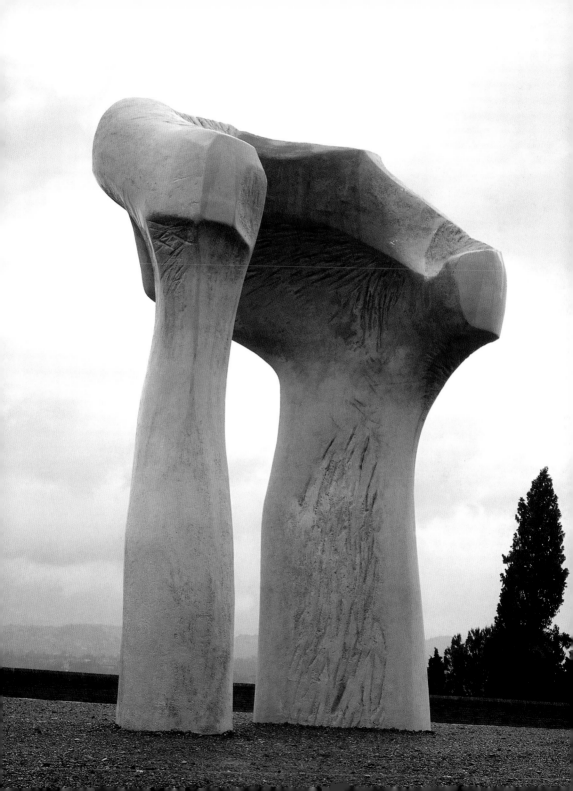

A. J. CASSON

Born: Alfred Joseph Casson, May 12, 1898 (Toronto, Ontario, Canada); died February 20, 1992 (Toronto, Ontario, Canada).

Artistic style: Neat, linear paintings; small Canadian villages and nature scenes; bright, vivacious colors; in later years, abstract two-dimensional patterns.

Masterworks

North Shore, Lake Superior 1928 (Private collection)

Mill Houses 1928 (Agnes Etherington Art Centre, Queen's University, Kingston, Ontario, Canada)

Approaching Storm, Lake Superior, c.1929–1930 (National Gallery of Canada, Ottawa, Canada)

Mill at Elora 1930 (Private collection)

Anglican Church at Magnetawan 1933 (National Gallery of Canada, Ottawa, Canada)

Summer Sun, c.1940 (National Gallery of Canada, Ottawa, Canada)

The White Pine 1957 (McMichael Canadian Art Collection, Canada)

A. J. Casson worked as an illustrator in Toronto with Franklin Carmichael, who invited him to become a member of the Group of Seven. Casson joined their ranks in 1926 but insisted on developing his own style. While the other members strove to represent the clarity, purity, and expansiveness of the Canadian wilderness, Casson produced delicate watercolors and oils of small villages and other rural scenes. In 1925, he founded the Canadian Society of Painters in Watercolour with Carmichael and F. H. Brigden. Inspired by the work of his colleague Lawren Harris, Casson simplified his style in later years and moved toward abstraction, reducing his subjects to two-dimensional patterns. **NSF**

LOUISE NEVELSON

Born: Leah Berliawsky, c.1899 (Kiev, Ukraine); died 1988 (New York, New York, U.S.).

Artistic style: Sculptor; signature sculptures from the 1950s that typically monumental, black, painted, wooden walls comprising stacked, open-faced boxes filled with found objects.

Masterworks

Sky Cathedral 1958 (Museum of Modern Art, New York, U.S.)

Dawn's Wedding Chapel 1959 (Whitney Museum of American Art, New York, U.S.)

An American Tribute to the British People 1960–1964 (Tate Collection, London, England)

Transparent Sculpture II 1967–1968 (Whitney Museum of American Art, New York, U.S.)

Seventh Decade Garden I 1971 (Beyeler Gallery, Basel, Switzerland)

Transparent Horizon 1973 (Massachusetts Institute of Technology, Cambridge, U.S.)

Sculptures in Louise Nevelson Plaza 1979 (New York, U.S.)

Dubbed "the Pharaonic Grande Dame of Sculpture," thanks to her immense false eyelashes, flamboyant dress, and regal air, Louise Nevelson found real acclaim at the age of almost sixty, with a sensational New York show *Moon Garden + One* (1958).

In 1905, Nevelson's family moved from Russia to Maine, where her father had a lumberyard; hence Nevelson's love of wood as a medium. Her early career included assisting Diego Rivera in his New York murals, and bit parts in European movies. After 1958, she produced outdoor sculpture, all-white and all-gold "environments," and experimented with materials such as perspex and steel. She was influenced by constructivism and cubism, and helped to shape modern installation art. **AK**

LUCIO FONTANA

Born: Lucio Fontana, February 19, 1899 (Rosario, Santa Fe, Argentina); died September 7, 1968 (Comabbio, Varese, Italy).

Artistic style: Founder of spatialism; painter and sculptor; monochrome paintings; bright colors; slashed or pierced canvases; sculptural forms evocative of the body.

Rather than continue to use the unconscious as a means to generate imagery and ideas, a number of artists working in postwar Europe adopted other strategies to represent the universality of human experience. Lucio Fontana's contribution to this debate was directed toward rendering the infinite somehow visible.

Born in Argentina, Fontana moved to Milan with his family when he was six. He remained in Italy until 1922 when he and his father, sculptor Luigi Fontana, returned to Argentina and established a sculpture studio. He went back to Milan six years later to study at the Accademia di Brera. His first solo exhibition was held in 1930 at the Gallerie del Milione in Milan.

Fontana experimented with a number of semiabstract styles prior to the outbreak of World War II, but after 1945 he started to develop his ideas in a cogent and methodical way. He began developing a formalized language based on his idea of spatialism. His wish to embrace science and technology, coupled with a need to break out of the confines of the Western pictorial tradition, resulted in a series of works marked by a desire to transform matter into energy and charged by their incursion into the fourth dimension. For example, in *Spatial Concept* (1949–1950), part of his famous *Buchi* series, the horizontal rows of punched *buchi* (holes) did not serve a decorative or compositional purpose but were thresholds to a pictorial and, by extension, transcendental, space that lay beyond the confines of the picture plane.

The significance of the *Buchi* and the *Tagli* (meaning "slashed") series centers on the highly novel way that Fontana managed to create works that tested the boundaries of how pictorial space could be conceived. **CS**

> "His slashes still have the power to open an entirely new perspective on painting."—*Time*

Masterworks

Spatial Concept, Expectations 1959 (Solomon R. Guggenheim Museum, New York, U.S.)

Nature 1959–1960 (Tate Collection, London, England)

Spatial Concept: Expectations 1960 (Museum of Modern Art, New York, U.S.)

Concetto spaziale. La fine di dio 1963 (Fondazione Lucio Fontana, Milan, Italy)

1800-99

ABOVE: Detail from a photograph owned by the Arici Graziano Archivo, taken in 1960.

HENRI MICHAUX

Born: Henri-Eugène-Marie-Ghislain Michaux, May 24, 1899 (Namur, Belgium); died October 18, 1984 (Paris, France).

Artistic style: Calligraphic drawings of "illegible writing;" written meditations upon the process of making; a concern with heightened, altered states of consciousness.

Masterworks

Alphabet 1927 (Private collection)

Narration 1927 (Private collection)

Yellow Figure 1948 (Musée National d'Art Moderne, Paris, France)

Miserable Miracle 1956 (Monaco: Éditions du Rocher, France)

Mescaline Drawing 1958 I (Musée National d'Art Moderne, Paris, France)

The extraordinary output of Belgian-born poet and artist Henri Michaux has so far been uneasily accommodated into histories of twentieth-century art. Famous for his experiments with the hallucinogenic drug mescaline in the 1950s, his glyphic drawings and energizing writings reveal an artist deeply committed to the exploration of altered states of being.

Michaux left Brussels for Paris in 1923 and became involved with a number of prominent artists and writers. Although he began to draw and paint only in a sustained way from the mid-1930s, two early works, *Alphabet* (1927) and *Narration* (1927), introduce concerns that would remain crucial to his subsequent practice. Striving to move beyond the limitations of formalized language, Michaux sought a more liberated means of expression. Employing a kind of "illegible writing," he hoped to register the trembling intensities of his life.

Michaux traveled widely throughout the 1930s, writing extensively and developing his interest in non-Western cultures. Following the death of his wife from horrendous burns in 1948, he executed hundreds of ink drawings at incredible speed. Yet it is for his experiments with mescaline that Michaux is best known. In 1957, he wrote "Mescaline multiplies, sharpens, accelerates, intensifies the inward moments of becoming conscious." The resulting drawings are vibrant congregations of swarming, frenetic marks, appearing as seismographs of the artist's altered experience. Michaux continued to write, exhibit, and travel throughout the next three decades, and influenced a diverse range of creative figures, such as writers Allen Ginsburg and Jorge Luis Borges and rap artist M. C. Solaar. He died in 1984 at the age of eighty-five. **EK**

> "I wanted to draw the consciousness of existing and the flow of time."

ABOVE: An intense-looking Henri Michaux, photographed in c.1960.

RUFINO TAMAYO

Born: Rufino Arellanes Tamayo, August 29, 1899 (Oaxaca, Mexico); died June 24, 1991 (Mexico City, Mexico).

Artistic style: Mexican artist known for his intensely colored, simplistic semiabstract depictions of human figures, animals, and still lifes.

Of Zapotec Indian descent, Rufino Tamayo was born in Oaxaca, Mexico. His parents died when he was young and he was brought up by his aunt in Mexico City, where he spent a lot of time at the National Museum drawing archeological cultural treasures from pre-Colombian Mexico, an experience that was to influence the art he produced for the rest of his life.

Tamayo produced works of stunning simplicity and intense colors, mixing traditional Mexican art with modern European styles, particularly those of Pablo Picasso and Henri Matisse. He produced vivid semiabstract forms, distorted using modernist techniques to make them more expressive. Although popular, the universal nature of the art he produced was heavily mocked by Mexican muralists such as Diego Rivera, José Clemente Orozco, and David Alfaro Siqueiros, who believed Mexican art should continue to depict revolutionary political ideology. So strong was their opposition that Tamayo felt he could no longer stay in Mexico and moved to New York.

Tamayo lived in the United States for a decade, experimenting with various European influences and teaching art at the Dalton School in Manhattan. He was a prolific artist, so much so he described himself as an artistic laborer, sometimes putting in eight hours of painting a day. Eventually, Tamayo was recognized as a great artist and returned to Mexico City a hero. With his wife, he opened the Tamayo Contemporary Art Museum in 1981. The couple donated their collected artworks to the nation. He also built the Museo Rufino Tamayo in Oaxaca. Rufino Tamayo died in 1991, leaving behind him an impressive legacy—from introducing Mexican modernism to the world to inspiring an entire generation of Latin-American artists. **JM**

Masterworks

Landscape 1930 (Art Institute of Chicago, Chicago, U.S.)

Murals 1933 (National Music Conservatory, Mexico)

Mujeres de Tehuantepec (*Women of Tehuantepec*) 1939 (Museum of Modern Art, Mexico City, Mexico)

The Fruit Vendor 1943 (Art Institute of Chicago, Chicago, U.S.)

The Birth of Nationality 1952 (Palace of Fine Arts, Mexico City, Mexico)

America 1955 (Bank of the Southwest, Houston, Texas, U.S.)

Matrimonio 1958 (Biblioteca Luis Angel Arango, Bogota, Colombia)

Prometheus Bringing Fire to Man 1958 (UNESCO building, Paris, France)

"Art is a way of expression that has to be understood by everyone, everywhere."

ABOVE: Tamayo photographed in his studio at the age of eighty-two.

YVES TANGUY

Born: Raymond Georges Yves Tanguy, January 5, 1900 (Paris, France); died January 15, 1955 (Woodbury, Connecticut, U.S.).

Artistic style: Dreamlike landscapes; underwater settings filled with biomorphic shapes; mineral and metallic forms; collaborative "exquisite corpse" drawings.

Recommended works

Mama, Papa is Wounded! 1927 (Museum of Modern Art, New York, U.S.)

Extinction of Useless Lights 1927 (Museum of Modern Art, New York, U.S.)

The Furniture of Time 1939 (Museum of Modern Art, New York, U.S.)

Le Palais Aux Rochers de Fenêtres 1942 (Centre Pompidou, Paris, France)

The Rapidity of Sleep 1945 (Art Institute of Chicago, Chicago, U.S.)

The Invisibles 1951 (Tate Collection, London, England)

A former merchant marine, Yves Tanguy was inspired to paint by an encounter in 1923 with Giorgio de Chirico's painting *The Child's Brain* (1914) in the window of a Paris gallery, and introduced to the surrealist group after stumbling across their manifesto in a bookshop the following year. Although reserved to the point of isolation, he became an important figure in the group, producing works that embodied André Breton's idea of art as an expression of the unconscious. He always professed to adhere to the surrealist method of automatism, eschewing planning or preparation. His paintings conjure the realm of the unconscious in brooding landscapes populated by biomorphic forms, rendered in tiny, meticulous brushstrokes. They recall the megalithic culture of the Finistère region, where he spent childhood holidays, returning there as a young man, accompanied from Paris by his friends writer Jacques Prévert and musician Maurice Duhamel. A trip to North Africa in 1930 further inspired this fascination with unusual rock formations.

In 1939, fleeing the impending war in Europe, Tanguy left France for the United States with painter Kay Sage. In New York, he joined the influential group of exiled surrealists, but later found a more rural setting in Connecticut, where, he said: "I have a feeling of greater space and light here—more 'room.'" He produced larger paintings that included increasingly metallic forms, influenced perhaps by his interest in firearms (he kept a collection of guns) as well as the militaristic imagery that pervaded the U.S. media. Tanguy remained in the United States after the end of the war, although he traveled to Europe frequently. He died in 1955, just as New York's Museum of Modern Art was in the final stages of preparations for his retrospective exhibition. **LB**

"In Yves Tanguy, we have Surrealism's iconographer of melancholy."—J. J. Sweeney

ABOVE: Tanguy photographed in 1938 by French photographer, Denise Bellon.

ALBERTO GIACOMETTI

Born: Alberto Giacometti, October 10, 1901 (Borgonovo, Stampa, Switzerland); died January 11, 1966 (Chur, Graubünden, Switzerland).

Artistic style: Sculptor, painter, draftsman, and printmaker; portraits, still life, and landscape paintings; figurative sculptures sporting elegant, elongated forms.

Because of his interests and friendship with the philosopher and writer Jean-Paul Sartre, Swiss-born Alberto Giacometti was the artist most closely linked with existentialism. He began drawing when he was nine and created his first sculpture at fourteen. His father, Giovanni, was a well-known post-impressionist painter. At eighteen, he studied in Geneva, then toured Italy, sketching and studying classical architecture.

Three years later, Giacometti moved to Paris, where he studied with Antoine Bourdelle, a former pupil of sculptor Auguste Rodin. Until then, Giacometti had revered the baroque and Renaissance masters, but he became inspired by Constantin Brancusi and Jacques Lipchitz and began experimenting with cubism and constructivism. After meeting André Breton in 1930, he joined the surrealists. In 1939, he met Sartre and Simone de Beauvoir, and they became friends. To escape the Nazi occupation of France, he moved back to Geneva during World War II. There he worked from memories of his models, making tiny figurative sculptures.

Giacometti returned to Paris in 1945 and developed his highly original style of sticklike figures, producing bronzes with an irregular finish such as *Walking Man* (1947). The female figures mainly stand, while most male figures seem to be walking, each one ambiguous, mysterious, and unemotional, often with shrunken heads and enormous, rooted feet. These haunting, anguished images have been described as absolute expressions of existentialist pessimism.

Giacometti said that he was rarely satisfied with his work, and would often destroy all he had created at the end of a day. He remained in Paris in the same studio he had occupied in the 1920s until the end of his life. **SH**

Masterworks

Walking Man 1947 (Alberto Giacometti Foundation, Zurich, Switzerland)

Man Pointing 1947 (Tate Liverpool, Liverpool, England)

Piazza 1947–1948 (Guggenheim Museum, New York, U.S.)

L'Homme Qui Marche Sous la Pluie 1948 (Beyeler Foundation Collection, Basel, Switzerland)

Standing Woman I 1960 (Tehran Museum of Contemporary Art, Tehran, Iran)

"Only reality interests me now . . . I could spend the rest of my life in copying a chair."

ABOVE: Giacometti at work on a sculpture in his studio, taken in 1958.

LEN LYE

Masterworks

Universe 1963 (Auckland Art Gallery Toi O Tamaki, Auckland, New Zealand)

Fountain 1963–1976 (Govett-Brewster Gallery, New Plymouth, New Zealand)

Trilogy: a Flip and Two Twisters 1977 (Govett-Brewster Gallery, New Plymouth, New Zealand)

Rain Tree and Earth 1977 (Govett-Brewster Gallery, New Plymouth, New Zealand)

Movies:

A Colour Box 1935 (Collection of the New Zealand Film Archive)

Rainbow Dance 1936 (Collection of the New Zealand Film Archive)

Colour Cry 1952–1953 (Collection of the New Zealand Film Archive)

Born: Leonard Charles Huia Lye, July 5,1901 (Christchurch, New Zealand); died May 15, 1980 (Warwick, Rhode Island, U.S.).

Artistic style: Maker of experimental films and animations; motion and sound sculptures; created abstract patterns and textures on celluloid; South Pacific themes.

Lye is recognized internationally for his pioneering contribution to animated film techniques. During the 1960s, he was also a prominent member of the kinetic art movement. He left New Zealand in 1919, after studying at Canterbury School of Art, yet retained his interest in Maori, Aboriginal, and South Pacific art. He lived in Samoa, Sydney, and London before settling in New York in 1944. Lye experimented with new photographic color processes—painting, stenciling, and scratching directly onto celluloid to create moving imagery with a new sense of rhythm and color. The inclusion of his work in the 1992 Territorium Artis exhibition in Bonn, with that of Pablo Picasso and Marcel Duchamp, is testimony to his enduring importance. **NG**

JEAN DUBUFFET

Masterworks

The Tree of Fluids 1950 (Tate Collection, London, England)

Triumph and Glory 1950 (Guggenheim Collection, New York, U.S.)

Le chien jappeur 1953 (Museu d'Art Contemporani de Barcelona, Barcelona, Spain)

Born: Jean Philippe Arthur Dubuffet, July 31, 1901 (Le Havre, France); died May 12, 1985 (Paris, France).

Artistic style: Art brut painter, lithographer, and sculptor; motifs and imagery drawn from peripheral artistic practices; primitive treatment of the human figure.

In both his art and his life, Jean Dubuffet raged against the societal norms within Western culture. Although other artists working within postwar Paris shared his perception of the dominant culture as both ultraconformist and morally bankrupt, none were as fascinated as Dubuffet by the truths revealed by art brut executed by outsiders, including the insane, prisoners, children, and graffiti artists. He adopted an eclectic range of styles, his oeuvre being marked by a refusal to pander to what was considered tasteful. Instead, Dubuffet's lifelong ambition was driven by the need to uncover, through his art, a more primordial reality that lay hidden beneath the veneer of respectability and social decorum. **CS**

WIFREDO LAM

Born: Wifredo Oscar de la Concepción Lam y Castilla, December 8, 1902 (Sagua La Grande, Cuba); died September 11, 1982 (Paris, France).

Artistic style: Afro-Cuban painter, sculptor, and ceramist; themes of voodoo, ritual, and Santería religion; jungle settings; earthy palette; masklike, hybrid forms.

Wifredo Lam's life was a melting pot of cultural and artistic influences, informing the creation of a style that was uniquely his. Born in Cuba to a Chinese father and Congolese-Cuban mother, Lam lived in Cuba, Spain, France, Martinique, Italy, and the United States. His peripatetic lifestyle saw him study art in the studio of Fernando Alvarez de Sotomayor (director of Madrid's Museo del Prado and Salvador Dalí's former teacher), mix with the cubists and surrealists in 1930s Paris, befriend Picasso and André Bréton, and explore voodoo ritual in Haiti.

Lam drew much from this transatlantic existence, incorporating the developments of contemporary European art into his own, distinctly Afro-Cuban blend of modernism. However far he strayed from his Caribbean homeland, the dominant themes of his work remained its lush jungle, the slave heritage of many of its people, and the iconography of the Santería religion derived from the beliefs of the Yoruba peoples of Nigeria. Santería was adopted by the slaves taken from West Africa to work on Cuba's sugar plantations, and many of Lam's works make references to its spiritual figures.

Lam said he wanted to depict the drama of his country, and his breakthrough piece *The Jungle* (1943) did just that, causing a stir when it was exhibited in New York. The painting shows a moonlit jungle populated by cubist masked figures who are half-human and half-beast, and who peer out accusingly out at the viewer from among the foliage of the surrounding sugar cane. At a time when European art was looking to Africa, Lam drew attention to Cuba's African heritage, all the while nodding to the culture of empire and commercialism that had formed the basis of the slave trade and caused the dislocation of millions. **CK**

Masterworks

Mother and Child 1939 (Museum of Modern Art, New York, U.S.)

Satan 1942 (Museum of Modern Art, New York, U.S.)

The Jungle 1943 (Museum of Modern Art, New York, U.S.)

Rumblings of the Earth 1950 (Solomon R. Guggenheim Museum, New York, U.S.)

Zambezia, Zambezia 1950 (Solomon R. Guggenheim Museum, New York, U.S.)

Ibaye 1950 (Tate Collection, London, England)

"I wanted with all my heart to paint the drama of my country."

ABOVE: This photograph of the artist was taken by Gjon Mili.

ABOVE: Mark Rothko photographed in his New York apartment in 1967.

RIGHT: *Untitled* (1960–1961) was painted at the height of his success.

MARK ROTHKO

Born: Marcus Rothkowitz, September 25,1903 (Daugavpils, Latvia; then Russia); died 25 February, 1970 (New York, U.S.).

Artistic style: Abstract expressionist painter and printmaker; colorist extraordinaire; aspects of surrealism; bold blocks of color and texture.

Mark Rothko, one of the world's greatest colorists, directly affected the future of abstract and modern art. He was born in what is now Latvia to Jewish parents, although the family emigrated to the United States in 1913. A brilliant academic, Rothko went to Yale University in 1921, then studied at New York's Art Students League under Max Weber.

In 1928, he exhibited for the first time, but fame was slow in arriving and his principal earnings for many years came from teaching art. His painting was influenced by Milton Avery's bold use of color, which Rothko took to exciting new depths and richness. Believing modern painting was at a dead end, he explored form, space, and color rather than representational subjects. In 1935, he helped found the Ten, artists sympathetic to abstraction and expressionism. He experminented with a surrealist style inspired by mythological fables and symbols; he also turned his hand to writing.

Fearing the growing Nazi influence in Europe, in 1938 he became a U.S. citizen and, in 1940, changed his name from Marcus Rothkowitz to Mark Rothko. That year he helped found the Federation of Modern Painters and Sculptors, intended to keep art free from political propaganda. After 1943, his friendship with abstract artist Clyfford Still influenced the development of Rothko's Color Field paintings. Large, ambiguous rectangles and hazy divisions of color convey a swathe of emotions, from despair to rapture. In the late-1940s, he began moving toward a totally abstract style, eliminating all representational figures from his work. In 1961, he finally achieved success and was given a major retrospective exhibition at MoMA in New York. In 1970, however, he committed suicide in his New York studio. **SH**

Masterworks

Slow Swirl at the Edge of the Sea 1944 (Museum of Modern Art, New York, U.S.)

Untitled (Purple, White, and Red) 1953 (Art Institute of Chicago, Chicago, U.S.)

Light Red over Black 1957 (Tate Collection, London, England)

No. 1/No. 1 1964 (Kunstmuseum, Basel, Switzerland)

Untitled (Black on Grey) 1969–1970 (Solomon R. Guggenheim Museum, New York, U.S.)

"I am not an abstract painter. . . I care about . . . the expression of man's basic emotions."

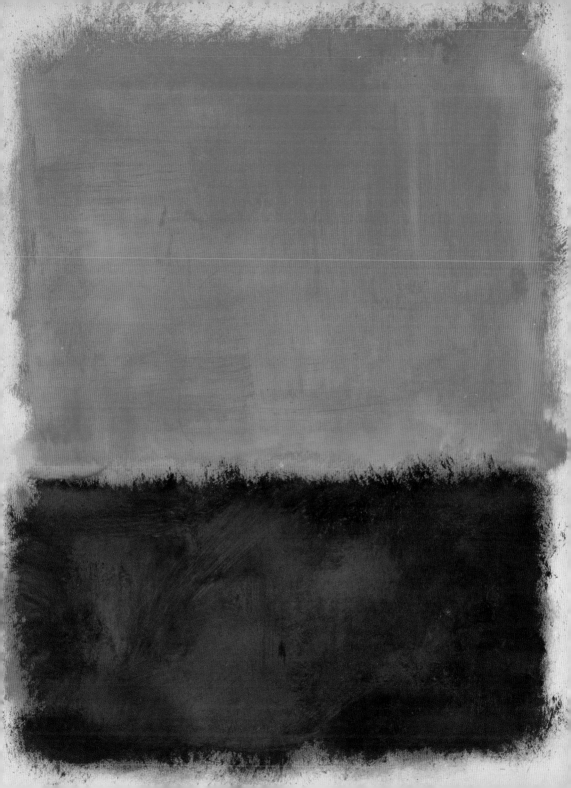

BARBARA HEPWORTH

Born: Jocelyn Barbara Hepworth, 1903 (Wakefield, West Yorkshire, England); died 1975 (Trewyn, Cornwall, England).

Artistic style: Abstract sculptures in bronze, marble, stone, and wood; often organic shapes on a large scale, and placed in a natural environment.

Masterworks

Infant 1929 (Tate Collection, London, England)

Kneeling Figure 1932 (Wakefield Art Gallery, Wakefield, England)

Mother and Child 1934 (Tate Collection, London, England)

Three Forms (Carving in Grey Alabaster) 1935 (Tate St. Ives, St. Ives, England)

Stringed Figure (Curlew), Version II 1956 (Tate St. Ives, St. Ives, England)

Single Form 1964 (United Nations Headquarters, New York, U.S.)

Dame Barbara Hepworth trained in sculpture at Leeds School of Art then at London's Royal College of Art. Together with sculptor Henry Moore, whom she met at Leeds, and her second husband, painter Ben Nicholson, Hepworth helped spearhead British abstraction in the 1930s. She was notable for her pioneering use of negative space, which she achieved by piercing her stone and wood sculptures. During World War II, Hepworth and Nicholson moved to St. Ives in Cornwall, where her work took on a larger scale and she started to make bronze sculptures. She and her husband, with painter Peter Lanyon, helped put the colony of St. Ives artists on the map by establishing the Penwith Society of Artists in 1949. **CK**

AARON SISKIND

Born: Aaron Siskind, 1903 (New York, New York, U.S.); died 1991 (Providence, Rhode Island, U.S.).

Artistic style: Urban social-documentarian; pioneer of abstract expressionism; found objects, architecture, isolated figures; distressed textures and surfaces.

Masterworks

Band at the Savoy Ballroom, Harlem Document 1937 (Smithsonian American Art Museum, Washington D.C., U.S.)

Gloucester 16 1944 (Museum of Contemporary Art, Los Angeles, U.S.)

Chicago 22 1949 (Cleveland Museum of Art, Cleveland, U.S.)

New York 2 1951 (Art Institute of Chicago, Chicago, U.S.)

Terrors and Pleasures of Levitation, No. 37 1953 (Eastman House Museum of Photography and Film, Rochester, U.S.)

Rome 150 (Homage to Franz Kline) 1973 (Museum of Contemporary Art, Los Angeles, U.S.)

Peru 129 1983 (Cleveland Museum of Art, Cleveland, U.S.)

Aaron Siskind became interested in photography in 1929, after receiving a camera as a honeymoon present. In the following decade he joined the New York Photo League, and created several acclaimed series documenting life in deprived areas of the city. During the 1940s, however, Siskind's work underwent a transformation: he began to produce tightly cropped close-ups of discarded objects, graffiti, and scoured, distressed surfaces. These placed him in the forefront of the emerging abstract expressionist movement, and he exhibited in the Charles Egan Gallery alongside Willem de Kooning and Franz Kline. From the 1950s he traveled widely and was recognized as one of the most influential figures in the field. **RB**

ARSHILE GORKY

Born: Vostanik Manoog Adoyan, April 15, *c.*1904 (Khorkom, Van, Turkey); died July 21, 1948 (Sherman, Connecticut, U.S.).

Artistic style: Abstract painter; early landscapes and portraits in Cubist and Surrealist style; coalescing biomorphic, curvilinear forms; use of vivid color.

The life of painter Arshile Gorky was typical of that of a struggling artist: wracked by poverty and upheaval, driven by a rampant self-belief, and with a tragic end. Yet Gorky's career is also a success story. He was an immigrant to the United States and his influence on the country's art was enormous. His lyrical abstract canvases, inhabited by brightly colored floating biomorphic shapes reminiscent of those of Joan Miró and Wassily Kandinsky, arrived on the cusp of the abstract expressionist movement, and inspired artists of the New York School, including Willem de Kooning, Lee Krasner, Jackson Pollock, Mark Rothko, Philip Guston, and Barnett Newman.

Born in what was then Armenia, Gorky's father left for the United States in 1910 to avoid military service. When the Turks invaded Armenia in 1915, Gorky fled with his mother and sister to escape the ensuing ethnic cleansing of Armenians. In 1919 his mother died of starvation, and Gorky emigrated to the United States a year later when he was only sixteen years old.

Masterworks

*The Artist and His Mother c.*1926–*c.*1942
(National Gallery of Art, Washington, D.C., U.S.)

*Nighttime, Enigma and Nostalgia c.*1931–1932
(Whitney Museum of American Art, New York, U.S.)

Painting 1936–1937 (Whitney Museum of American Art, New York, U.S.)

Garden in Sochi 1941 (Museum of Modern Art, New York, U.S.)

Waterfall 1943 (Tate Collection, London, England)

One Year the Milkweed 1944 (National Gallery of Art, Washington, D.C., U.S.)

The Liver is the Cock's Comb 1944 (Albright-Knox Art Gallery, Buffalo, New York, U.S.)

Untitled 1944 (Peggy Guggenheim Collection, Venice, Italy)

The Leaf of the Artichoke Is an Owl 1944 (Museum of Modern Art, New York, U.S.)

Water of the Flowery Mill 1944 (Metropolitan Museum of Art, New York, U.S.)

Diary of a Seducer 1945 (Museum of Modern Art, New York, U.S.)

Agony 1947 (Museum of Modern Art, New York, U.S.)

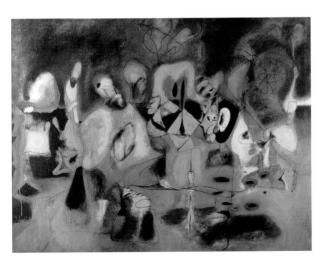

ABOVE: Armenian-born Arshile Gorky was a significant figure in abstract expressionism.

LEFT: The gray palette of *Diary of a Seducer* suggests a darker period in the artist's life.

1900–09

Fact or Fiction?

Gorky was notorious for embellishing the truth. He was quixotic regarding the year of his birth, which he frequently shifted by a few years. When he went to the United States, he changed his Armenian name to one that sounded more Russian and even claimed that he was a cousin of the writer Maxim Gorky. Perhaps nowhere is the artist's high hopes, and possible state of desperation, more evident than on a submission form held at the Gorky archive at the Frances Mulhall Achilles Library in New York's Whitney Museum of American Art. It was completed in the autumn of 1937 by the artist in response to an invitation by the museum to its Annual Exhibition of Contemporary American Painting. The invite was an important opportunity for Gorky to show his work and achieve the recognition he craved.

In response to the question regarding place of birth, he wrote, "Tiflis, Georgia, Russia," perhaps thinking Tiflis, now known as Tbilisi, would be more acceptable than citing the obscure Turkish village of his birth. For the question "Where studied," as well as listing educational institutions where he had studied, he added an extra one, "Providence, Rhode Island." Completing the open-ended section "Additional data," Gorky sold himself thus: "Have submitted works in every important exhibition of contemporary American and European art in New York City. . . . Taught seven years at Grand Central Art School." His most poignant flourish was his reply to the demand to list any prizes or awards received: "Not yet."

The tragedy and suffering he experienced are themes that feature in his work—for example, in paintings such as *The Artist and His Mother* (*c*.1926–*c*.1942), which shows the young Gorky standing beside his seated mother in what may have been a real or an imaginary idyllic past.

Gorky first lived in New England and studied at the New School of Design in Boston. In 1925, he moved to New York, changed his name to Arshile Gorky, and continued his studies at New York's Grand Central School of Art. The move to New York saw Gorky exposed to the work of modern European artists such as Paul Cézanne, Pablo Picasso, Georges Braque, and Miró, and his early work shifts from a cubist to a surrealist style, leading to some criticism that it was derivative. Although known as something of a loner, Gorky began mixing with New York's avant-garde, in particular painters Stuart Davis, John Graham, and de Kooning, with whom he was sharing a studio by the late 1930s.

Slowly but surely

Gorky often struggled to make ends meet and he was frequently helped out by friends and patrons. As the 1930s progressed, he slowly began to get his work shown and, in 1934, he had his first solo show at Mellon Galleries, Philadelphia. He also supported himself by working as a muralist for the WPA Federal Art Project from 1935 to 1939.

During the 1940s, the artist came into his stride and received increasing recognition from important New York galleries, such as the Whitney Museum of American Art and the Museum of Modern Art. The decade saw him produce his most famous works, including *Garden in Sochi* (1941), *Waterfall* (1943), *One Year the Milkweed* (1944), and *The Liver is the Cock's Comb* (1944). Perhaps aided by periods spent in the country in Virginia and Connecticut, his works seem almost abstract pastorals, with a color palette like a field of coalescing flowers and floating biomorphic shapes that lyrically meld and fuse into one another. Gorky also received a major endorsement in 1945 when surrealist poet André Breton hailed him as part

1900–09

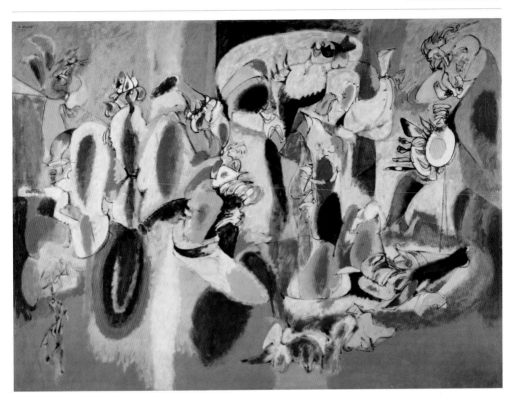

ABOVE: *The Liver is the Cock's Comb* is, arguably, Gorky's most important painting.

of the international surrealist movement and he received a favorable review from influential art critic Clement Greenberg.

However, just as Gorky's career was on the rise, his personal life took a nosedive. In January 1946, a fire destroyed his studio in Connecticut and approximately thirty of his paintings; then a month later he was diagnosed with intestinal cancer and had to undergo surgery. His ensuing depression is evident in the somber red and brown palette of his work *Agony* (1947). In June 1948, he suffered a broken neck in an automobile accident that left his painting arm temporarily paralyzed. His wife left him, taking their two children and, in July of that year, Gorky hanged himself in a barn. **CK**

"I communicate my innermost perceptions through art . . . my world view."

JEAN HÉLION

Born: Jean Hélion, April 21, 1904 (Couterne, Normandy, France); died October 27, 1987 (Paris, France).

Artistic style: French painter of abstract compositions that hint at reality in his early career; representational but surrealistic paintings in his later years.

Masterworks

Balance 1933 (Hamburger Kunsthalle, Hamburg, Germany)

Composition in Color 1934 (San Diego Museum of Art, U.S.)

Île de France 1935 (Tate Collection, London, England)

Défense D' 1943 (Galerie Daniel Malingue, Paris, France)

À Rebours (The Wrong Way) 1947 (Musée Nationale d'Art Moderne, Centre Georges Pompidou, Paris, France)

The Golden Mannequin Shop 1951 (Galerie Daniel Malingue, Paris, France)

"A mature artist is . . . aware of the futility of his achievement and the validity of the pursuit."

ABOVE: The viewer is drawn to the artist's eyes in this detail from Hélion's *Self-Portrait*.

Born in Normandy, Jean Hélion escaped a provincial background to study chemistry in Lille but soon left chemistry behind to become an architectural draftsman. Architecture in turn yielded to painting, but he retained the eye of a draftsman. During the 1930s, he was concerned with translating the architectural concepts of volume and mass into pictorial form.

Hélion depicted a parallel universe of abstract shapes, carefully shaded to balance and complement one another in color, form, and placement in space, producing images that evoke feelings of familiarity but defy complete recognition. Hinting at a lampshade here and an armrest there, *Composition in Color* (1934) and *Île de France* (1935), for example, bring to mind an art deco living room.

Hélion himself realized that complete abstraction eluded him because reality would always manage to intrude in some way. Nevertheless, as a founder member of the Abstraction-Création group formed in Paris in 1931, he traveled widely, befriending and encouraging abstract artists in Britain, Europe, and the United States, where he settled after his marriage. Reality broke out again in the shape of World War II, which motivated Hélion to enlist as a soldier in his native France. He was captured and sent to a Nazi prison camp. The irrepressible Hélion managed to escape in 1942 to return to the United States, but he had lost interest in abstraction. Even in this apparent *volte-face*, he remained true to his original artistic ideals. Human forms are evenly balanced in *À Rebours (The Wrong Way)* (1947), while unexpected surrealist details break through an apparent depiction of reality. Humorous and elusive, Hélion defies categorization—an escape artist in every sense. **SC**

ISAMU NOGUCHI

Born: Isamu Gilmour, November 17, 1904 (Los Angeles, California, U.S.);
died December 30, 1988 (New York, U.S.).

Artistic style: Sculptor, designer, and architect; explored organic forms through
wood, stone, and metal; shaper of public and private spaces, including gardens.

Isamu Noguchi described himself as "belonging to that increasing number of not exactly belonging people." Throughout his life, he embodied a fusion of diverse ethnic, cultural, and creative identities.

Born the son of an Irish-American writer and Japanese poet, Noguchi spent his childhood in Japan and the United States. A burgeoning interest in sculpture was rewarded in 1927 with a John Simon Guggenheim Fellowship to study in Paris, where he became enthralled with surrealist art and assisted the great modernist sculptor Constantin Brancusi. On his return to New York, Noguchi found the city unreceptive to European-style abstraction, so he concentrated on portrait-bust commissions. After a long sojourn in China and Japan, his childhood admiration for the simple forms of Zen gardens was rekindled, and he began designing public monuments and gardens. His first widely acclaimed piece, a massive art deco, stainless-steel bas-relief, was unveiled at Rockefeller Center in 1940.

During the 1940s, Noguchi worked hard to diffuse anti-Japanese sentiment while building a reputation for innovative industrial and interior design. Working in a sculptural organic style, he was responsible for many enduringly popular wooden furniture pieces. After World War II, he returned to Japan and helped to rejuvenate the economy with his famous designs for *Akari* (1951–1988), folding light lamps made from mulberry paper and bamboo. Noguchi went on to consolidate his status as one of the great shapers of the physical environment. Set designs, monuments, fountains, and gardens appeared worldwide that were eloquent marriages of *wabi-sabi* (sad beauty), Zen Buddhist aesthetics with the demands of a modern, secular age. **RB**

Masterworks

News 1940 (Rockefeller Center, New York, U.S.)

Contoured Playground 1941 (Noguchi Museum, Long Island City, New York, U.S.)

Garden 1956–1958 (UNESCO Headquarters, Paris, France)

Gift 1964 (Noguchi Museum, Long Island City, New York, U.S.)

Red Cube 1968 (HSBC Building, New York, U.S.)

Bolt of Lightning . . . A Memorial to Benjamin Franklin 1984 (Franklin Square, Philadelphia, U.S.)

Black Slide Mantra 1988–1990 (Odori Park, Sapporo, Hokkaido, Japan)

"Any material, any idea without hindrance born into space, I consider sculpture."

ABOVE: Isamu Noguchi photographed in New York in 1978.

SALVADOR DALÍ

Born: Salvador Domingo Felipe Jacinto Dalí y Domènech May 11, 1904 (Figueras, Spain); died January 23, 1989 (Figueras, Spain).

Artistic style: Surrealist images exploring the subconscious; extensive use of symbolism; barren and bright landscapes; eroticism; religious and scientific themes.

Masterworks

The Enigma of Desire 1929 (Staatsgalerie Moderner Kunst, Munich, Germany)

Partial Hallucinations: Six Apparitions of Lenin on a Grand Piano 1931 (Musée National d'Art Moderne, Paris, France)

The Persistence of Memory 1931 (Museum of Modern Art, New York, U.S.)

The Enigma of William Tell 1933 (Moderna Museet, Stockholm, Sweden)

Portrait of Gala 1935 (Museum of Modern Art, New York, U.S.)

Soft Construction with Boiled Beans 1936 (Philadelphia Museum of Art, Philadelphia, U.S.)

Autumnal Cannibalism 1936 (Tate Collection, London, England)

The Face of War 1940 (Boymans-van-Beuningen Museum, Rotterdam, the Netherlands)

Leda Atomica 1949 (Teatro-Museo Dalí, Figueras, Spain)

The Sacrament of the Last Supper 1955 (National Gallery of Art, Washington, D.C., U.S.)

Few artists have left a greater imprint on the twentieth century than Salvador Dalí, who trailblazed a colorful path through the art world—his work instantly recognizable, his eccentricities legendary. He attended the Real Academia de Bellas Artes de San Fernando in Madrid, where he first experimented with cubism and entered Madrid's avant-garde circle. He befriended poet Federico García Lorca and filmmaker Luis Buñuel, with whom he would make the controversial movie *Un Chien Andalou* (*An Andalusian Dog*) (1929).

Dalí traveled to Paris and joined the surrealist movement. The group of artists and writers—led by former dadaist, André Breton—rejected ideas or images that were susceptible to rational thought and looked toward people's subconscious for inspiration. Dalí's methods involved inducing himself into a hallucinatory state, a process he termed "paranoiac critical activity," in order to access the subconscious mind for images. His paintings depicted a dream world in which everyday objects metamorphose in an illogical manner, set within a

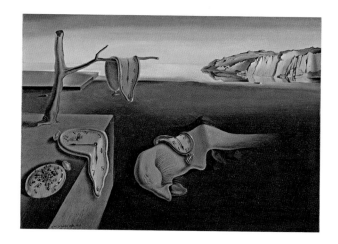

ABOVE: Dalí's inimitable moustache has become as much of an icon as his art.

RIGHT: The imagery of melting clocks in *The Persistence of Memory* is quintessential Dalí.

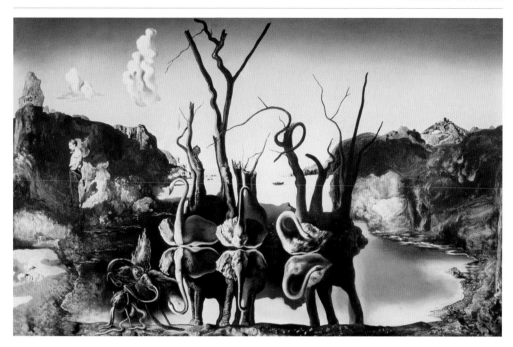

barren, sunlit landscape. This clash of the recognizable placed within an indecipherable context brought Dalí's work to the attention of the art world, especially in works such as *The Persistence of Memory* (1931), in which melting pocket watches are draped across a deserted landscape.

Dalí was ousted from the surrealist movement after refusing to follow their Marxist beliefs. He moved to the United States in 1940, receiving his first retrospective exhibition at the Museum of Modern Art in New York in 1941. There he spent much of his time working in film, theater, fashion, and advertising. Dalí admitted that the use of the atomic bomb in World War II "sent a seismic shock through me." His subsequent work gravitated toward a more academic style preoccupied with science, mysticism, and religion. Christian iconography dominated his paintings, though he continued to explore erotic subjects. His later works received a mixed public reaction, yet included masterpieces such as *Tuna Fishing* (1966–1967). **SG**

ABOVE: *Swans Reflecting Elephants* (1937) includes a portrait of its first owner.

Dalí in Hollywood

When movie director Alfred Hitchcock required a designer for a dream sequence in his psychoanalytical thriller *Spellbound* (1945), one name sprang to mind. The chance to join the ultimate dream factory was one Dalí could not ignore. He worked tirelessly with Hitchcock to create four scenes involving rooftops, pyramids, a ballroom, and a gambling scene in which a pair of oversized scissors cuts through an eye painted on a curtain. However, much of Dalí's scheme was dropped to eliminate costs, leading the artist to feel it was his name, rather than his nightmares, that was really in demand.

WILLEM DE KOONING

Born: Willem de Kooning, April 24, 1904 (Rotterdam, the Netherlands); died March 19, 1997 (East Hampton, Long Island, New York, U.S.).

Artistic style: Abstract expressionist painter; overtly figurative elements; brutal brushwork; clashing colors.

From 1916 for eight years, Willem de Kooning studied fine and applied art at night at the Academie voor Beeldende Kunsten en Technische Wetenschappen in Rotterdam while apprenticed to a commercial art and decorating company during the day. He then spent two years studying in Brussels and Antwerp before leaving Europe to settle briefly in New Jersey, where he worked as a house painter.

During the late 1920s and 1930s, de Kooning developed friendships with fellow painters Stuart Davis, John Graham, and Arshile Gorky and painted several murals for the Federal Arts Project before devoting himself full-time to a career as an artist in 1936. From then on, his fairly conservative work became more vigorous and avant-garde. In the late 1930s, his abstract art, as well as his figurative work, was primarily influenced by Pablo Picasso's cubism and surrealism and also by the work of Gorky, with whom he shared a studio in Manhattan. In 1938, probably under the influence of Gorky, he

Masterworks

Woman, I 1950–1952 (Museum of Modern Art, New York, U.S.)

Two Figures in Landscape 1968 (National Gallery of Australia, Canberra, Australia)

Red Man with Moustache 1971 (Thyssen-Bornemisza Museum, Madrid, Spain)

Untitled XII 1983 (Walker Art Center, Minneapolis, Minnesota, U.S.)

ABOVE: Willem de Kooning photographed after his move to Long Island.

RIGHT: *Two Women's Torsos* is a pastel work painted between 1952 and 1953.

embarked on a series of male figures while simultaneously starting a more purist series of lyrically colored abstractions.

During the postwar years, de Kooning painted in an extremely energetic and abstract style, similar to that of his contemporary Jackson Pollock. Of his own work, de Kooning said, "I might work on a painting for a month, but it has to look like I painted it in a minute." His first solo show, of black-and-white abstract paintings, was held in New York in 1948 and established his reputation as one of the leaders of the abstract expressionist movement.

Sensational women

Unlike that of Pollock, however, most of de Kooning's work retained some figuration, and in 1953 he caused a sensation when his *Women* series was shown at his third solo exhibition. The public were affronted by the grotesque depictions of women, and critics were disappointed by the inclusion of figurative elements in abstract art. Women continued to be a major recurrent theme in de Kooning's work, though. Their harsh, angular forms are rendered with slashing strokes and dripping paint, remarkable in their stark contrast to traditional representations of women in art as sensual, goddesslike beings.

In 1963, de Kooning moved to Long Island. The women and figures in his landscapes from the 1960s, with their lighter colors and less frenzied brushstrokes, were inspired by the light and water that surrounded him on Long Island. Toward the end of the decade, his creativity was considered by some to be waning. However, he continued to paint but also began to experiment with sculpture. In Rome in 1969, he executed his first figures, modeled in clay and later cast in bronze. He followed this with a series of life-size figures.

In 1975, after exploring the medium of sculpture, de Kooning began a new series of dense, richly colored abstract paintings. His late work consists of calligraphic, predominantly white canvases that demonstrate his synthesis of figuration, abstraction, painting, drawing, color, and line. **SH**

ABOVE: Between 1950 and 1952, de Kooning worked on several versions of *Woman, I.*

1900–09

Violent Women

De Kooning's paintings of women have been debated since he first exhibited them in 1953. His bulky, intimidating figures draw upon a combination of female archetypes, from ancient fertility goddesses to contemporary glamour models, challenging established traditions. Features are heightened by aggressive brushwork and frenzied paint marks. Combining voluptuousness and menace, they seem to represent both reverence for and fear of the power of women. Yet each work is planned and carefully executed, built up with streaks of thick paint in clashing colors.

BARNETT NEWMAN

Born: Barnett Newman, January 29, 1905 (New York, U.S.); died July 4, 1970 (New York, U.S.).

Artistic style: Painter of large-scale, monochromatic works; paintings often include series of vertical lines that traverse the entire height of the canvas.

Masterworks

Onement, I 1948 (Museum of Modern Art, New York, U.S.)

Eve 1950 (Tate Collection, London, England)

Vir Heroicus Sublimis 1950–1951 (Museum of Modern Art, New York, U.S.)

Adam 1951–1952 (Tate Collection, London, England)

ABOVE: A photographic portrait of Barnett Newman from the 1960s.

BELOW: *Vir Heroicus Sublimis* **translates as "Man, Heroic and Sublime."**

In an interview with historian Dorothy Gees Seckler in 1969, Barnett Newman asserted that if his paintings were genuinely understood, then it would signal "the end of state capitalism and totalitarianism." Although today this might appear to be the sort of bombastic statement that could have been made by a number of abstract expressionists, the scale and level of ambition represented by these words is in keeping with what Newman was attempting to achieve with painting during the 1950s and 1960s.

Born in New York to Russian parents who had recently emigrated from Poland, Newman's formal education began at the Art Students League in New York. The canvases he executed prior to 1950 can be seen as rehearsals for what would become an established formal vocabulary during the first half of the 1950s. For example, *Abraham* (1949), with its biblical title and austere, somber, and brooding presence, is organized around the asymmetrical placement of a dark brown column on a slightly lighter brown ground. From this point, Newman would

develop his aesthetic, gradually refining the relationship between figure and ground. In certain later paintings, such as *Profile of Light* (1967), the two become interchangeable, which often entailed punctuating vast expanses of unvariegated color with a series of what he labeled "zips." For example, *Vir Heroicus Sublimis* (1950–1951), painted the year he was offered his first solo show at the Betty Parsons Gallery in New York, is a canvas just under 18 feet (5.5 m) in length and incorporates five vertical stripes or zips. The effect is one of being immersed within a chromatic expanse, although importantly the zips enable the viewer to orient themselves in relation to the work as a totality, a work that Newman perceived could function in transcendental terms. Although his work appears to be an oxymoron when the abstract expressionist label is attached (what exactly is "expressionistic" about these rather cool, detached, and sparse objects?), the intent behind a work such as *Vir Heroicus Sublimis* matches that of a number of other painters working in New York at the time. Perhaps the only difference is how they arrived at what was the same point of critical understanding.

ABOVE: In *Onement, I,* Newman's trademark zip was applied on to a strip of masking tape.

1900–09

A notable sculptor, too

Although Newman is best known for his vast paintings, one cannot really grasp the singular nature of his contribution without considering his sculptures. Because his canvases centered upon the predicament of a figure in space, Newman's investigation into the primacy of this relationship took three-dimensional form. Newman's largest work, *Broken Obelisk* (1963–1967), comprises an inverted obelisk that appears to have been snapped off and rests upon the zenith of a pyramid. Its balancing act creates a heightened visual tension that is intrinsically dynamic and yet imbues the work with an overarching equilibrium. In a wider sense, the work seems indicative of Newman's oeuvre as a whole, an oeuvre that centered upon the acute visual sense of one's place in the world, its fragility, and its potential for it to be greater than the sum of its parts. **CS**

Newman's Voice

Of all the abstract expressionists, Newman was perhaps one of the most vocal and certainly one of the most articulate.

- In a joint statement with Adolph Gottlieb and Mark Rothko, Newman claimed in 1943, "To us art is an adventure into an unknown world, which can be explored only by those willing to take the risks."
- In an interview in 1962, Newman's concern was with "the fullness that comes from emotion, not with its initial explosion, or with its emotional fallout, or the glow of its expenditure."

DAVID SMITH

Born: David Rolland Smith, March 9, 1906 (Decatur, Indiana, U.S.); died May 23, 1965 (Bennington, Vermont, U.S.).

Artistic style: Sculptures based on forged and welded steel; impressive sculptures set against the backdrop of nature; constructed compositions from found objects.

Masterworks

Medals for Dishonor 1940 (Willard Gallery, New York, U.S.)

Reliquary House 1945 (Private collection)

Home of the Welder 1945 (Tate Collection, London, England)

Oculus 1947 (Private collection)

Royal Incubator 1949 (Private collection)

The Forest 1950 (Private collection)

The Cathedral 1950 (Private collection)

Agricola I 1951–52 (Smithsonian Institution, Washington, D.C., U.S.)

Tanktotem VI 1957 (Private collection)

Tanktotem VIII 1960 (Private collection)

Cubi XXVII 1965 (Solomon R. Guggenheim Museum, New York, U.S.)

David Smith revolutionized modern sculpture. He is most famous for using industrial materials, particularly welded iron, steel, and stone, to create large-scale sculptures. His manual labor skills were integral to his art.

Smith studied at Ohio University and then Notre Dame. In 1927, he moved to New York, where he joined the Arts Students League. Here he insatiably appropriated cubism into both painting and sculpture resembling the artistic innovations of Paris. He was particularly influenced by the metal sculptures of Pablo Picasso and Julio González, which led him to experiment with collage and relief in the abstract surrealist style. In the 1930s, he met Russian painter John Graham, who introduced him to Willem de Kooning, Edgar Levy, and Arshile Gorky.

Smith began his first signature-style metal sculpture in 1933; his earlier work included the use of natural materials

ABOVE: Smith, like his sculptures, is always associated with the outdoors.

RIGHT: *Wagon* (1964) is one of a series of three large-scale *Wagon* sculptures.

such as coral, wood, and stone. His artistic use of industrial materials poignantly characterizes twentieth-century social and political change and transformations of a rural existence into an industrialized state. His ideology is particularly prevalent in *Medals for Dishonor* (1940).

In 1950, Smith was awarded a fellowship by the Solomon R. Guggenheim Foundation. It gave him financial freedom and allowed him to construct major works such as *Agricola* (1951–1957) and *Tanktotem* (1952–1960). In 1962, he was invited by the Italian government to create two works for the fourth Festival of Two Worlds. He exceeded expectations by creating twenty-seven sculptures in thirty days, using a combination of tools and found objects. His major advances started when he began to experiment with polished stainless steel, creating rectangular and cylindrical forms reaching up to 9.8 feet (3 m) high for his series *Cubi* (1961–1965). **KO**

ABOVE: *Voltri XIX* (1962), created in Italy, is a sculpted collection of found objects.

Medals for Dishonor

Smith was politically active as a trade unionist; he also worked in the U.S. government's WPA Federal Art Project. His liberal political beliefs are clearly seen in *Medals for Dishonor*. The work is a series of fifteen small, cast-metal structures subverting the symbol of the war medal as a reward, instead emphasizing the destruction and carnage created. This is a reflection of Smith's observations on the developments of the modern world leading to the rise of fascism in Europe. Although perhaps his least known work, it remains one of the most powerful for its stab at government hypocrisy.

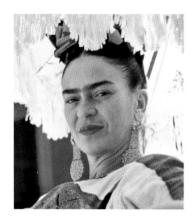

FRIDA KAHLO

Born: Magdalena Carmen Frida Kahlo y Calderón, July 6, 1907 (Coyoacán, Mexico); died July 13, 1954 (Coyoacán, Mexico).

Artistic style: Self-portraits; naive style drawn from ex-voto paintings; personal symbolism expressed through motifs such as masks, blood, colors, and vegetation.

Frida Kahlo was born in Coyoacán, Mexico, three years before the dictatorship of Porfirio Díaz was ended by the uprisings that became the Mexican Revolution (1910–1921). Educated at the exclusive National Preparatory School, she was part of an intellectual and politically radical elite who looked to embrace the pre-Columbian Mexican past as a means of moving away from European cultural imperialism.

At the age of eighteen, Kahlo was badly hurt in a bus crash. During her recovery, she was forced to remain immobilized in a full-body cast; to pass the time she began to paint. In her lifetime, she was best known as the wife of Mexican muralist Diego Rivera. (During their turbulent relationship, both had affairs—Kahlo's paramours included Marxist figurehead Leon

Masterworks

Self-Portrait Wearing a Velvet Dress 1926 (Private collection)

The Bus 1929 (Museo Dolores Olmedo Patiño, Mexico City, Mexico)

Frieda Kahlo and Diego Rivera 1931 (San Francisco Museum of Modern Art, San Francisco, U.S.)

Henry Ford Hospital 1932 (Museo Dolores Olmedo Patiño, Mexico City, Mexico)

My Grandparents, My Parents, and I (*Family Tree*) 1936 (Museum of Modern Art, New York, U.S.)

My Nurse and I 1937 (Museo Dolores Olmedo Patiño, Mexico City, Mexico)

The Two Fridas 1939 (Museo de Arte Moderno, Mexico City, Mexico)

Self-Portrait with Cropped Hair 1940 (Museum of Modern Art, New York, U.S.)

Self-Portrait with Thorn Necklace and Hummingbird 1940 (University of Texas at Austin, Austin, U.S.)

Self-Portrait as a Tehuana 1943 (The Jacques and Natasha Gelman Collection of Modern and Contemporary Mexican Art, Cuernavaca, Mexico)

Diego and I 1949 (Private collection)

ABOVE: Frida Kahlo often painted herself or chose to be photographed in Mexican dress.

RIGHT: *The Two Fridas* is one of Mexico's most treasured works by a female artist.

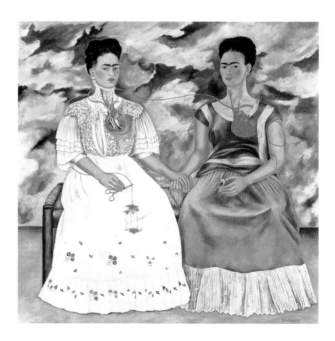

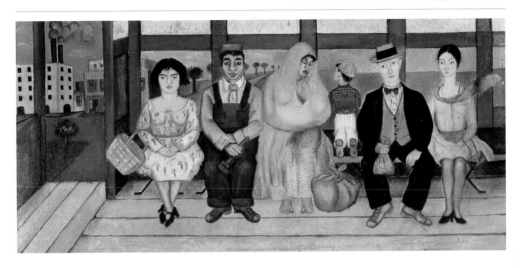

ABOVE: *The Bus* was painted early in Kahlo's career, the same year she married Rivera.

Trotsky; Rivera's included Kahlo's sister, Cristina.) However, the self-taught artist eventually gained recognition as a vibrant personality in her own right, her choice of unorthodox subject matter winning the admiration of the surrealists in particular.

Across a total output of fewer than 150 paintings, Kahlo displayed her view of life as a series of dialectical struggles between the personal and the political. Her visual repertoire of eclectic symbols, executed in the manner of popular Mexican naive painting, ranged from sources that combined European fine art traditions and avant-garde movements, popular and folkloric Mexican art, as well as belief systems as diverse as Roman Catholicism, Aztec culture, European philosophy, and communism, of which both she and Rivera were followers.

Between 1926 and 1954, Kahlo drew on her intimate (often painful) life experiences, from a fascination with identity and masquerade—explored in her many self-portraits—to the execution of still lifes as visual manifestations of national pride. Not until the year before her death did she receive her first solo show in Mexico, however. Kahlo's unflinchingly honest investigation and reinvention of the self through her art has since proved an influence on many creative individuals, including Madonna, Tracey Emin, and Cindy Sherman. **HPE**

The Two Fridas (1939)

This double self-portrait was created during Kahlo's separation and divorce from Rivera. On the right, she sits in traditional Mexican costume as the woman Rivera loved. She holds a picture of him as a child; her heart is exposed but whole. On the left is the despised Kahlo, in a colonial-style wedding dress; her heart is broken and an artery drips blood into her lap. Kahlo once said that *The Two Fridas* showed the "duality of her personality." The painting also signifies a cultural divide: the conflict implicit in the *mestizo* race, which was neither fully European nor fully Mexican Indian.

LEE KRASNER

Born: Lee Krasner, October 27, 1908 (Brooklyn, New York, U.S.); died June 19, 1984 (New York, U.S.).

Artistic style: Lyrical abstract paintings that often encompass collaged elements; abstract expressionistic canvases utilizing an "all-over" technique.

Masterworks

Untitled 1949 (Museum of Modern Art, New York, U.S.)

Gothic Landscape 1961 (Tate Collection, London, England)

Night Creatures 1965 (Metropolitan Museum of Art, New York, U.S.)

Gaea 1966 (Museum of Modern Art, New York, U.S.)

Although any consideration of Lee Krasner's oeuvre always has to take into account her relationship with her husband, painter Jackson Pollock, her contribution as an artist should be read on its own terms and not through the prism of Pollock's achievements.

Krasner had always intended to become an artist and it was while studying at Hans Hofmann's School of Fine Art that she developed her own painterly vocabulary. Krasner's work of this period is comprised of blocklike forms, delineated with bold, black outlines that have been worked and then subsequently reworked, such as her *Composition* (1939–1943).

Krasner married Pollock in 1945. Their decision to decamp to The Springs, near East Hampton in Long Island, afforded both artists the ideal opportunity for further experimentation. While Pollock was able to nurture his famous "all-over" technique, Krasner was busy developing what were titled her *Little Images* (1946–1949) series, comprising an indeterminate mass of discrete gestures that cohere on the picture plane as one single field or entity.

Having developed her position within the broader context of abstract expressionism, Lee Krasner subsequently experimented with a range of techniques, including collage, as a means of expressing within a work what she saw as important autobiographical content. A number of her pieces were often made from cut-up sections of Pollock's drawings. Krasner's unique contribution toward abstract expressionism, coupled with the fact that she was able to continue to develop her practice long after the movement's demise, is testimony to the distinctive character of the paintings that she produced. **CS**

"I think my painting is so autobiographical if anyone can take the trouble to read it."

ABOVE: Lee Krasner photographed in front of her work in the 1980s.

VICTOR VASARELY

Born: Vásárhelyi Győző, April 9, 1908 (Pécs, Hungary); died March 15, 1997 (Paris, France).

Artistic style: Father of op art; painter and designer of abstract art; innovative use of color, pattern, and optical illusion; screen prints and tapestries.

Victor Vasarely is known as the father of op art. His initial career choice was to be a doctor, and he studied medicine before becoming an artist. He trained at Muhely Academy, which taught in the style of the Bauhaus. This strong background in architecture and graphic design can be seen in the high-quality of Vasarely's design. Vasarely was also fascinated by color and optics.

In 1930, Vasarely held his first one-man show, in Budapest. Afterward he moved to Paris and began working in advertising as a graphic artist and creative consultant. Fascinated by linear patterning, he conjured up multidimensional works constructed out of layer upon layer of patterns to create an illusion of depth.

Over the ensuing years, Vasarely experimented with geometry, minimal colors, and abstract art. In 1943, he started using oils as his main medium, working on both abstract and figurative canvases. The following year he exhibited these at his first Parisian exhibition. Geometric shapes and colored lines were used to create optical illusions of movement. This led to experiments with kinetic art, exploring his belief that form and color are inseparable. During the 1950s, he wrote a series of manifestos on the use of optical phenomena for artistic purposes; it became a significant influence on younger artists. Vasarely maintained that the viewer's reaction to his art was of utmost importance rather than his own intention toward the piece. In 1970, he opened his first dedicated museum with more than 500 of his works on show. In 1976, he designed the Fondation Vasarely in Aix-en-Provence to house his works. The same year, the Vasarely Museum opened at his birthplace in Hungary. **SH**

Masterworks

Banya 1964 (Tate Collection, London, England)

Quasar 1966 (Fine Arts Museum of San Francisco, San Francisco, U.S.)

Vega-Nor 1969 (San Jose Museum of Art, San Jose, U.S.)

"The art of tomorrow will be a collective treasure or it will not be art at all."

ABOVE: Victor Vasarely photographed at an exhibition of his work (*c.*1970s).

CAREL WEIGHT

Born: Carel Weight, September 10, 1907 (London, England); died August 13, 1997 (London, England).

Artistic style: Painter; official war artist; portraiture and landscapes; narrative works in suburban and urban settings; wry humor; religious and literary themes.

Masterworks

Recruit's Progress: Medical Inspection 1942 (Imperial War Museum, London, England)

Sienese Landscape 1960–1963 (Tate Collection, London, England)

The Departing Angel 1961 (Royal Academy of Art, London, England)

Christ and The People 1963 (Manchester Cathedral, Manchester, England)

The Silence 1965 (Royal Academy of Art, London, England)

Clapham Junction 1978 (Tate Collection, London, England)

Carel Weight is remembered for his canvases of narrative dramas in suburban settings, for his work as a war artist in World War II, and as an influential teacher whose pupils included Sir David Hockney, Sir Peter Blake, and Ron Kitaj.

Weight studied at London's Hammersmith School of Art, and Goldsmiths College, going on to have his first solo exhibition at the city's Cooling Gallery in 1933. During World War II his commissions included the *Recruit's Progress* (1942), a series of four pictures. Weight's ability to depict humanity's vulnerabilities humorously can be seen to perfection in *Recruit's Progress: Medical Inspection* (1942), a portrayal of a nervous young recruit undergoing a medical examination. It was this talent that impressed the War Artists Advisory Committee and saw Weight appointed as an Official War Artist in 1945. He traveled to Austria, Greece, and Italy recording army education classes and wartime damage to buildings.

On Weight's return to London in 1947 he started teaching at the Royal College of Art; he was made Professor of Painting in 1957. He continued to paint, often reinventing the mundane suburban settings that surrounded him by using them as a backdrop for works such as *The Departing Angel* (1961). Set in his garden in Wandsworth, south London, the canvas depicts the Annunciation but in a contemporary context. Weight's playful humor is ever present: The Angel Gabriel wears house slippers, and the Virgin Mary is seated on a patio chair. Weight's tackling of religious stories has drawn comparisons with fellow British painter Sir Stanley Spencer, yet Weight differs from Spencer in his way of tapping into a vein of uniquely British humor evident in the works of artists such as Edward Burra and Beryl Cook. **CK**

"[As a child] *The Arnolfini Marriage* ... had a great effect on me, because it was so real."

ABOVE: In *Self-Portrait* (*c.*1930), Weight depicts himself as nervous and ill at ease.

BALTHUS

Born: Balthazar Klossowski de Rola, February 29, 1908 (Paris, France); died February 18, 2001 (La Rossinière, Switzerland).

Artistic style: Painter of landscapes and portraits; controversial depictions of pubescent girls in erotic poses; fantastic, emotionally intense, figurative work.

When Balthazar Klossowski, Count de Rola, better known as the artist Balthus, was only aged thirteen, forty of his drawings were published in a book, *Mitsou* (1921). The book's theme of a young boy in love with his cat is one with which Balthus could identify. Cats appear in many of his works, including the self-portrait that he titled *His Majesty the King of Cats* (1935).

When he was eighteen, Balthus visited Italy. In Florence, he studied and copied the work of Early Renaissance master Piero della Francesca. The other key influence on the young Balthus was impressionist painter Pierre Bonnard, who had been a family friend. In contrast to Bonnard, however, the way in which Balthus used his paintings to show off his considerable observational and technical skills won him admirers. Writer Albert Camus was a major fan. In 1949, in the introduction to a Balthus catalog, Camus wrote: "We did not know how to see reality and all the disturbing things in our apartments, our loved ones, and our streets conceal."

Many of the artist's most famous works feature pubescent girls. In *The Guitar Lesson* (1934) for example, there is a most unusual image of a young, half-naked girl with her female tutor—yet Balthus always insisted that his work was neither pornographic nor erotic. In his view, his paintings simply recognized the discomforting facts of children's sexuality.

In his final years, Balthus began dictating more than one hundred brief reminiscences and anecdotes that were edited together in an unusual memoir. It gained mixed reviews—but far better received was the lengthy biography written by Nicholas Fox Webber in 1999. Balthus was noted for being the only living artist who had his artwork in the Louvre's collection. **HP**

Masterworks

The Street 1933 (Museum of Modern Art, New York, U.S.)

The Guitar Lesson 1934 (Private collection)

The Living Room 1942 (Minneapolis Institute of Arts, Minneapolis, Minnesota, U.S.)

1900–09

"Painting is the passage from the chaos of the emotions to the order of the possible."

ABOVE: Detail from *His Majesty the King of Cats* (1935), a self-portrait with a tabby cat.

HENRI CARTIER-BRESSON

Born: Henri Cartier-Bresson, August 22, 1908 (Chanteloup-en-Brie, France); died August 3, 2004 (Céreste, Alpes-de-Haute-Provence, France).

Artistic style: The "father" of photojournalism; street photography; iconic imagery; an exceptional eye for detail and emotion; innovator of the 35mm format.

Masterworks

Hyères, France 1932 (Art Institute of Chicago, Chicago, U.S.)

Boys playing amid ruins—Spanish Civil War 1937 (New Paltz, New York, U.S.)

At the Coronation Parade of George VI, Trafalgar Square, London 1938, (National Gallery of Canada, Ottawa, Canada)

Shanghai 1948 (Metropolitan Museum of Art, New York, U.S.)

Henri Cartier-Bresson introduced the world to photojournalism. He became globally famous for incredible war- and peacetime images: the Spanish Civil War; starving children; secretly filmed images of Nazi-occupied France; the Liberation of Paris; Gandhi's funeral; the civil war in China; and the building of the Berlin Wall. He was also the first Western photographer to work freely in the Soviet Union after World War II.

At age nineteen he studied art at the studio of André Lhote, where he encountered cubism and surrealism. He went on to study English art and literature at Cambridge University in England, but photography became his overriding passion. By 1935, his photographs had been exhibited in New York, Madrid, and Mexico, and published in *Harpers' Bazaar*; he had also worked with film director Jean Renoir. In 1937, he photographed the coronation of England's King George VI, interestingly focusing, not on the king, but on the people lining the streets.

When World War II broke out, Cartier-Bresson joined the French army, was captured, and spent thirty-five months in prisoner-of-war camps before escaping (on his third attempt). When he got home he began his secret recording of the war. In 1947, *The Photographs of Henri Cartier-Bresson* was published, and a retrospective of his work was held in New York. In 1948 he met Mahatma Gandhi, just minutes before Gandhi was assassinated. A second book, *Images à la Sauvette*, was published in 1952 and in 1955 he held his first exhibition in France. His photography had attained iconic status, as had his name. Cartier-Bresson was the most famous photographer in the world—yet he was bored. He returned to fine art (exhibiting his drawings in New York in 1975) and rarely took another photograph. He died at age ninety-five. **SH/LH**

> "I suddenly understood that a photograph could fix eternity in an instant."

ABOVE: Henri Cartier-Bresson photographed in Brooklyn in 1946.

JORGE DE OTEIZA

Born: Jorge de Oteiza, 1908 (Orio, Guipúzcoa, Basque Country, Spain); died 2003 (Donostia-San Sebastián, Guipúzcoa, Basque Country, Spain).

Artistic style: Sculptor, painter, designer, poet, and theorist; themes of Basque cultural identity; explorations of the void in abstract sculptures.

In his youth, Jorge de Oteiza traveled to South America where he became interested in pre-Colombian art. This helped influence the shape of his work. He first came to attention in the late 1940s for his efforts to create abstract sculpture with a distinct Basque identity. His frieze of the apostles produced in 1950 for the Arantzazu Basilica proved contentious for its bare figures, and led him to seek exile in Paris where he co-founded Equipo 57 with other exiled compatriots in an attempt to promote abstract art. He later returned to Spain, but in 1959 famously retired from sculpture. He devoted most of the rest of his career to promoting Basque cultural identity through theoretical essays and art-education programs. **CK**

Masterworks

Pietá 1950–1955 (Arantzazu Basilica, Sanctuary of Arantzazu, Oñati, Basque Country, Spain)

Oteiza Apostoluak (*The Apostles*) 1950–1955 (Arantzazu Basilica, Sanctuary of Arantzazu, Oñati, Basque Country, Spain)

You Are Peter 1956–1957 (Guggenheim Bilbao, Bilbao, Spain)

Conjunción Dinámica de Dos Pares de Elementos Curvos y Livianos (*Dynamic Conjunction of Two Pairs of Curved and Light Elements*) 1957 (Fundació Museu d´Art Contemporani de Barcelona, Barcelona, Spain)

Homenaje a Mallarmé (*Homage to Mallarmé*) 1958 (Museo Nacional Centro de Arte Reina Sofia, Madrid, Spain)

LEONOR FINI

Born: Leonor Fini, August 30,1908 (Buenos Aires, Argentina); died January 18, 1996 (Paris, France).

Artistic style: Sexually charged subject matter; symbolic depictions of women as strong, protecting figures; fantastic natural forms and animals, especially cats.

Leonor Fini had a dramatic childhood spent largely in Italy; she was frequently disguised as a boy to foil her estranged father's kidnap attempts. When she moved to Paris in the 1930s, her eccentric persona quickly endeared her to the surrealists, although she refused officially to join their group. With an illusionistic style and visionary subject matter, she shared the surrealists' interest in dreams and the unconscious, but she was also influenced by symbolism and by Italian and German romanticism. Notorious for her many lovers, she presented a radical assertion of female sexual desire, both in her life and her art. Refusing categorization, her career embraced opera and ballet as well as book illustration and fashion. **LB**

Masterworks

Little Hermit Sphinx 1948 (Tate Collection, London, England)

The Alcove: An Interior with Three Women c.1939 (The Edward James Foundation, Sussex, England)

Composition with Figures on a Terrace 1939 (The Edward James Foundation, Sussex, England)

L'Ombrelle 1947 (The Edward James Foundation, Sussex, England)

FRANCIS BACON

Born: Francis Bacon, October 28, 1909 (Dublin, Ireland); died April 28, 1992 (Madrid, Spain).

Artistic style: Painter of portraits, nightmarish visions, and contorted images; use of oil; triptych format; images of crucifixion and screaming mouths.

Masterworks

Three Studies for Figures at the Base of a Crucifixion c.1944 (Tate Collection, London, England)

Painting 1946 (Museum of Modern Art, New York, U.S.)

Study from the Human Body 1949 (National Gallery of Victoria, Melbourne, Australia)

Study of a Baboon 1953 (Museum of Modern Art, New York, U.S.)

Study after Velazquez's Portrait of Pope Innocent X 1953 (Des Moines Art Center, Des Moines, Iowa, U.S.)

Portrait of Isabel Rawsthorne 1966 (Tate Collection, London, England)

Portrait of George Dyer in a Mirror 1968 (Museo Thyssen-Bornemisza, Madrid, Spain)

Second Version of Triptych 1944 1988 (Tate Collection, London, England)

"Imagination was given to man to compensate him for what he is not . . ."

ABOVE: Bacon photographed in 1976 at the Galerie Georges Bernard in Paris.

RIGHT: *Portrait of George Dyer in a Mirror (1968)* reflects Bacon and Dyer's relationship.

Born in Dublin, Francis Bacon suffered from chronic asthma as a child. He also spent the early years of his life moving between Ireland and England, which instilled in him a sense of displacement that would later come through in his work.

Bacon's strained relationship with his father (because of his perceived homosexuality) led to his banishment from the family home. He drifted for some years, living in London, Berlin, and Paris, where it is believed a Pablo Picasso exhibition inspired him to become an artist. He returned to London to work as an interior decorator, and rented a studio in Queensbury Mews West, where he began painting.

He enjoyed initial success exhibiting his work as part of a show at London's Mayor Gallery in 1933, but his breakthrough would not arrive until *Three Studies for Figures at the Base of a Crucifixion* (1944) was exhibited in 1945. The triptych contained many motifs that preoccupied Bacon's work for the rest of his career: crucifixion, isolated figures, an open mouth, Furies, and physical distortion. Bacon embarked on an inspired period of work during which his creative use of oil exposed nightmarish images of horror, violence, anger, and degradation. In 1962, a retrospective show of his work at London's Tate Gallery established his preeminence among contemporary British painters. One of Bacon's idiosyncrasies was to use the reverse side of a primed canvas, a method he stumbled upon after poverty left him unable to buy new canvases. Gradually, he made a break from ghostly forms in favor of lighter colors, applying paint in a coarser manner and using photography to achieve a new level of virtuosity. His influence is keenly felt in the work of contemporary British artists Damien Hirst and Jake and Dinos Chapman. **SG**

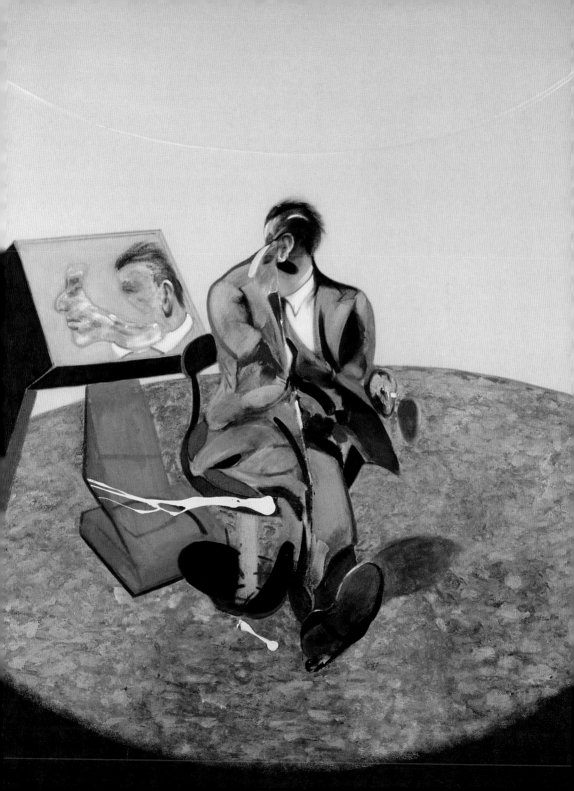

FRANZ KLINE

Born: Franz Rowe Kline, May 23, 1910 (Wilkes-Barre, Pennsylvania, U.S.); died May 13, 1962 (New York, U.S.).

Artistic style: Abstract expressionist; early representational style developing into black-and-white action paintings; later works reintroduced color outlines and fields.

Masterworks

Hot Jazz 1940 (Chrysler Museum of Art, Norfolk, Virginia, U.S.)

New York, N.Y. 1953 (Albright-Knox Art Gallery, Buffalo, U.S.)

Painting Number 2 1954 (Museum of Modern Art, New York, U.S.)

*Untitled c.*1955 (National Gallery of Art, Washington, D.C., U.S.)

C & O 1958 (National Gallery of Art, Washington, D.C., U.S.)

Black Reflections 1959 (Metropolitan Museum of Art, New York, U.S.)

Torches Mauve 1960 (Philadelphia Museum of Art, Philadelphia, U.S.)

Meryon 1960–1961 (Tate Collection, London, England)

After Jackson Pollock and Willem de Kooning, Franz Kline is the most famous action painter of abstract expressionism, the art movement that wrestled the modernist vanguard away from Europe and established New York as the new capital of the art world. Kline was a somewhat unlikely figure to have facilitated such a seismic shift. Born in Pennsylvania to an English mother and German father (who committed suicide when his son was seven), Kline's first artistic ambition was to be a cartoonist.

After completing his studies at Boston University in 1935, Kline traveled to London, where he studied illustration at the conservative Heatherley's School of Fine Art. In 1938, unable to obtain a work visa, Kline returned to the U.S. with his English wife and the couple settled in New York. During the 1940s,

ABOVE: Franz Kline photographed in December 1954 by Fritz Goro.

RIGHT: *Orange Outline* sees the addition of color to Kline's usual two-tone palette.

1910–19

ABOVE: A dramatic example of Kline's abstract style, *Orange and Black Wall* (1957).

Kline concentrated on urban scenes that referenced cubism and expressionism, but despite winning a major prize at the National Academy of Design's exhibition in 1943, he was earning very little and struggling to find an original voice. Frustrated at his lack of progress, Kline began to experiment with less representational methods. This led to a pivotal moment in 1949 at the studio of de Kooning. The Dutch painter had acquired a Bell-Opticon projector, and when Kline saw one of his own drawings massively enlarged, the ragged black lines—unrecognizable from their origin—pointed the way toward a powerful new language of complete abstraction.

Working, like Pollock, on large canvases with commercial enamel paint, Kline concentrated exclusively on his black-and-white paintings. Unlike Pollock, he worked from preliminary studies on scraps torn from phonebooks, so the appearance of spontaneity was deceptive. To the assumption that he was inspired by Japanese calligraphy Kline replied, "I paint the white as well as the black, and the white is just as important."

In the late 1950s, Kline gradually reintroduced color to his compositions. His last pieces seem to reach toward a reconciliation of action painting with the color field experiments of Barnett Newman and Mark Rothko. **RB**

Inspired by Kline

In 2006, London's Tate Modern gallery invited musician and ex-guitarist with the group Blur, Graham Coxon, a former art student at Goldsmiths College, to compose a piece of music inspired by a work in its collection. Coxon selected Kline's late painting *Meryon* (1960–1961), explaining, "There's something very spiritual about Kline, it's like experiencing the void. When I was younger, I used to faint a lot. When I came round, it was the closest I have ever felt to God. There is a stillness, a strength and a starkness to the sounds I have made that reminds me of that experience."

DOROTHEA TANNING

Born: Dorothea Tanning, August 25, 1910 (Galesburg, Illinois, U.S.).

Artistic style: Painter, printmaker, and sculptor; latent eroticism in earlier figurative paintings and later abstract compositions; surrealist themes of nightmares and fantasy.

Masterworks

Birthday 1942 (Philadelphia Museum of Art, Philadelphia, Pennsylvania, U.S.)

Eine Kleine Nachtmusik 1943 (Tate Collection, London, England)

The Friend's Room 1950–1952 (Private collection)

Some Roses and their Phantoms 1952 (Tate Collection, London, England)

Insomnias 1957 (Moderna Museet, Stockholm, Sweden)

Pincushion to Serve as a Fetish 1965 (Tate Collection, London, England)

U.S. artist Dorothea Tanning is a printmaker, painter, sculptor, poet, and novelist. She illustrated Aubrey Beardsley as a schoolgirl and steeped herself in Gothic novels, an interest evident in her themes of childhood nightmare and fantasy.

Her studies at the Art Institute of Chicago lasted a mere two weeks, and she left for New York in 1935. She worked at various jobs, including as a commercial artist, before she saw the exhibition that changed her life: *Fantastic Art: Dada and Surrealism* (1936) held at the Museum of Modern Art in New York. It determined the direction of her work and prompted an ill-advised trip to Paris in 1939 to meet the surrealists. After an escape through Sweden on board a train with members of the Hitler Youth movement, she returned to New York. There she met her future husband, German surrealist painter Max Ernst in 1942; he had seen and admired her somewhat menacing yet also beautiful self-portrait *Birthday* (1942) and sought out its creator. The couple married in 1946 and settled in Arizona.

Tanning's work of this period dealt with the unconscious but it was very different from that of the male surrealists. As an artist, she was largely overshadowed by her male contemporaries, although her work now receives the recognition it deserves. Her paintings depict disquieting, strong, and fierce female drives and often include young girls. For example, *The Friend's Room* (1950–1952) is a complex and sinister representation of adolescent sexuality. During the 1950s the direction of her work changed. Fragmented light became an important element while forms became less distinct, as can be seen in works such as *Insomnias* (1957). Tanning's soft sculptures from the 1970s are limp, biomorphic shapes, suggestive of body parts but never fixed or certain. **WO**

> "Art has always been the raft onto which we climb to save our sanity."

ABOVE: Detail from a photograph of Dorothea Tanning taken in 1961.

RIGHT: The imagery and composition of *The Friend's Room* is typically surrealist.

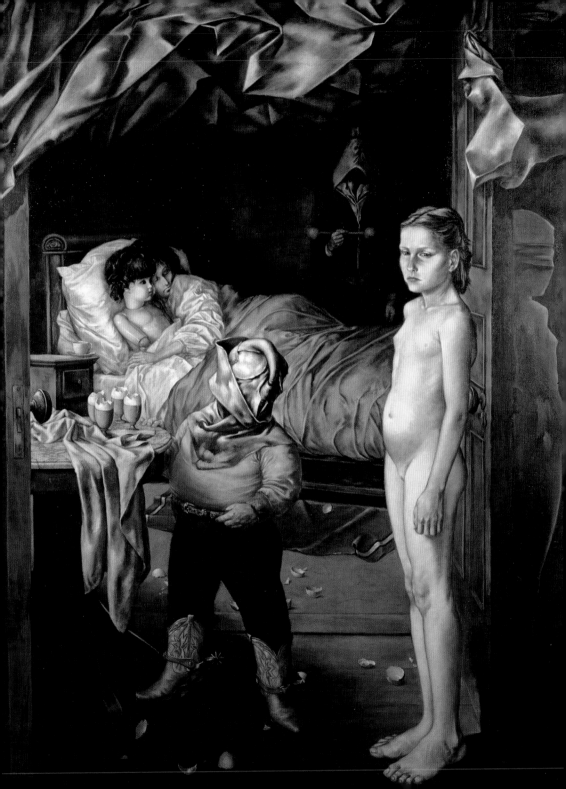

WILL BARNET

Born: Will Barnet, 1911 (Beverly, Massachusetts, U.S.)

Artistic style: Bold graphics; abstraction of form; spatial tension; flat color; minimal use of line; scenes of women and nature; humanism; simple, monumental forms.

Masterworks

Strange Bird 1947 (Museum of Fine Art, San Francisco, U.S.)

Fourth of July 1954 (Private collection)

The Three Brothers 1964 (Brooklyn Museum, New York, U.S.)

Woman Reading 1965 (Private collection)

Silent Seasons: Spring, Summer, Autumn, Winter 1967 (The Whitney Museum of Art, New York, U.S.)

Woman and the Sea 1972 (Private collection)

Aurora 1977 (Brigham Young University Museum of Art, Utah, U.S.)

The Mirror 1981 (Arkansas Arts Center, Arkansas, U.S.)

Four Generations 1984 (The Vatican Museum, Vatican City, Italy)

The lone wolf of U.S. modernist painting, Will Barnet has worked independently of the art establishment for more than seven decades. His solitary upbringing in New England—steeped in the puritanical traditions of austerity, discipline, and spirituality—was arguably a formative influence on the development of his signature minimalist-humanist style.

Barnet knew early on that he wanted to be an artist, and spent his childhood drawing, painting, and studying the work of artists such as Giotto, Honoré Daumier, and José Clemente Orozco. At seventeen years old, he went to the School of the Museum of Fine Arts in Boston, where he studied under Philip Hale, a former student of Claude Monet. Three years later, in 1931, Barnet moved to Manhattan to study painting with Stuart Davis and printmaking with Charles Locke at the progressive Arts Students League. In this liberal environment, Barnet began exploring the principles of abstract composition that became the driving forces of his modernist style.

In the 1950s, Barnet moved closer to abstraction and became associated with the Indian Space painters, who looked to Native-American art for inspiration; Barnet was particularly interested in the designs found on Hopi pottery. By the 1960s, he started to paint portraits and has continued to do so, mostly using his family and friends as sitters. *Woman and the Sea* (1972)—a powerful, elegiac portrait of a woman gazing out to sea—conveys a poignant sense of loneliness. The work exemplifies the artist's technique of constructing complex yet minimalist compositions with monumental shapes of bold, flat color juxtaposed vertically and horizontally to abstract an image to its essence and create a sense of emotional intensity. **SA**

"Age gives you freedom … great work can come at any stage of your life."

ABOVE: An intense photographic portrait of an artist whose work is imbued with feeling.

ROMARE BEARDEN

Born: Romare Bearden, 1911(Mecklenburg County, North Carolina, U.S.); died 1988 (New York, U.S.).

Artistic style: Photocollagist, painter, illustrator, printmaker, cartoonist, theater designer, jazz musician, and writer; themes of African-American life.

The multitalented Romare Bearden's talents spanned the visual arts, music, and writing. An author and jazz musician and composer of note, he is best remembered for his art showcasing the contemporary African-American experience, and in particular the move from the rural South to the urban North.

Bearden himself made that move when he was young and his family moved from North Carolina where he was born to New York's Harlem district. Bearden grew up in a lively and educated household that contributed to his wide-ranging interests, and his parents' friends included musicians Duke Ellington and Fats Waller, poet Langston Hughes, writer W. E. B. Du Bois, and artist Aaron Douglas. He graduated from New York University, and then studied at the Art Students League in New York under German artist George Grosz, who helped Bearden develop his satirical eye and interest in sociopolitics, before he completed his studies at the Sorbonne in Paris.

Bearden's oeuvre spans many different styles: from political cartoons in the 1930s, to social realist paintings in the 1930s and 1940s, and to abstract expressionist paintings in the 1950s. Yet he is most known for the photocollages he made from 1964 onward, a style he developed in the 1960s when he took up printmaking. A highly educated and ever inquisitive man, Bearden's work plunders history, literature, and art history with a dizzying array of references, all woven together in works that depict the street life and rituals of African-Americans of the era, depicting everything from family life to jazz clubs and brothels. His fragmented collages are almost visual jazz, and were inspired by its rhythms. Initially small-scale, his collages became larger over time, and he later developed his style to create murals for public spaces. **CK**

Masterworks

Tomorrow I May Be Far Away 1966–1967 (National Gallery of Art, Washington, D.C., U.S.)

Patchwork Quilt 1970 (Museum of Modern Art, New York, U.S.)

The Block II 1972 (National Gallery of Art, Washington, D.C., U.S.)

The Train 1975 (Museum of Modern Art, New York, U.S.)

The Street (Composition for Richard Wright) c.1977 (National Gallery of Art, Washington, D.C., U.S.)

"I paint ... as passionately and dispassionately as Brueghel painted the life ... of his day."

ABOVE: Romare Bearden, an influential chronicler of African-American life.

LOUISE BOURGEOIS

Born: Louise Bourgeois, December 25, 1911 (Paris, France).

Artistic style: Sculptor; works executed in a wide range of materials, from fabric to bronze; autobiographical themes; explorations of sexuality, femininity, and isolation.

Masterworks

Femme Volage, 1951 (Solomon R. Guggenheim Museum, New York, U.S.)

Avenza 1968–1969 (Tate Collection, London, England)

Cumul I, 1968 (Musée National d'Art Moderne, Centre George Pompidou, Paris, France)

Destruction of the Father, 1974 (Private collection)

Eyes and Mirrors, 1989–1993 (Tate Collection, London, England)

The Nest, 1994 (San Francisco Museum of Modern Art, San Francisco, U.S.)

Maman, 1999 (Guggenheim Bilbao, Bilbao, Spain and several other sites)

The Woven Child 2002 (Worcester Art Museum, Worcester, Massachusetts, U.S.)

> "Art is a guarantee of sanity. That is the most important thing I have said."

ABOVE: Louise Bourgeois, whose work deals with identity—her own and that of her art.

One of the twentieth century's most prominent artists, Bourgeois became famous for her groundbreaking sculptures as well as painting. She grew up in an artistic Parisian family, but her homelife was difficult and she would later describe her father as "tyrannical." Initially Bourgeois studied mathematics at the Sorbonne. She then attended the École des Beaux-Arts, and worked as an assistant to Fernand Léger. In 1938, married to American art historian Robert Goldwater, she moved to the United States and studied at the Art Students League. She worked with artists exiled from Europe, including surrealists. Their interest in the unconscious is a constant presence in her work, from early prints to later sculptures and installations.

Against the background of abstract expressionism, she began using a variety of materials, such as plaster, latex, wood, and stone. From the 1940s to the mid-1950s, she carved her *Personnages*—eighty wooden sculptures representing people in her life. It was her first major artistic reference to the miseries of her childhood. Seventeen of these works were exhibited in 1949 in New York. In the 1960s, Bourgeois dealt with sexuality explicitly in works such as *Cumul I* (1968), shrouded eggs and phalluses on a wooden box, and *The Destruction of the Father* (1974), which resonates with her feelings about her adulterous father. *Maman* (1999) references the artist's mother: cast six times in all, this 30-foot-tall (9.25 m) bronze spider dwarfs the viewer, but its rather intimidating presence is tempered by vulnerability—suggested by its long, spindly legs and the 26 marble eggs nestling in its belly. The work that brought her the widest public attention was *I Do, I Undo, I Redo* (2000) an installation of three 30-foot-tall (9.25 m) towers made for the opening of London's Tate Modern. **WO**

ROBERTO MATTA

Born: Roberto Sebastián Antonio Matta Echaurren, November 11, 1911 (Santiago de Chile, Chile); died November 23, 2002 (Tarquinia, Italy).

Artistic style: Automatic technique; "psychological morphologies" of interior emotional states; fluid landscapes; biomorphic and contorted machinelike forms.

Roberto Matta's first career was as an architect. He trained in Chile, before working as a draftsman in Le Corbusier's Paris office, traveling extensively throughout Europe. In 1934, in Spain, he met Salvador Dalí and Federico García Lorca. Dalí encouraged Matta to show some of his drawings to André Breton, whose interest in Sigmund Freud and the world of the unconscious would become a great influence on Matta's early development. Matta's friendship with Gordon Onslow Ford and an encounter with Pablo Picasso's *Guernica* (1937) in 1937 encouraged him to join the surrealist group (although he would be expelled in 1947) and to begin painting.

Working in intensely colored pastels and oils, Matta created the series *Psychological Morphologies* (late 1930s—early 1940s), depicting interior psychological states in abstract automatist imagery that reveals the influence of his mentor Yves Tanguy. Comparing the landscape of the mind to a geological terrain, Matta termed his investigatory works "inscapes."

Matta was among the first exiled surrealist artists to arrive in New York in 1939, where he had a profound effect on the young generation of painters who would become known as the New York school. He became especially close to Robert Motherwell, with whom he traveled to Mexico, drawing inspiration from its indigenous art and its volcanic landscape, reminiscent of his native Santiago. Matta's work of the late 1940s onward reflects a more political engagement, especially after his return to Europe in 1948. His later paintings were larger and more visually explosive, fusing the internal world of the psyche with a menacing social vision. He continued even late in life to work with an energetic speed on vast canvases that continued this lifelong investigation. **LB**

Masterworks

Psychological Morphology, 1938 (The Art Institute of Chicago, Chicago, U.S.)

Years of Fear, 1941 (Solomon R. Guggenheim Museum, New York, U.S.)

Listen to Living, 1941 (The Museum of Modern Art, New York, U.S.)

The Earth Is A Man, 1942 (The Art Institute of Chicago, Chicago, U.S.)

Here, Sir Fire, Eat!, 1942 (The Museum of Modern Art, New York, U.S.)

Black Virtue, 1943 (Tate Collection, London, England)

The Batchelors Twenty Years On, 1942 (Philadelphia Museum of Art, Philadelphia, U.S.)

The Vertigo of Eros, 1944 (The Museum of Modern Art, New York, U.S.)

"Painting has one foot in architecture and one foot in the dream."

ABOVE: Roberto Matta photographed in Madrid at the age of ninety.

JACKSON POLLOCK

Born: Paul Jackson Pollock, January 28, 1912 (Cody, Wyoming, U.S.); died August 11, 1956 (East Hampton, New York, U.S.).

Artistic style: Action painting; drip paintings; use of enamel and aluminum paints; abstract and surrealist automatism; gestural and spontaneous application of paint.

Masterworks

Male and Female c.1942 (Philadelphia Museum of Art, Philadelphia, U.S.)

The Moon-Woman Cuts the Circle 1943 (Musée National d'Art Moderne, Paris, France)

The She-Wolf 1943 (Museum of Modern Art, New York, U.S.)

Mural c.1943–1944 (University of Iowa Museum of Art, Iowa City, U.S.)

Night Mist 1945 (Norton Museum of Art, West Palm Beach, Florida, U.S.)

Full Fathom Five 1947 (Museum of Modern Art, New York, U.S.)

Cathedral 1947 (Dallas Museum of Art, Dallas, U.S.)

Summertime: Number 9A 1948 (Tate Collection, London, England)

Number 5, 1948 1948 (Private collection)

Number 1, 1950 (Lavender Mist) 1950 (National Gallery of Art, Washington, D.C., U.S.)

One: Number 31, 1950 1950 (Museum of Modern Art, New York, U.S.)

Blue Poles [Number 11, 1952] 1952 (National Gallery of Australia, Canberra, Australia)

Convergence 1952 (Albright-Knox Art Gallery, Buffalo, New York, U.S.)

ABOVE: Pollock photographed in his Long Island studio in 1949.

RIGHT: Jackson Pollock creating one of his large-scale canvases.

A leading exponent of abstract expressionism, Jackson Pollock was one of the first U.S. painters to be recognized during his lifetime as an equal to the European masters of modern art. Born in Cody, Wyoming, and raised in Arizona and California, Pollock began his journey as an artist in 1928 at Los Angeles' Manual Arts High School, where painter and illustrator Frederick John de St. Vrain Schwankovsky introduced him to the Theosophical Society. The group promoted metaphysical and occult spirituality, and Pollock embraced theosophical ideas that would affect his work in years to come.

Relocating to New York to enroll at the Art Students League, Pollock studied life drawing, painting, and composition under the regionalist painter Thomas Hart Benton. During the Great Depression, he was employed by the Federal Art Project as an easel painter. His work of the time comprised mainly landscapes and figurative scenes based on typically U.S. themes from the Wild West derived from his experiences of trips through the region and photographs of Cody.

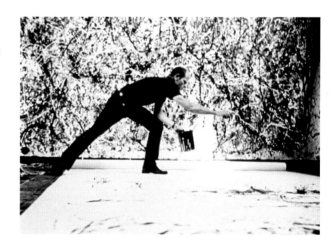

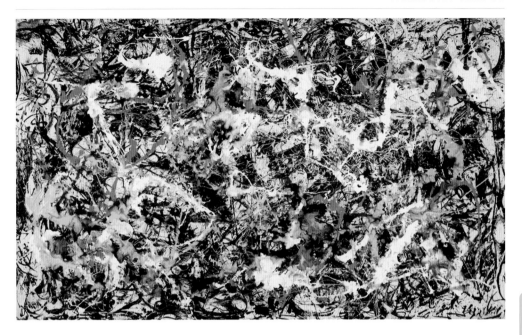

ABOVE: *Convergence* (1952) is a vast color-filled action painting.

A defining moment in Pollock's development came at a workshop by the Mexican muralist David Alfaro Siqueiros. Here, Pollock was exposed for the first time to the use of enamel paint, lacquers, and sand on a picture surface as well as the pouring and dripping of paint as an artistic technique.

Pollock endured an ongoing battle with alcoholism and depression. He spent four months in a psychiatric hospital in 1937, undergoing Jungian analysis. Afterward, his work began to shift toward abstraction. He started to incorporate motifs from the Spanish modernists Pablo Picasso and Joan Miró in his paintings, alongside the techniques he had learned from Siqueiros. His first wall-size work, *Mural* (c.1943–1944), showcased Pollock's initial step toward developing his own personal style, with the abandonment of figuration in favor of linear invention fused with surrealist methods of automatism and unconscious imagery.

"The painting has a life of its own. I try to let it come through."

Pollock on Film

In the summer of 1950, an aspiring photographer by the name of Hans Namuth approached the internationally recognized Jackson Pollock to ask if he could take shots of him while he was working. With much encouragement from his wife, Pollock agreed. When Namuth first arrived at the studio, he was told the work had been completed, but that he could take pictures of the artist by his picture. Namuth described how Pollock stared at the canvas and without warning, took a can of paint in his hand and began reapplying paint to the picture, dancing across the canvas, completely changing the appearance of the original piece. Pollock's modus operandi was captured by the photographer, and the public had its first access to the drip technique that had fascinated the art community.

Namuth next suggested making a documentary film. Shooting took place outside with a camera positioned under a pane of glass, and Pollock was told to work as though he were in the studio. For a man who believed in the unconscious image and reveled in the intimate interaction with a painting, the call to work on demand, as though acting and only pretending to paint for an audience, was too much. One night, after a heavy bout of drinking, Pollock violently tipped over a table, to his guests' dismay, and pointedly told Namuth, "I'm not a phony."

Pollock married artist Lee Krasner in 1945, and they bought a house and land in East Hampton, Long Island. He converted a barn on the property into his studio and it was there that he created some of his greatest works.

The drip technique

With the space to work on large formats, Pollock spread canvas across the floor so he could approach it from all four sides. Then he began pouring or dripping paint, using a stick or palette knife. He would walk across the piece—effectively becoming part of the painting—with a paint can in his left hand, making rapid flicks of paint with the right hand as he had observed Native-American sand painters do. The process could take weeks as he contemplated what to do next, building up layers of enamel paint as well as, on occasion, sand and glass. Pollock believed the painting had a life of its own but insisted the final product was always subject to artistic will.

From 1947 to 1951 Pollock created a series of drip paintings that rocked the art world. To some, he was merely creating meaningless and chaotic pieces (in 1956, *Time* magazine famously labeled him "Jack the Dripper"). Others, such as Clement Greenberg, lauded the talents of "the most powerful painter in contemporary America." Pollock's work had a lasting impression on subsequent art movements in the U.S., such as pop art. He remains a twentieth-century cultural icon. **SG**

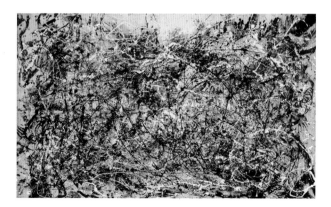

RIGHT: *Number 1* (1948) is one of the best examples of Pollock's "drip" technique.

MORRIS LOUIS

Born: Morris Louis Bernstein, November 28, 1912 (Baltimore, Maryland, U.S.); died September 7, 1962 (Washington, D.C., U.S.).

Artistic style: Abstract painter; series; large scale; colored acrylic paint applied in discrete layers or poured in lines directly onto the canvas.

Of all of the debates that were taking place within the context of the postwar U.S. avant-garde, one that for many artists appeared to be the most pressing was how to respond to the legacy of abstract expressionism and, in particular, the radical contribution Jackson Pollock made to the development of abstraction. Within this post-abstract-expressionist context, there remained a handful of painters who were committed to pursuing a line of enquiry that Pollock had pursued from 1947 to 1950 with his so-called "all-over" canvases. The way that Pollock had emphasized the liquid nature of the paint by letting it spill, trickle, and dribble provided abstract painter Morris Louis with the technical means by which he could develop his own way of working.

In 1953, Louis and Kenneth Noland visited the studio of Helen Frankenthaler and viewed *Mountains and Sea* (1952), a painting that had been executed using a "staining" technique Frankenthaler had developed. This experience confirmed for Louis how to go about making paintings.

Between 1954 and 1962, Louis developed the vocabulary of the painting by using this basic technique in discrete series of paintings. In *Beth Kuf* (1958), from his *Veil* (1954–1960) series, the unprimed canvas gradually absorbed the semitransparent layers of acrylic paint poured onto it. His later *Alpha-Phi* (1961) painting, from the *Unfurled* (1960–1961) series, comprises of a series of discrete lines of pure color poured diagonally across the bottom corners of the painting.

Despite Louis's untimely death at the age of only forty-nine, the unique contribution he had made to what the art critic Clement Greenberg had labeled "post-painterly abstraction" remains wholly evident today. **CS**

Masterworks

Charred Journal, Firewritten V 1951 (Jewish Museum, New York, U.S.)

Untitled 1958 (Museum of Modern Art, New York, U.S.)

Beth Kuf 1958 (Tate Collection, London, England)

High 1959 (Dallas Museum of Art, Texas, U.S.)

Dalet Zayin 1959 (National Gallery of Australia, Canberra, Australia)

Alpha Epsilon 1960 (Museum of Contemporary Art, Los Angeles, U.S.)

Alpha-Phi 1961 (Tate Collection, London, England)

Beta Kappa 1961 (National Gallery of Art, Washington, D.C, U.S.).

Partition 1962 (Tate Collection, London, England)

"When you put [Louis's works] together they talk to each other."—Valerie Fletcher, Smithsonian

ABOVE: This photograph of Morris Louis was taken in *circa* 1950.

JOHN CAGE

Masterworks

Sonatas and Interludes for Prepared Piano
1946–1948

Music of Changes 1951

4'33" 1952

Williams Mix 1952

Indeterminacy 1959

HPSCHD 1969

Born: John Milton Cage Jr., September 5, 1912 (Los Angeles, California, U.S.); died August 12, 1992 (New York, New York, U.S.)

Artistic style: Belief in everyday sound as music; percussive "prepared" piano; chance-based compositions; indeterminate scores; Zen-inspired; anecdotal.

Composer, artist, teacher, and writer, Cage's work spanned several disciplines, breaking down boundaries. He collaborated with choreographer Merce Cunningham, studied with Arnold Schoenberg and was profoundly influenced by Zen Buddhism and Marcel Duchamp. Cage believed all sound—even incidental or unintentional—is music. Early works were for piano "prepared" with unusual sounds. His most famous declaration was four minutes and thirty-three seconds of silence, in which the audience heard only the ambient sounds around them. Chance methods of composition, indeterminate scores, and the use of radios and recording equipment saw Cage's work greatly influence performance art. **LB**

WOLS

Masterworks

Bird 1949 (Menil Collection, Houston, U.S.)

Composition 1946 (Musée National d'Art Moderne, Paris, France)

Untitled (*Rolled Cheese*) c.1938–1939 (Kunsthaus, Zürich, Switzerland)

Born: Alfred Otto Wolfgang Schulze, 1913 (Berlin, Germany); died 1951 (Paris, France).

Artistic style: Gestural, expressive abstract paintings; small, intricate, immersive pen drawings; photographs of the everyday seen through dramatic shifts in scale.

Wols has come to epitomize the tortured existentialist painter. Moving from Germany to Paris in 1932, he befriended the surrealists, and developed his practice as a photographer and draftsman. In 1945, Wols exhibited his teeming, small-scale drawings. He began to experiment with oils that pioneered art informel and tachism. His works suggest busy raw microcosms, expressing what Jean-Paul Sartre described as the "universal horror of being in the world." Wols's vagabond lifestyle, his increasingly severe addiction to alcohol, and his premature death at the age of thirty-eight, have contributed to a mythologized biography; however behind the myth there is a legacy vital to the development of subsequent art. **EK**

AD REINHARDT

Born: Adolph Dietrich Friedrich Reinhardt, December 24, 1913 (Buffalo, New York, U.S.); died August 30, 1967 (New York, New York, U.S.).

Artistic style: Arch modernist; cerebral abstractionist; highly calibrated visual subtlety; monochrome paintings; pioneer of minimalism and conceptual art.

Ad Reinhardt was initially associated with abstract expressionism, making a cerebral and refined contribution to the development of abstraction. Having studied literature and art history at Columbia University, Reinhardt began his training as an artist at New York's American Artists School and then went to the National Academy of Design. Reinhardt's works of the late 1930s and early 1940s are primarily collage-based, geometric studies. He increasingly incorporated a more intuitive form of mark making, in line with developments in painting being made by abstract expressionism. During this time, he worked for the polemical newspaper *PM*, creating a series of cartoons that were as acerbic as they were amusing.

His break with abstract expressionism came at the start of the 1950s when Reinhardt deliberately adopted a more detached, geometric style of abstraction. He then developed the series of paintings with which his name has become synonymous. From 1955, he worked exclusively in black or near black. At first glance, these monochromatic paintings appear to have been made from one tone. On closer inspection, after allowing one's eyes to adapt, one can see the highly nuanced surface Reinhardt was able to create. What is noticeable is that paintings such as *Abstract Painting* (1963) are comprised of a grid of nine squares. With paintings such as these Reinhardt attempted make "art-as-art" so that all other things could be "everything else." These paintings, austere in their paired-down intellectualism, not only make significant statements in themselves but they also anticipated the logic and rationale that both minimalism and conceptual art would subsequently bring to the art object. **CS**

Masterworks

Abstract Painting No. 5 1962 (Tate Collection, London, England)

Abstract Painting 1963 (Museum of Modern Art, New York, U.S.)

Abstract Painting No. 34 1964 (National Gallery of Art, Washington, D.C., U.S.)

Abstract Painting 1960–1966 (Guggenheim, New York, U.S.)

1910–19

"The one object of fifty years of abstract art is to present art-as-art and as nothing else."

ABOVE: Detail from a photograph of Reinhardt by John Loengard in 1966.

PHILIP GUSTON

Born: Phillip Goldstein, June 27, 1913 (Montreal, Canada); died June 7, 1980 (Woodstock, New York, U.S.).

Artistic style: Early abstract expressionist; cartoonlike imagery; recurring motifs of the Ku Klux Klan, lightbulbs, cigarettes, hands, and nooses; use of red and gray.

Philip Guston is a key artist for subsequent generations of painters. Guston's social activism, interest in art history, and years of painting all come together in his late work when he made a radical move from abstraction to figurative work, combining surfaces that reveal their brushstrokes with brutal and enigmatic narratives. Much of the imagery in his late paintings can be traced back to Guston's childhood, during which his father hanged himself and the Ku Klux Klan was active. Guston came from a Russian-Jewish family.

Guston went to school with painter Jackson Pollock in Los Angeles, where they were both expelled for writing a paper criticizing the school for valuing sports over arts. During the 1930s he worked for the Federal Art Project producing murals influenced by Mexican muralist artists such as Diego Rivera and the Greek-Italian Metaphysical painter Giorgio de Chirico. The smoking hand and restless one-eyed head that feature in his paintings represent the artist in his intense struggle with painting, as documented in his daughter's book *The Night Studio: A Memoir of Philip Guston* (1988).

In the 1950s Guston became known as one of the chief exponents of abstract expressionism. His lyrical paintings of this period are reminiscent of Claude Monet's late series of water lilies. Guston revealed his return to figuration in his 1970 show at New York's Marlborough Gallery, horrifying some of his supporters, who thought his new work cartoonlike and ugly. However, he is best known for these paintings that he continued making up to his death in 1980. They have strongly influenced subsequent generations of painters by erasing the boundaries between the abstract and the figurative that previously had been seen as vital. **JJ**

Masterworks

Mother and Child 1930 (Private Collection)

Painting 1954 (Museum of Modern Art, New York)

For M 1955 (San Francisco Museum of Modern Art, San Francisco, U.S.)

The Return 1956–1958 (Tate Collection, London, England)

Head 1965 (Tate Collection, London, England)

City Limits 1969 (Museum of Modern Art, New York)

The Studio 1969 (Private Collection)

Painting, Smoking, Eating 1973 (Stedelijk Museum, Amsterdam, The Netherlands)

Monument 1976 (Tate Collection, London, England)

Talking 1979 (Museum of Modern Art, New York, U.S.)

"Painting is 'impure.' It is the adjustment of impurities which forces painting's continuity."

ABOVE: In the full picture, Guston leans on a bar as he holds a drink in one hand.

MERET OPPENHEIM

Born: Meret Oppenheim , October 6, 1913 (Berlin, Germany); died November 15, 1985 (Berne, Switzerland).

Artistic style: Surrealism; witty use of everyday objects in strange juxtapositions that appear erotic; explorations of femininity and the subconscious.

Sculptor Meret Oppenheim studied in Basle from 1929 to 1930 and in Paris in 1931. Paul Klee influenced her early works but it was Alberto Giacometti who suggested her first surrealist sculpture, the tiny bronze *Giacometti's Ear* (1933). Through him she met the surrealists and quickly became their idealized version of the female. She made no objection to this casting and enjoyed posing nude for Man Ray, most famously in *Portrait of Meret Oppenheim (Erotique Voilée)* (1933), smeared with ink and reclining against a printing press.

The work she is best known for, *Object* (1936), a fur-covered teacup, saucer, and spoon, has a latent eroticism and is perhaps a wry dig at the male-dominated art world she frequented. It is unclear how much Oppenheim was aware of this at the time, and from her account it seems the sexualization of the objects is almost accidental. *Object* is said to have been inspired by a conversation between Oppenheim, Pablo Picasso, and Dora Maar at a Paris café. Picasso complimented Oppenheim's fur-trimmed bracelets and said one could cover almost anything with fur. Oppenheim responded, "Even this cup and saucer."

Her return to Basle in 1937 marked an unhappy period where she produced little and destroyed a great deal, yet she could still cause a stir. In 1959, on the opening night of the Paris International Surrealist Exhibition, she made *Le Festin* (1959). Tantamount to an early happening, it comprised a nude female lying on a table covered in food. The piece was a reenactment—at the instigation of André Breton—of a banquet she arranged for friends as a spring rite. Again, Oppenheim seemed unaware of the implications of her work that attracted much criticism for its objectification of women and allusions to cannibalism. **WO**

Masterworks

Giacometti's Ear 1933 (Private collection)

Red Head, Blue Body 1936 (Museum of Modern Art, New York, U.S.)

Object 1936 (Museum of Modern Art, New York, U.S.)

My Nurse (1936) 1967 (Museum of Modern Art, Stockholm, Sweden)

"Every notion is born along with its form. I make reality of ideas as they come into my head."

ABOVE: *Meret Oppenheim Portrait with Tattoos* was made in 1980.

ROBERT MOTHERWELL

Born: Robert Motherwell, January 24, 1915 (Aberdeen, Washington, U.S.); died July 16, 1991 (Provincetown, Massachusetts, U.S.).

Artistic style: Abstract expressionist painter and printmaker; use of heavy black lines and blocks of color to convey mood and emotion.

Masterworks

Wall Painting III, 1953 (Museu d'Art Contemporani de Barcelona, Barcelona, Spain)

Elegy to the Spanish Republic 34, 1953–1954 (Albright-Knox Art Gallery, Buffalo, U.S.)

Elegy to the Spanish Republic 54, 1957–1961 (Museum of Modern Art, New York, U.S.)

Elegy to the Spanish Republic 108 (The Barcelona Elegy), 1966 (Dallas Museum of Art, Dallas, U.S.)

Blue Elegy, 1987 (National Gallery of Australia, Canberra, Australia)

"Art is much less important than life, but what a poor life without it."

ABOVE: Robert Motherwell photographed by Sahm Doherty in 1977.

At the outset of his career, having studied philosophy at Stanford University, Motherwell was naturally attracted to new ideas behind abstraction in art. In particular, he absorbed the idea of automatism—the spontaneous expression of emotion through similarly spontaneous brushstrokes—from European surrealists exiled in New York at the beginning of World War II.

Motherwell took this idea to its logical conclusion in several series of paintings and prints, including his most famous series, *Elegy for the Spanish Republic* (1948–1990). Monumental in scale and numbering more than a hundred works in over forty years, the sequence was inspired by a poem by Spanish poet Federico García Lorca on the tragedy of the Spanish Civil War. Unlike Pablo Picasso, who produced an instant response to the repression and horror of the war with *Guernica* (1937), Motherwell engaged with the same subject cumulatively and in retrospect. All the paintings are linked to one another by similar black forms: strong black verticals punctuated horizontally by rounded shapes, repeated and varied through the series. Each suggests something different: a cave painting shut up for millennia; eyes dilated in fright; hands gripping the bars of a prison; or elements of traditional Spanish culture, such as the hooves of a bull or a swirling flamenco skirt imprisoned by Fascism. Motherwell's strong strokes and smeared planes of color, although apparently random, directly articulated his inner responses to places, times, and cultures outside his own. By constantly pushing the boundaries to express his subconscious reactions to world events, Motherwell became one of the founders of the first artistic movement to be conceived and practiced in the U.S.: abstract expressionism. **SC**

ANDREW WYETH

Born: Andrew Newell Wyeth, July 12, 1917 (Chadds Ford, Pennsylvania, U.S.).

Artistic style: Magical realist painter; uses of watercolor, tempera, and drybrush; meticulous brushwork; still life; landscapes and genre scenes of his native area and its inhabitants.

When Andrew Wyeth exhibited *Christina's World* (1948) at a New York art gallery, it rocked the art world. Within weeks, the painting had been purchased by New York's Museum of Modern Art, and it soon attracted thousands of appreciative viewers. By the 1950s, he was as talked about as Jackson Pollock. What startled the art world was not Wyeth's talent but the content of the painting. Its almost hyperrealistic style went against the prevailing trend for abstract and expressionist art and it was unfashionably painted in old-fashioned egg tempera rather than oils or gouache.

Christina's World is typical of Wyeth's oeuvre in that it depicts the landscape and a person he knows. His paintings are of the Maine coast and Chadds Ford in Pennsylvania, where he grew up, and feature stark, somber hills; windblown trees; clapboard barns; and farm outbuildings. His sitters are his friends and neighbors. In *Christina's World* his disabled neighbor Christina Olson, her twisted form sitting on a hillside, is gazing up to forsaken buildings at the top of the hill. It appears realistic, but Wyeth is famous for rearranging the landscapes he depicts, and he leans toward magic realism. He omits features on a landscape and changes angles in order to convey the emotion or story that he wants to depict: a feeling or narrative that is often haunting or poignant. Wyeth's art has always been a highly personal and often family affair. His wife Betsy is his dealer, and his son James is also a painter. He says that after the death of his father, teacher, and mentor, the painter and illustrator Newell Convers Wyeth in an automobile accident in 1945, his work took on the emotional intensity that continues to inform the subjects he so skillfully depicts time and again. **CK**

Masterworks

Turkey Pond 1944 (Farnsworth Art Museum and Wyeth Center, Rockland, Maine, U.S.)

Christina's World 1948 (Museum of Modern Art, New York, New York, U.S.)

Snow Flurries 1953 (National Gallery of Art, Washington, D.C., U.S.)

Hay Ledge 1957 (The Greenville Collection, Greenville, South Carolina, U.S.)

Her Room 1963 (Farnsworth Art Museum and Wyeth Center, Rockland, Maine, U.S.)

Evening At Kuerners 1970 (Brandywine River Museum, Chadds Ford, Pennsylvania, U.S.)

Pageboy 1979 (Adelson Galleries, New York, New York, U.S.)

Field Hand 1985 (National Gallery of Art, Washington, D.C., U.S.)

"I think it's what you take out of a picture that counts. There's a residue. An invisible shadow."

ABOVE: Detail from *Andrew Wyeth in a Fur Coat,* by Richard Shulman in 1983.

LEONORA CARRINGTON

Born: Leonora Carrington, April 6, 1917 (Clayton Green, Lancashire, England).

Artistic style: Surrealist painter, sculptor, and tapestry maker; themes of magic, alchemy, and the occult; images of fantastic animals; concern with the feminine.

Masterworks

Self-Portrait at the Inn of the Dawn Horse,
1936–1937 (Private collection)

Do You Know My Aunt Eliza? 1941
(Tate Collection, London, England)

I am an Amateur of Velocipedes 1941
(Tate Collection, London, England)

Un Pescado Vestido 1977 (Meadows Museum,
Southern Methodist University, Dallas, U.S.)

Samhain Skin 1975 (National Museum of
Women in the Arts, Washington, D.C., U.S.)

Crookhey Hall 1986 (National Museum of
Women in the Arts, Washington, D.C., U.S.)

One of the last surviving surrealists, Leonora Carrington's work is dominated by images of hooded crones, fantastic animals, and strange beings that inhabit an imaginary world drawn from Celtic folklore, Mexican myth, the occult, fairytales, and nursery rhymes. Her paintings exude the creative power of the feminine coupled with a malevolent sense of foreboding.

Born the daughter of a wealthy textile magnet, she grew up in Crookhey Hall, Lancashire—the grand house went on to feature in many of her paintings as a sinister presence. She rebelled against her bourgeois upbringing and was expelled from various convent schools before her family sent her to study art in Italy at Florence's College of Miss Penrose, where she was exposed to the works of the Old Masters. On her return to London, she continued her artistic education at Chelsea School of Art, and the Academy of Amédée Ozenfant.

In 1937, she went to a party where she met surrealist Max Ernst—it was a meeting that changed her life. She eloped with Ernst to Paris, where she mixed with avant-garde artists such as Pablo Picasso, Salvador Dalí, and Joan Miró, and her work blossomed. When World War II struck, Ernst, who was German, was briefly imprisoned as an enemy alien before fleeing to the U.S. The experience devastated Carrington, who went to Madrid, where she suffered a nervous breakdown. Her family had her committed to a psychiatric hospital, yet she escaped to Mexico City via the U.S., where she continues to live to this day.

Her arrival in Mexico saw Carrington draw fresh inspiration from fellow artists, including Frida Kahlo, Diego Rivera, and Remedios Varo. She began to incorporate Aztec myth, mysticism, and alchemy into her work. Her later years have seen her sculpt as well as paint. **CK**

"You don't decide to paint. It's like getting hungry. . . . It's a need, not a choice."

ABOVE: Leonora Carrington, photographed in November 2000, at her home in Mexico.

RIGHT: *Baby Giant* (1947). The huge infant, surrounded by swirling birds, holds an egg.

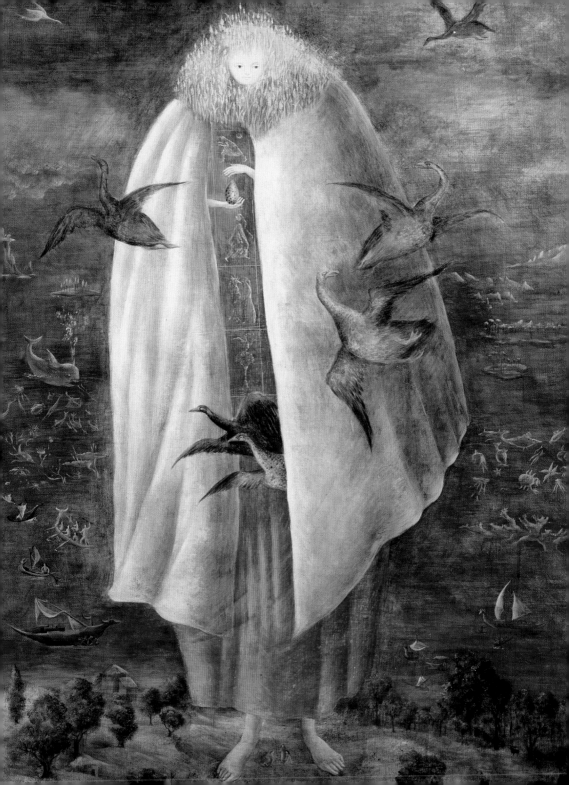

JOHN MINTON

Born: Francis John Minton, 1917 (Great Shelford, Cambridgeshire, England); died 1957 (London, England).

Artistic style: Neo-romantic painter, illustrator, and theatrical designer; figures, townscapes, and landscapes; oils and watercolors; lyrical scenes of urban decay.

Masterworks

Recollections of Wales 1944 (British Council Collection, London, England)

Children by the Sea 1945 (Tate Collection, London, England)

Rotherhithe from Wapping 1946 (Southampton Art Gallery, Southampton, England)

Street and Railway Bridge 1946 (Tate Collection, London, England)

*John Minton c.*1953 (National Portrait Gallery, London, England)

Portrait of Kevin Maybury 1956 (Tate Collection, London, England)

Composition: The Death of James Dean 1957 (Tate Collection, London, England)

John Minton studied at London's St. John's Wood School of Art, before moving to Paris where he shared a studio with Michael Ayrton. When World War II broke out Minton registered as a conscientious objector, but later joined the Pioneer Corps although he was discharged in 1943 because of ill health. He went on to share a studio with Robert Colquhoun and Robert MacBryde, and to teach at London's Camberwell School of Art and Crafts, Central School of Arts and Crafts, and at the Royal College of Art, having his first solo exhibition in 1945. After the war he traveled to Corsica, the West Indies, Morocco, and Spain in search for inspiration, and this influenced his color palette.

Minton was a leading figure in the British neo-romantic movement, along with Keith Vaughan and John Craxton, but he was also a prolific book illustrator, graphic designer, and set and costume designer for the stage. Works portraying 1940s Britain, such as his lyrical canvas of the Cornish coast *Children by the Sea* (1945), combined with poignant scenes of urban decay, such as *Rotherhide from Wapping* (1946), gained Minton widespread recognition, and drew comparisons with Samuel Palmer and John Piper. Such was his popularity that he was commissioned to paint a mural for the Festival of Britain in 1951. Minton was also a proponent of figurative painting, known for his portraiture. Sadly, the shift toward abstract expressionism in the 1950s fueled Minton's insecurities, and by the time he painted the poignant *Composition: The Death of James Dean* (1957) his work was no longer fashionable, and his career was in decline. Although Minton was a bon viveur well known in the bohemian circles of London's Soho, he was also an alcoholic prone to bouts of depression, and he committed suicide in 1957. **CK**

"The important thing is to be there when the picture is painted."

ABOVE: A detail from *Self-Portrait* (1946), in pencil, held in a private collection.

SIDNEY NOLAN

Born: Sidney Robert Nolan, April 22, 1917 (Melbourne, Australia); died November 28, 1992 (London, England).

Artistic style: Painter, lithographer, and set designer; landscapes of the Australian Outback; historical and mythic themes; use of commercial enamel paint.

Sir Sidney Nolan is Australia's best known painter. His work reveals his country's landscape through history and myth, featuring historical figures such as the explorers Robert O'Hara Burke and William John Wills. His series about the nineteenth-century bushranger, hero, and outlaw Ned Kelly, in homemade armor crossing the bush, have become part of Australian iconography. Nolan deliberately shied away from tradition. His seemingly naive style of figure painting was his way of creating an authentic idiom, and he used enamel paints to distance his work from the tradition of Australian landscapes. He continued throughout his career to use innovative painting techniques, such as PVA paint scraped across hardboard, and often worked in series, repeating earlier imagery and themes. A printmaker as well as a painter, Nolan's lithographs combine realistic images with his trademark Australian bush landscapes. The effect in works such as *The Slip* (1971) is both surreal and jolting. Nolan was also influenced by a love of music and poetry and, from 1940, he designed sets for ballets and the theater.

Nolan's personal life was turbulent. He began an affair with his married patroness, Sunday Reed, while living with her and her husband in their house "Heide" in the Melbourne suburbs. Known then as an artists' meeting place, the house is now a museum. The affair caused scandal and dissension in the avant-garde circle Nolan lived within. When Nolan ended the relationship, Reed refused to let him have his Ned Kelly works back. His tempestuous personal life seems to have been a mirror of his fluctuating critical reputation. Some accused him of spreading himself too thin, while others lavished praises, such as English art historian Kenneth Clark, who considered him Australia's only real painter. **JJ**

Masterworks

Steve Hart 1945 (Nolan Gallery, Tharwa, ACT, Australia)

Kelly and Horse 1945 (Nolan Gallery, Tharwa, ACT, Australia)

Ned Kelly 1946 (National Gallery of Australia, Canberra, Australia)

Death of Sergeant Kennedy at Stringybark Creek 1946 (National Gallery of Australia, Canberra, Australia)

The Slip 1947 (National Gallery of Australia, Canberra, Australia)

Burke and Wills Expedition 1948 (Nolan Gallery, Tharwa, ACT, Australia)

Dry Jungle 1949 (Art Gallery of New South Wales, Sydney, Australia)

Inland Australia 1950 (Tate Collection, London, England)

"If the moment is right . . . the paint itself . . . actually begins to spread itself into forms."

ABOVE: *Self-Portrait* (1943) was painted after Nolan was conscripted into the army.

COLIN McCAHON

Masterworks

Victory Over Death 1969 (Auckland Art Gallery Toi O Tamaki, Auckland, New Zealand)

Teaching Aids 3 1975 (Auckland Art Gallery Toi O Tamaki, Auckland, New Zealand)

Urewera Mural 1975–1976 (Aniwaniwa Visitors Centre, Lake Waikaremoana, New Zealand)

Rocks in the Sky Series 2, No. 5: The Lagoon: Plankton, 1976 (Auckland Art Gallery Toi O Tamaki, Auckland, New Zealand)

A Painting for Uncle Frank 1980 (Museum of New Zealand Te Papa Tongarewa, Wellington, New Zealand)

Born: Colin John McCahon, August 1, 1919 (Timaru, Canterbury, New Zealand); died May 27, 1987 (Auckland, New Zealand).

Artistic style: Somber colors; large, unstretched panels of canvas; landscape and religious themes; direct, expressionistic painting; use of text and numbers.

McCahon has posthumously acquired a reputation as New Zealand's greatest contemporary artist. He had a religious upbringing, and themes of faith, struggle, and commitment characterized his life and work. In 1942, he married painter Anne Hamblett. The couple lived with their children in various parts of the country, giving McCahon access to diverse New Zealand landforms that, along with religious and Maori references, formed his key subject matter. In 1958, he received a Carnegie Grant to paint and study in the U.S.; on his return he created large landscape abstractions on unstretched canvas. Exposure to abstract expressionist techniques and ideas in the U.S. contributed to his seemingly crude yet powerful style. **NG**

GORDON WALTERS

Masterworks

New Zealand Landscape 1947 (Museum of New Zealand, Te Papa Tongarewa, Wellington, New Zealand)

Untitled 1952–1953 (Auckland Art Gallery Toi O Tāmaki, Auckland, New Zealand)

Untitled 1955 (Museum of New Zealand, Te Papa Tongarewa, Wellington, New Zealand)

Tawa 1968 (Auckland Art Gallery Toi O Tāmaki, Auckland, New Zealand)

Genealogy 1972 (Auckland Art Gallery Toi O Tāmaki, Auckland, New Zealand)

Maho 1972 (Auckland Art Gallery Toi O Tāmaki, Auckland, New Zealand)

Untitled 1973 (Auckland Art Gallery Toi O Tāmaki, New Zealand)

Untitled 1982 (Auckland Art Gallery Toi O Tāmaki, New Zealand)

Born: Gordon Frederick Walters, 1919 (Wellington, New Zealand); died 1995 (Christchurch, New Zealand).

Artistic style: Geometric, hard-edged abstract paintings; stylized Maori and Pacific motifs; repeat patterns; black-and-white shapes; pastel shades; printlike surfaces.

After working as a commercial artist, Gordon Walters traveled to Australia and Europe, absorbing the influence of artists such as Jean Arp, Piet Mondrian, Paul Klee, and compatriot Theo Schoon. This led him to a method of applying paint that was graphic, pristine, and emphatically flat. His mature work, such as the *Koru* (1964–1989) series, is a compelling combination of hard-edged geometric figures, bands of color, and stylized Maori motifs reduced almost to abstraction. His strongly contrasting colors and pattern produce effects akin to op art. Walters was admired by successive generations of New Zealand artists yet, late in life, his appropriation of indigenous motifs was considered politically controversial. **NG**

WAYNE THIEBAUD

Born: Wayne Morton Thiebaud, 1920 (Mesa, Arizona, U.S.).

Artistic style: Painter; associated with pop art; depictions of objects familiar in consumer society; orderly composition; simple shapes, subtle tones, and textures painted from memory.

Wayne Thiebaud's works include landscapes, streetscapes, and stylized comforting images of food. After graduating from Sacramento State College, he worked as a cartoonist and designer in California and New York and as an artist in the U.S. Navy. After becoming a Master of Arts, he began teaching at Sacramento City College. He was assistant professor at the University of California during the 1960s and 1970s. As a teacher, he encouraged traditional disciplines and realism rather than conceptualism.

In his work, he was influenced by his abstract friends, Willem de Kooning and Franz Kline, as well as by pop artists Robert Rauschenberg and Jasper Johns. Also influenced by Giorgio Morandi for his subtle light effects, Thiebaud drags rich, smooth paint across his canvases to exploit the nature of oil paint and to represent the textures being depicted.

In the late 1950s, Thiebaud began a series of small paintings based on images of food and consumer goods, reminiscent of contemporary advertisements that demonstrated his experience in advertising design. In 1960, he had his first solo shows in San Francisco and New York. They received scant attention, but two years later a New York exhibition officially launching pop art brought him national recognition. Thiebaud, who admits all his subjects relate to his memories, dislikes viewers looking for symbolism in his paintings. He is associated with pop art because of his interest in objects of mass culture, yet his paintings of the 1950s and 1960s predate the works of the pop art movement. Whereas pop artists satirize consumer society, mass production, and advertising, Thiebaud's work portrays an appreciation for aspects of the U.S. experience that have disappeared. **SH**

Masterworks

Cakes 1963 (National Gallery of Art, Washington, D.C., U.S.)

Chocolate Cake 1971 (Tate Collection, London, England)

Three Machines 1963 (De Young Museum, San Francisco, U.S.)

Eight Lipsticks 1988 (National Gallery of Art, Washington, D.C., U.S.)

1920–29

"We all need critical confrontation of the fullest and most extreme kind."

ABOVE: Wayne Thiebaud, whose works ooze nostalgia for a lost American age.

PATRICK HERON

Born: Patrick Heron, January 30, 1920 (Headingley, Leeds, Yorkshire, England); died March 20, 1999 (Cornwall, England).

Artistic style: One of the first British artists to embrace abstraction, he introduced a post-war generation to the delights of pure color and visual sensation.

Masterworks

Long Table With Fruit 1945 (Tate Collection, London, England)

Boats at Night 1947 (Tate Collection, London, England)

Azalea Garden, May 1956 1956 (Tate Collection, London, England)

Scarlet, Lemon and Ultramarine: March 1957 1957 (Tate Collection, London, England)

Horizontal Stripe Painting : January-February 1958 1958 (Tate Collection, London, England)

Red Painting: July 25 1963 1963 (National Galleries of Scotland, Edinburgh, Scotland)

"[Heron's work is] . . . a thinking art as well as an expressive art."
—A. S. Byatt

ABOVE: Patrick Heron, whose work was largely inspired by the Cornish landscape.

RIGHT: *Horizontal Stripe Painting : January-February 1958* was executed in oil on canvas.

Although born in Yorkshire, Patrick Heron grew up in Welwyn Garden City and London before moving to Cornwall in 1956, the county with which he will forever be associated. He told his parents he had decided he wanted to be an artist at the tender age of three, and at eight years old he was making incredibly assured drawings of the Cornish coast. Perhaps helped by his father, whose company was Cresta Silks, Heron designed a best-selling fabric at the age of fourteen.

Soaking up the influences of Paul Cézanne, Henri Matisse, Georges Braque, Pierre Bonnard, André Derain, and Pablo Picasso, Heron's work was drenched with vivid color. Back in St. Ives in Cornwall, he befriended Ben Nicholson, Barbara Hepworth, Naum Gabo, and Ivon Hitchens. Heron embraced abstraction influenced by U.S. art and introduced a postwar generation to artworks that conveyed a wonderfully pure visual sensation. In 1958 he inherited Ben Nicholson's studio, and painted there for the rest of his life.

In 1960 he had his first solo exhibition at The Bertha Schaefer Gallery in New York, and in 1972 he showed at the Whitechapel Gallery in London. Another major show took place in 1985. Phaidon Press published *Patrick Heron* (1998) by Mel Gooding, which coincided with Heron's retrospective at London's Tate Gallery. Heron's own writings on art and criticism were also widely influential. In Heron's obituary published in *The Times* newspaper, an admirer summed up the feeling of Britain's art lovers: "In the ideal museum of twentieth-century art, his best color paintings will be on the wall between those of Matisse and those of the Americans Mark Rothko, Ellsworth Kelly, Kenneth Noland, and Barnett Newman And they will continue to sing." **HP**

KAREL APPEL

Born: Karel Appel, 1921 (Amsterdam, the Netherlands); died 2006 (Zurich, Switzerland).

Artistic style: Painter, muralist, printmaker, ceramist, and sculptor; landscapes, nudes, and figurative works; motifs of children and animals; use of black outlines.

Masterworks

Questioning Children 1949 (Tate Collection, London, England)

Hip, Hip, Hoorah! 1949 (Tate Collection, London, England)

People, Birds and Sun 1954 (Tate Collection, London, England)

The Crying Crocodile Tries to Catch the Sun 1956 (Peggy Guggenheim Collection, Venice, Italy)

Abstract Composition 1958 (Fine Arts Museums of San Francisco, San Francisco, U.S.)

The Cattle Slaughter 1982 (Stedelijk Museum, Amsterdam, the Netherlands)

Dutch artist Karel Appel lived in Amsterdam, Paris, and New York. He mixed with the avant-garde in each city, working in collaboration with artists and writers such as beat poet Allen Ginsberg. He is famed for his paintings' wild colors, energetic brushstrokes, and grotesque depictions of children, monsters, and fantastic animals. His childlike paintings were akin to the art brut of Jean Dubuffet, but in fact he was a founder of the influential European postwar art movement CoBrA.

Appel studied art at Amsterdam's Rijks-Academie from 1940 to 1943. He formed the CoBrA group in Paris in 1948, and the group remained active until 1951. The name CoBrA was taken from the initials of the members' home cities: Asger Jorn came from Copenhagen; Christian Dotremont and Joseph Noiret from Brussels; and Constant, Corneille, and Karel Appel from Amsterdam—a curled snake was the symbol of the group.

The members strove to break away from prevailing surrealist style to use vibrant color and incorporate fantastic imagery inspired by children's drawings. They aimed to experiment with different media and to make collaborative works. The group's first show was held at the Stedelijk Museum in Amsterdam in 1949. It received a lukewarm reception, and the paintings were described as "daubing, claptrap, and splodges." Yet the museum purchased works from the show, and later Appel painted two murals for the museum. These commissions partly compensated for a mural, *Questioning Children* (1949), that he painted at Amsterdam's Town Hall; it was deemed incomprehensible and covered up by wallpaper. The mural was one of a series of paintings Appel produced with the same title, referring to the poverty of Dutch children both during and immediately after World War II. **CK**

"If I paint like a barbarian, it's because we live in a barbarous age."

ABOVE: Appel pictured in front of one of his sculptures in 1993.

JOSEPH BEUYS

Born: Joseph Beuys, May 12, 1921 (Krefeld, Germany); died January 23, 1986 (Düsseldorf, Germany).

Artistic style: Unusual materials given complex symbolic significance; ritualistic public performances; sustained yet provisional drawing; zeal for public speaking.

A charismatic and controversial figure, the shadow of Joseph Beuys stretches far across the last forty years of artistic production. Made famous by a series of ritualistic public performances, he was a tireless champion of the healing powers of art and the redemptive value of human creativity. Through his actions, drawings, sculptures, environments, vitrines, and prints, as well as an extremely energetic teaching and lecturing schedule, Beuys proposed art as the only true "evolutionary-revolutionary power" capable of "dismantling the repressive effects of a senile social system that continues to totter along the deathline." Perhaps the last figure to be genuinely committed to a utopian vision for art, Beuys's achievement remains hotly contested.

Like all those of his age, in the 1930s Beuys was a member of the Hitler Youth, and during World War II he flew for the Luftwaffe. In March 1944, Beuys's Stuka Ju 87 plane crashed in Crimea. The story of this event has served as something of an origin myth for Beuys's artistic persona, and its status has been the subject of much controversy. After the war, Beuys enrolled

Masterworks

The Secret Block for a Secret Person in Ireland 1945–1976 (Hamburger Bahnhof, Berlin, Germany)

Plight 1958–1985 (Musée National d'Art Moderne, Paris, France)

How to Explain Pictures to a Dead Hare 1965 (Performance at Galerie Schlema, Düsseldorf, Germany, documented by photographs)

The Pack 1969 (Staatliche Museen Kassel, Neue Galerie, Kassel, Germany)

1920–29

ABOVE: Joseph Beuys photographed in Germany in 1982.

LEFT: *Sled #6* is one of fifty such sculptures, each with its own survival kit—fat and all.

Beuys's Plane Crash

In 1944, Beuys's Stuka Ju 87 plane crashed in Crimea, killing the pilot and leaving Beuys severely injured. What happened subsequently has been the subject of much speculation and controversy. According to Beuys, he was rescued by Tartar nomads, who took him back to their camp and wrapped his frozen body in animal fat and felt to conserve heat and nursed him back to health. "You're not German," they told him, "You're Tartar," and they asked him to join their clan.

By his own account, it was only after twelve days or so that Beuys came to in a German field hospital. The story has since served as a myth for an artistic identity born out of the ruins of a near-fatal accident and an otherworldly encounter with a tribal community. Given that in actuality Beuys arrived in the military hospital a day after his crash, his account certainly embellishes, and possibly completely fabricates, the encounter.

For some, the story has provided a compelling anchor to help interpret Beuys's works. For others, it has come to stand for his dangerous refusal to acknowledge his own involvement in Germany's Nazi past and his flight from that trauma into a language of myth and mystery. In any case, the story has made it impossible to separate fully the artist's work from his mythologized biography.

at the Staatliche Kunstakademie Düsseldorf art academy. During his time as a student and beyond, Beuys read widely. He assimilated an enormous range of artistic and philosophical ideas: from the multidisciplinary achievements of Leonardo da Vinci, to the Swiss alchemist Paracelsus, the German romantic writers Novalis and Friedrich Schiller, Carl Jung, Rudolph Steiner, and James Joyce. The 1950s, however, were hard years and plagued by dire poverty and artistic self-doubt Beuys suffered a mental and physical collapse.

Performance art

Not until the 1960s did Beuys truly arrive on the national and international cultural stage. After a brief fling with the fluxus movement, he developed an extraordinary series of performances. In *How to Explain Pictures to a Dead Hare* (1965), for example, Beuys took on a characteristically shamanic role. With his head covered in gold and honey and an iron slab strapped to his foot, he spent three hours cradling a dead hare, muttering into its ear a mixture of guttural noises and more formalized explanations of the drawings that hung on the gallery walls. Unusual materials such as fat, felt, honey, iron, and copper frequently entered Beuys's artistic vocabulary, and each had a very specific significance for him. Honey, for example, was the ambrosial product of the bee community that was described by Steiner as the ideal socialist state, full of warmth and brotherhood.

Beuys became increasingly interested in the connection between art and politics. Well known for the slogan "everyone is an artist," he championed the power of human creativity to build an entire society as an enormous artwork. This expanded concept of art meant a fierce rejection of the conventional boundaries and hierarchies that organize forms of human activity. Instead, everything becomes integrated, through both time and space, into one great project, "social sculpture."

Beuys campaigned tirelessly for his ideas. He was a committed teacher, lecturing across the world and founding political organizations. His abolition of entry requirements to

ABOVE: *Fat Battery* (1963) is sculpted using metal, cardboard, margarine, and felt.

his Düsseldorf class was famously controversial and caused him to be ousted from his position in 1972. Some have regarded Beuys's utopian vision for art, and the almost evangelical zeal with which he delivered explanations for his works, as troublesome. After all, artists are not in control of the institutional, economic, or discursive networks into which their work gets placed, and those people who do exert such control rarely aspire to similarly utopian ideals. Nevertheless, Beuys would gain substantial international recognition, especially after his work was presented in a huge retrospective exhibition in New York in 1979. Whether shaman or sham, heroic prophet or hopeless idealist, Beuys has become a figure around whom the big questions of art's potential have again and again been organized. **EK**

"The molding processes of art are taken as a metaphor for the molding of society."

LUCIAN FREUD

Born: Lucian Michael Freud, December 8, 1922 (Berlin, Germany).

Artistic style: One of the most celebrated living artists; earlier style characterized by intensely observed detail and linear clarity; intimate portraits of sitters well known to the artist; painterly, fleshy nudes; innovative representational painter.

Masterworks

Girl with Roses 1947–1948 (British Council Collection, London, England)

Gil with a White Dog 1950–1951 (Tate Collection, London, England)

Interior in Paddington 1951 (Walker Art Gallery, Liverpool, England)

Francis Bacon 1952 (Tate Collection, London, England)

Wasteground with Houses, Paddington 1970–72 (Private collection)

Naked Girl with Egg 1980–1981 (British Council Collection, London, England)

Standing by the Rags 1988–1989 (Tate Collection, London, England)

Nude with Leg Up 1992 (Hirshhorn Museum and Sculpture Garden, Smithsonian Institution, Washington, D.C., U.S.)

Sunny Morning—Eight Legs 1997 (Art Institute of Chicago, Chicago, Illinois, U.S.)

After Cezanne 1999–2000 (National Gallery of Australia, Canberra, Australia)

Portrait of the Queen 2000–2001 (Royal Collection, Windsor Castle, Windsor, England)

ABOVE: An enigmatic Lucian Freud photographed in 1958.

RIGHT: Daylight pours in on *Large Interior W11 (after Watteau)* (1981–1983).

Lucian Freud is something of a public and private paradox. A member of a famous family, he is the son of architect Ernst Freud; grandson of Austrian psychoanalyst Sigmund Freud; and one of his brothers, Clement, is a politician, writer, and broadcaster. He is nevertheless well known for his aversion to publicity, and rarely attends official functions. He is one of the foremost figurative painters of all time, yet because his pictures progress slowly, his reputation is based upon a relatively small oeuvre, and he is underrepresented in public art collections.

Freud was born in Berlin but moved to England in 1933 because of the rise of Nazism. His early works combined a surrealist arrangement of unexpected objects with a dreamlike neo-romantic quality. However, his primary interest emerged as the study of the human face and figure. In the 1940s and 1950s, he evolved a signature style in meticulously observed,

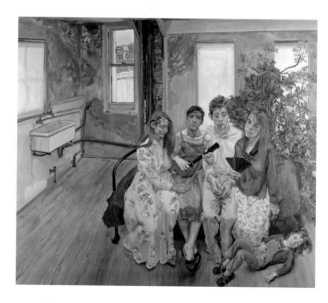

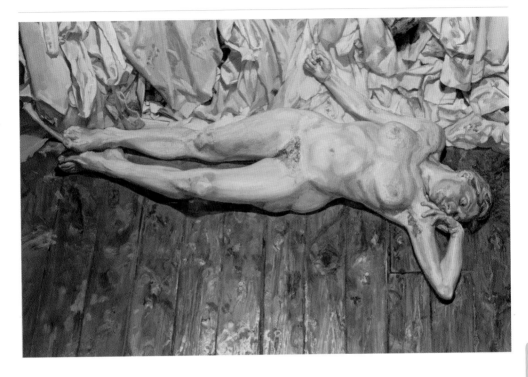

smoothly painted portraits that possess an exquisite clarity of line and texture and some naivety of form, notably in the exaggeration of overlarge facial features. He often juxtaposed his subjects with an object or animal—for example, the bull terrier in *Girl with a White Dog* (1950–1951)—and his sitters stare at the viewer with unnerving directness and solemnity.

This intensity of detail persists today in some of Freud's lesser-known paintings, such as his urban landscapes and studies of plants and flowers, but his figurative work underwent a significant stylistic change during the late 1950s. He abandoned sable brushes in favor of hog hair, and began using thicker paint and freer, fuller brushstrokes to depict the human body, both clothed and nude, with unparalleled unemotional objectivity. Freud always paints directly from life, and even his etchings are drawn directly onto the plate, constantly striving to create portraits that are "of people, not like them." **NM**

ABOVE: Painter Sophie de Stempel models for Freud in *Lying by the Rags* (1989–1990).

Freud's Models

Lucian Freud has described his work as autobiographical, and his models usually come from his inner circle. Among his most famous portraits are those depicting his mother, his daughters—Bella and Esther—and friend and fellow artist Francis Bacon. During the 1990s, he built up a close working relationship with two models whose body shapes interested him: performance artist Leigh Bowery and benefits supervisor "Big" Sue Tilley. He has also painted unconventional pictures of the supermodel Kate Moss (as a pregnant nude) and Queen Elizabeth II (an official—but highly controversial—study).

RICHARD DIEBENKORN

Born: Richard Clifford Diebenkorn, Jr., April 22, 1922 (Portland, Oregon, U.S.); died March 30, 1993 (Berkeley, California, U.S.).

Artistic style: Alternated between abstract expressionism and figuration, often combining the two; vivid colors allude to the essence of the U.S. landscape.

American painter and printmaker Richard Diebenkorn is widely recognized as one of the most influential painters of the postwar era. Born in Portland, Oregon, and raised in California, he is perhaps best known for *Ocean Park* (1967–1992); a series of over 140 large-scale abstract paintings, named after a community in Santa Monica where he had his studio. As an artist, he was heavily influenced by his immediate physical environment, and frequently used it to explore in depth the conflicting world of abstract and figurative painting.

Diebenkorn studied at Stanford University during the early 1940s, where he received his formal art training from Daniel

Masterworks

Palo Alto Circle 1943 (Private collection)

Woman by a Window 1957 (Phoenix Art Museum, Phoenix, Arizona, U.S.)

Ocean Horizon 1959 (Private collection)

Girl with Plant 1960 (The Phillips Collection, Washington, D.C., U.S.)

Cityscape I 1963 (San Francisco Museum of Modern Art, San Francisco, California, U.S.)

Ingleside 1963 (Grand Rapids Art Museum, Grand Rapids, Michigan, U.S.)

Window 1967 (Cantor Center for Visual Arts at Stanford University, Stanford, California, U.S.)

Ocean Park No.16 1968 (Milwaukee Art Museum, Milwaukee, Wisconsin, U.S.)

Ocean Park No.49 1972 (Los Angeles County Museum of Art, Los Angeles, California, U.S.)

ABOVE: Richard Diebenkorn, a major figure in postwar American art.

RIGHT: The eye is drawn to the corner of the canvas in *Ocean Park No. 79* (1975).

Mendelowitz. During this time he was introduced to the paintings of Edward Hopper, which clearly influenced the representational style that is evident in much of his early work, for example in *Palo Alto Circle* (1943). Diebenkorn's studies were then disrupted by a stint in the Washington Marine Corps during World War II. However, in Washington, the artist took the opportunity to visit the Phillips Collection, where he became inspired by Henri Matisse's self-conscious approach to painting, in particular his strong brushstrokes in the work *The Studio, Quai St. Michel* (1916). In 1946, Diebenkorn continued his education at the California School of Fine Arts. There he met his most influential teacher and friend, David Park. A year later he began teaching at the school, working alongside Park, Elmer Bischoff, and Mark Rothko, who encouraged him to move away from his still life and interiors toward abstract expressionism.

ABOVE: Vividly colored, *Woman by a Window* combines abstract and figurative painting.

Bucking the trend

Diebenkorn was not one to follow artistic trends: his dress and mannerisms were the antithesis of the chic artist of the beat generation. During the 1950s, while the New York art scene celebrated abstraction in painting, he was returning wholeheartedly to figuration. Along with artists such as Park and Bischoff, Diebenkorn formed the Bay Area Figurative School, combining the techniques developed through his abstract expressionist paintings with a reintroduction of the image. At this time, he produced many depictions of women observing landscapes from interiors, such as *Woman by a Window* (1957). During the late 1960s, when pop art was growing in reputation, Diebenkorn completely rejected representational form to reclaim and embrace abstraction in his famous *Ocean Park* series.

Since his death, Diebenkorn's work has been the feature of numerous major exhibitions around the world, including *Traveling Retrospective* (1997–1998) mounted by the Whitney Museum of American Art and the San Francisco Museum of Modern Art. **KO**

1920–29

Ocean Park

Diebenkorn returned to abstraction when he moved to a Californian beach community. Here he created the *Ocean Park* series, in which he abandoned figuration, producing more than 140 works with vivid geometric shapes painted in luminous tones on large canvases. In his work, he vaguely alludes to his observations of the California landscape in a manner that has been compared to Sir Peter Paul Rubens. *Ocean Park No. 83* (1975) is stylistically typical of the series in its unbalanced structural forms, loosely geometric composition, and intense brushstrokes.

RICHARD HAMILTON

Born: Richard Hamilton, February 24, 1922 (London, England).

Artistic style: British innovator of pop art; painter, printmaker, and photographer; radical, witty, sexy, gimmicky, and glamorous; teacher and exhibition organizer; use of computer technology.

Masterworks

Just What Is It That Makes Today's Homes So Different, So Appealing? 1956 (Tate Collection, London, England)

Adonis in Y Fronts 1963 (Tate Collection, London, England)

Kurt Schwitters's *Merzbarn* 1965 (Hatton Gallery, Newcastle, England)

Bathers 1967 (Smithsonian Hirshhorn Museum and Sculpture Garden, Washington, D.C., U.S.)

Richard Hamilton 1970 (National Portrait Gallery, London, England)

Countdown 1989 (Smithsonian Hirshhorn Museum and Sculpture Garden, Washington, D.C., U.S.)

A Renaissance man about the Tate Gallery, who was quite possibly the inventor of pop art, Richard Hamilton is one of a very few British artists to receive truly international acclaim. He grew up near London's Tate Gallery and studied at just about every major art school in London.

Hamilton had his first solo show with the Gimpel Fils Gallery when he was twenty-eight years old, soon after he met Roland Penrose, the driving force behind the Institute of Contemporary Arts. Penrose enabled two encounters that played an important part in shaping Hamilton's future. The first was with artist and architect Victor Passmore, who gave him a teaching job in Newcastle. The second was with the work of Dadaist Marcel Duchamp, which clearly put him on the road to success.

During the mid-1950s, Hamilton started to make what became known as pop art, which he later described as "popular, transient, expendable, low cost, mass produced, young, witty, sexy, gimmicky, glamorous, and Big Business." Possibly the first pop art image was his collage *Just What Is It That Makes Today's Homes So Different, So Appealing?* (1956).

His restless mind took him beyond conventional art practice to organize the preservation of Kurt Schwitters's *Merzbarn* (1947–1948) in Cumbria, and assemble the first British retrospective of Duchamp's work for the Tate. Hamilton went on to design The Beatles's *The White Album* (1968), and made a series of prints of The Rolling Stones's lead singer Sir Mick Jagger getting busted for drugs—Hamilton's work at this time largely had its roots in photography. The artist quit the fast lane and lives in rural Oxfordshire, still pushing the boundaries and continuing what Duchamp started: never chipping away at the edges and always cutting deep into the core. **SF**

"Elvis was to one side of a long line while Picasso was strung out on the other side. . ."

ABOVE: Richard Hamilton, the father of the British pop art movement.

ROY LICHTENSTEIN

Born: Roy Fox Lichtenstein, October 27, 1923 (New York, U.S.); died September 29, 1997 (New York, U.S.).

Artistic style: Pop art painter, lithographer, and sculptor; borrowed from popular advertising and comic books; use of strong primary colors; simple patterns.

Roy Lichtenstein studied art briefly at the New York Art Students League, then at Ohio State University. After serving in the army from 1943 to 1946, he returned to Ohio State University and gained a master's degree. To supplement his income, he did a series of part-time jobs, including working as a commercial artist, window dressing, and teaching. In the late 1950s Lichtenstein was influenced by abstract expressionism, but by 1961 he had changed direction and was painting cartoon characters and commercial images in a distinctive way. Surrounded by controversy within the media, his first solo exhibition in New York in 1962 was a sensational success.

His often vast pictures are based on the enlargement of details of advertisements of everyday objects and comics, using heavy black outlines and dynamic compositions. As in cheaply printed comic strips, Lichtenstein built up the colors and tones with primary-colored dots, but because his paintings were larger than newspaper comic strips, the dots were painted through stencils and known as "Benday Dots," after illustrator Benjamin Day. People in Lichtenstein's paintings are idealized, and any text is ambiguous. His compositions and use of strong primary colors or black and white translate effortlessly into uncomplicated but powerful patterns.

As with contemporary pop art artists such as Andy Warhol, Lichtenstein produced stereotypical and banal images of mass culture, abandoning the idea of the artist as a creative genius and aiming to challenge the importance of traditional high art. He also experimented with colored plastics, brass, and enameled metal sculpture. His deceptively simple paintings are complex compositions, carefully and precisely drawn and painted: satirical observations of life. **SH**

Masterworks

Takka Takka 1962 (Museum Ludwig, Cologne, Germany)

Whaam! 1963 (Tate Collection, London, England)

Drowning Girl 1963 (Museum of Modern Art, New York, U.S.)

Torpedo . . . Los 1963 (Private collection)

Still Life with Crystal Bowl 1973 (Whitney Museum of American Art, New York, U.S.)

"Picasso himself would probably have thrown up looking at my pictures."

ABOVE: Photograph of Roy Lichtenstein, taken four years before he died.

1920–29

LARRY RIVERS

Born: Yitzroch Loiza Grossberg, August 17, 1923 (Bronx, New York, U.S.); died August 14, 2002 (Southampton, New York, U.S.).

Artistic style: Revealing portraits of friends, family, and lovers; historical and literary subjects; large paintings that combine rough sketchiness with detailed areas.

Masterworks

Washington Crossing the Delaware 1953 (Museum of Modern Art, New York, U.S.)

The 25 Cent Summer Cap 1955 (Hirshhorn Museum and Sculpture Garden, Smithsonian Institute, Washington, D.C., U.S.)

Double Portrait of Berdie 1955 (Whitney Museum of American Art, New York, U.S.)

The Studio 1956 (Minneapolis Institute of Arts, Minneapolis, Minnesota, U.S.)

The Greatest Homosexual 1964 (Hirshhorn Museum and Sculpture Garden, Smithsonian Institute, Washington, D.C., U.S.)

History of the Russian Revolution from Marx to Mayakovsky 1965 (Hirshhorn Museum and Sculpture Garden, Smithsonian Institute, Washington, D.C., U.S.)

Larry Rivers was born to Ukrainian Jewish parents in the Bronx. His father was an amateur violinist, and Rivers became a professional jazz saxophonist, adopting the stage name of Irving Grossberg before becoming Larry Rivers. Introduced to painting by realist landscape painter Jane Freilicher, Rivers studied with Hans Hoffman in 1947 but rejected abstraction, feeling more inspired by the post-impressionist paintings he saw at the Museum of Modern Art and by his travels to Paris. A voracious reader, he turned to figural subject matter and the influence of literature and art history.

A central figure of the New York school of painters in the 1950s, Rivers enjoyed remarkable success, with a show every year from 1951 to 1962. His painting *Washington Crossing the Delaware* (1953), a reworking of Emanuel Leutze's 1851 painting, was bought by the Museum of Modern Art in 1955. Rivers said the work was "dedicated to a national cliché," subverting the heroic subject of the original painting on a

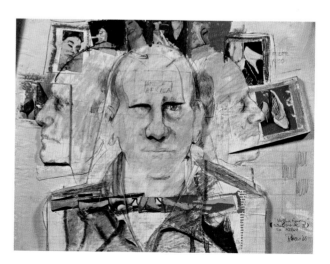

ABOVE: The hedonistic Larry Rivers, an icon of the New York school of painting.

RIGHT: *Vacation Economy* (1965) mixes portraiture with everyday genre painting.

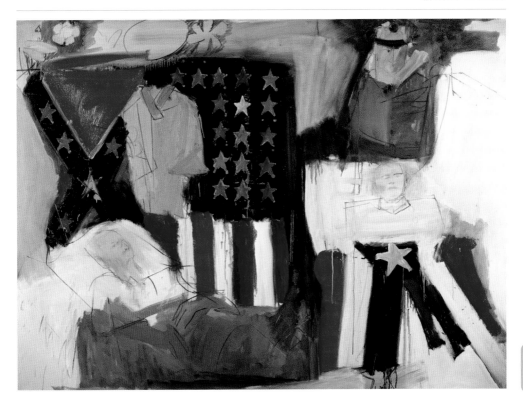

canvas interspersed with rough sketchy areas or raw canvas. He later treated other similarly historical narrative subjects to the same dense assemblage of images, such as in the complex construction *History of the Russian Revolution* (1965).

Rivers separated from his first wife and raised two sons with the aid of his mother-in-law, Berdie, one of his favourite muses. He married and divorced a second time (gaining two daughters and a son) and had many lovers. His children appear in later paintings, continuing a chronicle of family, friends, and lovers. He was sexually adventurous and ambiguous, and the sexual subject matter of many of his works is unashamedly clear. An important figure on the New York bohemian party scene and a friend of the Beats, Rivers was known as a wild entertainer, artistic rebel, and consummate self-promoter. **LB**

ABOVE: *The Last Civil War Veteran* is one of the artist's best known works.

Poetic Inspiration

Washington Crossing the Delaware inspired both artists and writers. Most notably the poet Frank O'Hara, a close friend and collaborator of Rivers's, who wrote the poem *On Seeing Larry Rivers's Washington Crossing the Delaware at the Museum of Modern Art* (1955). It develops images and ideas that are hinted at in the painting, elaborating on the flawed idea of the epic national hero and placing him side by side with the physical reality of the cold river, and his trembling nose.

ANTONI TÀPIES

Masterworks

Newsprint Cross 1946–1947 (Fundació Antoni Tàpies, Barcelona, Spain)

Collage of Bank Notes 1951 (Fundació Antoni Tàpies, Barcelona, Spain)

Earth and Paint 1956 (Fundació Antoni Tàpies, Barcelona, Spain)

Grey and Green Painting 1957 (Tate Collection, London, England)

Great Painting 1958 (Solomon R. Guggenheim Museum, New York, U.S.)

Assassins 1974 (Fundació Antoni Tàpies, Barcelona, Spain)

Two Piles of Earth 2001 (Fundació Antoni Tàpies, Barcelona, Spain)

Born: Antoni Tàpies, December 13, 1923 (Barcelona, Spain).

Artistic style: Painter, printmaker, and sculptor; innovative use of mixed media; rich textures; exploration of time and matter; themes of Eastern philosophy and medieval mysticism.

Self-taught artist Antoni Tàpies has been involved in various art movements over the years. He started out as a surrealist painter in the 1940s, and in 1948 helped found the Blaus group of Catalan artists and writers. He then associated with the Spanish informalist artists in the 1960s, going on to produce political works of social conscience. But what marks his oeuvre is his use of mixed media, which began in 1953 when he became involved in arte povera and has seen him use organic materials such as earth, stones, and sand to create richly textured works, often incorporating graffiti-like marks. He also tends to focus on images of the ordinary, such as an armpit, in an attempt to elevate the humble in a meditative fashion. **CK**

EDUARDO CHILLIDA

Masterworks

Doors 1950–1955 (Arantzazu Basilica, Sanctuary of Arantzazu, Oñati, Basque Country, Spain)

Modulation of Space I (*Modulación del Espacio I*) 1963 (Tate Collection, London, England)

From Inside (*Desde Dentro*) 1953 (Guggenheim Museum, New York, U.S.)

Comb of the Winds XV (*Peine del Viento XV*) 1976 (Paseo Eduardo Chillida, San Sebastián, Spain)

Mural G-47 1984 (Guggenheim Museum, New York, U.S.)

Born: Eduardo Chillida Juantegui, 1924 (San Sebastián, Spain); died 2002 (San Sebastián, Spain).

Artistic style: Early figurative sculptures; later Abstract pieces; themes of Basque identity, and man's relationship to nature; monumental works for public spaces.

Eduardo Chillida's early career was as part of a group of artists keen to create modernist abstract sculpture with a distinct Basque identity. They established a network of artist collectives when the prevailing mood of the Franco regime repressed the Basque language and customs. Later in life, Chillida became widely acclaimed as Spain's best living sculptor. His work became focused on man's relationship with nature, and saw him create a large number of monumental works for public spaces such as his series including *Peine del Viento XV* (*Comb of the Winds XV*) (1976). Yet these works also drew on his birthplace because he was often inspired by the sea, its misty skies, and the undulating valleys of its landscape. **CK**

ANTHONY CARO

Born: Anthony Caro, March 8, 1924 (New Malden, Surrey, England).

Artistic style: Abstract sculptor; assemblies of metal using found industrial objects; finishes in bold, flat color; self-standing sculptures that invite viewers to interact in a radical way.

Sir Anthony Caro has played a pivotal role in the development of twentieth- and twenty-first-century sculpture—prolific both as a practitioner and a teacher. Having gained a degree in engineering at Christ's College, University of Cambridge, he attended the Regent Street Polytechnic (now the University of Westminster) to study sculpture. He transferred to the Royal Academy Schools from 1947 until 1952 and had the good fortune to work as an assistant to Henry Moore during the 1950s. In the early 1960s, he was introduced to the U.S. abstract expressionist sculptor David Smith, who is famed for his steel geometric sculptures. Inspired, Caro then abandoned figurative work to start constructing sculptures by welding or bolting together prefabricated metal, often painting the finished works in bright colors.

In 1963, he achieved international acclaim when he exhibited large, boldly painted, self-supporting abstract sculptures at London's Whitechapel Gallery. His removal of the need for a plinth for his work was a radical departure from traditional sculpture, inviting viewers to approach and interact with the artwork from all sides, and it paved the way for future developments in three-dimensional art. From 1953 to 1979, Caro taught at London's St. Martin's School of Art, and his fresh approach inspired a younger generation of British sculptors, such as Richard Long and Barry Flanagan. In the 1980s, he began introducing more literal elements into his work, including figures drawn from classical Greece. He also produced large-scale installations and worked in a range of materials, including steel, bronze, silver, lead, stoneware, wood, and paper. To mark his eightieth birthday, a retrospective exhibition was organized by Tate Britain in 2005. **SH**

Masterworks

Early One Morning 1962 (Tate Collection, London, England)

Midday 1964 (Museum of Modern Art, New York, U.S.)

Odalisque 1983–1984 (Metropolitan Museum of Art, New York, U.S.)

Act of War (After Goya) c.1994–1995 (Bilbao Fine Arts Museum, Bilbao, Spain)

"I don't think that sculpture belongs in everyday life like a table does, or like a chair."

ABOVE: Sir Anthony Caro, a hugely inspirational British sculptor.

MARCEL BROODTHAERS

Born: Marcel Broodthaers, January 28, 1924 (Brussels, Belgium); died January 28, 1976 (Cologne, Germany).

Artistic style: Explored the wider institutional systems in which art is caught up; rebus-like objects and films; foregrounding the dialogue between artistic media.

Masterworks

Pense-Bête 1963 (Private collection)

Belgian Thighbone 1964–1965 (Bild-Kunst, Bonn, Germany)

La Pluie (Project pour un texte) 1969 (Musée National d'Art Moderne, Paris, France)

The Eagle from the Oligocene to the Present 1972

With laconic irony and a critical eye, Marcel Broodthaers explored the possibilities for making art in a society in which everything gets transformed into merchandise. Through a series of strategies of negation, Broodthaers asked pointed questions regarding the role of the artist and the function of art given the institutional and economic systems in which it is embedded.

Broodthaers began his career as a poet, but in 1963 he decided to give up poetry for art and, for his opening gambit, wedged the fifty remaining copies of his last book of poetry into a block of plaster, *Pense-Bête* (1963). The work demonstrated the tension between legibility and aesthetics: as a visual object, the books remain unreadable, but to remove the books would be to destroy the work's "sculptural aspect."

Well versed in contemporary theory and fascinated by the legacies of such figures as René Magritte and Marcel Duchamp, Broodthaers subtly needled common-sense assumptions about language and expression. In 1968, he founded his peripatetic Museum of Modern Art. Without any permanent collection or residence, the museum's activities were irregular, yet consistently subverted the accepted manner in which culture is consumed. In 1972, he borrowed hundreds of objects, some from an art context, others not, each of which was a representation of an eagle. The objects were exhibited in an official art museum, but each had a label that read: "This is not a work of art." While the choice of the eagle makes art's connection with authority and sovereignty clear, the gathering together of otherwise completely unrelated objects exposed how art works to unite objects that are historically, functionally, and geographically unconnected. With his precise fictions, Broodthaers exposed the very conditions of truth. **EK**

> "[Art] hangs on our bourgeois walls as a sign of power . . . but is it artistic?"

ABOVE: Marcel Broodthauers photographed in Düsseldorf in 1968.

ROBERT RAUSCHENBERG

Born: Robert Milton Ernest Rauschenberg, October 22, 1925 (Port Arthur, Texas, U.S.); died May 12, 2008 (Captiva Island, Florida, U.S.).

Artistic style: Enthusiastic embrace of everyday objects, urban media, and popular culture; cross-disciplinary experimentation and collaborative involvement.

Prolific and exuberant, Robert Rauschenberg has, for several decades, been a central player in the story of postwar art. Often credited with enabling the shift from the weighty angst of abstract expressionism to the numb, appropriated surfaces of pop art, his achievement is nevertheless remarkable well beyond the trends it connects.

After his training at the legendary Black Mountain College in the late 1940s, Rauschenberg quickly gained notoriety among New York artists. When he exhibited his evacuated *White Paintings* (1951), they were immediately read as gratuitous gestures of youthful rebellion. When he produced his infamous *Erased de Kooning Drawing* (1953), it cemented his early reputation as *enfant terrible*. From 1954, Rauschenberg began making his "Combine" pictures, into which an extraordinary range of materials was accommodated, leveling all aesthetic hierarchies. Stuffed animals share the picture space with old socks, 1950s cartoons, scrap metal, Old Master reproductions, friends' drawings, dripped paint, and family photographs. Crucially, the combines move away from the picture as analogue for perceptual experience (having a top and a bottom corresponding to the human visual field) and toward the picture as a kind of diagram for the mind, a switching station in which all manner of data and stimuli is processed.

In the late 1950s, Rauschenberg worked on a justifiably celebrated series of solvent transfer drawings to illustrate Dante Alighieri's *Inferno* (1308–1321). In 1962, after a visit to Andy Warhol's Factory, he began producing silk screens. In 1964, Rauschenberg became the first American to win the Grand Prize for Painting at the Venice Biennale; since then he has increasingly been involved in collaborations. **EK**

Masterworks

Erased de Kooning Drawing 1953 (San Francisco Museum of Modern Art, San Francisco, California, U.S.)

Rebus 1955 (Museum of Modern Art, New York, U.S.)

XXXIV Drawings for Dante's "Inferno" 1958–1960 (Museum of Modern Art, New York, U.S.)

Retroactive I 1964 (Wadsworth Atheneum, Hartford, Connecticut, U.S.)

"I always have a good reason for taking something out but never for putting something in."

ABOVE: Robert Rauschenberg, famous for his combine pictures.

JOAN MITCHELL

Born: Joan Mitchell, February 12, 1925 (Chicago, Illinois, U.S.); died October 30, 1992 (Vétheuil, Paris, France).

Artistic style: Large-scale abstract expressionist compositions; confident, athletic brushwork, using brushes of multiple widths drenched with paint; decorative drips.

Masterworks

Vity Landscape 1955 (Art Institute of Chicago, Chicago, U.S.)

Hemlock 1956 (Whitney Museum of American Art, New York, U.S.)

Ladybug 1957 (Museum of Modern Art, New York, U.S.)

Cous Cous 1961–1962 (Currier Museum of Art, Manchester, New Hampshire, U.S.)

Wet Orange 1971–1972 (Carnegie Museum, Pittsburgh, Pennsylvania, U.S.)

Sale Neige 1980 (National Museum of Women in the Arts, Washington, D.C., U.S.)

Land 1989 (National Gallery of Art, Washington, D.C., U.S.)

Joan Mitchell was raised in Chicago, Illinois, during a period of particular prosperity for the region. The city's Art Institute was aggressively building its formidable collection, and the progressive architecture of Frank Lloyd Wright was conspicuous, especially around the elegant and cerebral environs of the University of Chicago. These external factors complemented the atmosphere that surrounded Mitchell's home life.

Having traveled to Europe and Mexico by her early twenties, Mitchell recognized that there was a movement in New York that would launch her career in painting. By the early 1950s, she was acquainted with Franz Kline and Willem de Kooning. During this period, some important affirmation for the direction she had chosen began to arrive. Mitchell participated in the *Ninth Street Show* (1951) group show of paintings selected by Leo Castelli at the Artists' Club. In 1953 she had her first of seven solo exhibitions at The Stable Gallery. Such success helped Mitchell quickly establish herself as a skilled, inventive member of the small set of abstract expressionist artists that were, by then, dominating the art world in the United States and Europe.

ABOVE: Joan Mitchell, photographed in France in 1991.

RIGHT: *Maize* was painted in 1955 and is held in a private collection.

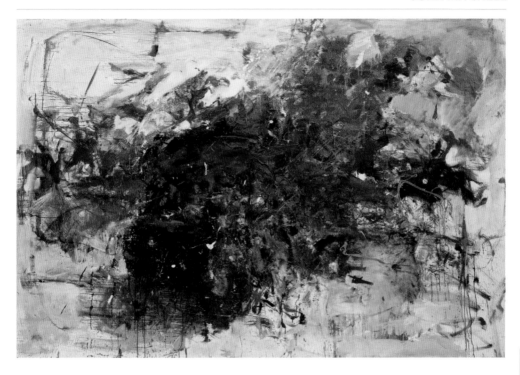

By the mid-1950s, Mitchell had made an enduring contribution to the abstract expressionist movement, for example *Hemlock* (1956), *George Went Swimming at Barnes Hole, But It Got Too Cold* (1957), and *Ladybug* (1957). Her large-scale abstract compositions are characterized by confident, athletic brushwork leaving her trademark decorative drips.

By the end of the decade, Mitchell moved to France where she lived for the rest of her career. Having settled on large, vocal abstract compositions, Mitchell created variations that, although differentiated in their use of color, clusters, and groupings, remained purely abstract. Of note are *Blue Tree* (1964), *Calvi* (1964), *Wet Orange* (1971–1972), *Clearing* (1973), and *Then Last Time No. 4* (1985). In each of these, Mitchell poetically arranged her abstract vocabulary based on her inner life, her wealth of experience, and her mastery of the magical and yet unforgiving abstract expressionist style. **RL**

ABOVE: Thick layers of paint in a swirling mass in *Grandes Carrières* (1961–1962).

Poetry and Language

Mitchell's formative years were informed by and conspired to provide the ingredients for comfort and fluency with abstract communication, especially given the openly experimental methodologies at work in poetry at the time. Mitchell was exposed to a circle of poets that included the likes of Dylan Thomas. It provided her with firsthand exposure to the lifestyle of poets in their societal wilderness. Moreover, she was aware of the unique and treasured potential of abstracted language to communicate ideas, and to capture and articulate emotions, moments, and memories.

FRED WILLIAMS

Born: Frederick Ronald Williams, January 23, 1927 (Melbourne, Australia); died April 22, 1982 (Hawthorn, Victoria, Australia).

Artistic style: Abstract landscapes that utilize a range of techniques and mark-making procedures; evocative depictions of place devoid of any horizon line.

Masterworks

The Charcoal Burner 1959 (National Gallery of Victoria, Melbourne, Australia)

Upwey Landscape 1965 (National Gallery Victoria, Melbourne, Australia)

Landscape '69 1969 (Art Gallery of New South Wales, Sydney, Australia)

The River, Werribee Gorge 1977 (Art Gallery of New South Wales, Sydney, Australia)

"I wanted something where I could move with great freedom and I felt I was at one with it."

ABOVE: Fred Williams, photographed a year before he died by Rennie Ellis.

Although the uniqueness of Fred Williams's canvases was partly the result of his exposure to the currents of European modernism, in many respects it was borne out of the desire to establish a painterly vocabulary appropriate to Australian landscape.

Having studied at the National Gallery Art School in Melbourne, Williams traveled to England, arriving in London in 1952. There he made a series of studies of Chelsea Palace, the Angel in Islington, and the Metropolitan. His desire to capture the fleeting nature of the theatrical spectacle is apparent in his music hall sketches and etchings, and within this series Williams conveys a sense of the flamboyant energy that was part of the music hall experience in London in the 1950s.

When he returned to Australia in 1957, Williams decided to concentrate on landscapes. Although his early landscapes were indebted to European artistic precedent, the paintings Williams made during the 1960s gradually established their own identity. This was achieved through the development of a range of painterly techniques that established William's vocabulary and afforded his work a fidelity to the landscape. For example, *Forest of Gum Trees III* (1968–1970) comprises a series of discrete gestural marks placed on an ocher ground. The absence of any traditional horizon line means that the painting is read either as a section of the landscape or as an aerial view. His landscapes of the 1970s often incorporate a series of horizontal bands, as in *Bega No. 3* (1975), but remain committed to evoking the experience of landscape rather than directly representing it.

Although Williams's works on canvas and paper are deeply bound up with notions of place, his oeuvre has justifiably established a prominent place within the landscape genre. **CS**

ALEX KATZ

Born: Alex Katz, July 24, 1927 (Brooklyn, New York, U.S.).

Artistic style: Pioneering new realist portrait painter, sculptor, and printmaker; elegant and deliberately impersonal; use of friends and family as subjects; flat graphics.

Alex Katz paints in a different way from most modern artists. Using the same methods as a Renaissance artist and working without photography, he sketches from life. He turns his best drawings into full-size cartoons that are transferred by pricking them onto canvas. The precise images are then fleshed out with hand-mixed color.

Katz is a New York painter. He worked first in Brooklyn, then Queens, and finally in Soho, where he has had a studio since 1968. He studied at The Cooper Union in New York, followed by a year at the Skowhegan School of Painting in Maine. His first solo show was held at the Roko Gallery in 1954 and his first retrospective at the Whitney Museum of American Art in 1986.

Katz's paintings are intentionally elegant and impersonal. His self-portrait *Passing* (1962–1963) combines avant-garde practice and traditional approaches. Coming out of pop art and an interest in the flat graphics of the advertising billboard, his paintings are of traditional subjects painted in a very straightforward and cool way. Often they depict friends and family, for example, *Hiroshi and Marsha* (1981) portrays two of Katz's now-divorced friends and pictures the couple against a background of Lower Manhattan seen through one of art critic Irving Sandler's windows. Katz has had numerous shows worldwide. He exhibited at the Saatchi Collection in London with *Alex Katz: Twenty Five Years of Painting* (1998); at the Albertina Museum in Vienna with *Alex Katz: Cartoons and Paintings* (2004–2005); and in 2007 at the Irish Museum of Modern Art in Dublin. Working from completely different starting points, Katz and fellow American painter Chuck Close have done more than any other living artists to make portraiture fashionable once again. **SF**

Masterworks

Passing 1962–1963 (Museum of Modern Art, New York, U.S.)

Vincent and Tony 1969 (Art Institute of Chicago, Chicago, U.S.)

Hiroshi and Marsha 1981 (Tate Collection, London, England)

Pas de Deux 1983 (Colby College Museum of Art, Waterville, Maine, U.S.)

Swimmer 1990 (Fine Art Museums of San Francisco, San Francisco, U.S.)

"You jump out a window style-wise . . . put it together before you hit the ground."

ABOVE: Alex Katz photographed in New York at the height of his career.

ALLAN KAPROW

Born: Allan Kaprow, August 23, 1927 (Atlantic City, New Jersey, U.S.); died April 5, 2006 (Encinitas, California, U.S.).

Artistic style: Performance-based artist; instigator of happenings; emphasis upon real or lived space and time rather than illusory depictions; ephemeral occurrences.

Masterworks

Untitled 1964 (National Gallery of Art, Washington, D.C., U.S.)

Rates of Exchange 1975 (D'Arc Press)

Although Allan Kaprow trained under the painter Hans Hofman, and like many artists of his generation looked toward the achievements of Jackson Pollock as a means by which to define his own practice, Kaprow's work was antithetical to the themes and issues that drove abstract expressionism. He was one of several artists who found abstract expressionism's tendency to favor bombast anathema. Although a number of other artists who moved away from the movement adopted strategies that centered upon the status of the object, Kaprow's energies became directed to a performative approach to art.

Beginning in 1956, Kaprow produced a series of "action collages" before studying music under the tutelage of avant-garde composer John Cage. Partly because of this, Kaprow decided to shift from making object-based pieces toward works more readily contingent with the inherent dynamics of real space and time. Kaprow developed a series of "environments" and "happenings." The first generally took the form of rooms filled with various assemblages of everyday objects. One of the intentions behind the environments and the happenings was to instigate a dynamic relationship between the viewers and what they were either being immersed within or confronted by. Kaprow's *18 Happenings in 6 Parts* (1959) took place in a New York gallery over six days and sought to activate the audience. They were given a set of instruction cards informing them which part of the gallery they should occupy at which points

> "[Today's artist] need no longer say 'I am a painter,' or 'a poet,' or 'a dancer.' He is simply an 'artist.'"

during the event. More than any other artist, Kaprow succeeded in making thought-provoking, challenging artworks that inhabited the gap between art and life, a gap that had first been identified by Robert Rauschenberg. **CS**

ABOVE: Allan Kaprow, performance artist extraordinaire.

HELEN FRANKENTHALER

Born: Helen Frankenthaler, 1928 (New York, U.S.)

Artistic style: Color field painter; fluid, chromatic expanses of acrylic paint poured onto canvases that appear like watercolors; a highly influential figure in the world of abstract expressionism.

Helen Frankenthaler has been credited with changing the direction of abstract expressionism in the 1950s. Her painting *Mountains and Sea* (1952) empitomises the significance of her contribution toward the development of abstraction within the postwar United States.

Art critic Clement Greenberg first met Frankenthaler in 1950. He was so impressed by her work that two years later he arranged for a number of artists, including Morris Louis and Kenneth Noland, to come and view *Mountains and Sea* in Frankenthaler's studio. For Greenberg, the painting's areas of thinned acrylic paint that had become absorbed within the very weft and warp of the unprimed canvas represented the potential way forward beyond abstract expressionism to what became known as color field painting. The creation of *Mountains and Sea* became the critical point of departure for a number of painters who adopted Frankenthaler's soak-stain technique, and experimented with using paint in a highly fluid and chromatic way; the Washington Color Painters were representative of this tendency.

Frankenthaler is keen not to associate her paintings with any overt or literal meaning, giving them such evocative titles as *Buddha's Court* (1964), *The Human Edge* (1967), and *Ocean Drive West # 1* (1974). When speaking of *Tangerine* (1964), and seeking to counter any claims that it is a still life, Frankenthaler said: "It is called *Tangerine* because of the color, which is tangerine." Instead, a painting such as *Sacrifice Design* (1981), with its combination of stained monochromatic ground together with a pronounced series of organic, painterly forms, alludes to a number of natural processes in a harmonious and evocative way. **CS**

Masterworks

Jacob's Ladder 1957 (Museum of Modern Art, New York, U.S.)

Interior Landscape 1964 (San Francisco Museum of Modern Art, San Francisco, U.S.)

Nature Abhors a Vacuum 1973 (National Gallery of Art, Washington, D.C., U.S.)

"With any picture, on paper or on canvas, the main idea is: Does it work? Is it beautiful?"

ABOVE: Helen Frankenthaler, an artist whose work inspired a new generation.

CY TWOMBLY

Born: Cy Twombly, April 25, 1928 (Lexington, Virginia, U.S.).

Artistic style: Graffiti-style markings; mythical and historical subject matter; incorporation of numbers, letters, and symbols; small sculptures made from discarded materials or bronze.

Masterworks

Panorama 1955 (Daros Collection, Zurich, Switzerland)

The Age of Alexander 1959–1960 (Menil Collection, Houston, Texas, U.S.)

Triumph of Galatea 1961 (Menil Collection, Houston, Texas, U.S.)

Leda and the Swan 1962 (Museum of Modern Art, New York, U.S.)

Hero and Leander 1962 (Daros Collection, Zurich, Switzerland)

Fifty Days at Iliam 1978 (Philadelphia Museum of Art, Philadelphia, Pennsylvania, U.S.)

Untitled (Say Goodbye Catallus, to the Shores of Asia Minor) 1994 (Menil Collection, Houston, Texas, U.S.)

Cy Twombly's interest in art began at an early age, and at only twelve years of age he studied with the Spanish artist Pierre Daura. At the suggestion of Robert Rauschenberg, he attended Black Mountain College from 1951 to 1952. Abstract expressionist painter Robert Motherwell, commenting that he had nothing to teach Twombly, recommended him to his art dealer Sam Kootz, and Twombly secured a solo show in 1951 in New York.

Having traveled to Europe, he settled in New York in 1953 and shared a studio with Rauschenberg. Responding to the abstract expressionist style that dominated New York galleries, Twombly forged a distinctive calligraphic style, filling his canvases with graffiti-like scrawls and scribbles that suggest an energetic spontaneity that belies his precise technique. He also made fragile painted sculptures out of wood and

ABOVE: Cy Twombly photographed in 1958 by David Lees.

RIGHT: The artist playfully interprets a Greek myth in *Leda and the Swan* (1962).

ABOVE: *Shades of Achilles, Patroclus, and Hector* (1978) in the *Fifty Days at Iliam* series.

discarded materials that recall the fetish bundles of Native-American or North-African cultures, as well as classical forms.

The artist settled permanently in Rome in 1959, married, and had a son, whose birth he commemorated with the painting *The Age of Alexander* (1959–1960). In Italy, his style moved away from the more expressionist marks of his earlier works. He created a complex lexicon of symbols that broke free from traditional iconography, incorporating figures, numbers, and words. Although he resisted the conventional depiction of narrative, Twombly took inspiration from classical mythology, poetry, and history, often making reference to epic subjects in the titles of his works.

In 1966, he moved away from the colorful baroque splendor of his mythical works, creating a series of starker, more geometric paintings on a gray background. In later decades he spent an increasing amount of time creating works that, although more contemplative, contain the same vivid energy as did his earlier paintings. **LB**

A Disastrous Show

When the successful New York art dealer Eleanor Ward offered Twombly a joint exhibition with his close friend Rauschenberg at the Stable Gallery in 1953, the two artists had to clean out the former livery stable on West 58th Street before installing their paintings. Despite their hard work and previous successes, the exhibition was poorly received. Ward later recalled the experience, "Everyone was hostile, with the exception of a few artists. One well-known critic was so horrified he came out on the street literally clutching his forehead, and then fled down the block."

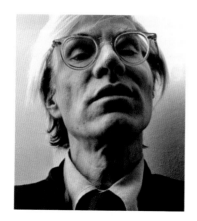

ANDY WARHOL

Born: Andrew Varchola, August 6, 1928 (Forrest City, Pennsylvania, U.S.); died February 22, 1987 (New York, U.S.).

Artistic style: King of pop art; bright colors overlaid on silk-screened images; celebrity icons and mass-produced consumer products; experimental filmmaker.

Masterworks

Gold Marilyn Monroe 1962 (Museum of Modern Art, New York, U.S.)

Marilyn Diptych 1962 (Tate Collection, London, England)

Campbell's Soup Cans 1962 (Museum of Modern Art, New York, U.S.)

Double Elvis 1963 (Museum of Modern Art, New York, U.S.)

Electric Chair 1964 (Tate Collection, London, England)

Flowers 1964 (Andy Warhol Museum Collection, Pittsburgh, Pennsylvania, U.S.)

16 Jackies 1964 (Walker Art Center, Minneapolis, Minnesota, U.S.)

Birmingham Race Riot 1964 (Tate Collection, London, England)

Self-Portrait 1967 (Tate Collection, London, England)

Myths 1981 (Andy Warhol Museum Collection, Pittsburgh, Pennsylvania, U.S.)

$ 1982 (Andy Warhol Museum Collection, Pittsburgh, Pennsylvania, U.S.)

Self-Portrait 1986 (Andy Warhol Museum Collection, Pittsburgh, Pennsylvania, U.S.)

ABOVE: Andy Warhol's face has become as famous as the images he created.

RIGHT: Deliberately provocative, *Electric Chair* (1967) sparked heated debate.

Andy Warhol is considered one of the most influential artists of the twentieth century because of his universal impact on the process and concept of postmodern art practice. He began his career as a commercial artist after receiving a degree in pictorial design from Carnegie Mellon University. He remained a very successful illustrator throughout the 1950s, creating shoe advertisements for companies such as I. Miller. During this time, he also illustrated books and designed sets. In 1956, Warhol's work was included in a group exhibition for the first time at the Museum of Modern Art in New York.

Warhol began experimenting with painting in the early 1960s and used comic strips such as *Popeye* and *Superman* as source material. His first major exhibit at the Ferus Gallery was one that showcased paintings of the thirty-seven varieties of Campbell's soup cans. The works produced in this decade are a commentary on the mass-produced and serialized nature of all aspects of U.S. culture, specifically the abundance of commercial products and celebrity iconography. For example, his images of Campbell soup cans reference the increasing desensitization

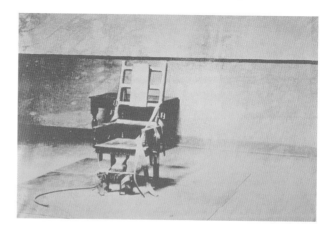

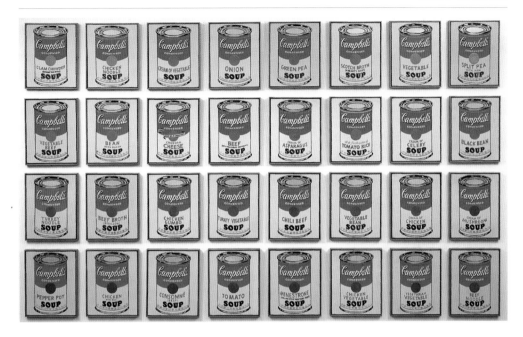

to commoditization, whereas his iconic image of Marilyn Monroe is laden with packaged tawdriness. Warhol's obsession with the silver screen manifests itself in his film stills of Elvis Presley, Marlon Brando, and Elizabeth Taylor, which illustrate that the compulsive repetition of these images engrains them in our memories forever. His disaster paintings, representations taken from newspaper clippings, and his race riot pictures, images of police dogs viciously attacking civil rights protesters, are important juxtapositions to his images of celebrity worship and banal commodities. Similarly, his pictures of electric chairs are politically engaged dialogues about the issue of the death penalty. Images of Jackie Kennedy produced shortly after her husband's brutal murder are reminders of highly charged times. Warhol's 1960s iconography gestures at the temporal aspects of fame and the reality of mortality in general.

ABOVE: The world's most famous soup cans, immortalized in 1962.

1920–29

"Being born is like being kidnapped. And then sold into slavery."

I Shot Andy Warhol

In 1968, Warhol was shot by a radical feminist writer named Valerie Solanas, who lived as a panhandling prostitute and is best known for writing the SCUM (Society for Cutting Up Men) manifesto. It discusses the potential of a society peopled only by women. After being introduced to Warhol in New York, Solanas asked him to produce her play entitled *Up Your Ass* (1966). Warhol not only refused but did not return the script to Solanas. After Solanas stalked Warhol and demanded the return of her script, he appeased her by giving her a role in his film *I, A Man* (1968).

Unsatisfied with Warhol's conciliation, Solanas waited for Warhol at The Factory and fired shots at the artist, his manager Fred Hughes, and art critic Mario Anaya. Warhol never fully recovered from his injuries but did survive the attack. Solanas turned herself in to the police, claiming that she shot Warhol because "he had too much control of [her] life." She received a three-year sentence, although Warhol did not testify against her.

Gunfire also occurred on two other occasions at The Factory. The first was when a stranger shot a bullet into the air. The other time was when a shot was fired by film star Dorothy Ponder, who targeted a stack of four paintings of Marilyn Monroe—her action was part of a bizarre art happening. The paintings substantially increased in value as a result.

RIGHT: The golden void of *Gold Marilyn Monroe* is as compelling as the image itself.

Highlights from the 1970s include portraits of Communist leader Mao Zedong and paintings commissioned by celebrities who wished to be immortalized in the classic Warhol style. In the 1980s, Warhol collaborated with younger artists such as Jean-Michel Basquiat and also painted images of dollar signs that mocked the outrageously bull contemporary art market.

Cult status

Warhol's work substantiates the premise of pop art, a derivative of popular art, which seamlessly integrated conventional notions of art and everyday life. Pop art made a statement about a society saturated and engrossed in commercialism and consumerism. Warhol even said, "I'm afraid that if you look at a thing long enough, it loses all of its meaning."

Nonetheless, Warhol embraced this culture of mass production and made his work through a silkscreen process the way that a machine would. Even his assistants at his studio were enlisted to make works, an intentional removal of the artist's hand from the finished product. Besides the elimination of individual authorship, another stylistic component of the pop art movement is a bold and vibrant color palette. Warhol often manipulated the original reference to include electrifying tones to underscore the superficial surface of U.S. icons.

Beyond catapulting the art world into a new direction, Warhol was also known for his theatrical presence and lavish lifestyle based around The Factory, which doubled as his studio and social haven. He associated with diverse social groups, spanning from Hollywood's underground elite to eccentric bohemians. He became a celebrated cult figure. The self-portraits he made at various points in his career emphasize his own desire to achieve celebrity status. In addition to his prolific painting career, Warhol also produced avant-garde films, such as *The Chelsea Girls* (1966) and *My Hustler* (1965), which surveyed gay culture and sexual exploration. He also produced the landmark record for the band The Velvet Underground and NICO, and in 1969 co-founded *Interview*, a magazine about the culture of media and entertainment. **MG**

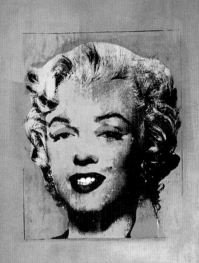

YVES KLEIN

Born: Yves Klein, April 28, 1928 (Nice, France); died June 6, 1962 (Paris, France).

Artistic style: Conceptual artist; monochromatic paintings; international Klein blue; unorthodox performances relating to his *Cosmogonies*, *Peintures de Feu*, and *Anthropométries* pictures.

Masterworks

IKB 79 1959 (Tate Collection, London, England)

Dimanche 1960 (Walker Art Center, Minneapolis, Minnesota, U.S.)

Anthropometry: Princess Helena 1960 (Museum of Modern Art, New York, U.S.)

Blue Sponge Relief (Kleine Nachtmusik) 1960 (Städel Museum, Frankfurt, Germany)

Blue Monochrome 1961 (Museum of Modern Art, New York, U.S.)

Portrait Relief I: Arman 1962 (Philadelphia Museum of Art, Philadelphia, Pennsylvania, U.S.)

Untitled (Fire-Color Painting) 1962 (Museum of Modern Art, New York, U.S.)

Despite being the son of two painters, Yves Klein displayed little interest in art as a child. Consequently, he did not receive any formal artistic training. He traveled extensively throughout his early twenties, supporting himself as a judo instructor. In 1955, he chose to settle permanently in Paris.

Klein soon began exhibiting monochromatic paintings. These pictures consisted of large canvases covered with a single uniform color. Klein experimented with different materials and chemicals to produce unusually vivid hues. Although Klein painted in red, orange, green, gold (*Monogolds*), and pink (*Monopinks*), the most famous of these monochrome colors was patented by the artist as "international Klein blue," a particularly distinctive and rich ultramarine hue. Invited to speak at the Sorbonne in 1959, Klein presented his theory of monochrome painting as an attempt to depersonalize color, stripping it of any subjective emotion and turning it into a metaphysical object.

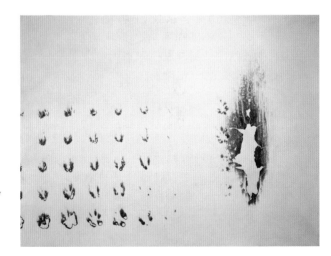

ABOVE: Klein in a bowler hat, in front of one of his Blue Sponge Sculptures, in 1959.

RIGHT: Klein collaborated with Gaz de France to create many of his *Fire Paintings*.

1920–29

Klein's experimentation with painting extended to his *Cosmogonies* (1960) series in which canvases recorded the unpredictable effects of wind and rain; the *Anthropométries* (1960–1961) series, which were large canvases imprinted with the human body; and the *Peintures de Feu* (1961–1962) pictures, created with a flame thrower. Moving progressively into the controversial realm of conceptual art, Klein mounted an "exhibition of emptiness" at Galerie Iris Clert in Paris. Entitled *The Void* (1958), Klein's sensation consisted of an empty gallery space painted entirely in white. He continued to shock by arranging the first public performance of one of his *Anthropométries*. Accompanied by his own musical score, *Monotone Symphony* (1949), Klein applied blue paint with a roller to the bodies of naked women. An audience dressed in formal evening wear observed as the women rolled and writhed across a large canvas laid upon the floor.

In 1960, Klein began his collaboration with the French art critic Pierre Restany. Together they founded the new realism movement, giving voice to a group of artists who incorporated real objects into their work to produce ironic comments on modern life. Klein died prematurely of a heart attack, yet in his short career he managed to produce a large and revolutionary body of work that was to exert a strong influence on countless other twentieth-century artists. **NSF**

ABOVE: Painted with sponges, *Accord Bleu* (1958) was an early monochrome work.

International Klein Blue

International Klein blue is a deep ultramarine that was patented by Yves Klein as IKB in 1960. Klein developed IKB with a group of chemists, suspending dry pigment in a clear synthetic resin to produce a color that has the same brightness and intensity whether it is dry or wet. For the artist, IKB was associated with pure light and space. When the hue made its first appearance in 1957, Klein described it as "a blue in itself, disengaged from all functional justification." Klein produced nearly 200 untitled IKB paintings before his death. Rotraut Klein-Moquay, the artist's widow, assigned each canvas a number posthumously.

DONALD JUDD

Born: Donald Clarence Judd, June 3, 1928 (Excelsior Springs, Missouri, U.S.); died February 12, 1994 (New York, U.S.).

Artistic style: Pioneering Minimalist sculptor; use of industrial materials such as Plexiglas, sheet metal, and plywood; angular objects comprising of serial units.

Masterworks

Untitled 1966 (Museum of Contemporary Art, Los Angeles, California, U.S.)

Untitled (Stack) 1967 (Museum of Modern Art, New York, U.S.)

Untitled December 23 1969 (Guggenheim Museum, New York, U.S.)

Untitled 1972 (Tate Collection, London, England)

The contributions made by Donald Judd as a critic and an artist were central to the debate surrounding the form art should take in light of the dissolution of abstract expressionism in the United States during the 1960s. His text *Specific Objects* (1964) was an unofficial manifesto for minimalism. In it Judd espoused the virtues of the new "three-dimensional work" that drew upon specific qualities from both painting and sculpture yet remained separate from these two historically bound media.

Significantly, Judd studied art history and philosophy with painting and sculpture. His first contribution to the burgeoning art scene in the United States took the form of a series of semi-abstract paintings. However, with his writing Judd was able to formulate his theories regarding the form art should take. Beginning in 1959, Judd wrote for a number of art journals and championed the work of a generation of artists who were following in the wake of abstraction.

During the first half of the 1960s, Judd continued to practice as an artist, creating a series of three-dimensional structures that were often painted. As the 1960s progressed, Judd refined the vocabulary of his sculptures, and by 1965 he was making objects that were materially—although not theoretically—sparse. The artist continued to explore the possibilities of creating three-dimensional work through the adoption of unusual—often industrial—materials and techniques and through their placement in space. By the 1970s Judd was creating larger-scale works, and in 1986 created an open-air museum in Marfa in Texas. It pays testimony to his achievements as an artist whose oeuvre moved beyond the categorical norms of sculpture while remaining rooted in the three-dimensional realm. **CS**

"The thing as a whole, its quality as a whole, is what is interesting."

ABOVE: Donald Judd, a writer and philosopher as well as an artist.

ARMAN

Born: Armand Pierre Fernandez, November 17, 1928 (Nice, France); died October 22, 2005 (New York, U.S.).

Artistic style: Accumulations of everyday objects; towering sculptures of car parts encased in concrete; fragments of destroyed instruments; trash-filled display cases.

Early in his career, Arman was associated with a group of artists, les nouveaux réalistes, who favored the use of manufactured and found materials. In 1959, he began to present rubbish as art in a series of *Poubelles*, meaning "dustbins," display cases filled with the debris of everyday life and robotic portraits of his friends constituted from their refuse. He expanded this gesture by filling the Parisian Galerie Iris Clert with rubbish in an exhibition called *Le Plein* (1960). Influenced both by cultural commoditization and by the destruction of World War II, the contents of Arman's so-called accumulations range from the faded luxury of consumer goods to collections of gas masks and false teeth that recall photographs of Holocaust relics.

From the 1960s, he made more explicit the relationship between destruction and creation in works titled *Colères* (tantrums), *Coups* (cuts), and *Combustions* (fires), in which he smashed and burned musical instruments and reproduction furniture. He displayed their splintered and charred remains in Plexiglas, calling the unsettling results "the conservation of catastrophe." One such piece was performed in New York during the exhibition *The Art of Assemblage* (1961), in which Arman featured. He named the piece *NBC Rage* (1961) after the documentary team that commissioned it.

The United States fascinated him, and he moved to New York in 1963, attracted by the trappings of its consumer culture. His most definitive gesture toward "the American dream" was the choreographed demolition of a suite of home furnishings at the John Gibson Gallery in New York. Arman remained in the United States, although he continued to make works in Europe, including a collaboration with Renault on a collection of car parts in concrete, his largest accumulation. **LB**

Masterworks

Condition of Woman 1 1960 (Tate Collection, London, England)

Home Sweet Home 1960 (Centre Georges Pompidou, Paris, France)

Chopin's Waterloo 1962 (Centre Georges Pompidou, Paris, France)

The Attila of the Violins 1968 (Stedelijk Museum, Amsterdam, the Netherlands)

Long Term Parking 1982 (Chateau de Montcel, Jouy-en-Josas, France)

" . . . you break a cello, and you end up with something romantic."

ABOVE: Nouveaux realiste Arman, famous for his accumulations.

SOL LEWITT

Born: Sol LeWitt, September 9, 1928 (Hartford, Connecticut, U.S.); died April 8, 2007 (New York, U.S.).

Artistic style: Minimalist and conceptual sculptor, painter, printmaker, and draftsman; wall drawings; geometric forms; themes of authorship and permanence.

Masterworks

Serial Project, I (ABCD) 1966
 (Museum of Modern Art, New York, U.S.)

Cubic-Modular Wall Structure, Black 1966
 (Museum of Modern Art, New York, U.S.)

Untitled from Squares with a Different Line Direction in Each Half Square 1971
 (Museum of Modern Art, New York, U.S.)

Five Open Geometric Structures 1979
 (Tate Collection, London, England)

Six Geometric Figures (+ Two) (Wall Drawings) 1980–81 (Tate Modern, London, England)

Distorted Cubes (B) from Distorted Cubes (A-E) 2001 (Museum of Modern Art, New York, U.S.)

Sol LeWitt was the consummate Minimalist artist. His explorations of geometric forms, such as cubes, cones, and stars in two or three dimensions preoccupied his entire oeuvre in a way that seems staggeringly persistent and methodical, but also resulted in intricate works of simple beauty noted for their use of color, repetition, and infinite subdivisions.

From the 1960s, LeWitt was rigorously focusing on variations and permutations of lines and cubes, often according to mathematical sequences. These were frequently drawings, paintings, and prints produced in his "artist books," but he also created three-dimensional works, such as *Serial Project, I (ABCD)* (1966), which consists of a series of open and closed enameled aluminum cubes resting on a large sheet of aluminum subdivided into painted white squares. From the 1980s, his

ABOVE: Sol LeWitt photographed at Rome's new contemporary art gallery, May 2000.

RIGHT: *Cubic-Modular Wall Structure, Black* (1966) is sculpted from wood and painted.

ABOVE: *White Styrofoam on Red, Yellow and Blue Walls* (1994) and *Complex Form #8* (1988).

palette shifted from primary colors to richer tones, and he began to incorporate more fluid shapes into his work.

LeWitt was a pioneer of conceptual art and wrote a seminal essay, *Paragraphs on Conceptual Art* (1967), emphasizing the importance of generating ideas rather than working with physical materials. Impressed by Renaissance art frescoes and the work of Giotto, from 1968 LeWitt experimented with "wall drawings" that consisted of pencil drawings of linear shapes, drawn directly on to a gallery wall for the duration of a show. Eventually these were drawn by a team of assistants following sketches produced by LeWitt, a practice in keeping with his belief that it is the artistic concept, rather than the process that is most important. The work was considered radical because the drawings were to be painted over once a show was finished, as LeWitt sought to incorporate his drawings with architectural space and explore concepts of craftsmanship, authorship, value, and transience, and the conservation of an artwork. **CK**

Too Good To Paint Over

LeWitt created 1,200 wall drawings throughout his career. His first was done at the Paula Cooper Gallery in New York in October 1968 for a group exhibition to benefit the Student Mobilization Committee to End the War in Vietnam. LeWitt's drawing consisted of two squares shown alongside one another. Each square was subdivided into four and the divided parts subdivided into four again. The gallery owner was so impressed with the work that she could not face painting it over as LeWitt intended and asked the artist to do it himself. He was more than happy to comply.

YAYOI KUSAMA

Born: Yayoi Kusama, March 29, 1929 (Matsumoto, Nagano Prefecture, Japan).

Artistic style: Installation and performance artist; use of obsessive repetition and polka dots; soft, phallic constructions that wittily challenge the male-dominated art world.

Masterworks

Infinity Nets 1951 (Museum of Modern Art, New York, U.S.)

Silvery Sea (Accumulation) 1981–1982 (Collection Neuberger Museum of Art, State University of New York, New York, U.S.)

Summer 1 1985 (Niigata Prefectual Museum of Modern Art, Japan)

Dots Obsession 1996 (Mattress Factory, Pittsburgh, Pennsylvania, U.S.)

Yayoi Kusama moved from Japan to New York in 1957. Although she was closer to the pop art idiom than other female artists at the time, because she was female and a non-Westerner, she also remained detached. This enabled her to make sharp, witty observations of the male-dominated world of pop art.

Her first work, *Infinity Nets* (1951), was a series of plain canvases covered with interlaced webs, typical of the patterned repetition that is characteristic of her work. She attributes the obsessive nature of her work to physical abuse and hallucinations she experienced as a child. She then created *Accumulation 1* (1962), a soft sculpted phallus that multiplied to cover armchairs, tables, and other pieces of furniture. In *Traveling Life* (1964), she developed the phallic form, this time covering a stepladder and inserted into stiletto shoes to mock phallic displacement in the context of the imagery being produced by male pop art proponents such as Tom Wesselmann and Andy Warhol.

Her soft stitched phalluses were often made from polka-dot fabric, symbolizing sexual disease, but looked more like the waving tentacles of psychedelic sea urchins. This is particularly evident in her large installations from the mid-1960s, such as the *Infinity Mirror Rooms* (1965), one of which, *Phalli's Field* (1965), reproduced the phallus and the viewer in endless reflections. In her last few years in New York, Kusama devoted most of her time to happenings, usually involving nudity such as *Grand Orgy to Awaken the Dead* (1969). She returned to Tokyo in 1973, where she now lives, once more returning to making phallus images, which frequently extend to form the snaking stamens of giant flowers. In 1993 she represented Japan in the Venice Biennale. **WO**

> "I want to impose my will on everything around me . . . I raise my art to the level of religion."

ABOVE: Kusama challenged the status quo of the male-dominated pop art world.

CLAES OLDENBURG

Born: Claes Oldenburg, January 28, 1929 (Stockholm, Sweden).

Artistic style: Pop art practitioner; oversized, floppy representations of everyday household objects and iconic foodstuffs made of vinyl and foam rubber; colossal public sculptures.

Claes Oldenburg befriended a number of young artists in New York who were rejecting abstract expressionism and manipulating popular commercial imagery in their work. Enlisted to create props for Allan Kaprow's happenings, Oldenburg began to experiment with painted plaster and formed wire mesh to create domestic objects akin to papier-mâché. He then launched *The Store* (1961) in his studio to sell these everyday art products. This unusual project foreshadowed the exhibition *The American Supermarket* (1964), in which Oldenburg and other pop artists, such as Roy Lichtenstein and Andy Warhol, contributed artworks of typical food items.

Oldenburg produced his first soft sculptures in 1962. Constructed of canvas or vinyl and stuffed with foam rubber, oversized pieces such as *Floor Burger, Floor Cake, and Floor Cone* (1962) lifted the banal into the realm of high culture and investigated issues of consumerism, mass production, fast-food culture, and the deification of mundane objects. He produced soft sculptures consistently throughout the 1960s, including *Soft Typewriter* (1963), *Shoestring Potatoes Spilling from a Bag* (1966), and the bathroom ensemble of *Soft Toilet* (1966), *Soft Bathtub* (1966), *Soft Scale* (1966), and *Soft Washstand* (1966).

Oldenburg then became interested in the potential of colossal public monuments. He created amusing sketches and collages of antimonuments that inserted ordinary items into familiar landscapes, such as *Lipsticks in Piccadilly Circus* (1966). The first sculpture to be realized, *Lipstick (Ascending) on Caterpillar Tracks* (1969), was installed at Yale amid great controversy. Since then, Oldenburg has installed forty or so monuments, including *Clothespin* (1976), *Knife Slicing Through Wall* (1986), *Saw, Sawing* (1996), and *Dropped Cone* (2001). **NSF**

Masterworks

Floor Cake 1962 (Museum of Modern Art, New York, U.S.)

Lipsticks in Piccadilly Circus, London 1966 (Tate Collection, London, England)

Shoestring Potatoes Spilling from a Bag 1966 (Walker Art Center, Minneapolis, Minnesota, U.S.)

Lipstick (Ascending) on Caterpillar Tracks 1969–1974 (Samuel F. B. Morse College, Yale University, New Haven, Connecticut, U.S.)

Clothespin 1976 (Centre Square Plaza, Fifteenth and Market streets, Philadelphia, Pennsylvania, U.S.)

Dropped Cone 2001 (Neumarkt Galerie, Cologne, Germany)

"I am for an art that is … heavy and coarse and blunt and sweet and stupid as life itself."

ABOVE: The artist photographed for his exhibition in Bonn, in 1996.

JASPER JOHNS

Born: Jasper Johns Jr., May 15, 1930 (Augusta, Georgia, U.S.).

Artistic style: Painter; use of found objects and materials; subjects from contemporary culture; appropriation of iconography and recognizable imagery; autobiographical references.

Masterworks

Flag 1954–1955 (Museum of Modern Art, New York, U.S.)

Target with Four Faces 1955 (Museum of Modern Art, New York, U.S.)

Three Flags 1958 (Whitney Museum of American Art, New York, U.S.)

Painted Bronze 1960 (Kunstmuseum, Basel, Switzerland)

Untitled 1972 (Museum Ludwig, Cologne, Germany)

Perilous Night 1982 (National Gallery of Art, Washington, D.C., U.S.)

Racing Thoughts 1983 (Whitney Museum of American Art, New York, U.S.)

The Seasons 1985–1986 (Private collection)

Green Angel works 1990s (Walker Art Center, Minneapolis, Minnesota, U.S.)

At the age of just five, Johns says, he knew he wanted to be an artist. Raised in small-town South Carolina, he attended South Carolina University briefly before the urge to head for New York City to pursue an artistic career became a reality. He arrived in the city in 1948. Over the next few years, he attended art classes, served as a soldier in the Korean War, and supported himself with casual jobs. For one of these jobs, designing store window displays, he worked with new friend Robert Rauschenberg, another now-legendary artist on the rise. Other members of Johns's circle in these early days included artist Marcel Duchamp, composer John Cage, and choreographer Merce Cunningham (for whom he designed costumes), positioning him at the heart of the progressive art scene.

In 1954, Johns had a dream that led him to paint his soon-to-be-groundbreaking picture of the United States flag (*Flag* 1954–1955). The dream proved happily prophetic. In 1958, New York City's up-and-coming Leo Castelli Gallery mounted Johns's first solo show, which was a sensational success. The

ABOVE: Portrait photograph of Jasper Johns taken by Malcolm Lubliner in 1971.

RIGHT: One of John's most iconic images, *Flag* was a first foray into a new medium.

Museum of Modern Art snapped up several pieces and Johns's fortune was sealed. From the 1970s onward, his work has broken successive price barriers for living American artists.

All these years later, Johns is perhaps still known best for work from that Castelli show era and immediately afterward—pieces from the 1950s and 1960s that incorporate American flags, maps, labels, targets, numbers, and letters. These revealed his love of playing with "things the mind already knows," as he once famously said. Part of this playing was painting two-dimensional, commonplace objects in an expressive way, helped greatly by his highly textural use of thick encaustic (pigment mixed into wax). Traditional spatial concepts were also overturned, as in *Three Flags*, where three United States flags superimposed on top of each other reverse normal expectations of visual perspective. He produced stand-out

ABOVE: *Racing Thoughts* is an expression of the contents of the artist's mind.

1930–39

"I like what I see to be real . . . the painting as an object, as a real thing in itself."

Johns in Print

Jasper Johns's extraordinary abilities as a printmaker are sometimes under-emphasized and even over-looked, but his talents in this area have been placed on a par with those of Albert Dürer and Pablo Picasso.

Printing has provided a major thread throughout Johns's work, featuring more and more prominently as the years have passed. Little wonder, in a way, that the print medium should appeal to a man working with the nature of the repeated image.

The story began in 1960, when a colleague handed over some stones for lithographic printing. What fascinated Johns about prints were the nuts and bolts of the technique and the possibility of pushing a completely different set of boundaries. In his *Two Maps I* (1966, Museum of Modern Art), he uses lithography to produce two versions of the U.S. map, one more distinct than the other, to promote looking at an old image with new eyes. He also likes exploring the relationship between printmaking and other processes and how they can play off each other in interesting ways. In 2001, Johns produced a series of thirteen works that variously mix collage, acrylic paint, aquatint, and etching.

Johns is also a talented draftsman and drawing has remained close to his heart since childhood. Interestingly, in his pursuit of the interaction of media, he typically makes drawings of his finished works, as opposed to the more traditional practice of using drawings as preparation studies for a major piece.

RIGHT: *Autumn*, from Johns's intensely poetic four-part cycle *The Seasons*.

pieces of modern art that made people look at ordinary objects afresh. Around 1960, he started to explore the monotone grays that characterize much of his work and that formed the central theme of a 2008 show at the Metropolitan.

Pushing the boundaries

The 1970s brought fertile experimentation with materials and techniques, plus a brand new direction—the use of cross-hatching in works such as his *Untitled* panel (1972). By the following decade, his vocabulary of pre-digested imagery had expanded to embrace everything from handprints to fragments of Matthias Grünewald's famous *Isenheim Altarpiece* (c.1515).

During the 1980s, Johns's long-held interest in psychology and philosophy—especially Wittgenstein's writing—helped to move him away from the cool detachment for which he was known toward a deeper exploration of his own life that has continued ever since. *Seasons* (1985–1986), for example, belongs to a growing blend of childhood memories with thoughtful reflections on his career. More recently, the issue of how "knowing often replaces seeing" (another classic Johns phrase) has led him to stir up preconceptions about his work once again. He has reinvestigated the borrowed image and used aspects from some of his earlier pieces to assess his own career and question exactly what art history means to us. Although considered a legend of modern art, the laconic, thoughtful Johns has always been aware of the tide of artistic history and has referenced artists as diverse as Leonardo and Picasso.

Some commentators have seen Johns's early use of ordinary, "flat" imagery, such as flags, as a revolutionary break with the abstract expressionists of the day (Jackson Pollock, et al). Others say Johns's painterly treatment partly contradicts this. His early choice of pre-made, familiar objects such as flags and beer cans (for the latter, see his *Painted Bronze* sculpture, 1960) makes others label him as a father of pop art. He is also frequently linked with conceptual art and minimalism. Amid all of this, what seems certain is that his work continually opens up debate about what art is trying to do. **AK**

JOHN DRAWBRIDGE

Born: John Drawbridge, December 27, 1930 (Wellington, New Zealand); died July 24, 2005 (Wellington, New Zealand).

Artistic style: Figurative and abstract paintings, murals, and prints; light, color, and texture; joyful, celebratory style; Pacific landscape and seascape themes.

Masterworks

Windflow 1966 (Auckland Art Gallery Toi O Tāmaki, Auckland, New Zealand)

Tanya, Going and Coming II 1967 (Auckland Art Gallery Toi O Tāmaki, Auckland, New Zealand)

Calvados No. III 1971 (Auckland Art Gallery Toi O Tāmaki, Auckland, New Zealand)

Untitled, Drawing No. 8 1974 (Auckland Art Gallery Toi O Tāmaki, Auckland, New Zealand)

Beehive Mural 1976 (Parliament Building, Wellington, New Zealand)

The Edge of Earth 1986 (Auckland Art Gallery Toi O Tāmaki, Auckland, New Zealand)

John Drawbridge is known as an accomplished muralist, painter, and printmaker. In 1957, he received a scholarship to attend the Central School of Arts and Crafts in London, where he studied with Mervyn Peake and Merlyn Evans. On graduation, he moved to Paris to work at the print workshops of Stanley William Hayter and Johnny Friedlaender, who printed the works of artist such as Pablo Picasso and Georges Braque—and so began a promising artistic career in Europe. But Drawbridge chose to return to his native New Zealand, where he set up house and studio in Wellington's Island Bay. His new home enjoyed a commanding view of the Cook Straits. The surrounding land and seascapes, structurally framed by the house interior, provided the inspiration for many of Drawbridge's finest compositions. The resulting intaglios, watercolors, and murals, whether figurative or abstract, are dominated by the concern with space, color, texture, and the effects of light.

In the early 1970s, Drawbridge received a commission to produce a large-scale mural for the New Zealand parliament building. The *Beehive Mural* (1976) is almost 140 feet (42.7 m) in length, and consists of narrow aluminum panels painted on both sides in enamel and gloss paint, with optically shifting color arrangements. It was installed around the central cylindrical wall of the building's banquet hall, where the viewer can walk around it. The impact of light and color can be seen in another of Drawbridge's commissioned pieces, a stained-glass window series for Our Lady Chapel at the Home of Compassion in Island Bay. The work represents the fourteen stations of the cross; it consists of glass silhouettes, simply colored and textured, and set behind steel stencils. **NG**

> "[Drawbridge's] art encapsulated elements of New Zealand."
>
> —*The Independent*, 2005

ABOVE: Drawbridge shown in a detail of a portrait for *Craft New Zealand* by Brian Brake.

ANTONIO SAURA

Born: Antonio Saura, 1930 (Huesca, Aragon, Spain); died 1998 (Cuenca, Spain).

Artistic style: Painter, sculptor, and printmaker; landscapes, imaginary portraits, crucifixions, and distorted nudes; use of black and white; thick paint; violent brushstrokes.

As a child, Antonio Saura made visits to Madrid's Museo del Prado where he became acquainted with the paintings of his compatriots Diego Velázquez and Francisco Goya, both of whose work would influence him greatly.

Saura started to paint in 1947 and went on to have his first solo show in 1950. In 1953 he moved to Paris for two years, where he became involved with the surrealists. He started to paint pictures focusing on the body and women in particular—themes he would return to throughout his career, subverting notions of female beauty with his distorted, savage imagery.

On his return to Madrid, Saura's response to the repressive regime of General Francisco Franco was to shift to an Expressionist style using swirling, almost violent brushstrokes and working predominantly in black and white. In 1957, he cofounded the El Paso (The Step), which sought to forge a new kind of Spanish art in keeping with international developments and which led to Spanish informalism. In 1957 he began his crucifixion paintings, and in 1958 his "imaginary" portraits that sometimes referenced works by his predecessors and included series devoted to Brigitte Bardot, Goya, and Goya's dogs.

Saura's paintings were part of his political actions against Franco's rule. For example, his *Imaginary Portrait of Goya* (1966) is an homage to Goya but also implies that as Goya was a witness to the horrors of the Napoleonic invasion, so Saura was aware of the shortcomings of the dictatorial regime. After Franco's death in 1975, Saura was eventually lauded in his own country. He continued to paint as well as develop his printmaking, and even ventured into set design for theater, ballet, and opera on occasion in collaboration with his brother, filmmaker Carlos Saura. **CK**

Masterworks

Maja 1957 (Museo de Bellas Artes, Bilbao, Spain)

Sagrario 1960 (Museo Patio Herreriano de Valladolid, Valladolid, Spain)

Retrato Imaginario de Brigitte Bardot 1962 (Museo Nacional de Bellas Artes, Buenos Aires, Argentina)

La Gran Muchedumbre Tríptico 1963 (Museo Nacional Centro de Arte Reina Sofia, Madrid, Spain)

Imaginary Portrait of Goya 1966 (Tate Collection, London, England)

Crucifixión 1966 (Museo Patio Herreriano de Valladolid, Valladolid, Spain)

1930–39

"That image [Christ on the cross] could be seen as a tragic symbol of our age."

ABOVE: Detail from a portrait photograph of Saura taken by Christopher Felver.

FRANK AUERBACH

Born: Frank Helmut Auerbach, April 29, 1931 (Berlin, Germany).

Artistic style: Thickly impastoed paintings and heavily worked drawings; female portraits; landscapes of Camden Town in London; intense observation and furious mark making.

Masterworks

Primrose Hill: High Summer 1959 (Scottish National Gallery of Modern Art, Edinburgh, Scotland)

Head of E.O.W. 1959–1960 (Tate Collection, London, England)

Head of J. Y. M. 1978 (Museo Thyssen-Bornemisza, Madrid, Spain)

J.Y.M. Seated IV 1992 (Art Gallery of New South Wales, Sydney, Australia)

Mornington Crescent: Summer Morning II 2004 (Ben Uri Collection, London, England)

Frank Auerbach's art is an intimate glimpse into a world full of atmospheric reality and some of the most celebrated of English postwar painting. Born in Berlin to Jewish parents, Auerbach was sent to England to escape Nazism in 1939—and never saw his parents again.

In London Auerbach studied at St. Martins School of Art and the Royal College of Art, but he was most inspired by his lessons from Vorticist painter David Bomberg at Borough Polytechnic, and by his friendship with future expressionist painter Leon Kossoff. In his first solo show in 1956, Auerbach was both criticized and championed for his thick impasto technique; some critics disliked its resemblance to sculpture.

Auerbach's working space and habitual practices have for years been the subject of much mythologizing. Since 1954 a Victorian studio in Camden, London, has provided him with an abiding retreat in which to devote his energy to painting. Reportedly working 364 days of the year, he concentrates on a limited number of sitters and on the urban landscapes immediately surrounding his studio. This fierce dedication results in a small annual output of twelve to fifteen paintings a year. His trademark layering of paint, often applied with his fingers, belies the fact that he often completely dismantles a painting and starts again. In a continual process of considered mark making and erasing, painting for Auerbach is an adrenaline-fueled frenzy. Obsessively devoted to his subject, Auerbach commented in 1990 that if it were not for the subject, painting would be meaningless, "It would simply be some sort of gesture.... What one hopes to do is somehow become the subject, and out of that identification to make a vivid memorial." **TC**

"I am influenced by my current private life, my feelings about it and my energy level."

ABOVE: Frank Auerbach photographed around 1995 by Gemma Levine (detail).

RALPH HOTERE

Born: Hone Papita Raukura Hotere, 1931 (Mitimiti, Northland, New Zealand).

Artistic style: Use of black color; materials such as corrugated iron; minimalist geometric abstractions; political and environmental concerns; literary references; large, foreboding installations.

Ralph Hotere was born in the small Maori community of Mitimiti in New Zealand's Northland into a family of devout Roman Catholic faith and Aupouri tribal affiliations. He trained as a teacher and served as a Royal New Zealand Air Force pilot before moving to Dunedin and embracing a career as an artist. In 1961 he received a New Zealand Arts Society fellowship to attend the Central School of Art in London, and his few years abroad proved to be formative. On his return home in 1965, he was said to be carrying his works in the form of a "suitcase" nailed together and tucked under his arm. This was to become typical of his approach to techniques and materials, with art imitating life and vice versa. In 1969, Hotere was awarded the Frances Hodgkins Fellowship.

Influenced by the British op art movement of the 1960s, Hotere's early works tended toward minimalism. Nevertheless, he retained something of the romantic pictorial tradition, and never embraced fully-fledged abstraction. In his paintings, sculptures, and large-scale installations, he aimed instead for a visionary, mythmaking effect by including the use of text and inscriptions. Comparisons are often made with his compatriot artist Colin McCahon, who also used text to invoke spiritual and religious concerns. Indeed, Hotere collaborated with McCahon and other artists as well as writers such as Cilla McQueen, his wife of twelve years, and Bill Manhire. The themes of life and death, loss and regeneration have recurred throughout his long career, and have been associated by critics with his Maori heritage. But this is something the artist has played down, preferring to see his art in more universal terms. Hotere is known for his hermetic refusal to discuss the meaning of his work. **NG**

Masterworks

Black Painting XIII from Malady a Poem by Bill Manhire 1970 (Museum of New Zealand Te Papa Tongarewa, New Zealand)

Aurora 1980 (Museum of New Zealand Te Papa Tongarewa, New Zealand)

Black Phoenix 1984–1988 (Museum of New Zealand Te Papa Tongarewa, New Zealand)

*Large Window Frame c.*1985 (Auckland Art Gallery Toi O Tāmaki, New Zealand)

1930–39

"It is the spectator who provokes the change and meaning in these works."

ABOVE: Detail from a photograph taken by Marti Friedlander in 1978.

BRIDGET RILEY

Born: Bridget Louise Riley, April 24, 1931 (London, England).

Artistic style: Op art painter; investigations into optical phenomena, perception, and human vision; dynamic use of black and white; illusion of movement; innovative perception about the role of color.

Masterworks

Fisson 1963 (Museum of Modern Art, New York, U.S.)

Hesitate 1964 (Tate Collection, London, England)

Arrest 2 1965 (Nelson-Atkins Museum of Art, Kansas City, Missouri, U.S.)

Achaian 1981 (Tate Collection, London, England)

Shadowplay 1990 (Fitzwilliam Museum, Cambridge, England)

Nataraja 1993 (Tate Collection, London, England)

Bridget Riley is not part of a school; she is an individual who has continually cut her own intellectually and emotionally balanced path through painting. She studied at London's Goldsmiths College and then the Royal College of Art. At the age of thirty-one she had her first solo show at Gallery One in London, and then she showed her work in *The Responsive Eye* (1965), an exhibition at the Museum of Modern Art in New York. Op art, as it became known, was probably invented by Victor Vasarely, but it was Bridget Riley who allowed her powers of invention and creativity to bring gravitas to what may appear at first glance to be work best left to computers.

The success of Riley's 1960s paintings lay in their ability to physically disorientate and destabilize the viewer. *Hesitate,* (1964) takes the audience out of the past and into the future, and willfully questions how people see and understand things to be true. Her paintings of this period also influenced a generation of fashion and product designers.

In the 1980s, following a visit to Egypt, Riley started to work with a different kind of color and oils rather than acrylic paint. *Achaian* (1981) came out of this series and was painted in what she called her "Egyptian palette." During that decade she worked to make the color in her paintings function structurally, using stripes as the carrier of color as opposed to a motif. In the 1990s Riley went one step further to complicate the equation by intersecting her vertical bands with diagonals to create woven fields of color as in *Nataraja* (1993).

> "I draw from nature. I work with nature, although in completely new terms."

ABOVE: Bridget Riley in a corridor she painted for St. Mary's Hospital, London.

RIGHT: *Fission* is on view at the Museum of Modern Art (MoMA) in New York.

Today Riley divides her time between West London and the south of France, making paintings that still physically confront the audience with her sense of order. They are not pictures of a world; they are worlds. **SF**

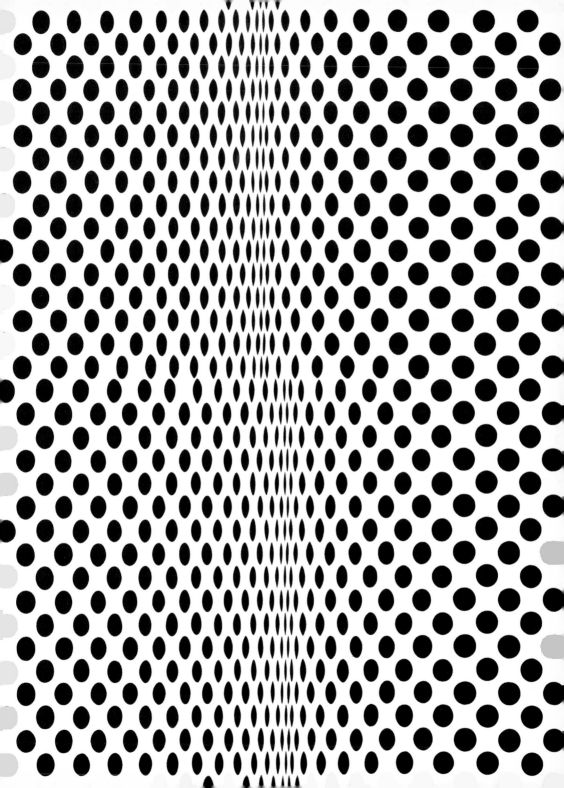

PETER BLAKE

Born: Peter Thomas Blake, June 25, 1932 (Dartford, Kent, England).

Artistic style: Founder of British pop art; painter, printmaker, and constructor of assemblages; making art accessible to the general public; a move away from elitism; a passion for the ephemera of popular culture.

Masterworks

On the Balcony 1955–1957 (Tate Collection, London, England)

Self-Portrait With Badges 1961 (Tate Collection, London, England)

The Beach Boys 1964 (Tate Collection, London, England)

Portrait of David Hockney in a Hollywood Spanish Interior 1965 (Tate Collection, London, England)

Puck 1977 (Royal Collection, London, England)

Montgomery Clift was a Twin 1981–1983 (Bilbao Art Museum, Bilbao, Spain)

The Owl and the Pussycat 1981–1983 (Bristol Art Museum, Bristol, England)

Untitled 1997 (Freud Museum, London, England)

"I wanted to make an art that was the visual equivalent of pop music."

ABOVE: Sir Peter Blake, the godfather of British pop art.

Sir Peter Blake first came to the art world's attention in 1961, when he exhibited at the Young Contemporaries exhibition along with David Hockney and Ronald Brooks Kitaj; he then won a prize in the John Moores Liverpool Exhibition (1961) with his painting *Self-Portrait With Badges* (1961)—now in the collection of the Tate Modern in London.

As one of the leading exponents of pop art, Blake helped steer the visual arts away from conservative and elitist values toward an art that was made for the people. Today he is best known outside of the art world for his involvement with cool pop music, his album design for The Beatles' album *Sgt. Pepper's Lonely Hearts Club Band* (1967), the Live Aid poster, and his album designs for Paul Weller and Oasis.

Blake's formal art education began when he was fourteen years old, at Gravesend Technical College Junior Art School, in Kent. In 1956, he went on to study at London's Royal College of Art. In the 1960s and 1970s, he began a prolific teaching career, working at St. Martin's School of Art, Harrow School of Art, Walthamstow School of Art, and the Royal College of Art.

In 1969 Blake established his home in a decommissioned railway station near Bath, England, where he gradually founded the briefly united Brotherhood of Ruralists, a group of painters who were more inclined toward folk art than pop art. Peter Blake, however, will be best remembered as a truly groundbreaking pop artist. He has had two retrospective exhibitions, both mounted by the Tate Gallery: the first in London in 1983, the second in Liverpool in 2007. In 1981 Blake was elected a Royal Academician. He was awarded the Order of the British Empire in 1983 and was knighted for services to art in 2002. He lives and works in London. **SF**

FERNANDO BOTERO

Born: Fernando Botero Angulo, April 19, 1932 (Medellín, Colombia).

Artistic style: Painter and sculptor; fleshy figures; use of rich, varied color; themes of identity, religion, art history, violence, political oppression, and officialdom.

The voluptuous figures of Fernando Botero's paintings and sculptures have been dismissed by some critics as mere kitsch. Perhaps their fleshy, sensual, almost cherubic forms are not fashionable at a time when Western culture values size zero, or maybe Botero's tongue-in-cheek reworking of cultural icons such as *Mona Lisa, Age Twelve* (1959) have made the artist's intentions appear merely playful. But this is a limited reading of his oeuvre. Among his joyous celebrations of the human body lie critiques of society. Sometimes the exaggerated proportions of his figures help serve him in his wish to satirize an institution, and sometimes the use of fat people in his more somber work makes his message resonate all the more.

A native Colombian, Botero has often depicted the results of social injustice and the suffering of his people under guerrilla warfare. *Mother and Child* (2000) nods to traditional depictions of the Madonna and child but shows a rotund pair of skeletons; and pieces like *Death in the Cathedral* (2002) are reminiscent of predecessors such as Francisco Goya, George Grosz, and Pablo Picasso in their focus on the havoc and destruction of war.

Botero's sense of obligation to highlight oppression seems to have grown over time. In 2005 he produced a series inspired by photographs of the abuse of detainees that took place at Abu Ghraib prison in Iraq in 2003. Across forty-five paintings and drawings, the plump, naked, almost statuesque figures are blindfolded and hooded with faces contorted in pain, and in some cases crouched, ready to receive a beating, as if they are Christlike figures waiting to be scourged before the crucifixion. The preponderance of flesh in these works makes the torment and humiliation of the prisoners portrayed more real—and more shocking. **CK**

Masterworks

Mona Lisa, Age Twelve 1959 (Museum of Modern Art, New York, U.S.)

Arzodiabolomaquia 1960 (Museo Nacional de Colombia, Bogotá, D.C., Colombia)

The Presidential Family 1967 (Museum of Modern Art, New York, U.S.)

Mother and Child 2000 (Museo Nacional de Colombia, Bogotá, D.C., Colombia)

Massacre in Colombia 2000 (Museo Nacional de Colombia, Bogotá, D.C., Colombia)

Death in the Cathedral 2002 (Museo Nacional de Colombia, Bogotá, D.C., Colombia)

Abu Ghraib 66, 2005 (Marlborough Gallery, New York)

Abu Ghraib 72, 2005 (Marlborough Gallery, New York)

"Art is a spiritual, immaterial respite from the hardships of life."

ABOVE: Colombian Fernando Botero often depicts social injustice in his work.

1930–39

HOWARD HODGKIN

Born: Howard Gordon Howard Eliot Hodgkin, August 6, 1932 (London, England).

Artistic style: An easel abstract painter who first painted his frames into the picture, and then the very walls they hung on; small-scale, brightly colored, vibrant, loosely painted abstract works.

Sir Howard Hodgkin's paintings clearly grow out of a European idea of lyrical abstraction. During the 1970s he was influenced by Henri Matisse, Pierre Bonnard, and Édouard Vuillard. By the 1990s, however, his brightly colored paintings that so often spill into their frames—such as *Night and Day*—were entirely his own.

Hodgkin started slowly as an artist but developed a powerful endgame. In just twenty years he went from being an obscure but well-thought-of-by-other-artists artist to becoming a trustee of London's National Gallery and Tate Gallery; and in 1992 he was knighted for his services to art.

His first art school was Camberwell Art School in London, which he attended for a year. In 1949 he began four years of study at Bath Academy of Art. After finishing art school, he taught at a boy's boarding school for two years before returning to teach at Bath Academy of Art for nine years. It was not until Hodgkin was forty, and back in London teaching at the Chelsea School of Art that he finally began to emerge as a major figure in British art. His recognition at this time was less because his work had changed than because there had been a radical shift in audiences' perception of his work. In 1976 Hodgkin had solo shows at the Serpentine Gallery in London and the Museum of Modern Art in Oxford. He gave up teaching at the Royal College of Art, and became artist in residence at Brasenose College, Oxford. It was a turning point in his career, after which he never really looked back. He went on to represent Britain at the Venice Biennale in 1984 and to win the Turner Prize in 1985—always showing his small-scale, brightly colored, vibrant, quite loosely painted abstract works, which often take several years to complete. **SF**

Masterworks

Mr. and Mrs. Stephen Buckley 1974–1976 (Tate Collection, London, England)

Lotus I 1978 (Norwich Castle Museum and Art Gallery, Norwich, England)

View from Venice 1984–1985 (Private collection)

Rain 1984–1989 (Tate Collection, London, England)

Night and Day 1997–1999 (National Gallery of Victoria, Melbourne, Australia)

Memories 1997–1999 (National Galleries of Scotland, Edinburgh, Scotland)

> "I don't think you can lightly paint a picture. It's an activity I take very seriously."

ABOVE: Howard Hodgkin, one of the most important artists working in Britain today.

EUAN UGLOW

Born: Euan Uglow, March 10, 1932 (London, England); died August 31, 2000 (London, England).

Artistic style: Euston Road School; naked female figures; enigmatic still lifes; stark, sculptured, pared-down compositions; fastidious, empirically measured paintings.

Euan Uglow was a very European painter of the Euston Road school of realist painters. His measured approach grew out of a love for the work of Nicolas Poussin, Jean-Auguste-Dominique Ingres, Paul Cézanne, and finally the influence of his mentor, realist painter Sir William Coldstream. Uglow studied at Camberwell College of Arts from 1948 to 1950 and then the Slade School of Art; he was taught by Coldstream at both institutions. On completion of his undergraduate studies, he won a Prix de Rome, a cash prize at that time, which he used to travel in northern Europe for six months. In 1954 he returned to the Slade as a postgraduate, but after six months was called up for National Service. He declared himself a conscientious objector, however, and was sent to work on the land.

Uglow's first solo show was at the Beaux Arts Gallery in London in 1961. The same year he began to teach at the Slade, Camberwell, and Chelsea College of Art and Design. There he became master of the life room and an influential force in keeping painting from life on the map.

Uglow is best known as a painter of the naked female figure and enigmatic still lifes. His pared-down compositions are stark, sculptured, and always in sharp focus, as seen in *Georgia* (1973). He often took years to complete his carefully measured paintings, once famously substituting a model with a body double when she began to change shape through her pregnancy. Standing before his subject, painting what he saw rather than what perspective theoretically dictated, he estimated his measurements using an instrument constructed from a modified music stand. His dealer Will Darby said of the artist, "Euan only wanted to paint, and felt he couldn't waste time on exhibitions of his work." **SF**

Masterworks

The Musicians 1953 (National Museum of Wales, Cardiff, Wales)

Georgia 1973 (British Council Collection, London, England)

Striding Nude, Blue Dress 1978–1980 (Private collection)

Zagi 1981–1982 (Tate Collection, London, England)

"I couldn't work on a painting without the model being there … the model is like a lighter."

ABOVE: Detail from a photograph of Euan Uglow taken by Sue Adler.

GERHARD RICHTER

Born: Gerhard Richter, February 9, 1932 (Dresden, Germany).

Artistic style: Painter and printmaker; blurred imagery based on photographs; abstracts, landscapes, seascapes, townscapes, snowscapes, portraits, and still lifes; themes of nostalgia and representation.

Masterworks

The Schmidt Family 1964 (Hamburger Kunsthalle, Hamburg, Germany)

Elizabeth I 1966 (Tate Collection, London, England)

256 Colours 1974 (Kunst Museum, Bonn, Germany)

Grey 1974 (Tate Modern, London, England)

Abstract Painting No. 439 1978 (Tate Collection, London, England)

Korn 1982 (Guggenheim Museum, New York, U.S.)

Seascape 1998 (Guggenheim Museum, Bilbao, Spain)

Eight Gray 2002 (Guggenheim Museum, New York, U.S.)

Gerhard Richter started to amass photographs in the 1960s, both his own and those taken from magazines, books, and newspapers. For his "photo paintings," he projects a photo onto canvas, traces its form, and uses the original to guide his color palette. Pigments are thinly applied and their imagery slightly blurred. As can be seen in *Elizabeth I* (1966), the result is a work that appears to capture the nostalgia of a fleeting moment, caught between the high art of romantic painting and the low art of a family snapshot. He has exhibited his photographic sources several times as *The Atlas* (1976 and onward).

ABOVE: Richter photographed in front of his work *Strontium* in 2005.

RIGHT: *Elizabeth I* is an example of Richter's ephemeral photo paintings

Richter's rejection of ideologies was prompted by an early life lived first under National Socialism and then East German Communism. He escaped to West Germany in 1961. In 1963, he formed the capitalist realist movement as a protest against consumer culture, with artists Sigmar Polke and Konrad Fischer. The same year saw him hold his first solo show at the Möbelhaus Berges, Düsseldorf. Richter's appreciation of the haphazard also informs his work and from the mid-1960s he has produced abstract works as well. His early works were based on "found" color charts, then he created a series of gray monochrome paintings, including the aptly titled *Grey* (1974), and colored abstract works, such as *Abstract Painting No. 439* (1978), again with a smooth, photolike finish.

Richter's later years have seen him veer between abstract and landscapes, such as *Seascape* (1998). He constantly challenges the viewer to consider painting versus photography and recording versus representation. **CK**

ABOVE: *Abstract Painting No. 439* reflects Richter's concern with the nature of painting.

A Question of Faith

Richter's 2007 design for a stained glass window for Cologne Cathedral replaces one of clear glass, in use since the original was destroyed during an air raid in 1944. Richter's abstract design of 11,200 panes of colored glass was created by random computer generation. It is meant to demonstrate that what appears to be coincidence is part of a divine design. It was not appreciated by all; Roman Catholic Cardinal Joachim Meisner would have preferred Saints Maximilian Kolbe and Edith Stein (both killed by the Nazis) to have been included. He commented, "It belongs in a mosque or another house of prayer, not this one. . . . It should be one that reflects our faith, not just any faith."

NAM JUNE PAIK

Born: Nam June Paik, July 20, 1932 (Seoul, South Korea); died January 29, 2006 (Miami, U.S.).

Artistic style: South Korean composer; first performer/artist to be labeled "video artist"; engaged in fluxus movement; installations with manipulated TV screens.

Masterworks

Moon is the Oldest TV 1965 (Centre Pompidou, Paris, France)

TV Garden 1974 (Nam June Paik Museum, Suwon City, Korea)

TV Buddha 1974 (Nam June Paik Museum, Suwon City, Korea)

The More the Better 1988 (National Museum of Contemporary Art, Seoul, Korea)

TV Clock 1989 version (Santa Barbara Museum of Art, Santa Barbara, California, U.S.)

TV Cello 2000 version (Queensland Art Gallery, Brisbane, Australia)

Widely regarded as an electronic pioneer, Paik enjoyed a prolific career that embraced TV projects, performances, installations, and collaborations. Initially, he studied the history of music and art in Japan, writing his thesis on composer Arnold Schoenberg. Later, in Germany, he met legendary avant-garde composer John Cage and under his influence Paik became involved in the 1960s radical art movement fluxus, founded by George Maciunas. For his first solo exhibition— *Exposition of Music-Electronic Television* (1963), held in Germany at Galerie Parnass, Wuppertal—he placed twelve TV sets in the gallery space and changed the course of video art history.

On moving to New York in 1964, Paik started collaborating with the classical cellist Charlotte Moorman to combine music, performance, and video. Together they performed pieces such as *Opera Sextronique* (1967), which saw a topless Moorman dressed by Paik in video objects she then used to play music.

One of Paik's most important artistic legacies is to have expanded the definition and language of the creation of art. Introducing the notion of video installation via his use of multiple monitors such as in *TV Garden* (1974), he added a new

ABOVE: Nam June Paik photographed in relaxed mode in 1984.

RIGHT: *Electronic Superhighway: Continental U.S., Alaska, Hawaii,* created by Paik in 1995.

dimension to the possibility of sculpture and installation art, while the concept of interactive art was already present in his pieces *Magnet TV* (1965) and *Participation TV* (1963).

The use of innovative technology was fundamental to Paik's career. Along with Japanese electrical engineer Shuya Abe, Paik developed *Video Synthesizer* (1969), one of the first artist-made video-image processors. Paik's global art project, *Good Morning, Mr. Orwell* (1984), was broadcast in New York, Paris, Berlin, and Seoul by satellite. His later postvideo works use lasers, as seen in a retrospective exhibition at the Guggenheim Museum in New York, *The Worlds of Nam June Paik* (2000).

Paik also collaborated extensively with friends and fellow artists from diverse disciplines: *Global Groove* (1973) includes sequences by John Cage and Allen Ginsberg. This method of working redefined artistic practice and saw Paik expand the understanding of the arts through different media. **JW**

ABOVE: A visitor observes Nam June Paik's video installation *Turtle*.

Ahead of His Time

The opening words of Paik's *Global Groove* (1973) were prescient: "This is a glimpse of a video landscape of tomorrow when you will be able to switch on any TV station on the earth and *TV Guide* will be as fat as the Manhattan telephone book." John Hanhardt, senior curator of film and media arts at New York's Guggenheim Museum, agrees: "Paik's work would have a profound and sustained impact on the media culture of the late twentieth century; his remarkable career witnessed and influenced the redefinition of broadcast television and transformation of video into an artist's medium."

1930–39

ILYA KABAKOV

Born: Ilya Jositovich Kabakov, September 30, 1933 (Dnipropetrovsk, Ukraine).

Artistic style: Immersive installations that require the viewer to become a willing participant in their intrigue and association; makeshift spaces about living under Communist rule.

Masterworks

Carrying out the Slop Pail 1980
 (Private collection)

Labyrinth (My Mother's Album) 1990
 (Tate Collection, London, England)

Healing with Paintings 1996 (Kunsthalle, Hamburg, Germany)

Although the provenance of installation as an artistic genre dates back at least to the 1920s, Ilya Kabakov has done the most to establish installation art as a category of contemporary art in its own right. Athough his artistic origins are in graphic arts—he began his career in the 1950s, illustrating children's books for several Moscow publishers—he became increasingly associated with the Russian avant-garde.

In the 1980s, Kabakov moved to New York and developed his practice as an installation artist. His works often reference his former life, such as *The Man Who Flew into Space from His Apartment* (1986). Its mise–en–scène staging appears to be a hallway along a partially boarded-up doorway that leads into a small bedroom. The intention is for the work to act as a stage set, a psychologically loaded backdrop against which the viewer becomes recast as a participant or an actor. This installation attempts to recall the activities and habits of occupants living under Communist rule.

Subsequent installations have developed the idea of the viewer's instrumental presence within a work. For example, in *Labyrinth* (*My Mother's Album*) (1990), Kabakov again created an immersive environment in the form of a long corridor. It is a communal space akin to that with which he would have been familiar in Russia, with two narratives in the form of a series of texts on the walls. Kabakov's intention is not only to evoke a sense of the narrator's journey but to have the journey mirrored in the dramaturgy of the viewer as they walk slowly down the prefabricated corridor. Kabakov's original and immersive installations, replete with meaning, intrigue, and association, have ensured that installation art has become a credible vehicle for artistic expression. **CS**

"The main actor in the total installation, the main center . . . is the viewer."

ABOVE: Installation artist Ilya Kabakov photographed in 2002.

ON KAWARA

Born: On Kawara, December 24, 1932 (Kariya, Aichi, Japan).

Artistic style: Conceptual artist; minimalist dated paintings containing factual-based information; exploration of how to represent time in painting; toying with methods of communication.

The paradox of how painting can represent time has been a consistent preoccupation with artists and thinkers. Renaissance artists attempted to overcome the static, two-dimensional nature of painting by juxtaposing different moments from the same episode of a biblical story. The eighteenth-century philosopher and art critic Gotthold Ephraim Lessing attempted to differentiate painting from poetry by claiming painting was a spatial art and poetry an art of time. In the present day, the work of conceptual artist On Kawara persistently attempts to grapple with this philosophical and aesthetic conundrum.

On January 4, 1966, On Kawara began the *Today* series of paintings. Consisting of a monochromatic field of color with the date the individual painting was made inscribed on it, each painting is stored in a handmade cardboard box together with a newspaper cutting taken from the same day—the paintings have been made in more than 100 countries. If he fails to finish a painting by midnight, he destroys it.

Time, space, and the individual's verification within are also discernable in a series of telegrams the artist began in the 1970s, initially with the message: "I am still alive." On Kawara worked to reverse the role of the telegram by replacing information that carries some significance, such as a birth or a death, with information that appears to be banal. Yet reading On Kawara's declaration within this context imbues his words and sentiment with a sense of pathos. Although On Kawara works within a set of clearly defined aesthetic and conceptual parameters, the nature of his practice is never hermetically sealed. The economy of his work encourages the viewer to engage with the same questions the artist continues to explore. **CS**

Masterworks

Title 1965 (National Gallery of Art, Washington, D.C., U.S.)

April 24, 1990 1990 (Museum of Modern Art, New York, U.S.)

March 16, 1993 1993 (San Francisco Museum of Modern Art, San Francisco, California, U.S.)

August 1, 1998 1998 (Museum of Contemporary Art, Los Angeles, California, U.S.)

"Kawara speaks at once to the creation of chronological time."—Lynne Cooke

ABOVE: On Kawara is notoriously private and never comments on his work.

JAMES ROSENQUIST

Born: James Rosenquist, November 29, 1933 (Grand Forks, North Dakota, U.S.)

Artistic style: Big, brash, bold canvases that draw on imagery deriving from U.S. popular culture; fragmented narratives and juxtapositions of motifs drawn from 1960s U.S. material culture.

Masterworks

President Elect 1960–1964

F-111 1964–1995 (Museum of Modern Art, New York, U.S.)

Campaign 1965 (Museum of Modern Art, New York, U.S.)

Evolutionary Balance 1977 (Museum of Fine Arts, Houston, Texas, U.S.)

The Swimmer in the Econo-mist (painting 3) 1997–1998 (Solomon R. Guggenheim Museum, New York, U.S.)

James Rosenquist was an instrumental force in the development of the American pop art movement, yet his highly ambitious and visually complex works are not allied only to this movement. Rosenquist trained at the University of Minnesota from 1952 to 1954 before enrolling at the Art Students League in New York in 1955. From 1957 to 1960 he worked as a billboard painter, allowing him to develop a range of skills he subsequently applied to his painting. A significant early work, *President Elect* (1960–1964), consists of three panels that one automatically reads left to right, from a portrait of John F. Kennedy through to a piece of cake, and then finally to the wheel of a '49 Chevrolet. The individual bombast of abstract expressionism is here transformed into the collective swagger of mass consumerism.

All the American pop artists somehow modified the ready-made images they worked with. Andy Warhol created images that entailed either a degree of deterioration or misregistration, and Roy Lichenstein enlarged his images to reveal the original patterning of benday dots. Yet Rosenquist was perhaps the most technically proficient of all of them all. This is evident in *F-111* (1964–1995), which established his international reputation. It consists of fifty-one panels and interweaves the image of an F-111 bomber between graphic representations of banal objects such as a tire, a cake, and a lightbulb. It also worked to differentiate Rosenquist from his counterparts by its apparent political dimension in its inclusion of the bomber. What Rosenquist continues to achieve with his choice of imagery drawn from popular or mass culture are a series of statements that, while visually compelling, do not constrict the possibility of their meaning. **CS**

> "His art is the product of New York, its styles, attitudes . . . and hectic intimacy." —Carter Ratcliff

ABOVE: James Rosenquist photographed in 1991 by Christopher Felver (detail).

RIGHT: *Campaign* (1965) was one of Rosenquist's earliest published works.

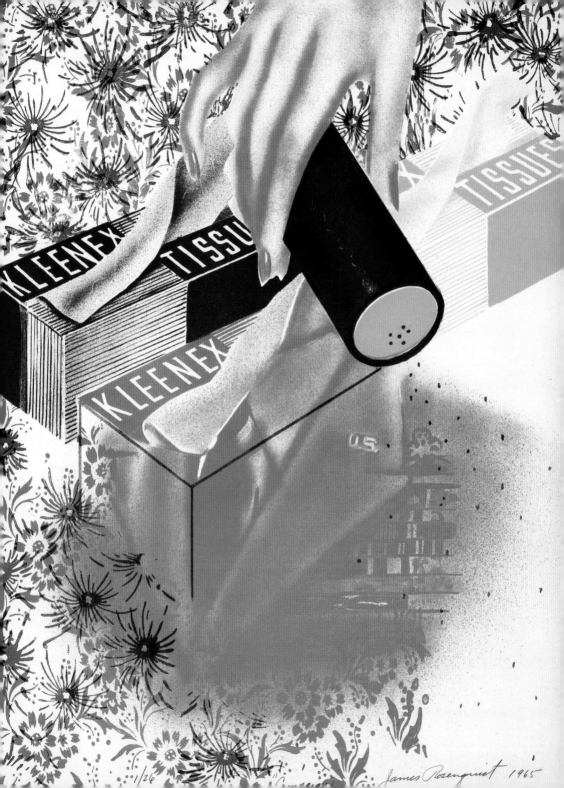

1/26 James Rosenquist 1965

CLIFFORD POSSUM TJAPALTJARRI

Masterworks

Warlungulong 1977 (National Gallery of Australia, Canberra, Australia)

Man's Love Story 1978 (Art Gallery of South Australia, Adelaide, Australia)

Yuelamu Honey Ant Dreaming 1995 (Art Gallery of South Australia, Adelaide, Australia)

Born: Clifford Possum Tjapaltjarri, *c.*1933 (Napperby Station, Northern Territory, Australia); died 2002 (Alice Springs, Northern Territory, Australia).

Artistic style: Large dot-and-circle paintings characteristic of the Aboriginal central desert style; multilayered stories; religious themes; strongly colored, intricate works.

An indigenous Australian, Tjapaltjarri was born shortly after his people were driven from their traditional camping grounds in the Central Desert region. He went on to become one of the best-known Australian Aboriginal artists of his time.

Tjapaltjarri's large, complex paintings bear some superficial resemblance to abstract expressionism, but they are, in fact, detailed, multilayered "maps of his dreaming," and part of how he expressed his religion. In these impressive works he plots out the sites of his heritage, ancestral sites that are of continuing, living significance to him. Supreme, aesthetically accomplished paintings, they are also declarations both of his entitlement and of his responsibility toward the land. **JR**

JERRY UELSMANN

Masterworks

Magritte's Touchstone 1965 (Addison Gallery of Contemporary Art, Phillips Academy, Andover, Massachusetts, U.S.)

Untitled 1969 (Museum of Contemporary Photography, Chicago, Illinois, U.S.)

Untitled 1970 (National Galleries of Scotland, Edinburgh, Scotland)

Untitled 1976 (Sioux City Art Center, Sioux City, Iowa, U.S.)

Born: Jerry Norman Uelsmann, 1934 (Detroit, Michigan, U.S.).

Artistic style: Photographer; black-and-white images; master of photomontage and postvisualization techniques; surreal juxtapositions of natural features, buildings, and solitary figures; questioning of photographic truth.

Uelsmann is one of the most popular and distinctive American art photographers of the late twentieth century. While teaching at the University of Florida, he mastered the technique of photomontage and began to challenge the contemporary orthodoxy of purist photography.

His composite prints, created in the darkroom using multiple negatives and enlargers, are reminiscent of the work of René Magritte and Man Ray but also herald a postmodern sensibility of subjective playfulness and New Age spirituality. Although such effects can now be achieved digitally, Uelsmann continues to experiment with traditional methods at his self-built visual research laboratory in Gainesville, Florida. **RB**

1930-39

GIOVANNI ANSELMO

Born: Giovanni Anselmo, August 5, 1934 (Borgofranco d'Ivera, Italy).

Artistic style: Conceptual artist; use of organic materials combined with inorganic substances; themes of time; exploration of forces of nature such as gravity and energy.

Italian Giovanni Anselmo began his artistic career as a painter, before turning to conceptual art in 1965. In 1968, he became one of the original members of the Italian movement arte povera, which was created as a reaction to the commercialism of pop art. The group sought to create work from unusual materials, such as live energy sources and even live animals, and to break down the barriers between the confinements of a gallery space and the outside world.

Time is a constant theme of Anselmo's work. In 1965, while taking a dawn walk on Mount Stromboli in Sicily, he experienced a sudden awareness of his own minuteness in the infinite space of the universe. This realization led him to explore the infinite as in works such as *Entering the Work* (1971), which records his attempts to beat the speed of the camera shutter while racing to a particular spot on a landscape.

This revelation also caused Anselmo to examine the nature of organic and inorganic materials, including water and electricity. In his sculpture *Untitled (Eating Structure)* (1968), a lettuce is held between two granite blocks bound by copper wire. As the lettuce wilts, the wire loses tension and the smaller of the two blocks starts to fall. The lettuce has to be continually replaced for the sculpture to exist, and the work thus demonstrates the power and limits of such natural forces as decay and gravity. Anselmo's fascination with materials and the forces of nature is at its most poetic in *Breath* (1969), in which the changing temperature of two iron bars causes a sea sponge to inflate and deflate, looking as if it were breathing. Works such as this involve the viewers on a physical level, making them aware of their own bodies, and transcend a mere visual experience. **WO**

Masterworks

Untitled (Eating Structure) 1968 (Musée National d'Art Moderne, Paris, France)

Torsion 1968 (Museum of Modern Art, New York, U.S.)

Breath 1969 (Museo di Arte Contemporanea, Turin, Italy)

Entering the Work 1971 (Private collection)

Towards Ultramarine 1984 (Castello di Rivoli Museo d'Arte Contemporanea, Torino, Italy)

1930–39

"I, the world, things, life—we are all situations of energy. The point is not to fix situations."

ABOVE: Giovanni Anselmo looks stern for his portrait by Christopher Felver (detail).

CARL ANDRE

Born: Carl Andre, September 16, 1935 (Quincy, Massachusetts, U.S.).

Artistic style: Minimalist sculptor; uses simple arithmetic combinations; repetition; geometrics; uses a variety of media; unlike traditional sculpture, the works are dismantled when not on display.

Masterworks

Trabum (Element Series) conceived in 1960; made in 1977 (Solomon R. Guggenheim Museum, New York, U.S.)

Chain Well 1964 (National Gallery of Australia, Canberra, Australia)

Equivalent VIII 1966 (Tate Collection, London, England)

Magnesium-Zinc Plain 1969 (Museum of Contemporary Art, San Diego, California, U.S.)

Sculptor Carl Andre uses simple arithmetic combinations to create his works of art, amassing and repeating identical units. After studying art at the Phillips Academy in Massachusetts and at Kenyon College, Gambier, Ohio, he worked at Boston Gear Works, earning enough money to travel to England and France. During this time, he wrote poetry, produced drawings, and created some geometric-shaped sculptures in Perspex and wood. In 1957, he settled in New York, where he worked as an editorial assistant for a publishing house.

In New York Andre met the artist Frank Stella and worked in his studio, developing a series of wooden "cut" sculptures that reveal the influence of Constantin Brancusi and of Stella's black paintings. In 1960 to 1964, he worked as a train driver and guard on the Pennsylvania Railroad, later maintaining that the repetition of shapes in train carriages and railway lines had a considerable influence on his art. Meanwhile, he was continuing to assemble sculptures out of simple blocks of material, exploring the idea that the use of multiple repeated elements emphasizes the shift from form and structure to the space occupied by the construction.

ABOVE: Carl Andre photographed in 1988, the year he was acquitted of murder.

RIGHT: *Lead Aluminum Plain* is a 6-foot-by-6-foot checkerboard of black and silver squares.

Andre's sculpture was first exhibited in a group show in 1964, followed by a solo exhibition at the Tibor de Nagy Gallery, New York, in 1965. In addition to making sculpture, he began to write poems in the tradition of concrete poetry, displaying the words on the page as if they were drawings.

Carl Andre's works are nonfigurative, usually consisting of identical ready-made commercial units, such as bricks, cement blocks, or metal plates, put together in simple geometric arrangements, horizontally along the ground and still emphasizing material, form, and structure—inviting viewers to question the space around them. He eliminates everything decorative or extraneous, reducing all components to precise and pure necessities.

In 1988 Andre was acquitted of murder following the death of his wife, the Cuban-American artist Ana Mendieta. He continues to live and work in New York. **SH**

ABOVE: *The Uncarved Blocks*, created in 1975 of red cedar wood blocks.

1930–39

Scandal!

In 1972 the Tate Gallery bought Carl Andre's *Equivalent VIII* (1966)—120 firebricks arranged two bricks high in a rectangle. There was an outcry about the alleged waste of public money, and the work was vandalized. It was one of the works from his solo exhibition seven years earlier. The titles came from Alfred Stieglitz's series of cloud photographs, called *Equivalents*. Andre's works have nothing to do with clouds, but in mathematical theory the equivalence relation is about sameness between elements, while in physics, the principle of equivalence demonstrates the distinction between forces of inactivity and gravity.

CHRISTO AND JEANNE-CLAUDE

Born: Hristo Yavashev, 1935 (Gabrovo, Bulgaria).
Born: Jeanne-Claude Denat de Guillebon, 1935 (Casablanca, Morocco).

Artistic style: Colossal wrapping projects; massive ephemeral interventions in landscapes; detailed architectural drawings and collages of projects.

Masterworks

Wrapped Chair 1961 (Cleveland Museum of Art, Cleveland, Ohio, U.S.)

Package 1965 (Walker Art Center, Minneapolis, Minnesota, U.S.)

Wrapped Coast, Little Bay, Australia 1969

Surrounded Islands: Project for Biscayne Bay, Greater Miami, *Florida* 1983

Pont-Neuf Wrapped 1985

Wrapped Reichstag: Project for Berlin 1995

Plans for *Over the River, Project for the Arkansas River, Colorado* 2000 (National Gallery of Art, Washington, D.C., U.S.)

Plans for *The Umbrellas, Joint Project for Japan and U.S.A.* 1991 (National Gallery of Art, Washington, D.C., U.S.).

The Gates, Central Park, New York 1979–2005

Christo studied at Sofia's Academy of Fine Arts from 1952 to 1956, lived in Prague in 1957, then escaped Communism by hiding in a truck bound for Austria. He studied under sculptor Fritz Wotruba in Vienna, spent time in Geneva, then moved to Paris in 1958. Commissioned to paint the portrait of Précilda de Guillebon, Christo met and married her daughter, Jeanne-Claude. Their partnership has resulted in one of the closest and most creative artistic collaborations of the twentieth century.

Christo began experimenting with *empaquetage*, or "packing," in early 1958, wrapping paint containers with canvas and adorning them with glue, sand, and car paint. Man Ray had produced similar creations, but it was Christo who elaborated wrapping as an art form, and pushed it to unusual extremes. After relocating to New York in 1964, Christo and Jeanne-Claude began planning massive wrapping projects.

Frequently their schemes take several years to organize, requiring a tremendous amount of negotiating and fundraising. Urban undertakings include the *Wrapped Kunsthalle* (1968) in Berne, the *Pont-Neuf Wrapped* (1985) in Paris, and the *Wrapped Reichstag* (1995) in Berlin. Their hugely ambitious *Wrapped Coast* (1969) saw a mile of coastline near Sydney being packaged and for *Surrounded Islands* (1983) eleven islands in Miami's Biscayne Bay were encircled with polypropylene fabric. In recent years, the artists have focused on ephemeral installations in rural and urban landscapes. After negotiating with the city of New York for more than twenty-five years, Christo and Jeanne-Claude finally installed *The Gates* (1979–2005) in Central Park. *Over the River* will be unveiled in Colorado in 2012, and a project for the United Arab Emirates, *The Mastaba*, is in the planning stage. **NSF**

"The concept is easy. Any idiot can have a good idea. What is hard is to do it."

ABOVE: Christo and Jeanne-Claude photographed in New York in 2003.

PAULA REGO

Born: Paula Figueiroa Rego, 1935 (Lisbon, Portugal).

Artistic style: Figurative painter, illustrator, and printmaker; dark, sinister, often childhood themes; use of animal imagery; magical realist, nursery rhyme, and storybook narratives.

Portuguese artist Paula Rego has lived in London since 1975, but her childhood in Portugal living under a dictatorship looms large in everything she does. She is probably best known for her output as a printmaker and her beautifully drawn illustrations of usually dark stories with a magical realist feel.

Rego was first educated at an English school in Portugal and then at a finishing school in the south of England. In 1952 she was admitted to the Slade School of Art, where her fellow students included her future husband Victor Willing. When they had completed their studies, Willing and Rego moved to Ericeira in Portugal, where they lived and painted until 1975.

During the mid-1980s, back in London, Rego was rapidly building a reputation as an artist. Her paintings were in general large in scale and painterly, almost drawings done with a brush. They were often ambitious, depicting risky images that, postwar, perfectly reconnected U.S. and European painting. During the late 1980s however, her work went into flux, and shortly before her husband's death she began to move away from her free-flowing, international style of painting toward another kind of image that was more gravity-driven, staged, and illustrative—her *The Maids* (1987) is an important work of this period. With this new style she moved to the Marlborough Gallery, in London, where she first exhibited the paintings that were to make her famous and was shortlisted for the Turner Prize in 1989.

As her career developed, and the events depicted in Rego's prints and paintings became more challenging and sinister, so the means she used of rendering those events became increasingly conservative. She also began using pastels in preference to oils, since she has said she dislikes the smell of oils. **SF**

Masterworks

Triptych 1998 (Abbot Hall Art Gallery, Kendal, England)
The Maids 1987 (Saatchi collection)
The Fitting 1989 (Saatchi collection)

> "If you put frightening things into a picture, then they can't harm you."

ABOVE: Artist Paula Rego at the South Bank Show Awards, London, January 27, 2005.

ALFREDO ALCAÍN

Masterworks

Cézanne petit-point II 1981 (Museo Nacional Centro de Arte Reina Sofía, Madrid, Spain)

Born: Alfredo Alcaín Partearroyo, 1936 (Madrid, Spain).

Artistic style: Spanish pop art painter, illustrator, and sculptor; use of heavy black outline and blocks of single bright color with repeating shapes; draws on patterning of traditional Andalusian tiles and ceramics.

Spanish painter, illustrator, and sculptor Alfredo Alcaín studied painting at Madrid's Escuela de Bellas Artes de San Fernando, and then printmaking and lithography at the city's y Litografía en la Escuela Nacional de Artes Gráficas. He became a leading member of the Spanish pop art movement with contemporaries such as Luis Gordillo and Eduardo Arroyo. Since the 1980s his works are notable for their use of heavy black outline, and blocks of single bright color with repeating shapes that appear to form an image. He appears to draw on the patterning of traditional Andalusian tiles and ceramics. He often incorporates materials such as wood in order to enhance the three-dimensional effect of his canvases. **CK**

ANTONIO LÓPEZ GARCÍA

Masterworks

Ataud (*Nina Muerta*) 1957 (Museum of Fine Arts, Boston, Massachusetts, U.S.)

Madrid seen from the Hill of Tío Pío 1962 (Museo Nacional Centro de Arte Reina Sofia, Madrid, Spain)

The Pantry (*Cupboard Cooler*) 1962 (Museum of Fine Arts, Boston, Massachusetts, U.S.)

Backs (*Man and Woman*) 1964 (Museum of Fine Arts, Boston, Massachusetts, U.S.)

Atocha (*Esparto*) 1964 (Museum of Fine Arts, Boston, Massachusetts, U.S.)

Sink and Mirror 1967 (Museum of Fine Arts, Boston, Massachusetts, U.S.)

View of Madrid from the Torres Blancas 1976–1982 (Private collection)

Born: Antonio López García, 1936 (Tomelloso, Ciudad Real, Spain).

Artistic style: Hyperrealist painter and sculptor of still lifes of domestic interiors, cityscapes, and portraits; incredible attention to detail; master of portraying the mundane.

In his depiction of still lifes, García continues in the tradition of artists such as Juan Sánchez Cotán and Francisco de Zurbarán. His subjects are taken very much from contemporary domestic life, however, from fridges to the detritus of daily life—such as clothes soaking in a sink. Every blemish and crack is shown, and it can take him years to complete a work. After graduation from Madrid's School of Fine Arts, he initially adopted a surrealist and magical realist style of painting before shifting his focus in the late 1950s to the minutiae of the physical world. In the 1960s he painted cityscapes of Madrid, including tower blocks and highways, confirming his ability to create beauty from everyday sights and situations. **CK**

JANNIS KOUNELLIS

Born: Jannis Kounellis, 1936 (Piraeus, Greece).

Artistic style: Member of the arte povera movement; installations made from unorthodox materials; works incorporating live animals, including horses and parrots and elements such as burning gas flames.

"I want the return of poetry with all means," said Jannis Kounellis in 1987, a statement that seems representative not only of his oeuvre but of the movement with which his name and achievements have become synonymous. Arte povera, meaning "poor art," was a movement that came to fruition in 1960s Italy while he was studying there.

Although Kounellis was born in Greece, he moved to Rome aged twenty to study at the Accademia di Belle Arti. His first solo show was at Rome's Galleria Arco d'Alibert in 1964. From the outset, his oeuvre has shown a willingness to embrace a diversity of materials and a live component. For example, for his exhibition in 1967 at the Galleria Attico, his installation incorporated a series of birdcages housing live birds. This live dimension has equally taken the form of a steel bed frame with a burning flame attached to it in his *Untitled* (1969) and a cellist playing a fragment of Johann Sebastian Bach's *Johannes Passion* (1724) in his *Untitled* (1971). Perhaps one of the most significant pieces that stem from this period is *Untitled* (*Twelve Horses*) (1969); it consisted of twelve horses installed in an underground garage in Rome. As well as having obvious connections to the history of Renaissance art, in particular the sculptural idiom of the equestrian statue, the piece was an attempt to circumvent the static, marketable artwork in favor of a more contingent, art-based event. Today, Kounellis continues to use a diversity of materials, though several motifs, including the use of a live flame, have been repeated. Just as the alchemist desires to turn base material into gold, Kounellis has repeatedly attempted to imbue a diversity of materials and objects with a set of associations and resonances that transcend the realm of the everyday. **CS**

Masterworks

Untitled 1968 (Tate Collection, London, England)

Untitled 1969 (Musée National d'Arte Moderne, Centre Georges Pompidou, Paris, France)

Untitled 1984–1987 (Art Gallery of New South Wales, Sydney, Australia)

"One needs to consider that the gallery is a dramatic, theatrical cavity. . ."

ABOVE: Greek-born Jannis Kounellis, a member of the arte povera movement.

LUCAS SAMARAS

Born: Lucas Samaras, September 14, 1936 (Kastoria, Greece).

Artistic style: Spiky assembled boxes and objects; furniture and room transformations; mirrored spaces; manipulated photographic self-portraits; vibrant acrylics and pastels.

Masterworks

Book #4 (Dante's Inferno) 1962 (Museum of Modern Art, New York, U.S.)

Untitled Box No. 3 1963 (Whitney Museum of American Art, New York, U.S.)

Untitled 1963 (Los Angeles County Museum of Art, Los Angeles, California, U.S.)

Box 1963 (Tate Collection, London, England)

Mirrored Room 1966 (Albright-Knox Art Gallery, Buffalo, New York, U.S.)

Box #61 1967 (Tate Collection, London, England)

Auto Polaroid 1969–1971 (Museum of Modern Art, New York, U.S.)

Lucas Samaras's childhood in Greece during World War II and the subsequent Greek Civil War impacted greatly on his choice of artistic materials and techniques. His aunt was a dressmaker and Samaras often played in her workshop, constructing toys from whatever he found. In 1948, the family moved to the United States and settled in New Jersey. Samaras became an American citizen in 1955 and majored in art at Rutgers University College of Arts and Sciences, where he met George Segal, Robert Whitman, and Allan Kaprow. He exhibited early paintings and pastels at the Reuben Gallery and was a regular participant in "happenings" and avant-garde film in the 1960s.

In the spring of 1960, Samaras began to use found materials in his paintings, also assembling boxes and small fetishistic objects that incorporated pins, nails, broken glass, and razor blades adorned with feathers, foil, lightbulbs, and mirrors, as well as including photographs of himself.

Self-portraiture infused much of his work. When he moved to Manhattan in 1964, Samaras installed a recreation of his New Jersey bedroom in the Green Gallery, filled with his personal belongings and artworks, making a private space into a public artwork. This was followed by a second room installation in 1966, its walls covered in mirrored tiles, creating an infinite repetition of whoever enters. Samaras used a range of media to continue his exploration of the idea of selfhood from the 1970s, including pastel, acrylic, fabric, film, and photography, creating colorful images in which his body is transformed and fragmented, and vibrant portraits of friends. Seemingly inexhaustible, he has created a rich world of diverse imagery and forms, most recently embracing the possibilities of the digital age. **LB**

"I go to shops—dime stores, antique stores, junk stores— and look for objects I can use."

ABOVE: Lucas Samaras explores the idea of selfhood in his colorful and diverse images.

FRANK STELLA

Born: Frank Stella, 1936 (Malden, Massachusetts, U.S.).

Artistic style: Abstract painter; ranges from the systematic to the lyrical; innovative use of materials; bold intelligent statements about painting in painted form; constantly experimental.

The singular career path of Frank Stella began with the *Black Paintings* (1958–1960). By deliberately purging from his canvases discernable gesture, illusion, and any identifiable signifier of expression, he appeared to achieve his maxim of 1964: "What you see is what you see." The viewer no longer had recourse to any of the traditional means by which painting was understood. To this end, even the shallow space of cubism and abstract expressionism had all but been emptied out.

Having adopted such an extreme position, Stella then went on to develop the visual language by which his paintings became conceived. With the introduction of color and a series of increasingly elaborate patterns that were often underscored by the actual shape of the canvas stretcher directly corresponding to the geometric design of a particular painting, the development of a richer vocabulary presented the artist with a different set of possibilities. The first half of the 1960s witnessed Stella explore a number of permutations that were first presented in the series of paintings that followed after *The Black Stripe* (1967) series. Toward the latter half of the decade, his *Irregular Polygon* (1965–1967) series was significant because it was the first time Stella included large expanses of unmodulated color in his overall design.

At this time Stella embarked upon what has proved to be a lifelong involvement with printmaking. The nature of his enterprise was further evidenced during the 1970s when he introduced relief into what remained, in effect, still paintings.

By increasing scale and the chromatic range of his palette, Stella's work has become increasingly exuberant, experimental, and playful. The only consistent feature of Stella's eclectic career is the onus he has placed on experimentation. **CS**

Masterworks

The Marriage of Reason and Squalor II (Black Paintings) 1959 (Museum of Modern Art, New York, U.S.)

Six Mile Bottom 1960 (Tate Collection, London, England)

Union III (Irregular Polygon Series) 1966 (Museum of Modern Art, Los Angeles, California, U.S.)

Inaccessible Island Rail 1977 (Museum of Modern Art, Los Angeles, California, U.S.)

1930–39

"The paintings got sculptural because the forms got more complicated."

ABOVE: American abstract painter Frank Stella is constantly experimental in his work.

PATRICK CAULFIELD

Born: Patrick Caulfield, January 29, 1936 (London, England); died September 29, 2005 (London, England).

Artistic style: British pop artist painter and printmaker; spare still lifes and interiors; flat areas of warm, bright color surrounded by black outlines.

Masterworks

Probably the most internationally underrated British painter of the twentieth century, Patrick Caulfield studied at London's Chelsea School of Art during the late 1950s and then at the Royal College of Art from 1960 to 1963 with David Hockney, Alan Jones, and R. B. Kitaj.

Like the pictures he painted, Caulfield was warm spirited, well informed, and, above all, clever. Always at the heart of his work was a simple black outline that simultaneously served to describe a form and separate areas of flat, carefully mixed colors from each other. As a painter he was clearly influenced by Fernand Léger and Juan Gris, and as a teacher both Michael Craig-Martin and Julian Opie clearly learned from his work.

By the mid-1970s, Patrick Caulfield was acknowledging postmodernism and including—as if just for the fun of it—photographically "real" painted elements as a part of his otherwise diagrammatic worlds, demonstrated in his paintings *After Lunch* (1975) and *Interior with a Picture* (1985–1986).

Caulfield did receive some recognition during his career. In 1987 he was nominated for the Turner Prize; in May 1993 he was elected a member of the Royal Academy; and in 1996 he was made a commander of the British Empire. One of his last works was central to his interests but atypical of his output. It was a decorative scheme carried out in the Academicians' Room at Burlington House in London (the home of the Royal Academy). Its walls are painted in black-and-red gloss to resemble a particular North African brothel, and the furniture is modernist black leather and chrome. There are no pictures, just a mirror and a beautiful rug woven to his design, which carries a monochrome image of a duck in profile sitting on its own water-distorted reflection. **SF**

"One of the most original image makers in a talented generation."—Nicholas Serota

ABOVE: Patrick Caulfield photographed with some of his work in 1995.

RIGHT: One of Caulfield's trademark screenprints, *Napkins and Onions* (1972)

Masterworks

An Ear in a Pond 1965 (San Francisco Museum of Modern Art, San Francisco, California, U.S.)

Ringaround Arosie 1965 (Museum of Modern Art, New York, U.S.)

Tomorrow's Apples (5 in White) 1965 (Tate Collection, London, England)

Untitled 1966 (Museum of Modern Art, New York, U.S.)

Addendum 1967 (Tate Collection, London, England)

Repetition Nineteen I 1967–1968 (Museum of Modern Art, New York, U.S.)

ABOVE: Eva Hesse photographed at the height of her career.

EVA HESSE

Born: Eva Hesse, 1936 (Hamburg, Germany); died 1970 (New York, U.S.).

Artistic style: Postminimalist sculptor and installation artist; use of unconventional and degradable materials; sexual imagery; exploration of the industrial versus handmade, and chaos versus order.

"Life doesn't last, art doesn't last, it doesn't matter . . . I think it is both an artistic and life conflict," said Eva Hesse in 1970 when contemplating whether to sell some of her latex sculptures. She knew that her fragile work would degrade over time so that, in essence, a collector would be left with nothing. This was deliberate, as she challenged the notion of what makes an artwork in her pioneering use of unconventional materials. She also knew that life was short, given that she had been diagnosed with a brain tumor in 1969 and died within a year.

The brevity of life was something of which Hesse was acutely aware, given that her Jewish family fled Nazi Germany in 1939. Her mother was traumatized by her life in exile and committed suicide when Hesse was just ten. Yet Hesse's focus on using industrial materials to create her art was not just an exploration of the fleeting existence of the material, it came about initially by necessity when she used a disused factory as her first studio space in the 1960s and began making her work from material she found in nearby abandoned warehouses.

Hesse's work was not merely about transience and the fine line between something and nothing. This was just one of the contradictions she explored, often with an absurdist sense of humor, using mundane materials such as string, balloons, screws, and sprockets to create sculptures with an erotic frisson. She focused on the nature of aesthetic beauty by seeking to avoid creating the beautiful; the industrial process versus the handmade, as she crafted art from industrial materials; and chaos versus order as she assembled the apparently disparate to create works of patterned precision. Perhaps her ultimate legacy is her ability to reveal that what constitutes art is in its making. **CK**

"Absurdity is the key word. It has to do with contradictions and oppositions."

ISAAC WITKIN

Born: Isaac Witkin, 1936 (Johannesburg, South Africa); died 2006 (Pemberton, New Jersey, U.S.).

Artistic style: New generation sculptor; abstract works in colored fiberglass, wood, welded steel, or poured bronze; use of a single color to unite separate elements.

Isaac Witkin studied at St. Martin's School of Art in London from 1957 to 1960 under Sir Anthony Caro and later worked as an assistant to Sir Henry Moore. He was one of a group of avant-garde British sculptors who became known as the "new generation" after the name of a series of shows held at London's Whitechapel Gallery in the early 1960s. The group was known for its innovative abstract sculptures painted in bright, industrial colors. In Witkin's later work, he moved on to creating heavier, industrial pieces from welded steel and then his signature pieces made from molten bronze poured on to a bed of wet sand to create softer, biomorphic shapes such as his *Linden Tree* (1983) and *The Bathers* (1991). **CK**

Masterworks

Vermont I 1965 (Tate Collection, London, England)

Angola I 1966 (Tate Collection, London, England)

Maquette for Chorale 1980 (Smithsonian American Art Museum, Washington, D.C., U.S.)

Firebird 1983 (Smithsonian American Art Museum, Washington, D.C., U.S.)

Linden Tree 1983 (Grounds For Sculpture, Hamilton, New Jersey, U.S.)

The Bathers 1991 (Grounds For Sculpture, Hamilton, New Jersey, U.S.)

PETER CAMPUS

Born: Peter Campus, 1937 (Manhattan, New York, U.S.).

Artistic style: Pioneering American video artist creating closed-circuit installations, photography, and computer-based imagery to explore video in relation to human perception.

An original and influential video artist, Campus pushed the use of video art to the peak of its potential. His work includes closed-circuit installations, photography, and computer-based images through which he explores the anatomy of the video signal in relation to human perception. In the mid-1970s, he was part of a group of artists who produced work in experimental TV at WGBH-TV in Boston and WNET/Thirteen in New York. In a series of videos (1971–1976), Campus identified the technical and symbolic constraints of the medium as metaphoric of the self. *Three Transitions* (1973) is arguably his most important work, in which he used chroma-key processors and video mixers to create a groundbreaking composition. **KO**

Masterworks

Three Transitions 1973 (Museum of Modern Art, New York, U.S.)

Interface 1972 (Closed-circuit video installation, glass pane, B&W, silent)

Mem 1975 (Digital video)

Bys 1976 (Digital video)

Edge of the Ocean 2003 (Digital video)

El Viejo 2004 (Digital video)

Time's Friction 2004 (Digital video)

1930–39

DAVID HOCKNEY

Born: David Hockney, July 9, 1937 (Bradford, Yorkshire, England).

Artistic style: Pop artist; painter, photographer, printmaker, illustrator, and stage set designer; portraits, panoramic landscapes, and swimming pool scenes; photomontage; themes of relationships and homosexuality.

Masterworks

Myself and My Heroes 1961 (Tate Collection, London, England)

Man in Shower in Beverly Hills 1964 (Tate Collection, London, England)

Peter Getting Out of Nick's Pool 1966 (Walker Art Gallery, Liverpool, England)

A Bigger Splash 1967 (Tate Collection, London, England)

Mr. and Mrs. Clark and Percy 1970–1971 (Tate Collection, London, England)

David Hockney (*The Student-Homage to Picasso*) 1973 (National Portrait Gallery, London, England)

Celia with Green Hat 1984 (Tate Collection, London, England)

40 Snaps of my House, August 1990 1990 (Tate Collection, London, England)

A Bigger Grand Canyon 1998 (National Gallery of Australia, Canberra, Australia)

David Hockney's fame began in the "swinging sixties" when he was at the center of the British pop art movement along with artists such as Sir Peter Blake. That some of his work had openly homosexual themes added to his early celebrity.

Hockney has continually reinvented himself: photographer, printmaker, illustrator, and stage set designer. Yet it is his paintings of Los Angeles swimming pools and apartments, combined with his numerous portraits, often of family and friends, for which he is best known. *A Bigger Splash* (1967), one of his first Los Angeles swimming pool paintings, conjures up a suggestion of wealth and sun-soaked glamour, with a human presence merely a splash in the swimming pool. After Hockney moved to California, his canvases became packed with vibrant color, bright patterns, palm trees, fit young men, and a hint of sensuality and laid-back decadence.

Of his portraits, the most famous is *Mr. and Mrs. Clark and Percy* (1970–1971). Hockney has painted many double portraits, giving him the opportunity to use his canvas to portray subtly

ABOVE: Hockney photographed with some of his theater sets in Paris in 1991.

RIGHT: David Hockney at work on a typically vibrant and colorful piece.

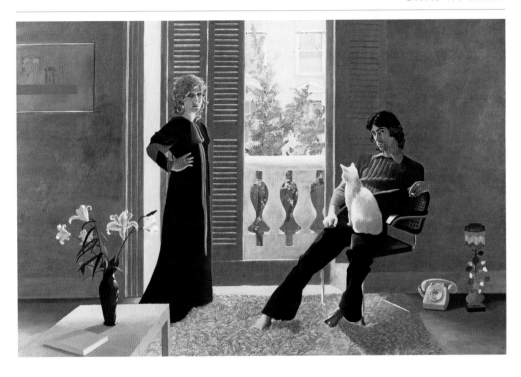

not just his sitters' likenesses but also their relationships. The eponymous *Mr. and Mrs. Clark* are fashion designer Ossie Clark and his wife, textile designer Celia Birtwell, with their cat, Percy, surrounded by the minimalist chic of a 1970s apartment. The painting's stillness causes viewers to wonder about their life, with the artist asking the viewers to supply their own narrative. Hockney has painted many of his subjects repeatedly, especially Birtwell, who has become known as his muse.

Hockney experiments with form and media: this includes etchings for literary works such as *A Rake's Progress* (1961); set design for ballets and operas, including *Die Zauberflöte* (1791) for New York's Metropolitan Opera in 1978; and forays into cubist photomontage. His capacity for direct observation—or "eyeballing" as he calls it—is, however, his greatest talent, and has led to his continuing exploration of portraiture and landscape, works that will stand the test of time. **CK**

ABOVE: *Mr. and Mrs. Clark and Percy* shows a concern with the quality of light.

1930–39

Focus on Photography

Digital photography has led Hockney to declare the art of photography dead, but in the late 1970s and early 1980s the artist concentrated on photography in preference to painting. He produced several series of photomontages from Polaroids, taking landscapes from various angles and at different times. He then joined the photos to make composite images revealing his movement through time and space. The results, distinctly Hockney in style, were obviously influenced by his hero Pablo Picasso's cubist phase in their depiction of a location from multiple angles.

ED RUSCHA

Born: Edward Joseph Ruscha IV, December 16, 1937 (Omaha, Nebraska, U.S.).

Artistic style: Words and text painted on backgrounds; exploration of light and landscape; Los Angeles iconography; an interest in graphic design; cinematic and commercial qualities.

Masterworks

Trademark #5 1962 (Tate Collection, London, England)

Actual Size 1962 (Los Angeles County Museum of Art, Los Angeles, California, U.S.)

Oof 1962–1963 (Museum of Modern Art, New York, U.S.)

Noise, Pencil, Broken Pencil, Cheap Western 1963 (Virginia Museum of Fine Arts, Richmond, Virginia, U.S.)

Standard Station, Amarillo, Texas 1963 (Hood Museum of Art, Hanover, New Hampshire, U.S.)

Norms, La Cienega on Fire 1964 (Broad Art Foundation, Santa Monica, California, U.S.)

The End #1 1993 (Tate Collection, London, England)

After attending the California Institute of the Arts, Ed Ruscha began his career as a layout artist for the Carson-Roberts Advertising Agency in Los Angeles. His quintessential California aesthetic is informed by both car culture and print advertising. In the 1960s, he painted Standard Gas stations, commentaries on the endless repetition of ordinary landmarks infiltrating the landscape. He also made series of photographs documenting anonymous Los Angeles buildings on the Sunset Strip, a similar statement rejecting the conventional principles of fine art.

Through documenting generic ready-made structures, Ruscha surrendered traditional composition in exchange for the logic of mass production. He associated with the progressive Ferus Gallery group and was included in the seminal exhibition of pop art entitled *New Painting of Common Objects* (1962) at the Pasadena Art Museum.

Ruscha's graphic design background appears in his works that are dependent upon literal use of language. He is best known for paintings that have a word or short phrase in the foreground. His text bank, gathered from a variety of sources, includes singular words such as "SPAM," as used in *Actual Size* (1962), and Shakespearian quotations such as "Words Without Thought Never to Heaven Go". Ruscha's heightened regard for palette and typeset is evident in his entire body of work. Through his career, he has continued to experiment with language, light, and landscape. Ruscha's repertoire includes images of Los Angeles cityscapes, majestic mountain ranges, and ominous silhouettes of ships at sea. Regardless of subject, his work embodies the irreverence associated with the pop art movement and champions a mechanical and processed aesthetic. **MG**

"The true landscape of our epoch is a mixed ribbon of signs and symbols and splashes."

ABOVE: Ed Ruscha, relaxing in his studio in Los Angeles in 2005.

HÉLIO OITICICA

Born: Hélio Oiticica, July 26, 1937 (Rio de Janeiro, Brazil); died March 22, 1980 (Rio de Janeiro, Brazil).

Artistic style: Painter, sculptor, and performance artist widely interested in experimenting with color; interactive works inspired the counterculture of his day.

The father of tropicalismo, Hélio Oiticica is now increasingly recognized as one of the twentieth century's greatest artistic innovators. His paintings, sculptures, and interactive and participatory performance works bridged the gap between the European modernist tradition and the growth of both a Brazilian avant-garde and the international contemporary art scene. Oiticica was born in Rio de Janeiro, and became an artist during a prosperous and optimistic period in Brazil when many national cultural activities—such as the first São Paulo Biennale and a number of architectural projects—achieved major international projection. Oiticica became involved with the Grupo Frente, a radical artist group influenced by abstract and modernist work, especially the use of color and geometric shape by artists such as Piet Mondrian and Paul Klee.

In 1959, along with Amilcar de Castro, Lygia Clark, and Franz Weissmann, he cofounded Grupo Neoconcreto, which lasted until 1961. At this time, Oiticica was making painted red-and-yellow wood constructions, which allowed color to break free from the two-dimensional picture plane. His next projects were the *Núcleos* (1960) series—simple, architectural, hanging maze constructs decorated with related colors and, sometimes, mirrors—and the *Penetrávels* (1960–1979), closed, sensory-stimulation environments.

Oiticica's interest in three-dimensional color culminated in his *Bólides* (1963–1964) series of small wooden boxes and his *Parangolés* (1964–1965)—brightly colored capes inspired by samba and designed to be worn while performing and dancing traditional samba. His most famous *Penetrável* is *Tropicália* (1967), the title of which inspired the name of the cross-discipline countercultural movement against Brazil's military dictatorship. **LNF**

Masterworks

Grand Nucleus 1960–1966 (César & Claudio Oiticica Collection, Rio de Janeiro, Brazil)

Singer and Composer Caetano Veloso Wearing PO4 Parangolé Cape 01 1964 (Projeto Hélio Oiticica, Rio de Janeiro, Brazil)

PO7 Parangolé Cape 04 Clark 1964–1965 (Cesar & Claudio Oiticica Collection, Rio de Janeiro, Brazil)

Tropicália, Penetrávels PN 2 "Purity is a Myth" and PN3 "Imagetical" 1966–1967 (Tate Collection, London, England)

> "Any conformity, intellectual, social or existential, is contrary to [tropicália]."

ABOVE: Oiticica in Rio de Janeiro, taken in 1970 by an unknown photographer.

1930–39

GEORG BASELITZ

Born: Hans-Georg Kern, January 23, 1938 (Deutschbaselitz, Saxony, Germany).

Artistic style: Painter, draftsman, printmaker, and sculptor; paintings of upside-down figures; neo-expressionist figurative paintings of heroic peasant rebels; wood sculptures.

Masterworks

Sex With Dumplings 1963 (Art Institute of Chicago, Chicago, Illinois, U.S.)

Rebel 1965 (Tate Collection, London, England)

Meissen Woodmen 1969 (National Gallery of Australia, Canberra, Australia)

Finger Painting: Nude 1972 (Stedelijk Museum, Amsterdam, the Netherlands)

The Gleaner 1978 (Solomon R. Guggenheim Museum, New York, U.S.)

Untitled (Figure with Arm Raised) 1982–1984 (National Galleries of Scotland, Edinburgh, Scotland)

The Lamentation 1983 (Museum of Fine Arts, Houston, Texas, U.S.)

Born Hans-Georg Kern, the artist adopted the pseudonym Georg Baselitz as a tribute to his hometown of Deutschbaselitz. He moved to what was West Germany in 1956, and in 1963 was given his first solo exhibition at West Berlin's Gallerie Werner & Katz. The exhibition caused a public scandal when two of the paintings were seized by the authorities purportedly "for reasons of public decency," one being *The Big Night Down the Drain* (1962–1963) of a boy masturbating.

In 1965, Baselitz spent six months in Florence, Italy (he has since returned to Italy many times). It was during this time that he first began painting people and objects upside down. This topsy-turvy theme was one he persisted with, as can be seen in *The Lamentation* (1983), painted almost two decades after his first trip to Italy. Baselitz explained his decision: "The reality *is* the picture; it is most certainly not *in* the picture."

After having suffered a difficult and controversial start, Baselitz's reputation and worldwide appreciation of his paintings have grown steadily. In 1975 he took part in the São Paulo Biennale in Brazil, and in 1980 he represented Germany at the Venice Biennale. In 1995 he was given his first major retrospective in the United States with his works being exhibited at galleries in New York, Washington, and Los Angeles. In 1997 a comprehensive survey of Baselitz's work was published in Italy. In 2004 he won the Praemium Imperiale award in Tokyo. In 2007 the Royal Academy of Arts in London held the popular exhibition *Georg Baselitz— A Retrospective*. Attempting to sum up what was special about the artist, Jill Lloyd of *Royal Academy Magazine* wrote, "Baselitz has an uncanny ability to portray startling, shocking, even ugly images in paintings of great tenderness and beauty." **HP**

> "The artist is not responsible to anyone. His social role is asocial."

ABOVE: Georg Baselitz photographed in 1999, during his heyday.

DANIEL BUREN

Born: Daniel Buren, March 25, 1938 (Boulogne-Billancourt, France).

Artistic style: Controversial conceptual artist who has used stripes to redefine space since 1965; works in situ creating site-specific installations and environments; won Gold Lion Award at 1986 Venice Biennale.

Daniel Buren believes that biographical details detract from the nature of his work. However, we do know that he was born in Boulogne-Billancourt, a suburb of Paris, in 1938 and that he graduated from the École Nationale Supérieure d'Arts et Métiers in Paris in 1960. His discovery, five years later, of a piece of striped awning cloth in a Paris textile market was a random yet fortuitous incident that enabled him to dispense with traditional ideas about painting. Since 1965 the stripe has become the sole motif in Buren's work. It removed the need for representation and became, for Buren, a mechanism through which to recognize, order, and experience reality and space. Rarely deviating from a width of 3.4 inches (8.7 cm), his minimal stripes are always white alternated with a color.

In early projects Buren employed guerrilla tactics to remove the artwork from the conventional setting of the art gallery. In 1968, for example, he pasted more than 200 green-and-white striped sheets on advertising hoardings across Paris; art was now integrated into the fabric of the city and interchangeable with everyday imagery. By removing the frame of the gallery, Buren was also seeking to question the institution's validity.

Buren has always worked in situ, refusing to have a studio, and his installations often respond directly to the environment in which they are situated. He has placed stripes on to an array of supports, from columns and placards to steps and escalators. In *Toile/Voile Voile/Toile (Canvas/Sail Sail/Canvas)* (1975), he arranged a sailing regatta in Wannsee, Berlin, with each boat displaying a striped sail, a work he has since repeated elsewhere. As Buren's works are site specific, they often exist for a limited period and can be experienced after the event by what he terms "photo-souvenirs." **LA**

Masterworks

Never the Same Twice (Jamais deux fois la même) 1968–2003 (Musée National d'Art Moderne, Centre Georges Pompidou, Paris, France)

Toile/Voile Voile/Toile (Canvas/Sail Sail/Canvas) 1975 (Collection M. et Mme. Selman Selvi, Geneva, Switzerland)

The Two Plateaux (Les deux plateaux) 1985–1986 (Palais Royal, Paris, France)

The Door (La portée) 2007 (Musée Fabre, Montpellier, France)

1930–39

"I reject art in general. Because it . . . leads you to think through somebody else."

ABOVE: Buren on the set of TV show "Ce Soir ou Jamais" in 2007.

BRICE MARDEN

Born: Brice Marden, October 15, 1938 (Bronxville, New York, U.S.).

Artistic style: Monochromatic paintings; distilled use of subdued color; textiles; emphasis on a painting's tactile qualities and the artist's hand; intuitive use of line; related series of works.

Masterworks

D'après la Marquise de la Solana 1969 (Solomon R. Guggenheim Museum, New York, U.S.)

Grove Group V 1973 (Museum of Contemporary Art, Chicago, Illinois, U.S.)

Red, Yellow, Blue Painting 1974 (Museum of Contemporary Arts, Los Angeles, California, U.S.)

Grove IV 1976 (Solomon R. Guggenheim Museum, New York, U.S.)

"You have to be able to bring all sorts of things together in your mind, your imagination."

ABOVE: Portrait of Brice Marden taken in 2007 in front of one of his artworks.

Beginning in 1964, when he created his first monochromatic painting, Brice Marden's career has explored the expressive potential of painting. Although stylistically Marden's paintings were initially aligned with the pared-down aesthetic and intellectual rigor of minimalism, the artist's overarching concerns, if not the means by which they were produced, remain distinct. Unlike minimalism's espousal of specific objects, Marden's own inquiry has worked toward the inclusion, rather than the exclusion, of meaning. Rather than explicitly describe a mood or feeling through recognizable imagery or motifs, his works' emotional resonance is achieved through a concentration on and distillation of the basic elements of painting: surface, scale, gesture, and color. These objectives are evident in works such as *Le Mien* (1972); its four oil-and-beeswax canvas panels function as a meditation upon what might be considered the essence of painting.

A decisive break in Marden's career came during the mid-1980s when the artist introduced a series of intuitive, organic lines into what had previously been monochromatic expanses of muted color. This calligraphic dimension—partly born out of the artist's visit to Thailand at this time—meant that the *Cold Mountain* (1988–1991) series of paintings appears closer in spirit to abstract expressionism and to the intricate tracery of lines that became a recognizable feature of Jackson Pollock's paintings for several years. In works that initially might be construed as mere formal exercises in the grammar and syntax of painting, on closer inspection they transcend their base materials by subtly alluding to and invoking a state of being and are indicative of Marden's contribution to the evolution of abstraction. **CS**

DAIDŌ MORIYAMA

Born: Daidō Moriyama, 1938 (Osaka, Japan).

Artistic style: Photographer; spontaneous and instinctive approach; gritty and blurred black and white books and prints of urban subject matter; themes of postwar industrialization.

Daidō Moriyama trained in photography in Osaka, the financial center of Osaka-Kobe-Kyoto and a thriving port and burgeoning metropolis at the mouth of the Yodo River. In his early twenties he took photos of Tokyo at the beginning of a period of intense and accelerated growth as Japan's foremost economic and industrial center. The attending social conditions both repelled and attracted him. Moriyama worked for the eminent experimental photographer and filmmaker Eikoh Hosoe before he went freelance in 1963. Hosoe, the work of artists Andy Warhol and William Klein, and the writing of Japanese novelist Yukio Mishima were the young photographer's main influences.

Masterworks

Stray Dog, Misawa 1971 (San Francisco Museum of Modern Art, San Francisco California, U.S.)

Shashinyo Sayônara (*Farewell Photography*) 1972 (Collection of photographs)

Karuido (*Hunter*) *Yokosuka* 1972

Hawaii 2007 (Exhibition at Taka Ishii Gallery, Tokyo, Japan)

Through Moriyama's photographs the city is fixed in a moment of transit—moving away from traditional prewar values in favor of more dynamic ideas attuned to its industrial hypercapitalism. Moriyama's black and white snapshots, taken with a 35mm handheld camera, capture the symptomatic nostalgia and emotions for an older Japan and its traditional way of life. At the same time, Moriyama bluntly relocates such classic sentiments to part of a bleaker and grittier present.

Moriyama's later output includes Polaroids and color photographs. Yet all his work suggests an objective and instinctive method of relating to the world, a method of mechanically fixing a series of encounters within an environment that is seemingly at odds with it. Moriyama's books and prints are indicative of a fast, grainy, and blurred approach to beauty. Their technical production harshly reproduces the urban surface while allowing it to become a poignant backdrop for the stripped-down lyricism and low-level intensity of the everyday life surrounding it. **EL**

"In the same way that people have them, towns have dreams and memories."

ABOVE: Moriyama's work gives familiar objects and landscapes a new perspective.

ROBERT SMITHSON

Born: Robert Smithson, January 2, 1938 (Passaic, New Jersey, U.S); died July 20, 1973 (Amarillo, Texas, U.S.)

Artistic style: Sculptural forms often executed on a monumental scale; use of natural materials and processes; work designed to be experienced physically.

Masterworks

Ithaca Mirror Trail, Ithaca, New York 1969 (Tate Collection, London, England)

Yucatan Mirror Displacements (1–9) 1969 (Guggenheim Museum, New York, U.S.)

Spiral Jetty April 1970 (Rozel Point, Great Salt Lake, Utah, U.S.)

Partially Buried Woodshed 1970 (A print of the land sculpture is at National Gallery of Art, Washington, D.C., U.S.)

Broken Circle Summer 1971 (Broken Circle Spiral Hill, Emmen, the Netherlands)

Amarillo Ramp 1973 (Tecovas Lake, Amarillo Texas, U.S.)

"A work of art ... in a gallery ... becomes ... disengaged from the outside world."

ABOVE: Robert Smithson photographed by Jack Robinson in 1969 (detail).

RIGHT: Once submerged, a drought has now brought *Spiral Jetty* back to the surface.

Robert Smithson was perhaps the most vocal spokesperson of the land art movement. Although he died tragically young, in an airplane crash when he was thirty-five years old, Smithson's influence was such that he is known as one of the artists responsible for moving artwork out of the space of a gallery and into the world at large.

In common with many of his peers, Smithson began his career by working as a painter. However, by the mid-1960s, he had shifted direction and now directed his energies toward becoming engaged with a more sculpturally bound form of artistic practice. The works he produced at this time were inflected with the vocabulary of minimalism. Like several other artists associated with land art, he was involved in making three-dimensional objects that were often serial in nature.

During the latter half of the 1960s, Smithson began to make and place artworks outside. These relatively small-scale works often featured mirrors, the reflections from which create an apparent displacement of space. From this point, Smithson's work became more ambitious, and toward the latter half of the 1960s he was responsible for a number of what became labeled "earthworks." The most famous of these is *Spiral Jetty* (1970), a 1,500-foot-long (457 m), 15-foot-wide (4.6 m) coil of black basalt rock, salt crystals, and mud branching out from Rozel Point to extend into Utah's Great Salt Lake. *Spiral Jetty* is meant to be walked upon, and experienced physically over a period of time, as much as it is to be simply viewed. Still extant today, the earthwork is fitting testimony to the scope of Smithson's ambitions and the unique contribution he made to what was, in the eyes of one critic, "sculpture in the expanded field." **CS**

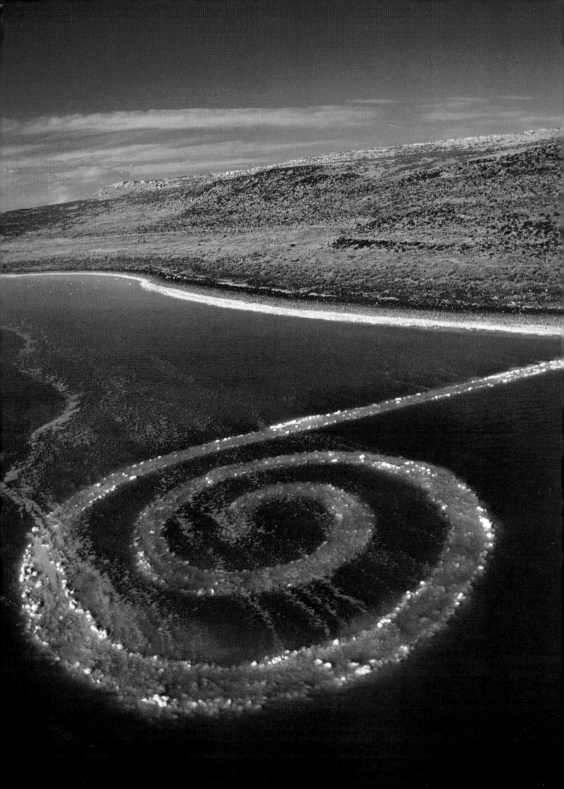

JUDY CHICAGO

Born: Judy Cohen, July 20, 1939 (Chicago, Illinois, U.S.)

Artistic style: Exploration of feminist issues; works in media such as needlework traditionally regarded as feminine but executed in an unexpected style; female genitalia as an artistic motif.

Masterworks

Menstruation Bathroom 1972

Through the Flower 1973 (Elizabeth A. Sackler Center for Feminist Art, Brooklyn Museum, New York, U.S.)

Female Rejection Drawing from the Rejection Quintet 1974 (San Francisco Museum of Modern Art, San Francisco, California, U.S.)

The Dinner Party 1974–1979 (Elizabeth A. Sackler Center for Feminist Art, Brooklyn Museum, New York)

Birth Project 1980–1985 (Various locations)

Powerplay 1983–1986

Holocaust Project 1985–1993

Judy Chicago is one of the most prominent figures in the development of feminist art. She studied painting and sculpture at the University of California, Los Angeles, then diversified her training by taking a course at an auto-body school to learn to spray paint, studying the art of boat building, and undergoing an apprenticeship with a pyrotechnic. Her early work, much of which was informed by her newly acquired techniques of working, was formal and minimalist in style and in keeping with that of her male contemporaries.

By the late 1960s, Chicago was increasingly interested in the feminist movement and wanted to explore her understanding of femininity and femaleness in her work. This resulted in the imagery for which she has become famous. Much of Chicago's feminist art is concerned with elevating and legitimizing traditionally feminine pursuits, such as needlework, and inserting female artists and a female point of view into what she considered to be a male-oriented history of art.

During the early 1970s, in addition to teaching her Feminist Art Program at two California universities, Chicago began to create works with floral imagery. She believes flowers are a symbol of femininity and the female core and that women are defined and united by their sexual organs. Her controversial work *The Dinner Party* (1979) is an homage to feminist history, celebrating traditional female activities. It includes place settings of symbolic ceramic plates for thirty-nine female guests of honor, including Georgia O'Keeffe. The mammoth work projected Chicago into the public eye. Since then she has continued to create art and promote her feminist and political concerns, but she is best known for the defining works she created in the 1970s. **WD**

"I wanted to aspire to … art that could clearly reveal my values and point of view as a woman."

ABOVE: Judy Chicago poses confidently for her portrait taken around 1975.

CAROLEE SCHNEEMANN

Born: Carolee Schneemann, October 12, 1939 (Fox Chase, Pennsylvania, U.S.).

Artistic style: Performance artist; engagement with cultural taboos and sexual politics through the media of film, installation, painting, performance, and video; the body and sexuality as subject matter.

Carolee Schneemann's importance in the world of feminist body art is incontestable. She is a painter, performance artist, writer, and filmmaker, and frequently combines different aspects of her practice in her work, which deals with body, sexuality, and gender. She is also a teacher and has influenced a new generation of artists.

Schneemann's painting during the 1950s is often compared to that of artist Robert Rauschenberg, who also became involved in performance with the Judson Dance Theater. Schneemann appeared as Édouard Manet's Olympia in sculptor Robert Morris's *Site* (1964), a contrast to her own performance work that began with *Meat Joy* (1964), a Dionysian rite involving semi-naked bodies, offal, chicken flesh, fish, and paint accompanied by Parisian street noise. Schneemann saw the need to document her performance in her film *More than Meat* (1979), which led to an interest in using film for its own sake. She has gone on to make her mark as an avant-garde filmmaker with films such as the erotic *Fuses* (1964–1967), *Plumb Line* (1971), and *Vesper's Stampede to My Holy Mouth* (1992).

Arguably her most important work is *Interior Scroll* (1975), which was first performed on Long Island. Its importance lies in the drawing together of the body and text. A response to criticism from a male structuralist was the withdrawal of text from her vagina while posing in the academic tradition of life drawing; the work has given rise to many interpretations. Schneemann has published several books, including *Cézanne, She Was a Great Painter* (1974) and has exhibited widely at venues, including the Los Angeles Museum of Contemporary Art, New York's Museum of Modern Art, and Paris's Centre Georges Pompidou. **WO**

Masterworks

Meat Joy 1964
Interior Scroll 1975
Mortal Coils 1994
Vulva's Morphia 1995

Books

Cézanne, She Was a Great Painter 1974
Vulva's Morphia 1997

1930–39

"[I use] the naked body … to eroticize my guilt-ridden culture."

ABOVE: Detail of a photograph taken of Schneemann by Christopher Felver.

RICHARD SERRA

Born: Richard Serra, November 2, 1939 (San Francisco, California, U.S.).

Artistic style: Sculptor; material- and process-based practice; precarious balanced lead sculptures; physically daunting balanced sheets of rolled steel that dominate participatory viewers.

Masterworks

Belts 1966–1967 (Solomon R. Guggenheim Museum, New York, U.S.)

Hand Catching Lead 1968 (Centre Georges Pompidou, Paris, France)

House of Cards (*One Ton Prop*) 1969 (Museum of Modern Art, New York, U.S.)

Inverted House of Cards 1969 (Los Angeles County Museum of Art, Los Angeles, California, U.S.)

Circuit II 1972–1986 (Museum of Modern Art, New York, U.S.)

Tilted Arc 1981 (Destroyed)

Fulcrum 1987 (Liverpool Street Station, London, England)

Torqued Ellipses 1996–2000 (DIA Art Foundation, Beacon, New York, U.S.)

The Matter of Time, 2005 (Solomon R. Guggenheim Museum, New York, U.S.)

The son of a shipyard pipe fitter, Richard Serra arrived in New York in 1966, having studied with abstract painter Josef Albers and spending two years traveling in Europe. He came into contact with sculptors Donald Judd and Robert Smithson and avant-garde choreographer Yvonne Rainer, who would greatly influence him. Alongside his peers Bruce Nauman and Eva Hesse, Serra forged a kind of minimalism that grew out of tangible physical experience, focusing on effort rather than intention. His work was centered on the specific nature of its materials and site. In the late 1960s, Serra compiled a now-famous list of verbs denoting actions that could be undertaken in relation to sculpture. It formed the basis of an ongoing experiment with unprecedented sculptural processes, resulting in works such as *Splashing* (1968), made by hurling molten lead against the wall, and the film *Hand Catching Lead* (1968), based on the verb "to grasp."

Serra explored his materials in terms of their mass, position in space, and relation to the viewer. In his propped lead pieces, he precariously balanced hefty lead sheets and cubes, leaving them secured by only gravity. In the 1970s, he began using rolled steel to construct immense public works that dominate those who walk into, and through, them. The real possibility of collapse heightens viewers' active engagement with the works through their own potential vulnerability. The highly charged participatory nature of such works led to controversy—such as the legal battle that surrounded the forced removal of Serra's striking New York Federal Plaza commission *Tilted Arc* (1981) in 1989. Nevertheless, the ways in which his works can still both impress and unsettle make them extremely popular and influential. **LB**

> "[We can] become something different from what we are, by constructing spaces."

ABOVE: Serra speaking at his exhibition
Richard Serra Sculpture: Forty Years in 2007.

BRETT WHITELEY

Born: Brett Whiteley, April 7, 1939 (Sydney, New South Wales, Australia); died June 15, 1992 (Thirroul, New South Wales, Australia).

Artistic style: Painter, sculptor, draftsman, and printmaker; views of Sydney; abstract semisurreal landscapes; curving lines; themes of protest and drug use.

Brett Whiteley received considerable praise for his youthful debut in the Whitechapel Gallery; his reputation established after the Tate Gallery purchased his *Untitled Red Painting* (1960). The sensuality of color, the erotic underpinnings, and the flowing contours of obliquely human shapes in Whiteley's early works revealed the distinct style that would come to define the artist's oeuvre. Returning to Australia in 1969, he produced one of his best-known works, *Alchemy* (1972–1973), a self-portrait on a gigantic scale; it summarized Whiteley's state of mind, with its myriad accumulation of influences in his own history as an artist. He died of a heroin overdose, ending one of the most prodigious careers in Australian art history. **TC**

Masterworks

Untitled Red Painting 1960 (Tate Collection, London, England)

Alchemy 1972–1973 (Art Gallery of New South Wales, Sydney, Australia)

Self-Portrait in the Studio 1976 (Art Gallery of New South Wales, Sydney, Australia)

Art, Life and the Other Thing (*Triptych*) 1978 (Art Gallery of New South Wales, Sydney, Australia)

NANCY GRAVES

Born: Nancy Stevenson Graves, 1939 (Pittsfield, Massachusetts, U.S.); died 1995 (New York, U.S.).

Artistic style: Sculptor, painter, printmaker, installation artist, and filmmaker; themes of anatomy, paleontology, and anthropology; maps, camels, and fossils.

Nancy Graves's childhood visits to the natural history section of the Berkshire Museum in Pittsfield, Massachusetts, gave her an interest in anatomy, paleontology, and anthropology and informed her later work, such as her realistic, life-size camels including *Camel VI* (1968–1969). She studied at the Yale University School of Art, after which she combined her interest in natural history with an abstract sense of line and form with works such as her film *Izy Boukir* (1971), made in Morocco following a group of camels. She continued this interplay of the abstract and the natural with paintings, prints, and drawings of maps of the weather, the ocean floor, and Antarctica, as well as geologic maps of the lunar surface. **CK**

Masterworks

Camel VI 1968–69 (National Gallery of Canada, Ottawa, Canada)

Pleistocene Skeleton 1970 (Smithsonian American Art Museum, Washington, D.C., U.S.)

Goulimine 1970 (Film)

Izy Boukir 1971 (Film)

1930–39

VITO ACCONCI

Born: Vito Hannibal Acconci, January 24, 1940 (Bronx, New York, U.S.).

Artistic style: Abstract poetry; performance and video works exploring issues of control, consent, and endurance; video and architectural installations; public architectural works.

Masterworks

Trademarks 1970 (San Francisco Museum of Modern Art, San Francisco, California, U.S.)

Conversions 1971 (Museum of Contemporary Art, Barcelona, Spain)

Pryings 1971 (Museum of Contemporary Art, Barcelona, Spain)

Remote Control 1971 (Museum of Contemporary Art, Barcelona, Spain)

Command Performance 1974 (San Francisco Museum of Modern Art, San Francisco, California, U.S.)

Under-History Lessons 1976 (Museum of Contemporary Art, Los Angeles, California, U.S.)

Bug House 1986 (Long Island, New York, U.S.)

Dirt Wall, 1992 (Arvada Center Sculpture Garden, Arvada, Colorado, U.S.)

Mur Island (Cafe and Playground) 2003–2004 (River Mur, Graz, Austria)

Vito Acconci's early career was spent as a fiction writer in New York and at the Iowa Writers' Workshop. He has cited an encounter with a painting by Jasper Johns as pivotal, inspiring him to write abstract "language pieces." After the transition to visual art in the late 1960s, language would remain central to his work. Echoes of his father's punning word games during his childhood in the Bronx, of the oppressive vocabulary of his very brief stint in the Marine Platoon Leaders Corps, and of his rigorous Roman Catholic education resound through his work of the late 1960s and 1970s. Issues of consent and personal space also inform much of his work: in one of his first performance works, *Following Piece* (1969), he documented the act of trailing strangers through the streets, following them until they entered a private building.

A key figure in the development of the body art movement, Acconci often placed his own body under duress, exploring and challenging his own physical capabilities by carrying out timed physical tasks according to fluxus-like sets of instructions, such as in the work *Step Piece* (1970). His identity as an Italian-American man has formed the basis of many of his explorations

ABOVE: Acconci photographed in the cut-out doorway of a dog kennel in 1984.

RIGHT: *Bug House*, in Long Island, New York, is one of Acconci's public space works.

of his own sexual and masculine identity in works such as *Conversions* (1971), *Trademarks* (1970), and *Seedbed* (1971). In his video works of the early 1970s, Acconci explored the complex dynamics of physical and psychological domination and submission, ideas reinforced by reading the work of sociologist Erving Goffman.

Acconci began to utilize his extremely distinct voice to enact scenarios that affect and manipulate his viewers as well as reflect his own states of guilt, aggression, accusation, and seduction. Later installations combining recordings of his voice with architectural structures and sculptural objects challenged the way people engage with their environment. In 1988, he formed the Acconci Studio with a group of architects in order to design highly innovative public buildings and landscapes, along with more experimental designs such as the *Mobile Linear City* (1991) and *Personal Island* (1992). **LB**

ABOVE: Vito Acconci's iconic *Mur Island* in the center of Graz, Austria.

Breathless Voice

Acconci hid himself in the cramped space underneath an artificial floor for the duration of his exhibition *Seedbed* in New York. Visitors entered what appeared to be an empty gallery but heard the artist's breathless voice elaborating sexual fantasies about them. Between the hours of 10 A.M. and 6 P.M., three days a week for three weeks, Acconci spoke to the unseen visitors, masturbating in response to their footsteps—quite a feat of endurance! It also took imagination. Acconci recalled, "I remember bringing some pornlike magazines down, but then realizing, I can't see a thing here, who am I kidding?"

1940–49

NOBUYOSHI ARAKI

Born: Nobuyoshi Araki, 1940 (Tokyo, Japan).

Artistic style: Photographer; taboo subjects such as sex, nudity, bondage, and death; erotic images of women and flowers; poetic scenes of Tokyo; part of contemporry Japanese love of fixing everything on film.

Masterworks

Sentimental Journey 1971 (Book)

Tokyo Autumn 1972 (Museum of Contemporary Art, Tokyo, Japan)

Erotic Women in Color 1998 (Museum of Contemporary Art, Tokyo, Japan)

The Eros of Married Women 1998–1999 (Museum of Contemporary Art, Tokyo, Japan)

Vaginal Flowers 1999 (Museum of Contemporary Art, Tokyo, Japan)

Arakimentari 2005 (Film)

"I only tie up a woman's body because I know I cannot tie up her heart."

ABOVE: Araki in a jovial mood during a press conference in Japan in 2003.

Japanese photographer Nobuyoshi Araki is most famous for his erotic images of women, sometimes seminaked, tied up in ropes and hanging from a ceiling, revealing genitalia and masturbating, or seductively wrapped in silk kimonos. His work has sometimes been labeled pornographic and misogynistic in its attempt to document social taboos regarding sex, nudity, bondage, and death. Such content has brought him into conflict with authority: in 1988 police ordered the magazine *Shashin Jidai* to be removed from sale because it contained Araki's photographs; in 1992 obscenity charges were leveled against him during an exhibition; and in 1993 a gallery curator was arrested for showing Araki's nude photographs.

Yet Nobuyoshi Araki's depiction of graphic nudity follows in the Japanese tradition of erotic art of *shunga* of the Edo period (1603–1867). He has updated the genre to fit today's culture of the glossy print, influenced by his own early spell working in a leading Japanese advertising agency after he finished studying photography and printmaking at Chiba University.

Erotica is also only part of his oeuvre. Famously declaring, "I am a camera," Nobuyoshi Araki photographs almost everything, from cats to flowers, to his wife, essayist Yōko Araki, dying of cancer. He has published his images in more than 350 books, including *Sentimental Journey* (1971), which contains pictures of his wife on their honeymoon. Araki's ability to photograph his surroundings has also seen him build a rich body of work that reveals tender portraits of Tokyo and its inhabitants undergoing the slow process of westernization post World War II. Provocative, transgressive, and controversial, Akira holds a mirror up to everyday life to tell its many stories. **CK**

DON BINNEY

Born: Donald Binney, March 24, 1940 (Auckland, New Zealand).

Artistic style: Painter of New Zealand coastal beaches and wildlife, notably birds; strong light; hard-edged realism; graphically depicted topographical imagery; ecological and postcolonial concerns.

Don Binney's work has been greatly influenced by his passion for the landscape of his native New Zealand, its flora and fauna, particularly the rugged beaches of Auckland's west coast and the many native birds that inhabit the coastline. A keen ornithologist from an early age, Binney has promoted the conservation of wildlife habitats and natural environments throughout his career, and is known to have dedicated part of the proceeds of the sale of his works to such causes. His art touches on issues of postcolonialism and Maori sovereignty, but is best known for its depiction of native birds of contrasting colors and exquisite feathers—such as the tui, pipiwharauroa, and kereru—hovering above or traversing the landscape.

Born in the Auckland suburb of Parnell, Binney grew up surrounded by stunning colonial houses, lush vegetation, and nearby beaches, all of which engendered in him an acute sense of place. His paintings bear the stamp of the strong light of the South Pacific. Their cool, luminous blues and greens convey a sense of openness, tranquillity, and a subtle illusion of movement against stylized natural forms depicted in modernist, hard-edged outline. In later years, he explored the image of the land in other countries—the United Kingdom, Hawaii, and Mexico. During these visits, and in keeping with the spiritual themes inherent to his work, he researched local places of ritual and healing, such as holy wells, sacred trees, and sites where chalk figures were inscribed into the landscape.

Binney was a dedicated teacher at Elam School of Fine Arts in Auckland for twenty-four years before retiring in 1998 and received the Order of the British Empire in 1995 for his services to the arts. He is also known for his drawings, photography, and various writings. **NG**

Masterworks

Colonial Garden Bird 1965 (Museum of New Zealand Te Papa Tongarewa, Wellington, New Zealand)

Sun Shall Not Burn Thee by Day Nor Moon by Night 1966 (Auckland Art Gallery Toi O Tāmaki, Auckland, New Zealand)

Tabernacle 1966 (Victoria University of Wellington, Wellington, New Zealand)

Kawaupaku, Te Henga 1967 (University of Auckland, Auckland, New Zealand)

Pacific Frigate Bird 1968 (Museum of New Zealand Te Papa Tongarewa, Wellington, New Zealand)

Puketotara, Twice Shy 1976 (Museum of New Zealand Te Papa Tongarewa, Welllington, New Zealand)

> "The most important thing is your dialogue with the place."

ABOVE: This photograph of Don Binney was taken by Kirsten Rødsgaard-Mathiesen.

1940–49

CHUCK CLOSE

Born: Charles Thomas Close, 1940 (Monroe, Washington, U.S.).

Artistic style: Intensely realistic, massive hyperrealist portraits, mainly of friends, and shown frontally as in passport photos; uses a complex grid system to reproduce a photograph on canvas, each piece of the grid itself a tiny painting.

Masterworks

Self-Portrait White on Black 1978 (Fine Arts Museum of San Francisco, Califorinia, U.S.)

Large Mark Pastel 1978 (Museum of Modern Art, New York, U.S.)

Cindy 1988 (Museum of Contemporary Art, Chicago, Illinois, U.S.)

Kiki 1993 (Walker Art Centre Minneapolis Sculpture Garden, Minneapolis, Minnesota, U.S.)

Chuck Close is one of the most influential artists of his generation. He graduated with a BFA from the University of Washington, Seattle in 1962, and then went on to complete an MFA at Yale where he worked as assistant to Master Printer Gabor Peterdi. After graduating, Close won a Fulbright grant which took him to the Akademie der Bildenen Kunste in Vienna. In 1967 he moved to New York, where in 1970 he had his first one-man show.

In the 1970s he was an early explorer of photo-realism. In the 1980s and 1990s as a cutting edge artist he celebrated the apparently hopelessly unfashionable subject of portraiture; working with photos on massive canvases, producing portraits, mainly of friends, the subject looking directly out, arrestingly. Today, as the inventor of a sophisticated hand-made system for translating photographic images into paint, he sits at the top of his game. His generation and fellow travelers are Brice Marden, Richard Serra, Martin Puryear and Philip Glass.

At present Close uses two studios, one in Manhattan and another at the East End of Long Island: a flat sandy strip, once covered by potato fields, where over the last 150 years many of the more successful city artists have drifted in search of space, light, and fresh air. He tends to work mostly in black and white in his Manhattan studio, and in color at the beach. Because of his generosity both as a painter and supporter of emergent artists, Close has become an artist much loved and respected by other artists.

"We were all nurtured by the same environment ... the same primordial ooze ..."

ABOVE: The face of Chuck Close has become easily recognizable through his own works.

RIGHT: Chuck Close sits in front of one of his paintings, a portrait of the artist Eric Fischl.

In 1998 Close was elected a Fellow of The American Academy of Arts and Sciences, then in 2000 was awarded both the Independent Curators International Leo Award and the National Medal of Arts. **SF**

DALE CHIHULY

Born: Dale Patrick Chihuly, September 20, 1941 (Tacoma, Washington, U.S.).

Artistic style: Organic, sensuous glass sculptures; multipart architectural sculptures; vibrant, celebratory colors; glass pieces reminiscent of plant or sea life forms; glasswork installations in nature.

Masterworks

Royal Blue Mint Chandelier 1998 (Mint Museum, Charlotte, North Carolina, U.S.)

Kalamazoo Ruby Light Chandelier 1998 (Kalamazoo Institute of Arts, Kalamazoo, Michigan, U.S.)

Rotunda Chandelier 1999 (Victoria & Albert Museum, London, England)

Polished Ivory Seaform Set with Charcoal Lip Wraps 2000 (National Gallery of Australia, Canberra, Australia)

Fern Green Tower 2000 (Corning Museum of Glass, Corning, New York, U.S.)

Glowing Gemstone Polyvitro Chandelier 2000–2003 (Joslyn Art Museum, Omaha, U.S.)

Sunset Boat 2006

1940–49

"I call myself an artist for lack of a better word There's no one name that fits me."

ABOVE: This photograph of Chihuly was taken in Jerusalem in 1999.

Originally a student of interior design and architecture, Dale Chihuly became captivated by glass blowing in the mid-1960s. He gained a Fulbright Fellowship in 1968, and became the first American artist to work in the Venini Fabrica on the island of Murano in Venice. He developed a collaborative approach to the creation of abstract glass works, challenging the stereotype of a solitary creative process. Also a teacher for many years, establishing an important glass department at the Rhode Island School of Design (RISD), he is largely responsible for the recognition of hand glass-making as a fine art.

Chihuly has produced many unique pieces in a dazzling variety of shapes and sizes throughout his career, but is probably best known for his multipart glass sculptures, such as *Towers* and *Chandeliers*. These massive architectural creations are composed of dozens of individual multicolored pieces assembled into striking, otherworldly forms.

Despite its seemingly abstract nature, his work is strongly autobiographical; his fascination with flower forms was fostered as a youth in his mother's garden. Series such as *Seaforms*, *Niijima Floats*, and *Boats* hark back to his childhood in Tacoma, and are characterized by his love of the sea.

Working with artists from all media, Chihuly continues to experiment with different materials and methods; he was already using neon, argon, and blown glass forms to create organic, plantlike imagery in the 1960s. He has also shown a recurring interest in ephemeral outdoor installations, most recently creating installations that are gardens themselves. A key pivotal figure in the early American studio glass movement, his work now figures in more than 200 museum collections across the globe. **NSF**

MICHAEL CRAIG-MARTIN

Born: Michael Craig-Martin, August 28, 1941 (Dublin, Ireland).

Artistic style: Installation artist and painter; detached conceptualism, minimal construction by artist and use of ready-made technique inspired by Marcel Duchamp.

Installation artist and painter Michael Craig-Martin is noted for his influence over the Young British Artists during the 1980s and 1990s. Born in Ireland, Craig-Martin both grew up and was educated in the United States. He moved to Britain in 1966 after completing a degree in fine art at Yale University, where he became one of the key figures in the first generation of British conceptual artists. He became particularly instrumental in the London student art show Freeze (1988).

His early work often makes reference to U.S. artists such as Jasper Johns and Donald Judd. His minimalist influence is primarily identifiable in his use of found objects (often ordinary household appliances) within his sculptures. In his later paintings, he evokes questions of representation and reality in art. By dealing with everyday objects drawn against a vivid color, he creates an intense relationship between image, line, word, and color.

Craig-Martin's work has been displayed in many solo and group exhibitions, and perhaps most importantly as part of *The New Art* (1972) at London's Hayward Gallery, a significant exhibition of conceptual art. As senior tutor at London's Goldsmiths College, he taught Damien Hirst, Sarah Lucas, Gary Hume, Mat Collishaw, and Tracey Emin.

Craig-Martin's most famous work is *An Oak Tree* (1973), which uses semiotics to explain why a conventional glass of water placed on a high shelf is in fact an oak tree. It demonstrates the supremacy of the artist's intention over the object itself and proved to be a great turning point in conceptual art. Ironically, when transporting the exhibit to Australia (due to the strict laws on allowing foliage into the country), he had to dismantle his concept and describe the artwork in its original form. **KO**

Masterworks

An Oak Tree 1973 (Private collection)

Deconstructing Seurat (Edition of 40) 2004

Scissors (*Wallpaper-Aqua*) 2004
 (Gagosian Gallery collection)

Untitled (*Glasses and Trainer*) 2004
 (Gagosian Gallery collection)

Untitled Painting #4 2005
 (Gagosian Gallery collection)

"I can make the image five stories high I can make it green, purple, upside down."

ABOVE: Michael Craig-Martin photographed at a restaurant in 2007.

BRUCE NAUMAN

Born: Bruce Nauman, December 6, 1941 (Fort Wayne, Indiana, U.S.).

Artistic style: Sculptor, performance artist, and photographer; use of neon, audio, fiberglass, and video; incorporation of text; themes of language, isolation, and communication.

Masterworks

The True Artist Helps the World by Revealing Mystic Truths 1967 (National Gallery of Australia, Canberra, Australia)

Life, Death, Love, Hate, Pleasure, Pain 1983 (Museum of Contemporary Art, Chicago, Illinois, U.S.)

Clown Torture 1987 (Art Institute of Chicago, Chicago, Illinois, U.S.)

Anthro/Socio (Rinde Spinning) 1992 (Hamburger Kunsthalle, Hamburg, Germany)

Untitled (Hand Circle) 1996 (National Galleries of Scotland, Edinburgh, Scotland)

Raw Materials 2004 (Audio installation)

Since the early 1970s, Bruce Nauman has been recognized as one of the most innovative of U.S. contemporary artists. He initially worked as an assistant to Wayne Thiebaud and in 1964 Nauman began experimenting with sculpture, performance art, and film. His oeuvre also includes holograms, neon wall reliefs, interactive environments, photographs, prints, and video.

Nauman's conceptual work stresses meaning over aesthetics and provokes viewers' participation. He often uses irony and wordplay to raise issues about existence and isolation. Since the mid-1980s, primarily using sculpture and video, Nauman has developed disturbing psychological and physical themes using imagery based on animal and human body parts. He has also received many honors, including an honorary doctorate of fine arts from the San Francisco Art Institute in 1989 and the Max Beckmann Prize in 1990. Nauman has cited John Cage, Samuel Beckett, Ludwig Wittgenstein, Philip Glass, La Monte Young, and Meredith Monk as major influences on his work.

Fascinated by language and communication in general, Nauman often expresses interaction and transmission of ideas in a seemingly lighthearted manner. There are, however,

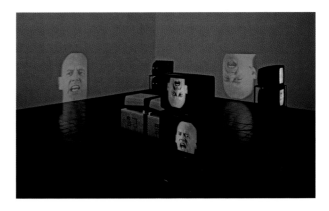

ABOVE: Nauman photographed in front of *The Battle of Worringen* in Dusseldorf in 2006.

RIGHT: *Anthro/Socio (Rinde Spinning)* (1992) explores our relationship with language.

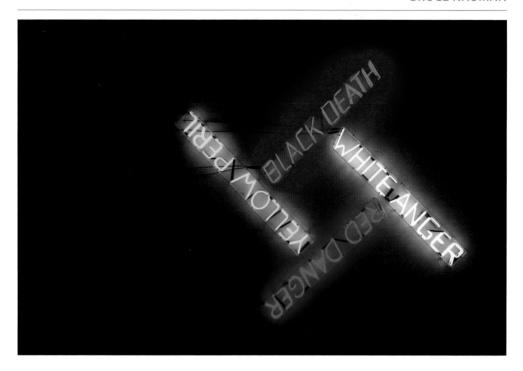

serious concerns at the core of his work as he examines how people coexist and communicate with each other, the inherent problems of language, and the role of the artist as communicator and manipulator of visual language. He concentrates less on style and more on the way in which a process or an activity can transform or become a work of art.

His work demonstrates a broad spectrum of methods and materials. For instance, text on an early neon work announces, "The true artist helps the world by revealing mystic truths." Initially hung in a shop window, the sign proclaimed a private thought to the public using a familiar means of communication. Nauman said, "The most difficult thing about the whole piece for me was the statement. It was a kind of test—like when you say something out loud to see if you believe it It depends on how you interpret it and how seriously you take yourself." Since the 1980s, he has lived in New Mexico. **SH**

ABOVE: *White Anger, Red Danger, Yellow Peril, Black Death* comprises neon slogans.

The Sound of Voices

Nauman created *Raw Materials* (2004) at the Tate Modern in London. He selected twenty-two texts from existing works to create an aural collage in the huge space of the Turbine Hall. Removed from their original context, the individual voices became muddled and meaningless. The exhibition also focused on Nauman's fascination with space and how it alters behavior and self-awareness. The gallery was filled with voices, some audible, some indistinct, that merged with sounds from visitors. Nauman transformed a vast space into a metaphor for the world, echoing to the endless sound of voices.

1940–49

SIGMAR POLKE

Born: Sigmar Polke, February 13, 1941 (Oleśnica, Poland).

Artistic style: Experimental painter and photographer; uses advertising imagery to parody consumer culture; paints on mass-produced, patterned fabrics; paints with unusual, sometimes toxic, materials.

Masterworks

Bunnies 1966 (Hirshhorn Museum and Sculpture Garden, Washington, DC., U.S.)

Untitled 1975 (Metropolitan Museum of Art, New York, U.S.)

o.T. 1981 (Kunstmuseum, Bonn, Germany)

Watchtower 1984 (Museum of Modern Art, New York, U.S.)

Untitled 1988 (Museum of Fine Arts, Boston, Massachusetts, U.S.)

Untitled 1989 (Museum of Fine Arts, Boston, Massachusetts, U.S.)

Ginkgo 1989 (Philadelphia Museum of Art, Philadelphia, Pennsylvania, U.S.)

The Hunt for the Taliban and Al Qaeda 2002 (Private collection)

Escaping the communist regime in what was then East Germany, Sigmar Polke's family moved to Düsseldorf in 1953. The young Polke worked as an apprentice at the Kaiserswerth stained-glass factory before enrolling in art studies at the Staatliche Kunstakademie in 1961. Studying under Karl Otto Goetz and Gerhard Hoehme, Polke became interested in working photographs and collage techniques into his paintings.

Collaborating with fellow students Gerhard Richter and Konrad Fischer, Polke organized the *Capitalist Realism* (1963) exhibition. Playing on socialist realism, the exhibition gave way to a painting movement that used the pictorial shorthand of advertising to parody the consumer-driven art of western capitalism. Polke painted banal, everyday objects such as matchsticks, chocolate bars, sausages, and biscuits and layered them with images from contemporary print media. This early work had strong connections with U.S. pop art, particularly in

ABOVE: Sigmar Polke relaxes for the camera in this portrait taken in 1989.

RIGHT: *Watch Tower in the Eifel* (1972) is part of Polke's *Hochsitze* series of paintings.

Polke's choice of subject matter and his adaptation of commercial printing techniques to the medium of painting. Polke also experimented with the raster dot, a key unit of the printing process, to create abstract patterns and add layers. He explored alternative grounds for painting, using mass-produced fabrics in place of canvas. Incorporating some textiles into his work, he wove figural and abstract forms through kitsch designs and lurid colors.

Polke took up photography in the 1960s and experimented with chemicals and different printing techniques. He captured haunting still lifes and miscellaneous items arranged into mysterious scenes. He produced mutated compositions that mixed negative and positive images, were underexposed or overexposed, and were constructed from multiple exposures.

Polke returned to painting in the 1980s, using experimental materials such as arsenic, meteor dust, beeswax, lavender oil, and gold leaf. These were mixed with solvents, varnishes, and resins to produce fascinating reactions on canvas. Polke's early work with stained glass is evident in these iridescent, almost transparent pictures. More recently, the artist has developed his "machine paintings" and has investigated how light alters the texture and colors of his painted canvases. **NSF**

ABOVE: *Paganini* (1982) is infested with half-hidden images of swastikas.

The Machine Paintings

Usually Polke chooses to re-create mechanical processes on his canvases by hand—his frequent representations of raster dots, for example, are achieved manually with a pencil's rubber eraser. In 2002, however, he turned to the computer to produce his "machine paintings." After using software to color and manipulate images selected from popular mass media, Polke photographically transfers the altered pictures to large fabric sheets and hangs them like sails. This new approach highlights Polke's continuing interest in the medium and his revolutionary role in the history of modern art.

1940–49

RICHARD TUTTLE

Born: Richard Dean Tuttle, July 12, 1941 (Rahway, New Jersey, U.S.).

Artistic style: Small-scale, lyrical objects; wall-mounted constructions, often placed at contrasting heights; objects made using a diversity of materials configured in contrasting ways.

Masterworks

Drift III 1965 (Whitney Museum of American Art, New York, U.S.)

Monkey's Recovery for a Darkened Room (Bluebird) 1983 (National Gallery of Art, Washington, D.C., U.S.)

Sand Tree 1988 (Museum of Contemporary Art, Los Angeles, California, U.S.)

Dawn, Noon, Dusk: Paper (1), Paper (2), Paper (3) 2001–2003 (Museum of Modern Art, New York, U.S.)

20 Pearls (7) 2003 (Museum of Contemporary Art, Los Angeles, California, U.S.)

Like the paintings of the minimalist artist Agnes Martin, the works of postminimalist Richard Tuttle are characterized both by a delicate materiality and a highly nuanced use of form, light, and texture. Having studied at Trinity College, Hartford, Connecticut, and then at Cooper Union in New York, Tuttle telephoned Martin—after seeing her work in a gallery—to ask if they could meet. Martin was to become both a close friend and an inspiration to Tuttle, and it was through her that he became an assistant at the Betty Parsons Gallery in 1963. A year later, the gallery staged his first show.

Tuttle's first works were painted reliefs. He initially adopted the formal economy of minimalism—though not at the cost of expression because the works he produced during this period were meaningful in the oblique, lyrical manner by which they attempted to assert their material presence. He has consistently sought to explore the inherent qualities of a specific material or configuration of materials in relation to their interaction both with the space they inhabit and the viewer who tentatively develops a relationship with them.

As well as working within the framework of reliefs and three-dimensional structures, Tuttle has explored the possibilities of printmaking, publishing a book of his woodcuts in the mid-1960s. The strength of Tuttle's practice lies in its continual ability to confound expectation and defy easy categorization. A piece such as *Drift III* (1965) carries certain painterly and sculptural attributes but also attempts to establish some form of autonomy outside those two disciplines. In the course of a career that has spanned more than forty years, Tuttle's work continues to explore and engage with questions fundamental to the object itself. **CS**

"He appreciates simplicity. You can see it in his work. Simplicity is never simple."—Agnes Martin

ABOVE: Richard Tuttle photographed at San Francisco Museum of Modern Art in 2005.

JAMES TURRELL

Born: James Turrell, 1943 (Los Angeles, California, U.S.).

Artistic style: Sculptor; installation artist; explorations of light and space; light-based installations that focus their effects on the phenomenology and physiology of perception.

Like many artists, James Turrell has explored rendering the effects of light and how this may be achieved through his work. There is, however, a fundamental difference between Turrell's installations and, for example, Piero's *The Baptism of Christ* (1450) or Giacomo Balla's *Street Light* (*c*.1910–1911). Whereas these artists sought to represent light through the medium of painting, Turrell's medium *is* light. His installations are intended to evoke a sense of contemplation in the viewer, if not revelation.

Turrell's first light piece was entitled *Afrum-Proto* (1966). After his first solo exhibition at the Pasadena Art Museum in 1967, Turrell decided to participate in the Los Angeles County Museum's art and technology program, where he worked alongside artist Robert Irwin and psychologist Edward Wortz. As a result of undertaking research into the physiology of light, Turrell created a series entitled the *Mendota Stoppages* (1969–1974), which allowed passages of light to enter his studio intermittently.

In many respects, Turrell's experiments with both physical and phenomenological perception during this period established the aesthetic framework within which he makes his installations today. Perhaps Turrell's most ambitious work so far has been his Roden Crater project, on which he began his research in 1974. It entails carving a series of tunnels into and through an extinct volcano in the Arizona desert. Turrell's intention is for the viewer to experience light as a palpable, material presence. The desire to complete such an ambitious project is perhaps fitting testimony to the artist's conviction of bringing the magical, otherworldly effects of light to the viewer. **CS**

Masterworks

Afrum I 1967 (Solomon R. Guggenheim Museum, New York, U.S.)

Acton 1976 (Indianapolis Museum of Art, Indianapolis, U.S.)

Danaë 1983 (Mattress Factory, Pittsburgh, Pennsylvania, U.S.)

A Frontal Passage 1994 (Museum of Modern Art, New York, U.S.)

1940–49

"Seeing is a very sensuous act—there's a sweet deliciousness to [it]."

ABOVE: Sculptor James Turrell photographed in 1999 by Christopher Felzer.

KRZYSZTOF WODICZKO

Born: Krzysztof Wodiczko, 1943 (Warsaw, Poland).

Artistic style: Maker of large-scale outdoor projections on architectural facades and monuments; series of nomadic instruments for homeless and immigrant operators; socially conscious; political themes.

Masterworks

Hirshhorn Museum, Washington, D.C. 1988
 (Hirshhorn Museum and Sculpture Garden, Washington, D.C., U.S.)

Homeless Vehicle 1988

A-Bomb Dome Projection 1999
 (Hiroshima, Japan)

Dis-Armor 1999–2001

Projection onto the facade of El Centro Cultural, Tijuana, Mexico 2001

Krzysztof Wodiczko graduated in 1968 from the Academy of Fine Arts in Warsaw, where emphasis was placed on architecture, industrial design, and the visual arts. In 1977 he moved to Canada and in 1983 to the United States. His work challenges the silent monumentality of buildings and seeks to activate it in different ways, for example exposing issues of democracy and human rights while characterizing the violence and inhumanity of urban existence and social interaction.

Wodiczko's early public interventions were slide projections onto buildings. They developed into more powerful and bigger projections placed onto the back of trucks or scaffolds, which allowed the transposition of politically charged motifs at night onto public monuments worldwide, such as his 1985 installation where he projected an image of a swastika onto the South African embassy as a protest against apartheid.

In 1996 he began using sound and motion and collaborating with the communities who lived in proximity to the public sites he used. By projecting images of members of the community—hands, faces, or entire bodies—onto architectural facades and combining them with spoken testimonies, Wodiczko succeeded in disrupting traditional definitions of public space and offering a degree of enfranchisement to those left behind by it. Later work has included fabricating "instruments" to communicate urban survival, designed for homeless and immigrant peoples. Such devices are envisioned as a prosthetic armor allowing the wearer to become symbolically empowered, extending certain physical abilities through technology, and so express problems of economic hardship, emotional trauma, and psychological distress that remain under shadow of a city. **EL**

"Democracy is one of the most challenging, if problematic, opportunities."

ABOVE: Wodiczko is best known for his large-scale outdoor projections.

GILBERT & GEORGE

Born: Gilbert Proesch, 1943 (San Martino, Italy); George Passmore, 1942 (Plymouth, Devon, England).

Artistic style: Self-portraits documenting everyday life; sexual imagery; brightly colored photographic composite works; cityscapes; images of urban decay.

Gilbert Proesch and George Passmore's partnership began in 1967 while they were studying at Central St. Martin's School of Art in London. Part of a generation of young conceptual artists, they criticized much of contemporary art as boring and inaccessible, setting out to produce art that was open to a nonspecialist audience, based upon familiar things and places. Disillusioned with the production of sculptures confined to a studio, they declared themselves "living sculpture," capable of venturing out into the streets. They presented themselves as *The Singing Sculpture* (1970). Posing on a table, their faces painted gold, they performed a stilted dance to a recording of the music hall song "Underneath the Arches" (1931).

Regarding themselves as both their subject matter and medium, in the early 1970s they documented several evenings spent getting drunk. These photographic works include *Smashed* (1972–1973) and *Raining Gin* (1973). From the mid-1970s, Gilbert & George have created large graphic works, usually involving self-portraits, alongside graphic sexual, scatological, and nationalistic photographic imagery, in bold outlines and bright colors that evoke stained-glass windows. In the 1990s, the pair controversially began to include magnified images of their own bodily fluids. The *Dirty Words* (1977) series contains crude graffiti, which epitomizes the provocative pronouncement that the only interesting contemporary drawings are found on lavatory walls. Smartly groomed and anachronistically besuited at all times, Gilbert & George have always affected an air of restrained aloofness accompanied by oblique and often contradictory statements about their work. Today, the East End of London acts as both their subject matter and their home. **LB**

Masterworks

The Nature of Our Looking 1970 (Tate Collection, London, England)

Bloody Life No. 1 1975 (Statens Museum fur Kunst, Copenhagen, Denmark)

Red Morning: Trouble 1977 (Tate Collection, London, England)

Cunt 1977 (Musée d'Art Moderne de la Ville de Paris, Paris, France)

Queer 1977 (Museum Boijmans Van Beuningen, Rotterdam, the Netherlands)

The Alcoholic 1978 (Art Institute of Chicago, Chicago, Illinois, U.S.)

Here 1987 (Metropolitan Museum of Art, New York, U.S.)

Shitty Naked Human World 1994 (Stedelijk Museum, Amsterdam, the Netherlands)

"There's no reason why an artwork must be completely baffling to anybody."

ABOVE: Gilbert & George photographed in front of *Blood Tears Spunk Piss* in 2007.

ANSELM KIEFER

Born: Anselm Kiefer, March 8, 1945 (Donaueschingen, Germany).

Artistic style: Painter, photographer, sculptor, and installation artist; themes of German history, myth, literature, and art history; biblical subjects; explorations of the taboo.

Masterworks

Occupations 1969 (Metropolitan Museum of Art, New York, U.S.)

Germany's Spiritual Heroes 1973 (Broad Art Foundation, Santa Monica, U.S.)

Parsifal III 1973 (Tate Collection, London, England)

Ways of World Wisdom: Hermannsschlacht 1976 (Deutsche Bank, Frankfurt, Germany)

The Rhine 1981 (Tate Collection, London, England)

Märkischer Sand 1982 (Stedelijk Museum, Amsterdam, the Netherlands)

Seraphim 1983–1984 (Guggenheim Museum, New York, U.S.)

Departure from Egypt 1984 (Museum of Modern Art, New York, U.S.)

Athanor 2007 (Musée du Louvre, Paris, France)

A former pupil of Joseph Beuys, like his mentor Anselm Kiefer explores themes of German history, myth, literature, and art history, in particular its period under Nazi rule and the Holocaust. This preoccupation has resulted in contentious works tackling the taboo, such as his photographic series *Occupations* (1969), depicting the artist in paramilitary outfits performing the *Sieg Heil* salute at various World War II battle sites or in romantic landscapes. In response to criticisms of these disturbing works, Kiefer commented, "I do not identify with Nero or Hitler, but I have to reenact what they did just a little bit in order to understand the madness. That is why I make these attempts to become a fascist."

Such explorations have also seen him produce large-scale canvases, photos, and structures reflecting the monumental scale of fascist rallies and the architecture of the Nazi's favorite architect, Albert Speer; as well as a series of paintings including *My Father Pledged Me a Sword* (1975), based on German composer Richard Wagner's *The Ring of the Nibelung* (1848–1874) cycle of operas that the Nazis appropriated for nationalistic propaganda. Kiefer's work is populated by the names of places and figures in history and is made of materials such as sand, straw, wood, ash, earth, clay, and lead, reflecting the ashes of the Holocaust and Germany's ruined state postwar, its moral decay, and eventual spiritual rebirth. Since the 1980s, Kiefer's focus has shifted toward works that tackle biblical subjects, myth, and metaphysical subjects. Yet he will perhaps best be remembered as an artist who grew up in postwar Germany and who was not afraid to attempt to understand and portray his country's recent past in his work. **CK**

"[Kiefer is] a painter of history and mythology."—Marie-Laure Bernadac, curator at the Louvre

ABOVE: Kiefer in the pavilion in Hoxton Square, built to house one of his works.

BARBARA KRUGER

Born: Barbara Kruger, 1945 (Newark, New Jersey, U.S.).

Artistic style: Use of imagery with text to explore themes of feminism, consumerism, and the nature of advertising; bold messages; signature colors of black, white, and red.

U.S. conceptual artist Barbara Kruger is renowned for bold works of art with equally bold messages. Trained as a graphic designer, she worked for fashion magazines and reached the position of chief designer at *Mademoiselle* magazine. In the late 1960s, she became an artist. Kruger is best known for the iconic works she began producing in 1977: severely cropped and enlarged grainy monochrome photographs overlaid with graphics and blocks of text that deliver short, powerful slogans. These are often mass produced and have appeared across the globe in a range of different formats in public locations, including on billboards and T-shirts, as well as gallery walls.

Although Kruger's work has been criticized for being no different to real advertisements, such a claim is arguably ignorant of her work's latent irony and intent. Working at a time dominated by rising conservative and consumerist forces, particularly during the 1980s when Margaret Thatcher and Ronald Reagan were in power, Kruger's work analyzes and questions the ways in which mass media and capitalism render, distort, and objectify people's understanding of reality, focusing on the issues of power, language, and the representation of women. The messages littered throughout her works communicate Kruger's political objective, and her use of direct and aggressive phrases draws attention to the absurdity of the accompanying photographic image. Kruger has continued to produce similar graphic images throughout her career and has branched out into media such as film and audio. In addition to the success she has enjoyed in the art world, her work has been featured in pro-abortion campaigns and used for commercial purposes by the London department store Selfridges. **WD**

Masterworks

Untitled (Your Gaze Hits the Side of My Face) 1981

Untitled (Buy Me, I'll Change Your Life) 1984

Untitled (Your Creation is Divine/Our Reproduction Is Human) 1984

Untitled (I Shop, Therefore I Am) 1987

Untitled (Your Body Is a Battleground) 1989

"I want to disrupt the dour certainties of pictures, property, and power."

ABOVE: Prize-winning artist Barbara Kruger photographed in 2005.

RICHARD LONG

Born: Richard Long, June 2, 1945 (Bristol, England).

Artistic style: Walks in nature recorded in photographs and texts; installations referring to prehistoric wall paintings or archeological monuments; themes of time and solitude.

Masterworks

A Line Made by Walking 1967 (Tate Collection, London, England)

Slate Circle 1979 (Tate Collection, London, England)

Kilkenny Circle 1984 (Museum of Modern Art, New York, U.S.)

Riverlines (Mud from Avon and Hudson Rivers) 2006 (Hearst Tower, New York, U.S.)

Involved in the arte povera movement in the 1960s, sculptor, photographer, and painter Richard Long began walking as an art form with *A Line Made by Walking* (1967). His walks are recorded in photographs, maps, drawings, and texts and have taken him from the Highlands of Scotland to the Sahara, Lapland, the Alps, and the Andes. A graduate of London's St. Martin's School of Art and Design, Long is a Turner Prize winner and the only artist to have been nominated four times.

His work is characterized by time, space, the movement of the body within nature, and solitude. He says time becomes subjective during a walk; the body's movement is discrete. Long is emphatic his work has nothing in common with performance art because there is no audience. Solitude implies the possibility of a relationship with the earth he traverses.

Sometimes Long intervenes in the landscape by moving or arranging rocks. His work is not part of an aesthetic rejection of the gallery, and such arrangements have migrated into the gallery in the form of sculptures that have a close affinity to archeological remains such as stone circles or cairns. These ancient references in a contemporary context question and challenge the practice of sculpture in western art. As well as specifically constructed sculptures or installations, evidence of his walks is exhibited as photographs or text. Although the purpose of his texts is to record his walks, they are often extraordinarily evocative and many have a poetic quality that leaves the reader with a memory of something seen, touched, or heard by Long. His work is in several collections, including the Tate Modern, London; the Museum of Modern Art, New York; and the Musée d'Art Moderne, Paris. **WO**

"For me the work is the meeting of the intellect and the body."

ABOVE: A relaxed Richard Long, photographed in 1986.

1940–49

SEAN SCULLY

Born: Sean Scully, June 30, 1945 (Dublin, Ireland).

Artistic style: Robust, human-scaled, abstract canvases comprising a series of horizontal and vertical bands of color; objectlike canvases that often incorporate inset panels.

If any single, overriding quality marks the work of Sean Scully, it is his conviction toward abstraction, both as an idea and as a means by which art, and specifically painting, might be produced. Over the past thirty years, the artist has displayed an indomitable belief in the continued relevance of an approach to painting that has, according to some commentators, fallen out of favor within the contemporary art world. The fact that Scully continues to carve out a critical position for the work and remains unperturbed by abstraction's detractors is testimony to the work's strength and the artist's own unfailing set of convictions.

Scully was born in Ireland and moved with his family in 1949 to England, attending classes at Croydon College of Art in London. In 1968, he enrolled in the bachelor of arts fine art program at Newcastle University, where he began to explore the potential of the grid as a compositional device. In 1975 he moved to New York and gradually began to move away from what had been a minimalist approach to picture making, evident within works such as *Fort #2* (1980).

During the 1980s, a loosening is evident in his application of brushstroke, and the objects of his paintings become imbued with a certain lyrical, poetic quality. Scully also developed the technique of insetting a smaller panel, often with a contrasting design of vertical and horizontal stripes, into the larger panel. The juxtaposition of what were two planes created a rich, vivid sense of the object's presence. During this period, Scully began to experiment with placing together separate canvases, as in *Paul* (1984). He continues to compellingly explore the language and vocabulary of abstraction. **CS**

Masterworks

Fort #2 1980 (Tate Collection, London, England)

Narcissus 1984 (Museum of Modern Art, New York, U.S.)

Paul 1984 (Tate Collection, London, England)

Tonio 1984 (Tate Collection, London, England)

"I'm very attracted to simple or basic systems of ordering . . . a strange and mysterious logic."

ABOVE: Sean Scully at a retrospective of his work at the Miro Foundation in Spain.

MARINA ABRAMOVICH

Born: Marina Abramovich, November 30, 1946 (Belgrade, Yugoslavia).

Artistic style: Provocative performance artist; works taking physical risk; use of symbolism and ritual; focus on the centrality of the body; themes of autobiography and sexuality.

Masterworks

Rhythm 10 1973
Lips of Thomas 1975
Breathing In/Breathing Out 1977
Rest/Energy 1980
The Lovers 1988
Biography 1992–1993
Balkan Baroque 1997
Balkan Erotic Epic 2005

Performance artist Marina Abramovich's background almost demanded she should be extraordinary. Her grandfather, the Orthodox Patriarch of Serbia, was made a saint after his murder by the king, and her parents were World War II partisans.

In the 1960s and 1970s, Abramovich studied in Belgrade and Zagreb. Much of her work deals with the fear of pain and death as seen in her early work *Rhythm 10* (1973), which involved recording the sound of rapid stabbing between her fingers with knives, which were changed each time she cut herself.

In 1976 she left Yugoslavia for Amsterdam, where she met, lived, and worked with the West German performance artist Uwe Laysiepen, known as Ulay. Their most notorious performance was *Rest Energy* (1980), in which both artists leaned backward while Abramovich gripped a bow and Ulay held the arrow taught on the bowstring pointing directly at her heart. Even their final separation became performance art when they walked toward one another from either end of the Great Wall of China for their final parting at the end of their relationship. As a result of this emotional trauma, Abramovich then focused on her own life and produced the theatrical performance *Biography* (1992–1993), which she periodically updates. She is a compulsive traveler who needs to experience other cultures. The incorporation of symbolism and ritual learned from her travels is a vital component of her work and led to works such as *Balkan Baroque* (1997), which involved scrubbing 1,500 heavy bones and won her the Golden Lion at the Venice Biennale. In a thematic departure, her video installation *Balkan Erotic Epic* (2005) explored sexuality in Balkan history and culture through a study of Serbian folklore. **WO**

"There is a physical limit: when you lose consciousness you can't … perform."

ABOVE: Marina Abramovich photographed at the 2007 Guggenheim International Gala.

GUILLAUME BIJL

Born: Guillaume Bijl, 1946 (Antwerp, Belgium).

Artistic style: Belgian sculptor; specializes in large-scale installations of "unreal reality" to challenge perceptions of everyday life; absurdist edge; playful sense of humor.

Guillaume Bijl is a mixed-media artist who uses the illusion of normality to provide a new perspective. Like Marcel Duchamp before him, Bijl's work focuses on the ready-made, but his art concerns not so much found objects as found environments: instead of a urinal, rather there is a whole building. One of his most famous examples is *Your Supermarket* (2003), where a gallery was filled with a replica of part of a supermarket and the shelves restocked with real products on a regular basis, but nothing was for sale. Other installations in this series have included a re-created quiz show set, an airport, and a laundromat. He enjoys taking these real-world set pieces out of their normal environment and using them to challenge the boundaries of what is everyday life and what is art.

Bijl adds an absurdist edge to this concept in one collection of works he calls *Sorry Installations* (1987–2006). The apology is because although the pieces look like found objects, they are created by the artist's imagination rather than re-created from life. For example, with his work *Archaeological Site* (2003), set in a park in Munster, the viewer can discover a 23-foot (7 m) hole containing what appears to be an excavated full-scale neo-Gothic church spire with a shovel next to it. He has also created a fake excavated *Roman Street* (1994) in the Antwerp Open Air Museum.

Bijl's surreal installations highlight his playful sense of humor, but they landed him in trouble in his early days. When he displayed a lamp in the Basel art market, other artists asked for him to be thrown out. However, Bijl fills a necessary role: the art world needs someone willing to question where reality stops and art begins. As Bijl is keen to stress, he is not making fun of contemporary art, but merely paying tribute to it. **JM**

Masterworks

Documenta Wax Museum 1992 (Ontario Museum, Toronto, Canada)

TV Quiz Decor 1993 (Biennale de Lyon, Lyon, France)

Roman Street 1994 (Middelheim Open Air Museum of Antwerp, Antwerp, Belgium)

Central Airport Basel 1996 (Theater Basel, Basel, Switzerland)

Guinness World Record Counting 2002 (Annie Gentils Gallery, Antwerp, Belgium)

Your Supermarket 2003 (Tate Liverpool, Liverpool, England)

Archaeological Site (A Sorry Installation) 2003 (Skulptur Projekte Münster, Münster, Germany)

"My work is critical. I make fun of institutions, of our civilization, of our habits."

ABOVE: Guillaume Bilj at the Documenta IX exhibition in Kassel, Germany, in 1992.

ROBERT MAPPLETHORPE

Born: Robert Mapplethorpe, November 4, 1946 (New York, U.S.); died March 9, 1989 (Boston, Massachusetts, U.S.).

Artistic style: Stylized black and white photographs; floral still lifes, celebrities, and homoerotic depictions of nudes; explorations of the tonal effects of light on skin.

Masterworks

Patti Smith 1975 (Robert Mapplethorpe Foundation, New York, U.S.)

X Portfolio Series 1978 (Robert Mapplethorpe Foundation, New York, U.S.)

Louise Bourgeois 1982 (Robert Mapplethorpe Foundation, New York, U.S.)

Melia Marden 1983 (Solomon R. Guggenheim Museum, New York, U.S.)

Ken Moody and Robert Sherman 1984 (Solomon R. Guggenheim Museum, New York, U.S.)

Calla Lily 1986 (Solomon R. Guggenheim Museum, New York, U.S.)

Andy Warhol 1986 (Robert Miller Gallery, New York, U.S.)

Self-Portrait 1988 (Solomon R. Guggenheim Museum, New York, U.S.)

Robert Mapplethorpe is a U.S. photographer famed for his sexually explicit works and the scandals surrounding them. It is important to note, however, that such an understanding is not a true reflection of his artistic achievements.

Mapplethorpe studied painting and sculpture at the Pratt Institute, two fields that influenced his later photographic work. He began using a Polaroid camera in 1971; a gift from John McKendry, curator of photography at the Metropolitan Museum of Art, New York. In 1974 the gift of a Hasselblad camera from his friend and eventual lover Sam Wagstaff encouraged him to explore the large-format medium. Mapplethorpe produced portraits of friends and acquaintances, including the musician Patti Smith, with whom he lived. The artist continued to work in this format throughout his illustrious career, photographing a number of famous people, such as pop art king Andy Warhol and rock singer Debbie Harry.

Mapplethorpe soon also began to produce photographs of floral still lifes and nude figures, the latter of which range from images that recall classical sculptures to explicit depictions of extreme sexual acts. Whether such works are acceptable for an artist to produce, publicly exhibit, and sell as art is an important debate but one that fails to acknowledge the aesthetic quality of Mapplethorpe's oeuvre. As the artist stated, he treated all his subjects in a similar fashion, transforming them into beautiful, abstract forms that explore the tonal effects of light on skin, musculature, and petals. In this way, Mapplethorpe's photographs are artificial, cosmetic constructs that are more concerned with surface effect than content, even though his critics and audiences may not always appreciate these intentions and priorities. **WD**

> " … photographing a flower is not much different than photographing a cock."

ABOVE: Mapplethorpe at his exhibition at the Robert Miller Gallery in 1985.

RIGHT: *Ajitto* (1981) is one of Mapplethorpe's most famous nudes.

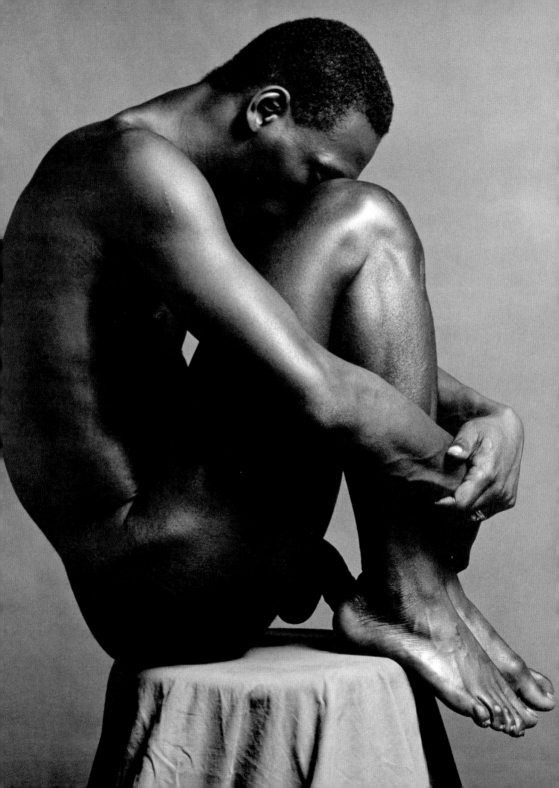

CHRIS BURDEN

Born: Chris Burden, 1946 (Boston, Massachusetts, U.S.).

Artistic style: Performance and installation artist; early proponent of body art; examines power structures and forms of endurance; influenced by technology, machinery, laws of physics, and architecture.

Masterworks

Shoot: Performance at F Space, Santa Ana, California November 19, 1971

Back to You: Performance at 112 Greene Street, New York January 16, 1974

A Tale of Two Cities 1981 (Orange County Museum of Art, Newport Beach, California, U.S.)

All the Submarines of the United States of America 1987 (Dallas Museum of Art, Dallas, Texas, U.S.)

Medusa's Head 1990 (Museum of Modern Art, New York, U.S.)

The Flying Steamroller 1996 (Novartis, Basel, Switzerland)

Ghost Ship 2005

"To be an artist should be without a real reason or purpose."

ABOVE: Chris Burden pictured at home in California in 1990.

Burden's role as a proponent of early West Coast performance art has secured his place in the history of conceptual practices, while the diversity of his output and his appetite for shattering boundaries have produced a unique body of work. In the course of his career, Burden has subjected himself to risk and pain, examined systems of communication and transportation and the laws of physics and technology, and dealt with weapons of mass destruction and images of authority. He has constructed model bridges, created miniature cities, and engineered autonomous machines such as his extraordinary *Ghost Ship* (2005), designed to be self-navigating.

Initially a student of architecture with an interest in physics, Burden graduated with a masters degree in fine art from the University of California in 1971. During the 1970s, the object of his art was his own body. His notorious performances saw him shot, crucified, crawl through broken glass, and expose himself to possible electrocution.

In the 1980s he ceased these activities and began making sculptures and installations that explored systems of authority and various technologies. In *Exposing the Foundation of the Museum* (1986), Burden excavated sections of concrete and earth to reveal the foundations of Los Angeles's Museum of Contemporary Art. Combining extraordinary vision and audacious feats of engineering, Burden's projects often result in awe-inspiring machines that are as frequently elegant as they are technologically innovative. Perhaps the pinnacle of his grandiose enterprises has been *The Flying Steamroller* (1996), comprising a steel pivot and carefully tuned hydraulics that enable a 12-ton steamroller to glide through the air. **LA**

GIUSEPPE PENONE

Born: Giuseppe Penone, April 3, 1947 (Garessio, Cuneo, Italy).

Artistic style: Exploration of dialogue between art and natural processes; unspectacular organic materials; engagement with the surfaces of contact between living beings and their environment.

Closely associated with the arte povera movement, Giuseppe Penone has, for the last four decades, explored people's contact with the natural world and its processes. With remarkably consistent formal means, Penone has found ways to visualize the progress of time, mimic the action of rivers, make landscapes of his skin, and reverse the growth of trees.

Penone was born on a farm near Garessio, within a rural community south of Turin. His practice embodies the profound symbiotic and participatory relationship with nature that has been established in this part of Italy for millennia. For *It Will Grow Except at This Point* (1968–1978), Penone made a steel cast of his hand gripping the trunk of a young tree. The cast was then fixed to the trunk and, as the years passed, the tree grew over and around it, elegantly rendering time's passage visible. For his series *Trees* (1969–2004), Penone purchased machine-cut blocks of industrial timber and, following the contours of the trunk's rings, carved the wood back to an earlier stage in its development. In dialogue with U.S. minimalism, Penone sought the organic memory of such geometrically hewn materials. In 1974 he began to produce huge charcoal drawings from tiny imprints taken from the surface of his body. The resulting prints were fashioned into rudimentary slides and projected many feet across the studio on to a wall. The projected image was drawn over, making vast territories of eyelids and foreheads.

In opposition to the gloss and spectacle of consumer culture, Penone has developed modes of practice based upon an ethics of touch and a simplicity of means. His collaborative engagement with natural materials embodies a way of making that is entirely relevant to our ecologically fraught times. **EK**

Masterworks

It Will Grow Except at This Point 1968–1978 (Garessio, Italy)

To Reverse One's Eyes 1970 (Private collection)

Eleven-Meter Tree 1975 (Kunstmuseum, Lucerne, Switzerland)

To Be a River 1981 (National Gallery of Canada, Ottawa, Canada)

Eyelid 1989–1991 (Collection De Pont Foundation, Tilburg, the Netherlands)

"According to me, all elements are fluid. Even stone is fluid: a mountain crumbles."

ABOVE: Giuseppe Penone photographed in June 2007.

BOYD WEBB

Born: Boyd Webb, 1947 (Christchurch, New Zealand).

Artistic style: Conceptual photographer and installation artist; large-scale fictitious photographs; witty, absurd, allegorical tableaux; sexual politics and environmental themes; scientific and technological concerns.

Masterworks

Nourish 1984 (Southampton City Art Gallery, Southampton, England)

Scott's Tent 1984 (Tate Collection, London, England)

First Principles 1984 (Tate Collection, London, England)

Blessed 1985 (Auckland Art Gallery Toi O Tāmaki, Auckland, New Zealand)

Unwrought 1995 (Auckland Art Gallery Toi O Tāmaki, Auckland, New Zealand)

Wrack wring 1997 (Auckland Art Gallery Toi O Tāmaki, Auckland, New Zealand)

"To take the domestic into realms beyond the imaginable … [is] a truly human aspiration."

ABOVE: Webb appeared in the unpublished shortlist for the Turner Prize in 1988.

Boyd Webb's photographs are deceptively simple in composition—so deceptive that the word is a constant theme in evaluations of his work. What appear to be natural forms or wide, open spaces turn out to be large pieces of plastic sheeting, floating pieces of food, or rippling bolts of textiles. In these large-scale photographic images, everyday materials are used to denote familiar objects or scenes, such as a wheat field or a distant galaxy. Yet there is no mystery because, for example, the viewer can see clearly that what initially appears to be the surface of a planet is instead a huge piece of crumpled carpet and part of a surrealistic play of manipulated and staged materials, animated by notions of the real, the apparent, and the artificial.

Webb's artistic training began when he left his native New Zealand in 1972 to study in the sculpture department of the Royal College of Art, London. He found the sculptural processes expensive and cumbersome and opted instead for the more contemporary idiom of photography. Within a short time he gained international acclaim in the new medium. But his sculptural roots continued to play an important supporting role in his artistic process. Webb constructed elaborate tableaux, rather like theatrical sets, and photographed them in his studio. *Nourish* (1984) is a work of this kind. It depicts a man suckling under a large greenish form that is the underbelly of a whale taking up two-thirds of the composition. The whale's flesh appears to be made from carpet-backing foam; the object the man sucks is a root vegetable with a painted nipple. It is this type of humorous, puzzling, or unsettling juxtaposition that characterizes Webb's photographic work. **NG**

ERIC FISCHL

Born: Eric Fischl, 1948 (New York, U.S.).

Artistic style: Figurative U.S. painter, photographer, and sculptor of nudes; suburban settings; themes of voyeurism, sexuality, relationships, taboos, and boundaries, often with disturbing undertones.

According to Eric Fischl, "America's not Disneyland. Things smell, things have edges, people can get hurt." A contemporary figurative painter, Fischl draws on the tradition of predecessors such as Edward Hopper and Edgar Degas. Like them, he paints suburban life and the boudoir—but there the similarity ends. The power of his paintings to disturb and ruffle psychological feathers is more akin to that of Edvard Munch, such is their capacity to create a feeling of discomfort and anxiety in the viewer. Looking at one of his canvases is the pictorial equivalent of watching a David Lynch movie.

Fischl was born in New York City, but his family moved to Phoenix, Arizona, in 1967 and he studied art at the California Institute of Arts from 1969 to 1972. In 1974 he began teaching painting at the Nova Scotia College of Art and Design, where he met his wife, painter April Gornik. The couple moved to New York City in 1978, where they remain.

Fischl opted for a realistic, figurative style of painting in the face of the contemporary taste for abstraction and minimalism. Early paintings such as *Bad Boy* (1981) set the tone for what was to follow. Fischl placed naked figures in suburban settings, but in a way that made viewers feel like voyeurs watching suburban life unfold behind closed doors.

Fischl's later work has included more conventional figurative watercolors, but he has continued to rattle cages, most recently with his life-size bronze sculpture *Tumbling Woman* (2002), which portrays a woman falling from one of 9/11's Twin Towers. First exhibited in New York's Rockefeller Plaza, it was removed because of the shock and offense it caused. Fischl's legacy as an artist who continues to use the body to wrestle with taboo subjects seems assured. **CK**

Masterworks

Bad Boy 1981 (Mary Boone Gallery, New York, U.S.)

New House 1982 (Private collection)

Tumbling Woman 2002 (Private collection)

Krefeld Project, Bedroom #6 (*Surviving the Fall Meant Using You for Handholds*) 2004 (Private collection)

"I think of art as a glue, a cultural and social glue ... to show us the things we believe in."

ABOVE: Eric Fischl as he appeared in *New York Times* magazine in October 2002.

1940–49

HIROSHI SUGIMOTO

Masterworks

Radio City Music Hall, New York 1978 (Museum of Fine Art, Boston, Massachusetts, U.S.)

*White Rhinoceros Aus/*From *Diorama* 1980 (Fotomuseum Winterthur, Zurich, Switzerland)

Time Exposed 1991 (Museum of Contemporary Art, Chicago, Illinois, U.S.)

Winnetika Drive-in, Paramount 1993 (Tate Collection, London, England)

Boden Sea 1993 (Metropolitan Museum of Art, New York, U.S.)

Studio Drive-In, Culver City 1993 (Museum of Contemporary Art, Los Angeles, California, U.S.)

English Channel, Weston Cliff 1994 (Art Institute, Chicago, Illinois, U.S.)

World Trade Center 1997 (Hirshhorn Museum, Washington, D.C., U.S.)

Henry VIII 1999 (Solomon R. Guggenheim Museum, New York, U.S.)

Born: Hiroshi Sugimoto, February 23, 1948 (Tokyo, Japan).

Artistic style: Large-scale black and white photographs; dioramas, portraits, seascapes, movies, and architecture; themes of light, memory, dreams, the history of representation, and time.

Hiroshi Sugimoto has developed a distinct style of large-scale black and white photography in which he explores the effects of light and time. His first series, *Dioramas* (1976), depicts natural history museum displays, whereas his later portrait series captures Madame Tussaud's wax figures of King Henry VIII and his wives. Through intricately re-creating a sense of the natural lighting, he makes these artificial representations resemble reality and painting, respectively. In his quintessential series of U.S. movie theaters and drive-ins, Sugimoto photographs both starkly minimal and decoratively ornate spaces. Other photographic projects have included hauntingly beautiful photographs of seascapes and architectural landmarks. **MG**

RICHARD PRINCE

Masterworks

Untitled (*Three Women with Heads Cast Down*) 1980 (San Francisco Museum of Modern Art, San Francisco, California, U.S.)

Untitled (*"I've Been Married . . ."*) 1986 (Museum of Modern Art, New York, U.S.)

Untitled (*Cowboy*) 1990 (Victoria & Albert Museum, London, England)

Untitled (*Girlfriend*) 1993 (San Francisco Museum of Modern Art, San Francisco, California, U.S.)

Nurses' Dormitory 2002 (Armand Hammer Museum of Art at UCLA, Los Angeles, California, U.S.)

Born: Richard Prince, 1949 (Former U.S.-controlled Panama Canal Zone, Republic of Panama).

Artistic style: Photographer and abstract expressionist painter; appropriation of pop cultural ephemera; multilayering of analog and digital surfaces; ready-mades.

Richard Prince moved to New York in 1973 and became involved in the thriving downtown art scene. He came to wider notice in the 1980s when he made a series of rephotographed Marlboro Man advertisements that he had cut out from magazines. Although artists had been questioning notions of authenticity and cultural value for decades, Prince's generation was immersed in popular culture and his conceptual irony was filtered through a deeper emotional engagement, reflected in his collecting of memorabilia. His recontextualization of discarded products of trash culture has since encompassed pulp fiction novels and biker magazines. From the mid-1990s, he has applied an abstract expressionist style of painting to found images. **RB**

PHILIP CLAIRMONT

Born: Philip Antony Haines, 1949 (Nelson, New Zealand), died 1984 (Auckland, New Zealand).

Artistic style: Distorted figuration; psychopathology; vivid color; fragmented gestures; anthropomorphized domestic interiors; self-portraits; themes of protest.

The popular image of Philip Clairmont is as one of the bad boys of New Zealand art. Together with peers Allen Maddox and Tony Fomison, he epitomized the myth of the hell-raising, tormented, and struggling artist. In Clairmont's case this included experimentation with hallucinatory drugs and ended with his untimely death by suicide at thirty-four years old.

Clairmont's brief career began as a student at the University of Canterbury School of Fine Arts from 1967 to 1970, where he came under the influence of Rudi Gopas, a Lithuanian expressionist painter. It is said that Clairmont particularly admired art brut and the work of Francis Bacon, Vincent van Gogh, Ernst Ludwig Kirchner, and Max Beckmann. From these foundations he devised a style of painting that appeared wild, rhythmic, and threatening to spill over, yet always managed to stay tightly delineated and controlled.

Clairmont had early success, producing his first solo exhibition in 1970. For subject matter, he rejected his country's landscape tradition to focus on interiors, both domestic and psychic, such as in his masterwork *Scarred Couch, the Auckland Experience* (1978). A large work, almost 10 feet (3 m) long by 5 feet (1.5 m) high, it has been seen as a symbolic self-portrait. It depicts a couch with its fabric faded and torn, and a sense of decay pervades the surface. Yet the overall effect of the piece is a huge burst of vivid and pulsating color.

Behind the bad-boy image, Clairmont was a serious and committed artist who concerned himself with the political issues of inequality and hypocrisy. He protested against the apartheid regime during the Springbok rugby tour of 1981, and produced some of the most powerful paintings to come out of the New Zealand expressionist movement. **NG**

Masterworks

Fireplace 1971 (Christchurch Art Gallery, Christchurch, New Zealand)

Portrait of a Washbasin, Blood in a Washbasin 1971 (Christchurch Art Gallery, Christchurch, New Zealand)

The Radio 1972 (Auckland Art Gallery Toi O Tāmaki, Auckland, New Zealand)

Scarred Couch, the Auckland Experience 1978 (Museum of New Zealand Te Papa Tongarewa, Wellington, New Zealand)

Untitled Painting (Chair) 1978 (Auckland Art Gallery Toi O Tāmaki, Auckland, New Zealand)

Staircase Night Triptych 1978 (Auckland Art Gallery Toi O Tāmaki, Auckland, New Zealand)

"His works challenge the perceptions of formal high art."—Ferner Galleries, New Zealand

ABOVE: Detail from a photograph of Philip Clairmont taken by Marti Friedlander.

1940–49

TONY CRAGG

Born: Anthony Cragg, 1949 (Liverpool, England).

Artistic style: Exploring the nature of physical matter and our relationships with it; early use of discarded urban waste; scientific ideas and imagery; work embraces wide range of materials; monolithic later works.

Masterworks

Stack 1975 (Tate Collection, London, England)

Britain Seen From the North 1981 (Tate Collection, London, England)

Postcard Union Jack 1981 (Leeds City Art Gallery, Leeds, England)

Axehead 1982 (Tate Collection, London, England)

Grey Moon 1985 (Museum of Modern Art, New York, U.S.)

Instinctive Reactions 1987 (Kunstmuseum, Wolfsburg, Germany)

Terris Novalis 1989 (installed on National Cycle Network route, Consett, England in 1990s)

New Forms 1991–1992 (Cullen Sculpture Garden, Museum of Fine Arts, Houston, Texas, U.S.)

Points of View installed 2005 (Corner of Calle Larios/Calle Strachan, Málaga, Spain)

A stimulating synthesis of scientific and artistic thinking, Cragg's sculpture tackles the very modern question of humans' relationship to their world. For Cragg, this world encompasses the tide of manufactured objects that surround us as well as natural materials and the landscape. His main starting point is the ways in which the natural world is affected by technology. He has worked in many different materials—plastic, clay, stone, bronze—as well as in mixed media. Cragg fosters a dynamic relationship with specific materials by letting their unique qualities play a major role in dictating the form of each work.

In the 1970s and 1980s, Cragg was known for assembling pieces that use "found" objects. His works built up from fragments of waste plastic include *Britain Seen From the North* (1981), a comment on his homeland's social problems. By 2007, much of his work was focused on monumental pieces made from metal (especially bronze) and wood; these include notable outdoor commissions, such as *Points of View* (2005). While his assemblages explored the strongly scientific question

ABOVE: Award-winning sculptor Tony Cragg photographed at a gallery in 1997.

RIGHT: *Postcard Flag (Union Jack)* (1981) is an acrylic and mixed media work.

ABOVE: *Species* (2003) was exhibited on the roof terrace of the Kunstmuseums, Bonn.

of how parts relate to a whole, his forms, in both sculptures and prints, have included laboratory flasks and test tubes.

An early mix of science and art explains Cragg's works. Two years as a technician at a rubber research laboratory in the later 1960s were followed by study at a succession of art colleges, including London's Royal College of Art. By his late twenties, Cragg was already a professor at the École des Beaux-Arts in Metz, France. Since 1977 he has lived in Wuppertal, Germany, where he simultaneously established a long-standing teaching career at Düsseldorf's Kunstakademie and a pattern of exhibiting regularly worldwide. He has become a leading international figure: France has made him a Chevalier des Arts et des Lettres (1992); Britain, a Royal Academician (1994) and CBE (Commander of the British Empire, 2003); Berlin has elected him to the Akademie der Künste (2001). He represented Britain at the 1988 Venice Biennale and has won the prestigious British Turner (1988) and Shakespeare (2001) prizes as well as a Japanese Praemium Imperiale (2007). **AK**

Art, Science, and Nature

Terris Novalis (1989) is an imposing work that stands on the National Cycle Network route near Consett, northeast England. Specially commissioned, it comprises two massive replicas of scientific measuring instruments. They rest on animal feet whose heraldic associations link with land and ownership issues. Towering 20 feet (6 m) above an industry-ravaged landscape, they are visible for miles around. The work is a reminder of the area's now-disappeared steel industry, a note of hope for its regeneration, a marker of the meeting of landscape and industry, and a practical landmark on a sustainable travel route.

1940–49

ENZO CUCCHI

Born: Enzo Cucchi, November 14, 1949 (Morro d'Alba, Ancona, Italy).

Artistic style: Neo-expressionist painter and draftsman of transvanguardia movement; incorporation of three-dimensional objects such as ceramics; themes of art history and myth.

Masterworks

On the Pavement during the Dogs' Party 1979 (Museo d'Arte Moderna e Contemporanea di Trento e Roverto, Roverto, Italy)

Dogs with Tongues Wagging 1980 (Museo d'Arte Contemporanea, Rivoli, Italy)

Palla-Santa 1980 (Museum of Modern Art, New York, U.S.)

Headless Hero 1981 (Museo d'Arte Contemporanea, Rivoli, Italy)

Giotto's Elephant 1986 (Art Gallery of New South Wales, Sydney, Australia)

Enzo Cucchi grew up on the Adriatic coast, and the rich colors of the countryside are evident in canvases such as *Dogs with Tongues Wagging* (1980). He started drawing in the 1970s and had his first solo show in 1977. By the early 1980s, together with compatriots Francesco Clemente and Sandro Chia, Cucchi was a leading member of Italy's transvanguardia movement, which was part of a wider European leaning toward neo-expressionism. Cucchi's bold paintings draw on his native culture, referencing myth and art historical precedents with works such as *Giotto's Elephant* (1986). He often focused on a solitary image amid an empty landscape, demanding an almost religious meditation on the part of the viewer. **CK**

RICHARD DEACON

Born: Richard Deacon, August 15, 1949 (Bangor, Wales).

Artistic style: Sculptor; works in a variety of materials including wood, metal, plastics, and clay; public works on a large scale; organic shapes; titles alluding to the senses and language.

Masterworks

It's Orpheus When There's Singing #7 1978–1979 (Tate Collection, London, England)

If The Shoe Fits 1981 (Tate Collection, London, England)

For Those Who Have Ears #2 1983 (Tate Collection, London, England

When the Landmasses First Appeared 1986 (British Oxygen Company Headquarters, Windlesham, England)

Moor 1990 (Victoria Park, Plymouth, England)

Individual 2004 (Marian Goodman Gallery, New York, U.S.)

Turner Prize winner Richard Deacon sculpts in a variety of everyday materials from laminated plywood and stainless steel to vinyl and leather. What unites his oeuvre is that he refuses to hide the process of construction, so that rivets and bolts become part of the final object. His fluid, organic-shaped sculptures snake, twist, and turn as if moving and appear to defy definition. Clues lie in the titles to Deacon's work and often allude to the senses or language, referencing literature from the Bible to Rainer Maria Rilke's poetry. It is as if his sinuous sculptures attempt to suggest the range of human experiences and feelings as they shift from one to another in his own form of poetic sculpture. **CK**

RIGHT: *Kiss and Tell* (1989) is sculpted from epoxy, timber, plywood, and steel.

1940–49

ANTONY GORMLEY

Born: Antony Mark David Gormley, August 30, 1950 (London, England).

Artistic style: British sculptor renowned for making lead casts of his own body; exploration of the body and its relationship to the environment; themes of mortality and spiritual awareness.

Antony Gormley studied archeology, anthropology, and art history at Trinity College, Cambridge, from 1968 to 1971. After graduating, he studied Buddhism in India and Sri Lanka. Back in England, he went to Goldsmiths College, London, and completed a graduate degree at Slade School of Art in 1979.

Gormley began using his own body as a cast for lead sculptures in the early 1980s and his sculptures have reinvented figurative sculpture, both in terms of their setting and their intention. His figures sit, kneel, stand, and crouch in everyday (sometimes vulnerable) poses; their lack of defined features and exposed welding lines focus the viewer's attention on the sculpture in its environment rather than on its surface detail and finish. Gormley's education and interest in the mystic and spiritual permeate his work. He encourages the viewer to consider the notion of the body within space and time, and his figures represent Everyman.

Often commissioned to create work for public spaces, the artist has taken his art beyond the gallery confine to beaches, the tops of buildings in urban environments, and even next to a major freeway—in the form of his imposing 66-foot-high (20 m) 177-foot-wide (54 m) *Angel of the North* (1998) in Gateshead, England. He has also collaborated on his public works—one such piece, *Field for the British Isles* (1994), won him the British Turner Prize in 1994. *Field* is a series of installations that Gormley has re-created over the years at various sites, aided by local communities. Thus, *Asian Field* (2003) saw the artist work alongside 300 locals from China's Hudau District in Guangzhou to create 120,000 small clay figures. Each time the series is different, the only common threads being the medium and rough design of each figurine. **CK**

Masterworks

Bed 1980–1981 (Tate Collection, London, England)

Untitled (For Francis) 1985 (Tate Collection, London, England)

Sound II 1986 (Winchester Cathedral, Winchester, England)

Field 1991 and subsequent re-creations (Various locations)

Testing a World View 1993 (Tate Collection, London, England)

Iron: Man 1993 (Birmingham, England)

Another Place 1997 (Crosby Beach, Liverpool, England)

Angel of the North 1998 (Gateshead, England)

Quantum Cloud 1999 (Greenwich, London, England)

"Art is not necessarily good for you or about communicating 'good things.'"

ABOVE: Antony Gormley pictured in his North London studio in 2005.

JENNY HOLZER

Born: Jenny Holzer, July 29, 1950 (Gallipolis, Ohio, U.S.).

Artistic style: Text as a visual art form; expressive and poetic phrases; prolific within feminist art movement; populist art; neo-conceptualism; often site specific; LED signage.

As one of the preeminent members of the feminist art revolution, Jenny Holzer investigates contemporary values of society through the rhetoric of language. She has received several accolades, including the Blair Award presented by the Art Institute of Chicago and the Leone d'Oro award for her work at the Venice Biennale, where she was the first woman to represent the American Pavilion.

While studying in New York, Holzer created her first series of *Truisms* (1979–1983): lists of short maxims that she both writes and borrows and that convey politically and socially conscious messages. She incorporates her candid thoughts on life's tribulations and her conception of universal truths. Examples of *Truism* phrases include "Abuse of Power Comes as No Surprise," "Sometimes Science Advances Faster Than It Should," and "Stupid People Shouldn't Breed."

Although she originally placed these idioms on white posters throughout the city landscape anonymously, she later used less underground forums to display her work, employing a variety of mediums such as city billboards, fashion apparel, and large-scale museum installation sites. She reinvented her signature semantics when she integrated modern information systems in the form of colorful LED signs to display her text. Her bold interfaces coupled with her poignant phrases suggest the purity of the minimalists and evoke the urgency of advertising. Holzer's subsequent bodies of work are often religious or violent in tone and have been displayed on bronze plaques and marble benches in addition to electronic signboards. No matter the channel through which her words are presented, they always provoke profound discourse and intellectual debate. **MG**

Masterworks

Truisms 1983 (Museum of Contemporary Art, Chicago, Illinois, U.S.)

Truisms 1984 (Tate Collection, London, England)

I Am a Man 1987 (San Francisco Museum of Modern Art, San Francisco, California, U.S.)

Laments (I Want to Live . . .) 1989 (Museum of Modern Art, New York, U.S.)

The Living Series 1989 (Walker Museum, Minneapolis, Minnesota, U.S.)

Untitled (Selections from Truisms, Inflammatory Essays, The Living Series, The Survival Series, Under a Rock, Laments, and Child Text) 1990 (Guggenheim Museum, New York, U.S.)

o.T. 1991 (Ludwig Forum für Internationale Kunst, Aachen, Germany)

"The 'author' projected by Holzer's texts is nowhere and everywhere. . ."—David Joselit

1950–59

ABOVE: Prize-winning artist Jenny Holzer photographed in May 2006.

JULIAN SCHNABEL

Born: Julian Schnabel, October 26, 1951 (Brooklyn, New York, U.S.).

Artistic style: Neo-expressionist painter and filmmaker of biopics; use of text, broken plates, velvet, tarpaulin, and former theater backdrops; energetic, physical brushstrokes.

Masterworks

Owl 1980 (Museum of Contemporary Art, Los Angeles, California, U.S.)

Homo Painting 1981 (Tate Collection, London, England)

The Student of Prague 1983 (Guggenheim Museum, New York, U.S.)

Corine Near Armenia 1984 (Museum of Contemporary Art, Los Angeles, U.S.)

Basquiat 1996 (Film)

Before Night Falls 2000 (Film)

Large Girl with No Eyes 2001 (Private collection)

Le scaphandre et le papillon (The Diving Bell and the Butterfly) 2007 (Film)

"Some people get inspired others get offended. But, that's good. I like that."

ABOVE: Schnabel pictured in 2004, in front of *Large Girl with No Eyes*.

Julian Schnabel has had an extraordinary career. In the 1980s, he became well known for his paintings incorporating broken plates, which were inspired in part by his experiences working as a cook. Yet it is his career as a filmmaker that has gone from strength to strength. It began with the biopic of his friend Jean-Michel Basquiat and has culminated in the Cannes Film Festival Best Director prize for *Le scaphandre et le papillon (The Diving Bell and the Butterfly)* (2007), his adaptation of the best-selling memoir by a paralyzed journalist who communicated by blinking one eye.

Schnabel was one of the most notorious painters of the 1980s art boom and became a leading figure of the neo-expressionist movement. His work combined words, images, and sometimes crockery in extremely large-scale paintings made with brutal energy and raw emotion on a variety of surfaces, including former theater backdrops. However, his meteoric rise, celebrity, and high auction prices led to a critical backlash. Robert Hughes wrote, "Schnabel is to painting, what Stallone is to acting—a lurching display of oily pectorals—except that Schnabel makes bigger public claims for himself." Schnabel's films are distinctive in their use of visual metaphors and lyrical storytelling. For his first offering, *Basquiat* (1996), he recruited David Bowie to play Andy Warhol and incorporated imagery of surfing as a metaphor for Basquiat's rise and fall. It received a mixed reception. His next project, *Before Night Falls* (2000), was another biopic, this time of Cuban poet Reinaldo Arenas. It received better reviews and won the Grand Special Jury Prize at the Venice Film Festival. Schnabel also remains an artist and has continued painting with a passionate engagement for the medium and its history. **JJ**

DONALD SULTAN

Born: Donald Keith Sultan, 1951 (Asheville, North Carolina, U.S.).

Artistic style: Painter, sculptor, and printmaker; large-scale still life paintings of traditional subjects such as fruit and flowers and everyday objects such as buttons; use of bold bright color, tar, and vinyl tiles.

U.S. artist Donald Sultan has brought the long-standing tradition of still life painting into the modern age with his large-scale works of classic subjects, such as flowers, fruit, and butterflies, as well as more mundane objects, for example dominoes, dice, and buttons.

Instead of painting on a conventional canvas, Sultan works on Masonite panels, which are covered with 12-inch (30 cm) vinyl floor tiles measuring up to an impressive 8 square feet (0.7 sq m) in total. He cuts the shapes he wants into the vinyl and fills the space with plaster and/or tar before painting over them to create a rich, textured surface.

Sultan's depictions of tulips, poppies, roses, irises, lemons, and oranges possess the contemplative power of traditional still lifes and all that resonates with them, yet his paintings are almost abstract in their minimalist use of bold, bright color, compact sense of composition, and cross sections of their subjects that render them as pure geometric form and color. He has taken the still life out of its domestic setting to find a place in contemporary art where it can be appreciated for its aesthetic beauty. His incorporation of everyday items like buttons, in works such as *Black Button* (1997), allows the viewer to contemplate the power of the ordinary. The large scale of the work overwhelms and almost disturbs the viewer, like a Mark Rothko canvas, and demands attention.

Sultan was brought up in North Carolina and studied for his bachelor of fine art at the state's University of North Carolina, Chapel Hill. He received his master of fine art from the School of the Art Institute in Chicago, Illinois. He then moved to New York in 1975 and had his first solo show in 1977 at New York's Artists Space. **CK**

Masterworks

Black Rose, Oct. 1989, from the suite *Black Roses, Dec. 1989* 1989 (Published 1990) (Smithsonian American Art Museum, Washington, D.C., U.S.)

The Album Series, Orange Feb. 27, 1996 1996 (Tate Collection, London, England)

The Album Series, Button March 1, 1996 1996 (Tate Collection, London, England)

Two Buttons 1996 (Amarillo College, Amarillo, Texas, U.S.)

Black Button 1997 (Ackland Art Museum, University of North Carolina, Chapel Hill, North Carolina, U.S.)

Four Reds Sept. 30, 2002 2002 (Smithsonian American Art Museum, Washington, D.C., U.S.)

"[My work has the ability to] turn you off and turn you on at the same time."

ABOVE: Sultan's work has revolutionized the tradition of still life painting.

BILL VIOLA

Born: Bill Viola, January 25, 1951 (New York, U.S.).

Artistic style: Pioneering, total-environment video artist; use of tape, installation, and broadcast; extreme slow motion; hyperreal clarity; emoting actors; referencing of religious art; spiritualism.

Masterworks

Information 1973
The Space Between the Teeth 1976
Nantes Triptych 1992
The Crossing 1996
The Quintet of Remembrance 2000
Surrender 2001
Five Angels for the Millennium 2001

Bill Viola studied photography, electronic music, and video in the Experimental Studios at Syracuse University's College of the Visual and Performing Arts. Nam June Paik, Andy Warhol, and a handful of others had begun to explore the possibilities of video art in the 1960s, but it was still very much in its infancy when Viola graduated in 1973. However, working in New York and Florence alongside contemporaries such as Woody Vasulka, Bruce Nauman, and Vito Acconci helped convince him that video could be his primary focus. In 1977, he exhibited at La Trobe University in Melbourne, Australia, where he met and later married its cultural arts director Kira Perov. The two formed a working partnership and spent time in Japan, where they were initiated in Zen Buddhism. After their return, Viola was offered a teaching post at the California Institute of Arts, and since then the pair have made California their home.

Viola's artwork is humanistic and unreservedly emotive, investigating phenomena of consciousness, heightened emotional states, and the desire for spiritual transcendence. As such, he is less interested in formal experiments than many of his peers but quick to adopt new technology where it can help

1950–59

ABOVE: Bill Viola photographed outlined by laser beams in 1998.

RIGHT: From *The Quintet of the Silent* (2000), a plasma display mounted on a wall.

dissolve the barriers between the audience and the medium. His trademark use of extreme slow motion first appeared in *The Greeting* (1995), whereas the ambitious *Going Forth By Day* (2002) surrounded the viewer in a digital, high-definition fresco. *The Passions* (2003) collection mixed small LCD panels with large rear-projection screens and was the first exhibition by a contemporary artist at London's National Gallery. Its referencing of Renaissance devotional images and altarpieces reflected the artist's long-term interest in religious mysticism.

Viola's installations are designed as meditative "total environments," requiring the viewer to spend time "perceiving rather than seeing" before meaning is revealed. This has provoked accusations of New Age pretension in some quarters, but over the last thirty years his work has proved popular and accessible to audiences worldwide, undoubtedly helping to establish video art as a credible and enduring form. **RB**

ABOVE: 'Departing Angel' from the *Five Angels for the Millennium* (2001) installation.

An Artist's Epiphany

In the late 1990s, when his father was gravely ill, Viola paid a visit to the Art Institute of Chicago and found himself in a room surrounded by late medieval and early Renaissance art. Suddenly, in front of a fifteenth-century painting of the mourning Madonna—Dieric Bouts's *Mater Dolorosa* (1480–1500)—he began weeping uncontrollably. Viola later remembered, "For the first time in my life I realized I was using a piece of art rather than just appreciating it. Maybe it should have been in a church—where people share silent communion—but it happened in an art gallery."

1950–59

GUSTAVO AGUERRE

Masterworks

SoloSol 1972–1974 (Museum of Modern Art, New York, New York, U.S.)

The Strindberg Quotations 1997–1998 (Drottninggatan (Queen's Street), Stockholm, Sweden)

Ibsen Sitat 2005–2007 (Karl Johan Street, Oslo, Norway)

Smitta.doc 2007 (Malmö Art Museum, Malmö, Sweden)

Born: Gustavo Aguerre, 1953 (Buenos Aires, Argentina).

Artistic style: Performance and installation artist, photographer, curator, writer, theater designer; examinations of social and cultural conventions; large-scale installations in public spaces.

Argentinean Gustavo Aguerre set up *SoloSol*, the first underground art magazine in South America, in 1972. It had a distinctly anarchistic edge that was revolutionary at the time. Two years later he went to study at the Munich Art Academy. He is best known for the art collective FA+ he established in 1992 with his Swedish wife, artist Ingrid Falk, in Stockholm, Sweden. The collective has worked on large-scale installations of sculpture, video, Internet works, and photographic projections in public spaces across Europe. FA+'s work often humorously examines social and cultural conventions such as geographic and political boundaries and highlights issues concerning immigration, asylum legislation, and human trafficking. **CK**

PHILIP-LORCA DICORCIA

Masterworks

Igor 1987 (Institute of Contemporary Art, Boston, Massachusetts, U.S.)

Ralph Smith; 21-Years-Old; Ft. Lauderdale, Florida 1990–1992 (Institute of Contemporary Art, Boston, Massachusetts, U.S.)

London 1995 (Institute of Contemporary Art, Boston, Massachusetts, U.S.)

Born: Philip-Lorca diCorcia, 1953 (Hartford, Connecticut, U.S.).

Artistic style: Photographer; fictionalized documentary; explorations of context and perception; depictions of contemporary urban street life; use of artificial and flash lighting to add rich detail and color.

In the 1980s, Philip-Lorca diCorcia's work was of the apparent banality of home life in images that appeared to be spontaneous snapshots but were actually staged interior tableaux featuring family and friends. By the late 1980s/early 1990s, he had moved to the streets of Hollywood before shifting to Berlin, Calcutta, New York, Rome, London, and Tokyo, where he shot scenes of contemporary urban life featuring passersby, male transvestites, prostitutes, drifters, and drug addicts. Once again what appeared to be snapshots were often elaborately staged images. diCorcia's fictionalized documentary style asks his viewers to decide what is real and what is fantasy in his images of the apparently everyday. **CK**

MARTIN KIPPENBERGER

Born: Martin Kippenberger, February 25, 1953 (Dortmund, Germany); died March 7, 1997 (Vienna, Austria).

Artistic style: Painter, printmaker, sculptor, and installation artist; absurdist projects; works emphasized his theatrical personality and satirical sociopolitical perspective.

Martin Kippenberger decided to make a career as an artist after attempting other creative outlets such as acting, writing, and promoting a punk rock nightclub. Not only did he embrace the romantic notion of the artist as a heroic figure, but he also fueled his artistic endeavors through brazen self-publicity that was often considered overtly egotistical. Kippenberger provoked a response through his irreverent actions, such as opening an art museum in an abandoned slaughterhouse, and building real entrances to a fake global subway system. Such absurd gestures are evidence that his art was inextricably linked to his cult persona and his mischievous conduct.

Kippenberger's diverse bodies of work include paintings, prints, sculptures, and installations that appropriate and draw from art history, political governance, and his life experience. His work rejected any trademark style or media, and instead welcomed any platform that conveyed his ideas. He participated in Junge Wild, a group of young rebellious German artists who grappled with the aftermath of the fall of the Berlin Wall. He also founded the Lord Jim Lodge group with fellow artists Jörg Schlick, Albert Oehlen, and Wolfgang Bauer. Members were obliged to incorporate the group's slogan "No one helps nobody" and the logo of a hammer, sun, and breasts in their works.

Kippenberger's cynical attitude was reflected in his sentiment that art is what you can get away with, and his work therefore criticizes both the art market and the traditional mechanisms of art production. His premature death truncated his prolific career, which was marked by his versatile style and controversial ideology. Regarded as an art world court jester, he is ultimately remembered as making a strong iconoclastic statement. **MG**

Masterworks

A Quarter of a Century. Kippenberger as One of You, Among You, With You 1978 (Tate Collection, London, England)

Kippenberger on the Theme of Fucking, Boozing and Selling 1982 (Tate Collection, London, England)

War Is Not Nice 1985 (Museum of Modern Art, New York, U.S.)

Self-Portrait 1988 (Saatchi Collection, London, England)

Martin, Stand in the Corner and Be Ashamed of Yourself 1990 (Museum of Modern Art, New York, U.S.)

Paris Bar Berlin 1993 (Saatchi Collection, London, England)

Balla Balla 1994 (Museum of Modern Art, New York, U.S.)

> "You really can't bring about anything new with art. I knew that already as a child."

ABOVE: Kippenberger carved himself a unique niche with his diverse body of work.

ANISH KAPOOR

Born: Anish Kapoor, March 12, 1954 (Mumbai, India).

Artistic style: Sculptor; large-scale, site-specific installations; early colored pigment floor pieces, and latterly objects that reflect the sky; themes of duality and metaphysics.

Masterworks

As If to Celebrate, I Discovered a Mountain Blooming with Red Flowers 1981 (Tate Collection, London, England)

Sky Mirror 2001 (Nottingham Playhouse, Nottingham, England)

Cloud Gate 2004 (Millennium Park, Chicago, Illinois, U.S)

Sky Mirror 2006 (Rockefeller Center, New York, U.S.)

In 1972 Anish Kapoor came to England to study art, first at Hornsey College of Art then Chelsea School of Art and Design. After completing his studies, he taught at Wolverhampton Polytechnic before becoming artist in residence at the Walker Gallery in Liverpool, after which he settled in London.

In the early 1980s, Kapoor emerged as one of a number of young British sculptors—including Richard Wentworth, Richard Deacon, and Bill Woodrow—who often exhibited at the Lisson Gallery, were heavily supported by the British Council, and worked in a new style that rapidly gained international recognition. As Kapoor's reputation grew, so did his ambition and the scale of his projects. In the early 1980s, he made works that were inspired by the mounds of brightly colored pigment he saw in Indian temples, such as *As If to Celebrate, I Discovered a Mountain Blooming with Red Flowers* (1981). To make these sculptures, Kapoor simply dusted intensely colored, powdered pigment over small forms placed onto the art gallery floor.

By the turn of the century Kapoor was working with more heavy-duty technology. *Marsyas* (2002), for example, is a large work made of steel and PVC that completely filled the Turbine Hall of the Tate Modern in London. He then exhibited a big mirrored sculpture, *Sky Mirror* (2006), at Rockefeller Center in New York. Rooted in metaphysics, the success of his later works lies in his ability to manipulate darkness, light, shadow, and reflection. As one of Britain's most influential sculptors, his reputation is international. Recent projects include a memorial to the British victims of 9/11 in New York and the design and construction of a subway station in Naples, Italy—both big commissions on a big scale. **SF**

"Work grows out of other work, and there are very few eureka moments."

ABOVE: Portrait of Anish Kapoor, photographed in October 2006.

RIGHT: *Cloud Gate* at Millennium Park has been nicknamed "The Electric Kidney Bean."

1950–59

MIKE KELLEY

Born: Mike Kelley, October 27, 1954 (Wayne, Detroit, Michigan, U.S.).

Artistic style: Scattershot and piecemeal multimedia installations with an interest in repressed memories and imposed nostalgia from beneath the U.S. mainstream; soft sculptures.

Masterworks

Monkey Island: Symmetrical Sets 1982–1983

Pay for Your Pleasure 1988

Half-a-Man; From My Institute to Yours 1988

Blackout 2001

A Continuous Screening of Bob Clark's film Porky's (1981), the Soundtrack of Which Has Been Replaced with Morton Subotnik's Electronic Composition "The Wild Bull," and Presented in the Secret Sub-Basement of the Gymnasium Locker Room 2002

Day Is Done (Extracurricular Activity Projective Reconstruction #2–#32) 2004–2005

Mike Kelley grew up in Detroit as part of a suburban music scene that spawned garage bands such as MC5. In 1973 he formed the experimental "antirock" noise band Destroy All Monsters before attending the California Institute of the Arts from 1976. His artistic practice has seen several projects in collaboration with other artists, such as Raymond Pettibon and Paul McCarthy, who share a sensibility littered with nostalgic irony, psychological repression, and pop cultural tatters.

Kelley uses a range of media in a practice that incorporates painting, sculpture, performance, writing, curating, and installations such as *Half-a-Man; From My Institute to Yours* (1988). In these, Kelley crudely invoked a subverted folk aesthetic involving copulating stuffed animals and rude felt banners alongside fetishistic craft sensibilities. Incorporating a bent for the multimedia, Kelley's installations have embraced the carnivalesque with music, shrieking voices, disco lights, and automated furniture.

His work is characterized by an impulsive obsession with regression and childhood. By using archives of source material such as high school yearbooks, Kelley examines the hallucinatory scraps of lost and heroic moments and restages them with an economy of sinister ritual. In this way, he accepts the contradictions of nostalgia as opposed to any inherent truth in it, highlighting society's compulsive approach to fantasy. The issue is further explored by video pieces where adults often play the roles of children, highlighting society's habitual projections onto teenage sexuality. Kelley challenges the legitimacy of values, such as those of the family, the church, and the school, by confronting them with the strangeness of their own presumptions. **EL**

" … a lot of '60s stuff recurs in my work … as a symbol of art's role as a means of sublimation."

ABOVE: Mike Kelley photographed at the George Pompidou Centre in 1999.

CINDY SHERMAN

Born: Cynthia Morris Sherman, January 19, 1954 (Glen Ridge, New Jersey, U.S.).

Artistic style: Photographer and filmmaker; conceptual self-portraits; known for her elaborately disguised self-portraits that comment on celebrity, social role playing, and sexual stereotypes.

Since the 1970s, many artists have worked with photography as a way of investigating the sincerity of the contemporary, image-dominated age. Cindy Sherman has explored methods of manipulation, both of photographic subjects and of photographs themselves, in order to comment on ways in which women are portrayed and perceived in contemporary society.

While growing up on Long Island, New York, Sherman was drawn to the television environment of the 1960s and fascinated by disguise and makeup. At college, she initially focused on painting until her photography tutor encouraged her to "just take pictures," and she soon found the immediacy of photography more appealing than painting.

Sherman's photographs are often black and white and are usually portraits of herself in situations that comment on clichéd female identities in the media. She draws her characters and settings from sources of popular culture, including old films, television, and magazines. Among 130 fake film stills taken between 1978 and 1980 are portraits of Sherman in the role of screen idols such as Sophia Loren and Marilyn Monroe. She said that this series was "about the fakeness of role playing as well as contempt for the domineering 'male' audience who would mistakenly read the images as sexy."

During the 1980s Sherman made oversize color prints, concentrating on lighting and facial expression, but soon began focusing on society's acceptance of perceptions of women. In the early 1990s, she re-created characters from Old Master paintings, appearing as grotesque creatures in period costume. Later that decade, using prosthetic appendages and copious amounts of makeup, she featured mutilated bodies to reflect concerns such as eating disorders, insanity, and death. **SH**

Masterworks

Untitled Film Still #6 1977 (Museum of Modern Art, New York, U.S.)

Untitled Film Still #15 1978 (Guggenheim Museum, New York, U.S.)

Untitled Film Still #13 1978 (Museum of Modern Art, New York, U.S.)

Untitled #224 1990 (Pulitzer Foundation for the Arts, St. Louis, Missouri, U.S.)

"I didn't want to make 'high' art, . . . I didn't want the work to seem like a commodity."

ABOVE: Sherman keeps an eye on style and celebrity at a New York fashion show in 2007.

KIKI SMITH

Born: Chiara Smith, January 18, 1954 (Nuremberg, Germany).

Artistic style: Feminist printmaker, sculptor, and bookmaker; expresses a personal approach to the human body through art making; uses a wide variety of materials; works range from monumental to miniature in size.

Masterworks

Tale 1992 (Private collection)

Lilith 1994 (Private collection)

Wolf Girl 1999 (Private collection)

Rapture 2001 (Private collection)

The daughter of minimalist artist Tony Smith, Kiki Smith came to prominence as an artist in the late 1970s. She was an active member of a New York artist cooperative group called Collaborative Projects Inc., which focused on community concerns as valid subject matter for art. Her varied body of work encompasses sculpture, printmaking, and bookmaking, and has an aesthetic that is symptomatic of both craft-based and conceptual art techniques.

Smith's output challenges the status quo, for example the typically erotic values placed on the female body by dominant versions of art history. Her sculptural work requires viewers to defamiliarize themselves with their response to the human form by emphasizing the frailness and candor of the body as Smith sees it and asks viewers to see it in emotional terms by representing it in a state of fragmentation or "insideoutness."

Smith uses a significant variety of materials, such as bronze, paper, glass, and wax, and in their deployment questions the relative values placed on them by traditional art history. She also employs a variety of scales, ranging from the miniature to the monumental, and, although her work has no overt polemic or agenda, many pieces allow a metaphorical value to be conferred on or alongside any personal or formal reading, for example through the use of domestic materials and narrative tropes such as classical or folk tales. Continuing with art as a method to locate the self within the world, throughout the 1990s Smith's work continued as an idiosyncratic exploration into mankind's relationships with the environment and the cosmos, culminating in shamanistic prints of animals and sculptures that portray organs, cellular forms, and the human nervous system. **EL**

"Our culture seems to believe that it's entertaining to teach women to be frightened."

ABOVE: Kiki Smith, pictured here in 2006, is best known for her sculptures.

FRED WILSON

Born: Fred Wilson, 1954 (Bronx, New York, U.S.).

Artistic style: Reinstallation of museum collections; explores race, bias, aesthetics, and history; provocative juxtapositions; use of archival materials, furniture, glass, lighting, sculpture, sound, and video.

Winner of the MacArthur Fellowship "genius grant," U.S. conceptual artist Fred Wilson shocked the art establishment and catapulted to international stardom with his introduction of a new medium for the exploration of race in the United States—the art museum.

Wilson first gained critical acclaim with his groundbreaking exhibition *Mining the Museum* (1992), in which he reinstalled the Baltimore Historical Society's collection to construct a powerful, sobering interpretation of the history of slavery in the United States. In *Cabinetmaking 1820–1960* (1992), Wilson placed four elegant parlor chairs upon blood-red pedestals, facing a crude wooden whipping post, set before a blood-red wall. His genius lies in his ability to present museum objects in provocative juxtapositions to create startling new contexts for the consideration of "institutional biases, presentation techniques, and accepted versions of cultural history."

For the Venice Biennale, Wilson entitled his exhibition *Speak of Me As I Am* (2003), from William Shakespeare's *Othello* (1603), to give voice to the Africans depicted in Venetian paintings and sculptures. The most compelling piece was the *Chandelier Mori,* (2003) a huge seventeenth-century-styled Venetian chandelier made from black glass instead of the usual pastel Murano glass, to serve as a metaphor for the oppression of Africans throughout history. As the artist says, "I do jarring, upsetting things, like exhibiting slave shackles next to lavish silver museum pieces, but I try to ease people into these juxtapositions. I use beauty as a way of helping people to receive difficult or upsetting ideas. The topical issues are merely a vehicle for making one aware of one's own perceptual shift—which is the real thrill." **SA**

Masterworks

Guarded View 1991 (Whitney Museum of Art, New York, U.S.)

Mining the Museum 1992 (Contemporary & Maryland Historical Society, Baltimore, U.S.)

Re:Claiming Egypt: Fred Wilson 1992 (International Cairo Biennial, Egypt)

Viewing the Invisible: An Installation by Fred Wilson 1998 (Ian Potter Museum of Art, University of Melbourne, Australia)

Chandelier Mori 2003 (United States Pavilion 50th Venice Biennale, Italy)

Fred Wilson: Objects and Installations 1979–2000 2004 (Studio Museum in Harlem, New York, Chicago Cultural Center, Illinois, Center for Art and Visual Culture, University of Maryland, Baltimore, U.S.)

"I try to unlock the meanings of objects by juxtaposing and eliciting a conversation . . ."

ABOVE: Detail from a photograph of Fred Wilson taken by Kerry Ryan McFate.

JEFF KOONS

Born: Jeff Koons, January 21,1955 (York, Pennsylvania, U.S.).

Artistic style: Neo-pop works focusing on high and low culture, fame, and kitsch; celebration of mass-produced items such as basketballs, vacuum cleaners, and inflatable toys.

Masterworks

Inflatable Flower and Bunny 1979
(Private collection)

Hoover Celebrity III 1980 (Museum of Contemporary Art, Los Angeles, California, U.S.)

Three Ball Total Equilibrium Tank 1985
(Tate Collection, London, England)

Rabbit 1986 (Museum of Modern Art, Chicago, Illinois, U.S.)

Michael Jackson and Bubbles 1988
(San Francisco Museum of Modern Art, San Francisco, California, U.S.)

Pink Panther 1988 (Museum of Modern Art, New York, U.S.)

Puppy 1992 (Guggenheim Museum, Bilbao, Spain)

Balloon Dog (Magenta) 1994–2000
(Private collection)

Jeff Koons is the great enigma of contemporary art and a major influence on a younger generation of artists such as Damien Hirst. His opaque personality and his obsession with kitsch objects have created confusion about whether he is an ironic critic or a genuine fan of pop culture and consumerism.

Koons was precocious in his appropriation; at the age of eight, he signed his copies of Old Master paintings "Jeffrey Koons" and sold them in his father's shop. He graduated from the Maryland Institute College of Art in 1976 and then moved to New York, where he quickly established a reputation as a flamboyant salesman at the Museum of Modern Art's membership desk. Koons's art at this time was daring in its use of ready-made objects such as inflatable toys.

Koons came to epitomize the 1980s with his unabashed self-promotion and elevation of mass-produced items to art status in a variety of media. He famously made a series of vacuum cleaners encased in vitrines that were part of *The New Series* (1980–1983). In his series *Equilibrium* (1985), which included basketballs floating in tanks of water, creating the

ABOVE: Jeff Koon presents *Pink Bow* in 2003 at Galerie der Gegenwart, Germany.

RIGHT: Koons epitomized the eighties to superb effect in *Michael Jackson and Bubbles*.

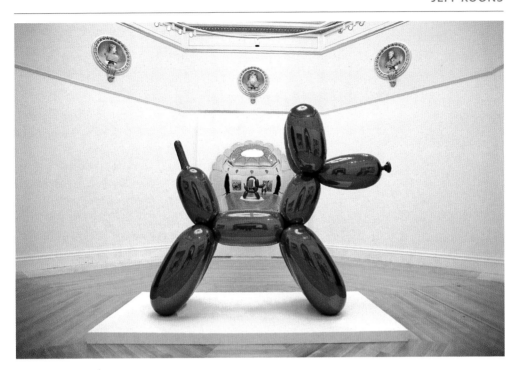

ABOVE: The highly polished finish of *Balloon Dog (Magenta)* adds to its obvious appeal.

illusion of time and motion paused, he continued to deal with iconic objects of U.S. culture. Throughout the 1980s, he took toys and other kitsch objects and turned them into stunning and immaculate large-scale sculptures in materials ranging from stainless steel to porcelain. In his *Banality* series (1988), he produced a life-size sculpture of Michael Jackson and his pet chimp Bubbles, raising issues of taste and celebrity.

In 1991 his notoriety increased when he married Italian porn star and member of parliament Ilona Staller. He first exhibited a controversial series titled *Made in Heaven* (1990–91), showing their relationship in sexually explicit detail, at the Venice Biennale. He received his greatest success, though, with *Puppy* (1992), a 43-foot-high (12 m) West Highland Terrier, which has been exhibited outside the Guggenheim Museum, Bilbao, since 1997. From the mid-1990s, he has focused on large-scale artworks that celebrate the inflatable world he so loves. **JJ**

Cute but not Cuddly

A 41-inch (104 cm) stainless steel rabbit is one of the iconic artworks of the 1980s. Nicknamed "The Brancusi Bunny," it reuses the inflatable rabbits of Koons's earlier work. The artist fuses minimalist sculpture with kitsch and perfect craftsmanship to create something that defies classification. Tension is added by the inflatable toy being cast in steel that resembles a shiny metallic balloon when highly polished. The mirrorlike surface also reflects the object's surroundings and the viewer. Koons's *Rabbit* has influenced artists such as Hirst and Gavin Turk, for example in Turk's bronze casts of trash bags.

1950–59

PEPÓN OSORIO

Born: Benjamin Osorio Encarnación, 1955 (Santurce, Puerto Rico).

Artistic style: Puerto Rican mixed-media artist; large-scale, flamboyant multimedia installations; commentary on cultural issues, including community, race displacement, empowerment, and loss.

Masterworks

La Cama (*The Bed*) 1987

El Chandelier (*The Chandelier*) 1988

100% Boricua 1991 (Walker Art Center, Minneapolis, Minnesota, U.S.)

En la barbería no se llora (*No Crying Allowed in the Barber Shop*) 1996 (Tyler Galleries, Temple University, Philadelphia, U.S.)

Las Twines 1998 (Storefront, South Bronx, New York, U.S.)

Tina's House 2000 (Home Visits)

My Beating Heart 2002 (Ronald Feldman Fine Arts, New York, U.S.)

Face to Face 2002 (Ronald Feldman Fine Arts, New York, U.S.)

Trials and Turbulence 2004 (Institute of Contemporary Art, Philadelphia, Pennsylvania, U.S.)

1950–59

"My principal commitment as an artist is to return art to the community."

ABOVE: Osorio's work has been greatly influenced by his Puerto Rican heritage.

Mixed-media artist Pepón Osorio moved to New York in 1975. Both his early exposure to the proud Puerto Rican culture and his work in the Bronx communities influence his art deeply.

Although his award-winning work has been exhibited in prestigious galleries from New York to South Africa, it is usually exhibited in local communities first. Installations are displayed in local shops, and his exhibition *Home Visits* (1999–2000) has gone one step further, by being displayed in various people's homes. Osorio's installations take the form of lavish large-scale collections of objects, linked by a central theme or emotion. They are often in the form of a colorful three-dimensional collage of seemingly inconsequential baubles or trinkets interspersed with video screens displaying random film clips.

These intricately built pieces deal with ownership, loss, and displacement. Notable examples include *100% Boricua* (1991), a contradictory collection of cheerful tourist souvenirs with statistics written over them detailing the real problems faced by immigrants; and *Tina's House* (2000), a tabletop representation of a collection of real possessions and trinkets that a family lost in a house fire. Osorio uses his art to make political statements. A repeated theme is the dispossession created when people are uprooted from one culture or situation to another, including tackling the impersonal way governments deal with issues such as immigration. These jumbled "sculptures," particularly those built out of real people's belongings or memories, have the power to evoke a range of strong emotions, from the melancholy of dispossession and loss to the recognition of hope, humor, and the strength of the human spirit. As Osorio says, " . . . what I wanted to do is to provoke change, not only socially but physically and spiritually." **JM**

ANDY GOLDSWORTHY

Born: Andrew Goldsworthy, July 25, 1956 (Cheshire, England).

Artistic style: British sculptor, photographer, and environmentalist; site-specific sculptures and land art using natural materials and a few rudimentary tools; works in the open air.

Since the mid-1970s, Andy Goldsworthy has been producing sculpture and land art in natural and urban settings. He has lived in Scotland since 1985. Most of his work is made in the open air: in Britain, Canada, Japan, the United States, the Australian outback, and the North Pole. With no preconceived ideas about what he will create, he relies on found objects such as flowers, twigs, icicles, leaves, sand, and stones, "feeling" nature's energy and turning it into art forms that emphasize the character of the environment. He often addresses issues of growth and decay, seasonal cycles, and the idea that art has a natural life cycle. Because of the transience of nature, Goldsworthy documents his works with photographs. **SH**

Masterworks

Sweet Chestnut, Autumn Horn 1986 (Yorkshire Sculpture Park, Wakefield, England)

Rowan Leaves Laid Around a Hole 1987 (Yorkshire Sculpture Park,Wakefield, England)

Storm King Wall 1997–1998 (Storm King Art Center, Mountainville, New York, U.S.)

Neuberger Cairn 2001 (Neuberger Museum of Art of the State University of New York at Purchase, U.S.)

CORNELIA PARKER

Born: Cornelia Parker, 1956 (Cheshire, England).

Artistic style: Sculptor and installation artist; themes of the potential of disused material and found objects, transience, memory, and associations; focus on minutiae and how it relates to the whole.

Sculptor and installation artist Cornelia Parker is known for installations that raise the notion of transience, such as *Cold Dark Matter: An Exploded View* (1991), which consists of the charred remains of a garden shed she had blown up by the British army. Parker suspended the fragments from a ceiling lit by a single lightbulb, as if they were captured at the point of detonation. Her work is also concerned with seeing the extraordinary in the ordinary, often using found and disused objects, or by transforming a preexisting object to challenge and change its meaning: for example, her collaboration with British actress Tilda Swinton, who slept inside a glass vitrine at the Serpentine Gallery for the piece *The Maybe* (1995). **CK**

Masterworks

Thirty Pieces of Silver 1988–1989 (Tate Collection, London, England)

Cold Dark Matter: An Exploded View 1991 (Tate Collection, London, England)

Object That Fell off the White Cliffs of Dover 1992 (Tate Collection, London, England)

Measuring Niagara with a Teaspoon 1997 (Tate Collection, London, England)

1950-59

CAI GUO-QIANG

Masterworks

Human Abode: Project for Extraterrestrials No. 1 1989 (Tama River and Kumagawa Shrine, Tokyo, Japan)

Project to Extend the Great Wall of China by 10,000 Meters 1993 (Jiayuguan City, China)

Service for the Biennale! 2001 (Venice, Italy)

Light Cycle: Explosion Project for Central Park, 2003 (Central Park, New York, U.S.)

Ye Gong Hao Long 2003 (Tate Collection, London, England)

Clear Sky Black Cloud, Transparent Monument, Nontransparent Monument, and Move Along, Nothing to See Here 2006 (Metropolitan Museum of Art, New York, U.S.)

Cai Guo-Qiang: I Want to Believe 2008 (Guggenheim Museum, New York, U.S.)

Born: Cai Guo-Qiang, December 8, 1957 (Quanzhou City, Fujian Province, China).

Artistic style: Installation artist; choreographed explosions using gunpowder; use of mixed media featuring feathers, roller coasters, life-size animal sculptures, glass, Chinese symbols, and vending machines.

Cai Guo-Qiang literally exploded onto the international art stage with *Human Abode: Project for Extraterrestrials No. 1* (1989), a series of spectacular "explosion events" produced for audiences outside China to protest against artistic and social oppression. Drawn to the spontaneous, violent, transformative, and ultimately ephemeral properties of gunpowder, Cai introduced the medium into his work as a dramatic contemporary metaphor for the artist as activist.

Now a prolific global phenomenon, Cai has expanded his conceptual and visual narrative to curating experimental social projects and creating site-specific installations and large-scale collaborative celebrations. **SA**

MIQUEL BARCELÓ

Masterworks

Pintor Damunt del Quadre 1982 (Museo Patio Herreriano de Valladolid, Valladolid, Spain)

Les Nourritures Terrestres 1986 (Museo Patio Herreriano de Valladolid, Valladolid, Spain)

Saison des Pluies No. 2 1990 (Fundació Museu d´Art Contemporani de Barcelona, Barcelona, Spain)

Sailing Against the Current 1991 (Private collection)

Des Portirons 1998 (Museo de Bellas Artes de Bilbao, Bilbao, Spain)

Born: Miquel Barceló i Artigues, 1957 (Felanitx, Mallorca, Spain).

Artistic style: Painter, sculptor, ceramist, collagist, and book illustrator; incorporation of earth, sand, and organic materials; dripping paint; themes of African culture.

Miquel Barceló's first contact with art was through his mother, who painted in the Mallorcan landscape tradition. He then studied art in both Palma de Mallorca and Barcelona. Barceló works across several disciplines, including sculpture, ceramics, collage, and book illustration, but he is most famous for his paintings that incorporate earth, sand, and organic materials.

Over the years Barceló has met some of the twentieth century's greatest artists, but the influence of Jackson Pollock has been the most profound. After seeing Pollock's work in 1979, he adopted Pollock's drip-paint technique. Since 1988 he has divided his time between Paris, Mallorca, and Mali, and his paintings often focus on African culture and landscapes. **CK**

FÉLIX GONZÀLEZ-TORRES

Born: Félix Gonzàlez-Torres, 1957 (Guaimaro, Cuba); died January 10, 1996 (New York, U.S.).

Artistic style: Conceptual artist; poetic use of everyday imagery and objects such as candies and clocks; installations involving the participation of the viewer.

Félix Gonzàlez-Torres studied at the International Center of Photography, New York University, and then joined a group of socially active artists known as Group Material. For the rest of his career he continued to make works that explored the interface between the public and the private. Yet the strength of his work lies in the fact that it is never entirely reducible to his politics, sexuality, or personal history. For example, his billboard piece *Untitled (Perfect Lovers)* (1992) consists of a monochrome photograph of two pillows, each fresh with the imprint of a person's head, and when it was shown across twenty-four billboards in New York, it struck a universally elegiac tone. **CS**

Masterworks

Untitled (A Corner of Baci) 1990 (Museum of Contemporary Art, Los Angeles, California, U.S.)

Untitled (Public Opinion) 1991 (Guggenheim Museum, New York, U.S.)

Untitled (Perfect Lovers) 1992 (Museum of Modern Art, New York, U.S.)

Untitled 1992–1993 (San Francisco Museum of Modern Art, San Francisco, California, U.S.)

LENNIE LEE

Born: Lennie Lee, March 4, 1958 (Johannesburg, South Africa).

Artistic style: Painter, photographer, and performance, video, and installation artist; use of discarded material in disused spaces; taboo themes such as incest, suicide, and death.

Lennie Lee moved to London when he was a child, and went on to study philosophy at Christ Church College, Oxford. In the 1980s he became interested in art, initially painting using a spray can. He then began to use objects found in disused spaces in London's East End to create site-specific installations. These were often temporary, such as his *Chariot of Death* (1986) that sat on a London street for a month. In 1991 he went to Berlin, where he became interested in performance art, and since then has worked across Europe. He developed an interest in the capacity of certain objects, such as bloodied tampons or putrid meat, to provoke revulsion and anger, and has explored taboo themes such as madness, incest, suicide, and death. **CK**

Masterworks

Chariot of Death 1986
Ode to the Goddess of the Rubbish Dump 1988
English Breakfast 2003
Which Tourist Attraction? 2003

1950–59

KEITH HARING

Born: Keith Haring, May 4, 1958 (Reading, Pennsylvania, U.S.); died February 16, 1990 (New York, U.S.).

Artistic style: Vibrant colors; cartoonlike figures; linear style; oversized, abstract sculptures; chalk subway drawings; dynamic, graphic patterns; public murals.

Masterworks

Subway Drawing 1980–1981 (Hyde Collection, Glens Falls, New York, U.S.)

Untitled 1982 (Student Union Collection, Wake Forest University, North Carolina, U.S.)

Andy Mouse 1985 (Keith Haring Foundation, New York, U.S.)

Crack Is Wack 1986 (Crack Is Wack Playground, Harlem, New York, U.S.)

Berlin Mural 1986 (Now destroyed) (Berlin Wall, Germany)

Acrobats 1986 (Keith Haring Foundation, New York, U.S.)

Skateboards 1986 (Keith Haring Foundation, New York, U.S.)

Pop Shop Poster 1986 (Keith Haring Foundation, New York, U.S.)

Untitled (Figure on Baby) 1987 (National Gallery of Canada, Ottawa, Canada)

Boxers 1988 (Daimler Chrysler Collection, Berlin, Germany)

Like many other famous twentieth-century artists, Keith Haring began his artistic career in New York and studied at the School of Visual Arts. It was during this period that the young artist discovered graffiti art in the streets, subways, and underground clubs of the city. Drawn to this alternative scene, he became friends with Kenny Scharf and Jean-Michel Basquiat, exchanging ideas and participating in exhibitions and performances.

In 1980, Haring began drawing in the city's subway stations with plain white chalk on empty black advertising panels. He quickly developed a unique and distinctive style, using very simple settings populated with cartoonlike figures and forms. One of Haring's most famous characters, "The Radiant Baby," appeared during this time. Inspired by this new medium, Haring sometimes created nearly forty new subway drawings per day. The underground spaces became a laboratory for his ideas and experiments.

Haring's ephemeral graffiti works in the New York subways catapulted the young artist to fame. He began working in acrylic, marker ink, and Day-Glo paint, creating brightly colored canvases peopled with outlined figures and exuberant patterns.

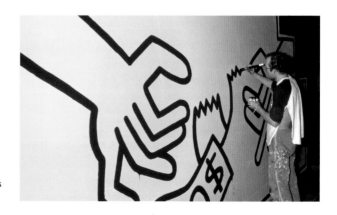

ABOVE: Detail from a photograph taken by Alen MacWeeney in 1986.

RIGHT: Keith Haring was one of the pioneers of the urban graffiti wall art genre.

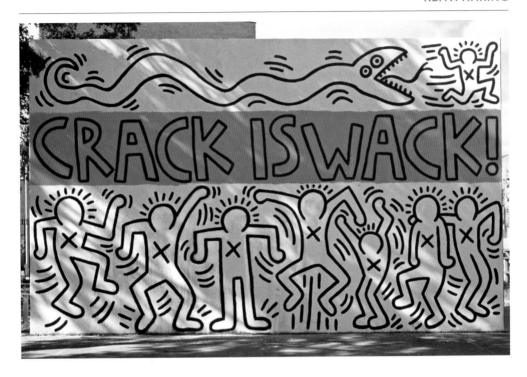

He also explored the medium of sculpture, painting over existing objects and producing his iconic characters in three dimensions. He had two successful solo exhibitions in the early 1980s and went on to participate in Documenta 7, the São Paulo Biennial, and the Whitney Biennial. The artist also busied himself with animation work for the Spectacolor billboard in Times Square and community projects with inner-city youth. He contributed to commercial projects for Swatch and Absolut vodka and worked on commissions for dozens of public murals.

Throughout his short but explosive career, Haring strove to tear down the barriers between high and low art. He hoped to make his work as accessible as possible to the public. In 1986, the artist opened his Pop Shop in Soho, inviting the community to share in the joy of his work outside of a gallery context. Diagnosed with AIDS in 1988, he established the Keith Haring Foundation to raise awareness of the disease. **NSF**

ABOVE: *Crack Is Wack* is an uplifting piece of public art for the youth of Harlem.

Crack Is Wack Mural

Troubled by a friend's drug addiction, Keith Haring decided to paint his *Crack Is Wack* (1986) mural. He chose the wall of a handball court in a playground adjacent to Harlem River Drive, envisioning the space as an attention-grabbing billboard. Haring painted the wall in bright orange with his trademark figures outlined in black. He wrote "Crack is Wack" in huge letters across the composition, speaking out against the crack epidemic raging through the inner-city neighborhoods. Initially fined $25 for his "act of graffiti," Haring was later invited to return and complete the mural.

1950–59

MARK WALLINGER

Born: Mark Wallinger, 1959 (Chigwell, Essex, England).

Artistic style: Painter, sculptor, and installation artist; intelligent, thoughtful Young Briitish Artist whose strength is quite possibly his scope; Britain's only serious public artist.

Masterworks

Half-Brother (Exit to Nowhere—Machiavellian) 1994–1995 (Tate Collection, London, England)

Ecce Homo 1999

Ghost 2001 (Tate Collection, London, England)

Sleeper 2004 (Tate Collection, London, England)

State Britain 2007 (Tate Collection, London, England)

"I wanted to make something visible that had been rendered invisible . . ."—on *State Britain*

ABOVE: Detail from a photograph taken by Nils Jorgensen in January 2007.

RIGHT: The stainless steel *Time and Relative Dimensions in Space* (2001).

The rewardingly difficult to pin down Mark Wallinger first emerged on the art scene as a painter but quickly moved on to build a reputation as a conceptual artist and maker of installations, videos, and sculpture. He was branded a Young British Artist and launched into the public eye by collector Charles Saatchi in 1993 as a result of his inclusion in the first of a series of shows held at the Saatchi Gallery in London.

Wallinger first studied painting at London's Chelsea School of Art and then earned a master of arts at Goldsmiths College. He is a man interested in art, sports, horse racing, and politics. Since the mid-1980s, he has chosen to focus his work on the "politics of representation and the representation of politics."

In his early career, Wallinger began making paintings about the bloodlines of racehorses and the urban homeless. More recently, he has tackled issues related to nationalism and religion. For example, *Ecce Homo* (1999) is a life-size Christ figure crowned with thorns made of barbed wire. The work was temporarily exhibited on the fourth plinth in London's Trafalgar Square. Wallinger also re-created British peace campaigner Brian Haw's Parliament Square protest. *State Britain* (2007) is a life-size reconstruction of Haw's campaign site; it consists of 600 meticulous copies of Haw's banners, photographs of atrocities, peace flags, and messages from well-wishers, arranged just as Haw had originally placed them on the grass before the Houses of Parliament.

Wallinger represented Britain at the Venice Biennale in 2001 and was short-listed for the Turner Prize in 1995, but it was not until 2007 that he was finally awarded the Turner Prize for his installation *State Britain*. **SF**

PETER DOIG

Born: Peter Doig, 1959 (Edinburgh, Scotland).

Artistic style: Painter of vast atmospheric landscapes; intense, hallucinatory color palette; timeless and ethereal scenes that appear both familiar and strange; haunting stillness.

Masterworks

Ski Jacket 1994 (Tate Collection, London, England)

Echo Lake 1998 (Tate Collection, London, England)

Gasthof zur Muldentalsperre 2000–2002 (Art Institute of Chicago, Chicago, U.S.)

100 Years Ago (Carrera) 2001 (Musée National d'Art Moderne, Centre Pompidou, Paris, France)

Grande Riviere 2001–2002 (National Gallery of Canada, Ottawa, Canada)

Lapeyrouse Wall 2004 (Museum of Modern Art, New York, U.S.)

Peter Doig came late to painting yet emerged as a leading figure of the British art scene in the 1990s, creating a sense of excitement around landscape painting when the slick, conceptual art of the Young British Artists was in vogue. His idiosyncratic, folksy aesthetic of brightly colored, layered surfaces and representational, even romantic, subjects of snowy mountainsides and empty dwellings in wooded enclaves won him international acclaim.

Doig finds inspiration in an eclectic archive of images. Snapshots, photographs from newspapers, postcards, and album covers are sampled and combined, triggering memories or sensations that take him to another reality where, through the process of painting, invention takes over. The vast, disquieting *Echo Lake* (1998) is distilled from a photograph he took of the cult horror film *Friday the 13th* (1980). A palpable sense of absence intensifies an ethereal quality in his work and compels the viewer to scan scenes for clues to a narrative that might lurk within its depths. His work oscillates between fantasy and reality. Deceptively simple subjects such as buildings, shorelines, and leisure pursuits are given ambiguous edge through reframing, toxic coloring, or epic scale. Costume transports the imagination, too. In *Gastof zur Muldentalsperre* (2000–2002), the curious couple hover in the middle ground as if from another time. This sense of transition is a palpable thread throughout his work, as is the idea of journeying, both geographically and mentally. Regardless of subject, Doig's rigorous attention to the picture surface, with its blobs, drips, and washes of paint, continually displaces the viewer's gaze and underpins one of the most innovative practices of his generation. **RT**

> "Often I am trying to create a 'numbness'… something that is difficult to put into words."

ABOVE: Detail from a photograph taken in January 2008 by Richard Saker.

COCO FUSCO

Born: Coco Fusco, 1960 (New York, New York, U.S.).

Artistic style: Writer, performance and video artist; use of large-scale projections, the Internet, and closed-circuit TV; explorations of globalization, race, gender, and sexuality.

Born in the United States to a Cuban family, Fusco's roots led her to examine issues of race, gender, and the disenfranchised. Her collaborative video performance with artist Guillermo Gomez-Pena, *The Couple in the Cage* (1993), saw the pair live in a golden cage for three days, acting as Amerindians from a supposedly undiscovered island in the Gulf of Mexico. It simultaneously touches on the concept of the noble savage, depictions of race in the media, and how globalization affects ethnic cultures. With later videos such as *a/k/a Mrs. George Gilbert* (2004) and *Operation Atropos* (2006), she moved on to using the documentary form to illustrate how the media portrays social issues and to challenge its point of view. **CK**

Masterworks

The Couple in the Cage 1993 (Video)

Pochonovela: A Chicano Soap Opera 1996 (Video)

a/k/a Mrs. George Gilbert 2004 (Video)

Operation Atropos 2006 (Video)

NEO RAUCH

Born: Neo Rauch, 1960 (Leipzig, Germany).

Artistic style: New Leipzig school painter; large-scale paintings influenced by surrealism and social realism; narrative themes of personal history and life under communist rule.

Painter Neo Rauch grew up in communist-ruled East Germany. His large-scale, rough-surfaced, acidic-colored, almost fantastic paintings populated by workers, jugglers, and hybrid animals have drawn comparison to Giorgio de Chirico and René Magritte. But Rauch's work is also resonant with his own past because he appears to plunder the style of Soviet-style posters and murals, giving his work a social realist feel, as his subjects seem to wander alienated and disillusioned among the illogical architectural landscape of the failed utopia he depicts. Rauch portrays the dislocation of his native country and its people as they shift from workers in a totalitarian state to consumers in Western society. **CK**

Masterworks

Der Pate 2005 (David Zwirner Gallery, New York, U.S.)

Die Fuge (The Fugue/The Gap) 2007 (David Zwirner Gallery, New York, U.S.)

Para 2007 (David Zwirner Gallery, New York, U.S.)

MAURIZIO CATTELAN

Born: Maurizio Cattelan, January 6, 1960 (Padua, Italy).

Artistic style: Italian sculptor and performance artist; witty, ironic humor; satiric jibes at the establishment, whether that be religion, politics, social activities, or the art world.

Masterworks

Stadium 1991 (Galleria Massimo de Carlo, Milan, Italy)

—76.000.000 1992 (Saatchi Gallery, London, England)

Bidibidobidiboo 1996 (Laure Genillard Gallery, London, England)

The Ninth Hour 1999 (Kunsthalle, Basel, Switzerland)

Him 2001 (Faergfabriken Center for Contemporary Art and Architecture, Stockholm, Sweden)

Ave Maria 2007 (Tate Collection, London, England)

When asked in a 2004 interview to describe his artistic style, sculptor and performance artist Maurizio Cattelan's reply was: "Lazy." The ironic response was in keeping with the subversive nature and dark humor of his oeuvre. Some critics have drawn comparisons between the artist and the Dadaists and others with Joseph Beuys, yet Cattelan's work almost defies definition.

His work is art that often verges on absurd comedy. In 1998, he commissioned an actor to don a cartoonlike mask of Pablo Picasso to greet visitors to New York's Museum of Modern Art, as if they were arriving at a theme park rather than a museum of contemporary art. This sense of satiric wit is what most defines his style: a talent with which he lampoons the establishment, whether that be religion, a soccer league, politics, the art world, or notions of history.

Cattelan spares no one and nothing in his desire to provoke the viewers into challenging their opinions and perceptions. His apocalyptic *The Ninth Hour* (1999) depicts a realistic figure of the late Pope John Paul II lying on the ground, struck drown by a meteorite. It takes on an important feature of Italian culture, the Roman Catholic Church. The ultimate ready-made and a comment on capitalism, *—76.000.000* (1992), is a safe that was broken into and from which 76 million lire was stolen. *Him* (2001) is a miniature figure of Adolf Hitler kneeling in prayer and alludes to the Führer's Roman Catholicism. The 22-foot-long (7 m), eleven-a-side soccer machine *Stadium* (1991) takes a sideswipe at the Italian national obsession with soccer and at its corruption.

> "I wanted to become a designer, but I wasn't smart enough."

Often shocking, always amusing, and frequently perceptive, perhaps Cattelan is more of a jester in the tradition of *commedia dell'arte* than an artist who belongs to a movement. **CK**

1960–69

ABOVE: This photograph of Maurizio Cattelan was taken in 1999.

TRACEY MOFFATT

Born: Tracey Moffatt, November 12, 1960 (Brisbane, Australia).

Artistic style: Film and photographic work with powerful, if unconventional, narrative structure; sophisticated manipulation of media images to deconstruct culturally received meaning.

Born to an Aboriginal mother and raised by a white family, Tracey Moffatt resists the label of "Aboriginal artist." Her films and photographic series explore the Aboriginal experience in Australia but also the nonracially specific experience of contemporary Western culture. She has, for instance, explored issues of prejudice, colonial oppression, and the marginalization of Aboriginal people: "tragic, funny tales of childhood [based on] true stories . . . told to me by friends" are explored in her *Scarred for Life* (1994) and *Scarred for Life II* (1999) series. Moffatt's highly stylized work, nearly always narrative in structure, draws upon high art, popular culture, and the vernacular. She is arguably Australia's most successful international artist. **JR**

Masterworks

Nice Coloured Girls 1987

Night Cries: A Rural Tragedy 1989

Something More 1989

Bedevil 1993

Scarred for Life 1994

Heaven 1997

Up in the Sky 1998

Scarred for Life II 1999

Innovations 2000

Fourth 2001

Under the Sign of Scorpio 2005

Portraits 2007

GRAYSON PERRY

Born: Grayson Perry, 1960 (Chelmsford, Essex, England).

Artistic style: Sculptor and photographer; classically shaped ceramics painted with explicit imagery; narratives of war, sex, violence, and autobiography; themes of social criticism.

Grayson Perry's cross-dressing has almost come to overshadow the superb quality of his work as a ceramist, yet it is his take on the classical pot that he will best be remembered for and that won him the Turner Prize in 2003. Perry's shimmering pots are opulently painted and meticulously crafted with photo transfers and glazes. From far away, they appear to be brightly colored vases. Only with closer scrutiny is their unconventional imagery revealed, perhaps a narrative of the horrors of war, child abuse, or sadomasochism. Perry's ability to take humdrum items and raise them beyond craft objects to works of art, packed with satiric comment on society's underbelly, is witty, challenging, and often shocking in its poignancy. **CK**

Masterworks

My Gods 1994 (Tate Collection, London, England)

We've Found the Body of Your Child 2000 (Saatchi Gallery, London, England)

Defenders of Childhood 2000 (Saatchi Gallery, London, England)

Aspects of Myself 2001 (Tate Collection, London, England)

Cuddly Toys Caught on Barbed Wire 2001 (Saatchi Gallery, London, England)

Over the Rainbow 2001 (Saatchi Gallery, London, England)

Saint Claire 37 Wanks Across Northern Spain 2003 (Saatchi Gallery, London, England)

1960–69

Portrait (Fall 11)

VIK MUNIZ

Born: Vik Muniz, 1961 (San Paulo, Brazil).

Artistic style: Unorthodox materials such as chocolate sauce and dust; appropriated images from art-historical references and popular culture; photographic representations.

Masterworks

Equivalent (Dürer's Praying Hands) 1993 (Museum of Fine Arts, Boston, U.S.)

Action Photo I (After Hans Namuth) 1997 (Victoria & Albert Museum, London, England)

Individuals 1998 (Metropolitan Museum of Art, New York, U.S.)

Medusa Marinara 1997 (Art Institute of Chicago, Chicago, U.S.)

Milan, The Last Supper (From Pictures of Chocolate) 1997 (Museum of Contemporary Art, San Diego, U.S.)

Narcissus, after Caravaggio 2005 (Museum of Modern Art, New York, U.S.)

Richard Serra, Prop, 1968 . . . (Picture of Dust) from *Pictures of Dust* 2000 (Art Gallery of New South Wales, Sydney, Australia)

Vik Muniz is an amalgam of painter, photographer, and jokester. Originally from Brazil, he moved to New York in 1983 where he became interested in how cultural imagery is represented and reproduced. Muniz is best known for reconstructing preexisting images and artworks. He draws his subjects from a culture governed by media and technology, invoking a consciousness about innate recollection, recognition, and perception.

To achieve his illusion, he paints, draws, and sketches with unconventional materials, including chocolate, ketchup, cotton, sequins, dust, soil, and industrial trash. His use of rudimentary, organic media makes his works whimsical and capricious. He also manipulates scale as a deceptive device in his reinvention of the original reference. The finished product is a photograph capturing the fresh likeness in a new form. Muniz has appropriated the famed photograph of Jackson Pollock painting in his studio in chocolate sauce and has recreated Andy Warhol's double image of Mona Lisa in peanut butter and jelly. He has also commissioned skywriters to replicate fake cloud forms and reproduced works from the Whitney Museum collection in dust that he collected from the site. Throughout his career, Muniz has explored the relationship between visceral expectations and visual reality by examining the praxis of traditional representational art. He further blurs the line between what people perceive and what exists by tackling the true sensibility of a photographic image. The ultimate effect of this multitiered approach induces the audience to question and consider the formation of optical memories. Regardless of whether he references an art-historical image or a famous cultural emblem, his witty work is never what it initially appears to be. **MG**

"If nobody ever saw what everyone remembers, what are those memories made of?"

ABOVE: Detail from *Self-Portrait (Fall 2)* which was made as part of a series in 2005.

PIERRE HUYGHE

Born: Pierre Huyghe, 1962 (Paris, France).

Artistic style: Use of film, video, sound, animation, and architecture in a varied catalog of works examining media and reality with emphasis on the freedom of thought.

Pierre Huyghe studied at the École Nationale Supérieure des Arts et Metiers in Paris. His original and dynamic art explores the notions of reality and fiction in the digital age. He uses a wide range of media to express his ideas, ranging from film and video installations to public events, including such works as a puppet theater and a recorded expedition to the Antarctic. In *The Third Memory* (1999), he examines the nature of fiction and specifically the cinema's capacity to distort memory and blur the boundaries of reality, suggesting that narrative form can be as tangible as any other life experience. Huyghe has won a number of awards and honors, including the fourth biennial Hugo Boss Prize from the Guggenheim Museum in 2002. **KO**

Masterworks

The Third Memory 1999 (Musée National d'Art Moderne, Centre Pompidou, Paris, France)

Even More Real Than You 2001 (Marian Goodman Gallery, New York, U.S.)

Streamside Day Follies 2003 Dia Center for the Arts, New York, U.S.)

This Is Not a Time for Dreaming 2006 (Marian Goodman Gallery, New York, U.S.)

Celebration Park 2006 (Tate Collection, London, England)

SARAH LUCAS

Born: Sarah Lucas, 1962 (London, England).

Artistic style: Visual and linguistic puns; cheeky, crude sense of humor; often uses everyday objects in her work to playful and unsubtle effects; more serious works deal with feminist themes.

After graduating from Goldsmiths College in London in 1987, Sarah Lucas showed at the Freeze (1988) exhibition. Lucas's entry was not well received, prompting her to temporarily stop making art. It was not until 1992 that she had her first major show and began to establish herself as a key figure in the British art scene of the 1990s. Lucas has since enjoyed global success with works that are often an amalgamation of everyday objects and materials such as furniture, cigarettes, and food used to represent human forms reduced to sexual organs with humorous effect. This playful element in Lucas's work is married with more serious feminist concerns, such as the sexual objectification of women in British tabloid newspapers. **WD**

Masterworks

Two Fried Eggs and a Kebab 1992 (Saatchi Collection, London, England)

Au Natural 1994 (Saatchi Collection, London, England)

Fighting Fire with Fire 1996 (Tate Collection, London, England)

Bunny 1997 (Murderme, London, England)

Chicken Knickers 1997 (Tate Collection, London, England)

Eating a Banana 1999 (Tate Collection, London, England)

Self-Portrait with Fried Eggs 1999 (Tate Collection, London, England)

Nobby 2000 (Sadie Coles HQ, London, England)

Mary 2004 (Private collection)

1960–69

JOHN CURRIN

Born: John Currin, 1962 (Boulder, Colorado, U.S.).

Artistic style: Painter; large-breasted women; art-historical references; caricature and distortion; kitsch, vintage pinups; mannerism; political incorrectness; portraits of couples; retro detail.

Masterworks

Bea Arthur Naked 1991 (Private collection)

Ms Omni 1993 (Private collection)

*The Wizard c.*1994 (Tate Collection, London, England)

Heartless 1997 (Private collection)

The Pink Tree 1999 (Hirshhorn Museum and Sculpture Garden, Smithsonian Institution, Washington, D.C., U.S.)

Fishermen 2000 (Private collection)

Lovers 2000 (Private collection)

Park City Grill 2000 (Walker Art Center, Minneapolis, U.S.)

Stamford After-Brunch 2000 (Gagosian Gallery, International Locations)

Thanksgiving 2003 (Tate Collection, London, England)

> "The subject of a painting is always the author, the artist."

ABOVE: The "irresistible" works of John Currin attract much media attention.

John Currin is one of the most important and controversial artists of his generation and has become known as the pinup boy of a post politically correct art world. His meticulous paintings, which are exquisite in detail and reference realist artists ranging from Lucas Cranach to Édouard Manet, revel in the technical challenges of rendering different surfaces. By combining confrontational subject matter with a defiantly old-fashioned devotion to his medium, Currin has administered a double blow to the taboos of contemporary art.

Currin studied art and graduated from Yale University in 1986. At that time, painting was being viewed as a somewhat reactionary practice in comparison to the more "modern" media of video, photography, and installation. Currin remained faithful to painting and his first show, of caricatured aging society women, at the Andrea Rosen Gallery in 1992, was deliberately provocative, both in style and content.

Following accusations of sexism, the artist responded provocatively by painting images of absurdly large-breasted women in situations of clichéd male fantasy. These works create an ironic playfulness by mixing art-historical references with images from porn magazines or satiric portrayals of bourgeois society. Currin has an uncanny ability to produce images that look familiar but are, in fact, amalgams of different sources. Although his pictures are not self-portraits, Currin says he identifies with his subjects' desires, hopes, and fears. He has commented, "My work is never a desire to counter the prevailing notion. It may turn out that way (e.g. politically), but it is always how I felt at the time."

Currin's oeuvre is wide; he has painted sometimes disturbing versions of portraits, genre scenes, still lifes, and nudes. In 2001

1960–69

he used a live model for the first time, and in 2002 he created his first portrait from life, a picture of his wife, the sculptor Rachel Feinstein. Although this is the only piece of his art that is directly named after Feinstein, much of his work is considered to be inspired by her or at least to be derived from her likeness.

In 2003, Chicago's Museum of Contemporary Art initiated a midcareer survey of Currin's work that traveled to the Serpentine Gallery in London and to the Whitney Museum of American Art in New York.

Currin's paintings returned to contentious subject matter in 2006 with erotic paintings derived from Old Master portraits, 1970s *Playboy* magazine advertisements, and mid-twentieth-century films. Once again, his queasy use of retro images combined with techniques and compositions from high art left critics praising Currin's ability to evade categorization. **JJ**

Politically Correct?

Currin sometimes makes politically incorrect statements and other times denies his work is sexist. He described his first show at Andrea Rosen Gallery as "paintings of old women at the end of their cycle of sexual potential . . . between the object of desire and the object of loathing." Kim Levin, a critic for the *Village Voice*, responded by writing: "Boycott this show." In 2002 Currin said, "My most sexist-looking paintings are in fact the most anti-male . . . if I could ever bring myself to paint men, they would be big and ugly and abject." He defends himself by ridiculing his own masculinity.

1960–69

TAKASHI MURAKAMI

Born: Takashi Murakami, 1962 (Tokyo, Japan).

Artistic style: Clear, linear, colorful characters and warped imagery inspired by Japanese animation art; oversized sculptures based on *anime* figures; Louis Vuitton monogram paintings.

Masterworks

And Then, and Then and Then and Then and Then 1994 (Queensland Art Gallery, Brisbane, Australia)

My Lonesome Cowboy 1998

Untitled 2000 (Ackland Art Museum, Chapel Hill, North Carolina, U.S.)

Smooth Nightmare Drawing 2000 (Deutsche Bank Collection, Museum Moderne Kunst, Passau, Germany)

Jellyfish Eyes 2002 (Museum of Contemporary Art, Chicago, Illinois, U.S.).

Army of Mushrooms c.2003 (Frank Cohen Collection, Manchester, England)

727 2003 (Edition of 300) (Augen Gallery, Portland, Oregon, U.S.)

Takashi Murakami was pursuing a doctorate at the Tokyo National University of Fine Arts and Music when he became interested in the *otaku* culture of Japan. Turning from *nihonga*, a nineteenth-century hybridization of Western painting with traditional Japanese materials, techniques, and conventions, Murakami immersed himself in the fantastic, frequently apocalyptic storylines of *manga* and *anime*. His concerns with *otaku* culture and its problematic connections with postwar Japanese society led to the creation and development of the artist's signature "superflat" style. Elaborated in 2000, this theory draws links between the flat planes of traditional Japanese painting and the dissolution of boundaries between high and low art in Japan. Superflat echoes *manga* and *anime* and comments upon issues rampant in Japanese society: rabid and shallow consumerism, the mindless Westernization of culture, and unbridled sexual fetishism.

Murakami founded the Hiropon (Tired Hero) factory in 1996, registering it as Kaikai Kiki Company Ltd. in 2001. The modern descendant of Andy Warhol's Factory, Kaikai Kiki employs more than 100 artists in Japan and the U.S. Murakami conceptualizes his work, and his assistants create a finished product. The factory produces sculptures, paintings, prints, videos, T-shirts, key chains, and plush dolls. Recurring motifs and characters, such as disembodied eyes, psychedelic mushrooms, laughing flowers, and the grinning Mr. DOB (a play on *dobojite/doshite*, the Japanese for "why?"), conjure a hallucinogenically demented vision of society. In 2003, Murakami designed the Monogram Multicolore range of handbags and other accessories with Marc Jacobs for the French fashion house Louis Vuitton. **NSF**

> "I wanted to [be an animator], but I gave up the idea because I don't have the talent."

ABOVE: Murakami at the *Little Boy* exhibition, which he curated, in 2005.

NAO BUSTAMANTE

Born: Nao Bustamante, 1963 (San Joaquin Valley, California, U.S.).

Artistic style: Performance artist; performance art, sculpture, installation, and video; provocative and humorous performances that tackle social conventions and rituals.

A graduate of the San Francisco Art Institute, Nao Bustamante's work is usually provocative, sometimes controversial, and always humorous. It encompasses performance, sculpture, installation, and video, and sometimes a mix of these. The voluptuous artist plays imaginary roles—occasionally in the nude—from the high-heeled archetype of a blonde sex-kitten and beauty pageant queen in *America, the Beautiful* (2002) to stunt exhibitionist in her playful efforts to challenge patriarchal norms. Her best-known work is the performance *Indigurrito* (1992), where she strapped a burrito to her loins and called for white men to come up on stage, take a bite from the burrito, and absolve themselves of 500 years of white man's guilt. **CK**

CLAUDE CLOSKY

Born: Claude Closky, 1963 (Paris, France).

Artistic style: Maker of auto-critical lifestyle productions; uses the logic and techniques of advertising and art-historical tropes; repetition of variants; plays with codes and hierarchies.

Claude Closky uses the logic and techniques of advertising and stretches them to breaking point. He proffers the viewer or subject a tantalizing sense of fake release from the everyday, making evident the general codes and hierarchies that mediate one's existence as a presumed consumer, as seen in his museum tickets, wallpaper, and fridge magnets for the Centre Georges Pompidou in Paris. He uses perfect and self-perpetuating rules or systems and delights in the remorseless repetition of variants. Closky's work also uses art-historical tropes of minimalism and conceptual art through books, text pieces, videos, and websites—both a celebration and criticism of mass communication and lifestyle consumption. **EL**

1960–69

TRACEY EMIN

Born: Tracey Emin, 1963 (Croydon, England).

Artistic style: Young British Artist; paintings, drawings, photography, installations, and video; use of text and appliquéd fabrics; confessional, intimate autobiographical themes; witty and irreverent.

Masterworks

Everyone I Have Ever Slept With from 1963–1995 1995 (Destroyed)

Why I Never Became a Dancer 1995 (Hamburger Kunsthalle, Hamburg, Germany; Neue Nationalgalerie, Berlin, Germany; Sammlung Goetz, Munich, Germany; Stedelijk Museum, Amsterdam, the Netherlands; Tate Collection, London, England)

Fantastic to Feel Beautiful Again 1997 (Museum of Contemporary Art, San Francisco, California, U.S.)

My Bed 1998 (Saatchi Collection, London, England)

The Last Thing I Said to You Is Don't Leave Me Here I 2000 (National Portrait Gallery, London, England)

Hate and Power Can Be a Terrible Thing 2004 (Tate Collection, London, England)

"For me, being an artist isn't just about making nice things . . . [it's] a message."

ABOVE: The life and works of Tracey Emin frequently attract media attention.

Tracey Emin lives and works in London; her work consists of paintings, drawings, photography, installations, and video. Using a wide range of media, including appliquéd fabrics, found objects, monoprints, and neon lights, her works communicate her emotions and details of her life, following in the tradition of artists such as Frida Kahlo. Raised in Margate, Kent, Emin suffered many traumatizing misfortunes and losses in her youth, and her work is often seen to be a way in which the artist deals with such pain. Indeed, Emin has studied and produced art since she was young, attending Maidstone Art College before moving to London to complete a master of arts at the Royal Academy of Arts in 1987.

In 1993, Emin sent letters asking people to invest £20 in her creative potential. One of those to reply was Jay Jopling, who later became her art dealer. He offered her a show at his groundbreaking gallery in London, White Cube. Emin ironically called the exhibition *My Major Retrospective* (1994) and used the opportunity to reveal her personal life to the public domain, exhibiting a range of works and memorabilia that referenced her past. The artist quickly became associated with many of her contemporaries who were referred to by the media as Young British Artists (or YBAs). She then opened The Tracey Emin Museum in Waterloo in London, welcoming the public to view intimate works, until it closed in 1998. The following year she was nominated for the Turner Prize for a piece entitled *My Bed* (1998). It consists of an unmade bed, littered with items such as soiled underwear, empty liquor bottles, and used condoms. Emin has since come to occupy a position in both the art world and mass media as an artist and a celebrity. **WD**

SHAHRAM ENTEKHABI

Born: Shahram Entekhabi, 1963 (Beroujerd, Iran).

Artistic style: Politically motivated; use of video art, photography, painting, drawings, installation, and performance art to highlight Middle-Eastern diaspora in the Western world.

Shahram Entekhabi has gained international recognition for his themes of invisibility and visibility and the alienation of ethnic minorities in contemporary culture. His work represents marginalized groups such as migrant communities, and he examines alternatives to Western ideology.

Inspired by the work of Charles Baudelaire and specifically his nineteenth-century concept of the *flâneur* (a person who walks the city in order to experience it), Entekhabi's work employs performative practices, digital media, and drawings as a platform for rejecting the notion that the urban space is specifically reserved for the practice and performance of the white, middle-class, heterosexual male.

He studied graphic design at the University of Tehran from 1976 to 1979, and went to Italy to study architecture, urbanism, and the language. From 1983 to 2000, he worked as a freelance architect in Berlin, but in 2001 he began to concentrate on his work as a media artist. He started to produce video art and installations with works such as *I?* (2004) that challenge the clichéd Western notion of typical migrant behavior.

Entekhabi is particularly concerned with addressing issues between secular governments and Muslim communities. He focuses on the dominant ideas surrounding Middle Eastern behavior, that men are presented as fundamentalist aggressors and women seen as oppressed. *Islamic Vogue* (2001–2005) is an example of his use of provocative and striking photography to question Western ideals of femininity. By utilizing the discourse of art to question these dominant notions, he also addresses the contemporary anxieties toward terrorism and the perceived threat of the Middle East toward the West. **KO**

Masterworks

Islamic Vogue 2001–2005
me? 2003–2004
Migrant 2004
I? 2004
mladen 2005

"Part of my work relates to the viewer through a commentary on how the West interprets."

1960–69

ABOVE: Entekhabi's work is exhibited in hundreds of galleries worldwide.

GILLIAN WEARING

Born: Gillian Wearing, 1963 (Birmingham, England).

Artistic style: Documentary-style photography and video work; focus on the individual; details everyday, contemporary life; use of members of the public and actors.

Masterworks

Signs that say what you want them to say and not Signs that say what someone else wants you to say 1992–1993 (Tate Collection, London, England)

Dancing in Peckham 1994 (Southampton City Art Gallery, Southampton, England)

Confess all on video. Don't worry, you will be in disguise. Intrigued? Call Gillian 1994 (Tate Collection, London, England; Kunsthaus, Zurich, Switzerland)

Sixty-Minute Silence 1996 (London Arts Council Collection, London, England)

"I'd like to find out as many facets as possible about people."

Gillian Wearing's fame was secured after being awarded the prestigious Turner Prize in 1997. Trained at the Chelsea School of Art before completing a bachelor of arts in fine art at Goldsmiths College, London, Wearing was thrust into the public spotlight after a number of highly publicized group exhibitions in the 1990s, including *Sensation* (1997) at the Royal Academy in London. The tenacious British media began to group Wearing and her contemporaries under the infamous umbrella term Young British Artists (YBAs).

Wearing's early work often depicts members of the public the artist has randomly found by stopping them on the street, or placing ads into local papers. The artist briefs her subjects before photographing them performing a personal, confessional act such as writing down what they are currently thinking about. This results in intimate works that can be read as commentaries of everyday life, as well as reflections on contemporary fly-on-the-wall TV documentaries. Social concerns are matched with questions of how the identities of Wearing's sitters are constructed and who controls their representation. Such power issues are particularly evident in Wearing's video works including *Sixty-Minute Silence* (1996), a film that features a group of police officers asked to be filmed for an hour without moving. The video at first appears to be a photographic portrait but gradually reveals its medium as the subjects become restless, forcing the viewer to acknowledge the arbitrary nature of power that Wearing effortlessly usurps. Wearing has since stopped her spontaneous approach, instead using scripted actors while maintaining the impression she is reflecting on everyday life, further blurring the lines between fact and fiction in her art. **WD**

ABOVE: Prize-winning artist Gillian Wearing, photographed in 2006.

1960–69

RACHEL WHITEREAD

Born: Rachel Whiteread, 1963 (London, England).

Artistic style: Sculptural forms made by casting the negative spaces of domestic objects; utilization of a minimalist vocabulary; objects are often psychologically charged and poetically resonant.

In many ways, Rachel Whiteread's *Closet* (1988) sculpture established her vocabulary as an artist. A plaster cast of a wardrobe covered in black felt, the work sought to evoke a particular space children inhabit, and although rich in association, it nevertheless formally borrows from the very austere aesthetic of minimalism.

From this time onward, Whiteread began making casts of negative spaces derived from a number of domestic objects salvaged from various locations across London's East End. For example, *Ghost* (1990) is a plaster cast of the space occupied by a room in a Victorian house.

In the same year that she was awarded the Turner Prize, Whiteread created *House* (1993). Consisting of a cast of a house, this technical feat was accomplished by spraying liquid concrete onto the interior shell of the house and then peeling away its outer walls to reveal a bunkerlike form. Although it had a lifespan of only two-and-a-half months, it was enough to establish Whiteread's international reputation. Four years later, she represented Great Britain at the Venice Biennale.

The scale of the artist's ambition and her willingness to take on projects that are fraught with technical and social issues were evidenced by her decision to build a cast interior of a room-sized library *Holocaust Monument (Nameless Library)* (2000) for the Judenplatz in Vienna despite much legal and diplomatic wrangling. Her temporary installation in the Turbine Hall of London's Tate Modern, *Embankment* (2005–2006) consisted of 14,000 casts made from different cardboard boxes, and is testimony to her continued ability to derive an evocative form of visual poetry from seemingly banal or overlooked objects. **CS**

Masterworks

Ghost 1990 (National Gallery of Art, Washington, D.C., U.S.)

Untitled (Air Bed II) 1992 (Tate Collection, London, England)

Untitled (Paperbacks) 1997 (Museum of Modern Art, New York, U.S.)

Holocaust Monument a.k.a. *Nameless Library* 2000 (Judenplatz, Vienna, Austria)

Untitled (Stairs) 2001 (Tate Collection, London, England)

Untitled (Basement) 2001 (Guggenheim Collection, New York, U.S.)

"My work . . . is trying to find a sense of what people have done to the land."

ABOVE: Whiteread with her largest work *Embankment,* 14,000 casts of empty boxes.

DAMIEN HIRST

Born: Damien Hirst, June 7, 1965 (Bristol, England).

Artistic style: Animals in formaldehyde in glass cabinets; spot paintings; medicine cabinets; butterflies; themes of pharmaceuticals, narcotics, love, the nature of existence, mortality, and religion.

Masterworks

The Physical Impossibility of Death in the Mind of Someone Living 1991 (Private collection)

Pharmacy 1992 (Tate Collection, London, England)

Mother and Child Divided 1993 (Astrup Fearnley Museum of Modern Art, Oslo, Norway)

Home Sweet Home 1996 (Museum of Modern Art, New York, U.S.)

Beans & Chips 1999 (Tate Collection, London, England)

Charity 2002–2003 (Private collection)

For the Love of God 2007 (Private collection)

Damien Hirst rose from an inauspicious record of achievement as a schoolboy to become the leading figure in the British art scene and the world's most successful living artist. He gained a place at Goldsmiths College studying fine art, and as the curator of the student exhibition *Freeze* (1988) he made his first dent on the London art crowd. No one was more overwhelmed than the advertising mogul Charles Saatchi, who purchased numerous pieces of Hirst's work in the following years.

Through his installations, paintings, and sculptures, Hirst challenged the traditional boundaries between art, science, and popular culture. Inspired by Francis Bacon and op art, he produced conceptual art pieces that presented animals in glass vitrines suspended in formaldehyde. *The Physical Impossibility of Death in the Mind of Someone Living* (1991), displayed at the Saatchi Gallery, features a 14-foot (4.3 meter) tiger shark and sought to re-examine traditional perceptions of the meaning of life. It gained notoriety for Hirst because the

ABOVE: Hirst at the preview of his exhibition Beyond Belief in 2007.

RIGHT: *The Sleep of Reason* was a fixture at Hirst's Pharmacy restaurant.

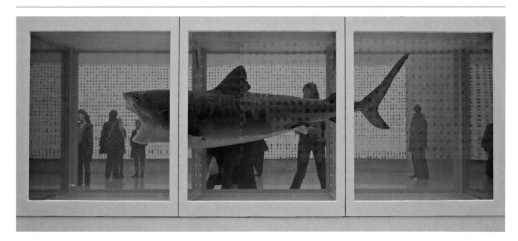

ABOVE: *The Physical Impossibility of Death in the Mind of Someone Living* (1991).

British media took a bemused interest in the work, and he was soon polarizing views like few, if any, artists before him.

More formaldehyde works followed at the Some Went Mad, Some Ran Away (1994) exhibition at London's Serpentine Gallery. A sheep in a tank entitled *Away from the Flock* (1994) and a cow and a calf cut in half called *Mother and Child Divided* (1993) helped Hirst win the 1995 Turner Prize. Undeniably provocative, some critics saw the works as using deliberately controversial subject matter in order to gain publicity.

To look beyond the hype is to witness art that depicts the terrible beauty lurking in death and the inevitable decay bound within beauty. It is this visceral and visually challenging aspect that has made Hirst the most talked-about contemporary artist.

Hirst has also produced paintings and cabinet sculptures. His most famous paintings are almost minimalist, nodding to the gestural paintings of abstract expressionism in their mechanized production, and are divided into two categories. His *Spin* series of paintings are created by pouring paint onto a round canvas and then mechanically spinning them at high speeds. The *Spot* paintings contain uniform-sized dots of energetic colors

"Amazing what you can do with an E in A Level art, twisted imagination, and a chainsaw."

For the Love of Bling

A whole year before the unveiling of *For the Love of God* at his solo exhibition Beyond Belief (2007), Hirst announced to the British media that he was intending to create the world's most expensive work of art. He explained the concept behind his extravagance, "I just want to celebrate life by saying to hell with death. What better way of saying that than by taking the ultimate symbol of death and covering it in the ultimate symbol of luxury, desire, and decadence?"

- The life-size cast of a human skull in platinum was covered by 8,601 ethically sourced diamonds, weighing a total of 1,106.18 carats, with the centerpiece being a pear-shaped, pink, 50-carat diamond set in the skull's forehead.

- Hirst was inspired to make *For the Love of God* after viewing an Aztec turquoise skull at the British Museum.

- Production costs have been estimated between $20 and $30 million (£10 and £15 million), making it the world's most expensive piece of art and a significant increase on the price of the eighteenth-century skull, purchased from a shop in North London, from which the staggering work was cast.

- After the sale there were even rumors that the piece had not been sold at all, rather it was still in Hirst's possession as part of a deliberate move to increase the value of his work.

assembled in rigid grid formations that imbue a state of calm in the viewer. The titles refer to pharmaceuticals, a common theme in Hirst's work, and imply a link between art and medicine in their capacity to heal. His medicine cabinet sculptures display surgical tools or pill bottles and medical packaging on highly ordered shelves—yet another example of the artist's detailed arrangement of color, shape, and form.

More shock and awe

The new millennium saw Hirst delve further into religion with a series of works based on the life of Jesus and his disciples. The Gagosian Gallery in London put on *A Thousand Years & Triptychs* (2006) showing works influenced by Bacon. The exhibition featured Hirst's take on the tradition of the *vanitas* in art, *A Thousand Years* (1989), a glass cabinet containing a life cycle of maggots hatching into flies, feeding on a severed cow's head with an "insect-o-cutor" lurking ominously above. Hirst continues to shock: his *momento mori* diamond-encrusted skull, *For the Love of God* (2007), was bought for $105 million (£50 million) by an investment group and broke the record for a piece of work sold by a living artist. **SG**

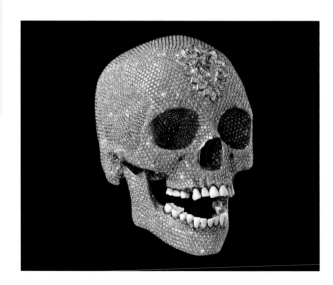

RIGHT: Hirst collected in the region of 8,500 diamonds to make *For the Love of God*.

JEREMY DELLER

Born: Jeremy Deller, 1966 (London, England).

Artistic style: Collections of folk and vernacular art; popular-music culture subject matter; postal art; historical reenactment of modern political events; documentary-style films.

Born in London, Jeremy Deller studied art history there at the Courtauld Institute of Art. His transition into making and curating art came in 1993 when, while living with his parents, he arranged an exhibition in his bedroom while they were on vacation, making a series of paintings about the life and work of rock star Keith Moon.

Continuing to create work that mingles high art and popular culture, he has frequently drawn inspiration from popular music and visual culture. Song lyrics, album covers, graffiti, postcards, notice boards, and personal ads provide not only the subject matter of his works but also frequently their medium. In 1997, he posted advertisements in the music press asking fans of The Manic Street Preachers to send him artworks, writing, and memorabilia inspired by the band. The resulting collection, titled *The Uses of Literacy: "Manic Street Preachers"* (1999), is typical of his fascination with the eclectic nature of vernacular expression. The recuperation of artworks made by those on the fringes of the artistic mainstream was the basis for Deller's *Folk Archive* (2005) that presented images and artifacts of contemporary folk culture from the United Kingdom.

In his aim to explore specific cultural, social, and historical situations, he has undertaken many such collaborative projects that harness the participation of the public with Deller in the role of curator, director, or publisher. His subjects are often geographically specific and politically charged, such as in *The Battle of Orgreave* (2001), a historical reenactment of the violent clash between striking miners and police in Yorkshire in the 1980s, and the documentary-style film *Memory Bucket* (2003) that focused on the siege in Waco, Texas, and which earned Deller the Turner Prize in 2004. **LB**

Masterworks

The History of the World 1998 (Tate Collection, London, England)

The Uses of Literacy: "Manic Street Preachers" 1999 (Published by Book Works Projects)

The Battle of Orgreave Archive (An Injury to One Is an Injury to All) 2001 (Tate Collection, London, England)

Folk Archive: Contemporary Popular Art from the UK 2005 (Published by Opus Projects)

"If pop art is about liking things, as Andy Warhol said, then folk art is about loving things."

ABOVE: Deller photographed in front of his Turner Prize-winning work in 2005.

1960-69

ROMAN ONDÁK

Masterworks

Announcement 2002 (Museum Ludwig, Cologne, Germany)

Good Feelings in Good Times 2003 (Tate Collection, London, England)

It Will All Turnout Right in the End 2005–2006 (Tate Collection, London, England)

Born: Roman Ondák, 1966 (Zilina, Slovakia).

Artistic style: Installation artist whose works incorporate sculpture, drawing, performance, interventions, and sound; explorations of inequality, social norms, and bureaucracy.

Roman Ondák was born two decades before the fall of the Berlin Wall. His works investigating inequality, social norms, and bureaucracy often resonate of times in Communist Eastern Europe. *Good Feelings in Good Times* (2003) shows a line of people, which never moves, harking back to the lines for food in the 1970s and 1980s. It is typical of his temporary interventions focused on institutionalized bureaucracy. As actors in the line pretend to be bored and frustrated, the power of the work lies not just in observation of gestures and rituals; it signifies the hierarchical nature of bureaucracy and its injustice and that social behavior and its meaning mutate depending on context and each viewer's imagination. **CK**

JAKE AND DINOS CHAPMAN

Masterworks

Year Zero 1996 (Walker Art Center, Minneapolis, Minnesota, U.S.)

HMS Cockshitter 1997 (Bernardo Collection, Lisboa, Potugal)

Disasters of War 1999 (British Museum, London, England)

Exquisite Corpse 2000 (Tate Collection, London, England)

Hell 2000 (Burned in Saatchi Collection fire)

The Chapman Family Collection 2002 (Saatchi Gallery, London, England)

Born: Jake Chapman, 1966 (Cheltenham, Gloucestershire, England).

Born: Dinos Chapman, 1962 (London, England).

Artistic style: Members of Young British Artists movement; conceptual art; sensational, gruesome imagery; themes of violence, commercialism, exploitation, and pedophilia; use of mixed media.

Young British Artists and brothers Jake and Dinos Chapman began working together in 1992. Like many of their contemporaries, they attended London's Royal College of Art, where they worked as assistants to Gilbert and George. The brothers were nominated for the Turner Prize in 2003.

Their provocative work reveals an interest in mutilation, torture, and intercourse. The conceptual nature of their work is enhanced by expert craftsmanship, apparent in their models and engravings. In cultivating a rude aesthetic, they engage with the discourse of art history, commercialism, and philosophy, emphasizing prurient human fascinations. **MG**

RIGHT: *Sex* (2003) depicts bodies being picked at by maggots, snails, and rats.

1960–69

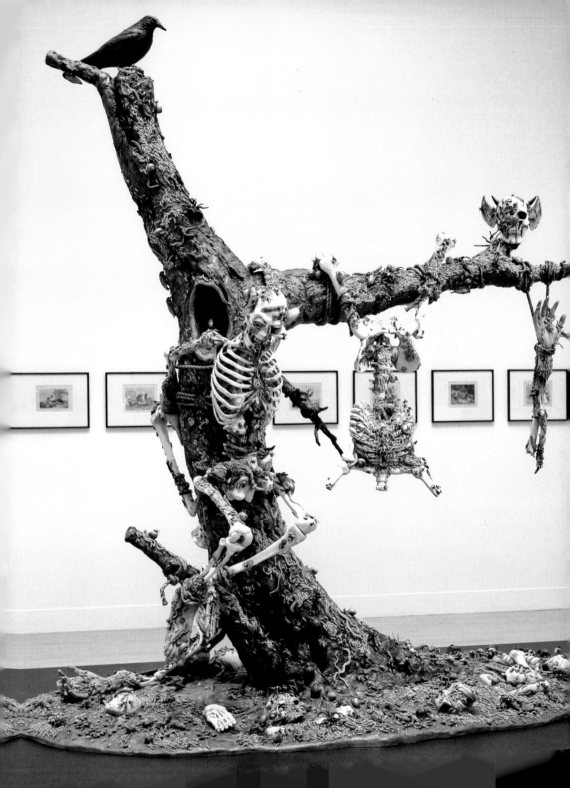

DOUGLAS GORDON

Masterworks

Meaning and Location 1990 (University College London, London, England)

24 Hour Psycho 1993 (Centre Pompidou, Paris, France)

Something Between My Mouth and Your Ear 1994 (Private collection)

10ms-1 1994 (Tate Collection, London, England)

Confessions of a Justified Sinner 1995 (Fondation Cartier pour l'Art Contemporain, Paris, France)

Feature Film 1999 (Centre Pompidou, Paris, France)

Déjà-vu 2000 (Tate Collection, London, England)

Blind James (White) 2002 (Tate Collection, London, England)

Zidane: A 21st Century Portrait 2006

Born: Douglas Gordon, 1966 (Glasgow, Scotland).

Artistic style: Video and installation artist; often Hollywood cinematic themes; explores the notions of identity, mortality, perception, and how the viewer attaches meaning via context.

Installation artist Douglas Gordon studied at the Glasgow School of Art and then at London's Slade School of Fine Art. He uses video, film, photography, and texts in his search to challenge perceptions of the world. Much of his work references and uses icons of popular culture to do so. For example, he has filmed the play of French soccer star Zinedine Zidane and famously projected Sir Alfred Hitchcock's thriller *Psycho* (1966) at slow speed to make the action last twenty-four hours. His fascination with playing with the moving image and context causes viewers to review their expectations and opinions of a classic or received narrative to come to a different point of view of their and others' place in the world. **CK**

DAMIÁN ORTEGA

Masterworks

Módulo de construcción con tortillas 1998 (Galeria Kurimanzutto, Mexico City, Mexico)

Cosa Cósmica (Cosmic Thing) 2002 (Galeria Kurimanzutto, Mexico City, Mexico)

Born: Damián Ortega, 1967 (Mexico City, Mexico).

Artistic style: Sculptor and political cartoonist; explorations of the political and cultural connotations of everyday objects and how they relate to Mexico; satirical treatment of subjects..

Damián Ortega started out as a political cartoonist and this satiric humor remains evident in his Dadaist, playful works. His sculptures, installations, performances, and videos are inspired by everyday objects from cars to tortillas, and explore the objects' political, economic, and cultural connotations. *Cosmic Thing* (2002) comprises a Volkswagen Beetle car taken apart and suspended from a ceiling by wire to comment on how an iconic car invented in Nazi Germany was last produced at a factory in Puebla, Mexico. To show how form is ever changing through time, perception, and context and that sculpture does not have to be static, he often reworks his pieces, sometimes presenting them as works in progress. **CK**

TOMMA ABTS

Born: Tomma Abts, 1967 (Kiel, Germany).

Artistic style: Small, uniformly sized canvases depict unfolding, self-referential geometric shapes; final design crafted through color layers; first woman painter to win Turner Prize.

The twenty-first century has seen Tomma Abts expand the possibilities of abstract visual languages on her signature small, 19 by 15-inch (48 by 38 cm), acrylic and oil canvases, formulating a highly personal lexicon of signs based around an orderly, intuitive, and consistent artistic process.

A former student of Hochschule der Künste, she studied mixed-media art and had no training in painting. At a time when multidisciplinary references and appropriation are popular catalysts of artistic creation, she famously begins with nothing but the blank surface of a precisely uniform painting platform. Her absence of source material predicates her strikingly intuitive, yet controlled, abstractions of form and color, with curves appearing to coalesce and emerge, half by chance and half by associative impulse, among multiple layers of paint.

Abts describes her works as: "A concentrate of the many paintings underneath." Each title is taken from a book of German first names and engages the viewer with the potential enormity of a series, hinting at a sense of identity continually in the process of being made. There is a suggestion of self-contained spatial ambiguity, of individual perfection that unfolds the narrative of its own story, but there is also an element of the counterintuitive within the logic of each canvas. What appears to move to the foreground is often an element from a deep structural layer; and what seems to be teetering on the cusp of figurative representation is only marginally so. The compositional use of repetitive artificial patterns over starkly vacuous backgrounds subtly articulates a unique meditation on the fragile randomness of meaning. Abts was awarded the 2006 Turner Prize for her contributions to the language of abstract painting. **LNF**

Masterworks

Epko 2002 (Greengrassi, London, England)
Ebe 2005 (Greengrassi, London, England)
Lubbe 2005 (Greengrassi, London, England)

"... the tension of potential movement is stronger in a painting than in a film."

1960–69

ABOVE: In 2006, Abts became the first woman painter to win the Turner Prize.

MATTHEW BARNEY

Born: Matthew Barney, 1967 (San Francisco, California, U.S.).

Artistic style: Performance, film, and installation artist; references to cinematic genres; use of medical instruments and viscous substances; themes of athletes, performers, destiny, and sexuality.

Masterworks

Program: Houdini, O'Williams, Otto (HO2) 1991 (Museum of Modern Art, New York, U.S.)

Cremaster 4 1995

Cremaster 1 1996

Cremaster 5 1997

Cremaster 2 1999

The Cabinet of Baby Fay La Foe 2000 (Museum of Modern Art, New York, U.S.)

Cremaster 3 2002

Matthew Barney is an artist people love or loathe: some see his wild, extravagant films as pretentious, on occasion almost pornographic, and a summation of everything that gives contemporary art a bad name. Others see him exploring new avenues with imagination, panache, and limitless creativity.

Barney's 35mm films are big-budget movies, but unlike Hollywood fare, they are shown at art galleries and festivals. They come complete with large casts—often including famous names such as Norman Mailer or Ursula Andress—prosthetics, extravagant sets, and a complex, circular narrative. Barney writes, designs, performs, and directs. The result are films packed with opulent color, wild images, bizarre stories, intricate soundtracks, beautiful locations, and fantastic costumes and sets, so much so that it seems the artist has gone into the territory of surrealism.

Nowhere is this more apparent than in Barney's masterpiece, the epic *Cremaster 1–5* (1995–2002) cycle of five feature-length films—not created in chronological order. The title *Cremaster* refers to the male cremaster muscle that controls testicular contractions in response to external stimuli. Barney's saga is

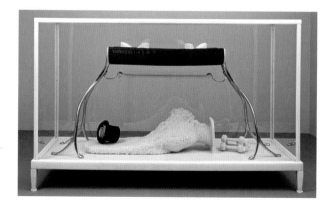

ABOVE: Barney was a jury member at the 56th Berlin International Film Festival.

RIGHT: The elements in *The Cabinet of Baby Fay La Foe* are based on *Cremaster 2*.

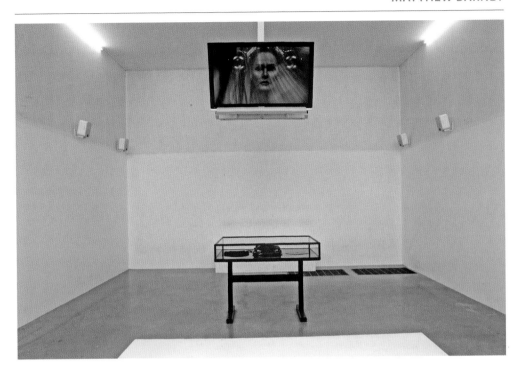

ABOVE: *Cremaster 5* is an opera set in Hungary; it features Ursula Andress.

full of allusions to the reproductive organs. The myth he has created wanders through the lives of real people such as murderer Gary Gilmore and escapologist Harry Houdini, is set in striking locations such as New York's Chrysler Building, and is inhabited by imaginary beings such as water sprites.

Each *Cremaster* movie has a particular look that suggests a distinct cinematic or theatrical genre: 1930s Busby Berkeley musicals: Leni Riefenstahl's Nazi propaganda films; Gothic Western; gangster and disaster films; the road movie; and romantic tragedy or lyric opera. Each film is accompanied by related sculptures, photographs, and drawings such as *The Cabinet of Baby Fay La Foe* (2000) that both document and enhance the experience, as well as being artworks in their own right. In fact, Barney calls himself a sculptor, but any definition he is given by himself or others does little justice to the perhaps new art form he has created. **CK**

Curious Cabinet

The intriguing sculpture *The Cabinet of Baby Fay La Foe* at first glance seems a perverse Victorian curio: a glass cabinet housing a top hat filled with honeycombed beeswax, a curvaceous steel-legged séance table, dumbbells, and a resin organic form that could almost be a used kinky condom. The only real hint to its meaning is its title. Baby Fay La Foe was a clairvoyant and the grandmother of Gary Gilmore, as well as a character in Barney's *Cremaster 2*. Perhaps a comment on destiny, perhaps a comment on chance, or perhaps both—its meaning remains enigmatic.

1960-69

SAM TAYLOR-WOOD

Born: Sam Taylor, 1967 (London, England).

Artistic style: Young British Artist filmmaker, video artist, and photographer; use of slow or accelerated film speeds; celebrity collaborations; ironic commentary on urban lifestyles.

Masterworks

Fuck, Suck, Spank, Wank 1993 (Matthew Marks Gallery, New York, U.S.)

Killing Time 1994 (Tate Collection, London, England)

Five Revolutionary Seconds 1 1995 (Walker Art Center, Minneapolis, Minnesota, U.S.)

Still Life 2001 (White Cube, London, England)

David 2004 (National Portrait Gallery, London, England)

Crying Men 2004 (White Cube, London, England)

Self-Portraits Suspended 2004 (White Cube, London, England)

Bram Stoker's Chair 2005 (White Cube, London, England)

The Last Century 2006 (White Cube, London, England)

> "I'm interested in taking raw human emotions and then isolating them."

ABOVE: Detail from a photograph taken by Johnnie Shand Kydd.

RIGHT: *Bram Stoker's Chair VI* (2005) is part of Taylor-Wood's suspended series.

Sam Taylor-Wood is a prominent member of the Young British Artists who coalesced at London's Goldsmiths College and attracted the patronage of advertising guru Charles Saatchi. After completing an art foundation course in Hastings, she returned to London to graduate from Goldsmiths College with a Bachelor of Arts in Fine Art in 1990.

Taylor-Wood works with film, video, and photography, and her work is broadly concerned with the difference between perceived appearance and actual being. Her breakthrough came with the video installation *Killing Time* (1994), featuring four people miming to an opera score. It brought her to the attention of her future husband Jay Jopling, art dealer and owner of London's White Cube gallery. She has since created stage visuals for the Pet Shop Boys, directed an Elton John video starring Robert Downey Jr., filmed soccer player David Beckham sleeping in *David* (2004) for the National Portrait Gallery, and photographed male Hollywood actors for her series *Crying Men* (2004). In this work, the actors all appear to be in distress, prompting many questions about perceived reality in media. Taylor-Wood shares some of the same themes and techniques as U.S. video-art pioneer Bill Viola; but where Viola's work is essentially hopeful, Taylor-Wood's is capable of feeling configured for a more cynical audience. Her art reflects the ennui of a self-regarding urban elite, examining the dislocation between public and private identities endemic to a celebrity-obsessed culture. In the last decade, she has overcome cancer twice, experiences that inform her more playful *Self-Portraits Suspended* (2005) series, showing the artist floating seemingly unsupported in her London studio. **RB**

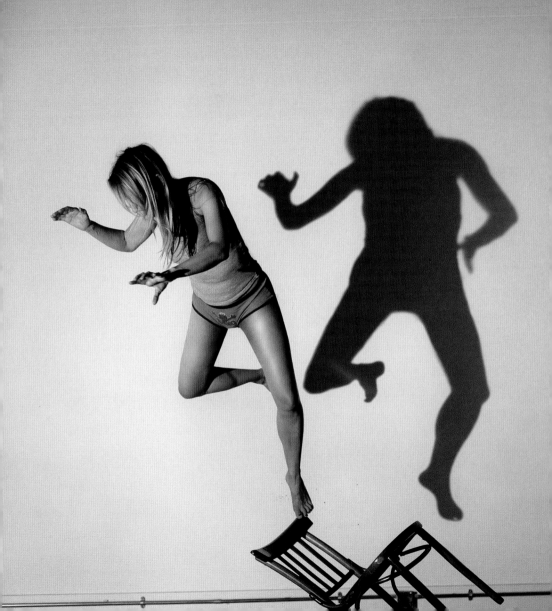

CHRIS OFILI

Born: Chris Ofili, 1968 (Manchester, England).

Artistic style: Painter; themes of Nigeria, religion, blaxploitation, race, and pornography; use of elephant dung, glitter, and collage; shimmering translucent glazes; rich color.

Masterworks

The Upper Room 1992–2002 (Tate Collection, London, England)

Holy Virgin Mary 1996 (Saatchi Collection, London, England)

No Woman, No Cry 1998 (Tate Collection, London, England)

In 1998 when Chris Ofili won the Turner Prize, it was for his "inventiveness, exuberance, humor, and technical richness in painting," but more important than the prize is how the citation sums up so well the part he played during the 1990s in reinvigorating painting, not just in the auction houses and galleries, but in the minds of young art students.

Ofili is ten years younger than Peter Doig, but they traveled a parallel journey to success during the decade. Ofili is one of the few Young British Artists not to study at London's Goldsmiths College. Instead, he completed an undergraduate degree at Chelsea School of Art and then a postgraduate at the Royal College of Art, graduating in 1993.

Ofili's reputation was first established through the important collector Charles Saatchi and then a traveling exhibition organized by the Royal Academy of Arts, *Sensation* (1997), which went to the Brooklyn Museum of Art in 1999 and precipitated a lawsuit against the museum filed by Mayor Rudy Giuliani.

Holy Virgin Mary (1996), the Ofili painting that caused all the trouble, depicts a black African Madonna surrounded by images cut from pornographic magazines and embellished with spherical pieces of elephant dung.

His lust for life and confidence as an artist and craftsman has enabled him to sustain his position in the art world long after the first rush of publicity. In 2003 h

"The way I work comes … out of a love of painting, a love

GEORGINA STARR

Born: Georgina Starr, 1968 (Leeds, West Yorkshire, England).

Artistic style: Video, film, performance, and installation artist; explorations of identity, memory, history, performance, and silent cinema; autobiographical themes; use of found objects.

Sometimes referred to as a Young British Artist (YBA), video, film, performance, and installation artist Georgina Starr studied at London's Middlesex Polytechnic and Slade School of Art and at Amsterdam's Rijksakademie Van Beelende Kunst. Her art has been described as "confessional" along the lines of YBA Tracey Emin, and like Emin, Starr draws upon her life in the work she creates. Her installation *The Nine Collections of the Seventh Museum* (1994) incorporates found and collected objects, such as toys and souvenirs, that detail her life as an artist, revealing the anxiety and loneliness felt when creating a work. Starr later documented the piece with photographs.

Her videos and films see her performing in narratives that may be based on personal experience, but also often see her working with a cast and crew, as in her four-screen work *Big V* (2005), which explores the relationship between Roman Catholicism and notions of guilt regarding emerging sexuality and uses a group of teenagers who recreate some of Starr's adolescent memories of growing up in Leeds.

Starr's film and installation *Theda* (2007) takes the viewer into the world of silent films and that of the big screen's first sexualized woman, vamp Theda Bara. Many of Bara's forty productions are now lost, and Starr carefully recreated scenes using scripts, playing Barr's roles herself. Starr's work explores the boundaries between fiction and reality, blurring representation and fact, as she recreates from memory and painstaking research time past, both her own and that of other women. There may be a sense of nostalgia, but there is also a sense of how the mundane and trivial random events of everyday existence can give life meaning and form one's identity. **CK**

Masterworks

The Nine Collections of the Seventh Museum 1994 (Museum of Modern Art, New York, U.S.)

The Nine Collections of the Seventh Museum #7 Birth of Sculpture 1994 (Tate Collection, London, England)

The Making of Junior (+ Entertaining Junior) 1994 (Tate Collection, London, England)

Hypnodreamdruff 1996 (Tate Collection, London, England)

English Rose 1996 (Tate Collection, London, England)

Big V 2005 (Leeds City Art Gallery, Leeds, West Yorkshire, England)

Theda 2007 (Sala Minor Consiglio, Palazzo Ducale, Genoa, Italy)

"My work starts from a personal place, but the work isn't 'personal'. It's for everyone."

ABOVE: Starr at a charity auction in 2004, where British artists customized scooters.

1960–69

HALUK AKAKÇE

Masterworks

Birth of Art 2003 (Cosmic Galerie, Paris, France)

Forms of Life 01 (*Fluid Continuity*) 2003 (Cosmic Galerie, Paris, France)

Novocaine for the Soul 2004 (Cosmic Galerie, Paris, France)

Born: Haluk Akakçe, 1970 (Ankara, Turkey).

Artistic style: Installation and video artist; videos mix painting, sculpture, and sound and fuse mechanical apparatus, figures, and flora; art historical and futuristic references.

Haluk Akakçe studied architecture at Bilkent University in Ankara, and video and performance art at the School of the Art Institute of Chicago. His work mixes video projections, wall paintings, and sound installations to create fantastic imagery depicting mechanical apparatuses, figures, and hyperrealistic flora in a futuristic virtual world of fluid line and mutating forms. He draws on art deco, Islamic architecture, art history, science fiction, and comic books to examine people's relationship with technology. He uses digital media mixed with conventional methods to extend what constitutes a twenty-first-century painting. Yet despite his use of the latest technology, his works convey a sense of peace and tranquility in the digital age. **CK**

JENNY SAVILLE

Masterworks

Plan 1993 (Saatchi Gallery, London, England)

Strategy 1993–1994 (Private collection)

Juncture 1994 (Collection Marguerite and Robert Hoffman)

Passage 2004–2005 (Private collection)

Born: Jenny Saville, 1970 (Cambridge, England).

Artistic style: Young British Artist; painter of massive canvases and monumental nudes in mottled hues; sensual depictions of skin texture; themes of obesity, deformity, and transgender.

Jenny Saville paints images of women, often using herself as a model. She focuses on flesh and confronts obesity, deformity, and transgender. She studied at the Glasgow School of Art, the Slade School of Art in London, and the University of Cincinnati, where she says she saw, "Lots of big women. Big white flesh in shorts and T-shirts. It was good to see because they had the physicality I was interested in." In 1993, collector Charles Saatchi bought all her work and commissioned works for another two years. To create them, she spent hours observing plastic surgery operations in New York. In 2002, she collaborated with photographer Glen Luchford to produce huge Polaroids of herself lying on a sheet of glass, taken from below. **SH**

RIGHT: Saville characteristically overwhelms the viewer with flesh in *Rubens' Flap* (1999).

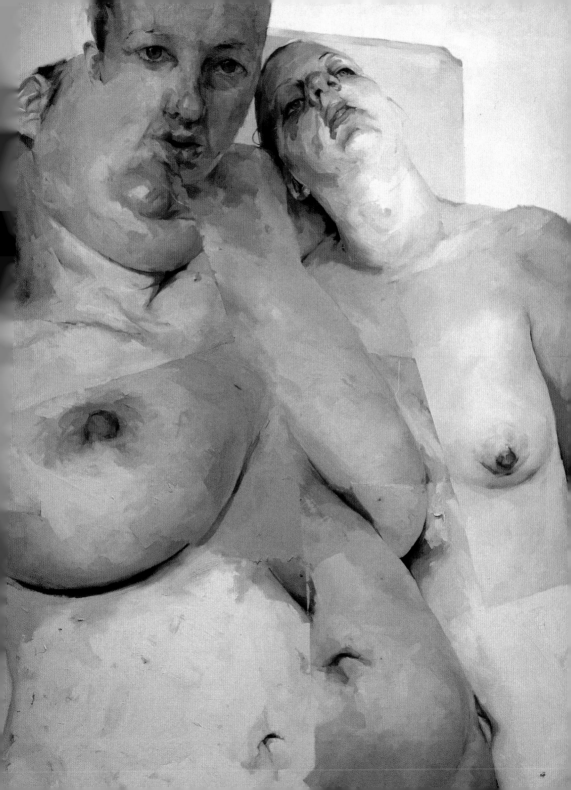

AHMED AL SAFI

Born: Ahmed Al Safi, 1971 (Diwaniya, Iraq).

Artistic style: Abstract impressionist figurative sculptor and painter; vibrantly colored oil, watercolor, and acrylic paintings; bronze sculptures; use of Mesopotamian mythic imagery.

Masterworks

Men 1999 (Private collection)
2 Men 1999 (Private collection)
Dragon 2002 (Private collection)
Lovers 2002 (Private collection)
Farmer and Dragon 2004 (Private collection)
The Dismissal 2004 (Private collection)

Ahmed Al Safi studied sculpture at Baghdad University's College of Fine Arts. He succeeded in winning the Ismail Fatah Al Turk prize for young sculptors in 2000. His bronze sculptures depict elongated figures reminiscent of the works of Swiss sculptor Alberto Giacometti that appear to fly or walk like graceful acrobats within geometric shapes. His vibrantly colored, mythic paintings fuse together a myriad of cultural influences, from the ancients to the modern.

Incredibly, Al Safi continued to work in Baghdad during the U.S.-led invasion in 2003 and the conflict that surrounded him. His work ethic reflects the 1990s generation of Iraqi artists who have lived through a period of international embargo and dictatorship yet have continued to produce diverse and fascinating compositions.

Al Safi's use of Mesopotamian imagery pays homage to his cultural heritage. Mesopotamian mythology is the collective term given to Sumerian, Akkadian, Assyrian, and Babylonian legends of the Tigris and Euphrates Rivers in Iraq. Al Safi echoes such ancient art by representing images of gods and goddesses in a similar vein to the Greek antiquities. His recognition of the importance of contemporary art is also apparent by his fusion of such imagery with an abstract impressionist style using acrylics, oils, and watercolors. His paintings use simple lines and rapid brushwork, referencing the German neo-expressionists of the 1980s. He has had a number of solo exhibitions, showing at Abbaye de La Prée in France in 2006 and 2007. His group exhibitions include the French Cultural Center in Baghdad in 1994 and the Babylon Festival in 1995. He continues to actively work in Baghdad, and also at his studio in Abbaye de La Prée in Ségry in France. **KO**

"I think documenting the war [with art] is very important, as it is in life."

ABOVE: Ahmed Al Safi in his studio in Baghdad, the heart of a new art scene.

BANKS VIOLETTE

Born: Banks Violette, 1973 (Ithaca, New York, U.S.).

Artistic style: Abstract Gothic sculptor and painter, creator of stark, large-scale installations often referencing the black-metal genre; incorporates droning music into minimalist installations.

Notorious for referencing death metal, ritual murder, and teenage suicide, Banks Violette's Gothic installations explore the excesses of youth culture through strikingly dark imagery. His past as a tattoo artist and crystal meth addict is wildly romanticized by the media. Violette studied at the School of the Visual Arts in New York and at Colombia University. At his first solo exhibition at New York's Whitney Museum of American Art, he assembled a life-size replica of a burned-out church on a black stage—a clear reference to a series of instances of arson committed by black-metal enthusiasts in Norway. This homage to a black-metal album cover addresses the boundaries between fantasy and reality within popular culture. **KO**

Masterworks

Hate Them 2004 (Saatchi Gallery, London, England)

Black Hole (*Single Channel*) 2004 (Saatchi Gallery, London, England)

Untitled 2005 (Whitney Museum of American Art, New York, U.S.)

SunnO))) / (Repeater) Decay / Coma Mirror 2006 (Saatchi Gallery, London, England)

TRENTON DOYLE HANCOCK

Born: Trenton Doyle Hancock, 1974 (Oklahoma City, Oklahoma U.S.).

Artistic style: Allegorical works using print, drawing, and collaged felt paintings; series of a story of mythical creatures called Mounds; strong emphasis on narrative and social issues.

At the age of twenty-five, Trenton Doyle Hancock became one of the youngest artists represented at the Whitney Biennial Exhibition. His work has featured in many group exhibitions and resides in numerous museum collections. The body of his work is dominated by the story of the Mounds, mythical creatures who are half-animal, half-plant and preyed on by evil beings called Vegans. The compositions weave together allegory, satire, and pun through print, drawing, and collaged felt paintings, delivering a clever and amusing critique of racial, sexual, body, and social issues. Much of Hancock's work is inspired by popular culture and comics; his style is associated with artists outside the academic program of training. **KO**

Masterworks

Bye and Bye (*Finale*) 2002 (Contemporary Gallery, Dallas, Texas and James Cohan Gallery, New York, U.S.)

Vegans Do Their Dirtiest Work 2002 (James Cohan Gallery, New York, U.S.)

Choir 2003 (Whitney Museum of American Art, New York, U.S.)

Cult of Color 2004 (James Cohan Gallery, New York, U.S.)

St. Sesom and the Cult of Color 2005 (James Cohan Gallery, New York, U.S.)

Sesom's Dream 2005 (James Cohan Gallery, New York, U.S.)

Vegan Arm 2006 (James Cohan Gallery, New York, U.S.)

SHIRANA SHAHBAZI

Masterworks

Goftare Nik/Good Words Series 1998–2003
(Photographer's Gallery, London, England)

The Annunciation 2003 (Venice Biennale, Venice, Italy)

Born: Shirana Shahbazi, 1974 (Tehran, Iran).

Artistic style: Photography reflecting the ordinary details of life in Iran; dismantles stereotyped notions of assumed social, cultural, and religious differences; works in collaboration with other Iranian artists.

Shirana Shahbazi's photographs of everyday life create a humanized, powerful alternative image of Iran that is a far cry from the sensationalistic point of view often seen within the popular media. Born in Tehran, the artist moved to Stuttgart in 1985 and trained as a photographer in Germany and Switzerland, where she works. Her personal style has been influenced by the detached, objective photographic aesthetic traditional in her adopted countries. Shahbazi's portraits of life do not romanticize their subject matter but focus on documenting what is normal and banal to universalize contemporary Iranian identity. Beauty and poignancy are to be found in her ordinary images of ordinary things: a woman at work, a man wearing a soldier's uniform, a young bride dressed in the Western style standing among blossoms.

Shabahzi's *Goftare Nik/Good Words* (1998–2003) series was awarded the prestigious Citigroup Photography Prize in 2002 in London, bringing her work to international prominence. The title references a Zoroastrian saying against passing judgment and reflects on the potential influence images may have in breaking stereotypical cultural construction. Behind this series is another way of seeing Iran's cultural complexities and its situation, somewhere between Islamic theocratic rule and globally influenced social reality. The artist has also become known for her large-scale graphic and woven gallery installations, striking projects in which she uses her own images, often portraits, as the basis for painted murals and carpets made in collaboration with Iranian painters and artisans. Exploiting the effect of images on billboards within closed spaces, Shahbazi invites viewers to confront a humanized image of the often unrepresented other. **LNF**

"How you read a picture is very complex, and that's the challenge of photography."

ABOVE: Shahbazi is well known for her portrait of a veiled woman smoking.

RIGHT: Shahbazi's mural at the 50th Biennale of Art in Venice, 2003.

GLOSSARY

avant-garde
An umbrella term for art that is ahead of its time and usually considered unacceptable by the establishment of the day. The avant-garde movement began in *c*.1860 and can be said to have ended *c*.1970.

baroque
A dramatic form of art dating from the early seventeenth to the mid-eighteenth centuries. Baroque art is often religious and associated with the Catholic church, although it does also encompass other art forms, such as portraiture. It is characterized by extravagance, grand subject matter, emotion and rich but sombre colors.

bijinga
Japanese art form, defined as paintings of beautiful women.

chiaroscuro
The technique of using light and shade; also used to describe the effects produced by this technique.

classicism
Term describing the use of the rules or styles of classical antiquity. Renaissance art incorporated many classical elements, as did other eras, such as the eighteenth century. The term can also be used to mean formal and restrained.

color field painting
Coined in the 1950s to describe the works of the abstract expressionists, whose paintings often used large, flat blocks of bold color.

conceptual art
Art in which the most important factor is the idea or concept; as opposed to the form, medium or final appearance of the work.

cubism
Art in which the forms resemble geometric shapes, such as triangles or cubes, and whose structure is often created by a series of seemingly unconnected forms vaguely fitted together to form a whole.

direct carving
Developed by Brancusi in 1906. The sculptor doesn't plan out a piece beforehand or work from a model, (s)he simply begins work, allowing the carving to develop and thereby creating the finished piece. The technique varies according to the medium being used.

divisionism
A method of painting: small dots of unmixed colors are applied to the canvas instead of being mixed together first on the palette.

expressionism
A type of art that originated in Germany, especially associated with the groups Die Brücke and Der Blaue Reiter. Expressionist art is intense, characterized by loose, flowing brushstrokes and often showing a distortion of the subject's form. It is literally "expressive" of the artist's state of mind when creating it.

fauvism
An early avant-garde movement which originated in Europe before World War I. The most famous fauve artist is Henri Matisse. The name "Les Fauves" (the wild beasts) was first attributed to Matisse and his fellow group of artists when they exhibited works characterized by bold colors and untamed brushwork.

figurative art
Also called "representative art." Art in which figures and forms are faithfully recreated; the antithesis to abstract or expressionist art.

fresco
A type of wall painting; paint is applied directly onto plaster which is still wet.

futurism
Italian art movement. It was founded in 1909 by poet Filippo Marinetti and initially referred only to literature although it soon became associated with art. As its name suggests, futurist art looks to the future, especially concerning itself with technological advances, attempting to disregard the influences of the past.

gothic
Influential style of art and architecture that flourished in Europe from the twelfth to the sixteenth centuries; characterized by tall, pointed spires and intricate carvings. Most commonly seen on and in churches and important civic buildings. The term also refers to later art which was inspired by the art, architecture and literature of this period. Many romantic artists (in the eighteenth century) painted in a gothic style.

grand manner
Grandiose style of painting that flourished in the eighteenth century. The term refers to paintings whose subject and style were influenced by academia, ancient history, mythology and heroism, all painted in an idealized and deeply formulaic style. Encompasses "history painting"—which idealized heroic people doing noble deeds.

impressionism
Artistic style that originated in France in the 1860s. The name came from a painting by Claude Monet called *Impression, Sunrise* (1874), and the impressionists became famous for painting outdoors (*en plein air*) using loose brushwork which created a general impression rather than a distinct rendering of the subject portrayed.

international gothic
Artistic style that flourished in Europe in the fourteenth and fifteenth centuries. It is characterized by elegance and a close attention to natural details.

limner
A painter; the word was originally used to describe someone who illuminated manuscripts, later applied to portraitists.

luminism
A type of painting that focuses strongly on light effects.

mannerism
An artistic movement whose name comes from the Italian word for "style"; characterized by distortion of the human body, exaggeration, and sensuality. Mannerism flourished in Italy in the sixteenth century.

minimalism
An abstract artistic style made famous in the second half of the twentieth century. It celebrates the most simplistic forms of art and sculpture, with painted works using mainly monochrome and primary colors.

modernism
Beginning in the second half of the nineteenth century, the modernist premise was that art should reflect modern times, not hark back to the past. Used as an umbrella term to encompass a variety of other modern artistic movements that have flourished since the 1850s.

naturalism
An artistic style in which artists paint their subjects as they really see them, not as idealized scenes. A concept rather than a specific movement, it cannot be pinpointed to any single period of time.

neo-classicism
A movement that celebrated ancient Greek and Roman art and architecture. It gained momentum in Britain in the 1740s and was a hugely dominant force throughout the second half of the eighteenth century.

neo-romanticism
A twentieth century movement that harked back to the romantic movement of the

eighteenth century, focusing on emotional responses to the world as captured on canvas and in sculpture. As it began in the 1930s, much neo-romantic work focuses on World War II and the changes in the world immediately before, during and after it.

op art
Short for 'optical art', this 1960s movement focused on art that would deceive or confound the eye of the viewer, mainly geometric patterns and optical illusions that, after being observed for a while, start to change shape in the viewer's vision.

papier collé
Literally means "pasted paper". A collage technique in which flat materials—not only paper, other materials used include cloth and string—are incorporated into paintings.

photomontage
Literally a montage of photographs, combining a number of photographic images into one work of art. The expression can also be used to describe art that combines photography with text, painting and drawing.

pop art
Style of art that celebrates popular culture, including pop music, the film industry and everyday graphic art such as advertising images. The movement began in the mid 1950s and was the defining movement, in both the US and UK, of the 1960s.

post-impressionism
The movement that came immediately after the heyday of impressionism and refers to art that has its roots in impressionism but incorporates a stylistic change. Several impressionist artists began to paint in a post-impressionist style from the late 1880s onwards, making changes to the way they used color or chose subject matter.

pre-raphaelite brotherhood
A group of seven rebellious art students at the Royal Academy in London who decided to change the accepted artistic formula, taking their work back to a similar style used in art of the time before Raphael. The brotherhood lasted only from 1848 till 1853, but spawned a much longer-lasting pre-raphaelite movement.

realism
Literally art that depicts its subject in a realistic manner. The term "réalisme" was first coined in France in the mid-eighteenth century and referred not only to aesthetically realistic paintings, but also to those that showed the true state of the world, in a socially responsible manner.

renaissance
Literally "rebirth"; a movement that encompassed art, literature and philosophy. It began in Italy in the fourteenth century and spread throughout northern Europe. The earliest renaissance artist was Giotto, others include Sandro Botticelli, Leonardo da Vinci and Michelangelo.

reredos
A wall or screen behind an altar or communion table, which has been carved and/or decorated.

restoration
The restoration of the monarchy in England after the Civil War. Refers to the reign of King Charles II (1660–1685).

rococo
An artistic and architectural style characterized by playfulness, light colors and graceful elegance. A reaction against the heavy, sombreness of the Baroque style. Rococo was most popular in France, but spread to Britain and elsewhere in Europe in the later seventeenth century.

romanesque
A style of European art and architecture which dominated the tenth and eleventh centuries. It took its inspiration from the ancient Roman Empire.

romanticism
The antithesis of classicism, romanticism was an artistic, literary and philosophical movement which focused heavily on emotional responses to nature. Often seen as at odds with formulaic Christianity, it was however a deeply spiritual movement, many of whose adherents were strong, visionary Christians. Subject matter often refers to awe-inspiring nature, such as avalanches, angry seas and achingly beautiful scenes from nature.

scumble
Style of painting in which a layer of opaque color is brushed over another layer of color, allowing the under layer to show through only occasionally and at random.

sfumato
From the Italian for "smoky"; a painting technique in which colors are blended so skillfully they appear to turn into one other effortlessly, without leaving any obvious lines or edges.

socialist realism
A Russian art movement in the time of Stalin (1929–1953): propaganda painting that promoted positive images of life under Stalin's regime painted in a realistic style.

social realism
Any artwork painted in a realistic fashion and which includes a clear social, or political, reference.

still life
A two-dimensional painting depicting objects such as flowers, food or everyday items; anything that is inanimate (which can include dead animals).

suprematism
An expression coined by Kasimir Malevich in 1913. Russian abstract art that encompassed elements of cubism, using geometric shapes as well as the empty spaces on a canvas as an artistic medium in their own right. Associated with the Russian Revolution.

surrealism
An artistic movement that originated in Paris in 1924. Andre Breton—a follower of Sigmund Freud—launched the movement by publishing his Manifesto of Surrealism; other famous surrealists include Salvador Dalí and Rene Magritte. Surrealism aimed to recreate on canvas the workings of the subconscious and unconscious mind. It spread from the art world into cinema, music and literature.

synchromism
An abstract art movement founded in Paris in 1912 by two American artists, Morgan Russell and Stanton Macdonald-Wright. Concerned with the use of pure colors, synchronized by being blended together.

tempera
A type of painting medium produced by mixing pigment with thickening materials, such as egg yolk.

ukiyo-e
Japanese art movement that took as its subjects the everyday life of ordinary people.

vignette
Usually a small, simple picture, such as a portrait sketch, without a border.

vorticism
A British avant-garde group formed in 1914 by Percy Wyndham Lewis (1882–1957); heavily influenced by cubism, the machine age and realism. A very short-lived movement effectively ended by World War I.

INDEX

CONTRIBUTORS

(AB) Aliki Braine is an artist who studied at the Ruskin School, Oxford, the Slade School, and the Courtauld Institute. She is a freelance lecturer for the National Gallery, London, and regularly exhibits her work.

(AK) Ann Kay is a writer and editor with a degree in History of Art and Literature at Kent University and a postgraduate qualification in graphic design from London University. She is currently undertaking postgraduate study in art history at Bristol University.

(CK) Carol King is a freelance writer based in London and Italy. She studied Fine Art at Central St. Martin's and English Literature at the University of Sussex. She writes about art, travel, film, and architecture.

(CS) Craig Staff is an artist, writer and lecturer based in Northamptonshire.

(EK) Dr. Ed Krčma is an art historian living and working in London. He received his Ph.D. from University College London in 2007 and has taught in numerous Art History and Fine Art departments including UCL, Camberwell College of Art and the University of York. He also publishes as a critic.

(EL) Ed Lehan makes very fast, very colorful art with London's New Dome (www.thenewdome.com) and he encourages you to start a band.

(HP) Harry Pye is an artist represented by Contemporary Sartorial Art. He has been a contributor to magazines such as Log, The Face, Untitled, Frank, and The Rebel. He writes a regular column for an Estonian newspaper called Epifiano and has contributed to several books including Frozen Tears 2. He lives in London.

(HPE) Helena Perez obtained a BA in Art History at Birckbeck College, and an MA in Visual Cultures from Goldsmiths College, London. She has collaborated as a researcher for Tate Modern and works as a freelance lecturer and educational tour manager.

(IZ) Iain Zaczek is a writer who lives in London. He studied at Wadham College, Oxford, and the Courtauld institute of Art. His previous books include The Collins Big Book of Art, Masterworks and Ancient and Classical Art.

(JJ) Jasper Joffe is a painter and writer. He once painted 24 paintings in 24 hours at the Chisenhale Gallery and exhibits internationally. His first novel Water was published by Telegram Books in 2006. He is the founder of worldwidereview.com and The Free Art Fair. (www.jasperjoffe.com)

(JM) Jamie Middleton is a freelance writer and editor for numerous lifestyle magazines and books. Based in Bath, he has an extensive classical-art background and has worked on a range of diverse subjects, ranging from the Milau Bridge and Jaguar cars to laptops and fine wines.

(JR) Julie Roberts lectures at Monash University, Melbourne; her research focuses on Australian and New Zealand art.

(JW) Jane Won is a Korean-born curator based in the U.K. Recent exhibitions include Shin Azumi & Norman McLaren at Chelsea space, London.

(KKA) Karly Allen trained in studio arts (drawing), followed by an MA in Japanese Art History. As an art lecturer and writer in London, UK, she has worked for the National Gallery, Courtauld Institute of Art Gallery, Victoria and Albert Museum, National Portrait Gallery and Wallace Collection.

(KO) Katy Orkisz is a recent graduate of English Literature and Cultural studies and a published reviewer of Theatre, Art, Cinema and Music. A dedicated promoter of the Arts, she lives in a creative hovel with six flatmates in Stoke Newington, London.

(LA) Lucy Askew gained a postgraduate Masters degree from the Courtauld Institute of Art, and is based in London, U.K. Since 2004 she has been Assistant Curator (International Art Collection) at Tate, primarily working on research, displays and acquisitions. She co-curated the exhibition *Illuminations* held at Tate Modern from December 2007-February 2008.

(LB) Lucy Bradnock gained her BA and MA from the Courtauld Institute, specializing in post-war French art and theory. Following work at Tate and at Hauser & Wirth London, she is currently completing a Ph.D. at Essex University on the reception of Artaud in post-war American art.

(LH) Lucinda Hawksley is an art historian, lecturer and author. Her books include *Katey: The Life and Loves of Dicken's Artist Daughter*, *Lizzie Siddal: The Tragedy of a Pre-Raphaelite Supermodel*, and *Essential Pre-Raphaelites*. She gives regular talks at the National Portrait Gallery in London and is represented by a professional speakers' agency.

(LNF) Lupe Núñez-Fernández is a writer and editor based in London and Madrid. Formerly the senior editor at ArtReview, she is a regular contributor to several art blogs and publications, and occasionally curates experimental film screenings and collaborates on artists' books. She is also one half of Pipas, a pop duo.

(MC) Mary Cooch has a BA (Hons) Degree in History and works as a freelance journalist. She loves to spend time in Italy seeking out Renaissance art and architecture.

(MG) Megan Green studied art history at Stanford University and completed a tutorial at Oxford University focusing on the Young British Artists. She interned at the Museum of Contemporary Art in Chicago, contributed to *1001 Paintings You Must See Before You Die*, and collects contemporary art.

(NG) Nuala Gregory is an Irish Artist and Academic. She has lived and worked in Auckland, New Zealand since 1997. Her research interests are in Painting, Drawing, Contemporary Theory and Arts Education.

(NM) Nicola Moorby is a Curator at Tate Britain. She is co-author of Tate's catalog

on the Camden Town Group and has previously published on Turner, Sickert and other British artists. She is currently working on an new revision of the catalog of the Turner Bequest.

(NSF) Nathalie Sroka-Fillion completed her MA in Medieval Art and Architecture at the Courtauld Institute of Art in London, U.K. She is currently researching architectural illuminations in the thirteenth-century Cantigas de Santa Maria, and divides her time between London and Montreal.

(PS) Philippa Simpson has a BA (hons) in History of Art from the Courtauld Institute of Art, an MsC res from Edinburgh University and is currently completing her Ph.D. as Tate-Courtauld Fellow. In this role she has worked on a number of exhibition and display projects for Tate Britain.

(RB) Richard Bell studied Visual Cultures at the University of Derby and subsequently completed a postgraduate Diploma in Publishing at the London College of Printing. He currently works for an educational publisher in London.

(RL) Randy Lerner was born in Ohio in 1962. He graduated from Columbia College in 1984 and currently lives in New York.

(RM) Rebecca Man graduated from Sussex University in History of Art. She worked at the National Art Collections Fund and the Arts Council of England before moving to Chelsea College of Art and Design, where she worked as a researcher for Stephen Farthing until moving recently to California.

(RS) Rowland James Smith began a journey to experience oriental art at first hand in 1993. He worked initially as an archaeological illustrator in Israel and Sri Lanka. A further four years were spent working in north Thailand helping to restore temple murals, studying Lanna art and architecture indigenous to north Thailand.

(RT) Rachel Tant is an Assistant Curator at Tate Britain, London where she co-curates the Art Now programme of exhibitions by emerging British Artists. She also organized the mid-career survey exhibition of the work of Peter Doig at Tate Britain in 2008.

(SA) Sandra April is an arts consultant in Manhattan who has worked at The Museum of Modern Art, Solomon R. Guggenheim Museum, and the New York Academy of Art. She is the originating editor of *Will Barnet: In His Own Words* and a contributor to *1001 Paintings You Must See Before You Die*.

(SC) Serena Cant studied Anglo-Saxon art at the University of Exeter. She is an art history lecturer specializing in sign-language talks to deaf audiences on the subject of Western art and architecture.

(SF) Stephen Farthing is a painter and the Roostein Hopkins Research Professor in Drawing at the University of the Arts, London. In 1990, he was elected Master of Ruskin School of Drawing, University of Oxford, and a professional Fellow at St. Edmund Hall, Oxford. In 1998 he was elected a Royal Academician.

(SG) Simon Gray studied Media at Sheffield Hallam and worked as editor for Itchy City Guides for four years before starting up a telecommunications company. He divides his time between his business, travel and writing.

(SH) Susie Hodge is an illustrator and teacher, and is also the author of over fifty books and articles. She also writes web resources and booklets for galleries and museums. She has an MA in History of Art and is a Fellow of the RSA.

(TA) Thomas Ardill graduated with an MA from the Courtauld Institute of Art, and has worked on cataloging, curatorial, research and interpretation projects at Tate Britain and the National Portrait Gallery. He specializes in 20th Century British Art and J. M. W. Turner.

(TC) Tracy Le Cornu-Francis studied History of Art and Design at Winchester School of Art, England. Moving to London in 2000, she managed a Modern British art gallery for three years, later taking up a research position in a post-impressionist and modern art gallery. She now lives and freelances in Sydney, Australia.

(TP) Tamsin Pickeral studied History of Art before furthering her education in Italy. She divides her time between writing about art and horses, her most recent publications being *Van Gogh*, *The Impressionists*, *The Dog in Art* and *The Horse in Art*.

(WD) William Davies is a London-based writer and researcher. Currently studying at the Courtauld Institute of Art, he was also a press coordinator for the opening of White Cube's Mason's Yard space.

(WO) Wendy Osgerby is a senior lecturer in History of Art at the University of Northampton, England. Apart from writing on art, she writes fiction, and enjoys being involved in curating.

PICTURE CREDITS

Every effort has been made to credit the copyright holders of the images used in this book. We apologize in advance for any unintentional omissions or errors and will be pleased to insert the appropriate acknowledgment to any companies or individuals in any subsequent edition of the work.

8 National Palace Museum, Taiwan, Republic of China **9** National Palace Museum, Taiwan, Republic of China **10** Asian Art & Archaeology, Inc/Corbis **11** Burstein Collection/Corbis **12 t** Mary Evans Picture Library/Alamy **12 b** The Art Archive/San Francesco Assisi/Alfredo Dagli Orti **13 l** Alinari Archives/Corbis **13 r** Galleria degli Uffizi, Florence, Italy, Giraudon/The Bridgeman Art Library **14** akg-images/Electa **15** Museo dell'Opera del Duomo, Siena, Italy, Alinari/The Bridgeman Art Library **16 t** Louvre, Paris, France/The Bridgeman Art Library **16 b** Scrovegni (Arena) Chapel, Padua, Italy/The Bridgeman Art Library **17** Pinacoteca Nazionale, Bologna, Italy, Alinari/The Bridgeman Art Library **18** Universidad de Sevilla **19** Elio Ciol/Corbis **20** De Agostini/ Photolibrary Group **21** Universidad de Sevilla **22** akg-images/Joseph Martin **23** Tretyakov Gallery, Moscow, Russia/The Bridgeman Art Library **24 t** Universidad de Sevilla **24 b** Museo dell' Opera del Duomo, Florence, Italy/The Bridgeman Art Library **25** The Art Archive/Duomo Florence/Gianni Dagli Orti **26** akg-images/Erich Lessing **27 t** Louvre, Paris, France/The Bridgeman Art Library **27 b** akg-images **28** akg-images/Rabatti – Domingie **29** akg-images/Orsi Battaglini **30** National Gallery Collection; By kind permission of the Trustees of the National Gallery, London/ Corbis **31** akg-images/Erich Lessing **32** Museo di San Marco dell'Angelico, Florence, Italy/The Bridgeman Art Library **33** akg-images/Orsi Battaglini **34 t** Louvre, Paris, France/The Bridgeman Art Library **34 b** © Ashmolean Museum, University of Oxford, UK/The Bridgeman Art Library **35** National Gallery Collection; By kind permission of the Trustees of the National Gallery, London/ Corbis **36** The Gallery Collection/Corbis **37** akg-images/Joseph Martin **38** Sandro Vannini/Corbis **39** akg-images/Cameraphoto **40 t** Universidad de Sevilla **40 b** Galleria degli Uffizi, Florence, Italy, Alinari/The Bridgeman Art Library **41** Galleria Nazionale delle Marche, Urbino, Italy/The Bridgeman Art Library **42** Museu de Arte de Catalunya, Barcelona, Spain/The Bridgeman Art Library **44 t** akg-images / Erich Lessing **44 b** © Muzeum Narodowe, Gdansk, Poland/The Bridgeman Art Library **45** Galleria Sabauda, Turin, Italy, Alinari/The Bridgeman Art Library **46** Musee Conde, Chantilly, France, Lauros/Giraudon/The Bridgeman Art Library **47 t** De Agostini/ Photolibrary Group **47 b** Louvre, Paris, France, Lauros/Giraudon/The Bridgeman Art Library **48** Palazzo Ducale, Mantua, Italy, Alinari/The Bridgeman Art Library **49** Kunsthistorisches Museum, Vienna, Austria, Ali Meyer/The Bridgeman Art Library **50** Universidad de Sevilla **51** Sandro Vannini/ Corbis **52 t** Universidad de Sevilla **52 b** Galleria degli Uffizi, Florence, Italy/The Bridgeman Art Library **53** Galleria degli Uffizi, Florence, Italy, Giraudon/The Bridgeman Art Library **54** The Art Archive/Gianni Dagli Orti **55** Santa Trinita, Florence, Italy/The Bridgeman Art Library **56 t** Galleria degli Uffizi, Florence, Italy/The Bridgeman Art Library **56 b** Louvre, Paris, France/The Bridgeman Art Library **57** Vatican Museums and Galleries, Vatican City, Italy, Giraudon/The Bridgeman Art Library **58 t** Biblioteca Reale, Turin, Italy/The Bridgeman Art Library **58 b** The Art Archive/Galleria degli Uffizi Florence/Gianni Dagli Orti **59** The Gallery Collection/Corbis **61** Louvre, Paris, France, Giraudon/The Bridgeman Art Library **62** © 1990 Photo Scala, Florence **63** Mary Evans Picture Library **64 t** Prado, Madrid, Spain, Giraudon/The Bridgeman Art Library **64 b** Graphische Sammlung Albertina, Vienna, Austria/The Bridgeman Art Library **65** l Galleria degli Uffizi, Florence, Italy/The Bridgeman Art Library **65 r** Private Collection/The Bridgeman Art Library **66** Galleria degli Uffizi, Florence, Italy/The Bridgeman Art Library **67** Metropolitan Museum of Art, New York, USA/The Bridgeman Art Library **68 t** akg-images/Erich Lessing **68 b** akg-images/Electa **69** akg-images/Erich Lessing **70** akg-images/Erich Lessing **71** Corbis **72** Graphische Sammlung, Kassel, Germany © Museumslandschaft Hessen Kassel/The Bridgeman Art Library **73** akg-images **74 t** Galleria degli Uffizi, Florence, Italy/The Bridgeman Art Library **74 b** Vatican Museums and Galleries, Vatican City, Italy, Giraudon/The Bridgeman Art Library **75 l** akg-images/Erich Lessing **75 r** akg-images/Rabatti – Domingie **77** Dunham Massey, Cheshire, UK, National Trust Photographic Library/Angelo Hornak/The Bridgeman Art Library **78** Galleria degli Uffizi, Florence, Italy/The Bridgeman Art Library **79 t** Prado, Madrid, Spain/The Bridgeman Art Library **79 b** National Gallery Collection; By kind permission of the Trustees of the National Gallery, London/Corbis **80** Gianni Dagli Orti/Corbis **81** Santa Maria Gloriosa dei Frari, Venice, Italy, Giraudon/ The Bridgeman Art Library **82** Gemaldegalerie, Brunswick, Germany, Giraudon/The Bridgeman Art Library **83** National Gallery, London, UK/The Bridgeman Art Library **84** © Samuel Courtauld Trust, Courtauld Institute of Art Gallery/The Bridgeman Art Library **85** Gabinetto dei Disegni e Stampe, Uffizi, Florence, Italy/The Bridgeman Art Library **86 t** Arte & Immagini srl/Corbis **86 b** National Gallery, London, UK/The Bridgeman Art Library **87 l** © National Gallery of Scotland, Edinburgh, Scotland/The Bridgeman Art Library **87 r** Private Collection/The Bridgeman Art Library **88** Mary Evans Picture Library **89** Kunsthistorisches Museum, Vienna, Austria, Ali Meyer/The Bridgeman Art Library **91** Galleria degli Uffizi, Florence, Italy/The Bridgeman Art Library **92 t** Louvre, Paris, France, Lauros/Giraudon/The Bridgeman Art Library **92 b** National Gallery, London, UK/The Bridgeman Art Library **93** Galleria dell' Accademia, Venice, Italy, Cameraphoto Arte Venezia/The Bridgeman Art Library **94 t** akg-images **94 b** The Gallery Collection/Corbis **95** The Gallery Collection/Corbis **96** Bibliotheque de l'Histoire du Protestantisme, Paris, France/The Bridgeman Art Library **97** akg-images/Erich Lessing **98** Alinari Archives/Corbis **98 b** Louvre, Paris, France, Peter Willi/The Bridgeman Art Library **99** National Gallery Collection; By kind permission of the Trustees of the National Gallery, London/Corbis **100** Mary Evans Picture Library **101** Muzeum Zamek, Lancut, Poland/The Bridgeman Art Library **102 t** Francis G. Mayer/ Corbis **102 b** Purchase, Joseph Pulitzer Bequest, 1924. Acc.n.: 24.197.1. © 2007. Image copyright The Metropolitan Museum of Art/Art Resource/Scala, Florence **103** Archivo Iconografico, S. A./Corbis **104** Victoria & Albert Museum, London, UK, The Stapleton Collection/The Bridgeman Art Library **105** Zenodot Verlagsgesellchaft **106 t** Galleria degli Uffizi, Florence, Italy/The Bridgeman Art Library **106 b** Massimo Listri/Corbis **107** Palazzo Farnese, Rome, Italy/The Bridgeman Art Library **108** AISA Media **109** Classic Image/Alamy **110 t** Galleria Borghese, Rome, Italy, Lauros/Giraudon/The Bridgeman Art Library **110 b** National Gallery Collection; By kind permission of the Trustees of the National Gallery, London/Corbis **111** Co-Cathedral of St. John, Valletta, Malta/The Bridgeman Art Library **112 t** Galleria degli Uffizi, Florence, Italy/The Bridgeman Art Library **112 b** The Gallery Collection/Corbis **113** National Gallery Collection; By kind permission of the Trustees of the National Gallery, London/Corbis **114** Sotheby's/akg-images **116** akg-images/Erich Lessing **117** Sotheby's/akg-images **118 t** Louvre, Paris, France, Giraudon/The Bridgeman Art Library **118 b** National Gallery of Victoria, Melbourne, Australia/The Bridgeman Art Library **119** © Wallace Collection, London, UK/The Bridgeman Art Library **120** National Gallery, London, UK/ The Bridgeman Art Library **121** Prado, Madrid, Spain, Index/The Bridgeman Art Library **122 t** Galleria Borghese, Rome, Italy/The Bridgeman Art Library **122 b** Galleria degli Uffizi, Florence, Italy/The Bridgeman Art Library **123** l Massimo Listri/Corbis **123 r** Galleria Borghese, Rome, Italy, Lauros/Giraudon/The Bridgeman Art Library **124** Mary Evans Picture Library **125** Private Collection/The Bridgeman Art Library **126** Reproduced by permission of The State Hermitage Museum, St. Petersburg, Russia/Corbis **127 t** Museo de Bellas Artes, Seville, Spain, Giraudon/The Bridgeman Art Library **127 b** Prado, Madrid, Spain, Giraudon/The Bridgeman Art Library **128** National Gallery Collection; By kind permission of the Trustees of the National Gallery, London/ Corbis **129** Metropolitan Museum of Art, New York, USA/The Bridgeman Art Library **130** Musee des Beaux-Arts, Tours, France/The Bridgeman Art Library **131 t** National Gallery, London, UK/ The Bridgeman Art Library **131 b** © Staatliche Kunstsammlungen Dresden/The Bridgeman Art Library **132** Burstein Collection/Corbis **133 t** National Gallery Collection; By kind permission of the Trustees of the National Gallery, London/Corbis **133 b** Mauritshuis, The Hague, The Netherlands/The Bridgeman Art Library **135** Rijksmuseum, Amsterdam, The Netherlands/The Bridgeman Art Library **139** Burstein Collection/Corbis **140** The Gallery Collection/Corbis **© Lawrence Steigrad Fine Arts, New York/The Bridgeman Art Library **141** Private Collection, Photo © Christie's Images/The Bridgeman Art Library **142** akg-images **143 t** akg-images/Erich Lessing **143 b** akg-images/Erich Lessing **144** akg-images/Erich Lessing **146** Museo Civico, Treviso, Italy, Lauros/Giraudon/The Bridgeman Art Library **147** akg-images **148** Yale Center for British Art, Paul Mellon Collection, USA/The Bridgeman Art Library **149** Private Collection/The Bridgeman Art Library **150 t** Bibliotheque Nationale, Paris, France, Giraudon/The Bridgeman Art Library **150 b** National Gallery Collection; By kind permission of the Trustees of the National Gallery, London/ Corbis **151** Hermitage, St. Petersburg, Russia/The Bridgeman Art Library **153** Araldo de Luca/Corbis **154 t** Galleria degli Uffi.., Florence, Italy/Giraudon/The Bridgeman Art Library **154 b** The Gallery Collection/Corbis, London 2008 **155** Private Collection/ Photo © Rafael Valls Gallery, London, UK/The Bridgeman Art Library **156 t** © Walker Art Gallery, National Museums Liverpool/The Bridgeman Art Library **156 b** Royal Academy of Arts Library, London/The Bridgeman Art Library **157** National Gallery of Victoria, Melbourne, Australia/The Bridgeman Art Library **158** Royal Academy of Arts, London, UK/The Bridgeman Art Library **159** akg-images **160** Smithsonian Institution/Corbis **161** Yale Center for British Art, Paul Mellon Collection, USA/The Bridgeman Art Library **162** Galleria degli Uffizi, Florence, Italy/The Bridgeman Art Library **163** Musee Bonnat, Bayonne, France/Giraudon/The Bridgeman Art Library **164 t** Real Academia de Bellas Artes de San Fernando, Madrid, Spain/The Bridgeman Art Library **164 b** Prado, Madrid, Spain/Giraudon/The Bridgeman Art Library **165** The Gallery Collection/Corbis **167** Archivo Iconografico, S.A./ Corbis **168 t** Louvre, Paris, France/The Bridgeman Art Library **168 b** Musee Nat. du Chateau de Malmaison, Rueil-Malmaison, France, Lauros/Giraudon/The Bridgeman Art Library **169 l** Louvre, Paris, France/Giraudon/The Bridgeman Art Library **169 r** Musees Royaux des Beaux-Arts de Belgique, Brussels, Belgium/The Bridgeman Art Library **170** British Library, London, UK/© British Library Board. All Rights Reserved/The Bridgeman Art Library **172** Galleria degli Uffizi, Florence, Italy/The Bridgeman Art Library **174** © National Gallery of Scotland, Edinburgh, Scotland/The Bridgeman Art Library **175** Lordprice Collection/Alamy **176** Galleria degli Uffizi, Florence, Italy/Giraudon/The Bridgeman Art Library **177** The Print Collector/Alamy **178 t** The Art Archive/ Bibliothèque des Arts Décoratifs Paris/Gianni Dagli Orti **178 b** UCL Art Collections, University College London, UK/The Bridgeman Art Library **179** Musee Claude Monet, Giverny, France/ Giraudon/The Bridgeman Art Library **181** © Nationalmuseum, Stockholm, Sweden/The Bridgeman Art Library **182** Hamburger Kunsthalle, Hamburg, Germany/The Bridgeman Art Library **183 t** © Sheffield Galleries and Museums Trust, UK/The Bridgeman Art Library **183 b** National Gallery Collection; By kind permission of the Trustees of the National Gallery, London/Corbis **185** National Gallery Collection; By kind permission of the Trustees of the National Gallery, London/Corbis **186** Victoria & Albert Museum, London, UK/The Bridgeman Art Library **187 t** National Gallery, London, UK/The Bridgeman Art Library **187 b** Private Collection/The Bridgeman Art Library **188 t** Koninklijk Museum voor Schone Kunsten, Antwerp, Belgium/Giraudon/The Bridgeman Art Library **188 b** Louvre, Paris, France/Lauros/Giraudon/The Bridgeman Art Library **189** Louvre, Paris, France/Giraudon/The Bridgeman Art Library **190** King's College, University of London, UK/The Bridgeman Art Library **192** Courtesy www.portrait.kaar.at **193** Vanni Archive/Corbis **194 t** Musee des Beaux-Arts, Rouen, France/Lauros/Giraudon/The Bridgeman Art Library **194 b** Louvre, Paris, France/Giraudon/The Bridgeman Art Library **195** Musee des Beaux-Arts, Rouen, France/Lauros/Giraudon/The Bridgeman Art Library **196** Hulton-Deutsch Collection/ Corbis **197** Louvre, Paris, France/Giraudon/The Bridgeman Art Library **198** © Leeds Museums and Galleries (City Art Gallery) U.K/The Bridgeman Art Library **199** Louvre, Paris, France/Lauros/ Giraudon/The Bridgeman Art Library **200** © Collection of the New-York Historical Society, USA/The Bridgeman Art Library **201** Private Collection/The Bridgeman Art Library **203** Private Collection/The Stapleton Collection/The Bridgeman Art Library **205** Burstein Collection/Corbis **206** Private Collection/The Stapleton Collection/The Bridgeman Art Library **207** akg-images **208 t** Musee Fabre, Montpellier, France/Giraudon/The Bridgeman Art Library **208 b** Musee Fabre, Montpellier, France/Giraudon/The Bridgeman Art Library **209** Musee d'Orsay, Paris, France/The Bridgeman Art Library **210** Fogg Art Museum, Harvard University Art Museums, USA/Bequest of Grenville L. Winthrop/The Bridgeman Art Library **211** Hulton-Deutsch Collection/Corbis **212** Musee Gustave Moreau, Paris, France/Roger-Viollet, Paris/The Bridgeman Art Library **213** Bettmann/Corbis **214** Visual Arts Library (London)/ Alamy **215** Chris Hellier/Corbis **216 t** © Birmingham Museums and Art Gallery/The Bridgeman Art Library **216 b** ©The Barber Institute of Fine Arts, University of Birmingham/The Bridgeman Art Library **217** © Birmingham Museums and Art Gallery/The Bridgeman Art Library **218** © Walker Art Gallery, National Museums Liverpool/The Bridgeman Art Library **219** Musee d'Orsay, Paris, France/The Bridgeman Art Library **220** akg-images **221** Musee d'Orsay, Paris, France/The Bridgeman Art Library **222 t** Private Collection/ Peter Willi/The Bridgeman Art Library **222 b** The Gallery Collection/Corbis **223** The Gallery Collection/Corbis **224** © Samuel Courtauld Trust, Courtauld Institute of Art Gallery/The Bridgeman Art Library **225** Musee Conde, Chantilly, France, Giraudon/The Bridgeman Art Library **226 t** The Detroit Institute of Arts, USA/Gift of Henry Glover Stevens/The Bridgeman Art Library **226 b** Musee d'Orsay, Paris, France/The Bridgeman Art Library **227 l** © Yale Center for British Art, Paul Mellon Fund, USA/The Bridgeman Art Library **227 r** The Detroit Institute of Arts, USA/Gift of Dexter M. Ferry Jr./The Bridgeman Art Library **228 t** Museu Calouste Gulbenkian, Lisbon, Portugal/Giraudon/The Bridgeman Art Library **228 b** Art Gallery and Museum, Kelvingrove, Glasgow, Scotland/© Glasgow City Council (Museums)/The Bridgeman Art Library **229** Musee d'Orsay, Paris, France/The Bridgeman Art Library **230** Summerfield Press/Corbis **231** Bettmann/Corbis **232** Galleria degli Uffizi, Florence,

ACKNOWLEDGMENTS

Quintessence would like to thank the following people for their help in the preparation of this book:

Rob Dimery

Phil Hall

David Hutter

General Editor Acknowledgments

Stephen Farthing would like to thank Randy Lerner for his support and guidance.